The Apocalypse
in the Middle Ages

The Apocalypse
in the Middle Ages

Edited by

Richard K. Emmerson
and
Bernard McGinn

Cornell University Press

Ithaca and London

Dedicated to

Marjorie E. Reeves

Contents

Abbreviations

CC *Corpus Christianorum: Series Latina.* Turnhout, 1954– .

CCCM *Corpus Christianorum: Continuatio Mediaevalis* (part of the *CC*).

CSEL *Corpus Scriptorum Ecclesiasticorum Latinorum.* Vienna, 1866– .

EETS *Early English Text Society. Original Series.* London, 1864– .

MGH *Monumenta Germaniae Historica.* Hannover and Berlin, 1826– .

 MGHAA. Auctores Antiquissimi.

 MGHEp. Epistolae.

 MGHLdl. Libelli de Lite.

 MGHLL. Leges.

 MGHPoetae. Poetae Latini Medii Aevi.

 MGHQ. Quellen zur Geistesgeschichte des Mittelalters.

 MGHSS. Scriptores.

 MGHSSrrG. Scriptores rerum Germanicarum.

PL J. P. Migne, ed. *Patrologiae Cursus Completus: Series Latina.* Paris, 1844–64. 221 vols.

SC *Sources chrétiennes.* Paris, 1940– .

Preface

Few books begin as straightforwardly, proceed as obscurely, and end as hopefully as John's Apocalypse. John starts by telling us exactly what the book is and whence it comes: "The revelation of Jesus Christ which God gave him, to make known to his servants the things that must shortly come to pass; and he sent and signified them through his angel to his servant John. . . . Blessed is he who reads and those who hear the words of this prophecy, and keep the things that are written therein; for the time is at hand" (Apoc. 1:1–2). After twenty-two chapters as noted for their obscurity as for their powerful imagery, the book concludes with a direct address from Jesus, the true Apocalypticist, guaranteeing the authenticity of the message and promising its imminent fulfillment: "He who testifies to these things says, 'It is true, I come quickly.' " To which John the recipient, or perhaps the communities to which he conveyed the revelation, respond, "Amen! Come Lord Jesus!" (Apoc. 22:20).

The Apocalypse of John is not only an insistent book, but a puzzling, even an upsetting book, filled with scenes witnessing to God's glory, but also with a spirit of vengeance, both divine and human, that seems at war with much of the rest of the New Testament. It is written in a bizarre form of Greek, even by New Testament standards, and its literary structure appears to have been a puzzle almost from the beginning. In every age (not least our own) some bold readers have been convinced that they have finally uncovered the true secret of its meaning; but these readings have been judged at best partial, more usually erroneous, by subsequent generations. It is difficult for the historian to believe that the most detailed historical-critical analyses of current biblical scholarship, as well as the cleverest recent literary appraisals, are not meant for the same fate. The Apocalypse—more than all the other revelations of antiquity—appears as a *coincidentia oppositorum*, a revelation that conceals.

The Apocalypse's success in hiding its own meaning has been at least partially compensated for by its ability to reveal so much about the character of its interpreters. Few books in Scripture have been so frequently commented upon, and fewer have had such an impact on the symbolic imagination of Western culture. Even those modern readers who no longer believe that the Apocalypse, or the Bible as a whole, is in any way a sacred book, are increasingly convinced that it is one of the necessary books—a cultural artifact that has variously shaped and influenced our civilization for almost two thousand years.

The full story of this influence has not been told, though some useful contributions exist. This volume attempts to present an important part of the story by studying some of the uses of the Apocalypse during the period of more than a millennium usually called the Middle Ages. Beginning with fourth-century appropriation of the book, both in the creative new readings of Tyconius and Augustine and in the early monuments of the art of triumphant Christianity, it tries to portray major elements of the Apocalypse's influence down to the fifteenth century and the eve of the Reformation. Obviously, even a lengthy book will leave many parts of the story untold; but we hope that the essays contained here will at least begin to reveal some of the ways John's veiled unveiling shaped the Christian culture of the Middle Ages.

In teaching the history of medieval apocalypticism to students over the years, we had both come to sense the acute need for a survey of the central role of John's Apocalypse in medieval culture. To the best of our knowledge, there was no volume in English (or in any other language) that tried to present the impact the Apocalypse had, not only on theology and exegesis, but also on art, on literature, on historical thinking, and on the myriad components that make up the indefinable complex we call culture. To try, however imperfectly, to present this richness was a task calling for a team of experts from diverse disciplines. A generation ago this book probably could not have been written. Fortunately, over the past few decades the study of the Apocalypse's influence has attracted the attention of just such a diversity of excellent scholars. Hence the time seemed ripe to gather in a single volume at least some of the fruits of this outpouring of scholarship. The results of our efforts are to be found in the pages and pictures that follow.

A word about the format of the book: From our earliest discussions, it was clear that a threefold model was necessary. The theological appropriation of the Apocalypse in medieval thought, especially through the history of its exegesis, was the foundation on which the other uses of the book were based, and it therefore required a section of its own. The impact of the Apocalypse in art obviously formed a second clearly delineated area of study. But theology and art by no means exhaust the story of the Apocalypse in the Middle Ages. Even literature, unless taken in the broadest possible sense, does not capture all the ways in which John's powerful revelation seeped into almost every aspect of medieval life. And so a third

section, under the general rubric of the Apocalypse in Medieval Culture, seemed necessary.

Each section begins with an introductory essay. In the case of the first part, "The Apocalypse in Medieval Thought," Bernard McGinn's piece, "John's Apocalypse and the Apocalyptic Mentality," concentrates on background, surveying the place of the Apocalypse in the development of apocalyptic eschatology and analyzing how the book was received by the early Church. The five essays that make up Part I illustrate the most important chapters in the appropriation of the Apocalypse in medieval thought from the fourth through the fourteenth centuries. Peter Klein's essay, "The Apocalypse in Medieval Art," is a large survey summarizing the wealth of appearances of the Apocalypse in medieval art. It provides an overview that frames the more detailed thematic and formal analyses of the other five essays in Part II. Finally, Richard Emmerson's essay, "The Apocalypse in Medieval Culture," takes on the difficult task of introducing the more elusive, but equally important roles of the Apocalypse in the medieval imagination, particularly its literary imagination. Of the four essays in Part III, two deal primarily with literature, one with liturgy, and one with historical writing. Obviously, other areas of medieval culture might have been included, but we considered these good examples of the range of the Apocalypse's influence. Throughout the essays the text of the Bible is quoted according to the Douay-Challoner-Rheims translation since this version is based on the Latin Vulgate used in the Middle Ages. All translations from medieval sources, unless otherwise noted, are by the contributors.

We thank, first and foremost, our contributors, both for the enthusiasm with which they greeted the project and for their efforts in making a wish into a reality. We appreciate the considerable patience they have all shown throughout the time of this apocalyptic gestation. We also thank Jeffrey Burton Russell, for steering us in the direction of Cornell University Press, and especially John Ackerman, the director of the Press, for the encouragement and help he has given the project from its very early stages. To the many libraries, museums, and other institutions who have generously given permission for the use of illustrated materials (without which the book, as we envisaged it, could not have been), we also offer heartfelt thanks. Bernard McGinn would like to thank Shawn Madison Krahmer and Amy Limpitlaw for valuable help in the editorial process. Richard Emmerson would like to thank the librarians of Georgetown University and Western Washington University and to acknowledge with genuine gratitude the unwavering support of Sandra Clayton-Emmerson.

Finally, we take great pleasure in dedicating this volume with gratitude to Marjorie E. Reeves, whose research on the history of medieval apocalypticism has enriched all scholars working in the area and whose unfailing generosity and warm affection have put so many in her debt.

RICHARD K. EMMERSON and BERNARD McGINN

PART ONE

The Apocalypse in
Medieval Thought

Introduction:
John's Apocalypse and
the Apocalyptic Mentality

Bernard McGinn

The most direct and obvious aspect of the Apocalypse's influence in the Middle Ages is to be found in the history of theology, especially the history of exegesis, which in recent years has rightfully assumed a major role in medieval studies. Most patristic and early medieval theology was inseparable from exegesis and expressed itself either in commentaries on the sacred text or in homilies on biblical pericopes. Even after the creation of the new Scholastic model of theology in the twelfth century, theologians were expected to be practicing exegetes as well as speculative systematizers.

For this reason it is important to begin our considerations of the role of the Apocalypse in medieval society with a look at the theological meaning of the text and its reception. Though the book's impact spread far beyond theology in the narrow sense, and although it is often difficult to draw direct connections between exegetic and theological debates and broader cultural impact, some knowledge of the book's role in religious thought in the technical sense is necessary, if not sufficient, for comprehending its wider influence.

The essays in this first part examine key understandings of the Apocalypse from the fourth through fourteenth centuries. Paula Fredriksen presents the beginning of the story: the important interventions of Tyconius and Augustine that were to shape the Western, nonmillenarian view of the Apocalypse for centuries to come. E. Ann Matter studies the evolution of this view through the early medieval commentators up to the twelfth century. That century witnessed important shifts in the understanding of the

This essay is based in part on the first of three Haskell Lectures delivered at Oberlin in April of 1988. I thank the Oberlin College community and the Haskell Committee for the opportunity to present my ideas and for the helpful suggestions I received.

Apocalypse, as the essays of Robert E. Lerner and E. Randolph Daniel
show. Millenarianism in the broad sense of hope for a period of final peace
on earth before the end of time had not been completely crushed by Au-
gustine. Revived by the teachings of Joachim of Fiore (see Daniel's essay),
it became increasingly popular in the late Middle ages, even leading to a
return of literal views of the thousand-year reign of Christ and the Apos-
tles (see Lerner's essay). The conflict over interpretations of the meaning
of the Apocalypse which these and other hermeneutic differences engen-
dered is particularly evident in thirteenth- and fourteenth-century exege-
sis, nowhere more richly than in the commentaries of the Franciscans and
Dominicans which David Burr delineates in the final essay in Part I. To be
sure, the work of commenting on the Apocalypse did not cease in the four-
teenth century; but it is fair to say that all the major interpretive possi-
bilities of the medieval period had by then emerged.

The medieval use of the Apocalypse was not created in a vacuum. Ty-
conius and Augustine were wrestling with a text many Christians had
found problematic for at least two centuries. Medieval understandings of
John's mysterious unveiling need always to be seen against the back-
ground of the meaning of apocalyptic eschatology as a religious phenom-
enon and the patristic debates over the Apocalypse. Although medieval
authors obviously lacked modern historical-critical insight into the ori-
gins and development of apocalyptic eschatology as a distinctive theology
of history, they did have direct access to an apocalyptic world view, not
only through the Apocalypse but also through many other texts, both ca-
nonical and noncanonical. They may have understood these texts better
than we do, at least insofar as they shared apocalyptic views of the nature
and meaning of history.

APOCALYPTIC ESCHATOLOGY

The ambiguous relation of Michelangelo's stupendous *Last Judgment*,
painted on the west end of the Sistine Chapel between 1536 and 1541, to
the harmonious portrayal of salvation history he had executed on that
chapel's ceiling between 1508 and 1512 may provide us with a visual an-
alogue for the relation of the new vision of reality found in the apocalypses
of late Second Temple Judaism (ca. 300 B.C.–A.D. 70) to earlier stages in
the evolution of the Jewish religion. The effect of this dynamic and fright-
ening fresco, as some art historians have claimed, is to introduce "a sec-
ond reality" into the artistic ensemble of the chapel.[1] The spectator—one
might better say "humanity as spectator"—is disoriented by this abrupt
break, enigmatic and fearful, with the generally serene order of Old Tes-

[1] See Pierluigi de Vecchi, "Michelangelo's Last Judgement," *The Sistine Chapel* (New
York, 1986), 184, citing J. Wilde, *Michelangelo: Six Lectures* (Oxford, 1978), 162–63.

tament history presented on the ceiling. Michelangelo's *Last Judgment* might be described as an iconoclastic icon, an image that threatens the existence and meaning of the other images and the view of sacred history they represent.

Michelangelo's apocalyptic *Last Judgment* and the "second reality" it compels the viewer to address is an apt reflection of the multiple disturbances apocalyptic literature introduced into Western religious history, first in Judaism and subsequently in nascent Christianity. These new apocalyptic texts were in many ways disruptive of the religion of the earlier strata of the Hebrew Bible. In Christian history, especially through its greatest monument, the Apocalypse of John, the apocalyptic mentality has continued to produce new religious challenges, no matter how often it has been domesticated and routinized.

Recent study has emphasized the relation of the Jewish and early Christian apocalypses to a whole range of religious literature of the Hellenistic world in the last centuries before the Christian era.[2] For over a century, much attention has also been given to the roots linking the apocalypses to earlier parts of the Hebrew Bible, especially to the prophetic and wisdom literature.[3] Significant as these connections are (no phenomenon in human history is totally new), it is more important to emphasize how radically far the apocalyptic mentality was both from traditional Jewish religious thought and from similar concerns with eschatology found elsewhere in the Hellenistic world. The new and challenging nature of the religious vision found in the apocalypses and in related texts is evident in the manner of the revelation, the content of the message, the kind of God who reveals, even the kind of salvation promised.[4]

The novelty of the apocalyptic world view becomes clearer when we make the seemingly elementary distinction between an apocalyptic genre of revelatory literature and an apocalyptic eschatology, the latter being apocalypticism understood as a particular view of history and its final events. The fifteen or so Jewish texts of the Second Temple period which can be said to fulfill the formal requirements of "apocalypse" as a mediated revelation of heavenly secrets to a human sage, contain a variety of messages—cosmological, speculative, historical, eschatological, and moral. They form the entry point into Western history for not one, but an interconnected series, of new religious mentalities.

[2] See, e.g., the essays in *Apocalypticism in the Mediterranean World and the Near East*, ed. David Hellholm (Tübingen, 1983).

[3] For a brief survey of the study of apocalyptic literature in biblical theology since the nineteenth century, see Walter Schmithals, *The Apocalyptic Movement: Introduction and Interpretation* (Nashville, 1975), 50–67.

[4] See, e.g., Ithamar Gruenwald, "Jewish Apocalypticism to the Rabbinic Period," *The Encyclopedia of Religion*, ed. Mircea Eliade et al. (New York, 1987), 1:336–42; Michael Stone, "Eschatology, Remythologization, and Cosmic Aporia," in *The Origins and Diversity of Axial Age Civilizations*, ed. S. N. Eisenstadt (Albany, 1986), 241–51; and John J. Collins, *The Apocalyptic Imagination* (New York, 1984).

The genre apocalypse appears to fall into two broad types, one based on a heavenly journey in which the seer receives his message in the celestial realm through the mediation of an angel, the other in which the message is conveyed on earth but also through the agency of some celestial figure.[5] The secrets are revealed through both visual and auditory means. The heavenly journey type tends to be more interested in the revealing of cosmological and astronomical secrets and in the eventual fate of the soul; the other type is usually more concerned with the meaning of history, especially the approaching final drama of crisis and divine judgment. Nevertheless, the interest in the heavenly world and the concern for history and its end are frequently intermingled in the apocalypses, both Jewish and Christian, as are the modes of revelation. This is also true of John's Apocalypse and of its later interpreters and users.

In its Jewish origins, the apocalyptic mode of revelation is always pseudonymous, that is, fictionally ascribed to a long-dead sage in order to provide it with enhanced authority. It is also invariably mediated by an angelic figure. Above all, it is textual: something meant to be written down. Thus apocalyptic revelation is part of a broad movement away from the word of God conveyed in oral proclamation and tradition and toward the word of God fixed in written texts. The apocalypses are products of a learned elite. Sociologically speaking, they appear to be tied to challenges to more traditional priestly authority by scribes with the skills to compose and interpret sacred writings.

The scribal context was common to much of the literature of this period of Judaism.[6] The apocalypses, however—unlike the Qumran texts (i.e., the Dead Sea Scrolls) and the New Testament with its habit of citing Old Testament texts as prophecy fulfilled—are not directly exegetic. In reacting against older biblical forms of expressing God's communication to humanity, the authors of the apocalypses tried to have it both ways by pseudonymously composing their new texts in the name of ancient biblical heroes (Adam, Enoch, Moses, Ezra, and so forth) and at the same time insisting that these heroes, like themselves, were visionaries and scribes whose divine commission was to write down what they had seen and heard in a book to store it up for the learned scribes (the authors themselves) who would subsequently "re-reveal" it to the faithful.

The scribal milieu within which the apocalypses were born helps explain how, especially in apocalyptic traditions, interpretation becomes new creation. Later apocalypses, both Jewish and Christian, built on ear-

[5] The most complete recent study of the genre is John J. Collins, ed., *Apocalypse: Morphology of a Genre* (Missoula, 1979).

[6] The best overview is Michael E. Stone, ed., *Jewish Writings of the Second Temple Period*, sec. 2 of *Compendia Rerum Iudaicarum ad Novum Testamentum* (Philadelphia, 1984). Many of these writings, including the noncanonical apocalypses, appear in new translations in James H. Charlesworth, ed., *The Old Testament Pseudepigrapha*, vol. 1, *Apocalyptic Literature and Movements* (New York, 1983).

lier ones in complex ways. The Apocalypse of John is, at least in part, a reworking of the canonical apocalypse of Daniel and other traditional materials. The fact that in the history of Christian apocalypticism, it is the exegesis of John's book and the other scriptural apocalyptic texts that takes center stage, not the production of new visions of the End (though these, too, have their importance), is the outcome of a tendency present in apocalyptic eschatology from the start.

Both the apocalypses themselves, and the broader apocalyptic mentality present in other texts from the Second Temple period, witness to a renewed emphasis on visionary experience as a form of religious authentification for messages from God.[7] The great vision described in Ezekiel 1 was an important source for this turn toward the visionary which is so powerfully present in John's Apocalypse, but apocalyptic visions differ from this prototype in several ways, especially because they often take place in heaven.

"The heavens are the heavens of the Lord, but the earth he has given to the sons of men" (Ps. 115:16). No Hebrew prophet, not even Isaiah and Ezekiel, had gone up to heaven. God had always condescended to come down to earth. The apocalyptic seers, however, do make heavenly ascents in order to receive divine mysteries that older Jewish beliefs had held to be inaccessible to humanity. As Ithamar Gruenwald puts it, "Seen from the point of view of scripture, the type of knowledge found in apocalypticism is unprecedented in its scope, depth, and, what is even more important, its finality."[8] This wisdom is both "vertical," that is, a revelation of the secrets of heaven and the universe, and "horizontal," an uncovering of the meaning of history and its end. Apocalypses emphasize one or the other of these broad modes of secret knowledge, although they often coexist, as I have already noted.

In the horizontal dimension, angelic mediators show the seer the meaning of history conceived of as a divinely predetermined, universal teleological process. The apocalyptic view of history is far from any modern idea of progress: no form of human effort within history prepares for the End, but it is still this end, understood as pure divine irruption, which gives meaning to the whole and allows us to speak of apocalyptic eschatology as teleological. Such apocalyptic renderings of history sometimes include a more or less developed sketch of the succession of ages that constitutes the whole of history, though the Apocalypse does not.[9] They always, however, contain a prophetic account of the imminent triple drama of the last times: a present crisis (frequently one of persecution), a coming,

[7] See Christopher Rowland, *The Open Heaven: A Study of Apocalyptic in Judaism and Early Christianity* (New York, 1982).

[8] Gruenwald, "Jewish Apocalypticism," 340.

[9] See Jacob Licht, "Time and Eschatology in Apocalyptic Literature and in Qumran," *Journal of Jewish Studies* 16 (1965): 177–82.

decisive divine intervention or judgment, and the final reward of the just and the punishment of the evil.

The older prophets of the Hebrew Bible had looked forward to the coming "day of the Lord" to vindicate God's justice on earth. They also had a profound sense of divine intervention in the historical events of the day. Behind this conviction stood the foundational event of the religious identity of the Jewish people, the conviction that God had delivered them from their Egyptian persecutors and had brought them into the land of promise. Deeper still lay the primordial myth they shared with other Near Eastern peoples, of the struggle between the Creator God and the forces of chaos symbolized by the monstrous Dragon. The apocalyptic myth of history subsumes all these elements or levels, recasting them into a new form. As Michael Stone has said, "The biblical conception of God's action was stubbornly retained, but the meaning of that action and of history was sought in encompassing patterns leading from *Urzeit*, through history, to *Endzeit*."[10]

The reemergence of ancient mythical patterns in apocalyptic eschatology gives the apocalyptic view of history not only much of its symbolic power but also a dualistic coloring, both through its emphasis on the cosmic battle between good and evil powers above and below and through its contrast between two aeons or ages, the present evil age and the good, messianic era to come. But we must not exaggerate this dualism into one of a metaphysical Gnostic or Manichaean sort. What sets apocalyptic eschatology apart from its biblical predecessors, as well as from the strong dualisms, is its conviction of God's absolute and predetermined control over the whole of history, a mystery hidden from all ages but now revealed to the apocalyptic seer. If apocalypticism expresses pessimism about the present aeon, it is profoundly optimistic about the aeon to come, whether it is to bring about the immediate entry of the just into eternal joy or a messianic kingdom as an earthly preparation for everlasting happiness. This optimistic messianic element in apocalyptic eschatology is reflected in the famous announcement of the future thousand-year reign of Christ and the saints on earth in Apocalypse 20:4–6, one of the most controversial passages in the book.

For the apocalypticist, history is universally conceived and deterministically structured. Hence the seer, unlike the prophet, issues no general call to repentance to turn the Lord from his anger (he is far too angry for that!). The moral message of apocalypticism—always an important part of the intent of these texts—is a call to the elect to reaffirm their commitment to God. This moral appeal is frequently presented as an ethic of patient endurance of evils until God brings his plan to completion.[11]

[10] Stone, "Eschatology, Remythologization, and Cosmic Aporia," 245.

[11] The moral dimensions of apocalypses, especially John's, were, of course, capable of many interpretations and readings; see, e.g., essays in this collection by Karl F. Morrison and Ronald B. Herzman.

Two other elements in the apocalyptic view of history are important for understanding texts like John's: what we can call the "legibility" of history, and the imminence of the End. The apocalypticist sees meaning where the uninitiated sees only chaos or catastrophe. Knowledge of God's plan not only gives a sense of history's general structure and meaning but also provokes the search for the "signs of the times," for the significance of current events in relation to the coming end. This legibility of history, the ability to read the course of events as one reads a text, requires a sense of the imminence of the final times. But both legibility and imminence admit of many emphases. Some apocalypses, like Daniel's, seek to provide timetables, if mysterious ones, that allow for real prediction.[12] Others convey a more general sense of the approach of a great judgment, while some apocalypses and apocalyptic fragments, like the famous "Little Apocalypse" ascribed to Jesus in the Synoptic Gospels, actually warn against attempts to predict the End (see Mark 13:32 and parallels). Even this last group, however, while they emphasize that the full mystery of the end of times is hidden in God, invite the reader to place him- or herself in an apocalyptic situation in which present action is determined by reference to, and in light of, the coming final events. A kind of "psychological imminence" is always part of apocalyptic eschatology.

The God who reveals his secrets to the sage is paradoxically both nearer and farther away than the God of the prophets. He is nearer in the sense that some sages at least ascend to heaven to see and hear him and to bring his secrets back to the faithful. But he is also farther away, more transcendent, because his power over history is hidden in this age in which evil forces dominate and because he acts and reveals through intermediaries, the angelic powers to whose exuberant proliferation the apocalypses contributed so much in both Jewish and Christian history.

Finally, we must also note that the kind of redemption promised in the apocalypses differs from that promised in earlier strands of the Hebrew Bible. Gershom Scholem has pointed out that although the two elements of messianic apocalypticism (a catastrophic view of redemption and the utopianism of the messianic kingdom) were already present in writings of the prophets, the fusion of the two into a potent force in Jewish history was the work of the authors of the apocalypses.[13] In these works, redemption expands outward from the national and innerhistorical perspective to a cosmic and transhistorical one, with the coming messianic kingdom poised ambiguously between real time and eternity, just as the apocalyptic sage hovers between the terrestrial and the celestial realms. Thus the apocalyptic view of redemption remains supremely optimistic about the cosmic and often earthly renewal to come. Apocalyptic texts contain our

[12] See Lars Hartman, "The Functions of Some So-called Apocalyptic Timetables," *New Testament Studies* 22 (1975): 1–14.

[13] Gershom Scholem, *The Messianic Idea in Judaism and Other Essays* (New York, 1972), 4–12.

earliest clear references to the resurrection of the dead (e.g., Dan. 12:2), and the hope for personal immortality, for the transcendence of death, has been central to apocalyptic ideas of redemption.[14]

Apocalyptic eschatology was the child of Second Temple Judaism and, at least in some sense, the mother of Christianity. The "second reality" introduced in the apocalypses, in both its vertical and horizontal dimensions, was formative for early Christianity and has remained important to Christian history down to the present. Over a quarter of a century ago, Ernst Käsemann's provocative statement that "apocalyptic . . . was the mother of all Christian theology" was not so much a novelty as an exaggerated summary of a long tradition of biblical scholarship which, even since Hermann Samuel Reimarus in the late eighteenth century, had stressed the centrality of apocalyptic elements in the New Testament and the early Church.[15] Research up to the time of Albert Schweitzer and Martin Werner in the middle decades of this century tended to emphasize the apocalyptic dimensions of Jesus' preaching, but more recent scholarship has generally tried to put a distance between Jesus' own preaching of the Kingdom of God, which is viewed as making use of apocalyptic elements but essentially founded on a recognition of the presence of the kingdom, and the more thorough-going futuristic apocalypticism of Jesus' earliest disciples. Some scholars have continued to argue that Jesus was more of an ardent apocalypticist than current trends in gospel research suggest,[16] but almost all are agreed that the earliest members of the Jesus movement were apocalypticists who saw his resurrection as the beginning of the new aeon.

While this conclusion is of the greatest moment for the history of Christianity—one strong reason Christians have always found it difficult to be indifferent to apocalyptic eschatology—it must not be taken as a magic solution to all questions about the nature of the new religion, its growth and success. From its beginnings, the apocalyptic mentality, as we have seen, displayed a variety of theologies in its revelatory enthusiasm. Similarly, there appears to have been, among the early Christians, no single understanding of the meaning of Jesus and his resurrection, even from the apocalyptic perspective. The evidence of the New Testament and of the Apostolic Fathers, stretching over almost a century (ca. A.D. 50–140), indicates multiple interpretations of the Resurrection as far back as our documents take us. Early Christianity, as it first appears to us, is already more than an apocalyptic sect within Judaism, however much it owes to this Jewish matrix.

One other issue of the relation between early Christianity and apocalyptic eschatology needs to be taken up before turning to the Apocalypse

[14] John J. Collins, "Apocalyptic Eschatology as the Transcendence of Death," *Catholic Biblical Quarterly* 36 (1974): 21–43.

[15] Ernst Käsemann, "The Beginnings of Christian Theology," in *Apocalypticism*, ed. R. W. Funk (New York, 1969): 40.

[16] E.g., Lars Hartman, *Prophecy Interpreted* (Lund, 1966), esp. 245–47.

itself: the problem of the delay of the *parousia*, or glorious return of the Risen Christ. If Christianity was founded on the hope for the imminent return of Jesus to manifest fully the new aeon that had begun with his rising from the dead, as seems clear from such documents as Paul's first letter to the Thessalonians (1 Thess. 4:13–5:11), then it stands to reason that the delay in this return must have occasioned difficulties for the Christian communities that proliferated through the Roman Empire in the second half of the first century A.D. One standard interpretation of the history of early Christianity makes this delay of the *parousia the* central event in the growth of the Church.[17] According to this reading, the Apocalypse would have been one of the last expressions of the soon-superseded earliest phase of Christianity, because during the second century A.D., Christianity had to be rebuilt from the ground up on a new and no longer apocalyptic basis: on a sacramental and salvation-historical understanding of Jesus' resurrection as the midpoint of history and the foundation of the institutional Church as the instrument of salvation. It would be as foolish to deny the important element of truth in this theory as it would be to think that it affords a full explanation of early Christianity and the reasons for its success. Apocalypticism did not die out in the second century of the Christian era, in neither its original nor it transformed manifestations. Many Christians, right down to the fourth century, continued to view imminent apocalypticism as normative. Not only did apocalypticism continue to live on in patristic Christianity; but the apocalyptic mentality, the "second reality" introduced into Western religious history by the apocalypses, influenced many other aspects of Christian history, especially visionary mysticism, in ways that some of the essays in Parts II and III of this volume will touch upon.[18]

THE APOCALYPSE OF JOHN

John's Apocalypse breaks with the Jewish apocalyptic tradition in several ways. The most evident is the abandonment of pseudonymity, a fact that has led some investigators to deny that the text is an apocalypse at all.[19] But this is an exaggeration. What we are dealing with is a new type of apocalypse made possible by a new apocalyptic situation: belief in the resurrection of Jesus. John, the author of the book, is conscious that he is

[17] Most powerfully put by Martin Werner, in *The Formation of Christian Dogma*, trans. S. G. F. Brandon (1941, 1st German ed.; Boston, 1957).

[18] E.g., those by Suzanne Lewis, Michael Camille, and Richard K. Emmerson.

[19] For a survey of the issue and a defense of the book as a true apocalypse, see John J. Collins, "Pseudonymity, Historical Reviews and the Genre of the Revelation of John," *Catholic Biblical Quarterly* 39 (1977): 329–43. See also the more recent essays of David Hellholm and David E. Aune in *Early Christian Apocalypticism: Genre and Social Setting*, ed. Adela Yarbro Collins (Decatur, Ill., 1986), 13–96.

writing not from the vantage point of the end of the old aeon but from that of the new age begun by the Risen Christ. From this perspective, pseudonymity is no longer important, nor is a sketch of the history of the ages which have already been put to an end. But since there is still a brief interim before the full manifestation of Christ's triumph in his saints, John can use the apocalyptic scenario of crisis-judgment-vindication to announce what will come to pass in the near future.

In traditional Jewish apocalypticism, one did not openly prophesy the future from the perspective of the present; rather, one pretended to convey an already-revealed message about what was to come. John, however, speaks as a prophet, one who asserts that he is the present recipient of a message found in a heavenly, not an earthly, book. This message is conveyed to him by celestial intermediaries, both the Risen Christ (e.g., Apoc. 1:1, 1:9–20, 5:5) and various celestial beings (e.g., 7:13–17, 10:1–11, 17:1–18:24, 19:9–10, 21:9–22:15). John thinks of himself as both a prophet (e.g., 1:2–3, 22:7, 22:18–19) and an apocalyptic seer. This mingling of the prophetic consciousness revived in early Christianity with the scribal or "bookish" character of the communication of secrets in the apocalypses is one of the distinctive marks of John's text.[20] The Apocalypse is not only a book containing a secret message but also a book full of book imagery, especially the closed book with the seven seals (5:1ff.) and the open book that the "strong angel" commands John to eat (10:2–11). The role of the book as a symbol, even a talisman, of authority and power in the Middle Ages owes not a little to the Apocalypse.[21]

Another distinctive mark of this Christian apocalypse in relation to its Jewish forbears (and most other Christian apocalypses) is its strong liturgical character. As noted in Clifford Flanigan's essay, the Apocalypse contains several powerful descriptions of the heavenly liturgy (e.g., the present liturgy in 4:1–11 as well as the ultimate liturgy in the New Jerusalem of 21:9–22:5). The book was probably intended to be read aloud in the context of the liturgical celebration of the day of the lord, in which past, present, and future were fused through an action that combined commemoration of Christ's resurrection, unification of the earthly worshiping community with the eternal celestial liturgy, and the proclamation of the imminent judgment. This mingling of times and realms has a background in the scenes set in the heavenly court in the Jewish apocalypses (e.g., Dan. 7:9–10), but the Christian text goes beyond its Jewish ancestors in identifying the liturgical context as the place where the integration of the vertical and the horizontal dimensions of the message is effected. Later Christian interpretations, as demonstrated in many of the following essays, have usually chosen to lay greater emphasis on one or the other pole

[20] On the Apocalypse's relation to early Christian prophecy, see Elisabeth Schüssler Fiorenza, *The Book of Revelation: Justice and Judgment* (Philadelphia, 1985), chap. 5.

[21] See Penn Szittya's essay herein.

of the original message, that is, chosen either to see the book as just a prophecy of what is to come or else to interpret it ahistorically as about the soul's (and the Church's) relation to supernal realities.[22]

Who was John and when did he write? In the struggle over the inclusion of the book in the canon of the New Testament, the apocalyptic John came to be identified with John the beloved disciple and purported author of the Fourth Gospel. This identification, doubted by some in antiquity but universally accepted in the Middle Ages, is not supported by modern scholarship. John appears to have been a late first-century itinerant Christian prophet active in Asia Minor, the location of the seven churches to whom the introductory letters are directed. He was probably of Jewish-Christian origin, which explains his odd Greek and evident familiarity with the world of Jewish apocalyptic eschatology. The majority of modern scholars, in accordance with some ancient sources, date the text to the last years of the first century (ca. A.D. 95) in the reign of the emperor Domitian, traditionally seen as a persecutor of Christians. A minority view has continued to argue that it was written almost thirty years earlier, at the end of the reign of the archetypal persecutor, Nero (d. 68).[23]

Given the Apocalypse's savage opposition to Rome, especially in Chapter 13 and 17–18, the book has generally been seen as written during a crisis of persecution, as a passage addressed to the martyrs awaiting God's vengeance indicates: "And they were told to rest a little while longer, until the number of their fellow servants and their brethren who are to be slain, even as they had been, should be complete" (6:11). Modern scholars, noting the absence of evidence of severe persecution in Asia Minor at this time, have doubted this explanation.[24] But what constitutes a crisis is very much in the eye of the apocalyptic author in search of the signs of the times. Others, especially modern historians dependent on fragmentary sources, may not view (or even be able to view) things in the same way. It may well be that rather minor persecution of some of the small Christian communities in Asia Minor was the spark that ignited John to his dramatic portrayal of the absolute conflict between the satanic force of imperial Rome and the holy community of the hard-beset saints. The Apocalypse's call for divine judgment on the world is more rooted in a conflict of world views than in reaction to particular events of the day.

The structure, the message, and the intention are the aspects of the Apocalypse that have continued to provoke fundamental disagreement among its interpreters. It is difficult to imagine a reader who would not be

[22] The latter tendency won out decisively in the Tyconian-Augustinian interpretation, as seen below; but it never completely submerged the more historicizing and millenarian reading.

[23] For a survey of questions of authorship and dating, see Adela Yarbro Collins, *Crisis and Catharsis: The Power of the Apocalypse* (Philadelphia, 1984), chaps. 1–2.

[24] Ibid., chap. 3; Collins reviews the weak foundations of the usual "crisis of persecution" explanation.

puzzled by the repetitions, sudden switches, and inconsistencies of the narrative. It is true that many other apocalypses, both Jewish and Christian, are no less confusing. In many instances, however, the confusion has been shown to result from the compilatory character of the final text, as in the case of 1 Enoch, composed of no less than five different Jewish apocalyptic texts dating from the third century before the Christian era to the first century afterward. Some have argued that the Apocalypse is also a composite text, either a Jewish apocalypse redone for a Christian audience (a view popular in older German scholarship) or a cobbling together of two redactions of a Christian revelation. But if there is one thing that recent scholarship seems to agree on (in this, at least, in conformity with traditional views), it is that the book is basically the product of one author, whatever earlier sources and reinterpretations of sources may be involved.

How then to explain the structure of the Apocalypse? Three options have been expressed in the history of Apocalypse interpretation, variations still relied upon by modern students.[25] The book has been read in a linear-prophetic fashion, as if projecting a sequential history of what was to come between John's own time and the approaching end. In the Middle Ages, Alexander Minorita, Peter Aureol, and Nicholas of Lyra (see David Burr's essay) were among those who held this view. Its most influential later adherent was Martin Luther,[26] but it has often reappeared in new guises in the later history of Apocalypse interpretation. A second approach has been to see the Apocalypse as a theological treatise organized according to some nonhistorical pattern, a view that is implied (if not always fully spelled out) in many of the early medieval commentators following Augustine, as demonstrated in E. Ann Matter's essay. Nor is this approach dead today, as is evident from the writings of Austin Farrer, Jacques Ellul, and others.[27] Finally, there is the cyclic, or recapitulative, reading of the text, which sees it as a prophetic account of what is to come before the End but in the form of complex repetitions, or alternative accounts of the same message. This approach, first found in Victorinus of Pettau, a bishop of the period of the Great Persecution (shortly after A.D. 300), was renewed by Joachim of Fiore in the late twelfth century. Although it died out in the eighteenth century, it has been revived in our own time.[28] Most recent interpreters, whether they adopt historical-critical, structuralist, or hermeneutic-theory viewpoints, believe that the Apocalypse was constructed according to some recapitulative model, though they differ markedly in how they actually understand this structure.

[25] On these three interpretations, see Bernard McGinn, "Revelation," in *The Literary Guide to the Bible*, ed. Robert Alter and Frank Kermode (Cambridge, Mass., 1987), 525ff.

[26] See Hans-Ulrich Hoffman, *Luther und die Johannis-Apokalypse* (Tübingen, 1982).

[27] Austin Farrer, *A Rebirth of Images: The Making of St. John's Apocalypse* (London, 1949); Jacques Ellul, *Apocalypses: The Book of Revelation* (New York, 1977).

[28] The modern revival was sparked by Gunther Bornkamm, "Die Komposition der apokalyptischen Visionen in der Offenbarung Johannis," *Zeitschrift für die Neutestamentliche Wissenschaft* 36 (1937): 132–49.

The recapitulative model seems best adapted to the almost-oppressive numerical symbolism of the Apocalypse, especially the constant repetitions of patterns of seven. Astute readers will also note the recurrence of half-seven (i.e., 1,260 days, three-and-a-half years, or forty-two months, as in Apoc. 12:6, 12:14, and 13:5, respectively). Seven—the sum of the three that represents the divine world and the four of the created realm—signifies the perfection of the divine plan. Half-seven is a demonic antitype: the imperfect and brief time when the forces of evil will be given power over the just. An analogous number symbolism is evident in the famous 666 ascribed to the Beast in 13:18. Whether or not the number contains a cryptogram for a personal name, such as that of "Neron Kaisar" (in Hebrew, Greek and Latin letters had numerical values), it is evident that three sixes were as indicative of imperfection as three sevens were of ideal goodness.

One way to understand the structure of the book is to see it as composed of an introduction (the letters to the seven churches of Chapters 2 and 3) and two main parts consisting of the revelation of the content of the closed book of seven seals (Chaps. 6–11) and of the open book in the hand of the strong angel (Chaps. 12–22). Each of these sections is introduced by a commissioning vision: the vision of the Risen Son of Man that John receives on Patmos (1:9–20); the vision in which he is taken up into heaven to view the celestial liturgy and the Lamb opening the book (Chap. 4–5); and the vision of the angel descending from heaven with the open book (Chap. 10). Each major part in turn consists of series of sevens. In the "closed book" section, we have the opening of the seven seals (6:1–8:5) and the sounding of the seven trumpets (8:2–11:9), while the "open book" section contains seven unnumbered visions (12:1–15:4), the seven bowls (15:5–16:21), and seven more unnumbered visions (19:11–21:8).[29] The various sections are interrelated in complex ways through the use of such devices as inclusion (where a new sequence is seen as contained in the final act of its predecessor, as in 8:1–2) and intercalation (two contiguous episodes being interrupted by a third, as in 8:2–6). This general structure does not preclude the addition of extraneous sections, such as the woes over Babylon (17:1–19:10) and the vision of the descent of Jerusalem (21:9–22:5).

Difficulties about the true structure of the Apocalypse are nothing in comparison to those concerning its message and intent. Even in the midst of current broad agreement that the book is indeed an apocalypse, it is difficult to find two modern interpreters who would agree on the best way or ways to elucidate its essential message. One recent study has detailed no less than eight modes of interpretation, but even these are merely broad heuristic devices capable of interminglings, subdivisions,

[29] This account of the structure is largely dependent on that outlined by A. Y. Collins in *Crisis and Catharsis*, 111–16, and *The Apocalypse* (Wilmington, Del., 1979).

and complications.[30] Perhaps it may be helpful to see the Apocalypse as the supreme example of the "second reality" that the apocalyptic mentality introduced into Western religious traditions. Certainly the text is a good illustration of both the vertical and the horizontal poles of the unveiling of the divine secrets. Though the book has its primary interest in announcing the imminent events of the End, its concern for disclosing the heavenly world, where these events have already been decided, provided a good basis for those who subsequently wished to internalize and dehistoricize its message, as was largely the case in early medieval exegesis and most medieval art.[31] Still, the historical dimensions of the "second reality" of the Apocalypse were always present in the text. Late medieval exegetes, with Joachim of Fiore leading the way, were able to revivify the horizontal, or historical, pole of the Apocalypse's intent with powerful effect (see the essays by E. Randolph Daniel and Robert E. Lerner).

Finally, it is important to note that one of the reasons the Apocalypse was so powerful and yet so malleable an influence in the history of medieval culture was its dramatically symbolic mode of communication.[32] Symbols, by their very nature, have a magnetic effect on the human psyche which mere concepts rarely, if ever, enjoy. But symbols are also polyvalent and often ambiguous. What is especially characteristic of the symbolism of the Apocalypse is the way in which it portrays the absoluteness of the final struggle between good and evil through a wide range of opposites. On every level of the work, mostly overtly but sometimes covertly, these contrasts abound. I have already, because of its effect on the structure of the work, had occasion to note the temporal symbolism of seven and half-seven. There is also a whole menagerie of human, animal, and theriomorphic symbolic figures set in an arena of opposed spatial symbols, such as the evil city Babylon the Great with her seven hills (Apoc. 17–18) and the holy city Jerusalem, foursquare with twelve gates (Apoc. 21).

For example, we have opposed feminine figures (each city is also a woman): the Great Whore riding on the seven-headed Beast versus the Bride of the Lamb. To counter the Christian Trinity, symbolically portrayed as "him who sits upon the throne" (Apoc. 4:10), the Lamb who was slain (5:6), and (at least according to one possible interpretation)[33] the Holy Spirit symbolized by the Woman clothed with the sun and moon

[30] John M. Court, Myth and History in the Book of Revelation (Atlanta, 1979), chap. 1: chiliastic, allegorical, recapitulative, historical-prophetic, eschatological, historical-contemporary, literary, and comparative.

[31] See the survey of monuments in Peter K. Klein's essay.

[32] I have surveyed some of these symbols and their effect in the Middle Ages in "Symbols of the Apocalypse in Medieval Culture," Michigan Quarterly Review 22 (1983): 265–83. One of the first modern writers to appreciate the symbolic power of the Apocalypse, though he abhorred its message, was D. H. Lawrence, whose Apocalypse first appeared in 1931.

[33] Gilles Quispel, The Secret Book of Revelation (New York, 1979), 76–80.

(12:1), we have the perverse trinity that seeks to dominate the cosmos, figured by the seven-headed Dragon who appears in the heavens (12:3) and his servants, the Beast who comes out of the sea (13:1) and the second Beast "coming up out of the earth" (13:11). Along with these major players, a host of mysterious and dramatic smaller roles are introduced, of both good and evil spirits and good and evil humans: the Four Horsemen and their strangely colored horses (6:2–8); the angel with the seal of the living God who signs the 144,000 (7:2–8, cf. 14:1–5); the seven angels with trumpets (8:2 ff.); the locust-beasts from the abyss with their king, Abaddon (9:3–11); the Two Witnesses (11:3–12); the seven angels with the seven last plagues (15:1 ff.); the Rider on the white horse and his angelic army (19:11–21). The list could go on. Though not always easy to depict, each of these figures is an enigmatic image of mythical power capable of profoundly effecting the imagination. It is easy to see why the generations of believers who took the Apocalypse so seriously sought to discover the identity of these beings and the hour of their coming.

The acceptance of the Apocalypse by the early Church was not a foregone conclusion.[34] Adherents of the new religion continued to produce apocalypses until the fourth century at least (even longer in the Greek-speaking East). Many of the earlier ones maintain an interest in the eschatological dimension of the apocalyptic second reality and show variations on the traditional triple pattern of coming crisis-judgment-vindication; most later apocalypses, such as the widely read Vision of Paul, emphasize the heavenly journey and the revelation of the fate of souls.[35] Although direct citation from John's Apocalypse is rare in second-century texts, it was apparently known and used by major authors, such as Irenaeus, whose work *Against Heresies* is the most important theological document of the time. But there were problems with the Apocalypse, especially with Chapter 20's prophecy of the thousand-year reign of Christ and the saints on earth.

This doctrine, called both "chiliasm" (from the Greek *chilia*, or one thousand) and "millenarianism" (from the Latin *millennium*, meaning the same), was often held to be an integral part of the message of Jesus.[36] Such a materialistic understanding of the coming kingdom was, however, not only a political threat to Roman control but also a very "Jewish," that is, literal, understanding of the promise of salvation. Christians who,

[34] For a sketch of the reception of the book, especially in the Latin West, see Bernard McGinn, *The Calabrian Abbot: Joachim of Fiore in the History of Western Thought* (New York, 1985), chap. 2.

[35] For a survey of these writings, see Adela Yarbro Collins, "Early Christian Apocalypses," in J. J. Collins, *Apocalypse: Morphology of a Genre*, 61–121.

[36] Both Irenaeus and, later, Eusebius mention the witness of Papias, an early bishop of Asia Minor, who conveyed a saying of Jesus about the superabundant richness of the millennial kingdom, in which each vine will have 10,000 branches and each branch 10,000 twigs with 10,000 clusters of 10,000 grapes each—all crying out to the saints to be picked!

unlike John, began to think of the possibility of some form of accommodation with Rome, and those, too, who stressed the spiritual understanding of Scripture and the rewards it promised, began by the end of the second century A.D. to see the Apocalypse as an embarrassment. Opponents of the Montanists, a second-century group from Asia Minor who engaged in ecstatic prophecy and hoped for the imminent descent of the heavenly Jerusalem on one of their villages, began to circulate the rumor that the book was written not by John the Beloved but by his great enemy, the heretic Cerinthus. Suspicion about the book was especially strong in Eastern Christianity.

Origen of Alexandria, the premier exegete of the early Church, had an important role in domesticating the book in Greek-speaking Christianity. Though he did not live to write the commentary he had promised, Origen cited the Apocalypse often in his writing and preaching, emphasizing how its symbolism was to be interpreted in a spiritual, not a literal, or "Judaistic," sense.[37] Later Greek exegetes, such as Methodius of Olympus, give detailed spiritual interpretations of parts of the book.[38] Bishop Dionysius of Alexandria, a follower of Origen in the second half of the third century, attacked the crude millenarianism of his fellow bishop, Nepos of Arsinöe, but refused to condemn the Apocalypse, a work "of which many good Christians have a very high opinion."[39] Suspicions about the Apocalypse remained in some circles, and most Greeks who made use of it insisted on a spiritual reading; but many other Christians, especially in the West, continued to read the Apocalypse literally and maintain their firm belief in the material nature of the coming millennium. The witness of African Christianity which Paula Fredriksen discusses in her essay; the writings of the major Latin Christian writer of the early fourth century, Lactantius;[40] and the earliest surviving commentary on the book, that of the Dalmatian bishop Victorinus of Pettau,[41] all show that millenarianism was alive and well in fourth-century Christianity and that the Apocalypse was widely read and used despite the struggle over its reception.

Both in the East and the West, the weight of tradition guaranteed the book's inclusion in the canon, or official list of recognized Scripture. But Saint Jerome, in his *Commentary on Isaiah*, written early in the fifth century, recognized the divergence of views that John's Apocalypse had already produced in Christian history: "I know how much difference there is among people . . . about the way in which John's Apocalypse is to be understood. To take it according to the letter is to 'Judaize.' If we treat it in

[37] See, esp., Origen *On First Principles* 2.11, which deals with how scriptural promises are to be interpreted.

[38] See Methodius's reading of Apocalypse 12 in his *Symposium* 8.4–13.

[39] As recounted in Eusebius *Church History* 7.24–25.

[40] For my translation and commentary on the apocalyptic seventh book of Lactantius's *Divine Institutes*, see my *Apocalyptic Spirituality* (New York, 1979), 17–80.

[41] On Victorinus, see Ann Matter herein.

a spiritual way (as it was written), we seem to go against the views of many older authorities: Latins, such as Tertullian, Victorinus and Lactantius; Greeks, such as Irenaeus. . . ."[42]

Though the spiritual and nonmillenarian interpretation won the day, largely through the efforts of Jerome, Tyconius, and Augustine, the horizontal or historically apocalyptic dimension of the book could never be totally expunged, even by the most ingenious of purely ecclesiological or moral readings. It remained, not lurking under the surface of the text but rather openly in the structure and symbols of the book, for those, like Joachim of Fiore, who had the eyes to see it. The Apocalypse's ability to project such arresting symbols of both the horizontal and the vertical poles of the "second reality" of the ancient apocalyptic mentality was the key to its unusual power in the Middle Ages and to the continuing fascination with it. The Apocalypse, as Joachim of Fiore put it, is "the key of things past, the knowledge of things to come; the opening of what is sealed, the uncovering of what is hidden."[43]

[42] Jerome *Commentarium in Isaiam* 18. prol. (*CC* 83A:40–41).

[43] Joachim of Fiore *Expositio in Apocalypsim* (Venice, 1527; reprint, Frankfort on the Main, 1964), fol. 3r.

2

Tyconius and Augustine on the Apocalypse

Paula Fredriksen

for Robert Markus,
magistro meo

Christianity began with the announcement that time and history were about to end. This message, preserved variously in those documents that came to make up the New Testament, found its most flamboyant expression in the book that closes the Christian canon, the Apocalypse of John. John's vision of the final happenings—celestial disturbances, plagues, and huge carnage; the persecution of the righteous by the Whore of Babylon; the resurrection of the saints and their thousand-year reign with Christ—has long held pride of place in a paradoxically enduring tradition of millenarian apocalyptic expectation: the belief that Christ is about to return *soon* to establish his kingdom on earth.[1] As Christianity developed from its Jewish messianic origins into a central institution of late Roman imperial culture—as history, in other

Research for this essay was funded by the National Endowment for the Humanities.
[1] I use *eschatology* to mean those beliefs concerned with the end of time and the final destiny of humankind: they imply no necessary timetable. *Apocalypticism* holds that the End, however conceived, is imminent. *Millenarianism* holds that the redemption brought by the End, whenever it comes, will be collective, historical, and earthy (as opposed to heavenly or exclusively spiritual): the earth will sprout fruit in abundance; both human and animal society will be transformed and at peace. The idea of a thousand-year period implied by the term is less essential to its import than is its focus on the earth, and human history, as the ultimate arena of redemption. *Apocalyptic millenarianism*, finally, holds that such redemption is imminent. For further discussion of these distinctions, see Richard Landes, "Lest the Millennium Be Fulfilled: Apocalyptic Expectations and the Pattern of Western Chronography, 100–800 CE," in *The Use and Abuse of Eschatology in the Middle Ages*, ed. Werner Verbeke, Daniel Verhelst, and Andries Welkenhuysen (Leuven, 1988), 205–8. More detailed consideration of these various Christian understandings of history and salvation may be found in my expansion of the present essay, "Apocalypse and Redemption: From John of Patmos to Augustine of Hippo," *Vigiliae Christianae* 45.2 (1991):151–83.

words, persistently failed to end on time—the Church, of necessity, had to come to terms with its own foundational prophecy ("The kingdom of God is at hand!"), especially as embodied in the Book of the Apocalypse.

In the story of the Western church's efforts, Tyconius and Augustine hold a special place. Many earlier theologians had either allegorized any historical and temporal reference out of John's prophecy or repudiated the text altogether. Other Christians, and most especially those in North Africa, had on the authority of the Apocalypse asserted an enthusiastic and socially disruptive millenarianism. Against these two extremes, Tyconius and, following him, Augustine introduced in the late fourth and early fifth centuries a reading of John that affirmed its historical realism while liberating it from the embarrassments of a literal interpretation. As we examine their North African environment, we can come to a clearer appreciation of the exegetic innovation wrought by these two men; and as we measure its effects, both social and literary, on subsequent Latin Christianity, we measure as well the continuing power—and danger—of John's vision of the End.

The Apocalypse in Africa

North Africa was the "Bible belt" of the Mediterranean. At once severe and enthusiastic, fundamentalist and traditional in their biblical orientation and proud of their origins as the "church of the martyrs," North African Christians gave the Latin church its earliest *acta martyrorum* and most energetic cult of the saints. They buried their dead in wet plaster to preserve every detail of the body's outline; they could break into near riot if "ivy" was substituted for "gourd" in a reading from the prophet Jonah during a sermon.[2] Its experiences in the drastic days of the Roman persecutions determined the African church's view both of itself and of the outside world: it was the community of the holy, the ark of salvation sealed against the temptations and tempests of a hostile environment, a permanent option to pagan

[2]On the cult of the dead, particularly the feasting and drinking associated with it, see Frederick van der Meer, *Augustine the Bishop* (New York, 1961), 471–526; and Peter Brown, *Augustine of Hippo* (Berkeley and Los Angeles, 1967), 207, 299; also idem, *The Cult of the Saints: Its Rise and Function in Latin Christianity* (Chicago, 1981), for the Western church generally; and W. H. C. Frend, *The Donatist Church: A Movement of Protest in Roman North Africa*, 2d ed. (New York, 1985), 114, 174 (and also 99, for this burial practice, apparently by pagans too). On the "ivy" controversy—the result of introducing Jerome's new translation at Mass—see Augustine *Epistolae* (hereafter *Epp.*, and *Ep.* for singular) 71.3.5 and 75.6.21, 7.22; on a congregant's similar response to liturgical innovation, see idem, *Retractationes* 2.11; discussed in van der Meer, *Augustine the Bishop*, 341.

society. "Outside the Church there is no salvation" (extra ecclesiam nulla salus).[3]

This community was undergoing one of its characteristic upheavals in the wake of persecution at the moment when Constantine entered the Church. Admired ideal and established ideology notwithstanding, many North African Christians had given way under the pressure of his predecessor's actions nearly a decade earlier. Through a series of edicts issued between A.D. 303 and 305, Diocletian had sought to coerce the participation of ecclesiastics and, eventually, laymen in the *pax deorum*, the *entente cordiale* between heaven and earth that sustained the empire. Christian clergy in particular were ordered to turn their holy books over to imperial soldiers. Those who complied would suffer no disability; those who refused, imprisonment and even death.

Many clergy did comply. Those who did not, clergy and lay, resented these *traditores*. They challenged *traditor* ordinations and insisted that the lapsed be restored to the church through rebaptism.[4] This last put local practice too much at odds with transmarine custom. In 313, finally, the Roman pope pronounced the rebaptizers guilty of schism. The rigorists subsequently lost their appeal to the newly involved emperor. They were no longer Catholics: they were the Donatist church.[5]

Despite imperial patronage, the Catholics were and remained a minority in North Africa up through the late fourth century. Matched in terms of dense episcopal bureaucracy,[6] Donatists enjoyed strong local support: Catholicism was the import to Africa. And, despite occasional outbursts of violence, these North Africans married each other, bequeathed or inherited property to and from each other, and in short, established a modus

[3]See esp. R. A. Markus, *Saeculum: History and Society in the Theology of St. Augustine* (Cambridge, 1970), 106–9, and "Christianity and Dissent in Roman North Africa: Changing Perspectives in Recent Work," in *Studies in Church History* 9, ed. Derek Baker (Cambridge, 1972), 21–34. The slogan derives from Cyprian *De unitate catholicae ecclesiae* 5–6.

[4]The authority of Cyprian stood behind rebaptism as a way to reintegrate the lapsed (e.g., *Epp.* 69–75); and the experience of the African church in the wake of the Decian persecution rehearsed, in many ways, events after Diocletian. See Hans Lietzmann, *History of the Church*, vol. 2 (London, 1961), 250–57; Frend, *Donatist Church*, 125–40; Paul Monceaux, *Histoire littéraire de l'Afrique chrétienne*, vol. 2 (Paris, 1920); and Jean Paul Brisson, *Autonomisme et Christianisme dans l'Afrique romaine de Septime Sevère à l'invasion vandale* (Paris, 1958), 33–121. On Catholicism's betrayal of African Cyprianic Christianity, see Markus, *Saeculum*, 106–15.

[5]On the origins of the schism, see Brown, *Augustine of Hippo*, 213ff.; Frend, *Donatist Church*, 1–24; Monceaux, *Histoire littéraire*, vols. 3 and 4; and Lietzmann, *History of the Church* 3:82–93.

[6]On the dense pattern of North African bishoprics, see Robin Lane Fox, *Pagans and Christians* (New York, 1987), 272; and Brown, *Augustine of Hippo*, 203; see also 226 on the Donatist majority in Numidia. Frend, in *Donatist Church*, passim, analyzes the geographic distribution of allegiances in terms of local (i.e., African) vs. Roman culture. Donatists would go to Augustine to settle disputes in the early years of his episcopacy (*Ep.* 33.5) and on occasion would attend Catholic services and public debates (Possidius *Vita* 4, 7). On Catholics and Donatists cohabiting, see *Ep.* 35.2.

vivendi.[7] Beyond the social webbing of family and property relations, they were bound together by a shared Latin Christian culture.[8]

An uncomplicated millenarianism figured prominently in this culture. Late fourth-century North African Christians, as Christians elsewhere, continued to look forward to the approaching kingdom on earth. Its due date (worked out two centuries earlier by Julius Africanus, affirmed a century later by his compatriot Lactantius) was drawing near: in 397, the bishop Hilarianus reiterated that the year 6000 since the Creation was a scant century off.[9] If Catholics thought this way, and they had the empire on their side, how much more so the Donatists, who "beneath the purple and scarlet robes of the apocalyptic whore . . . could still recognize Rome?"[10]

[7]On violence, see Brown, *Augustine of Hippo*, 227–43. On the mysterious Circumcellions, see ibid., 229; Brisson, *Autonomisme*, 325–57; and Emin Tengström, *Donatisten und Katholiken: soziale, wirtschäftliche und politische Aspekte einer nordafrikanischen Kirchenspaltung* (Göteborg, 1964), 24–83. Anti-Donatist legislation after 393 specifically targeted the familial and social relations this modus vivendi expressed and facilitated; see Brown, *Augustine of Hippo*, 227.

[8]Persuasively argued by Peter Brown, in "Christianity and Local Culture in Late Roman Africa," *Religion and Society in the Age of St. Augustine* (New York, 1972), 279–300, an interpretation developed and nuanced further by Markus, in "Christianity and Dissent" and *Saeculum*, 105–32. Augustine's Donatist counterpart, the bishop Parmenian, was himself Italian, not African; see the entry in *Prosopographie Chrétienne du Bas-Empire*, ed. André Mandouze, vol. 1 (Paris, 1982).

[9]Julius Africanus *Chronographia* (fragments), in *The Ante-Nicene Fathers* 6.130–38. Lactantius states, ca. 313, that "the entire expectation or length of time left seems no greater than 200 years" (*Divine institutiones* 7.25). Hilarianus's affirmation of this traditional timetable (*De cursu temporum*, in *Chronica minora*, ed. C. Frank [Leipzig, 1892] 1.55–74) may in fact have been a delaying tactic: were some in his community insisting that the End would come sooner? See Landes's remarks in "Apocalyptic Expectations," 152f. Efforts to view Hilarianus as Donatist rather than Catholic seem to me a somewhat desperate disavowal of Catholicism's own normative millenarianism (*Prosopographie*, 558). Martin of Tours believed that Antichrist had already been born and was approaching maturity (Sulpicius Severus *Dialogues* 1.14); crowds in Constantinople were thrown into a premillennial panic in 398 after witnessing signs and prodigies (Augustine *De excidio urbis* 6.7; Philostorgius *Historia ecclesiastica* 11.6–7; for additional ancient literature addressing this event, see Landes, "Apocalyptic Expectations," 155 n. 70a). The fact that the elusive Commodian can arguably be placed anywhere between the third and fifth centuries obliquely makes the same point: millenarianism was normative. On Commodian, see esp. Pierre Courcelle, *Histoire littéraire des grandes invasions germaniques* (Paris, 1964), 319–37; and Brisson, *Autonomisme*, 378–410; cf. Henri Grégoire, *Les persécutions dans l'empire Romain* (Brussels, 1959), 114–17.

[10]Markus, *Saeculum*, 55. Donatists preserved the continuity of persecution with millenarian hope. Catholics, on the contrary, could see in Constantine's and the empire's conversion the realization of biblical prophecies of God's righteous kingdom. Hesychius, bishop of Salona, argues this apocalyptic interpretation of current events ca. 418 (Augustine *Epp.* 197–99); see G. Coulée's discussion in *La cité de Dieu XIX–XXII*, in *Bibliothèque augustinienne* (hereafter *BA*), vol. 37 (Paris, 1960), 763–65 n. 24; also J.-P. Bouhot, "Hesychius de Salone et Augustin," *S. Augustin et la Bible* (Paris, 1986), 229–50; and Markus, *Saeculum*, 39. Mutatis mutandis, Eusebius of Caesarea argued similarly: Constantine's conversion realized Isaiah's millenarian prophecies. Eusebius of Caesarea is a nonapocalyptic millenarian thinker (e.g., *Laus* 16.6–7). Augustine and his

In the cult of the dead, energetically observed by both sides, we have unobtrusive, extraliterary evidence for these enthusiasms. "All Africa," observed Augustine, "is filled with holy bodies" (Ep. 78.3), and to these the faithful regularly repaired to feast, dance, and get splendidly drunk.[11] On the *laetitia*, or day of joy, of the saint, people gathered to hear the martyr's *passio* and receive cures, while (as the word *laetitia* suggests) thoroughly enjoying themselves and their wine.[12] Augustine, annoyed to distraction by such "carnal sousing," complained to a colleague that these observances were pagan corruptions brought into the Church with the influx of forced converts after 399.[13] Perhaps true: pagans too feasted their dead at family gravesites. But in the abandon round the martyr's mensa, in the drinking and feasting of the faithful gathered at the shrine of the saint, we also glimpse ancient Christian hopes for life after the *prima resurrectio*, an affirmation that when the kingdom came, status distinctions would dissolve, life would be joy, labors would cease, the earth would yield its fruits in abundance, and God would wipe away every tear.

TYCONIUS AND THE APOCALYPSE

From this world, sometime in the closing decades of the fourth century, emerges the elusive figure of the lay Donatist theologian Tyconius. We know little about him, and his literary legacy—four known writings, of which all but one are lost—is exiguous.[14] Nonetheless, it is Tyconius who

colleagues thought similarly in 399, when imperial fiat led to the destruction of pagan property—in more prophetic perspective, the overthrow of idols "secundum propheticam veritatem" (*Enarrationes in Psalmos* 62.1, 149.7); cf. *Sermo* 24.6; *De consensu Evangelistarum* 1.14, 21, 34, 52. See the discussion in André Mandouze, "Saint Augustine et la religion romaine," *Recherches Augustiniennes* 1 (1958): 187–223; and in Markus, *Saeculum*, 22–44, esp. 30ff.; on Hesychius in particular, see 39; Peter Brown, "St. Augustine's Attitude toward Religious Coercion," *Religion and Society*, 265–74; and his reprise of this discussion, *Augustine of Hippo*, 231f.

[11]See esp. van der Meer's wonderful evocation of these festivals in *Augustine the Bishop*, 471–557, esp. 498ff.; Brown's *Cult of the Saints*, where he places the cult within its larger context of Latin Christendom, extending up to the period in Gaul of the Franks; his *Augustine of Hippo*, 206, 217–20, 229; Frend's *Donatist Church*, 172–75, where he notes the prominent role of the Circumcellions (*circum cellas*) in such observances; and Brisson, *Autonomisme*, 293f., on martyrs.

[12]See van der Meer, *Augustine the Bishop*, 514f. Ambrose kept a tight reign on such observances: Monica was prevented by the sacristan in Milan from taking a meal at the oratory (*Confessiones* 6.2).

[13]*Ep.*, 29.11. On forced conversions after 399, see *Sermo* 10.4, 47.17; and Brown, *Augustine of Hippo*, 230f., 234.

[14]These are *De bello intestino* (ca. 370?), evidently on the universality of the Church; a subsequent defense of his position, *Expositiones diversarum causarum* (ca. 375?); the sole surviving work, the *Liber regularum* (ca. 382), on scriptural exegesis; and finally, perhaps ca. 385, the now-lost commentary on the Apocalypse (on which, see n. 16 below). On Tyconius himself, see Gennadius of Marseilles, *De viris inlustribus* 18 (PL 58:1071); Monceaux, *Histoire littéraire*, vol. 5, 165–219; *Prosopographie*, 1122–27.

stands at the source of a radical transformation of African—and thus, ultimately, of Latin—theology and whose reinterpretation of his culture's separatist and millenarian traditions provided the point of departure for what is most brilliant and idiosyncratic in Augustine's own theology.[15] And it is Tyconius, most precisely, whose own reading of John's Apocalypse determined the Western church's exegesis for the next millennium.

His commentary on the Apocalypse no longer exists—or perhaps more accurately, it lives on obscured in the penumbra of the later Catholic commentaries that drew on Tyconius even as they repudiated him.[16] Its literary vestiges attest to his remarkable originality: Tyconius championed a typological reading of this text which avoided the ahistoricism of allegory while insisting—against earlier Western apocalyptic commentary in general and the temperament and traditions of African Christianity, especially Donatism, in particular—that the time of the End and the identity

[15]On his transformation of his own tradition, see Markus, *Saeculum*, 56, 115–26; and my own discussion, "Tyconius and the End of the World," *Revue des Études Augustiniennes* 18 (1982): 59–71. On his influence on Augustine, see esp. the latter's view on grace, and thus on Paul and conversion, in Alberto Pincherle, *La formazione teologica di Sant'Agostino* (Rome, 1947), 185ff. Specifically on Augustine's reading of Tyconius during the crucial decade of the 390s, see idem, "Sulla formazione della dottrina agostiniana della grazia," *Rivista de Storia e Letteratura Religiosa* 11, no. 1 (1975): 1–23; Ulrich Duchrow, *Christenheit und Weltverantwortung* (Stuttgart, 1970), 216–33, with special reference to the early interpretation of Paul; W. S. Babcock, "Augustine's Interpretation of Romans," *Augustinian Studies* 10 (1979): 54–74, and "Augustine and Tyconius: A Study in the Latin Appropriation of St. Paul," *Studia Patristica* 18, no. 3 (1982): 1210f.; Eugene TeSelle, *Augustine the Theologian* (London, 1970), 180–82; and my own essay, "Beyond the Body/Soul Dichotomy: Augustine on Paul against the Manichees and the Pelagians," *Recherches Augustiniennes* 23 (1988): 87–114, esp. 99–101. I address below the issue of Tyconius's influence on Augustine's ideas on history and the cult of the saints, with reference to *De civitate Dei*; for a recent minimalist interpretation of this influence, see Martina Dulaey, "L'Apocalypse: Augustin et Tyconius," in *Saint Augustin et la Bible*, A.-M. LaBonnardière, ed. (Paris, 1986), 367–86.

[16]Jerome evidently used Tyconius for his own demillenarianizing reedition of Victorinus of Pettau's Apocalypse commentary (see Johannes Haussleiter's edition, *CSEL* 49); also influenced were the Apocalypse commentaries of Apringius (ed. M. Férotin, Paris, 1900); Beatus (ed. Henry A. Sanders [Rome, 1939]); Bede (*PL* 93:129–206); Caesarius of Arles (ed. Germain Morin [1942], 2:209–77); Primasius (*PL* 68:793–936); and finally, the Turin fragments (ed. I. F. Lo Bue [Cambridge, 1963]). Gerald Bonner has attempted to reconstruct Tyconius's text by collating passages from these later commentaries in *St. Bede in the Tradition of Western Apocalyptic Commentary* (Newcastle upon Tyne, 1966), 3 and esp. app. 21–29, and "Toward a Text of Tyconius," *Studia Patristica* 10 (1970): 9–13. More recently, L. Mezey has tentatively identified a fragment of a Budapest MS as Tyconian ("Un fragment d'un codex de la première époque carolingienne [Tyconius *in Apocalypsin*?]," in *Miscellanea Codicologia F. Masai dicata*, vol. 1 [Gent, 1979], 41–50]; cf. Alberto Pincherle's response to Mezey's original Hungarian article (pub. 1976), "Alla ricerce di Ticonio," *Studi Storico-Religiosi* 2 (1978): 355–65. See also the substantial textual note in Gerhart B. Ladner, *The Idea of Reform: Its Impact on Christian Thought and Action in the Age of the Fathers* (Cambridge, Mass., 1959), 260f. n. 93. These studies have now been superseded by Kenneth B. Steinhauser, *The Apocalypse Commentary of Tyconius: A History of Its Reception and Influence* (Frankfort on the Main, 1987).

of the saved could in no way be known.[17] The details of his exegetic argument are lost to us. Its logic, however, can be inferred from his sole remaining work, the *Liber regularum*.[18]

The Law, says Tyconius (by which he intends both Old and New Testament), is mediated through seven rules. These rules are *mysticae:* they are the compositional principles of Scripture, encoded in the text itself, which conceal or obscure its meaning.[19] Sometimes, for example, the Bible speaks of the Lord; other times, seeming to, it actually speaks of the Church, his body (Rule I, *de Domino et corpore eius*). And the Lord's body is itself bipartite, *permixtum:* it is both "black" and "beautiful"; the good and the wicked both abide therein (Rule II, *de Domini corpore bipertito*). The Law *is* the Bible, and thus it encompasses God's promise; it speaks both to the period of Israel and to the period of the Church. Both Law and promise obtain at all times, and the Law works in the predestined to arouse faith (Rule III, *de promissis et lege*). Scripture can ambiguously express general truths through seemingly simple reference to particular persons and events (Rule IV, *de specie et genere*); naming periods of time quite precisely, it nonetheless resists calculation, for the numbers themselves are elastic, infinitely interpretable *mystica* (Rule V, *de temporibus*). Something as seemingly straightforward as narrative conceals complica-

[17]Gennadius says that Tyconius "nihil in ea [i.e., the commentary] carnale sed totum intelligens spirituale" (*De viris inlustribus* 18). In his preface to his *Liber regularum* (hereafter *LR*), Tyconius calls his exegetic principles "mysticae" and argues specifically that the time of the End cannot be calculated or even deduced. His own disclaimer notwithstanding, modern scholars have incoherently maintained both that Tyconius was the source of the later Catholic antimillenarian commentaries on the Apocalypse and that he expected the End in his own lifetime. This misreading seems to have begun with F. C. Burkitt's efforts to fix a terminus ad quem for the composition of the *Liber:* he focused on Tyconius's invocation of the period of 350 years (as mentioned, variously, in Apoc. 11; *LR* V, pp. 60–61) to conclude that Tyconius was himself making millenarian calculations (Burkitt, *The Book of Rules of Tyconius* [Cambridge, 1894], xviii). A near-century of authoritative scholarship then repeated this fundamentally incoherent interpretation; see, e.g., Traugott Hahn, *Tyconius-Studien* (Leipzig, 1900), 6–7; Wilhelm Kamlah, *Apokalypse und Geschichtstheologie: Die mittelalterliche Auslegung der Apokalypse vor Joachim von Fiore* (Berlin, 1935), 10, 71; and Erich Dinkler's excellent article in *Pauly-Wissowa Realencyclopädie der klassischen Altertumswissenshaft* (1936) 6A, 1, col. 853. Bonner follows Kamlah in *St. Bede*, 5 and n. 21. Dulaey most recently has reiterated this misreading of Tyconius's use of the 350-year period in her "Augustin et Tyconius," 374 (again citing Burkitt and Rule V); cf. my arguments against this particular misconstrual in Fredriksen [Landes], "Tyconius and the End," 60–63; so also in Markus, *Saeculum*, 58.

[18]Burkitt's is still the critical edition; for an English translation, W. S. Babcock, *The Book of Rules of Tyconius* (Atlanta, 1989). On the immediate relation of the *Liber* to Tyconius's lost commentary, see esp. the current work of Charles Kannengiesser, *A Conflict of Christian Hermeneutics in Roman Africa: Tyconius vs. Augustine* (Berkeley, Calif., 1989); also Pamela Bright, *The Rules of Tyconius: Its Purpose and Inner Logic* (Notre Dame, Ind., 1988), 185.

[19]"Necessarium duxi ante omnia quae mihi videntur libellum regularem scribere, et secretorum legis veluti claues et luminaria fabricare, sunt enim quaedam regulae mysticae quae universae legis recessus obtinent et veritatis thesauros aliquibus invisibiles faciunt" (*LR* prol.1.1–5).

tions: apparently sequential events may actually reiterate each other, so that what seems like sequence is really repetition (Rule VI, *de recapitulatione*). Even references to the devil are less than clear: when scripture speaks of Satan, it might well intend his "body," those who follow him, the unrighteous (Rule VII, *de diabolo et eius corpore;* cf. Rule I).

By so complicating the biblical text, Tyconius gained a way to approach some of its most unabashedly apocalyptic and millenarian passages head on, affirming their historical significance while obscuring their eschatological value. Rules I and VII, for example, enable him to insist with seeming simplicity that the Son of Man really will arrive seated at the right hand of power and coming on the clouds of heaven[20] and that God and the "mystery of lawlessness" really will be revealed in time of persecution:[21] but since these traditionally apocalyptic figures refer, according to Tyconius's hermeneutic, to the Church and to the unrighteous within the Church, respectively, their "appearance" is within history, not at its edge. So also on the issue of persecution generally. Tyconius can agree with his Donatist colleagues that the suffering they now endure at the hands of Rome was indeed foretold in Daniel and in Apocalypse. Nonetheless, he can insist, what currently occurs in Africa must take place *per orbem:* persecution itself does not indicate that the End is at hand.[22] Nor, until that hour, does it serve to identify the community of the righteous. Until the End comes, the righteous and unrighteous must and will remain together, mixed, within the Church.[23]

As with these typological figures and events, so with numbers and periods of time: their multiple referents defy easy categorization. In Rule V, sums long favored in traditional millenarian calculations skitter across Tyconius's page: 6,000 (the years of the age of the world); 1,000 (the reign of the saints); 7, 10, 12, 144,000 (the number of the redeemed, Apoc. 7:14);

[20]Matt. 26:64; cf. *LR* I.4.13–5.10 on the distinction between the continuous coming of Christ's glorious body, the Church, and Christ's own *parousia* at the End.

[21]2 Thess. 2:7; Ezek. 39:1–4 (cf. Apoc. 20:7f.); *LR* VII.74.16–75.6.

[22]*LR* VI.67.7–28. Apparently, in his Apocalypse commentary, Tyconius correlated anti-Donatist persecution with John's prophecy; Bede criticized him for it ("et martyria vocans, has [these persecutions] in eadem gloriatur Apocalypsi fuisse praedictas," *PL* 93:133a). Augustine levels a like critique against Gaudentius (*Contra Gaudentium* 1.27.30–31). Similarities between Apocalypse 6:9–11 and present circumstances probably struck most thinking Donatists as obvious, and for obvious reasons. See my earlier discussion, "Tyconius and the End," 65f., 69, 72. And if persecution does not indicate the nearness of the End, neither does the cessation of persecution: Tyconius's invocation of the "peace of the Church" 350 years after the Passion (which occurred, according to North African Christian chronology, in A.D. 29) refers not to an expected *parousia* in 379 but, more likely, to the accession of Flavian, himself a Donatist, as senior imperial officer in Africa after a period of severe anti-Donatist legislation. Cf. *LR* V.60–61; Frend, *Donatist Church*, 199f.; Brown, *Augustine of Hippo*, 226; and Fredriksen [Landes], "Tyconius and the End," 73 and n. 69.

[23]Such an ecclesiology, as Augustine was quick to point out, shatters the theological foundation of Donatist separatism (*De doctrina Christiana* 3.30, 42ff.; *Contra epistolam Parmeniani* 1.1.1; Markus, *Saeculum*, 111–26; Dinkler, "Tychonius," *Pauly-Wissowa*, col. 855).

1,260 (days, Apoc. 11:3); 42 (months, Apoc. 11:2); 350 (years, derived from three and a half days, Apoc. 11:11). Thanks to the principle of synecdoche—the whole for the part and vice versa—Tyconius, with vertiginous ease, can stretch each of these so many different ways that any absolute numerical value evaporates. Scriptural numbers do not and cannot quantify: rather, they symbolize and indicate certain spiritual truths. Thus "10," for example, can signify either a perfect whole or a part representing a whole or a simple sum, and it has the same significance even if squared or further multiplied by itself.[24] Hence, though the world is to endure 6 days, or 6,000 years, says Tyconius, and though humanity currently finds itself in the "last day," since during this day "the Lord was born, suffered, and rose again," nonetheless, what is left of this last day is also called "1,000 years"—more particularly, it is "the 1,000 years of the first resurrection" during which the believer has received his "spiritual body" through baptism. The Son of Man—that is, the Church—has come and, during this last day and final hour, risen from the dead; Satan is now bound, and the thousand-year reign of the saints progresses now, on earth, through the Church.[25]

Tyconius likewise dissolves the gross periodization of "old" dispensation and the "new"; or, rather, he insists that the important distinction is moral and spiritual rather than temporal. For, he argues, the dynamics of salvation, that subtle and mysterious interplay of grace, free will, and divine foreknowledge, are constant across nations, times, and individuals: whether for Jacob or for the generation of the Babylonian captivity, for Paul or for the contemporary believer, they remain the same.[26] As a process, then, salvation history is less linear than interior. And it is the Bible that stands as the historical annals of these interior events, the inspired record of God's saving acts. To understand the Bible, then, is to understand the relation of prophecy, grace, and history; to understand, in brief, how God works in human time.[27]

[24]In other words, 10, 100 (10 × 10), and 1,000 (10 × 10 × 10) all have the same "value" and can stand for perfection. See LR V.59.20ff; see also V.60–61 for his exegetic feat of establishing an essential synonymity between 42, 350, and 1260.

[25]LR V.56.10–20, on the 1,000 years of the first resurrection; for the Church as the "spiritual body," see LR VI.43.1–5: "nubes corpus est spiritale post baptisma et claritas filii hominis; primus est enim adventus Domini iugiter corpore suo venientis"—a complex deeschatologizing of one of Paul's most apocalyptic and eschatological concepts (1 Cor. 15:23–53). Despite his spiritualizing of these classically millenarian passages, however, Tyconius nonetheless also insisted on fleshly resurrection and a historical Kingdom of God, both in the Liber and, according to Gennadius, in his commentary as well (De viris inlustribus 18).

[26]Thus, in a striking conflation, Tyconius (LR III.25.10–13) understands Isaac to have received "the spirit of the adoption as sons, crying 'Abba,' Father" (Rom. 8:15).

[27]This confluence of salvation history and interiority, which Tyconius in Rule III works out with special attention to the letters of Paul, marks as well Augustine's early Pauline commentaries, written in 394. The chronology is difficult—we have no sure proof that Augustine had read Tyconius until he mentions him in Ep. 41, written in

Tyconius's reading of Scripture thus emphasized the historical realization of prophecy while denying the sort of social and temporal transparency to the text which would allow for a millenarian interpretation. A radical agnosticism controls his estimate of both current events and traditional prophecies: neither persecution nor relative peace indicates God's ultimate timetable; and no exterior fact (like persecution), conforming to a church's view of itself as holy (hence persecuted), can actually confirm that view. The time of the End is unknowable in principle; and until it comes, the Church must remain a *corpus permixtum,* containing both sinner and saint.

AUGUSTINE AND THE APOCALYPSE

Augustine himself had once been a millenarian, believing that the first resurrection, as described in Apocalypse 20:1–6, would be bodily and that the sabbatical rest of the saints after this resurrection would last for a thousand years. Still, he later insists, he had held even then that the saints' delights would be of a spiritual character, unlike "those people" who asserted that the raised would "spend their rest in the most unrestrained material feasts, in which there will be so much to eat and drink that those supplies will break the bounds not only of moderation, but also of credibility"—a fair description of the prophecy of superabundance preserved in ancient Christian tradition and actively anticipated in the *laetitiae* observed by Catholic and Donatist alike.[28]

The years of Augustine's episcopacy coincided with a stream of apocalyptic due dates and events, both within Africa and beyond.[29] Of these,

396—but I incline toward seeing influence. See my earlier discussions, *Augustine's Early Interpretation of Paul* (Ann Arbor, 1979), microfilm, 209–15, and "Body/Soul Dichotomy," esp. 99–101. Pincherle, *Formazione teologica,* 175 f., is the standard study; see also his comments, "Da Ticonio a Sant'Agostino," *Richerche Religiose* 1 (1925): 464. See too Monceaux, *Histoire littéraire* 5:218–19; TeSelle, *Augustine the Theologian,* 180–82; and Babcock, "Augustine's Interpretation of Romans," 67–74, and "Augustine and Tyconius," 121of.

[28]*De civitate Dei* 20.7.1; see esp. Georges Folliet, "La typologie du *sabbat* chez Saint Augustin: Son interprétation millénariste entre 386 et 400," *Revue des Études Augustiniennes* 2 (1956): 371–90.

[29]An alternative Christian chronology that had named A.D. 400 as the year 6000 since Creation "coincided closely with a series of independent eschatological traditions in which computists variously added some 350, 365, or 400 years to Christ's birth or death in order to discover the end of the interim period between the First Coming and the Parousia. In the period between 350 *Annus Incarnationis* and 400 *Annus Passionis,* then, a series of target dates for the Parousia fell due, coming most densely in the final years of the 4th century" (Landes, "Apocalyptic Expectations," 155). See ibid., nn. 68–70a, for abundant citations to primary documents. Bernhard Koetting lists a series of signs and prodigies occurring between the years 389 and 420 throughout the empire (Rome, Jerusalem, Constantinople, Africa) in "Enzeitprognosen zwischen Lactantius und Augustinus," *Historisches Jahrbuch* 77 (1958): 125–39, esp. 137f. For Augustine's own

Alaric's invasion of Rome in 410 was by far the most dramatic. "Behold, from Adam all the years have passed," some Christians exclaimed, "and behold, the 6000 years are completed ... and now comes the day of judgment!"[30] The pious noted prodigies and watched for signs of the End. Spurred by a recent solar eclipse that had coincided with great drought and an earthquake, the bishop of Salona, Hesychius, inquired whether the faithful might now rejoice, as the evangelist Luke had urged, "for redemption is at hand" (Luke 21:28). Hesychius, further, based his case on a fundamentally optimistic reading of recent Roman history. Since the emperors had become Christian, he urged, most of the signs of the approaching *parousia* predicted in the gospels had been accomplished, and the gospel had been preached throughout the whole world (Matt. 24:14).[31]

Against such sentiments, Augustine argued tirelessly. He made commonsense observations: a specifically named deadline invites disappointment and lack of faith once it is past; and inferences cannot be drawn from wars and portents, because wars and portents occur constantly, and Christians might thus be mocked "by those who have read of more and worse things in the history of the world."[32] He cited the evangelists: if Jesus himself preached that man was not to know the hour of the End (Acts 1:7) and taught that not even the Son, but only the Father, knew when it would be (Mark 13:32 and parallels), then human calculation was worse than dangerous: it was actually forbidden. And, finally, armed with Tyconius's exegetic strategies, Augustine moved to confront the premier text of Christian millenarianism, the Apocalypse of John.

Augustine's most mature and measured statement of this argument appears in Book 20 of *De civitate Dei*. Asserting that belief in God's final judgment and the Second Coming of Christ is the standard of orthodoxy, Augustine immediately cautions against any facile understanding of the texts bespeaking such things (1.2). Jesus himself proclaims the coming Son of Man, the destruction of Jerusalem and final judgment, and the end of the age; but many of these passages, culled from Matthew, are ambiguous. On examination, they turn out to refer "to the coming of the Savior in the sense that he comes throughout this present age in the person of his

discussion of such phenomena and calculations, see his correspondence with Hesychius, *Epp.* 197–99, and *De civitate Dei* 20–22 passim; cf. his earlier discussion of the pagan prophecy that the Church would end 365 years after the Crucifixion (ibid. 18.53.2); his sermon on the fall of Rome in 410 (*CC* 46:249–62) and his *De excidio urbis, Ennarationes in Psalmos* 89.

[30]*Sermo* 113.8 (*PL* 38:576).

[31]Hesychius's first letter to Augustine, written in 418, is lost; *Epp.* 197, 198 (Hesychius's answer to Augustine's first response), and 199 (Augustine's final rebuttal of Hesychius's position) record their remaining correspondence. For the argument drawing on the two evangelical passages cited above, see *Ep.* 198.5.6.

[32]*Ep.* 198.15 (disappointment); 198.34–39 (the eschatological worthlessness of arguments from current events).

Church; . . . the destruction may be only of the earthly Jerusalem," and so on. Augustine refers his reader to his correspondence with Hesychius for an extended demonstration of how best to understand these passages in the gospels (1.4). What concerns him is the distinction between the first and second resurrections. The second resurrection, he urges, is the resurrection of the body; as such, it can only occur at the end of the world (6.1). But the first resurrection is of the soul, which through its reception of baptism and life in the Church is raised from the death of irreligion. The first, for the saints, brings life; the second, for all humankind, will bring judgment (6.1–2). Having established this line of interpretation through an appeal to Matthew, the Gospel of John, and the Pauline letters (1.5–62), Augustine then moves to discuss directly the actual scriptural source of the teaching on the double resurrections, Apocalypse 20:1–6.

This passage, explains Augustine, has been a seedbed of many materialist and millenarian misconceptions. Some people, assuming that the first resurrection would be bodily, have interpreted these verses together with 2 Peter 3:8 and Psalms 89:4 and, "particularly excited about the number 1,000," conjectured that there will be a millennium-long Sabbath rest of the saints at the end of the six ages ("days") of creation (7.1). But what might seem like final events have in fact, Augustine argues, already been accomplished. With the First Coming of Christ and the establishment of his Church, for instance, the devil has already been bound, that is, his power has been bridled. "For a thousand years" may indeed indicate that this binding is accomplished "in the last thousand years, that is, in the sixth millennium, the sixth day," which accordingly should be understood to last 1,000 years.[33] Or maybe not: "1,000" is a perfect symbolic number and thus might stand simply for "totality" or "all generations" (6.2). Satan thus is bound until—not at—the end of the age. And "bound" where—in what abyss? In the "innumerable multitude of the impious, in whose hearts there is a great depth of malignity against the Church of God" (6.3).[34]

Thus Satan is bound and the Church, ruled by its own enthroned authorities, reigns with Christ for the "thousand years" (however long that might actually be) of his kingdom, that period stretching from its foundation to the end of the age (9.1–2). Both righteous and unrighteous dwell in this kingdom, and will until the final judgment (9.2). This present period of mixed membership is nonetheless the thousand-year reign of the saints, because the martyrs, whose bodies have not yet been restored to them, rule spiritually with Christ in his church through their souls (9.2).

[33]In the traditional interpretation of the Apocalypse, this thousand-year period begins in the *seventh* age, *after* the *parousia* of a sovereign Jesus. Augustine, by placing it in the sixth age, before the year 6000, moves it back into "normal" history, before the Second Coming.

[34]On these Tyconian themes, see *Le cité de Dieu* (*BA* 28:720 n. 10).

Augustine asserts this, through his Tyconian reading of the Apocalypse, in Book 20; but this conviction shapes the final book of his lengthy master-work, where he closes 22.8 with a review of the miracles known to him and accomplished through the relics of the martyrs. These miracles are en-ergetic proof of the saints' power and manifest presence, evidence that they truly do reign "now," in the age before the End. Thus these end-time events and more—Antichrist, Gog and Magog, the sea giving up its dead—Augustine, through Tyconius, can consistently deeschatologize, transpos-ing them back into the present, where they serve to describe typologically the current experience of the Church.

But Augustine's reliance on Tyconius was both more profound and more independent than his simple reiteration of the latter's exegetic strategies might imply. The long meditation on Paul begun in the 390s, when he had first encountered Tyconius, had led Augustine to formulate ideas on time and history—as experienced objectively and culturally, on the one hand, and individually and subjectively, on the other—which radically altered the terms in which he would discuss traditional Christian millenarianism.

Augustine too had argued that salvation history was both linear and in-terior in one of his early readings of Romans, the *Expositio quarundam propositionum ex epistola ad Romanos*. He maintained there that Paul's letter had implied a history of salvation stretching from Adam "before the Law" to the imminent redemption of humanity and indeed all creation at Christ's Second Coming.[35] Schematizing this history—*ante legem, sub lege, sub gratia*, and *in pace*—Augustine had related these four stages spe-cifically to the spiritual development of the individual believer, who sins freely before knowing the Law; struggles not to, once it is known; and suc-ceeds in this struggle with the reception of grace. Man ceases to need to struggle against sin only with the transformation of his body in the fourth stage, when he will have perfect peace.[36]

Scriptural history and the individual's experience thus coincide at their shared extremes: birth in Adam, eschatological resurrection in Christ. What interests Augustine is the interior history, the anthropology this

[35]E.g., death in Adam (Rom. 5:12f.); the promise of redemption to Abraham (4:1–24); salvation in Christ, proleptically in baptism (5:6–11, 6:5–14); final redemption with Christ's Second Coming (8:12–38, 11:25–36), etc. To call this a "pattern" is to exagger-ate Paul's organization. On his argument in Romans, and the ways it contrasts specifi-cally with Augustine's exegesis of it, see my essay "Paul and Augustine: Conversion Narratives, Orthodox Traditions, and the Retrospective Self," *Journal of Theological Studies* 37, no. 1 (1986): 3–34, esp. 27f.; for an English translation of Augustine's com-mentary, see Paula Fredriksen [Landes], *Augustine on Romans* (Chico, Calif., 1982).

[36]*Expositio quarundam propositionum ex epistola ad Romanos* 13–18 and passim. The outlines of a fourfold scheme of history appear a few years earlier, in q. 61.7 (*De 83 diversis quaestionibus*), when Augustine is considering Matt. 14:16; he develops it fully with Romans. See F. C. Cranz, "The Development of Augustine's Ideas on Society before the Donatist Controversy," in *Augustine*, ed. R. A. Markus (New York, 1972), 355; Au-guste Luneau, *L'histoire de salut chez Pères de l'Eglise: La doctrine des âges du monde* (Paris, 1964), 357–83; and Fredriksen, "Body/Soul Dichotomy," 89–92.

scheme implies: how, given man's fallen nature, does one move *sub lege* to *sub gratia*? In the agitated stream of works on Paul produced in the mid- to late 390s, Augustine no sooner formulates an explanation for the dynamics of this crucial moment than he discards it.[37] Finally in his response to Simplicianus, meditating once again on Romans 7 and 9, Augustine arrives at an answer from which he never wandered: he does not know. If God can give grace to such an enthusiastic, flamboyant, unrepentant sinner as Saul, if he can hate Esau when Esau was still in the womb and had therefore done nothing to deserve either mercy or condemnation, then God is absolutely inscrutable, his ways "past finding out."[38]

God's opacity is matched by the individual's. Because of the great sin that marks the beginning of human history, man cannot know or control himself. Not only does his spirit struggle against "this body of death," his flesh as now constituted (Rom. 7:7–25), but within his soul, man's will is itself divided: loves are disordered, compulsion governs desire, volition and affect diverge, morally paralyzing the child of Adam. Constructing this image of fallen man with great theological precision in the *Ad Simplicianum*,[39] Augustine repeats the image as self-portrait in its autobiographical companion piece, the *Confessions*. Despite its ostensibly "happy" resolution, the conversion rendered with such passion in Book 8, the *Confessions* is a terrifying book, an unflinching acknowledgement of how little one can understand, even of one's own experience, because of the "wounded will . . . this monstrousness . . . the mysterious punishment that has come upon all men, the deep, hidden damage in the sons of Adam" (*Confessions* 8.9.21). As Augustine catalogs the history of his self-deceptions and mistakes, he acknowledges that they have been revealed as such only within the "eschatological" perspective of his conversion. The pattern of God's actions covertly guiding Augustine to the saving moment in the garden could be recognized retrospectively only once the "ending"—the conversion—was known.

So too with public history. Augustine's brief seduction by the "mirage of his generation," the triumphalism of the Theodosian reforms with their coercive antipagan legislation, gave way to a thorough-going historical agnosticism from which, again, he never wandered.[40] Scripture alone, he argues, records the unambiguous acts of God in history; but the period

[37] The works on Paul in this period are the two commentaries on Romans, the *Expositio* (n. 36 above) and the *Inchoata expositio*; the *Expositio Epistolae ad Galatas*; qq. 66–68 of *De 83 diversis quaestionibus*; and finally, capping this period, the *Ad Simplicianum* and the *Confessiones*.

[38] *Ad Simplicianum* 1.2.16, a reference to Rom. 11:33. I analyze his exegesis and soteriological argument in "Paul and Augustine," 23–28, and "Body/Soul Dichotomy," 92–105. His formulation depends on the development of his idea, when working on these texts, of the *massa damnata*.

[39] On the psychology of delight, and the ways that love escapes conscious control, as proof that the will is not free, see *Ad Simplicianum* 1.2.13–22; and Brown, *Augustine of Hippo*, 154–57.

[40] See references to Brown, Markus, and Mandouze in n. 10 above.

corresponding to the record of those actions had, by Augustine's day, long passed. The present might be punctuated by infinite miracles, but it remains nonetheless inscrutable: God's current actions cannot be divined with any security, no matter how strenuous the effort to match prophecies to contemporary events. Here public history is even more opaque than personal history, because the Christian *does* know how the story will end: with the Second Coming of Christ, the resurrection of the dead and the transformation of the body, and the establishment of God's kingdom.[41] But history's time frame is known only to God; and if the hour of the End is unknowable in principle, it cannot serve to impose a plot on time— none, rather, that those living *in* time can discern.[42]

Given this radical agnosticism, history cannot serve as the prime medium of salvation. Augustine emphasizes, rather, the individual as the locus and focus of God's saving grace[43] and so plays stunningly creative variations on the great themes of Christian millenarianism—communal corporeal redemption, the Kingdom of God, and the millennial Sabbath rest of the saints. The fleshly body will be raised spiritual, he insists with Paul (1 Cor. 15:44–54); but "spiritual" refers to the body's moral orientation, not its substance.[44] The risen body will have a corporeal substance. It will even have gender: women, too, shall as women be raised.[45] But this raised corporeal body will not dwell on a transformed earth. In nonchalant defiance of the scientific thinking of his day, Augustine insists that these corporeal bodies will dwell in the heavens: the Kingdom of God will not come on earth.[46] Apocalyptic traditions of agricultural fecundity

[41]See his affirmation of the order of the final events, *De civitate Dei* 20.30.

[42]See esp. Markus, *Saeculum*, 154–86, on the secularization of history, the empire, and in a certain sense, the Church concomitant with such a view.

[43]True already in 392, when Fortunatus, in the course of their debate, criticized Augustine's views on evil and redemption as androcentric and hence insufficient; *Contra Fortunatum* 21, 22. Cf. Augustine's comment on Rom. 8:8–24: the "creatura" who groaned for redemption was man himself (*Expositio . . . epistola ad Romanos* 53.4). On his creation of the introspective self as his premier theological category, see Fredriksen, "Paul and Augustine," 25–28; cf. Ulrich Duchrow, "Der sogennante psychologische Zeitbegriff Augustins im Verhältnis zur physikalischen und geschichtlichen Zeit," *Zeitschrift für Theologie und Kirche* 3 (1963): 267–88.

[44]On the eschatological spiritual body, see, e.g., *De genesi ad litteram* 12.7.18 (cf. 12.35.68); and *De civitate Dei* 22.21, where he insists on the corporeality of this spiritual body. I consider the ways this view contrasts with Paul's meaning in 1 Cor. 15:50 ("Flesh and blood can obtain no part in the Kingdom"), a key passage for Augustine, in "Vile Bodies: Paul and Augustine on the Resurrection of the Flesh," *Biblical Hermeneutics in Historical Perspective*, ed. Mark S. Burrows and Paul Rorem (Grand Rapids, Mich., 1991), 75–87.

[45]There had obviously been some debate on the issue (*De civitate Dei* 22.17). Augustine asserts emphatically that gendered resurrected bodies will not be sexually active; cf. Lactantius *Divinae institutiones* 7.24.

[46]He enjoys defying contemporary science and scientific philosophy against arguments concerning the weights of the elements (*De civitate Dei* 22.4–5, 11). Cf. his earlier critique of philosophy's view of the human body, 23.16–19; on this point, see Agostino Trapè, "Escatologia e antiplatonismo di Sant'Agostino," *Augustinianum* 18 (1978): 237–44.

and social harmony thus drop out of Augustine's picture: no food, sex, or social relations in the kingdom. His saved individuals in their perfected bodies—spiritually oriented, physically flawless, thirty-something—stand in comradely contemplation of the beatific vision of God.[47] In a final reinterpretation of a classically millenarian theme, Augustine wrenches all temporal reference away from that amalgam of the seventh world age and John's thousand-year reign of the saints in Apocalypse 20, the Sabbath rest of the saints. The six preceding world ages are indeed historical; but the Great Sabbath, the eschatological seventh day, is the saints themselves. "After this present age God will rest, as it were, on the seventh day; and he will cause us, *who are the seventh day,* to find our rest in him" (*De civitate Dei* 22.30.5).

THE IMPACT OF THE TYCONIAN-AUGUSTINIAN TRADITION

How successful was this Tyconian-Augustinian tradition? And how do we gauge success? In terms of establishing orthodoxy's hermeneutic approach to the Apocalypse, this tradition, as I have noted, succeeded famously. Tyconius and Augustine virtually defined the content of all later Catholic commentaries. And, of course, in terms of empirical verification, the essence of their argument has been vindicated by the simple passage of time, which has continued not to end.

Contemporaries, however, were less convinced. Events combined with long tradition to undermine the persuasiveness of a nonapocalyptic understanding of current history. Thanks to the Vandal invasions of the Western empire in the midfifth century, where Christian chronographic calculation had long fixed A.D. 500 as the year 6000 since Creation and thus the expected date of the *parousia,* the world very nearly did "end" on time. The Donatist chronicler of the *Liber genealogus* knew exactly, in A.D. 452, how things stood: he had divined that the name of the Vandal king of Carthage, Genseric, revealed the number of the Beast, 666.[48] His contemporary, Augustine's own student, Quodvultdeus, in his analysis of salvation history, the *Liber de promissionibus,* argued strenuously that the apocalyptic signs of the approaching end time were currently— again, thanks to the barbarian invasions—being fulfilled. John's Apocalypse and the prophecies in Daniel both pointed to the holy city's humiliation by the forces of Antichrist, in particular "from the heretics

[47]See *De civitate Dei* 22.15, the determination of age based on Christ's at the time of his resurrection; see also 22.19 (people fat in this life will not be fat in the kingdom) and 22.20 (amputees will have their limbs restored).

[48]*Liber genealogus,* in *Chronica minora* (*MGHAA* 9:194, for the year A.D. 452). This text is a pastiche of earlier apocalyptic chronographies, notably those of Augustine's contemporary, Hilarianus, and the Latin translation of Hippolytus's chronology, as well as Victorinus of Pettau's commentary on the Apocalypse. Both chronologies had named A.D. 500 as the end of the sixth age of the world. On this text, see Monceaux, *Histoire littéraire* 6:249–53; see too Landes, "Apocalyptic Expectations," 162.

and especially the Arians who were then very powerful" (ab haereticis et maxime Arrianis qui tunc plurimum poterunt: 4.13.22; these tribes, of course, were Arian). The *Getae* and the *Massagetae*, furthermore, two other tribes, were none other than the long-foretold forces of Gog and Magog.[49]

Even after the year 500/6000 slips past, and the Western empire begins to settle into the Middle Ages, allusions to active millenarian expectation, popular and clerical, glimmer in our problematic sources. "False christs" appear and gather followings; chronographers nervously recast the global timetable when the recalculated year 6000 draws near; *rustici* importune more learned clerics for the age of the world, the better to know when it will end; famine, earthquakes, and assorted terrestial and celestial disturbances continue to send populations into panic.[50] Such movements continue throughout the Middle Ages and on into the modern period. And in our own day, with the approaching end of both the century and the millennium, we see once again that the combination of current events, biblical apocalypses, and millennial numbers continues to exert its ancient appeal.[51]

Western culture, in brief, continues to move within the charged field that lies between the twin poles of the Christian message, the "now/not yet" of a messiah who has come and a messianic age yet to arrive. Though few moderns, Christian or otherwise, know the ancient traditions of the

[49]*De civitate Dei* 22.11, where Augustine states precisely the opposite. (Quodvultdeus dropped Augustine's "non sic sunt accipiendae.") See the discussion with respect to Tyconius in Fredriksen [Landes], "Tyconius and the End," 67f.; and also Landes, on the Vandals' stimulation of such interpretations, in "Apocalyptic Expectations," 156–65.

[50]On the false christ of Bourges, see Gregory of Tours, *Historia Francorum* 10.25. On recalculating the year 6000 (a concern of, inter alia, Isidore of Seville, Julian of Toledo, Fredegar, Bede, Adémar of Chabannes, and the Carolingian computists), see Landes, "Apocalyptic Expectations," 161–203, with copious references to primary sources; see esp. his graph in 210–11. On the *rustici* who demand "quot de ultimo miliario saeculi restent anni" and Bede's letter defending his decision to alter traditional computus, see *Epistola ad Pleguinem* 14, in *Bedae opera de temporibus* ed. C. W. Jones (Cambridge, Mass., 1943), 313. On the effect of prodigies and signs, e.g., the apocalyptic panic in the year 968 induced in the army of Otto I by an eclipse, see *MGHSS* 5:12; on the similar response to an earthquake in the year 1000, see *MGHSS* 4:202.

[51]"Everything is falling into place. It can't be too long now. Ezekiel says that fire and brimstone will be rained upon the enemies of God's people. That must mean that they'll be destroyed by nuclear weapons. They existed now, and they never did in the past.

"Ezekiel tells us that Gog, the nation that will lead all the other powers of darkness against Israel, will come out of the North. Biblical scholars have been saying for generations that Gog must be Russia. What other powerful nation is to the north of Israel? None. But it didn't seem to make sense before the Russian revolution, when Russia was a Christian country. Now it does, now that Russia has become communistic and atheistic, now that Russia has set itself against God. Now it fits the description of Gog perfectly." (Remarks made after dinner by Ronald Reagan, 1971; quoted in Martin Gardner, "Giving God a Hand," *New York Review of Books*, August 13, 1987; Gardner's source is Grace Halsell, *Prophecy and Politics: Militant Evangelists on the Road to Nuclear War* [Westport, Conn., 1986]).

world ages and the chronographic countdowns to the millennial Sabbath rest of the saints, the year 2000 nonetheless serves as a focus of apocalyptic speculation. Christianity's texts and its doctrine permit—indeed, encourage—the pursuit of the millennium as a perpetual possibility; and thus John's vision of the End will continue to inspire those who hope to live to see the coming of God's kingdom.

3

The Apocalypse in
Early Medieval Exegesis

E. Ann Matter

The last book of Christian Scripture, with its vivid imagery and sweeping promises of the triumph of the faithful over the persecutions of Antichrist, was among the first biblical texts to be systematically explicated in Latin. Exegesis of the Apocalypse in the early Middle Ages is a complicated story of obscure authors, tangled texts, and at least two paradoxes. The first paradox is the doubtful orthodoxy of the first Latin interpretations, which emerge in the fourth century; the second is the commentaries' transformation of apocalyptic fervor into an extended allegory of the Church. This essay is an overview of the development of Latin Apocalypse commentary to the twelfth century, keeping in focus how each author adapted received material into new forms in response to the particular concerns of the Church of his age.

The earliest known Latin interpretation of the Apocalypse was the commentary written by Victorinus of Pettau (in the Pannonia region of modern Steiermark) in about 300, and it is one of several exegetic works attributed to him. This commentary set off in a direction repudiated by later Latin exegetes; nevertheless, in three revised forms bearing the *auctoritas* of the great biblical scholar Jerome, it remained a standard for many centuries.[1]

This essay was developed from a paper given at the Patristic, Medieval and Renaissance Conference at Villanova University in September 1978. A University of Pennsylvania Summer Faculty Grant in 1983 allowed me to continue my research in European manuscript libraries.

[1]The critical edition of Johannes Haussleiter in *CSEL* 49 gives facing-page texts of an "Editio Victorini" and Jerome's emended version, "Y"; a post-Vulgate recension, "O"; and a later version that conflates the two. It is actually quite difficult to compare Jerome's corrections with the original, because Haussleiter establishes the "Victorinus" text from fifteenth- and sixteenth-century manuscripts, which are in any case not overwhelmingly different. The three recensions of Jerome's version show that this text was as unstable as it was popular and that the original is essentially lost.

Victorinus seems to have taken his interpretive clue from the opening statement that the revelation to John shows "the things that must shortly come to pass" (Apoc. 1:1). Perhaps understandably for one who lived (and died) in the persecutions of Diocletian, he understood "soon" as "now" and saw the promises and threats of the Apocalypse as a literal representation of the Church in his age. Victorinus's interpretation of the Apocalypse was essentially chiliastic; that is, it looked forward to the thousand-year reign of Christ, which would be a sign of the end times. This reading appeared problematic for the Christian society of the post-Constantinian age, in which the Church grew into more solid institutional forms and developed more complicated (if essentially safer) relationships to the temporal power of the empire.[2]

It was, therefore, Jerome's task to mold the Apocalypse exegesis of Victorinus into a form that better reflected a Church at peace with the empire, if not always with the world. This he partially accomplished, as later exegetes noted with approval, by transforming a literal reading of the text to one with an allegorical framework, suggesting a series of meanings for Victorinus's chiliasm. In the prologue to his revision, for example, Jerome explains that Victorinus's expectation of a thousand-year reign of Christ as a historical event is an overliteral reading of Apocalypse 20, necessitating a series of corrections.[3]

Within this framework of multiple meanings, Jerome was able to save a concept that Victorinus (influenced by Tertullian and Irenaeus) had applied to the Apocalypse in classic form: the theory of recapitulation. As understood through recapitulation, the Apocalypse presents a series of typological events *recurring* in sacred history from the time of the patriarchs, through the unknown future of the Church on earth, to the *parousia*. For example, for Victorinus, the seven trumpets of Apocalypse 8 echo from the empire of Babylon into the future, and Antichrist can be seen in the history of the Roman emperors as well in the one who will come in the last days.[4] Such an approach to New Testament prophecy, the linking of the historical moment to a transcendent purpose, has been described by Marjorie Reeves as the very basis of medieval apocalyptic thought.[5] It was

[2]For a discussion of this change, see François Paschoud, "La doctrine chrétienne et l'idéologie impériale romaine," in *L'Apocalypse de Jean: Traditions exégétiques et iconographiques; IIIe–XIIIe siècles*, ed. Yves Christe (Geneva, 1979).

[3]"de mille annorum regno ita ut Victorinus senserunt. et quia me litteris obtestatus es; nolui differre . . . A principio libro usque ad crucis signum quae ab imperitiis erant scriptorum vitiata, correximus, exinde usque ad finem voluminis addita esse cognosce" (*CSEL* 49:14, 15). These phrases are echoed in the prefaces of Ambrose Autpert and Alcuin, among others.

[4]See Victorinus's commentary on Chapter 8 and Chapters 13–17 (*CSEL* 49:86–87, 118–21); and Wilhelm Bousset, *Die Offenbarung Johannis*, 6th ed. (Göttingen, 1906), 53–55.

[5]Marjorie Reeves, "The Development of Apocalyptic Thought: Medieval Attitudes," *The Apocalypse in English Renaissance Thought and Literature: Patterns, Antecedents and Repercussions* (Manchester, 1984), 40.

for this insight that the commentary of Victorinus was preserved by Jerome; this preservation in turn gave later exegetes the freedom to interpret the text in congruence with the specific tribulations of their broadly variant ecclesiastical worlds.

The conflated text that resulted from Jerome's emendations of Victorinus presents an interpretation of the Latin Apocalypse that is basically sequential but in places is arranged according to a conceptual scheme. That is, the interpretation follows the order of the Apocalypse text for the most part, not commenting on every verse, but emphasizing and rearranging for the sake of the interpretation. This anticipation is especially evident in the two chapters that treat the Beasts from the land and the sea: these conflate parts of Chapters 13 and 17 with verses from Chapters 14 and 17; the exposition then continues with Chapter 15 (which does not discuss the Beast) but skips Chapters 16 and 18 completely.[6]

The commentary of Victorinus/Jerome (as I refer to it from this point on) is significant for the history of Apocalypse exegesis because it opened up some important themes of interpretation and emphasis. An easily evident example, and one that shows the complexity of the textual traditions, is the interpretation of 13:18, "This calls for wisdom: let him who has understanding reckon the number of the beast, for it is a human number, its number is six hundred and sixty six." The "Y" version of the text, Jerome's first revision, reckons the number of the beast by ascribing Pythagorean number equivalences to the Greek word *antemos*, meaning "contrary to honor," which, when broken down to letter-by-letter numerical equivalences and added up, totals 666. This reckoning may have originated with Victorinus, but a later hand is visible in the following computation of the name Gensericus (king of the Vandals, d. 477) as also equivalent to 666. Jerome's post-Vulgate redaction instead calculates the 666 from the Greek name "Teitan," numerically equivalent to the Latin "Diclux," the false sun, the Antichrist, whereas the later composite recension conflates the two explanations. These explanations are found over and over again in early medieval Apocalypse commentaries, often with elaborations bringing the examples up to date.[7]

The second source from the late antique period of Latin exegesis, a text also problematic to medieval scholars, was the sevenfold interpretation of the Apocalypse by Tyconius. As a member of the Donatist church of North Africa, Tyconius presented an obvious cause for suspicion. Yet Au-

[6]"Cap. XIII et XVII" (*CSEL* 49:117–31) covers Apoc. 13:1–2, 17:9–16, and 13:3–17; "Cap. XIV et XVII" (131–37) conflates 14:6, 17:6, and 14:8–20. "Cap. XV" comments only on 15:1–2 and is followed by "Cap. XIX," which begins with Apoc. 19:11. The commentary is arranged with roughly one chapter for each chapter of the Apocalypse; the exception is the section on Antichrist, where parts of Chapters 13 and 17 are combined in one analysis (*CSEL* 49:117–31) and 14 and 17 in another (131–37).

[7]See the Haussleiter edition, *CSEL* 49:123–27. The later elaborations on these formulas are discussed below. That the text was widely available is evident from Haussleiter's use of pre-1100 manuscripts from England, Tours, Arras, and South Germany.

gustine's guarded admiration for his exegetic schemes, and his careful response to Tyconius's Rules in *De doctrina Christiana*, ensured that the Apocalypse exegesis of Tyconius would be taken seriously. The complicated relationship between Tyconius and Augustine (considered in detail in Paula Fredriksen's essay in this book) left the two intrinsically linked in Apocalypse exegesis of the early Middle Ages. Augustine was the obvious "antidote" for Tyconius, as was Jerome for Victorinus.

A "catholicized" version of Tyconius on the Apocalypse, extant in a manuscript from the Italian monastery of Bobbio, shows that the text survived independently as late as the eleventh century; it also seems to have been used by Jerome in his revision of Victorinus.[8] The direct influence of Tyconius on exegetes in widely diverse early medieval intellectual environments—Primasius in North Africa, Caesarius in Gaul, Bede in Northumbria, Ambrose Autpert in the Lombard kingdom of Benevento—may be seen in the accompanying table. Through these intermediaries, Tyconius's themes of Apocalypse interpretation, including a clear rejection of chiliasm, the emphasis on the Incarnation so characteristic of his century,[9] and a theory of recapitulation expounded within his seven Rules, are used by many medieval authors who were probably not directly aware of Tyconius. For example, Ambrose Autpert, at the end of the eighth century, acknowledges that Primasius put together Tyconius and Augustine into one commentary; perhaps a decade later, Alcuin, who probably did not know Tyconius, repeats this information verbatim.[10] The commentary of Primasius marks the second stage of early medieval Apocalypse exegesis.

The later tradition is, in fact, so indebted to Primasius that it could be argued that he, rather than Victorinus or Tyconius, is the start of medieval Latin Apocalypse exegesis. Primasius's text on the Apocalypse is essentially a synthesis of the two influential but heterodox exegetes of the fourth century, read, of course, through the lenses of their redactors: the major themes of his interpretation are all to be found in Victorinus/Jerome and Tyconius/Augustine.

[8]For a transcription of the Bobbio manuscript, now Torino, Biblioteca Nazionale MS. 882 (F.IV.1), see "Tyconii Afri Fragmenta Commentarii in Apocalipsim," *Spicilegium Casinense* 3 (1897): 261–331, which compares the text to Primasius, Bede, Caesarius, and occasionally Beatus, and the edition of I. F. Lo Bue, *The Turin Fragment of Tyconius' Commentary on Revelation* (Cambridge, 1963). For Jerome and Tyconius, see Haussleiter, *CSEL* 49:xlii–xlv, and Paula Fredriksen [Landes], "Tyconius and the End of the World," *Revue des Etudes Augustiniennes* 18 (1982):74.

[9]Besides in Augustine and Tyconius, the interpretation of the Apocalypse in light of the Incarnation is found in the prologue to *Tractatus super Psalmos* of Hilary of Poitiers (ed. A. Zingerle, *CSEL* 22:7–8).

[10]Compare Alcuin's prologue (*PL* 100:1087B–C), to that of Ambrose Autpert (ed. Robert Weber, *CCCM* 27:5–7). The list of interpreters is repeated automatically, with Primasius as a central figure of transmission. The concept of "picking the flowers of Tyconius" comes directly from Primasius's prologue to *Commentarius in Apocalypsin* (ed. A. W. Adams, *CC* 92:1).

Latin interpretation of the Apocalypse in the early Middle Ages

Author	Date	Place	Form	Sources
Early Tradition:				
Victorinus/		Pannonia/		
Jerome (V/J)	ca. 300/360	Bethlehem	C	
Tyconius (TY)	ca. 380	Numidia	C	
Sixth Century:				
Primasius (P)	ca. 540	Numidia	C,5	V/J, TY
Caesarius (C)	ca. 540	South Gaul	S	TY, V/J
Apringius (AP)	ca. 550	Iberia	S	V/J
Cassiodorus (CAS)	ca. 575	South Italy	C	?
Eighth Century:				
Venerable Bede (VB)	ca. 730	Northumbria	C,3	P, TY
Ambrose Autpert				
(AA)	ca. 760	Benevento	C,10	P, TY, V/J
Beatus of Liébana				
(BL)	ca. 780	Iberia	C,12	P, AP, TY, V/J
Carolingian:				
Alcuin (AL)	ca. 800	Frankland	C,5; Q/A	VB, AA
Haimo (H)	ca. 840	Frankland	C,7	VB, AA, P
Anonymous (AN)	9th c.	Frankland	C	VB, AA, AL, H
		Region of		
Glossa Ordinaria	ca. 1100	Laon	Gloss	VB, AA, H

Note: C,# = Commentary, # of books; S = Sermons; Q/A = Question/ Answer.

Primasius was the bishop of Justiniapolis (Hadrumentum) in the North African province of Numidia, from 527 to 565. A staunch supporter of Justinian, Primasius lived through both the Byzantine reconquest of the Arian Vandal kingdom in North Africa and the collapse of this imperial enterprise.[11] His role as a Catholic ecclesiastical leader in a tumultuous time and place is at least partially responsible for his interest in the Apocalypse. Primasius follows the lead of his expurgated sources, however, in presenting a spiritual reading of the text. His prologue explains at some length his relationship to the interpretation of Tyconius and praises Jerome for the insight that "in these single words [of the Apocalypse] lie multiple understandings."[12]

[11] For an overview of Justinian's *renovatio* and its aftermath, see W. H. C. Frend, *The Rise of Christianity* (Philadelphia, 1984), 828–34, 854–56.

[12] "In his verbis singulis multiplices latent intelligentiae" (prologue, *CC* 92:3); see also the discussion of Tyconius, prologue, 1–2. For Primasius's use of Victorinus/Jerome, compare the commentaries on Apoc. 7:9 (the multitude from every nation before the Lamb, 2.7 in *CC* 92:125–26) with the Haussleiter edition (*CSEL* 49:81).

Primasius's commentary is quite original in its organization; for it is here that the problem of dividing the text for the purpose of interpretation is addressed for the first time. This structural problem is especially interesting in early medieval exegesis because Bible texts had not yet been shaped into standardized chapters and verses; one manuscript tradition, for example, divides the Apocalypse into forty-eight chapters; others present the text with essentially no numerical headings.[13] This gave exegetes freedom from the *a priori* interpretation latent in the division of the text and allowed for the spontaneous selection and matching of passages we have already seen in Victorinus. Primasius divided his commentary into five books, which discuss (1) the seven churches; (2) the seven seals; (3) the seven trumpets and the Woman clothed with the sun; (4) the Beasts from the land and the sea, the seven plagues, the seven bowls; and (5) the Lamb on the throne, the new heaven, and the new earth. His sense of the rhythm of the text was enormously influential and is very possibly evident in the fact that his Books 2–5 essentially mark the beginnings of Chapters 5, 8, 13, and 18 in the standard division of the received Apocalypse text.[14] As becomes evident, however, later Latin exegetes were by no means bound to Primasius's division when structuring their own commentaries. Nor was the popularity of this commentary affected by the fact that Primasius used a text of the Apocalypse that can be placed squarely in North Africa, one that differs at points from the text of Tyconius, agreeing sometimes with Tyconius against the Vulgate, and at other points going its own way.[15]

The trust later interpreters placed in Primasius's explanation of the Apocalypse is evident from its extraordinary influence on the tradition. As my table shows, all later commentaries were influenced by this one, either directly or indirectly. The way in which Primasius was filtered through later commentators is especially evident in the ease with which his original addition to Jerome's number symbolism of Apocalypse 13:18 is cited by later exegetes. Primasius added a breakdown of *arnsume*, meaning "I deny" (*nego*), which equals 666, while, in contrast, *Cristei* totals 1,225.

[13]For the development of biblical chapter and verse divisions in general, an essentially local process that became standardized in thirteenth-century Paris, see Samuel Berger, *De l'histoire de la Vulgate en France* (Paris, 1887), 11; and Beryl Smalley, *The Study of the Bible in the Middle Ages*, 2d ed. (1952; reprint, Notre Dame, Ind., 1964), 222–24. The 48-chapter Latin Apocalypse, found in at least three manuscripts, is described by Johannes Haussleiter in "Die lateinische Apokalypse der alten afrikanischen Kirche," in *Forschungen zur Geschichte des neutestamentlichen Kanons und der altkirchlichen Literatur*, ed. Theodor Zahn, vol. 4 (Erlangen, 1891), 197–99.

[14]For a comparative chart of the divisions made by the nine early medieval commentaries, see Yves Christe, "Traditions littéraires et iconographiques dans l'interprétation des images apocalyptiques," in Christe, *Apocalypse de Jean*, 134ff.

[15]See Haussleiter, "Lateinischen Apokalypse," xiii, for a comparative chart of the Bible texts of Primasius, Tyconius, and the Vulgate. Haussleiter also reconstructs this African version with the help of other ancient manuscript fragments (80–175).

The difficulty of tracing textual influences through this increasingly dense filter of sources is evident from the fact that few commentators (for example, Bede) distinguish which example came from which source.[16]

Finally, the commentary of Primasius, in its interpretation of the Apocalypse as a text about the Church on earth, shares a concern about orthodoxy with the fourth-century redactors of Victorinus and Tyconius and in a way that marks a path for later exegetes. Primasius understands the Woman of Apocalypse 12:1 as the Virgin Mary and pauses to give a list of heretics (ancient and contemporary, famous and obscure) who misunderstand the Incarnation: Valentinus, Bardezanes, Apollinaris, Nestorius, Eutyches, Timotheus Hilarius.[17] Near the end of the treatise, Primasius shows his hand a bit more clearly in an open polemic against the heretics who really presented the greatest challenge to his Church: the Arians. His interpretation of Apocalypse 22:13, "I am the Alpha and the Omega, the first and the last, the beginning and the end," uses number symbolism to show the consubstantiality of the Father and the Son, and the unity of the Holy Spirit, the third person of the Trinity. The letters alpha and omega have the same value as *peristera*, the Greek word for dove, the form in which the Holy Spirit appeared in the baptism of Jesus. Therefore, the Arians, who assert alien natures of the Father and the Son, are refuted by biblical warrant, since the numbers show that all three persons of the Trinity are equal.[18]

The importance of Primasius's commentary can also be measured by contrast with the other Apocalypse commentaries of the sixth century: those of Apringius of Béja, Cassiodorus, and Caesarius of Arles. Apringius, who wrote under the Visigothic (and Arian) king Theudis in the part of the Iberian Peninsula that is now Portugal, seems to have been inspired by the same forces that moved Primasius. His commentary survives in only one copy, a twelfth-century manuscript of Barcelona, now in Copenhagen, which conflates an original commentary on three sections of the Apocalypse (1:1–5:7, 18:6–19:21, and 20:1–end) with sections from the commentary of Victorinus/Jerome.[19] Apringius's interpretation of the Apocalypse may have originally been a set of homilies intended for the liturgical season between Easter and Pentecost, when selections from the Apocalypse were read in the Visigothic church.[20] The influence of this

[16]For Primasius's lengthy treatment of Apoc. 13:18, see 4.13 (*CC* 92:203–8); cf. Bede (*PL* 93:172), and Haimo (*PL* 117:1102–4).

[17]These "heretici male de Christi incarnatione sentientes" are discussed in 3.12 (*CC* 92:179–90).

[18]5.22 (*CC* 92:307–8).

[19]The best edition of Apringius is that of M. Férotin, *Apringius de Béja: Commentaire de l'Apocalypse écrit sous Theudis, Roi des Wisigoths, 531–48* (Paris, 1900), partially reprinted in *PL* supp. 4:1221–48.

[20]This is the theory of Berthold Altaner; see his review of the Apringius edition by A. C. Vegas, *Theologische Revue* 4 (1942): 119–20. Altaner cites Canon 17 of the Fourth Council of Toledo (633), in J. D. Mansi, *Sacrorum Conciliorum . . . collecatio* 10:624.

text seems to have been limited to the Iberian Peninsula, as the only later author to cite it is Beatus of Liébana. The *Complexiones in Apocalypsin* of Cassiodorus also survives in only one manuscript, a sixth-century copy from northern Italy; it is a largely original work in thirty-three sections, each providing an allegorical comment on a short pericope of the biblical text.[21] In contrast, the Apocalypse sermons of Caesarius of Arles circulated widely throughout the Middle Ages, but under the name of Augustine.[22] As the specific interpretations of these homilies are drawn from the treatises of Victorinus/Jerome and Tyconius, it is quite difficult to measure their influence on the later tradition of Apocalypse exegesis. Nevertheless, it is clear that no Apocalypse commentary from the sixth century was equal to that of Primasius in influence on the later tradition.

All three of the commentaries of the eighth century, the next great flowering of Apocalypse exegesis, depend heavily on Primasius, although they also draw directly from earlier commentaries. The interpretation of Beatus of Liébana, probably the latest of the three to be written, quotes lavishly from four of its predecessors: Victorinus/Jerome, Tyconius, Primasius, and Apringius, as well as from a number of other sources.[23] The commentary of Beatus has a rather peculiar fame among twentieth-century scholars because of the stunning full-page illustrations of the surviving manuscripts, all from the tenth century or later.[24] In the Middle Ages, however, the text was relatively little known and, it would seem, known not at all outside of Spain. Perhaps this is because of the extremely dense character of the commentary, or perhaps because of its equally extreme topicality. The commentary of Beatus is divided into twelve books, each with an extensive prologue; the sheer length and complexity of the work have inhibited modern scholars (and I here am no exception) from undertaking a thorough analysis of its function in eighth-century Spanish Christianity.

[21]*PL* 70:1405–18; see also James J. O'Donnell, *Cassiodorus* (Berkeley and Los Angeles, 1979), 224–25, and 226, where the meaning of *complexiones*, a sequential commentary, is distinguished from Cassiodorus's *breves*. O'Donnell's contention that the work is "resolutely literal," with "virtually no allegorical interpretation" (227), is open to debate and certainly depends on what one might conceive as a literal interpretation of the Apocalypse.

[22]*PL* 35:2417–52, under the name of Augustine; see also Germain Morin, "Le commentaire homilétique de S. Césaire sur l'Apocalypse," *Revue Bénédictine* 45 (1933): 43–61.

[23]Eugenio Romero Pose, ed., *Sancti Beati a Liébana Commentarius in Apocalipsin*, 2 vols. (Rome, 1985). The "Index Fontium" to this edition shows that Beatus also quotes from Irenaeus, Augustine, Ambrose, Fulgentius, Gregory of Elvira, Gregory the Great, and Isidore of Seville. For a study of these sources, see Mateo Del Alamo, "Los Comentarios de Beato al Apocalipsis y Elipando," *Miscellanea Giovanni Mercati*, vol. 2, *Letteratura Medioevale* (Vatican City, 1946), 16–33.

[24]On these manuscripts, see Wilhelm Neuss, *Die Apokalypse des hl. Johannes in der altspanischen und altchristlichen Bibel-Illustration*, 2 vols. (Münster, 1931), esp. vol. 1; and the three volumes published as *Actas del Simposio para el estudio de los códices del "Comentario al Apocalipsis" de Beato de Liébana* (Madrid, 1978–80). In this collection, see esp. John Williams, "The Beatus Commentaries and Spanish Bible Illustration," 1:201–19.

But even a cursory glance at the titles of each book makes evident the major themes of the treatise: the sanctity of the Church and the defense of the divinity of Christ against the Adoptionist theology of the followers of Bishop Elipandus of Toledo. As John Williams has pointed out, the promises of the triumph of the true Church over all enemies may have also struck a comforting note with Beatus because of the increasing threat of Muslim domination of Christian Spain, although no open reference to Islam can be discerned in the text.[25] At any rate, the particular combination of ecclesiological and christological exegesis in this treatise is parallel to Latin exegesis of the Song of Songs. Beatus quotes lengthy passages from the Song of Songs at several key points, borrowing interpretations from the *Moralia* of Gregory the Great, the letters of Jerome, and the commentary on Luke by Ambrose.[26]

It is, in fact, in the eighth century that the link between exegesis of the Apocalypse and the standard readings of the Song of Songs becomes clearly visible. Of the exegetes on the Apocalypse up to this point, only the shadowy Victorinus is said to have written on the Song of Songs as well; but from this period on, the Apocalypse and the Song of Songs seem to attract the same exegetes. In the period covered by this essay alone, there are extant commentaries on both books by Bede, Alcuin, and Haimo, while Ambrose Autpert is credited with a Song of Songs commentary that does not survive.[27] The association of the Apocalypse and the Song of Songs, on first consideration perhaps rather unlikely, derives from the tradition of allegorical exegesis in the ecclesiological mode (the "allegoria" of John Cassian[28]), which had become a standard tool of monastic exegesis by the eighth century. An assumption that the most mysterious books of the Bible could and ought to be explained by means of a ready-made hermeneutic (that is, that the texts are "really" about the story of the Church on earth, whatever they may seem to be about) emphasizes the central im-

[25]Williams, ibid., 219. It seems clear that the threat of Islam influenced illustrations of the famous tenth-century manuscripts of Beatus. Books 1, 2, 6, and 12 are explicitly about the Church, whereas Books 3 and 11 take up specific issues of the divinity of Christ.

[26]Cf. Book 12 (*Actas del Simposio* 2:421) for the interpretation of Song of Songs 1:2 borrowed from Gregory the Great; Book 4 (1:650) for Jerome's reading of Song of Songs 1:3; and Book 6 (2:147) for Ambrose on Song of Songs 2:15. For the connections between exegesis of the Apocalypse and the Song of Songs, see my own *The Voice of My Beloved: The Song of Songs in Western Medieval Christianity* (Philadelphia, 1990).

[27]For Victorinus, see n. 1 above. Bede's Song of Songs commentary is edited by D. Hurst, *CC* 119B; Alcuin's compendium of this text is printed in *PL* 100:642–66; Haimo's commentary on the Song of Songs is in *PL* 117:295–358. For Ambrose Autpert, see the introduction by Robert Weber to *Expositio in Apocalypsin* (*CCCM* 27); the Song of Songs is quoted more than forty times in this text.

[28]"Hierusalem quadrifarie possit intellegi: secundum historiam ciuitas Iudaeorum, secundum allegoriam ecclesia Christi, secundum anagogen ciuitas Dei illa caelestis, quae est mater omnium nostrum, secundum tropologiam anima hominis" (Cassian, *Collationes* 14. 8, ed. E. Pichery, *SC* 54:190). For a discussion of the role of this formula in medieval exegesis, see Smalley, *Study of the Bible*, 28.

portance of ecclesiology. The Early Middle Ages in Latin Christianity were marked by a sharp concern for the *survival* of the Church, even to the point of draining the Apocalypse of its apocalyptic fervor.

Eighth-century commentaries on the Apocalypse also mark a turning point in the transmission of sources. Just as Primasius had become a filter for earlier interpretation, so the commentaries of Bede and Ambrose Autpert incorporate Primasius and his sources and become in turn the major sources of Apocalypse exegesis for the Carolingian age. The *Explanatio Apocalypsis* of the Venerable Bede is a sophisticated analysis of the Apocalypse, one that carries on a reading of the text as the history of the Church on earth while keeping a watchful eye on the larger picture of cosmic history. In the dedicatory epistle, Bede makes use of the seven rules of Tyconius to describe the seven ages (*periochas*) of the world reflected in seven movements of the text.[29] First, after a lengthy preface, the Apocalypse speaks of the seven churches of Asia which are really the one Church of Christ (1:1–3:21); the second period, marked by the four animals and the opening of the seven seals, reveals the future conflicts and triumphs of the Church (4:1–8:1); the third, under the form of seven angels blowing trumpets, describes future happenings of the Church (8:2–11:19); the fourth opens the works and victories of the Church under the figure of the Woman giving birth and the Dragon pursuing her (12:1–15:4); the fifth is the *periocha* of seven plagues that will infest the earth (15:5–16:21); the sixth is the damnation of the Great Harlot, that is, the impious city (17:1–20:15); and the seventh will see Jerusalem, adorned as the Bride of the Lamb, descending from heaven (21–22). The commentary that follows, made up of three books, conforms closely to this scheme.[30] The aspect of Bede's commentary on the Apocalypse that proved most interesting to later medieval exegetes was this working out of the text in accordance with a broad scheme of the Church moving through universal history into sacred time—and it is especially useful of Bede to have left the *periochas* undefined. Latin Christians of later centuries, reading or commenting on the Apocalypse, had Bede's framework, a result of the distillation of earlier commentary, ready to plug in to the interpretation of particular events of the life of the Church in the world.

The commentary of Ambrose Autpert, in contrast, provides an exhaustive spiritual reading of the Apocalypse for future generations. Written

[29]*PL* 93:129–34; the commentary continues to 206. See also Gerald Bonner, *Saint Bede in the Tradition of Western Apocalypse Commentary* (New Castle upon Tyne, 1966). Bonner discusses the relationship between Bede's *periochas* and the stages of universal history developed in his other works (14–15) and gives an appendix of the passages in Bede's Apocalypse commentary borrowed from Tyconius.

[30]Book 1 (*PL* 93:133–53) comments on *periochas* 1 and 2; Book 2 (*PL* 93:153–78), on *periochas* 3 and 4; and Book 3 (*PL* 93:177–206), on 5, 6, and 7. Bede's three books thus divide the Apocalypse between 8:1 and 8:2 and between 14:29 and 15:1. These are not the divisions of Primasius; see n. 14 above.

between 758 and 767 in the Lombard duchy of Benevento, the ten books of
this treatise absorb the Apocalypse commentaries of Victorinus/Jerome,
Tyconius, and Primasius, as well as large sections of Augustine's *De civ-
itate Dei* and the *Moralia* of Gregory the Great.[31] By far the most visible
source for this commentary is Primasius, who is quoted literally hundreds
of times. A study of the sources makes it clear that one motivation for
Ambrose Autpert was to create a smooth conflation of his sources; yet his
own selection of biblical texts, particularly from epithalamic writings
such as Song of Songs, Psalms, and Ephesians, focuses the commentary on
a special theme, Christ's Incarnation and his spiritual marriage with the
Church. This focus is especially evident in the long prologues to Books 5
and 9, books that cover Apocalypse 10:1–12:12 (the opening of the seventh
seal and the persecution of the Woman by the Dragon) and 19:11–21:8 (the
binding of the Dragon and the rise and fall of Gog and Magog).[32]

Although the Apocalypse commentaries of Victorinus/Jerome, Tyco-
nius, and Primasius still circulated, and were even recopied, after the
eighth century, the particular selections from this earlier tradition com-
piled and arranged by Bede and Ambrose Autpert became the major
sources for Carolingian commentary. An excellent example of the weaving
together of Bede and Ambrose Autpert can be seen in the incomplete
Apocalypse commentary of Charlemagne's schoolmaster, Alcuin, a text
written around the turn of the ninth century.[33] Alcuin begins with Bede's
seven periods, to which he immediately appends (word-for-word) Ambrose
Autpert's discussion of the commentaries from the fourth to the seventh
century.[34] The Carolingian dependence on Bede is even clearer in an anon-
ymous, unpublished question-and-answer text on the Apocalypse which
may be associated with Alcuin; here, the "questions" are all verses of the
Apocalypse "answered" by selections from Bede's commentary.[35] The
commentary of Haimo of Auxerre is also a conflation of Bede and Am-
brose Autpert: it is organized in seven books, showing the influence of the

[31]*Ambrosius Autpertus Expositio in Apocalypsin Libri I–X* (ed. Robert Weber, *CCCM*
27:27A. The ten books divide the Apocalypse at 1:19, 3:13, 5:14, 9:21, 12:12a, 14:13b,
16:21, 19:10b, and 21:8. The treatise was usually copied in two volumes and is well-
attested by Carolingian manuscripts. See Weber's extensive "Index Fontium" for a list of
sources.

[32]Prologue to Book 5 (*CCCM* 27:365–85); prologue to Book 9 (*CCCM* 27A:717–22).

[33]Alcuin *Commentariorum in Apocalypsin* (*PL* 100:1087–1156).

[34]*PL* 100:1087; cf. *PL* 93:129–31 and *CCCM* 27:5. The commentary is divided into
five books, which cover Apoc. 1:1–12:9; this division of the text follows the first five
books of Ambrose Autpert.

[35]This text is found in one manuscript, Munich, Bayerische Staatsbibliothek MS Clm
13581 (c.9, Sankt-Emmeram, Regensburg), fols. 3–31. For a discussion of Alcuin's
method of excerpting from standard exegetic texts, in both commentary and question-
and-answer form, see my "Exegesis and Christian Education: The Carolingian Model,"
in *Schools of Thought in the Christian Tradition*, ed. Patrick Henry (Philadelphia, 1984),
90–92.

former, but these divisions are adapted from the ten books of the latter.[36] Haimo characterizes the Apocalypse as an "intellectual vision" about the present and future Church, a vision that can be related to the prayer said every day by Christians: "thy kingdom come."[37]

Haimo's commentary shows clearly the distance between actual apocalyptic expectation and the Latin Apocalypse exegesis that had become standard by the ninth century. That the Apocalypse was assumed to be an allegory of the Church is evident throughout Carolingian exegesis, as in an anonymous ninth-century Frankish commentary (attributed by the manuscripts to Jerome and Isidore) that develops its interpretation by allegorical explication of each group of seven in the Apocalypse.[38]

All the Apocalypse commentaries from the Carolingian world thus show the continuing assumption of the text as an allegory of the Church, and a continuing process of filtering specific interpretations from earlier commentaries to support that assumption. There is little in these texts that shares the radical assumption of the imminent end evident in the Apocalypse. Instead, early medieval exegesis presents the Apocalypse as a book about the integrity and purity of the Church on earth. As Paula Fredriksen has shown, Tyconius's insistent rejection of chiliasm led to an interpretation of the Apocalypse which understood the book not as a warning of the imminent end of the world but as a guide for the Church on earth in expectation of the final joining of the spiritual and physical churches.[39] Cassian's term *anagogic* is perhaps more appropriate than "apocalyptic" in characterizing this literature.

This is not to argue, though, that there was no apocalyptic thought in the early Middle Ages. On the contrary, these centuries give evidence of a definite tradition of apocalyptic literature, in which the Apocalypse played a decisive role, one that centers around a figure whose advent is spoken of in the Apocalypse: the Antichrist. Antichrist actually comes from an ancient (certainly pre-Christian) tradition; in Jewish apocalyptic literature he is

[36]Haimo *Expositionis in Apocalypsin B. Johannis* (PL 117:937–1220). Haimo's Book 1 covers the same text as Books 1 and 2 of Ambrose Autpert; Book 2 matches the text of Autpert's Books 3 and 4; Haimo's Books 3, 4, and 5 parallel Autpert's Books 5, 6, and 7; Haimo's final two books cover the same text as Autpert's Books 8, 9, and 10, dividing the text at Apoc. 18:24.

[37]"Ibique meruit videre hanc prophetiam de statu praesentis et futurae Ecclesiae. . . . Haec omnis Ecclesia loquitur in Joanne, optans ut veniat Christus ad judicium. Unde et quotidie in Dominica oratione postulat suppliciter: Adveniat regnum tuum" (PL 117:937, 1220).

[38]Grazia Lo Menzo Rapisarda, ed., *Incerti Auctoris: Commentarius in Apocalypsin* (Catania, 1966). The clearest correspondence is to Ambrose Autpert, Alcuin, and Haimo (12). Joseph T. Kelly dates the work somewhat earlier and follows Bernhard Bischoff in asserting for it an "Irish character," but with little discussion of these claims ("Early Medieval Evidence for Twelve Homilies by Origen on the Apocalypse," *Vigiliae Christianae* 39 [1985]: 273–79).

[39]Fredriksen [Landes], "Tyconius and the End," 74–75.

spoken of as Belial, "the lawless one."[40] In canonical Scripture besides the
Apocalypse, medieval Christians found references to Antichrist in Daniel
(especially the evil king of Daniel 11:36), and 2 Thessalonians (especially
2:3–4). Commentaries on these biblical texts develop the apocalyptic ex-
pectation of the advent of Antichrist far more than do the commentaries
on the Apocalypse; a glance at Jerome's commentary on Daniel confirms
this, as does a comparison of Haimo's discussion of Antichrist in his com-
mentary on 2 Thessalonians to his mere repetition of the etymologies (an-
temos, teitan, etc.) derived from Primasius when discussing Antichrist in
his Apocalypse commentary.[41]

An even more impressive testimony to early medieval apocalyptic is the
tenth-century De ortu et tempore Antichristi, a text written by Adso of
Montier-en-Der at the request of Queen Gerberga.[42] This handbook to the
Antichrist drew from many sources, including Jerome on Daniel, Haimo
on 2 Thessalonians, and Bede on the Apocalypse; it was so popular that it
circulated in at least seven versions and was attributed to Alcuin, Augus-
tine, Methodius, and Anselm of Canterbury. The most significant thing
about Adso's treatise is that it coexisted with a tradition of Apocalypse ex-
egesis that continued spiritual, anagogic readings of the last book of the
Bible for centuries to come. In the twelfth century, for example, both the
Glossa ordinaria and the popular commentary of Rupert of Deutz are far
more ecclesiological than eschatological in their focus.[43] Yet it is also in
the twelfth century that the future of Apocalypse exegesis begins to
change, when the apocalyptic themes of Christian symbolism gain prece-
dence over the ecclesiological symbolism that dominated the earlier pe-
riod and when this shift to the apocalyptic begins to affect even Latin
commentary on the Apocalypse.

[40]Richard Kenneth Emmerson, Antichrist in the Middle Ages: A Study of Medieval
Apocalypticism, Art, and Literature (Seattle, 1981); Wilhelm Bousset, The Antichrist
Legend: A Chapter in Christian and Jewish Folklore, trans. A. H. Keane (London, 1896),
135–37; Bernard McGinn, Visions of the End: Apocalyptic Traditions in the Middle
Ages (New York, 1979), 16–17, 22–24.
[41]Jerome's Commentary on Daniel, trans. Gleason L. Archer, Jr. (Grand Rapids, Mich.,
1977). See also Jay Braverman, Jerome's Commentary on Daniel: A Study of Compara-
tive Jewish and Christian Interpretations of the Hebrew Bible (Washington, D.C., 1978).
Cf. Haimo In Epistolam II ad Thessalonicenses (PL 117:777, 780–81), to his commen-
tary on Apoc. 13:18 (PL 117:1102).
[42]CCCM 45:20–30; trans. Bernard McGinn, Apocalyptic Spirituality (New York,
1979), 81–96.
[43]Glossa ordinaria (PL 114:709–52); see also Smalley, Study of the Bible, 46–66. Ru-
pert of Deutz In Apocalypsim (PL 169:825–1214); see the discussion by John Van Engen,
in Rupert of Deutz (Berkeley and Los Angeles, 1983), 275–82.

4

The Medieval Return to the Thousand-Year Sabbath

ROBERT E. LERNER

Inveighing against millennialism shortly before the year 400, Saint Jerome declared: "The saints will in no wise have an earthly kingdom, but only a celestial one; thus must cease the fable of one thousand years."[1] And so it ceased. Of course a few words from Saint Jerome did not alone extinguish the vigorous millennialism of early Christianity, but the combined attack on "the fable of one thousand years" by several prominent post-Nicene Fathers accomplished that goal. If millennialism is construed loosely as any hope for impending, supernaturally inspired, marvelous betterment on earth before the End, such a view disappeared as a documentable influence on Western thought and conduct for some seven centuries after "Jerome's curse."[2] Even more dramatically, millennialism was absent longer if it is construed as the expectation of a coming thousand-year reign of the saints in terms taken from Chapter 20 of the Apocalypse. But literal millennialism did return. Having previously considered the revival of millennialism in the loose sense, I propose here to treat the revival of a literal

This essay was written in the Institute for Advanced Study; blessed is he that hath part in such bliss.
[1]Jerome *Commentarium in Danielem* (*CC* 75A:848 = *PL* 25:534A): "Sancti autem, nequaquam habebunt terrenum regnum, sed caelestum. Cesset ergo mille annorum fabula."

[2]My definition of *millennialism* in the loose sense conforms to standard usage. See Yonina Talmon in *International Encyclopedia of the Social Sciences* (1968), 10:349; or my "Black Death and Western Eschatological Mentalities," *American Historical Review* 86 (1981): 537 n. 13, with literature there cited. I take *millennialism, millenarism, millenarianism,* and *chiliasm* to be interchangeable terms. Elsewhere I have most often referred to *chiliasm* in deference to German usage and to save syllables; here I conform to usage found in this volume.

millennialism based on the Apocalypse's "binding of Satan for one thousand years."[3]

Of all the post-Nicene patristic assaults on millennialism, the one advanced by Saint Augustine in the *City of God* was the most influential. Reviewing eschatological issues in the *City of God* item by item, Augustine reprehended any hope for miraculous collective betterment on earth. Since faith and charity required Christians to despise delight in earthly existence and to live solely for the end of enjoying God in heaven, there could be nothing superior to the Church militant as an earthly institution designed to forward that end. Therefore it followed that when Saint John told of a thousand-year earthly reign of Christ and the saints (Apoc. 20.1–6), he could not have been referring to a coming dispensation but had to be telling of the present Church. For Augustine, belief in a future kingdom was "ridiculous" since "even now the Church is the Kingdom of Christ."[4]

Two additional points regarding Saint Augustine's critique of millennialism in the *City of God* must be considered in order to comprehend later developments. The first is that Augustine vehemently repudiated any literal reading of "one thousand" even if applied to the present. Here his motive was to ensure that no one would begin to count years to the end of the world by adding one thousand to whatever date might be taken for the founding of the Church. To all such reckoners Augustine said "relax your fingers, and give them a little rest." According to him, nothing in the Bible could serve for calculating the date of the End because Christ had twice warned against seeking to know the "day and hour" or "times or dates" that "the Father has fixed by his own authority" (Matt. 24:36; Acts 1:7).[5] If the Apocalypse's thousand years could not be interpreted literally, they

[3]This essay is the third in a series. In "Refreshment of the Saints: The Time after Antichrist as a Station for Earthly Progress in Medieval Thought," *Traditio* 32 (1976): 97–144, I surveyed the origins and development of a theologically respectable "post-Antichrist" millennialism; and in "Joachim of Fiore's Breakthrough to Chiliasm," *Cristianesimo nella Storia* 6 (1985): 489–512, I treated the transmutation of this tradition by Joachim of Fiore. Here I pursue the radicalization of the same tradition as it approached the goal of literal millennialism. Regarding the less theologically respectable "Sibylline" or "pre-Antichrist" millennialism, see my "Refreshment of the Saints," 99–100, and my *The Powers of Prophecy* (Berkeley, 1983), 54–56. The anemic expression of Sibylline millennialism by Adso of Montier-en-Der (tenth century) is an exception regarding the lack of millennialism in the early Middle Ages that proves the rule.

[4]*De civitate Dei* 20.7: "in quasdam ridiculas fabulas verteretur"; ibid., 20.9: "Ergo et nunc ecclesia regnum Christi est regnumque caelorum. Regnant itaque cum illo etiam nunc sancti eius." On humanity's goal, see 14.28. Augustine may have drawn heavily for his own figurative reading of Apoc. 20 on the lost Apocalypse commentary of the Donatist Tyconius; see Bernard McGinn, *The Calabrian Abbot: Joachim of Fiore in the History of Western Thought* (New York, 1985), 81, 83–84.

[5]*De civitate Dei* 18.53: "Frustra igitur annos, qui remanent huic saeculo, conputare ac definire conamur, cum hoc scire non esse nostrum ex ore Veritatis audiamus; quos tamen alii quadringentos, alii quingentos, *alii etiam mille* [emphasis added] ab adscensione Domini usque ad eius ultimum adventum conpleri posse dixerunt. . . . Omnium vero de hac re calculantium digitos resoluit et quiescere iubet ille, qui dicit: *Non est vestrum scire tempora, quae Pater posuit in sua potestate* [Acts 1:7]."

had to stand figuratively for the world's last thousand years, of which the Church's reign would be a part, or else they had to be taken as a perfect number representing an indeterminate totality.[6]

Second, the saint allowed his readers to conclude that "spiritual" millennialism might be less reprehensible than its materialistic alternative. Early in his discussion of Apocalypse 20, Augustine stated that belief in a coming earthly Sabbath "would be in some degree tolerable if it were held that delights of a spiritual character were to be available for the saints." Moreover, he added that he had once subscribed to such a belief himself.[7] Proceeding to lament that the millennialists of his day awaited "the most unrestrained material feasts," he launched into his own interpretation of the meaning of Apocalypse 20 and, in so doing, implicitly eliminated the possibility of future "spiritual delights." Nevertheless, anyone who wished to explore the possibility of collective earthly spiritual progress would have seen that Augustine had voiced no opposition to such a possibility in principle.

Passing over the ways in which Saint Jerome and Saint Gregory joined in Augustine's antimillennialist litany,[8] it suffices to say that a prohibition against applying Apocalypse 20 to the future was established during the late patristic era and remained in force for centuries thereafter. Yet during that same era a theological basis for undermining the prohibition was created unwittingly, on technical grounds, by a few exegetes who themselves were ardent antimillennialists.[9] None other than Saint Jerome was the first to propose that a brief interval of earthly "silence" or "peace" would occur between the death of Antichrist and the Last Judgment. Although

[6]Ibid., 20.7. Augustine's first alternative shows that he assumed the world would end in less than one thousand years.

[7]Ibid.: "Quae opinio esset utcumque tolerabilis, si aliquae deliciae spiritales in illo sabbato adfuturae sanctis per Domini praesentiam crederentur. Nam etiam nos hoc opinati fuimus aliquando."

[8]Briefly, the burden of Saint Jerome's attack was that "to take John's Apocalypse to the letter is to Judaize"; see Lerner "Refreshment of the Saints," 101 n. 16. For Gregory the Great's repeated insistence that John's thousand years had to be understood figuratively as referring to "Holy Church," see Daniel Verhelst, "La préhistoire des conceptions d'Adson concernant l'Antichrist," *Recherches de Théologie Ancienne et Médiévale* 40 (1973): 79 n. 149. In the second half of the seventh century, Julian of Toledo often denounced literal millennialism as a Jewish doctrine; Julian also succinctly expressed Augustine's position in saying that the Apocalypse's millennial reign referred to "the Church of God, which, by the diffusion of its faith and works, is spread out as a kingdom of faith from the time of the Incarnation of Christ until the time of the coming Judgment." See, respectively, Richard Landes, "Lest the Millennium be Fulfilled: Apocalyptic Expectations and the Pattern of Western Chronography, 100–800 CE," in *The Use and Abuse of Eschatology in the Middle Ages*, ed. Werner Verbeke, Daniel Verhelst, and Andries Welkenhuysen (Leuven, 1988), 172 n. 141; and Julian's *Antitheses* (PL 96:697), cited by Jaroslav Pelikan in *The Growth of Medieval Theology, 600–1300* (Chicago, 1978), 43.

[9]I pursue the fortunes of this doctrine in my "Refreshment of the Saints" and hence limit myself here to aspects of it that led to the retrieval of literal millennialism. For the point of departure in Saint Jerome, see 101–3.

this proposition arose solely from internal requirements Jerome found necessary for interpreting a passage in Daniel, he employed it for interpreting a passage in Matthew as well. And once Jerome's authority stood behind the concept of a brief silence after Antichrist, the concept was applied elsewhere by orthodox expositors of Scripture until it became an exegetic commonplace.

For present purposes we may limit ourselves to its use for interpreting passages in the Apocalypse. The exegete who introduced Jerome's peace after Antichrist into Apocalypse exegesis was the Venerable Bede.[10] Seeking coherence in the visions of John of Patmos, Bede treated the vision of the seven seals (Apoc. 5:1–8:1) as a discrete unit wherein the successive openings of seals were stages in the development of the Church. In this scheme, the white Horseman of the first seal represented the purity of the primitive Church, the following three Horsemen represented three successive wars against the Church, and the souls "under the altar" were ahistorical. On this basis it followed that the woes of the sixth seal were the final earthly trials under Antichrist, and the "silence in heaven about the space of half an hour" was the brief time of rest between Antichrist and the Last Judgment already identified by Saint Jerome.

Bede's reading of the silence of the seventh seal did not stem from any desire on his part to undermine the Augustinian prohibition against positing a better time in the earthly future. On the contrary, Bede, who branded millennialism as "heretical and worthless," did all he could to make the time of silence seem like a negligible *caesura*. According to him, the period would only last for forty-five days, or slightly longer (Jerome had said forty-five days without qualification, but Bede wanted to avoid an exact counting of final "times and moments"), and it would bring no delights—material or spiritual—but solely "rest" for the saints parallel to Christ's rest between the Crucifixion and the Resurrection. Furthermore, Bede read Apocalypse 20 without demurrer as referring to the present, and he resisted an obvious opportunity to introduce the coming peace in interpreting John's vision of the seven angels with the seven trumpets (Apoc. 8:2–11:19). In the latter case, Bede interpreted the septenary of angels with trumpets as a historical sequence parallel to the vision of the seven seals, but he made the blowing of the seventh trumpet stand for Judgment Day instead of an earthly rest.

Yet despite all his precautions, Bede's exegesis of the seven seals was to prove a fruitful source for millennialism in ways he may not have consid-

[10]On Bede, see ibid., 103–6; Wilhelm Kamlah, *Apokalypse und Geschichtstheologie: Die mittelalterliche Auslegung der Apokalypse vor Joachim von Fiore* (Berlin, 1935; reprint, Vaduz, 1965), 12, 21–22, 48–49; and the essay by E. Ann Matter in this volume. Gerald Bonner, *Saint Bede in the Tradition of Western Apocalyptic Commentary* (Newcastle upon Tyne, 1966) is helpful on Bede's sources. The standard edition unfortunately remains *PL* 93:129–206, wherein the commentary on the seven seals is at 146C–154C, that on the seven angels with the seven trumpets at 153D–165D, and that on the thousand-year binding of Satan at 191A–192D.

ered. First, as opposed to Saint Jerome, who referred to a final earthly time divorced from any developmental framework, Bede placed it within a developmental history of the Church. Second, by making it a seventh term in a septenary, he turned it into a "Sabbath," a concept obviously replete with positive connotations in Christian thinking. And finally, once an earthly Sabbath was present in an authoritative Apocalypse commentary, it was there for other exegetes to employ in ways that Bede himself had resisted.

Bede's Sabbath was appropriated by a succession of school-based Apocalypse commentators during the twelfth and thirteenth centuries, whose motives evolved from desire for orderliness to ideological commitment. The point of departure for this trend was the "Ordinary Gloss" (Glossa ordinaria), a collective work compiled in Laon around 1120 for teaching and reference purposes.[11] Although the author of the gloss on the Apocalypse drew from the commentaries of both Bede and Haimo of Auxerre (ca. 850),[12] he preferred tidy sequences for the purposes of "scholastic" instruction and therefore appropriated Bede's schematizations whenever they offered such tidiness. Because Bede's readings of the septenaries of angels with seals and angels with trumpets offered orderly units, the Laon glossator followed Bede on both. His "search for order" can be seen in the fact that he straightened out Bede's succession of wars against the Church in the vision of seals to make it match the order of wars Bede had mentioned in interpreting the vision of angels with trumpets.[13] But the glossator drew back from matching the respective seventh terms in the two sequences, letting the former remain as a brief earthly Sabbath (he called it a time of "peace and tranquillity") and the second, the announcement of Judgment Day. Had he felt strongly about the forecast of a Sabbath one way or the other, he could have inserted it as the last term in the vision of trumpets or deleted it as the last term in the vision of seals. But apparently he was indifferent.

Since the Glossa ordinaria took the form of a collection of statements rather than a continuous commentary, it remained for Richard of Saint

[11]A detailed modern study of the Glossa ordinaria is lacking. In its absence, see Beryl Smalley, The Study of the Bible in the Middle Ages, 2d ed. (Oxford, 1952), 56–66; Guy Lobrichon, "Une nouveauté: Les gloses de la Bible," in Le Moyen Age et la Bible, ed. Pierre Riché and Guy Lobrichon (Paris, 1984), 103–11; and, with particular reference to the gloss on the Apocalypse, Kamlah, Apokalypse und Geschichtstheologie, 27–35, 48–49. The abbreviated edition of the Glossa ordinaria in PL 114 is unsatisfactory; see instead any of the multivolume folio-sized editions of the Biblia sancta cum Glossa ordinaria published between the late fifteenth and the early seventeenth centuries.

[12]Haimo's commentary (PL 117:937–1220, mistakenly under the name of Haimo of Halberstadt) stood at a pole from Bede's in interpreting the Apocalypse ahistorically as a collection of moralities. See on it Kamlah, Apokalypse und Geschichtstheologie, 14–15, 20–22; Guy Lobrichon, "L'ordre de ce temps et les désordres de la fin: Apocalypse et société, du ix^e à la fin du xi^e siècle," in Verbeke, Verhelst, and Welkenhuysen, Use and Abuse of Eschatology (see n. 8), 221–41; and Matter's essay herein.

[13]This observation was first made by Kamlah, in Apokalypse und Geschichtstheologie, 48–49.

Victor to rework the gloss on the Apocalypse into a self-standing work shortly before 1150.[14] Yet although Richard went further than the Laon glossator in imposing order—he transformed the vision of the seven angels with seven vials (Apoc. 16) into a third historical septenary—he was no more seduced than his predecessor by Bede's hint of millennialism. Thus Richard adhered to the *Glossa ordinaria* in stating that the time typified by the opening of the seventh seal would be one of "peace and tranquillity" for the Church, but he muted any potential joy about this by characterizing the time as short and by stating that it would serve for the "testing of the just" and "preparation for heavenly glory."[15]

In contrast, a Dominican who drew on Richard's work around 1236 to produce his own Apocalypse commentary displayed an unmistakable millennializing spirit.[16] This exegete, who worked in the Parisian convent of Saint Jacques, was a man with a cause. Determined to propagandize for the preaching mission of his order against episcopal recalcitrance, he viewed the goal of Church history as triumphant evangelization. Hence, when he treated the opening of the seventh seal, he declared that the earthly Sabbath of the Church would include "freedom of preaching." In addition, he took the step of introducing the Sabbath into the sequence of seven angels with seven trumpets, specifying that when the seventh angel blew his trumpet, there would be "peace and propagation of the faith." Last but not least, he introduced the Sabbath into the vision of angels with vials by stating that the seventh term in that sequence stood for a wondrous final time when an order of preachers would evangelize securely and the saints would work miracles.

Although the Dominican commentator demonstrated how the Bedean tradition could be utilized for consistent millennializing (and his work in this regard was not exceptional),[17] he was still far from recreating a literal

[14]*PL* 196:683–888; the basic analysis remains Kamlah, *Apokalypse und Geschichtstheologie*, 41–53.

[15]*PL* 196:776AB: "Silentium quasi media hora, pax et tranquillitas ultimo . . . [Ait] de parvi temporis pace et tranquillitate que eis post Antichristum in fine mundi, et in his omnibus de justorum probatione, et ad celestem gloriam preparatione." In his reading of Apocalypse 20, Richard not only adhered to the Augustinian interpretation of the millennial kingdom as the Church but added an other-worldly dimension to it by stating that the "first resurrection" applied to the beatitude of the just who already were in paradise (855AB).

[16]The following two paragraphs are based on my "Poverty, Preaching, and Eschatology in the Revelation Commentaries of 'Hugh of St Cher,' " in *The Bible in the Medieval World: Essays in Memory of Beryl Smalley*, ed. Katherine Walsh and Diana Wood (Oxford, 1985), 176–79.

[17]See ibid., 180–81, on a second Parisian Dominican commentary, written around 1242, which accepted the millennializing of the first, albeit toning it down. More striking is a Franciscan Apocalypse commentary apparently written in Paris between ca. 1230 and ca. 1250, perhaps by Alexander of Hales, treated in this volume by David Burr. Burr, in "Millenarian Views of the Spiritual Franciscans" (Paper delivered at the 101st

millennium. For one, although he exulted in the expectation of a coming Sabbath, he adhered to tradition in specifying that the Sabbath would be short. Moreover, while he applied millennialist readings to passages where that took some ingenuity, he eschewed a literal reading of the original millennialist passage itself: Apocalypse 20:1–6. Indeed, since he had no inclination to quarrel with Saint Augustine, he adhered so closely to the received interpretation of Apocalypse 20 that it might have seemed as if centuries had never passed.

Such by no means could be said of the Apocalypse exegesis of Joachim of Fiore. I have considered the Saint Jacques Dominican out of chronological sequence in order to show how far someone working within the Bedean tradition could advance toward millennialism without Joachim's help. But that is only to say that Joachim's treatment of the future was literally and figuratively epoch making.[18] An ardent devotee of monasticism, the Calabrian Abbot began to seek out chronological patterns in Scripture around 1180 in order to learn all he could about the role of monasticism in the divine plan. In so doing, he decided that a wondrous earthly Sabbath would transpire between the death of Antichrist and the judgment because such was revealed by the Bedean interpretation of the seventh seal and confirmed by his own predictive extrapolations from the Old Testament (Joachim's concordance hermeneutic). Then, seeking to determine whether the Apocalypse might confirm his vision of the future in other ways, he concluded that it could be interpreted not only as a series of discrete visions but also as a continuous account of the entire history of the Church.

Joachim thereupon was placed in a quandary. Reading the Apocalypse continuously had the advantage of allowing the millennial verses of Chapter 20 to foretell the future Sabbath; but of course it had the disadvantage of violating a prohibition that had originated with Saint Augustine. An autobiographical passage in Joachim's Apocalypse commentary tells of the resolution. Blocked in his desire to penetrate the full meaning of the Apocalypse for the length of a year, while sunk in the deepest contemplation one Easter morning, he was allowed to see the "plenitude" of that book "with clear insight by the mind's eye." After this moment of truth, he plunged ahead. Fortified by a sense of divine approbation, he publicized a

Annual Meeting of the American Historical Association; Chicago, 1986), reports that this commentary alludes unambiguously to a period of "exultation and praise in the Church" after Antichrist's death.

[18]Documentation for the following interpretation of Joachim's intellectual progress appears in my "Joachim of Fiore's Breakthrough." See also my "Antichrists and Antichrist in Joachim of Fiore," *Speculum* 60 (1985): 553–70. For an interpretation of the relationship of Joachim's Apocalypse commentary to the broad principles of his exegesis, see E. Randolph Daniel's essay in this volume.

vision of the future that included the application of the Apocalypse's millennium to a coming time between Antichrist and the End.

Joachim's daring in surmounting the Augustinian barrier was an extraordinary assertion of doctrinal independence. Although he acknowledged in his completed commentary (finished shortly before 1200) that the
millennial reign of the saints might stand "in part" for the entire terrestrial reign of the Church, he thereby was offering no more than a small
palliative to Saint Augustine since he declared in the same context that
the "fullest" application of the passage was to a future earthly Sabbath.[19]
Joachim also accorded the Sabbath its own highly exalted salvational-
historical dignity—no "carnal" delights but the most wondrous spiritual
ones. For him the Sabbath was simultaneously the seventh time of the
Church and the "third *status* of grace"—the time of the Trinity's providential unfolding wherein all humanity would obtain the fullest possible
earthly illumination by the Holy Spirit.[20] Since no one in the Christian
tradition had ever expressed such progressivist views before, the abbot of
Fiore surely stood for a turning point in the history of European attitudes
toward the future.

That said, a crucial qualification arises for the present analysis, namely
that Joachim expected the final Sabbath to be short. Joachim was no more
willing than Saint Augustine had been to take John's "thousand years" literally. Rather, he maintained that the thousand years stood for plenitude
just as Genesis told of Abraham and Isaac dying "full of days."[21] How long

[19]Joachim *Expositio in Apocalypsim* (Venice, 1527; reprint, Frankfort on the Main,
1964), fol. 211rb: "secundum partem incepit ab illo sabbato quo requievit Dominus in
sepulchro, et secundum plenitudinem sui a ruina bestia et pseudo prophete." The best
analyses of Joachim's confrontation with Augustine regarding the interpretation of
Apoc. 20 are Bernhard Töpfer, *Das kommende Reich des Friedens* (Berlin, 1964), 81–83;
and McGinn, *Calabrian Abbot*, 154. I share McGinn's view that "probably no single
part of his long commentary shows Joachim's break with 700 years of Latin exegetical
tradition more decisively than his treatment of the Apocalypse's description of the
thousand-year reign of Christ and the saints upon earth."

[20]E.g., Joachim *Enchiridion super Apocalypsim*, ed. Edward K. Burger (Toronto, 1986),
23, lines 462–64: "In tribus denique statibus distinguitur tempus legis et gratie: sub
lege, sub gratia, sub ampliori gratia; quia gratiam, inquit [John 1:16] pro gratia dedit nobis"; ibid., 62, lines 1740–43: "in tertio statu, qui videlicet status totus in ipsum sabbatum reputandus est, de quo nimirum regno per Joannem dicitur, sacerdotes Dei
sederunt et regnaverunt cum Christo [Apoc. 20:4, 6]."

[21]*De vita Sancti Benedicti* 32, ed. Cipriano Baraut, "Un tratado inédito de Joaquín de
Fiore," *Analecta sacra Tarraconensia* 24 (1951): 102: "quanticumque sint anni isti, pro
mille reputandi sunt propter fructus copiam et ubertatem quam daturi sunt"; Joachim
De ultimis tribulationibus, ed. E. Randolph Daniel, "Abbot Joachim of Fiore: The *De
ultimis tribulationibus*, " in *Prophecy and Millenarianism: Essays in Honour of Marjorie Reeves*, ed. Ann Williams (Burnt Hill, Essex, 1980), 187, lines 5–9 [I alter some
punctuation]: "'mille anni,' i.e. tempus quod designatur in mille annis, iuxta illud quod
scriptum est de iusto viro, 'consumatus in brevi, complevit tempora multa,' et ubi agitur
in veteri testamento de obitu sanctorum patriarcharum, scriptum est, 'mortuus est
Abraham vel Ysaac senex et plenus dierum.' " For other examples of the same point in
Joachim's Apocalypse commentary, see Töpfer, *Reich des Friedens*, 82 n. 174.

would the duration of the Sabbath then be? Granting that Scripture did not divulge exact lengths of future "times and moments," he yet expressed his conviction that the Sabbath would be brief on the grounds of Christ's statement that "unless those days had been shortened, no living creature would be saved" (Matt. 24:22; Mark 13:20).[22] For Joachim, God's plan dictated the growing compression of salvational developments as the march toward the Last Judgment progressed. Thus the length of a generation between Noah and David was much shorter than one between Adam and Noah, and the lengths of Judean royal reigns became shorter from David to the captivity.[23] Most important, since the Lord had accomplished much more during the world's sixth age (lasting from the Incarnation to Antichrist) than he had in the previous five together, it followed that his work would be even more compressed during the Sabbath.[24]

Given that the logic of providential acceleration dictated that the Sabbath would probably be short, the abbot of Fiore went further to surmise that it would be fleeting—indeed, that it probably would not last for more than about half a year. This proposal derived from taking the silence of the seventh seal as a figure for the Sabbath: since John told of a "silence in heaven, as it were for half an hour," (Apoc. 8:1), the Sabbath would last about half a year because an "hour" was a "time" and a "time" was a year.[25] At such a juncture, the student of Joachim's thought must stand

[22]On the uncertainty of any predictive dating, see, e.g., Joachim *Liber de concordia Noui ac Veteris Testamenti* 3.2.6 (= fol. 41vb of Venetian ed. of 1519), ed. E. Randolph Daniel (Philadelphia, 1983), 304: "Tempus autem quando hec erunt, dico manifeste quia prope est; diem autem et horam dominus ipse novit" (the modern edition is incorrectly punctuated because it misses the implicit citation of Matt. 24:36]; *De ultimis tribulationibus*, 189, lines 15–26; and *Expositio in Apocalypsim*, fol. 141rb: "Sed hoc non est nostrum scire." On the speed-up principle, see *Liber de concordia* 4.1.44 (= fol. 56ra of Venetian ed.): "istam generationem . . . non puto supputandam esse sub numero annorum aliarum quadraginta, quia scriptum est 'Nisi breviasset Dominus dies illos, non fieret salva omnis caro' " (401).

[23]Joachim *Liber de concordia* 2.1.19 (= fol. 12rb of Venetian ed.), 98; see also ibid., 2.1.21 (= fol. 12vb of Venetian ed.): "ut enim longe minores sunt generationes huius temporis generationibus antiquis, ita fortassis generationes tertii status satis minores erunt generationibus nostris" (101–2).

[24]Joachim *Enchiridion*, 24, lines 497–502: "sabbatum dico vigilie Pasche, in quo septimum tempus illud designatum est . . . quia et ipse pro hebdomada una, hoc est, septima accipiendus est, quia . . . propter electos suos quos eligit et preeligit omnipotens, breviabuntur [Matt. 24:22], ut ait Dominus." For the same point in the *Expositio super Apocalypsim*, see Töpfer, *Reich des Friedens*, 83, citing *Expositio*, fol. 141rb.

[25]Joachim *Liber de concordia* 3.2.7 (= fol. 41vb of Venetian ed.): "Brevissimum autem esse puto tempus septime apertionis . . . mediam horam in loco isto pro dimidio anno accipiendam esse puto" (306). Idem, *Expositio in Apocalypsim*, fol. 123rb: "Mediam autem horam arbitror vocari tempus illud, quod vocatur in scripturis dimidium temporis; quod, scilicet, tempus quasi septimum erit, respectu trium temporum que in sex dimidiis temporum dividuntur; sive secundum veritatem sex menses, sive secundum typicum intellectum tempus illud septimum quod ultimis sex mensibus designatur." Joachim's arithmetic in the latter passage depends on the "time and times and half a time" of Dan. 7:25. Töpfer, in *Reich des Friedens*, 83–87, considers several other passages that show Joachim expecting the Sabbath to be very short.

back momentarily and wonder whether the abbot here was not driven by some private impulse. Perhaps the "law of acceleration" was all that drove him, but it seems more likely that he saw the need for defending himself against charges of error regarding his entire system of the future and sought to disarm criticism by making the Sabbath extremely fleeting.

Although Joachim gained many followers who tended to embellish aspects of his thought, none until the end of the thirteenth century (so far as is currently known) endeavored to lengthen his Sabbath.[26] To take two central examples, the author of the pseudo-Joachite Jeremiah commentary welcomed the concept of a Sabbath but did not refer to its duration, and the author of the pseudo-Joachite Isaiah commentary assumed that the final Sabbath would be brief.[27] An intriguing question arises as to whether the north-German Franciscan Alexander Minorita, who completed an Apocalypse commentary in 1235 (with interpolations and additions in the 1240s), was influenced by Joachim inasmuch as Alexander treated all of the Apocalypse as a continuous account of Church history but offered no forecast of a coming Sabbath.[28] Whatever the case, Alexander is of relevance here because he was the first medieval commentator to interpret the Apocalypse's thousand years literally. Specifically, he took John's millennium to be the Church's earthly reign from its triumph under Constantine and Pope Sylvester until the presumed Last Judgment in 1326 or soon thereafter.[29] Although in so doing, Alexander was the first to break with

[26]An intriguing passage in the pseudo-Joachite *Epistola subsequentium figurarum* allows that the forty-five days between Antichrist and the End allotted from Dan. 12:11–12 could really be forty-five months, years, or centuries; see text in Jeanne Bignami-Odier, "Notes sur deux manuscrits de la Bibliothèque du Vatican contenant des traités inédits de Joachim de Flore," *Mélanges d'Archéologie et d'Histoire* 54 (1937): 225. It is unclear to me whether this statement arises from an attempt to emphasize the uncertainty of final dates or from a latent desire to expand the length of the Sabbath. Unfortunately the dating of the passage is also uncertain since the *Epistola* seems to have originated in the early thirteenth century, but the passage in question is most likely an interpolation made around 1290, on which see Marjorie Reeves and Beatrice Hirsch-Reich, *The Figurae of Joachim of Fiore* (Oxford, 1972), 109–10 (the authors overlook a convergence of arguments for the interpolation having been made around 1290).

[27]On the two commentaries, I follow Töpfer, *Reich des Friedens*, 118, 137. On different versions of the Jeremiah commentary, see Stephen E. Wessley, *Joachim of Fiore and Monastic Reform* (New York, 1990), 114–23.

[28]Alexander Minorita *Expositio in Apocalypsim* (ed. A. Wachtel, MGHQ1). As Kamlah points out in *Apokalypse und Geschichtstheologie*, 119–20, Alexander was the first to abandon the principle of recapitulation whereby the Apocalypse was interpreted as a succession of discrete visions that alluded more or less to the same events in different terms. (Joachim offered both a continuous reading and an exposition by recapitulation.) Whether or not Alexander was influenced in any way by Joachim remains uncertain. See further, Sabine Schmolinsky, *Der Apokalypsenkommentar des Alexander Minorita: Zur frühen Rezeption Joachims von Fiore in Deutschland* (Hannover, 1991).

[29]For Alexander's application of the millennium to the time beginning with the Church's triumph under Constantine and Sylvester, specifically A.D. 326, see his *Expositio* (MGHQ 1:114–15, 412–13, 443, 509). It is striking that Alexander knew the Augustinian position that the thousand years stood figuratively for perfection (see 443–44) but declined to use it. To guard against violating the eschtological uncertainty principle, Alexander allowed that the Lord might grant at his will an additional space of time of

the Augustinian tradition that divested the millennium of any chronological significance, his literalizing was not thought to be doctrinally offensive, apparently because it had nothing to do with a coming Sabbath.[30]

Thus it was only with the full-scale renovation of the Joachite heritage by the southern-French Franciscan Peter Olivi at the close of the thirteenth century that a genuine advance was made toward positing an enduring Sabbath on earth. Unlike Joachim, Olivi treated the future in the heat of the fray.[31] As a prominent Franciscan Spiritual, he had been censured by his own order early in his career and afterward had good reason to fear that he and his partisans would have to face martyrdom. Accordingly Olivi's greater radicalism in comparison to Joachim was probably the product of his sense of crisis: Antichrist was at the door, and a deadly struggle was in progress between his minions and the brave few who stood as "witnesses" for the truth; yet the few would triumph and gain recompense in an earthly Sabbath of some considerable length.

David Burr has written expertly about the "apocalyptic timetable" found in Olivi's Apocalypse commentary.[32] In this work of 1297 (still unpublished), Olivi adopted a generally Joachite framework for the plan of future events but broke with Joachim regarding the length of the final earthly era.[33] In his view, the Sabbath would have to last for an extended

uncertain duration after the thousand years (443). This would hardly be a Joachite Sabbath, however, since, if it occurred at all, it would be meant only to provide an opportunity for penance.

[30]On the "reception" of Alexander, which included the appropriation of his system by the non-Joachite Franciscans Peter Aureol and Nicholas of Lyra, see Wachtel's comments in Alexander's *Expositio in Apocalypsim* (MGHQ 1:XLI–XLIV); and Schmolinsky, *Apokalypsenkommentar des Alexander Minorita,* 128–30. On the apparent adoption by Peter Olivi of Alexander's application of the thousand years to the earthly triumph of the Church beginning with Constantine, see below.

[31]The best survey of Olivi's career is David Burr, *The Persecution of Peter Olivi* (Philadelphia, 1976).

[32]David Burr, "Olivi's Apocalyptic Timetable," *Journal of Medieval and Renaissance Studies* 11 (1981): 237–60; see also Töpfer, *Reich des Friedens,* 230. I draw primarily on these accounts for the following two paragraphs. It is important to note that even while Olivi considered exegesis guided by "spiritual intelligence" optimal, he maintained outright that a literal reading of a scriptural passage can sometimes be more "spiritual" than an allegorical one, especially in matters concerning "final goods." See David Burr, "Olivi, the *Lectura Apocalypsim* and Franciscan Exegetical Tradition," in *Francescanesimo e cultura universitaria: Atti del XVI Convegno Internazionale* (Assisi, 1990), 127–28. Clearly this position interrelated with Olivi's willingness to count biblical numbers predictively.

[33]Raoul Manselli, in his *La "Lectura super Apocalipsim" di Pietro di Giovanni Olivi* (Rome, 1955), is unconvincing in attempting to deny the primarily Joachite and millennialist nature of Olivi's prophetic thought. See, instead, Töpfer, *Reich des Friedens,* 237: "Indem beide [Olivi and Ubertino of Casale] die Möglichkeit zulassen, dass jener Zeitraum, in dem der Satan gebunden ist, mit dem kommenden 7. Status identisch ist, stellen sie sich im wesentlichen auf den gleichen Standpunkt wie die altchristlichen Chiliasten." A full-dress critique of Manselli and demonstration of Olivi's Joachism is offered by Gian Luca Potestà's *Storia ed escatologia in Ubertino da Casale* (Milan, 1980), 67–92.

duration because time would be needed for the conversion of the entire world and for there to be an unfolding of "morning, midday, evening, and night."[34] How long was long? Although Olivi raised the possibility that the Sabbath would last for a thousand years, he quickly dropped this idea in favor of applying the thousand years of Apocalypse 20 (with Alexander Minorita) to the Church's earthly reign beginning with Constantine.[35] Otherwise, guarding against possible heresy charges by referring to "other people's" views rather than speaking for any position himself (he had already been charged with "temerariously predicting future events" at the time of his first censure),[36] he considered various alternatives. Among these he did not rule out a view that the Sabbath would dawn in the fourteenth century and last for one hundred years.[37] But he dwelt on a set of interrelated calculations, taken from the Bible and a "Hebrew truth," according to which the Sabbath would begin sometime during the early fourteenth century and then endure for somewhat less than seven hundred years (that is, until the year 2000).[38] Although Olivi did not say that he subscribed to this scheme, he lavished such attention on it that his preference was clear.

Evidence for the position that Olivi's sense of historical crisis was not strictly personal resides in the fact that after a century when no one dared to propose that a coming Sabbath might be long, the ink was hardly dry on Olivi's Apocalypse commentary when three other students of last things began to propound the same idea. Of these, only one was directly indebted to Olivi. This was his foremost Italian disciple, Ubertino of Casale, who treated eschatology in his *Arbor vite crucifixe Jesu* (1305) and asserted vigorously therein that it was "ridiculous to say, as some rave [ut aliqui fabulantur], that God wished the highest perfection of the Church after the death of the great Antichrist in which all the Jews and all the world would

[34]Burr, "Timetable," 241. Olivi's language—copied by Ubertino of Casale—is quoted in Marino Damiata, *Pietà e storia nell' Arbor Vitae di Ubertino da Casale* (Florence, 1988), 267 n. 26.

[35]Burr, "Timetable," 256 n. 52, citing Olivi's Apocalypse commentary, where the author is referring to the views of "others": "An autem septimus status a morte huius Antichristi usque ad Gog novissimum habeat ad litteram mille annos, multo minus sciunt." Ibid., 256, for the "period of 1,000 years running from the early fourth century." So far as I know, no one has noticed that this conception was probably borrowed from Alexander Minorita.

[36]Burr, *Persecution of Peter Olivi*, 39.

[37]Burr, "Timetable," 257–58, with the recognition that the calculation in question comes from the anonymous *Liber de semine scripturarum*, thought by Olivi to have been written by Joachim.

[38]Burr, "Timetable," 255–57, 258–59; see also Töpfer, *Reich des Friedens*, 230. The "Hebrew truth" must be that according to which the world was to last for six thousand years—two thousand "before the law," two thousand "under the law," and two thousand under the messiah. On this, see, e.g., Martin Haeusler, *Das Ende der Geschichte in der mittelalterlichen Weltchronistik* (Cologne, 1980), 105–6, 164 and n. 75, 166–67. Bernard McGinn informs me that the reckoning is a commonplace in the Talmud, e.g., BT Sanhedrin 97a and 'Abodah Zarah 9a.

be converted to last for only forty-five days or months."[39] Otherwise, however, Ubertino adhered so closely to the thought and language of Olivi's Apocalypse commentary regarding the length of the Sabbath that for practical purposes he offered nothing new.[40]

Very different was a proposal offered by the Catalan physician turned prophetic evangelist, Arnold of Villanova. Misunderstanding about Arnold's relationship to Olivi has arisen from the fact that Arnold was allied with Spiritual Franciscans from about 1302 until his death in 1311. But before then, he had no notable Franciscan connections and studied eschatology on his own. Indeed, Arnold devised a system of predictive chronology around 1290, well before the date of Olivi's commentary.[41] Pondering the significance of Daniel 12:11–12, he concluded that Antichrist's reign would begin in 1365 or slightly later and that a subsequent Sabbath would last for forty-five years.[42] Since Arnold was not licensed to pronounce on theological issues because he was a layman, he refrained from publicizing his reckonings until 1300, when circumstances allowed him to present a treatise containing them to the theological faculty of the University of Paris.[43] Not surprisingly the Parisian theologians condemned the treatise, but very surprisingly an intervention by Pope Boniface VIII in 1301 allowed Arnold to promulgate the condemned findings in a new work.[44] (Boniface VIII was indifferent to Arnold's eschatology but treasured his services as a physician.) Arnold of Villanova's specification of forty-five years for the Sabbath must count as a landmark because unlike Olivi he expressed his position in his own voice and presented it as infallible truth gained from biblical science. Admittedly a timespan of forty-five years

[39]Ubertino of Casale *Arbor vite* 5.1 (Venice, 1485; reprint, Turin, 1961), 418a; alternatively, 416b: "Ridiculosum est enim dicere quod summam perfectione ecclesie que erit in conversione Judeorum et totius orbis post mortem antichristi magni Deus nolit durare nisi per xxxx et v dies [ed.: "xxx et 1 dies," but I assume this is a corruption] vel menses ut aliqui fabuluntur." The passage is cited by Damiata, in *Pietà e storia*, 267 n. 26, who reports that it is not taken from Olivi.

[40]Ubertino of Casale *Arbor vite* 5.12 (484a–485a; alternatively 482a–483a). Some of the most apposite passages are quoted by Damiata, in *Pietà e storia* 323.

[41]The dating is based on an autobiographical passage in Arnold of Villanova's *Responsio objectionibus que fiebant contra tractatum Arnaldi de adventu Antichristi*, ed. Miquel Batllori, "Dos nous escrits espirituals d'Arnau de Vilanova," *Analecta sacra Tarraconensia* 28 (1955): 52, 60–61. On the authenticity of the treatise, see my "Prophetic Manuscripts of the 'Renaissance Magus' Pierleone of Spoleto," in *Il Profetismo Gioachimita tra Quattrocento e Cinquecento*, ed. Gian Luca Potestà (Genoa, 1991), 108–9.

[42]The reckoning was first expressed in Arnold's treatise, *De tempore adventu Antichristi*; see the edition by Josep Perarnau in *Arxiu de Textos Catalans Antics* 7/8 (1988/89): 149–50, 152.

[43]The best narrative of Arnold's evangelical activities is in Heinrich Finke's *Aus den Tagen Bonifaz VIII* (Münster, 1902), 191–226; see also my "The Pope and the Doctor," *Yale Review* 78 (1988/89): 62–79.

[44]The new treatise was *De mysterio cymbalorum ecclesie*. See the edition by Josep Perarnau in *Arxiu de Textos Catalans Antics* 7/8 (1988/89): 7–133; see esp. 61 n. 136. The specification of a Sabbath of forty-five years also appears in Arnold's *Expositio super Apocalypsi* of 1306; see the edition by Joaquim Carreras i Artau (Barcelona, 1971), 119.

may not seem very long to us, but compared to everything that had been said before about the length of a Sabbath after Antichrist, it might have seemed like an epoch.

Also expressed as infallible biblical truth was the predictive chronology of "frater Columbinus," first circulated around 1300.[45] According to this person, whose exact identity remains uncertain (perhaps he was a French Franciscan), the Apocalypse revealed that Church history was to unfold in seven equal units of 220 years, of which the last, an earthly Sabbath after Antichrist, was to begin in 1320. "Columbinus" thus had the Sabbath beginning sooner and lasting much longer than did Arnold of Villanova. But if he was bold in his predictions, the strong likelihood that his name was a pseudonym shows that he was unwilling to defend them personally.

What might have happened to the author of the Columbinus prophecy had he identified himself can be inferred from what did happen to Olivi, Ubertino, and Arnold when watchdogs of orthodoxy resolved to correct eschatological errors. A lull of tolerance prevailed from 1301, when Boniface VIII allowed Arnold to reproduce his prophecies with the services of papal scribes,[46] through the pontificate of Clement V (1305–14), who retained Arnold as his physician and was by nature latitudinarian. Clement's patronage of Arnold seemed so threatening to a traditionalist such as Augustinus Triumphus (an Augustinian in name, order, and world view) that he addressed a treatise to the pope early in 1311 warning him against commerce with "diviners and dreamers."[47] In the same year, moreover, attempts were made by writers of position papers for the Council of Vienne to prod Clement V into action against "false and fantastic prophecies about the Church," but to no avail.[48]

Meanwhile most of the texts discussed here were circulating widely and contributing to a mood of expectation among evangelical zealots. Olivi's Apocalypse commentary in particular bristled with subversive

[45]Elizabeth A. R. Brown and Robert E. Lerner, "On the Origins and Import of the Columbinus Prophecy," *Traditio* 45 (1989/90): 219–56.
[46]For Arnold's account of this incident, see his *Protestatio* of 2 June 1304, ed. Josep Perarnau in *Arxiu de Textos Catalans Antics* 10 (1991): 205–6.
[47]Pierangela Giglioni, "Il 'Tractatus contra divinatores et sompniatores' di Agostino d'Ancona: Introduzione e edizione del testo," *Analecta Augustiniana* 48 (1985): 7–111.
[48]See the list of accusations against Olivi drawn up by spokesmen for the Franciscan conventuals, Raymond of Fronsac and Bonagratia of Bergamo, ed. Franz Ehrle, "Zur Vorgeschichte des Concils von Vienne," *Archiv für Literatur- und Kirchengeschichte des Mittelalters* 2 (1886): 370: "Et falsas ac fantasticas prophetias de ecclesia dixit, scripsit et docuit in libris et scriptis suis, et maxime in postilla, quam scripsit super Apocalypsim." The fact that the Council of Vienne had an opportunity to legislate against Olivi's eschatological tenets but did not do so was conceded by Bonagratia in 1317 and was also adduced in Olivi's behalf by one of his disciples in trial testimony in 1327; see, respectively, Bonagratia's *Articuli probationum contra fr. Ubertinum*, cited by Joseph Koch, in "Der Prozess gegen die Postille Olivis zur Apokalypse," *Recherches de Théologie Ancienne et Médiévale* 5 (1933): 302 n. 3; and Raoul Manselli, *Spirituali e beghini in Provenza* (Rome, 1959), 326: "Item dixit se credere doctrinam et scripturam fratris Petri Iohannis Olivi esse sanctam et catholicam et fuisse approbatam in concilio Viennensi."

implications because in addition to foretelling the imminent advent of Antichrist and a subsequent Sabbath, it vaunted the unique status of the Franciscan rule and dilated on the rivalry between "spiritual" and "carnal" churches.[49] Soon after Olivi's death in 1298, his devotees in Languedoc, within the Franciscan order and also among the laity, began to venerate "Peter of John" as a saint and to spread versions of his prophecies in the vernacular as well as in Latin.[50] Yet as the Olivi cult grew, so did the displeasure of the anti-Spiritual majority among the Franciscans.

Needless to say, it was the party of order that won out. Facing a supercharged situation in Languedoc adjacent to the papacy's new home in Avignon, John XXII resolved in 1317 to take the firmest measures against potential schismatics and subversive prophets. Among other steps, he summoned Ubertino of Casale to Avignon and saw to his forced departure from the Franciscan order,[51] and he commissioned an examination of a vernacular compendium of Olivi's prophetic ideas which resulted in its condemnation by two of his "in-house" theologians.[52]

Most centrally, John XXII put Olivi's Apocalypse commentary "on trial" in 1317.[53] Without pursuing here all the complicated twists and turns of examination that went on in several phases until 1326, it should be said that all the theologians who pronounced on the orthodoxy of the

[49]Good treatments of Olivi's complete system are Burr, *Persecution of Peter Olivi*, 17–24; Töpfer, *Reich des Friedens*, 220–32; and Potestà, *Storia ed escatologia*, 55–177. Burr points out that Olivi expressed various aspects of his eschatological thought in several works antecedent to his Apocalypse commentary; nonetheless this was the text that attracted the most attention.

[50]On the veneration, see Burr, *Persecution of Peter Olivi*, 73–74, 85–86. Bernard Gui's *Practica inquisitionis*, written between ca. 1317 and ca. 1324, in *Manuel de l'inquisiteur*, ed. Guillaume Mollat, vol. 1 (Paris, 1926), 110, refers to a vernacular translation of Olivi's Apocalypse commentary that circulated among his lay followers in Languedoc. On a vernacular compendium of positions from the commentary (said to have been written in Catalan, but Catalan would not have been very different from Provençal), see Koch, "Prozess gegen die Postille Olivis," 305; and the edition of Latin extracts from this compendium edited by José Maria Pou y Marti, *Visionarios, beguinos y fraticelos catalanes* (Vich, 1930), 483–512.

[51]On Ubertino's departure from the Franciscans, see Frédégand Callaey, *L'idéalisme Franciscain Spirituel au XIVe siècle: Étude sur Ubertin de Casale* (Louvain, 1911), 217–21. Later, in 1325, Ubertino was tried in Avignon for upholding the orthodoxy of Olivi's Apocalypse commentary and fled rather than await the outcome; see ibid., 236–38.

[52]Koch, "Prozess gegen die Postille Olivis," 305. Already in November of 1316 the vicar of the archbishop of Tarragona issued a proscription of most of Arnold of Villanova's religious writings: see text in Francesco Santi, "Gli 'scripta spiritualia' di Arnau de Vilanova," *Studi medievali*, ser. 3, 26 (1985): 1006–10. A useful treatment of John XXII's relevant procedures, which came to my attention after this essay was finished (without affecting any of my findings), is Thomas Turley, "John XXII and the Franciscans: A Reappraisal," in *Popes, Teachers, and Canon Law in the Middle Ages*, ed. James R. Sweeney and Stanley Chodorow (Ithaca, N.Y., 1989), 74–88.

[53]See the account in Burr, *Persecution of Peter Olivi*, 80–87, and at greater length, in Koch, "Prozess gegen die Postille Olivis," and Edith Pásztor, "Le polemiche sulla 'Lectura super Apocalipsim' di Pietro di Giovanni Olivi fino alla sua condanna," *Bullettino dell'Istituto Storico Italiano per il Medio Evo* 70 (1958): 365–424.

work assumed that whenever its author ascribed controversial views to"others," he was really speaking for himself.[54] On these grounds, a commission of eight ruled in 1319 that sixty tenets found in Olivi's commentary offended the faith. Some of these bore no relation to millennialism, but one that did was the position that after the death of Antichrist, the world would last for six-to-seven hundred years. As if to announce that Augustinianism still ruled, the eight theologians deemed this position erroneous, "because of the method of reckoning and because of the length of time."[55]

Not only theory was at stake in the Avignon procedures. In 1319, a Franciscan general chapter legislated against owning or referring to Olivi's Apocalypse commentary under pain of excommunication, and in 1326, John XXII condemned the commentary for Christianity at large.[56] Concurrently, from 1318 to 1328, inquisitorial campaigns were mounted to destroy Olivi's popular following in southern France.[57] (Some defendants in the resultant trials expressed their faith that after the imminent reign of Antichrist, the saints would enjoy a marvelous Sabbath to last for one hundred years.)[58] In sum, many copies of Olivi's writings were destroyed and many of his followers put to death, but it proved impossible to eradicate Olivi's vision of the future; for hardly had the fires in Languedoc died down when a young man studying in Toulouse gained knowledge of Olivi's prophetic thought and started to reconceive it in ways that would make Olivi look restrained.

The young man was John of Rupescissa, the author of the boldest prophetic system of the later Middle Ages.[59] Having been apprised of Olivi's views in Toulouse in 1332, he thereupon joined the Franciscan order, but by 1344 he had become such an embarrassment to his superiors because of

[54]This was already part of the indictment against Olivi by Raymond of Fronsac and Bonagratia of Bergamo in 1311; see Ehrle, "Zur Vorgeschichte des Concils von Vienne," 370: "Item proponimus, quod nulla potest esse occasio excusationis . . . quod dicatur, ipsum fratrem P. Johannis scripsisse et docuisse aliqua ex predictis oppinando et protestando, quod non intendebat ea asserere precise."

[55]Littera magistorum, in Miscellanea sacra, ed. Stephanus Baluze and J. D. Mansi (Lucca, 1761), 258–70; see art. 58 (at 270): "Item quod dicit quod septigenti vel sexcenti anni sint dandi septimo statui quem supra dixit incipere a morte Antichristi, tum ratione determinatis, tum ratione prolongationis, erroneum reputamus."

[56]Koch, "Prozess gegen die Postille Olivis," 306–7, 315; Pásztor, "Polemiche sulla 'Lectura super Apocalipsim,' " 377–80.

[57]The standard treatment of this subject is Manselli, Spirituali e beghini, but more work is necessary.

[58]See Gui Practica inquisitionis 1:152, and the English translation by Walter L. Wakefield and A. P. Evans, Heresies of the High Middle Ages (New York, 1969), 426. Gui's account derived from his own experience as an inquisitor.

[59]Best hitherto on Rupescissa is Jeanne Bignami-Odier, Études sur Jean de Roquetaillade (Johannes de Rupescissa) (Paris, 1952), lightly revised in Histoire Littéraire de la France 41(1981): 75–240. But most of the following is based on my introduction to Christine Morerod-Fattebert's critical edition of Rupescissa's Liber secretorum eventuum (hereafter LSE) forthcoming in Spicilegium Friburgense.

his own prophesying that he was arrested and held in a succession of Franciscan prisons. Finally, in 1349, he was brought to trial before the papal curia in Avignon. The *Liber secretorum eventuum*, a systematic treatise he wrote for the purposes of this trial, shows how Rupescissa devised his own system on the basis of borrowings from both Olivi and Arnold of Villanova combined with his own reading of the Apocalypse. Building on Olivi's scenario of a struggle between "spiritual" and "carnal" churches to culminate in the reign of Antichrist and a subsequent Sabbath, he drew on Arnold's reckonings to conclude that Antichrist would come in 1366 and be destroyed at the end of 1369.[60] But instead of following Olivi or Arnold concerning the length of the Sabbath, he proposed on the basis of Apocalypse 20:1–6 that the Sabbath would last for exactly one thousand years.

Rupescissa conceded that his literal reading of Apocalypse 20 was contrary to the "glosses and sayings of the saints" and that Saint Augustine in particular had opposed it in the *City of God*. But he swore that he had been granted privileged knowledge of its truth by means of an "intellectual vision," vouchsafed to him "in the twinkling of an eye," while he was languishing in captivity in 1345. This miracle had revealed to him "most certainly, infallibly, and necessarily" that the war with Antichrist, the thousand-year Sabbath, and the final loosing of Satan were successively foretold in the sixteenth through twentieth chapters of the Apocalypse.[61] Granted that Augustine had interpreted the thousand years "mystically," Rupescissa was obliged to conclude that Augustine had "not been given to understand" the real meaning of the binding of Satan.[62]

Despite Rupescissa's claim that knowledge of the Sabbath had come to him suddenly, the text of the *Liber secretorum eventuum* shows that he probably considered several choices before accepting the infallibility of literal millennialism. He must have taken note of Arnold of Villanova's Sabbath of forty-five years and Olivi's of roughly seven hundred years because

[60]*LSE* §15–18; Rupescissa's source must be Arnold of Villanova's *De mysterio cymbalorum ecclesie* because Rupescissa draws from that work in *LSE* §21, 46, 49.

[61]*LSE* §3: "factum est autem, eodem anno [1345], in mense Iulii, circa festum sancti Iacobi Apostoli [25 July] . . . subito in instanti, in ictu oculi, apertus est intellectus meus, et de futuris intellexi, visione intellectuali"; §74: "intellexi mille annis solaribus debere durare seculum ad minus antequam veniat finis mundi, computando istos mille annos solares a die mortis proximi Antichristi. Et fuit michi in instanti intellectus apertus quod hec conclusio erat certissima, infallibilis et necessaria, conscripta in divina Scriptura. Fui enim in hac apertione plurimum stupefactus, quia glosis et dictis sanctorum repugnare videtur. Et quia hesitare temptabam—nec mirum—fuit michi hoc secretum, per me anterius non auditum, datum intelligi contineri in divina Scriptura."

[62]*LSE* §84: "Notandum est autem quod ideo conatus fuit Augustinus exponere mistice mille annos predictos, quia sibi non fuit datum intelligere quod ligatio draconis predicta deberet fieri in die mortis proximi Antichristi, sicut patet in libro *De civitate Dei*. Nec in omnibus tenemur sequi expositiones omnium doctorum quas posuerunt opinando, potius quam aliquid contra veritatem textus temere asserendo, nisi ex sacro textu vel ex determinatione Ecclesie probaretur quod Augustino et ceteris doctoribus olim preteritis fuerunt omnia Scripturarum et prophetiarum archana funditus revelata, ita quod posteris non deberet aliquid ulterius revelari."

he included both of these periods of time as subperiods within his own thousand-year Sabbath.[63] Furthermore, he seems also to have taken note of the length of the Sabbath posited by "Columbinus" because at one point he referred to the erroneous belief that the coming Sabbath would last for "200 years at the least."[64] Most likely Rupescissa had wrestled with the problem of the Sabbath's duration before his transport of 1345; in any case, by 1349 he certainly had concluded that all ingenious reckonings were superfluous when Apocalypse 20:1–6 spoke so clearly.[65]

The spread of literal millennialism in Western Europe after Rupescissa's "certain, infallible, and necessary" insight into the true meaning of the earthly reign of the saints remains a wide-open field for study. Yet two conduits for the reentry of literal millennialism into the European prophetic imagination can be identified with certainty. The first was Rupescissa's prophetic output. Despite the Franciscan's extraordinary daring, he was not condemned for heresy, probably because his judges were unsure whether he was divinely inspired. Instead, from 1349 until 1356 (and perhaps slightly later), he was held prisoner in Avignon but allowed to compose treatises to his heart's content. Thus he engaged in a remarkable outpouring of vaticination. And since his numerous treatises, all of which reiterated his certainty about the coming of a thousand-year Sabbath, were coveted by cardinals and visitors to the curia, they gained a vast, Europe-wide circulation.[66]

The second conduit for the reentry of literal millennialism into European prophetic thought was the renewed respect paid to the authority of

[63]Respectively, *LSE* §102, 128.

[64]*LSE* §92.

[65]I treat Rupescissa's discussion of the actual conduct of life during the millennium in my introduction to the forthcoming edition of the *LSE*. Here two points are relevant. First, Rupescissa shunned "carnality." Therefore, assuming that the foundation for the post-Nicene Christian interpretation of the Apocalypse was the Tyconius commentary that "exposed nothing carnally, but everything spiritually" (the report of the fifth-century writer Gennadius, in *PL* 63:1071), such an approach remained constant for a thousand years. Second, although Rupescissa stipulated that Christ would come "corporeally, personally, and visibly" to slay Antichrist and resurrect those who had died under Antichrist's persecution (*LSE* §79), he did not propose that Christ would reign incarnate with the saints during the earthly millennium. Nevertheless, such a view was rare even in the literal millennialism of seventeenth-century England.

[66]Regarding the popularity of the *LSE*, six complete pre-1500 copies are currently known, as well as one copy of a complete Catalan translation and ten copies of extracts and résumés. Rupescissa's *Vade mecum in tribulatione* of 1356 was even more popular: I currently know of the existence of twenty-two complete copies and twelve copies of extracts from the original Latin (an English family of Latin extracts omits the prediction of a literal millennium); in addition there were German, Castilian, Catalan, and French translations of the complete work; résumés of it in French, German, and Italian; and extracts in German, English, and Italian. Although Rupescissa placed the beginning of his Sabbath in 1370, later "editors" frequently altered that date in order to rescue the remainder of his prophetic system.

Lactantius, the "most eloquent of all Christians."[67] Although this Latin Father had foretold in his *Divine Institutes* that Christ would "dwell for a thousand years among men, governing them with totally righteous rule,"[68] the *Institutes* were neglected throughout the High Middle Ages; I know of no explicit reference to Lactantius's literal millennialism in the Latin exegetic-prophetic tradition before the late fourteenth century. But after Lactantius's cause was taken up by a succession of Italian humanists, and his *Divine Institutes* consequently came into vogue, the millennialism of the "Christian Cicero" could no longer be ignored.

Although Rupescissa and Lactantius were a rather odd couple, their convergence as authorities behind literal millennialism occurred at least twice in the years around 1400. Specifically, the Catalan Franciscan, Francesc Eiximenis, in his *Dotzè del Crestià* of 1385, foretold the coming of a thousand-year Sabbath as part of an eschatological scenario borrowed heavily from Rupescissa but drawing as well on the authority of Lactantius.[69] Then, doubtless independently of Eiximenis, a copyist of Rupescissa's *Liber secretorum eventuum*, working shortly after 1400, added the following words after Rupescissa's pronouncements about the coming thousand-year kingdom: "On the aforesaid, see book seven of *Against the Gentiles*, which is called 'On the Blessed Life,' of Firmianus Lactantius."[70]

Of course Rupescissa and Lactantius had their separate influences as well. Rupescissa was surely the major inspiration behind the literal millennialism propagated in Lower Saxony and the Rhineland from 1389 until

[67] Nicole Bériou has informed me of an attack on Lactantius's millennialism by Eudes of Châteauroux in a sermon delivered shortly after 1260; see Rome, Archivio Santa Sabina, MS. XIV.34, fol. 221ra. I am not aware of any sustained treatment of the medieval career of Lactantius. On his popularity among Italian humanists (Boccaccio, Salutati, Bruni, Traversari), see Charles L. Stinger, *Humanism and the Church Fathers: Ambrogio Traversari (1386–1439) and Christian Antiquity in the Italian Renaissance* (Albany, N.Y., 1977), 117–20. The designation of Lactantius as "vir omnium Christianorum proculdubio eloquentissimus" is Bruni's; see ibid. 265 n. 116.

[68] *Divine Institutes* 7.24, 26. I quote from the translation of Bernard McGinn, *Apocalyptic Spirituality* (New York, 1979), 72–73.

[69] See the edition published by Lambert Palmart (Valencia, 1484), chaps. 200, 428, 466; and Pere Bohigas, "Prediccions i profecies en les obres de Fra Francesc Eiximenis," in *Franciscalia* (Barcelona, 1928), 30–34. Although Eiximenis cited Lactantius explicitly in the *Dotzè del Crestià* (chap. 200), he avoided naming Rupescissa. Yet Rupescissa's influence is evident beyond doubt, and Eiximenis indeed identifies Rupescissa as a source by name in his *Vida de Jesucrist*: see Bohigas, "Prediccions," 36, and Bignami-Odier, *Études*, 210–13. A sustained analysis of Eiximenis's eschatological thought is needed.

[70] The words "de suprascripto xx° intellectu videatur liber vii adversus gentes qui de beata vita titulatur, quem edidit Firmanus Latencius" appear in the text of Rupescissa's *LSE* immediately after the "20th intellectus" in MS Vat. Reg. lat. 1964. The manuscript in question was copied in northern France and dates from the early fifteenth century; but the fact that the gloss appears in the body of the text suggests that it came from an exemplar.

1392 by the German Franciscan Frederick of Brunswick; indeed, Rupescissa's influence was noted by one of Frederick's opponents, who referred to Frederick's having been deluded by "the fables of the Jews and the ravings of brother John of Rupescissa."[71] And in 1480 the Italian Dominican Annius of Viterbo's *On the Future Triumph of the Christians against the Saracens* (apparently the first expression of literal millennialism in print) cited Lactantius as the only authority behind the earthly Sabbath aside from the Apocalypse itself.[72]

Meanwhile, as the daring assertions of Rupescissa and the restored prestige of Lactantius opened the floodgates of literal millennialism, various prophets in different parts of Europe began proposing different extended lengths of time for an imminent earthly Sabbath other than an exact thousand years. Thus one of the most influential of late-medieval seers, the pseudonymous "Telesphorus," tendentiously misquoted Joachim of Fiore

[71]For recent treatments of the thought and career of Frederick of Brunswick, see Alexander Patschovsky, "Chiliasmus und Reformation im ausgehenden Mittelalter," in *Ideologie und Herrschaft im Mittelalter*, ed. Max Kerner (Darmstadt, 1982), 481, 483, 492 n. 44; and his "Eresie escatologiche tardomedievali nel regno teutonico," in *L'attesa della fine dei tempi nel Medioevo*, ed. Ovidio Capitani and Jürgen Miethke (Bologna, 1990), 221–44. In these accounts, Patschovsky is unaware of the first phase of Fredrick's career as a disseminator of literal millennialism in Lower Saxony, as documented in the chronicle of Dietrich Englehus (written in Lower Saxony, ca. 1423); see Haeusler, *Ende der Geschichte*, 128, 254 n. 50; and for a better reading of the passage in question, Otto von Heinemann, "Ueber die Deutsche Chronik des D. Engelhus," *Neues Archiv der Gesellschaft für ältere deutsche Geschichtskunde* 13 (1887/88): 179. In addition, I have discovered a full-length treatise by Dietrich von Arnevelde, O.F.M., *Silencium contra prophecias prophetarum Saxonie*, written against Frederick in 1389 in Lower Saxony. (The treatise is in Paderborn, Erzbischöfliche Akademische Bibliothek, MS. Ba 5, item 6 [the MS is unfoliated]). It is Dietrich who identifies "fabula iudeorum et delirimenta fratris Joh. de Rupessissa" as the sources of Fredrick's errors. (I certainly erred in "Refreshment of the Saints," 132, when I stated that Rupescissa's literal millennialism was "not taken up by others.")

[72]Annius of Viterbo (otherwise known as Giovanni Nanni or Johannes de Viterbio), O.P., *De futuris Christianorum triumphus in Saracenos* (Genoa, 1480; and several times thereafter); see chap. 20 (I quote from Nürnberg, P. Wagner [ca. 1485], sig. aiiᵛ): "Prima resurrectio est totius ecclesie ad universalem unionem sub uno pastore Christo . . . et de hac loquitur hoc capitulum [viz. Apoc. 20] et Lactantius." On Annius's treatise, see further Lynn Thorndike, *A History of Magic and Experimental Science*, vol. 4 (New York, 1934), 263–67; and Cesare Vasoli, "Profezia e astrologia in un testo di Annio da Viterbo," *Studi sul Medioevo Cristiano offerti a Raffaello Morghen* (Rome, 1974), 1027–60. The treatise was the main provocation for Johannes von Paltz, O.E.S.A., *Questio determinata in quodlibeto studii Erfordensis, anno 1486*, published twice in 1486 and now in a critical edition in Johannes von Paltz, *Werke*, vol. 3, *Opuscula*, ed. Christoph Burger et al. (Berlin, 1989), 37–138. Note that von Paltz identified Lactantius, Joachim, and Rupescissa as the three main sowers of error concerning apocalyptic reckonings (83). To my knowledge, the question of how Lactantius's literal millennialism created problems for his quattrocento admirers has never been raised by modern scholarship. A point of departure might be the analysis of Antonius Raudensis (Antonio da Rho), O.F.M., *De Lactantius erratis, dialogi tres*, written in 1443; this is available in manuscripts (e.g., Vat. lat. 227), incunabula, and extracts printed in G. F. H. Beck, *Dissertatio inauguralis de Orosii fontibus . . .* (Marburg, 1832).

in 1386 to say that the Sabbath would be long;[73] and others, in the fifteenth century, offered specific durations of 500, 890, 1400, 1477, and even 6,000 years.[74] Granted that the Augustinian taboo against literal millennialism had by no means been lifted, ever more Western European prophets were beginning to challenge it. In other words, faith in a wondrous earthly future was growing just when Western Europeans were poised to storm the globe and survey the heavens.

[73]The prophetic treatise of "Telesphorus" is in *Expositio magni prophete Ioachim in librum beati Cirilli de magnis tribulationibus* (Venice, 1516), see fol. 38vb: "annus millenarius. . . . Circa quem annum Joachim in libro de ultimis tribulationibus notanter dicit . . . [quod] non debet intelligi quod mille annis post mortem Antichristi debeat pax durare, sed longo tempore." Joachim does argue against literal millennialism in *De ultimis tribulationibus* (see n. 21 above), but the last phrase is not his. On "Telesphorus," see Roberto Rusconi, *L'attesa della fine* (Rome, 1979), 171–84; and Richard Spence, "MS Syracuse University Von Ranke 90 and the *Libellus* of Telesphorus of Cosenza," *Scriptorium* 33 (1979): 271–74 (Kenneth Pennington kindly called my attention to the latter). There remains an urgent need for a detailed study of Telesphorus's work; currently even his nationality remains uncertain.

[74]On 500 years, the prophecy of 1422 by the Florentine Antonio da Rieti, O.F.M., see Donald Weinstein, "The Myth of Florence," in *Florentine Studies,* ed. Nicolai Rubinstein (London, 1968), 36. On 890 years, see the prophecy of 1410 by Giacomo Palladini da Teramo; see Rusconi, *Attesa,* 127. On 1,400 years, see the anonymous prophecy apparently dating from about 1400 in Turin, Biblioteca Nazionale MS. K². IV. 13, fol. 129r: "a Christo usque ad leonem potentissimum fuerunt anni MCCCC; a leone usque ad finem mondi erunt anni MCCCC." On 1,477 years, see the anonymous prophecy of ca. 1409 reported in 1466 by the Erfurt theologian Johannes Dorsten, in Ruth Kestenberg-Gladstein, "The 'Third Reich': A Fifteenth-Century Polemic against Joachism and Its Background," *Journal of the Warburg and Courtauld Institutes* 18 (1955): 269. On 6,000 years, see the second error of the layman Nicholas of Buldesdorff, tried in 1446 by the Council of Basel, see Patschovsky, "Chiliasmus," 481; and Basel, MS. A.I.31, fol. 163r: "Post Antichristum per sex millenarios erit regnum Dei et vita venturi septimi seculi sanctissimi . . . tunc dominus Iesus Christus reddet promissa sua eciam hic in terra." This list is almost certainly not exhaustive.

5

Joachim of Fiore:
Patterns of History
in the Apocalypse

E. RANDOLPH DANIEL

One of the most striking apse mosaics in Rome is in S. Clemente, built in the 1120s to replace a late antique basilica, the surviving walls of which have been excavated below the present church. The mosaic, certainly contemporaneous with the building of the church, is unique in combining antique, early medieval, and innovative twelfth-century motifs. The procession of lambs toward the *agnus dei* and the symbols of the four evangelists, familiar from SS. Cosma e Damiano and Sta. Prassede, were customary elements on Roman arches and apses from the fifth century onward. The vine that coils over the surface of the apse is clearly an antique motif. New, however, is the scene in the center, showing Jesus on the cross—his head drooping, the wounds visible in his hands, feet, and side; his blood flowing—mourned by Mary and John, who stand on either side of the cross. Interwoven into the vine are numerous scenes of daily life.[1] A woman is feeding her chickens. Goats are being milked. Two birds are feeding their young, whose beaks protrude upward out of the nest. A *daimon* playfully rides a dolphin. The figures in these scenes are alive and vibrant, rather than stiff and hierarchical. While

The following abbreviations are used for the works of Abbot Joachim: *Enchiridion:* Enchiridion super Apocalypsim, ed. Edward K. Burger (Toronto, 1986); *Expositio:* Expositio in Apocalypsim (Venice, 1527; reprint, Frankfort on Main, 1964; *Lib conc (Dan):* Liber de concordia Noui ac Veteris Testamenti, ed. E. Randolph Daniel (Philadelphia, 1983); *Lib conc (Ven):* Liber de concordia Noui ac Veteris Testamenti (Venice, 1519; reprint, Frankfort on Main, 1964); *Lib fig:* Liber figurarum, in *Il Libro delle Figure dell'Abate Gioacchino da Fiore*, ed. Leone Tondelli, Marjorie Reeves, and Beatrice Hirsch-Reich, 2 vols. (Turin, 1953); and *Lib introd:* Liber introductorius in Apocalypsim, printed with the *Expositio*, fols. 1vb–26va.

[1]On the mosaic at S. Clemente, see Richard Krautheimer, *Rome: Profile of a City, 312–1308* (Princeton, 1980), 182–87; Walter Oakeshott, *The Mosaics of Rome from the Third to the Fourteenth Centuries* (Greenwich, Conn., 1967), 98, 247–50; and Mary Stroll, *Symbols as Power* (Leiden, 1991), 118–31.

many of these scenes may have symbolic meaning, the mosaic conveys the overall impression that Christ has come to renew life on earth as well as to make it possible for Christians to enter heaven.

The mosaic reflects two tendencies central to an understanding of the twelfth century and Abbot Joachim. First, this was an era both of renewal and of innovation. Joachim was very much of his time, a monk with a conservative bent, but his treatment of the Apocalypse breaks sharply with earlier commentaries. It offers both an interpretation that is radically new in the way it historicizes John's book and a method of exegesis that had no real antecedents, the *concordia*. Second, the twelfth century was optimistic about history and the future. The Gregorian reformers certainly believed that they could dramatically reform and purify the Church on earth. Joachim, who was clearly Gregorian in his sympathies, believed that history was evolving toward the *status* of the Holy Spirit (*status* is for Joachim a synonym for *tempus* or age and a state of grace) when the Church would enjoy a historical era of peace and spiritual attainment that would far surpass anything achieved in the past. Just as the mosaic reflects a world that is alive and vibrant, so history for Joachim was pregnant with possibilities for a better world.

Richard Krautheimer's interpretation of the apse mosaic at S. Clemente emphasizes the element of antique revival, but the crucifixion scene is an innovation. Its central position gives it preeminence. The twelfth century has been depicted as a renaissance, expressed in a revival of interest in and study of classical culture.[2] This thesis emphasizes the period's debt to antique models and therefore puts its stress on those elements that are imitations of classical patterns, especially on the renewed study of classical literature and the revival of classical style. The concept of a renaissance, however, underplays the innovative elements in the period from the late tenth century through the middle of the thirteenth century.[3] Two of these new developments are especially important for understanding Abbot Joachim and his treatment of the Apocalypse. They are the change in the way nature and history were conceived and the change in the meaning of the concept of reform.

The late antique and early medieval view of nature is clearly exemplified in an incident recounted by Gregory of Tours. The monastery of Latte possessed relics of Saint Martin. One day, a force of Frankish troops came

[2]Krautheimer, *Rome*, 182–87. The classic works are Charles H. Haskins, *The Renaissance of the Twelfth Century* (1927; Cleveland, reprint, 1957); and G. Paré, A. Brunet, and P. Tremblay, *La Renaissance du XIIe siècle: Les écoles et l'enseignement* (Ottawa, 1933). On the thesis of Haskins, see Robert L. Benson and Giles Constable, with Carol D. Lanham, *Renaissance and Renewal in the Twelfth Century* (Cambridge, Mass., 1982).

[3]Among studies that emphasize the innovative aspect are Charles Radding, *A World Made by Men: Cognition and Society, 400–1200* (Chapel Hill, N.C., 1985); Carolyn Walker Bynum, *Jesus as Mother: Studies in the Spirituality of the High Middle Ages* (Berkeley and Los Angeles, 1982); and M.-D. Chenu, "Nature and Man: The Renaissance of the Twelfth Century," in *Nature, Man, and Society in the Twelfth Century*, ed. and trans. Jerome Taylor and Lester K. Little (Chicago, 1968), 48.

by and, seeing the monastery across a river, decided to plunder it. Twenty soldiers came across in a boat despite the warnings of the monks that the monastery belonged to Saint Martin. The soldiers gathered their plunder and set out to recross the river in their boat. When they were in the middle of the stream, the boat began to swirl around in the water and eventually split apart beneath them. Nineteen of the twenty soldiers died. The only survivor had apparently rebuked the others for their wrongdoing. Saint Martin's protection of his house and revenge for its violation was immediate, concrete, and precise. The saint, as well as the demons, were always close by, not off in some transcendent paradise. The invisible powers were constantly active in ordinary life. Saintly vengence, therefore, was swift and accurate. The thieves did not have to wait until after their deaths to suffer for their misdeeds. Martin struck them down before they could recross the stream, and their punishment was visible and effective.[4] If we look at this account from another standpoint, nothing happened that cannot be explained naturally. The sudden swirling of the water was unusual but can probably be explained. Gregory, however, is unconcerned with explanations. Latte was Saint Martin's holy ground, and what happened there was his doing.

The view of the world and God's place in it changed in the twelfth century, which witnessed the emergence of the notion of the natural world as an entity in itself, distinct and normally separate from the divine world. M.-D. Chenu suggested that during this era nature was discovered, by which he meant that the sensible world was desacralized, a process that culminated in the emergence of Saint Thomas Aquinas's distinction between the natural and the supernatural worlds, between the realm of sense experience, reason, and natural processes and the divine order of wisdom, revelation, and grace.[5] The activity of the invisible powers came to be understood as extraordinary rather than normal. Angels and demons did cross over, but less frequently, and some people, at least, came to believe that ordinarily the sensible world operated according to its divinely instituted norms, without interference from supernatural beings.[6] A person could no longer take for granted the constant presence and activity of the divine and demonic powers.

[4]Gregory of Tours *The History of the Franks* 4. 48, trans. Lewis Thorpe (Harmondsworth, Middlesex; 1974), 244–45.

[5]Chenu, "Nature and Man," 4–18, esp. 14–15.

[6]One of the most difficult problems confronting a discussion of a change in mentality such as this is the one of ascertaining when and among what kinds of people the changes were occurring. Written sources are only available to us from a small elite, mostly clerics and monks, who have left us written materials. Chenu, in "Nature and Man," sees the desacralization of nature as primarily the work of theologians, especially of the Platonists of Chartres, and argues that from that school the new outlook penetrated to other intellectuals and to technology (see 37–48). Radding, in *World Made by Men*, believes that the changes in cognition began among the jurists at Pavia in the later tenth and early eleventh centuries and from there spread to the schools in the north and into wider circles (153–254).

The meaning of this shift can be perceived by looking at the change in attitude toward the use of ordeals. Since the ninth century at least, ordeals had been used widely in the Latin West as a means of resolving legal disputes, where the evidence was insufficient to resolve the case or there were no witnesses. Their use, like the employment of oathhelpers, was in fact a resort to divine help. God knew the truth and would make it clearly and plainly evident by means of the water or the red-hot iron or the combat. All that was required was to conduct the proceedings so as to ensure that it was God or the beneficent divine power that acted, not a demonic one. Hence priests consecrated the instruments, and the ordeal was conducted on holy ground. No one doubted that ordeals were valid, because everyone took for granted that both divine and demonic powers were constantly present and incessantly acting in ordinary life.[7] To ensure one's salvation one could only become a monk, because only within the cloister, only in that sacred and protected ground, could one escape the constant efforts of the demons, or if not escape, at least be reasonably assured of divine help and protection. The importance of the relics of the saints is intelligible, if it is remembered that such relics guaranteed the sanctity of the place and, therefore, of the holiness of the power operating there. Suddenly, in the twelfth century, doubts appeared about the validity of the ordeals. Such doubts were clearly due to the new awareness of the natural world as a realm in which ordinarily "natural" rules or laws prevailed and only on "extraordinary" occasions did divine or demonic powers intervene.[8]

The ancient, classical world's acceptance of oracles and auspices are indications that the early medieval mentality was a continuation of the ancient one. The Neoplatonists distinguished between the world of sense experience and the intelligible order, between the world of matter and the realm of pure being, but not between nature and supernature as the twelfth century came to distinguish these. On the contrary, Christian Neoplatonists like the Pseudo-Dionysius believed in a hierarchy of beings between God and human souls, which in a sense linked souls with divinity.[9] The apocalyptic authors believed that they were granted the privilege of being allowed to see into the invisible world, that is, to see

[7]Radding, *World Made by Man*, 5–6. Radding treated the subject more fully in his "Superstition to Science: Nature, Fortune, and the Passing of the Medieval Ordeal," *American Historical Review* 84 (1979): 945–69.

[8]Radding, *World Made by Man*, 6–22; idem, "Superstition to Science," 957–59. Radding prefers to interpret these changes as a shift in cognitive modes of perception, using for this purpose the theories of the Swiss psychologist Jean Piaget. Because the mode of perception he attributes to the early medieval mentality is one that Piaget found in children, his explanation has not been well-received. I prefer to see the shift as one in *mentality*, using the term here almost as a synonym for *Weltanschauung*. Mentality here refers to those categories by which people interpret themselves, the world around them, and the divine order, without generally realizing that they are in fact using these categories.

[9]Pseudo-Dionysius, *The Complete Works*, ed. and trans. Colm Luibheid and Paul Rorem (New York, 1987), contains introductions to the entire corpus.

into the heavenly sphere itself. They had no notion of a truly transcendent God, a God who is outside time and space, beyond the celestial universe. Ancient apocalyptists only felt that their eyes could not see up into the celestial realm, but they were convinced that that realm *was* within the universe. The angelic messengers linked the celestial and the terrestrial, journeying back and forth from higher to lower. The Gnostics believed that their *gnosis* contained the passwords that would permit souls to make the heavenward journey past the guard stations of the demonic archons. The journey was, however, a journey into the celestial spheres.[10]

The new awareness of nature as a self-contained entity fundamentally challenged these assumptions. People still believed that God had created the "natural" world, that God still operated in it, but that such operations were usually by natural means and only exceptionally by supernatural ones. So long as the ancient and early medieval mentality prevailed, the assumption of a glimpse into heaven required no examination. In the twelfth century, such a glimpse necessitated an inquiry into how a human observer could attain such knowledge or how such a claim could be substantiated. Richard of Saint Victor formulated theories of spiritual vision and placed them at the very beginning of his commentary on the Apocalypse.[11] Joachim's interpretation rested on principles of biblical exegesis the truth of which could be demonstrated historically. The *concordia*, as we see later, was just such a proof of Joachim's conclusions.

The mosaic at S. Clemente also exemplifies the transition from a focus on the Risen Christ as Lord to one on Jesus as a man who lived on earth, suffered, and died on the cross. One could only obey the Risen Lord, but the *viator*—the christian wayfarer on earth—was summoned to imitate and to identify with the earthly Jesus. Saint Francis of Assisi's desire to feel in his own body the agony of the Crucifixion, a desire that culminated in the stigmata, had no parallel in early Christian or early medieval spirituality.[12]

The new spirituality was clearly connected with the reform movements of the eleventh and twelfth centuries, especially those described as "semieremitic" or "evangelical." These movements emphasized preaching and poverty not only as marks of personal holiness but as means of communicating the reform message to other Christians in order to inspire them

[10]The best example of an apocalyptist seeing into the heavens is 1 Enoch: 72–82, in which Enoch is permitted to see the gates of the heavens and the courses of the planets.

[11]Richard of Saint Victor, *In Apocalypsim Ioannis libri septem* (PL 196: 686–90).

[12]R. W. Southern, *The Making of the Middle Ages* (London, 1953), 221–40; Bernard McGinn, "The Human Person as Image of God in Western Christianity," in *Christian Spirituality: Origins to the Twelfth Century*, ed. Bernard McGinn, John Meyendorff, and Jean Leclercq (New York, 1986), 312–30. On Francis of Assisi, see E. Randolph Daniel, *The Franciscan Concept of Mission in the High Middle Ages* (Lexington, Ky., 1975), 26–54.

to join in the renewal.[13] The new hermits went from being wandering preachers to founding monastic communities. The Gregorian or papal reformers sought to implement their program by controlling the papacy and the body of cardinals. The Gregorians strove to liberate the clergy from lay control and to bring both clergy and laity under papal control in order to achieve their aim of making Latin Christendom truly the "body of Christ" on earth, purified from the corruption they perceived around them.[14]

Reform for Augustine had been personal, a process by which an individual, predestined Christian could be freed from sin and the bonds of this sensible, visible universe and undertake a "spiritual" journey toward God. Augustine never envisioned a reform of the Church. The reformers of the eleventh and twelfth centuries still thought of reform in individual terms, but their primary thrust was to purify and renew the Church.[15] These reformers were certainly confident that the Church on earth could be made more holy and more worthy of Christ. Not only was it possible, but they believed that it had to be done.

For John of Patmos, the future seems to have been a series of catastrophes and persecutions, which would culminate in a final climax of evil. Then God would intervene, destroy the persecutors, and restrain Satan, and the tortured saints could then enjoy their millennial reward. The millennium was not the goal of history, but it would come after the end of the present and last age.[16] John was typical of the Jewish and Christian apocalyptic writers in expecting only mounting evil in the present world. Augustine and Tyconius were just as pessimistic about the future. The City of God and the earthly city would be in conflict until the End. The Apocalypse was an allegory indicating the way in which elect individuals could attain salvation.[17]

Abbot Joachim belonged to a quite different world from that of John of Patmos and Augustine. History had a different significance. Although the ultimate goal of Christians was in eternity beyond history, God's plan for

[13]Henrietta Leyser, *Hermits and the New Monasticism: A Study of Religious Communities in Western Europe, 1000–1500* (New York, 1984). Caroline Walker Bynum's "The Spirituality of Regular Canons," *Jesus as Mother,* 22–58, emphasizes the importance of preaching as a factor that differentiated the spirituality of the canons from that of the monks.

[14]Southern, *Making of the Middle Ages,* 118–69, and *Western Society and the Church in the Middle Ages* (Harmondsworth, Middlesex, 1970), 34–44, 100–33.

[15]Gerhard Ladner's *The Idea of Reform* (New York, 1967) is a superb analysis of the development of the idea of reform from Paul through Augustine. Ladner's "Die mittelalterliche Reform-Idee und ihr Verhältnis zur Idee der Renaissance," *Mitteilungen des Instituts für Österreichische Geschichtsforschung* 60 (1952): 31–59, is little more than a sketch.

[16]See n. 46 below on the definition of the term *millennium.*

[17]Bernard McGinn, *The Calabrian Abbot: Joachim of Fiore in the History of Western Thought* (New York, 1985), 80–85; Peter Brown, *Augustine of Hippo* (Berkeley and Los Angeles, 1967), 313–24.

humanity would culminate in a historical Sabbath, which would evolve from the past and the present. Instead of a pattern of increasing evil, cosmic catastrophe, and new beginnings, Joachim saw history as moving through purifying catastrophes from one stage to a better one. In his notion of a third *status*, the age of the Holy Spirit, Joachim expressed the innovative developments of his era, its emphasis on history as having a meaning of its own and the desire to reform and to purify the Church within history.

Joachim used Ezekiel's vision of the wheels (Ezek. 1:4–28) as an organizing principle for understanding the relationship of the Apocalypse to the other books of the Bible.[18] The concept of *concordia* enabled Joachim to correlate the events of the general history with the Apocalypse and therefore to interpret the symbols and visions of the Apocalypse as predicting a series of persons and events parallel to those of the general history. As he put it in one place:

> All of the forests of histories which overshadow the Old Testament are divided into five parts, of which one is general, four special. For there is one wheel, having four faces. There is one general history to which four special [histories] are joined. The general history is that which proceeds from the beginning of the world straight through to the book of Ezra. . . . There are as well four special, little [histories], of which the first is Job, the second Tobit, the third Judith, [and] the fourth Esther. That is the wheel, these the faces.[19]

The four gospels correspond to the four special books and "for the general history the book of the Apocalypse has been given."[20] The general history is the outer wheel, the Apocalypse the inner wheel.[21] The general history consists of the historical books of the Old Testament from Genesis through Ezra, especially the history of Israel from Abraham to the return from exile. The inner wheel is a correlative of the outer one. The whole course of history is contained, therefore, in the Apocalypse, although its visions are primarily directed toward the history of the Church since the birth of Christ. The *concordia* links the two wheels.

Joachim defined the *concordia* as "a similarity of equal proportion between the New and the Old Testaments, equal, I say, as to number, not as to dignity."[22] Joachim also says that "that understanding, which is called the *concordia*, is like a continuous road which extends from the desert to the city, along which there are low valleys where the *viator* may wonder

[18]Delno C. West and Sandra Zimdars-Swartz, *Joachim of Fiore: A Study in Spiritual Perception and History* (Bloomington, Ind., 1983), 95–98.
[19]Joachim *Enchiridion*, pp. 10–11; cf. *Lib introd* 1, fols. 2vb–3rb.
[20]Joachim *Enchiridion*, p. 11; *Lib introd* 1, fol. 3ra–rb. The text in the *Liber introductorius* considerably expands that in the *Enchiridion*.
[21]Joachim *Enchiridion*, p. 11.
[22]Joachim *Lib conc (Dan)* 2. 1. 2, p. 62; *Lib conc (Ven)* 2. 1. 2, fol. 7rb.

whether he is on the right road, and just as much there are high mountain passes where he is able to look backward from whence he has come and forward to his destination."[23] The *concordia* meant the harmony or parallels between the history of the Old Testament from Adam to the last generation before Jesus Christ and the history of the New Testament from Uzziah, king of Judah, to the coming of Christ in glory. For example, Abraham, Isaac, and Jacob are counterparts of Zechariah, John the Baptist, and the man Christ Jesus. The twelve tribes of Israel correspond to the twelve churches (the five patriarchates and the seven churches to which John of Patmos wrote in the Apocalypse), and the Chaldeans of Nebuchadnezzar are equated with the German emperors of Joachim's time. The *concordia* or harmony between these "pairs" consists in their having similar generational positions within their respective *tempora* or *status*, and in similarities in their characters and acts, although they may also be dissimilar in many ways. Jacob belongs to the same generation in the first *status* as *Homo Christus Ihesus* does in the second. As founders, there is a similarity between them in act, although certainly they were dissimilar in character. Joachim is careful to specify that the similarity is in number, that is, in their generational place and deeds, not in dignity. *Homo Christus Ihesus* stood on a higher plane than Jacob—for Joachim this meant that he possessed a level of spiritual understanding and attainment superior to that of Jacob—as did the persons and orders of the second *tempus* generally in comparison with those of the first.

The *concordia*, as Bernard McGinn has argued, precedes and is different from the twelve spiritual senses, which Joachim delineated. Especially, the *concordia* is not to be equated with the seven typological senses.[24] The patterns of history, most importantly the *prima diffinitio* or pattern of three *status mundi* and the *secunda diffinitio* or notion of two *tempora*, are drawn from the *concordia*, and hence these patterns are also not part of the *intelligentia spiritualis*. Joachim's concords are derived from the historical books, most notably from Genesis through Nehemiah, and the four Gospels plus the book of the Apocalypse. The *concordia* can be said to belong to what was then called the literal sense, but it differs considerably from what that meant then and from what is now understood by that term. For Joachim, the historical books are a narrative of what has happened, written by the Holy Spirit, through which the structure of the past, the present, and the future may be grasped. Joachim's overall plan to comment on Scripture, if it had been completed, would have covered the

[23]Joachim *Lib conc (Dan)* 2. 1. 4, p. 66; *Lib conc (Ven)* 2. 1. 4, fol. 8ra–rb.

[24]McGinn, *Calabrian Abbot*, 130–31. West and Zimdars-Swartz, in *Joachim of Fiore*, 43–44, suggest the same thesis, but not as clearly. Henri Mottu, in *La manifestation de l'esprit selon Joachim de Fiore* (Neuchâtel, 1977), 98–123, follows Henri de Lubac, *Exégèse médiévale: Les quatre sens de l'écriture*, pt. 2, vol. 1 (Paris, 1961), 437–59, arguing that the *concordia* is a part of the spiritual understanding and is to be identified with the seven typological modes. McGinn, *Calabrian Abbot*, 129, gives a convenient table of Joachim's spiritual senses.

historical and prophetic books of the Old Testament, the four Gospels, probably the Acts of the Apostles, and the Apocalypse. The wisdom literature and the Epistles would not have been treated, because they were not histories and were, therefore, outside the *concordia*, to use an expression of Joachim himself.[25]

Following the example of Saint Augustine, Joachim structured the history of Israel into *aetates* on the basis of numbers of generations, not numbers of years. These generations are traced according to the genealogies of Jesus, primarily that given in Matthew 1:1–17 supplemented by Luke 3:23–38 for the generations before Abraham.[26] The *concordia* between individuals and institutions is based on their belonging to the same generations in the Old Testament and in the New. Books 2, 3, and 4 of the *Liber de concordia* work out these parallelisms and the patterns of history that Joachim believed were inherent in them.

Joachim divided the Apocalypse into eight parts: the introduction and letters to the seven churches (1:1–3:22); the opening of the seven seals (4:1–8:1); the sounding of the seven trumpets (8:2–11:18); the two Beasts (11:19–14:20); the seven vials of wrath (15:1–16:17); the overthrow of Babylon (16:18–19:21); the millennium (20:1–10); and the vision of the New Jerusalem (20:11–22:21). These eight parts corresponded to the seven *tempora* of the era of the Church, followed by eternity. Each of the series of sevens (seven letters, seven seals, seven trumpets, etc.) is treated also in terms of the seven *tempora*. To these *tempora* correspond seven orders, seven persecutors, and the seven heads of the Beast. Each passage is interpreted according to its place in this pattern.[27] Thus Joachim interprets the opening of the seven seals as signifying the succession of the seven *tempora*. In Book 3 of the *Liber de concordia*, Joachim worked out the seven seals as seven *tempora* of the old Israel. The New Testament *tempora*, or openings of the seals, correspond to this earlier series *secundum concordiam*.

Hence when Joachim comes to the sixth letter, addressed to the church at Philadelphia, his commentary interprets this letter as a prophecy of

[25]Joachim *Lib conc (Dan)*, pp. xxii–xxv; West and Zimdars-Swartz, *Joachim of Fiore*, 46–52.

[26]Joachim *Lib conc (Dan)* 2. 1. 12–13, pp. 81–83; *Lib conc (Ven)* 2. 1. 10–11, fol. 10va–vb; Augustine *De civitate Dei* 22. 30, (*cc* 48:865); West and Zimdars-Swartz, *Joachim of Fiore*, 30–33. Underlying Joachim's patterns of history is the Augustinian one of the eight *aetates*, the difference being that for Joachim, the seventh lies within history and follows the sixth. On this, see E. Randolph Daniel, "Abbot Joachim of Fiore: the *De ultimis tribulationibus*," in *Prophecy and Millenarianism: Essays in Honour of Marjorie Reeves*, ed. Ann Williams, (Burnt Hill, Essex, 1980), 167–89. In his brief treatise *De ultimis*, Joachim treats the seventh *aetas* as contemporaneous with and following the sixth.

[27]McGinn, *Calabrian Abbot*, 148–49, has a convenient table showing the divisions of the Apocalypse and the correspondences. West and Zimdars-Swartz, *Joachim of Fiore*, 74–75, has a table giving the folio numbers to the Venetian edition of the *Expositio in Apocalypsim*.

the coming sixth *tempus,* which will begin after the year 1200. Much of his commentary, however, focuses on the conception and birth of John the Baptist and of Jesus. Jesus, Joachim argues, was conceived in the sixth month of Elizabeth's pregnancy, because in this sixth *tempus* Christ will clarify the virgin, chaste Church of the orders of spiritual men.[28] The sixth seal also refers to this same sixth *tempus.* Here Joachim looks forward to a future pope, who like Zerubbabel, will be sent to "Jerusalem" from "Babylon" to renew the Church, oppressed by the sixth and seventh heads of the Dragon.[29]

Finally, the sixth part of the Apocalypse (16:18–19:21) deals primarily with this same sixth *tempus.* The fall of Babylon and the return to Jerusalem correspond to the fall of ancient Babylon at the hands of Cyrus and the return of the exiles, led by Zerubbabel and Jeshua (Ezra 2:1–2). Babylon is understood as Constantinople and the churches of the Greeks as well as all of those members of the Latin church who are reprobate.[30]

In the *Expositio,* Joachim correlates the first four *tempora* with the four faces of the wheel and the fifth with the center, the seat of God.[31] This pattern is taken directly from the third book of the *Liber de concordia,* as the following text shows:

> In as much as I can estimate and understand, the *tempora* of the seals are to be distinguished thus; so that, just as there are four animals, each having six wings [or] a total of twenty-four—which four [animals] designate four special orders, the apostles, namely, martyrs, confessors, and virgins—thus twenty-four generations should be allotted to the four seals and the same number of generations to their openings. And just as the seat *[sedes]* is written in the fifth place, thus [the time] from the twenty-fifth generation . . . to the fortieth generation is [allotted] to the fifth seal in such a way . . . that the ten generations which by comparison to the others are outside the numeration—for these [ten generations] were peaceful—ought to be accepted as outside the course of the concords and the harmony of the Old and New [Testaments], only six being left from all of them in the fabric. Only the forty-first generation, moreover, is to be accepted as one [generation standing for] two—rightly it could be described as twice six—precisely because a double tribulation is going to

[28]Joachim *Expositio,* fols. 82va–84vb.

[29]Ibid., fols. 120vb–211ra.

[30]Ibid., fols. 192rb–93rb.

[31]Ibid., fol. 191va–vb: "Quinque precedentibus partibus diligenter inspectis—secundum quod notare curauimus in summa libri—inuenimus quatuor generales ordines designatos in quatuor animalibus habuisse conflictum cum quatuor bestiis, quas scribit Daniel, singuli per singula tempora specialiter, et tamen omnes simul ab ipso principio generaliter. Deinde in quinto tempore sedem dei, hoc est ecclesiam generalem que dicta est in spiritu Hierusalem, cum ecclesia malignantium, que uocatur Babylon, quatenus completis quinque preliis istis, recipiat utraque ciuitas in successione sue prolis secundum opera sua, et appareat quod differat inter iustos et impios, non modo in futuro seculo, uerum etiam in hac uita presenti."

occur under the sixth opening in parallel with the passover, in which, the
shadows being doubled, Christ has suffered. In the forty-second genera-
tion, indeed, which will be a Sabbath, the seventh seal will be opened.[32]

Joachim believes that the seven seals and the seven openings should
comprise forty-two generations, thus giving six generations to each seal
and making the seventh, thirteenth, and so on, the beginning of the next
seal or opening. He keeps to this pattern through the first four seals but
then alters it decisively. In effect he takes ten generations from the sixth
and seventh seals and adds them to the fifth seal. Thus the sixth seal has
only one generation, the forty-first, and the seventh one, just the forty-
second; but the fifth has sixteen. If one recalls that the fortieth generation
would end in the year 1200 and that Joachim was writing between 1183
and the later 1190s, then his purpose is clear. Joachim is living and writing
literally on the brink of the sixth seal.

Joachim justified this manipulation of the generations by referring to
the prophecy of Isaiah on King Hezekiah (Isa. 38:5–6), where God prom-
ised to add fifteen years to Hezekiah's reign, and also to an incident in
the reign of Hezekiah when God moved the shadow back ten steps on
the stairs of Ahaz (2 Kings 20:8–11; Isa. 38:6–8).[33] The fifth seal thus be-
gan with Hezekiah and ended with the fall of Jerusalem and the exile
to Babylon.[34]

The sixth seal took place during the exile and the return under Zerub-
babel and Jeshua. Joachim argued that the persecutions recorded in Judith
and Esther, by the Assyrians and by Haman respectively, took place dur-
ing this sixth seal and will have their parallels in the forty-first genera-
tion of the New Testament *tempus*.[35] As has been noted above, the sixth
and seventh heads of the Dragon will parallel these persecutions. The
sixth might be the Turks, perhaps headed by Saladin; the seventh will

[32]Joachim *Lib conc (Dan)* 3. 1. 1, pp. 209–10; *Lib conc (Ven)* 3. 1. 1, fol. 25va. The text
is translated from the Daniel edition, which reads: "Quantum uero estimare et intellig-
ere queo, ita sunt distinguenda tempora signaculorum; ut, secundum quod quatuor sunt
animalia, senas alas habentia—hoc est simul uiginti quatuor que quatuor spèciales or-
dines designant apostolorum, scilicet, martyrum, confessorum, et uirginum—ita uiginti
quatuor generationes quatuor signaculis ascribantur totidemque generationes apertion-
ibus eorum. Et sicut quinto loco sedes scribenda est, ita a uicesima quinta generatione
usque ad quadragesimam signaculo quinto; ita tamen ut decem generationes, que extra
numerum sunt—sicut absque bello transierunt—respectu aliarum, ita extra cursum
concordie et coaptationem ueterum et nouarum accipiantur, sex tantum ex omnibus in
textura relictis. Porro generatio quadragesima prima sola ipsa una pro duplici est accip-
ienda, ut ius dici possit bis sexta, nimirum quia duplex tribulatio sub sexta apertione
futura est ad similitudinem parasceue, in quod, dupplicatis tenebris, passus est Christus.
Sane quadragesima secunda, que erit in sabbatum, aperietur signaculum septimum."
[33]Joachim *Lib conc (Dan)* 2. 1. 28–30, pp. 115–28; *Lib conc (Ven)* 2. 1. 25–26, fols.
14vb–16va.
[34]Joachim *Lib conc (Dan)* 3. 1. 1, pp. 211–14; *Lib conc (Ven)* 3. 1. 2, fols. 25vb–26rb.
[35]Joachim *Lib conc (Dan)* 4. 1. 43–45, pp. 400–403; *Lib conc (Ven)* 4. 30–31, fols.
55vb–56va.

be the *maximus antichristus*. This same seal, however, also includes Zerubbabel and his counterpart, the expected pope who will reform the Church. The writing of history and prophecy ceased after Malachi, whom Joachim placed in the days of Zerubbabel and Jeshua, because the forty-second generation and the seventh seal and its opening will be a Sabbath era, Joachim believed, as was the era between the return from exile and the birth of Christ.[36]

The concept of the *concordia* was innovative, having no real parallel in the thinking of Christian exegetes. Superficially it bears resemblance to older typologies, but the similarities are only on the surface. Christians had used typology to argue that Old Testament events and persons foreshadowed Christ and, therefore, that Christ was the fulfillment of the earlier prophecies and promises. Typology in this sense belonged, as Joachim argued, to the spiritual senses. The *concordia*, however, posited a consistent parallelism between the history of the people of Israel and Christian history. *Homo Christus Ihesus*, the human Jesus, was a figure within this *concordia*, a notion entirely alien to traditional typology but essential to Joachim's *concordia*.[37]

Joachim verified the *concordia* by trying to prove that there were significant parallels between the persons and events of the Old Testament history and those of the New. Hence the validity of the concept could be demonstrated historically.[38] Thus the *concordia* appealed to the widespread desire in the twelfth century to see meaning in human history. At the same time, the *concordia*, with its grounding in human persons, peoples, and wars, would have been completely alien to the Neoplatonist Augustine, who saw meaning only in those prophetic moments that pointed toward Christ.[39] In the *concordia*, Joachim was truly innovative and genuinely at the forefront of the new outlook of the twelfth century.

[36]See 34 above. Joachim's notion of final antichrists is conveyed most clearly in the figure of the seven-headed Dragon (*Lib fig*, pl. xiv), where the proper Antichrist, or *magnus antichristus*, is equated with the seventh head and the final antichrist with the tail. A translation of this figure can be found in Bernard McGinn, *Apocalyptic Spirituality* (New York, 1979), 135–41. The same interpretation of the Dragon is given in *Lib introd*, fols. 10ra–11ra and *Expositio*, fol. 196ra–vb. For a commentary, see Beatrice Hirsch-Reich and Marjorie Reeves, *The Figurae of Joachim of Fiore* (Oxford, 1972), 146–52. Richard Kenneth Emmerson, in *Antichrist in the Middle Ages: A Study of Medieval Apocalypticism, Art, and Literature* (Seattle, 1981), 60–62, gives a brief summary, pointing out that, for Joachim, Antichrist precedes the third *status* and, therefore, comes well before the end of history. Robert Lerner, in "Antichrists and Antichrist in Joachim of Fiore," *Speculum* 60 (1985): 553–70, points out the innovative aspects of Joachim's teachings on the Antichrists.

[37]Joachim *Lib conc (Dan)* 2. 1. 2, p. 62; *Lib conc (Ven)* 2. 1. 2, fol. 7ra–va; McGinn, *Calabrian Abbot*, 128–34.

[38]Joachim, *Lib conc (Dan)* prol., p. 13, where he says that "quanta sit in utrisque [testamentis] concordia . . . in duorum testamentorum consonantia assignare curauimus, quatinus dum testibus ueritatis ydoneis nostra fides munitur, nullis possit erroribus a soliditate diuelli." Cf. *Lib conc (Ven)* prol., fol. 3vb.

[39]Brown, *Augustine of Hippo*, 318–19.

The two *diffinitiones*, the first of the three *status* and the second of the
two *tempora*, are syntheses drawn from the *concordia*.[40] To the two tes-
taments, the Old and the New, two *tempora* correspond, the first from
Adam to Christ, and the second from Christ to the end of history. The first
tempus belonged to the Jewish people, the second to the Christian. From
these two testaments proceeds one spiritual understanding, just as the one
order of *viri spirituales* emerge from the two peoples. Both *tempora* are
characterized by seven major wars or persecutions and end with Sabbaths.
Such is the *secunda diffinitio*. The *prima diffinitio* is tripartite. The first
status belonged to the first person of the Trinity and to the order of the
married laity. Chronologically it is identical with the first *tempus*, run-
ning from Adam to Christ. The second *status* belongs primarily to the sec-
ond person of the Trinity but secondarily to the Holy Spirit. The dominant
order is clerical, although monks were also present from Elijah onward.
The beginning of the second *status* was identical to that of the second
tempus, but the second *status* would endure for forty to forty-two gener-
ations (1,200–1,260 years) from the birth of Christ. The third *status* be-
longs to the Holy Spirit and to the monastic order. Its initial phases began
from Elijah and from Saint Benedict, but its mature period *(fructificatio)*
would occur shortly after 1200 and coincide with the Sabbath of the sec-
ond *tempus*.

Joachim compared the three *status* to trees. Each had its initial phase
when the tree itself was growing from its roots upward, its mature phase
when it bore leaves and fruit, and its final phase of decline. Before Christ's
Resurrection, the Jews had understood only the letter of the Old Testa-
ment, although the Holy Spirit was operating especially in Elijah, Elisha,
and the *viri spirituales*. Since Christ rose, the Church had understood
both the letter of the two testaments and some of the spiritual meaning,
because Christ had sent the Holy Spirit to his disciples. The Holy Spirit
was also active in the development of the monastic orders among the
Greeks and the Latins, culminating in the appearance of the Cistercians.
Joachim was living and writing on the edge of the opening of the sixth
seal, during which opening, the *status* of the Holy Spirit would become
mature—the *clarificatio* or *fructificatio* is meant. Then the fullness or
plenitudo of the *intelligentia spiritualis* would become known. The third
status would have a third set of figures, who would be in *concordia* with
those of the first two *status*. Because most of these were still to come in
the future, Joachim could only suggest some of them, notably the five

[40]On the two *diffinitiones* and their relationship to each other and to the *concordia*,
see E. Randolph Daniel, "The Double Procession of the Holy Spirit in Joachim of Fiore's
Understanding of History," *Speculum* 55 (1980): 469–83. Joachim describes the two *dif-
finitiones* briefly at the beginning of Book 2 of the *Liber de concordia*, immediately after
he has defined the meaning of the terms *concordia* and *allegoria* (see *Lib conc [Dan]* 2.
1. 4–2. 1. 11, pp. 66–84, *Lib conc [Ven]* 2. 1. 4–2. 1. 9, fols. 8ra–10rb). A concise sketch
of the two *diffinitiones* is found in *Lib introd* 3–7, fols. 4ra–10ra.

principal Cistercian motherhouses as the parallel to the first five tribes of Israel and to the five patriarchates (Rome, Constantinople, Alexandria, Antioch, and Jerusalem). Although the temporal duration of the third *status* could not be determined, the *status* would have the same basic structure as the first two, because it also was part of the *concordia.*[41]

The *status* of the Holy Spirit was Joachim's vision of the goal desired by the reformers of the eleventh and twelfth centuries. The opening of the sixth *tempus* of the New Testament would occur in or shortly after 1200 (the forty-first generation if each generation had thirty years). The twin persecutions of the sixth and seventh heads of the Dragon of Apocalypse 12 would make this sixth opening an era of persecution and exile, parallel to the exile and persecutions of the Jews in Babylon. Joachim interpreted the seventh head as the Great Antichrist, traditionally associated with events at the end of the world. For Joachim, however, these persecutions would purify the Church, which would then enjoy the Sabbath *tempus,* or opening of the seventh seal, in the forty-second generation. The seventh *tempus* would be the same as the *fructificatio* or *clarificatio* of the third *status,* the era of the Holy Spirit. Hence the persecutions and the appearance of the Great Antichrist were no longer signs of the end of history, but of the full attainment of history's goal.[42]

In Book 4 of the *Liber de concordia,* Joachim compared the generations of the Old Testament and those of the Church one by one. Having reached his own generation (the fortieth), Joachim devoted a chapter to a condemnation of the clergy and monks of his own day, using *Lamentations* as a base. Like the Jews on the eve of the exile, Latin Christians deserved to suffer and must suffer exile and persecution in order to be purified.[43] Then, in the forty-second generation,

when the general tribulation has been completed and the wheat diligently separated from all of the chaff, a new leader will rise up from Babylon, namely a universal pontiff of the new Jerusalem, that is of holy Mother Church; of whom the Apocalypse says that "I have seen an angel ascending from the rising of the sun, having the sign of the living God. . . . He will rise up, moreover, not by a physical journey or by moving from one place to another but because he will receive complete freedom in order to renew *[innovare]* the christian religion and to preach the word of God.[44]

[41]Joachim *Lib conc (Dan)* 4. 2. 2, p. 419; *Lib conc (Ven)* 4. 39, fol. 59va. Figure 2 of the *Liber de concordia* consists of three circles, representing the three *status,* to each of which Joachim gives three sets of *viri spirituales* (see *Lib conc [Dan]* 2. 2. 6, p. 161, through 2. 2. 7, p. 172; and *Lib conc [Ven]* 2. 2. 6, fol. 22ra–vb).

[42]See 36 above.

[43]Joachim *Lib conc (Dan)* 4. 1. 39, pp. 390–94; *Lib conc (Ven)* 4. 25, fol. 54ra, through 4. 27, fol. 55ra.

[44]Joachim *Lib conc (Dan)* 4. 1. 45, p. 402; *Lib conc (Ven)* 4. 31, fol. 56ra-rb. "peracta prius tribulatione generali et purgato diligenter tritico ab uniuersis zizaniis, ascendet quasi nouus dux de Babilone, uniuersalis scilicet pontifex noue Ierusalem, hoc est sancte

In the second part of Book 4, Joachim compared Saint Bernard of Clairvaux to Moses, giving Bernard the role of a leader of a final exodus. As we have just seen, Cîteaux and its four daughter houses were the parallel in the third *status* to the five tribes that had received their inheritance in the Holy Land before the other seven.[45] Clearly Joachim saw the persecutions of the sixth *tempus* as a process of reform and all of these events as both an exile and a new exodus that would culminate when the Church, possessed with the full understanding of spiritual things, enjoyed its reign of peace and contemplation.

Joachim's third *status* has often been described as chiliastic or millennial,[46] which implies that it constitutes a new beginning, the emergence of a spiritual church that would replace the corrupt clerical church. Certainly the millennium as depicted in Apocalypse 20 is a new beginning, but Joachim's *status* of the Holy Spirit is not millennial in this sense.

Joachim's understanding of the three *status* as three trees that grow from one root and of the third tree as growing from both the first and second proves that for him the *status* of the Holy Spirit is a culmination of a process begun with Adam, not a new beginning.[47] The abbot's insistence that

matris ecclesie; in cuius typo scriptum est in Apocalipsi: 'Vidi angelum ascendentem ab ortu solis, habentem signum dei uiui' (Apoc. 7:21). . . . Ascendet autem non gressu pedum aut immutatione locorum, sed quia dabitur ei plena libertas ad innouandam christianam religionem et ad predicandum uerbum dei" (text from Daniel). In his *Expositio*, fols. 120vb–21ra, Joachim comments on the angel of the sixth seal and suggests that while this may refer to a Roman pontiff, it may also refer to Christ and hence to the *ordo martyrum*.

[45] See 41 above.

[46] I understand the term *millennial* in the same sense in which Norman Cohn defined *millennium* as a collective, terrestrial, imminent, sudden, total, and miraculous replacement of the existing era by a new reign of peace and blessedness; see Norman Cohn, *Pursuit of the Millennium*, rev. ed. (New York, 1970), 15. Joachim's third *status* would indeed be collective, terrestrial, and total; but while it would be imminent, it would not be sudden, and while it would clearly be an act of God, it would not be miraculous but would grow out of previous developments. Wilhelm Kamlah, in *Apokalypse und Geschichtstheologie: Die mittelalterliche Auslegung der Apokalypse vor Joachim von Fiore* (Berlin, 1935; reprint, Vaduz, 1965), 115–24, argued that Joachim historicized the exegesis of the Apocalypse but that his radical notion of a coming *status* that would replace or supplant the existing one put him outside the mainstream of exegesis. Henri de Lubac, in *Exégèse médiévale*, pt. 2, vol. 1:437–84, took a similar position, as did Beryl Smalley in her *Study of the Bible in the Middle Ages*, 2d ed. (1952; reprint, Notre Dame, Ind., 1964), 287–89, and Henri Mottu, *Manifestation*, 98–123. Kamlah, de Lubac, Smalley, and Mottu all argue that one of the reasons Joachim envisioned this complete new beginning for a new Church was his twelve spiritual senses of Scripture. Marjorie Reeves has argued against a millennial view of the third *status* and for institutional continuity, although she also seems to believe that the *concordia* was part of the twelve senses; see "The Abbot Joachim's Sense of History," in *1272—Année Charnière: Mutations et Continuités* (Paris, 1977), 781–96. Robert Lerner, in "Antichrists," 556–57, 560, applies the terms *chiliast* and *chiliasm* to Joachim and his notion of the three *status*.

[47] Joachim *Lib conc (Dan)* 2. 1. 25, pp. 107–11; *Lib conc (Ven)* 2. 1. 21–22, fols. 13va–14rb. Joachim was never able to draw the trees properly, so that the figures in the manuscripts are of one tree only. I believe that Table 7, which follows the trinitarian circles in

the *status* of the Holy Spirit and the monastic order began with Elijah in the Old Testament and with Saint Benedict in the New underlines the thesis that in Joachim's mind the coming order of monks is a goal toward which history has been moving from the first. The persecutions and wars, although couched in traditional apocalyptic language, function in Joachim as vehicles to purify and to carry on the process of spiritualization, rather than as endings and beginnings. Joachim's thinking is evolutionary, not revolutionary. He was a reformer, not a millennialist. The most original and important contribution of the abbot of Fiore, therefore, was to make the vision of a reformed and purified Christendom the goal of an evolutionary process and to show how its roots were already there in the days of Abraham.

The Apocalypse for Joachim was the wheel within the wheel, the inner key to the meaning of the general history of the historical books of the Old Testament. The patterns of generations, therefore, which Joachim had elaborated in the *Liber de concordia*, are the basic elements of his exegesis of the Apocalypse. Understood in Joachim's terms, the Apocalypse was not an addendum to the New Testament, canonized but kept apart from the rest. On the contrary, it was the culmination and summary of the entire course of history. Joachim broke decisively with the Tyconian-Augustinian tradition of interpreting the Apocalypse allegorically and instead interpreted it historically.

In so doing, Joachim was one of those innovators who made the twelfth century an era of new developments. Joachim started from Augustine's scheme of the *aetates*. Whereas Augustine concentrated on the two cities, effectively seeing the era of the Church as an indefinite period of time during which the predestined would be saved and the reprobate damned, Joachim emphasized the evolution of historical entities, generations, peoples, and orders within a meaningful, definite chronological framework. For Augustine, the Apocalypse functioned primarily as a guide toward and an opening into heaven. For Joachim, it was the key to the meaning of human history.

Joachim's *concordia* was a new notion. John of Patmos had no such scheme in mind, and no such concept can be found in earlier

Book 2 of the *Concordia*, is the closest Joachim could come to the envisioned trees. In this table, two parallel columns begin with Adam and Ozias respectively and culminate with Joseph and the forty-second generation after Christ. These represent the first and second trees, or *status*. Two other columns begin at the generation of Asa in the first tree and at the sixteenth generation in the second tree. For the sake of clarity, these may be called columns 3 and 4. Column 3 is placed between the first and second columns, and 4 is to the right of the second column. After columns 1 and 2 end, 3 and 4 continue, showing that they represent the two beginnings of the third *status*, or tree. Generation 43 of the second *status* is labeled as *Christus* in the third tree and as *Spiritus Sanctus* in the fourth tree, thus indicating that the third *status* is christological as well as pneumatologic. See *Lib conc (Dan)* 2. 2. 7, pp. 169–78. This table is omitted from the Corsini manuscript and from the Venetian edition.

commentaries. The concords, however, are not surprising in an era of re-
form, when piety was beginning to focus on the life, suffering, and death of
Jesus and when human history, like nature, was becoming a center of at-
tention. Joachim was a man who responded to, and at the same time
shaped, the forces at work in his world, giving the Apocalypse a meaning
for his time.

Mendicant Readings of the Apocalypse

David Burr

Whether one's interest lies primarily in apocalyptically oriented polemic or in scholarly exegesis of the Apocalypse, the mendicants are worth considering. Viewed from the first perspective, they are seen to have relied heavily on apocalyptic discourse in their self-justification, just as their enemies made extensive use of it in attacking them. Observed from the second perspective, they emerge as trendsetters in medieval exegesis whose reading of the Apocalypse is interesting as a particular application of general interpretive techniques.[1] In either case, it is hard to discuss the Middle Ages without dealing with the mendicants.

We must begin by setting some realistic boundaries. This essay examines Franciscan and Dominican Apocalypse commentaries through Nicholas of Lyra. That is to place a threefold limitation on the topic: only two mendicant orders, only one century of writing (Lyra wrote his commentary in 1329), and only Apocalypse commentaries. In the first two spheres, the restriction is hardly onerous, since the great mendicant contribution to exegesis was made by the middle of the fourteenth century, and by those two orders. In the third sphere, the limitation is serious indeed, since it precludes consideration of how the mendicants utilized the Apocalypse in other writings like commentaries on the *Sentences*, quodlibetal questions, and polemical works, or how the spiritual Franciscans used it to justify their defiance of papal authority; yet it seems better to do one thing well, and the purpose of this volume justifies concentration on

[1]For the first perspective, see Marjorie Reeves, *Influence of Prophecy in the Later Middle Ages: A Study in Joachimism* (Oxford, 1969); for the second, Beryl Smalley, *Study of the Bible in the Middle Ages,* 2d ed. (1952; reprint, Notre Dame, Ind. 1964), chap. 6.

the commentary tradition.[2] I examine sixteen commentaries, eleven obviously Franciscan and three obviously Dominican. Two others are difficult to assign, but one is probably Dominican and the other Franciscan. These sixteen cannot be taken as the total number of extant mendicant Apocalypse commentaries,[3] but they certainly comprise the overwhelming majority of them through 1329 and can be used as a representative sample.

In three Dominican cases, one can be relatively confident about authorship. The commentary published in 1620 under the name of Nicholas of Gorran is generally acknowledged to be his,[4] while that published in 1890 under the name of Albert the Great is now attributed to Peter of Tarantaise.[5] The commentary beginning *Aser pinguis*, continually published among the *postillae* of Hugh of Saint Cher, is probably to be identified with Hugh, although Robert E. Lerner presents a strong argument that it is the work, not of an individual, but of a "team" working under Hugh's supervision somewhat as a fresco cycle might be produced under a master's name by his workshop.[6] Lerner's thesis is important because it raises basic questions, not only about procedure but about purpose as well.

A fourth commentary beginning *Vidit Iacob in somniis* was published in two editions of Thomas Aquinas's *Opera*,[7] but no one accepts that attribution. Lerner makes a strong case for assigning it to Hugh's prolific *bottega*, after *Aser pinguis*.[8] Whether one accepts the "team" thesis or sees Hugh as working alone (with all of the attendant difficulties so clearly indicated by Lerner), his name seems a good one to associate with *Vidit Iacob*. The attributions on various manuscripts show that some medieval readers made the same association, and Lerner shows that the commentary fits neatly into Hugh's chronology.

[2]Moreover, these other areas have received some attention. See, for example, Bernard McGinn, *The Calabrian Abbot: Joachim of Fiore in the History of Western Thought* (New York, 1985), pt. 3: Reeves, *Influence of Prophecy*; Raoul Manselli, *Spirituali e beghini in Provenza* (Rome, 1959).

[3]For example, Henry of Cossey and Poncio Carbonell both commented slightly after Lyra.

[4]*In Acta Apostolorum . . . et Apocalypsim commentarii* (Antwerp, 1620). See Ludger Meier, "Nicholas de Gorham, O. P., Author of the Commentary on the Apocalypse Erroneously Attributed to John Duns Scotus," *Dominican Studies* 3 (1950):359–62; Robert Lerner, "Poverty, Preaching, and Eschatology in the Revelation Commentaries of 'Hugh of St Cher '" in *The Bible in the Medieval World: Essays in Memory of Beryl Smalley*, ed. Katherine Walsh and Diana Wood (Oxford, 1985), 160–61.

[5]*In Apocalypsim B. Joannis Apostoli luculenta expositio*, in Albert the Great (Albertus Magnus), *Opera*, vol. 38 (Paris, 1890), 465–792. See Lerner, "Poverty, Preaching, and Eschatology," 160–61.

[6]Lerner, "Poverty, Preaching, and Eschatology," 157–89. I refer to the work as *Aser pinguis* and cite the edition found in Hugh of Saint Cher (Hugo de Sancto Caro) *Biblia Latina cum postilla* (Paris, 1545).

[7]Thomas Aquinas, *Opera*, vol. 23 (Parma, 1879), 325–511; *Opera*, (Paris, 1871–80), 31:469–661, vol. 32; 1–89. I refer to the work as *Vidit Iacob* and cite the Parma edition.

[8]Lerner, "Poverty, Preaching, and Eschatology," 157–89.

A network of dependence binds these four commentaries together. *Vidit Iacob* seems to draw on *Aser pinguis*, Peter of Tarantaise to draw on both, and Nicholas of Gorran to draw on *Vidit Iacob*.[9] The connections are especially significant because, as we shall see, *Vidit Iacob* is also closely related to two Franciscan commentaries.

Two of the Franciscan commentaries are incomplete. The first of these, by Matthew of Aquasparta, survives in two manuscripts, one containing the first nine chapters and the other covering only Apocalypse 2:13–5:9.[10] The second incomplete work exists in a single manuscript entitled *Distinctiones super Apocalypsim* and attributed to Raymond Rigaud.[11] It seems to represent excerpts assembled, without any attention to continuity, from a full-scale Apocalypse commentary.

The complete Franciscan commentaries fall into two groups. Of the nine that are definitely Franciscan, six are linked to one another as well as to the two incomplete commentaries by a common exegetic scheme and often by common material. The other three form an equally coherent group. The authors can be identified with varying degrees of precision. In the first group, one can be confident that Peter Olivi is the author of the commentary edited in a 1972 Tübingen dissertation by Warren Lewis,[12] while John Russel authored the one found in a single Oxford manuscript.[13] It also seems safe to say that William of Meliton wrote the commentary now found in two Assisi manuscripts.[14]

We enter more dangerous waters when dealing with three other commentaries in this first group. Two have a common *incipit*, which obviously confused medieval readers. One of the two is probably by John of Wales and the other by Vital du Four, but it is hard to be sure about either.[15] One can be even less sure about a commentary published in 1647

[9]Thus ibid., 160–65.

[10]Matthew of Aquasparta (Matthaeus de Aquasparta) *Expositio super Apocalypsim*, Assisi MSS. 51, 57.

[11]Raymond Rigaud (Raymundus Rigaldi) *Distinctiones super Apocalypsim*, Hereford Cathedral MS. P 3.3 (XIV).

[12]Peter Olivi (Petrus Ioannis Olivi) *Lectura super Apocalypsim*, in Warren Lewis, "Peter John Olivi: Prophet of the Year 2000" (Ph.D. diss., Tübingen, 1972). See Raoul Manselli, *La "Lectura super Apocalypsim" di Pietro di Giovanni Olivi* (Rome, 1955). Another edition is currently being prepared by Paolo Vian.

[13]John Russel (Iohannes Russel) *Expositio super Apocalypsim*, Oxford, Merton College MS. 122. See Beryl Smalley, "John Russel," in *Recherches de Théologie Ancienne et Médiévale* 23 (1956):277–320.

[14]William of Meliton (Guilelmus de Militona) *Expositio super Apocalypsim*, Assisi MSS. 82, 321. See Ignatius Brady, "Sacred Scripture in the Early Franciscan School," in *La sacra scrittura e i francescani* (Rome, 1973), 81.

[15]John of Wales (Iohannes Gallensis) *Expositio in Apocalypsim*, Assisi MS. 50, Todi MS. 68, Breslau University MS. 83 (I.F. 78), and elsewhere; Vital du Four (Vitalis de Furno) *Expositio super Apocalypsim*, Assisi MSS. 46, 66, 71, 358, and elsewhere. The first commentary is attributed to John by the Todi and Breslau MSS but is assigned to Vital du Four by Assisi 50. The second commentary is attributed to Vital by Assisi 66 and 71, and to both Vital and *fratre Petro doctore sacrosante romane ecclesie* (by

under the name of Alexander of Hales, then in 1773 among the works of
Saint Bonaventure.[16] There is little reason to think that it is by either.[17]
Some manuscripts suggest that it is by Vital,[18] and that possibility must
be taken seriously because the commentary shares a substantial amount
of common material with the one I have assigned tentatively to him. Since
the situation is somewhat reminiscent of that concerning *Aser pinguis*
and *Vidit Iacob*, one might be tempted to suggest that Vital commented
twice on the Apocalypse; yet the matter is complicated by two consider-
ations. One is that much of the common material is also shared by *Vidit
Iacob*, and the other is that the common material is interspersed with pas-
sages reflecting different minds with divergent interests. There is some ev-
idence that the common material in all three works is derived from
dependence on a fourth work, but the matter is a very open one. In fact,
one of the most striking things about this first group of Franciscan com-
mentaries (with the exception of Olivi's and Russel's) is the almost com-
plete lack of research on them so far. In this essay I refer to the unidentified
author of this last commentary as "Alexander" simply because we must
call him something.

This first Franciscan group may include another member. The commen-
tary beginning *Vox domini praeparantis cervos*, published in the same edi-
tions of the Aquinas *Opera* that include *Vidit Iacob*, seems to offer only
one hint as to its date and provenance. It appeals to the life of a saint only
three times, and in two cases the saint in question is Francis of Assisi.[19] In
both of these cases, the author is citing Thomas of Celano's first life of
Saint Francis, not Bonaventure's *Legenda major*. Thus it seems likely that
the author was a Franciscan writing before 1266, when the *Legenda major*
became the official biography.

different hands) in Assisi 358. A note inside the front cover of 358 argues for authorship
by "Petrus," blaming the Vital attribution on confusion caused by the common *incipit*,
yet refers to the Vital attribution in Assisi 50, which I have assigned here to John of
Wales. Most of the work found in Assisi 46, etc., is published in Bernardinus Senensis
Commentarii in Apocalypsim, in *Opera*, vol. 3 (Paris, 1635), but the edition turns to a
completely different work at Apoc. 20:12 and thereafter echoes various authors includ-
ing William of Meliton and Nicholas of Lyra. In fact, it differs from the work in Assisi
46, etc., at specific points all along the way. On both commentaries, see Dionisio Pacetti,
"L'expositio super Apocalypsim' di Mattia di Svezia," *Archivum Franciscanum Histori-
cum* 54 (1961):297–99. Balduinus ab Amsterdam, "The Commentary on St. John's Gos-
pel Edited in 1589 under the Name of St. Bonaventure," *Collectanea Franciscana* 40
(1970):71–96, uses still another manuscript of John's commentary. The list of manu-
scripts in Jenny Swanson, *John of Wales* (Cambridge, 1989), 233–56, is a product of the
same *incipit* problem that misled whoever added the note to Assisi 358.
 [16]Alexander of Hales (Alexander Halensis) *Commentarii in Apocalypsim* (Paris, 1647);
Bonaventura *Sancti Bonaventurae.... operum...supplementum* vol. 2, (Trent, 1773).
 [17]See the analysis by the editors in their prolegomena to Bonaventure's Bible commen-
taries, in Bonaventura, *Opera*, vol. 6 (Quaracchi, 1893), ix–xiii.
 [18]See the evidence considered by the editors in ibid.
 [19]Aquinas, *Opera* 23:570, 573. In the other case, the saint is Catherine of Alexandria.

The second group of Franciscan commentaries contains three works by readily identifiable authors: Alexander Minorita, Peter Aureol, and Nicholas of Lyra. The first two are available in modern editions, and the third in a host of early modern editions.[20] Each of the three has received (and is receiving) scholarly attention.

The Dominican commentaries and the first group of Franciscan commentaries are in some ways quite similar. We might think of them as revealing the standard thirteenth-century mendicant approach to the Apocalypse. This approach was in some ways quite conservative, following and developing an exegetic tradition that went back through Richard of Saint Victor, the *Glossa ordinaria*, and Haimo of Auxerre all the way to Bede.[21] That alone would provide various commentaries with common material, but their homogeneity goes well beyond the tradition on which they draw and suggests a substantial amount of borrowing, not only within orders, but among them as well. Here the most significant example is *Vidit Iacob*, which is closely related not only to the Dominican *Aser pinguis* but to the Franciscans Vital and "Alexander."

Authors in this first group share some or all of the following assumptions. First, the Apocalypse is divided into seven visions, some of which are recapitulative in the sense that they cover all of Church history. Thus the first vision (the letters to seven churches), the second (the seven seals), and the third (the seven trumpets) can each be seen as an outline of history from Christ to the *eschaton*. The word *can* is important. Only Olivi, Peter of Tarantaise, and *Aser pinguis* attempt to see the first vision in this way, and only Olivi devotes any serious attention to the effort. Our commentators are almost unanimous in interpreting the second and third visions historically, however. The only exception is John Russel concerning the second.

Almost all the commentators distinguish between the first four visions, which deal with all of ecclesiastical history (or, as they often say, the *status generalis* of the Church), and the last three, which deal only with the final times (the *status finalis*), comprising the time of Antichrist, the period after his death, final judgment, and eternal rewards or punishments. Having made this distinction, several commentators are then lured away from it by the fifth vision (the seven angels with vials), which they treat as

[20]Alexander Minorita *Expositio in Apocalypsim* (*MGHQ* 1); Peter Aureol (Petrus Aurioli) *Compendium sensus literalis totius divinae scripturae* (Quarachi, 1896); Nicholas of Lyra *Postilla super totam Bibliam* (Strasbourg, 1492). On the important illuminations in Alexander's commentary, see Richard Kenneth Emmerson and Suzanne Lewis, "Census and Bibliography of Medieval Manuscripts Containing Apocalypse Illustrations, ca. 800–1500," pt. 3, *Traditio* 42 (1986):443–50.

[21]On the tradition, see Robert E. Lerner, "Refreshment of the Saints: The Time after Antichrist as a Station for Earthly Progress in Medieval Thought," *Traditio* 32 (1976):97–144, and the essays by E. Ann Matter and Robert E. Lerner in this volume.

another tour of Church history.[22] *Aser pinguis* actually makes room for this interpretation by offering a five/two rather than a four/three division.[23] Olivi is a partial exception inasmuch as he occasionally sees all seven visions as recapitulative;[24] yet his exegesis of the last two visions brings him closer to his mendicant colleagues than one might at first imagine.

Given these common assumptions, it is hardly surprising that our commentators share another, namely, that Church history is divided into seven periods (*status*). That, too, was a commonplace of the tradition on which they drew. Even the periods are quite traditional. They include an initial period when the primitive Church was attacked by the Jews; a second when it was persecuted by the Roman Empire; a third when it was assaulted by the great heresies; and a fourth when it was subverted from within by hypocrites. The fifth period is less clearly delineated, partly because the tradition itself offered varying possibilities. Interpretations of the fifth seal are varied and often vague. There is substantially less hesitation about the fifth trumpet, though. Most of the commentators identify it with the precursors of Antichrist, sent to pave the way for him.[25] Many commentators are also enamored with Richard of Saint Victor's suggestion that the fifth period is a grand finale of sorts. Having introduced his temptations singly in the first four periods, the devil now deploys them all at once.[26]

Our commentators are unanimous on the sixth period: It is that of Antichrist. The only dissenter on this score is Olivi, who differs from the others in portraying the sixth period not only as the time of Antichrist but also as an age of renewal initiated by Saint Francis. Olivi sees this period as closely connected with the seventh and with the eternal bliss that comes after judgment. A new age of peace and contemplation begins in the sixth period, is perfected in the seventh so far as is possible in this life, and attains complete fulfillment in eternity. Thus the sixth and seventh periods correspond to the inauguration and fulfillment of Joachim of Fiore's age of the Holy Spirit.[27]

This difference is symptomatic of a more general one. While many of our commentators cite Joachim, none except Olivi uses him extensively or

[22]William, Vital, "Alexander," Olivi, *Vidit Iacob*, and *Aser pinguis* all do so to some extent, and Peter of Tarantaise at least suggests that interpretation.

[23]*Aser pinguis*, fol. 378ra.

[24]Nevertheless, Olivi notes that the seventh vision is not divided into seven parts as the others are (*Lectura super Apocalypsim*, 22–23).

[25]John Russel and *Aser piinguis* are exceptions, since they are too vague to be categorized in this way.

[26]*In Apocalypsim Ioannis* (PL 196:783).

[27]Sometimes he identifies the third age with the sixth and seventh periods, sometimes with the seventh alone; yet this is hardly an inconsistency. His point is that the third age will be fully realized only after the death of Antichrist. For Olivi's view of Joachim, see David Burr, "Olivi, Apocalyptic Expectation, and Visionary Experience," *Traditio* 41 (1985):273–88.

acknowledges his threefold division of history into the ages of Father, Son, and Holy Spirit. Normally they tend to cite Joachim in contexts that do not force engagement with what is distinctive in his theology of history. Joachim appears as one of many *auctoritates* marched before the reader's admiring eyes.[28] Olivi works much differently. He depends heavily on Joachim, and his commitment is seen precisely in the importance he gives to the threefold division of history. He explicitly cites Joachim over 140 times in the course of his Apocalypse commentary. He writes with three books before him: the Apocalypse itself, Joachim's commentary, and Richard of Saint Victor's commentary. These two commentaries are almost the only ones he mention. The *Glossa* is cited only twice; Bede is not even mentioned. He discusses Augustine at length in dealing with Apocalypse 20 but largely rejects him. He cites Richard just as often as he cites Joachim but uses him for different purposes. In the final analysis, his interpretation is Joachite, not Ricardian.

The seventh period is seen by our commentators as a genuine period after the death of Antichrist in which there will be peace, holy men will be allowed to preach freely, humankind will receive a final chance to repent, and the Jews will be converted. All except Olivi base this interval not on the millennium of Apocalypse 20 but on Jerome's interpretation of Daniel 12, which allows a period of forty-five days. They often follow a variant in this tradition in speaking of forty rather than forty-five days, and they also often follow the developing tradition in seeing it as a minimum figure to which God can add more time if he wishes.[29]

Because these commentators follow Augustine in interpreting the millennium as the entire time from Christ to the coming of Antichrist,[30] they do not identify it with the seventh period. Only Olivi challenges Augustine on this issue. He sees Apocalypse 20 as applicable to three different periods in Church history, one of which is the Joachite third age. This strategy allows him to suggest a devalued millennium of approximately eight-hundred or nine-hundred years, running from the time of Francis— or slightly before, if one sees the renewal as foreshadowed in the first

[28]There are reflections, though. See, for example, the celebration of the seventh period in Alexander Hales *Commentarii in Apocalypsim*, 204–6; or the lengthy *concordia* in Vital du Four *Expositio super Apocalypsim*, Assisi MS. 66, fols. 40vb–41ra, which reflects Joachim *Liber de concordia Noui ac Veteris Testamenti*, ed. E. Randolph Daniel (Philadelphia, 1983), 139, 286, 409; or the list of opposites sent by the devil in *Vidit Iacob*, 443, reflecting Joachim *Expositio in Apocalypsim* (Venice, 1527), fol. 10v; or the list of peoples raised up to oppose the Church in *Vidit Iacob*, 433–34, and Vital ibid., fols. 98vb–99rb, reflecting Joachim, ibid. fols. 162–163v; or the echo of Joachim on the seven heads in *Vidit Iacob*, 432–33, Vital ibid., fols. 98vb–99rb and 129rb, and Alexander, ibid., 236–37, reflecting Joachim, ibid. fols. 10r–10v. Reeves notes several of these parallels in *Influence of Prophecy*, 87.

[29]For this tradition, see Lerner, "Refreshment of the Saints," as well as his essay in this volume, esp. 53–57.

[30]Augustine *De civitate Dei* 20:9.

Crusade and resultant new orders—to the end of the world around the year 2000.[31]

Having spoken thus generally, I must pause to register a cautionary note. While all of these commentators are open to the sevenfold pattern of Church history and willing to see it in the Apocalypse, they vary sharply in their willingness to locate themselves within it or even to make much use of it. One end of the spectrum is occupied by John of Wales, who inherits the idea of seven periods from tradition but hardly rejoices in it. He does little more than acknowledge it occasionally, then return to the task of atemporal moral interpretation. Not once does he pause to ask which period he himself is in.

The opposite end of the spectrum is occupied by Vital, "Alexander," *Vidit Iacob*, and preeminently, Olivi. The first three place themselves at the beginning of the fifth period, that of the precursors of Antichrist, and are willing to supply corroborating evidence. The result is a grim picture of contemporary decadence in the secular and sacred spheres, but especially among the *praelati*.[32] Olivi locates himself in the interstice between the fifth and sixth periods. The renewal of the sixth period has already begun in the time of Francis, but the decay of the fifth period proceeds apace. The Church has now become "infected from head to toe and turned, as it were, into a new Babylon."[33] The opposition between these two tendencies will sharpen in the near future, and proponents of the new age ("spiritual men") will be persecuted by proponents of the old (the "carnal church"), who will have gained eminence in the ecclesiastical hierarchy. In fact, Olivi seriously considers the possibility that they will control not only the Franciscan order but the Church as a whole.

That is a great deal farther than other commentators are willing to go. While others are willing to contemplate the fifth period as one of decline leading to the persecution of Antichrist in the sixth period and are often willing to attack the *praelati* (with whom the mendicants understandably believed they had a score to settle), they are conspicuously unwilling to implicate the prelate of prelates, the pope himself, much less to suggest that in the future a minion of Antichrist or perhaps Antichrist himself will don the papal tiara.[34] Olivi says that and more. He raises the possibility that the pope may be implicated in persecuting the elect, not only during the reign of Antichrist, but even before; that the resultant persecution will be terminated only when Rome is destroyed by a pagan army;

[31]See David Burr, "Olivi's Apocalyptic Timetable," *Journal of Medieval and Renaissance Studies* 11 (1981):237–60.

[32]They point to heresy and corruption. *Aser pinguis* contains an equally vehement attack.

[33]Olivi *Lectura super Apocalypsim*, 52.

[34]There is at least a fleeting recognition of this possibility in *Vidit Iacob*, 414, but so brief and ambiguous as to be insignificant.

and that, after the persecution of Antichrist, the capital of Christianity may be established elsewhere.[35]

Olivi may be atypical in his willingness to place himself in the sixth period, identify Saint Francis as the founder of that period, and see the sixth period as closely connected with the seventh; yet he is not entirely unfranciscan in doing so, since Bonaventure takes an analogous position in the *Collationes in Hexaemeron*.[36] Olivi is much more willing to speculate on the shape of things to come, and his scenario displays a concreteness lacking in Bonaventure's brief, evocative discussion; yet their common positive reading of the sixth period, willingness to put themselves in it, and linkage of it with the seventh period connect them in a significant way, making Olivi the only Franciscan commentator who can take literally Bonaventure's celebration of Francis as angel of the sixth seal in Apocalypse 7:2.[37] Three of the others mention Francis in expositing this passage, and one of them, Vital du Four, sees him in other passages as well; yet their way of placing themselves within history prohibits them from taking such identifications as anything more than handy preaching topics based not on the literal sense of Scripture but on its moral sense.[38] This difference has a series of repercussions, not least of which is that it allows Olivi to discuss the nature of the sixth and seventh periods with more confidence and more specificity than others.

Nevertheless, Olivi departs from Bonaventure in two important respects. First, there is no Bonaventuran equivalent of Olivi's ruminations on the future corruption of ecclesiastical authority at the highest levels. Second, although Bonaventure implies that the afflictions currently suffered by the order stem from its laxity concerning poverty,[39] he does not make the defense of poverty a central issue in the coming tribulation, as Olivi does. In both of these respects, Bonaventure is closer to the main line of mendicant exegesis than he is to Olivi. These are important differences, particularly when taken in combination. Like Bonaventure, most mendicant commentators avoid locating the institutional source of the coming great temptation too precisely, and thus the pope's role in it is not so much denied as never faced at all. They do attempt to locate its moral source, and their way of doing so is traditional yet quite contemporary. It

[35]Ibid. 492–93, 538, 548, 735–38, 751, 801–809, 816, 819–20, 858.
[36]See the comparison in David Burr, "Bonaventure, Olivi and Franciscan Eschatology," *Collectanea Franciscana* 53 (1983): 23–40. On Bonaventure's theology of history, see Joseph Ratzinger, *The Theology of History in St. Bonaventure* (Chicago, 1971).
[37]See esp. Bonaventure *Legenda major* prol. 1, 13. 10, in *Opera*, vol. 8 (1898), 504, 545. Bonaventure returned to the theme in other works; see Stephanus Bihel, "S. Franciscus Fuitne Angelus Sexti Sigilli?" *Antonianum* 2 (1927): 29–70; and Stanislao da Campagnola, *L'Angelo del sesto sigillo e l'alter Christus* (Rome, 1971).
[38]See David Burr, "Franciscan Exegesis and Francis as Apocalyptic Figure," in *Monks, Nuns, and Friars in Mediaeval Society*, ed. E. B. King, J. T. Schaefer, and W. B. Wadley (Sewanee, Tenn., 1989), 51–62.
[39]Bonaventure *Collationes in Hexaemeron* 20:30, in *Opera*, vol. 5 (1891), 430.

is traditional in reducing the temptation to the two traditional dangers of heresy and laxity, but contemporary inasmuch as it often translates these dangers into very modern terms. When Bonaventure mentions heresy as a serious temptation in the present and immediate future, he is likely to begin agonizing over heterodox Aristotelianism. When Hugh of Saint Cher, "Alexander," and others bemoan laxity, they can be expected to strike a passing blow at the *praelati*, thus extending the secular-mendicant battle into the apocalyptic sphere. Such tactics give their apocalyptic speculation a lively relevance but do not make it dangerous, since neither heterodox Aristotelianism nor secular opposition to the mendicants was destined to triumph. In both cases, the mendicants could look to the pope as their protector, not as their would-be destroyer.

In Olivi's case, the situation was quite different. In forecasting that the pope and Franciscan leaders would soon reject his notion of true Franciscan poverty, he was offering a remarkably accurate prediction of what would in fact occur within two decades, under John XXII. It occurred even earlier for others, depending on their particular definition of Franciscan poverty. Thus Olivi's interpretation was dangerous in a way that others' were not.

This fact was hardly unnoticed. There is evidence of concern as early as the reign of Boniface VIII, who faced an apocalyptically oriented Franciscan opposition in Italy shortly after his accession.[40] Under John XXII, the concern became a formal investigation of Olivi's Apocalypse commentary, which dragged on for eight years before resulting in a 1326 condemnation.[41] A papal commission, reporting on the commentary in 1319, saw the dangers clearly and elaborated on them at length.[42] In some ways, their report—and the reports of other writers asked to render opinions in the early 1320s—represented an attack not only on what was unique in Olivi but also on the common ground shared between Olivi and Bonaventure, since these reports tended to implicate the Bonaventuran and Olivian tendency to interpret Francis, his rule, and his order as apocalyptic events. They saw that if Francis and his rule were literally apocalyptic events through which God had acted to restore the same evangelical life practiced by Christ and his disciples, then the pope had no more authority over the Franciscan rule than he had over the Gospel, a conclusion that John XXII and his advisors preferred to avoid. Even here, however, there was something special about Olivi. Bonaventure may have implied as much on occasion, but Olivi said it, over and over.

[40]See David Burr, *Olivi and Franciscan Poverty* (Philadelphia, 1989), 112–24.
[41]See Joseph Koch, "Der Prozess gegen die Postille Olivis zur Apokalypse," *Recherches de Théologie Ancienne et Médiévale* 5 (1933): 302–15; Edith Pásztor, "Le polemiche sulla 'Lectura super Apocalypsim' di Pietro di Giovanni Olivi fino alla sua condanna," *Bullettino dell'Istituto Storico Italiano per il Medio Evo* 70 (1985): 365–424.
[42]In Stephanus Baluze *Miscellanea*, vol. 2 (Lucca, 1761) 258–70.

This brings us at last to the second group of Franciscan scholars and their strikingly different interpretive strategy. The first is Alexander Minorita, who informs us that he received his approach directly from God while taking communion.[43] Alexander treats the Apocalypse as a continuous reading of Church history proceeding from the primitive Church in Chapter 1 to the *eschaton* in Chapter 22. The resultant commentary is very historical and very specific, packed with names and dates taken from a variety of sources including patristic writings, papal letters, Joachim's Apocalypse commentary, the pseudo-Joachim commentary on Jeremiah, and contemporary German chronicles. He is in no hurry. By Apocalypse 7:2 he is merely up to Constantine, and by 20:2 he has just discussed the emperor Henry V.

Thus 20:3 seems an odd place to encounter the thousand-year binding of Satan, but Alexander makes at least rough sense of it. He obliquely suggests that the number cannot be taken literally, and he seems to grant some validity to the Augustinian notion that it began with Christ; yet he also takes the notion of a thousand-year reign of Christ after Pope Sylvester seriously enough to note that there are at least seventy years of it left in his own time.[44] After that, we can expect the reign of Antichrist at any moment.

Francis, Dominic, and their orders are tucked in at 20:6, just in time for the millennium to expire at Apocalypse 20:7[45] Then come Gog, Magog, and Antichrist,[46] but by 20:10 they have been consigned to the lake of fire, followed in 20:15 by those not included in the book of life. We are now ready for the new heaven and earth. Alexander sees the descent of the heavenly Jerusalem as souls returning from heaven to reanimate their bodies for final judgment,[47] and thus he seems to have run through all of history this side of Judgment Day by the beginning of Chapter 21, leaving him free to see the rest as a description of heavenly bliss. He has a surprise in store, though. When he turns to 21:9 and the angel who leads the tour of the holy city, he notes that while this section speaks of the city after final judgment, Jerusalem must be built by the elect with good works before the last day. Then he doubles back to his own time and interprets the New Jerusalem as a prediction of the Franciscan and Dominican orders.[48] His

[43]Alexander Minorita *Expositio in Apocalypsim* (*MGHQ* 1:6). His description reminds one of Joachim's narrative in *Expositio in Apocalypsim*, fol. 36va.

[44]Alexander Minorita *Expositio in Apocalypsim*, 443, 450. His message is hardly clear, though. Moreover, he sees the millennium as a minimum figure, to which God can add a space for conversion if he wishes.

[45]Ibid., 436–37, 493–95, cites the prediction of two new orders in the pseudo-Joachim *Super Hieremiam* (Cologne, 1577), 8, 76–79.

[46]Alexander Minorita *Expositio in Apacalypsim*, 450–58, an odd and not particularly consistent mixture of Augustine, the Tiburtine Sibyl, and Hildegard of Bingen.

[47]Ibid., 462.

[48]Ibid., 469–501, already anticipated on 453–54.

commentary on the last two chapters deals almost exclusively with the mendicants.

Alexander's approach was well outside the interpretive mainstream and seems to have left almost no mark on subsequent thirteenth-century exegesis;[49] yet two of the brightest scholars in the early fourteenth century found it useful. Peter Aureol not only follows Alexander's successive reading but explicitly argues for its superiority over other current interpretive schemes. The intention of the Apocalypse, he says, is to predict "all the notable sufferings, changes, persecutions and novelties occurring to the Church, and not just the persecution under Antichrist." Thus there is no reason why God would waste space repeating the same general pattern over and over. "It does not seem rational that what is said in chapter seven should refer to the end of the world, and yet at the beginning of the eighth we're back to the early Church!"[50]

While one can appreciate Peter's concern, one is also tempted to wonder what else was involved in his decision to reject the common exegetic strategy in favor of Alexander's. Perhaps an answer is provided by the first article of the 1319 censure directed at Olivi's commentary. The commission begins by saying,

> The sevenfold division of the periods of the church, understood as he [Olivi] will explain it in the following articles—i.e., that the sixth and seventh periods of the Church are a notable advance beyond the first five, and thus they repudiate all those earlier ones as the Church repudiated the Synagogue—should be considered heretical. We consider it temerarious that he says the seven periods of the Church are described in those seven visions of the Apocalypse, given the way he applies and exposits this idea.[51]

The commission is attacking not the mainstream interpretation but Olivi's variations on that theme; yet one can see how the situation might have made interpreters nervous about the approach itself and encouraged them to look for an alternative. Did it? There is no way of knowing without further investigation.

At any rate, Peter's interpretation is doubly safe in that it eliminates much of Alexander's attention to the mendicants. Peter echoes, sotto voce as it were, Alexander's reference to Francis and Dominic at 20:5, but he omits any echo of the pseudo-Joachim *Super Hieremiam*, a less respectable document in the early fourteenth century than it had been

[49]There are echoes. Bonaventure reflects it in *Sermones de S. Patre Nostro Francesco* 4, in *Opera*, vol. 9 (1901), 386–87, and Olivi's commentary might be said to effect a partial harmonization of the two approaches.

[50]Peter Aureol (Petrus Aurioli) *Compendium sensus literalis totius divinae scripturae* (Quaracchi, 1896), 454–56.

[51]Baluze *Miscellanea* 2:258.

in the midthirteenth. Moreover, he completely excises the mendicants from his treatment of the New Jerusalem, interpreting it entirely in relation to heaven.[52]

Nicholas of Lyra, writing in 1329,[53] also accepts the successive interpretation, but after Apocalypse 16, he departs significantly from the structure accepted by Alexander and Peter. He observes that some people think everything up to Chapter 20 already has occurred, but such an interpretation seems *impropria et extorta*. It seems safer to assume that the events predicted in Chapters 17–20 remain uncompleted. Since he himself is no prophet, he cannot speak of the future except insofar as the Bible, saints, or doctors instruct him. Thus he will leave the exposition of these chapters to wiser men, although he promises to get in touch with us should the Lord further enlighten him.

With this bit of mild sarcasm, Nicholas puts himself in a position to evade any discussion of the mendicants. Thus it is all the more intriguing that, in dealing with the heavenly Jerusalem, he takes the trouble to refute Alexander's interpretation of the heavenly city explicitly and at length (though without mentioning him by name). His refutation includes the rather jarring observation that, whereas according to the Apocalypse nothing soiled or of abominable conduct will enter the heavenly city, not all the mendicants can be described as such, "nor do all who enter persevere in the good, but many become apostates and the worst sorts of person."[54] These words may reflect something more than scholarly dissent. Nearly a century of Franciscan infighting, some of it very unpleasant, separated Nicholas from Alexander. Nevertheless, the skeptical, analytic, slightly sardonic attitude suggested by this remark is seen elsewhere in Nicholas's analysis of Church history.

Thus there is some justice in the title of this essay. We must refer to mendicant readings of the Apocalypse rather than to a single reading. We find two basic approaches, and notable variations within each approach. One approach is limited to three Franciscans, the other shared by both orders. Is there, then, no sense in which one might speak of the Franciscan *versus* the Dominican approach to the Apocalypse? The sheer preponderance of Franciscan over Dominican commentaries in our sample might suggest that Minorites felt called upon to come to terms with that book in a way the Preachers did not. The dangers of such an argument are obvious. Manuscripts survive for a variety of reasons, and some of the Franciscan commentaries described above came perilously close to disappearing entirely. Nevertheless, the imbalance does raise a question.

[52]Peter Aureol *Compendium*, 550–55.

[53]Nicholas of Lyra *Postilla super totam bibliam* (Strassburg, 1492), at Apoc. 13:18 (the pages of this edition are unnumbered).

[54]Note, however, that in his *Postilla moralis*, completed in 1339, Lyra does acknowledge as the *moral* meaning of Apoc. 7:2 that it signifies a preacher and can refer especially to Francis.

It would be understandable if the Franciscans saw a special need to comment on the Apocalypse. We know from Salimbene and others that a number of them cherished an apocalyptic interpretation of their order well before Bonaventure wrote.[55] Their enthusiasm was dampened but hardly extinguished by the scandal of the Eternal Gospel in the mid-1250s,[56] and after 1266, when the order decreed that Bonaventure's *Legenda major* should be the sole official biography of Francis, the identification of Francis with Apocalypse 7:2 was enshrined in a canonical text.

The Dominican experience was quite different. In 1255 the Dominican and Franciscan leaders, Humbert of Romans and John of Parma, were willing to issue a joint encyclical that claimed an apocalyptic significance for both orders, and scattered Dominicans continued thereafter to envisage such a role for their order;[57] yet they did not continually encounter such an idea in a widely distributed official document as Franciscans did, and the man who would emerge as the authoritative theological voice in the order, Thomas Aquinas, had little sympathy for apocalyptic speculation.[58]

Thus one might say that, although the general tendency in both orders was to edge away from an apocalyptic interpretation of the mendicant phenomenon (Olivi was a notable exception, but we know his posthumous fate), that movement cost the Franciscans substantially more effort. The scandal of the Eternal Gospel and subsequent controversy with the Spiritual Franciscans gave Minorite scholars a lively sense of the dangers lurking in apocalyptic speculation; yet sermons and *collationes* on Francis as angel of the sixth seal continued to be preached in Franciscan houses, as the Bonaventuran legacy suggested they must. Thus the Franciscan task was not so much to eliminate apocalyptic statements as to define their significance. Some did so implicitly, by commenting on the Apocalypse without mentioning Francis and the order, thus implying that, whatever legitimacy such references might have in other contexts, they had no place in sober academic enterprises. Others made the same point explicitly by mentioning such identifications but specifying that they were valuable *for preaching*. In either case, one had to come to terms with the Apocalypse.

If such a distinction between the two orders is valid—and even I find it somewhat hypothetical—it is nonetheless of secondary importance when compared with the general similarities in approach and content that unite most mendicant commentaries in the period.

[55]See the comments on Rudolph of Saxony, Gerard of Borgo San Donnino, Hugh of Digne, John of Parma, and Salimbene himself in Salimbene *Cronica* (Bari, 1966), 332–34, 339–43, 361, 367, 428, 439–40, and elsewhere. Salimbene's remarks suggest that early Franciscan apocalyptic thought was heavily indebted to Joachim of Fiore and to the pseudo-Joachim *Super Hieremiam*.

[56]See Reeves, *Influence of Prophecy*, 59–70. Their ardor was also decreased by Frederick II's death before he had performed his appointed apocalyptic role and by the passing of the year 1260 without major incident.

[57]See ibid., 146–47, 161–74.

[58]See McGinn, *Calabrian Abbot*, pt. 3.

PART TWO

The Apocalypse
in Medieval Art

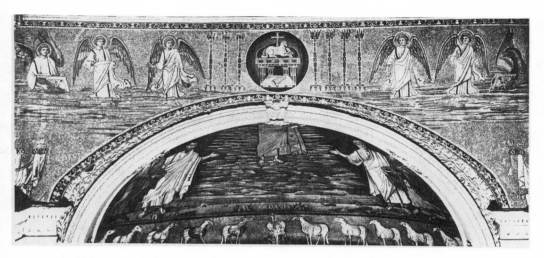

1. Adoration of the Lamb. Rome, SS. Cosma e Damiano, triumphal arch mosaic. Photo: Peter Klein.

2. Vision of the Lamb. Bamberg, Staatsbibliothek, Misc. bibl. 140, fol. 13ᵛ. Photo: Staatsbibliothek Bamberg.

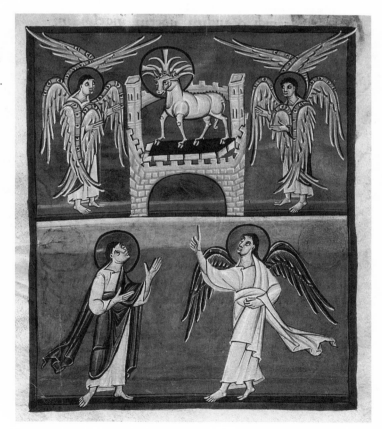

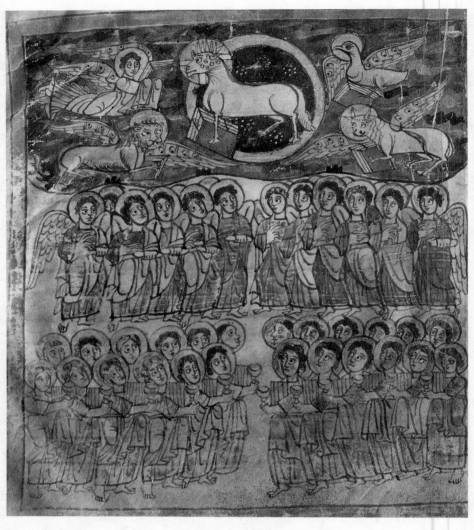

3. Adoration of the Lamb. Trier, Stadtbibliothek, Cod. 31, fol. 18ᵛ. Photo: Bildarchiv
Foto Marburg, Universität Marburg.

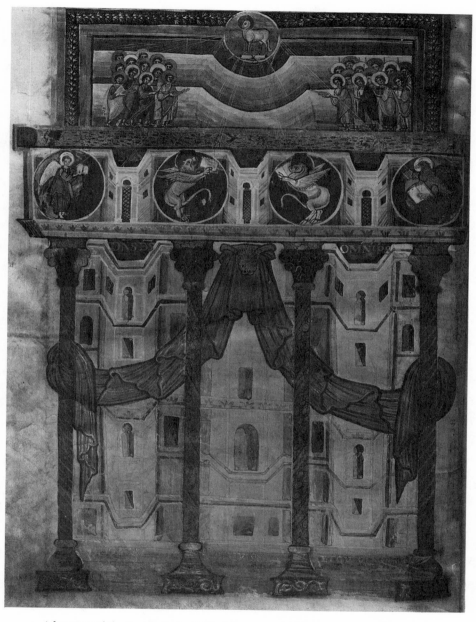

4. Adoration of the Lamb. Paris, Bibliothèque nationale, MS lat. 8850, fol. 1ᵛ. Photo: Bildarchiv Foto Marburg, Universität Marburg.

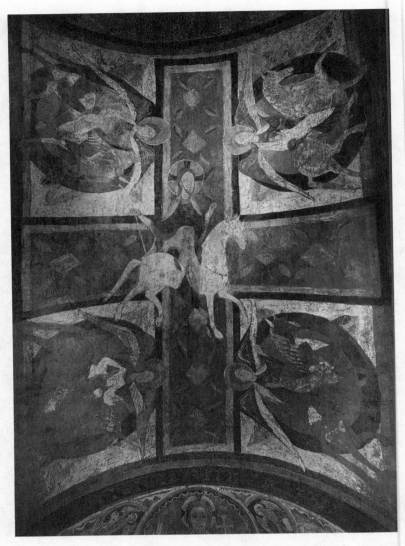

5. The Rider "Faithful and True." Auxerre cathedral crypt, vault painting.
Photo: Foto Hirmer, Munich.

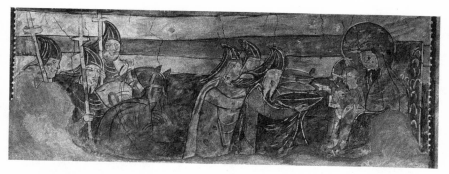

6. (a) Adoration of the Magi;

(b) Michael fighting the Dragon. Saint-Pierre-les-Eglises church, apse painting. Photo: Archives photographiques, Paris.

7. The Heavenly Rider. Saint-Nectaire church, choir capital. Photo: Foto Hirmer, Munich.

8. Apocalypse window. Bourges cathedral, ambulatory. Photo: Peter Klein.

9. Saint John on Patmos. Rome, Biblioteca Vallicelliana MS. B.25.2, fol. 675ʳ. Photo: Biblioteca Vallicelliana.

10. Saint John on Patmos. Moissac cloister, south gallery capital.
Photo: Peter Klein.

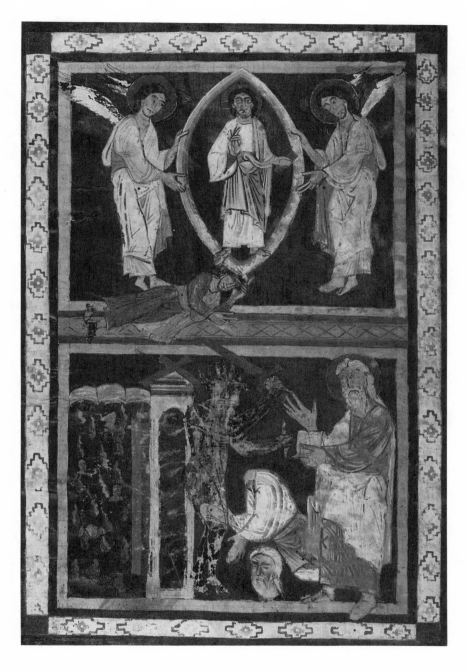

11. (Top) Vision of Christ; (bottom) killing of the Witnesses. Vienna, Österreichische Nationalbibliothek, Cod. ser. nov. 2702, fol. 229r. Photo: Bildarchiv Foto Marburg, Universität Marburg.

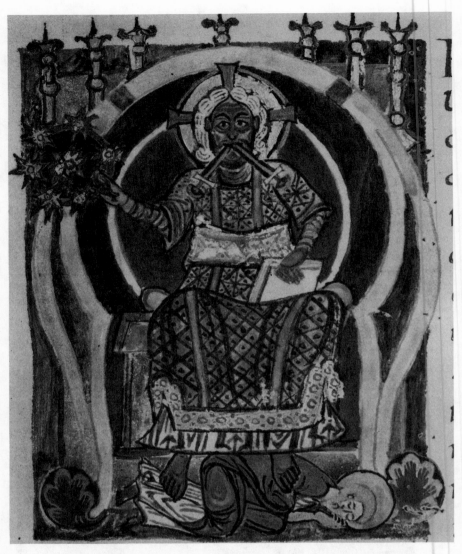

12. Vision of Christ between the candlesticks. London, British Library MS Add. 28107, fol. 234ʳ. Photo: By permission of the British Library.

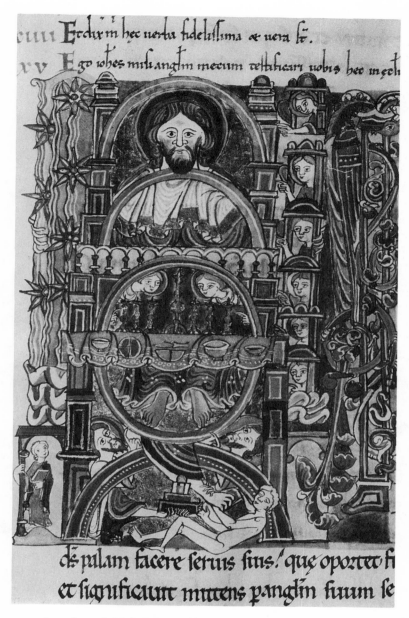

13. Apocalypse initial. Dijon, Bibliothèque municipale MS. 2, fol. 470ᵛ. Photo: Service photographique de las Caisse nationale des Monuments histo-riques et des Sites, Paris.

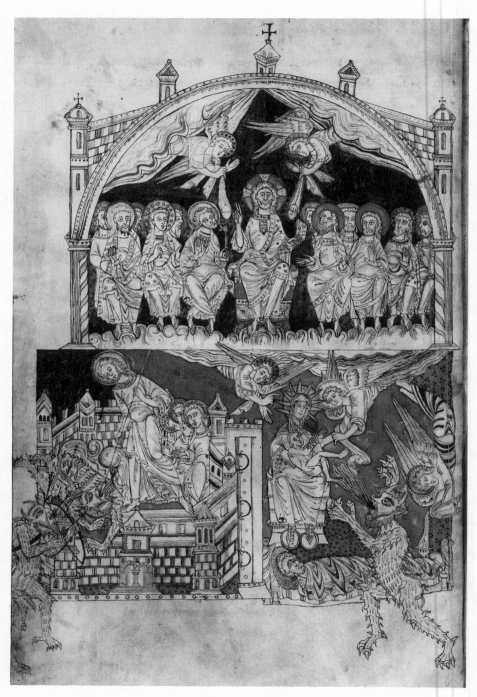

14. Scenes of Apocalypse 12. Oxford, Bodleian Library MS Laud. misc. 469, fol. 7ᵛ.
Photo: Bodleian Library.

15. Angels restraining the four winds. Cambridge, University Library MS. Mm.V.31, fol. 32ᵛ. Photo: Peter Klein.

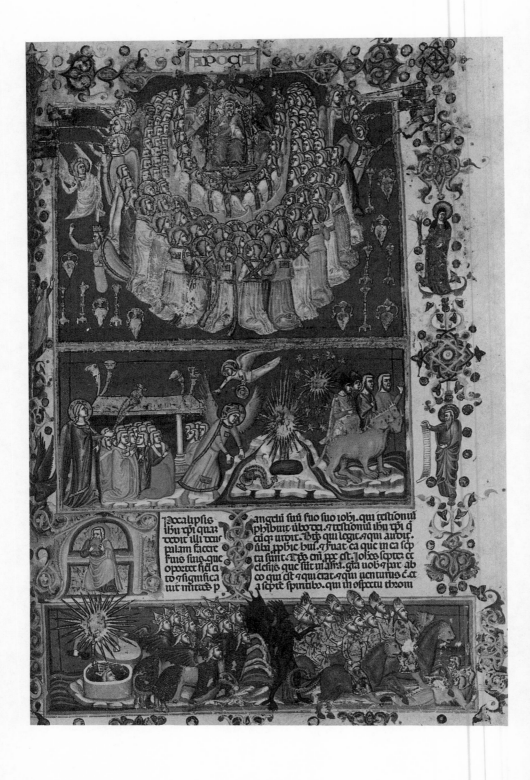

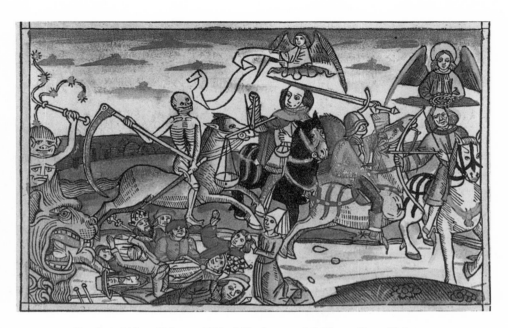

17. The Four Riders. Koberger Bible (Nürnberg, 1483). Photo: Peter Klein.

16. Scenes of Apocalypse 5–10. Berlin, Staatliche Museen, Kupferstichkabinett MS. 78.E.3, fol. 456ʳ. Photo: Peter Klein.

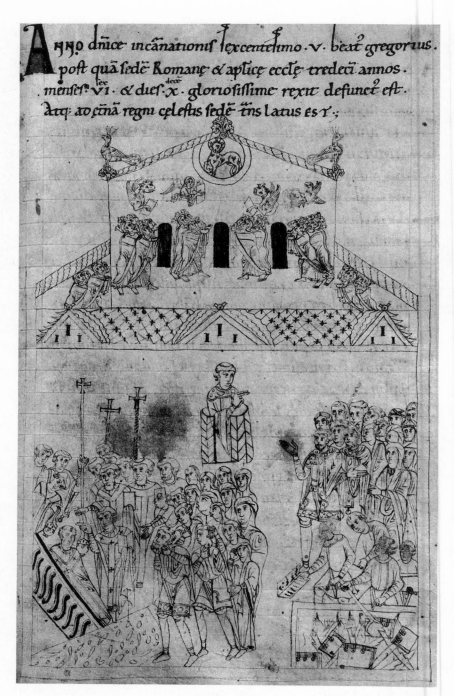

Anno dnice incarnationif fexcentefimo .v. beat gregorius.
poft quã fedẽ Romanẽ & aplice eccl̃e tredecĩ annos.
menfef vĩ. & dief x. gloriofiffime rexit defunc̃ eft.
Atq: ad etnã regni celeftis fedẽ tñs latus es r.;

18. Adoration of the Lamb by the Elders. Facade of old St. Peter's, Rome. Eton College Library MS. 124, fol. 122ʳ. Photo: Eton College Collections.

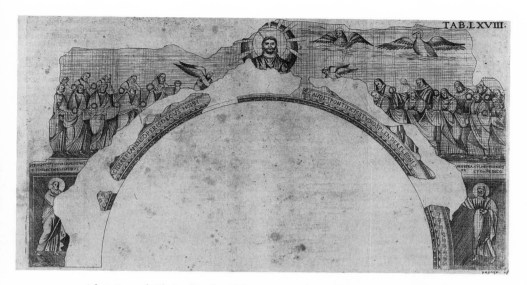

TAB.LXVIII.

19. Adoration of Christ by the Elders. Triumphal arch of S. Paolo fuori-le-mura, Rome. J. Ciampini, *Vetera monumenta*, vol. 1 (1690), pl. LXVIII. Photo: Biblioteca Apostolica Vaticana.

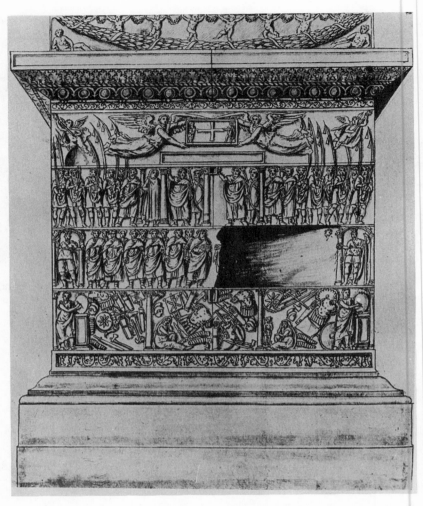

20. *Aurum oblaticium.* Drawing of base of the Column of Arcadius, Istanbul. After E. H. Freshfield, *Archaeologia* 72(1921/22): pl. XXIII. Photo: Bryn Mawr College.

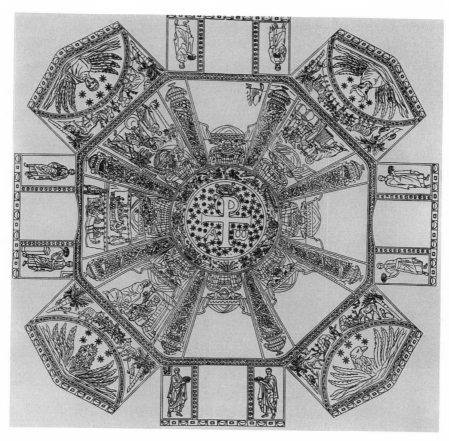

21. The Four Living Creatures. Diagram of the mosaic decoration of S. Giovanni in Fonte, Naples. After Jean-Louis Maier, *Le baptistère de Naples* (1964), pl. II. Photo: Bryn Mawr College.

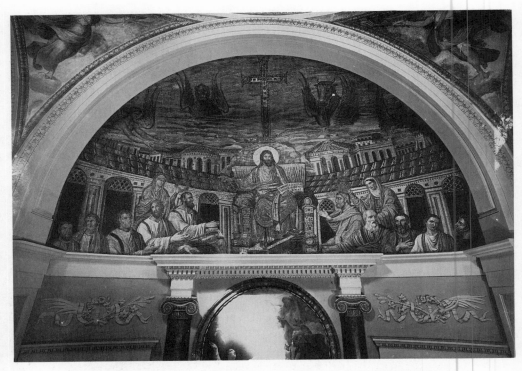

22. Christ in the company of the Apostles. Rome, S. Pudenziana, apse mosaic. Photo: Istituto Centrale per il Catalogo e la Documentazione, Rome.

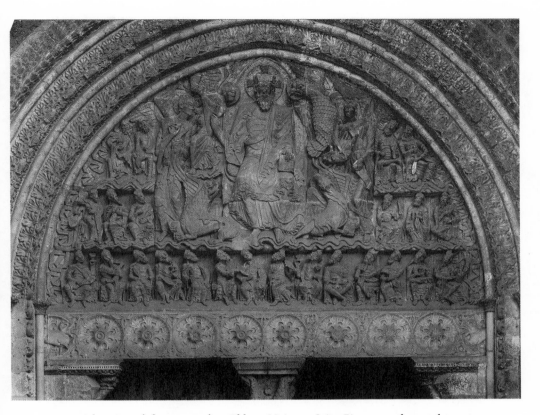

23. Adoration of the twenty-four Elders. Moissac, Saint-Pierre, south portal tympanum. Photo: University of Chicago and James Austin.

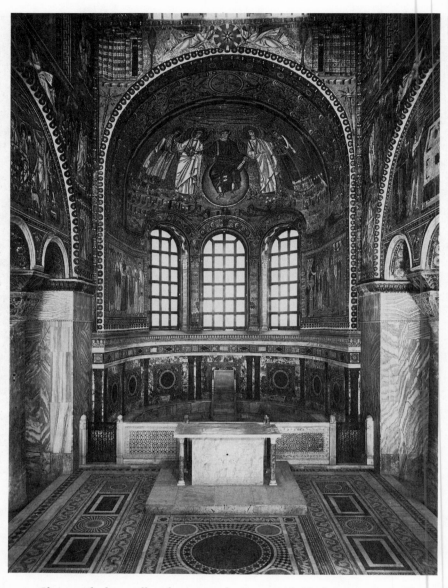

24. Christ with the scroll with seven seals. Ravenna, S. Vitale, apse mosaic. Photo: Alinari/Art Resource.

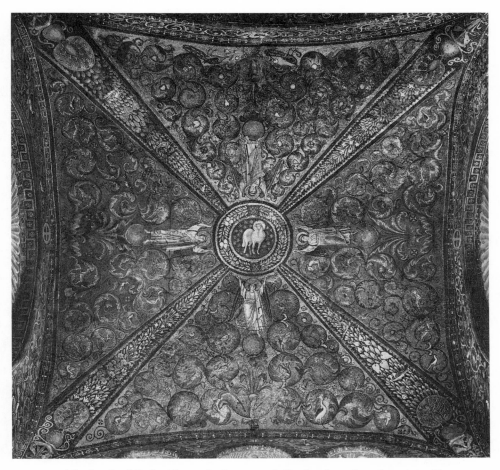

25. The Lamb of God with angels. Ravenna, S. Vitale, chancel vault mosaic. Photo: Alinari/Art Resource.

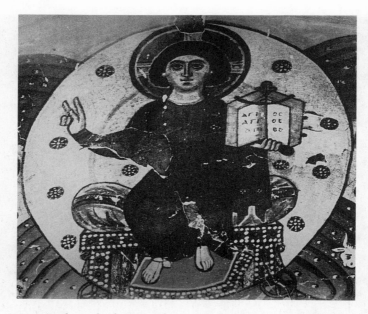

26. Enthroned Christ, with the Four Living Creatures. Bawit, Chapel XVII, apsidal niche fresco (detail); after J. Clédat, *Le monastère et la nécropole de Baouît*, vol. 2 (1906), pl. XLII. Photo: Bryn Mawr College.

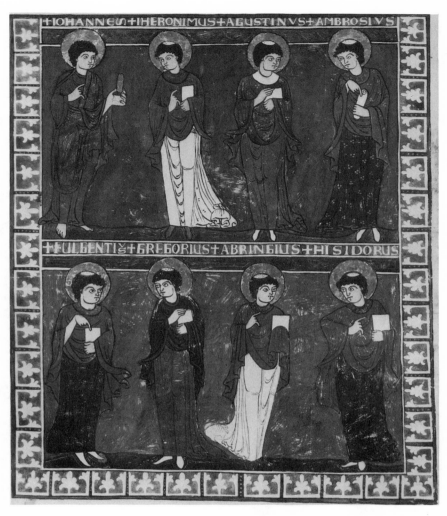

27. John and Apocalypse exegetes. Paris, Bibliothèque nationale MS lat. 8878, fol. 13ᵛ. Photo: Bibliothèque nationale.

28. The Whore of Babylon. Madrid, Biblioteca Nacional MS Vitr. 14-1, fol. 134ᵛ. Photo: Biblioteca Nacional.

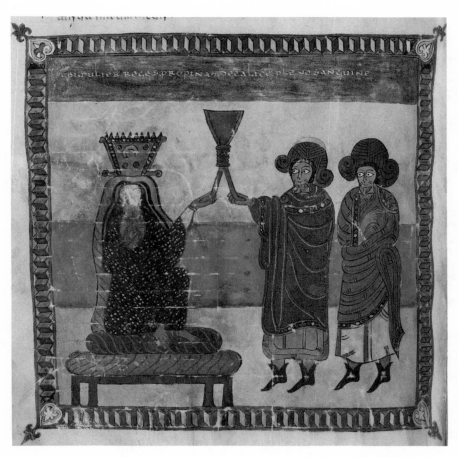

29. The Whore of Babylon. New York, Pierpont Morgan Library MS. M.644, fol. 194ᵛ.
Photo: The Pierpont Morgan Library.

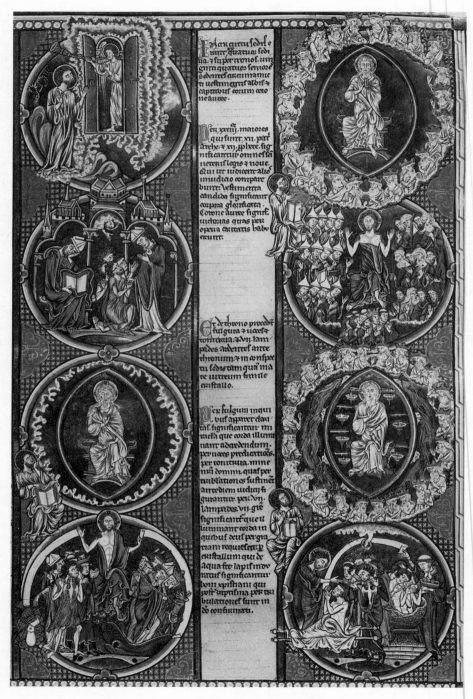

30. *Bible moralisée* representation of Apocalypse 4–5. Vienna, Österreichische National-
bibliothek, Cod. 1179, fol. 226ʳ. Photo: Österreichische Nationalbibliothek.

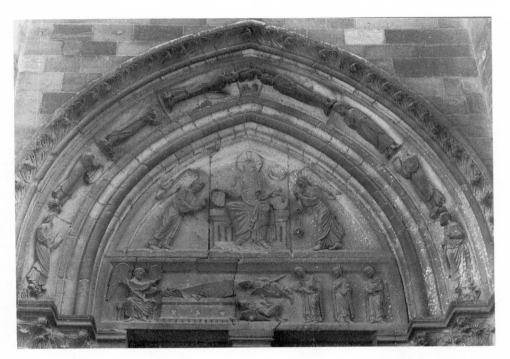

31. Enthroned Christ, with the visit of the women to the tomb and Resurrection. Mantes collegiate church, left portal of the west facade. Photo: Viviane Siffert.

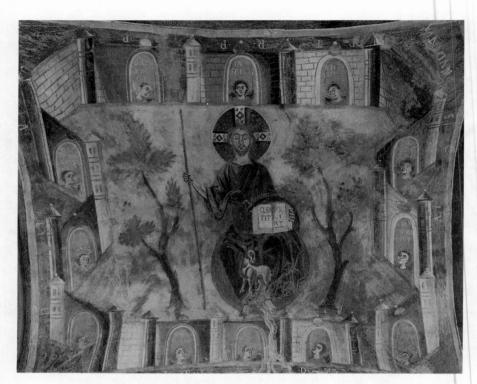

32. Heavenly Jerusalem. Civate, S. Pietro al Monte. Photo: Viviane Siffert.

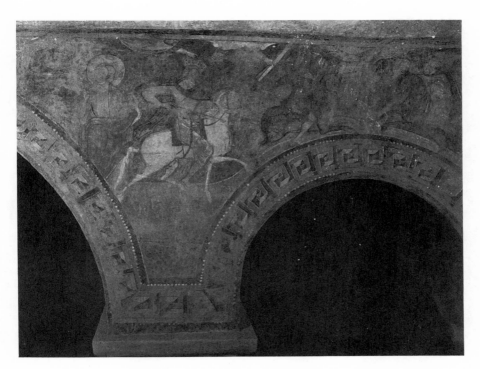

33. The angel addresses John; the first Horseman. Poitiers, Saint-Hilaire, apse fresco.
Photo: Centre d'Études Supérieures de la Civilisation Médiévale, Poitiers.

34. The angel addresses John; the first Horseman. Méobecq, Notre-Dame, apse fresco. Photo: Viviane Siffert.

35. Angels restraining the four winds. Mozac, Saint-Pierre, capital. Photo: Viviane Siffert.

36. Christ between the candelabra. La Lande-de-Fronsac church, south portal. Photo: Viviane Siffert.

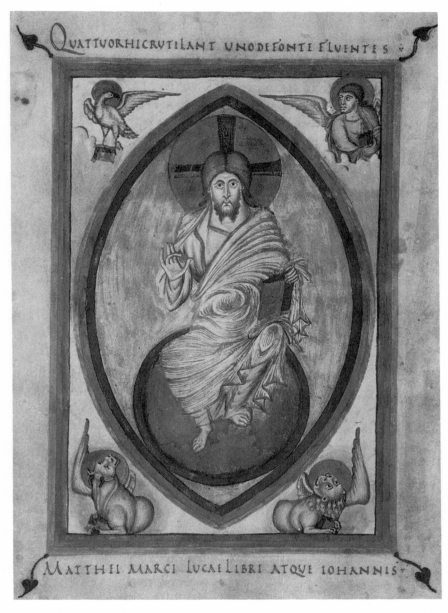

37. *Majestas domini*. Paris, Bibliothèque nationale MS lat. 266, fol. 2ᵛ. Photo: Bibliothèque nationale.

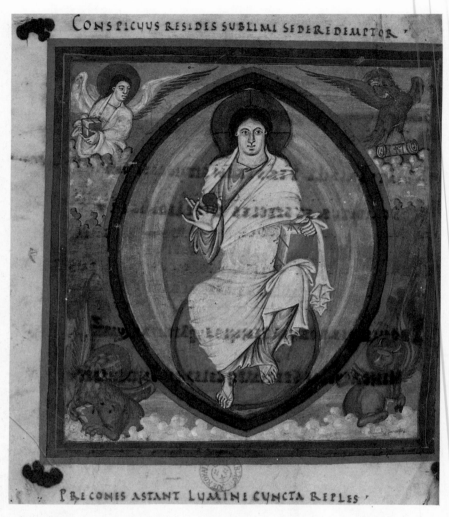

CONSPICVVS RESIDES SUBLIMI SEDE REDEMPTOR

PRECONES ASTANT LUMINE CVNCTA REPLES

38. *Majestas domini*. Paris, Bibliothèque nationale MS lat. 9385, fol. 179ᵛ. Photo: Bibliothèque nationale.

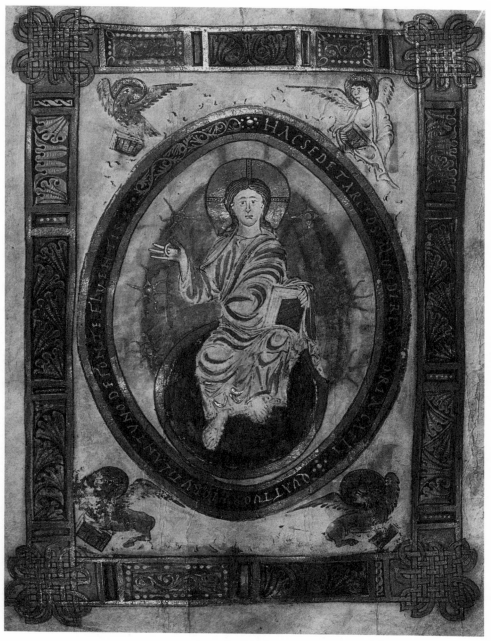

39. *Majestas domini.* Paris, Bibliothèque nationale MS lat. 261, fol. 18ʳ. Photo: Bibliothèque nationale.

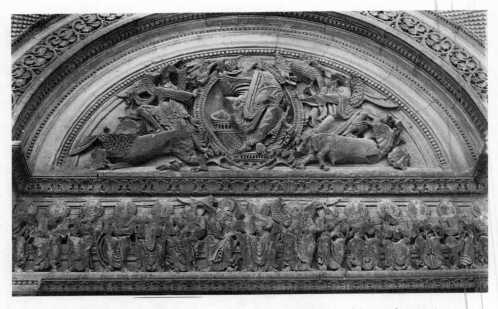

40. *Majestas domini*. Charlieu, Saint-Fortunat, north facade of the narthex, main portal. Photo: Viviane Siffert.

41. The sixth seal. London, Lambeth Palace MS. 75, fol. 13ᵛ. Photo: The Conway Library, Courtauld Institute of Art; by permission, Lambeth Palace Library.

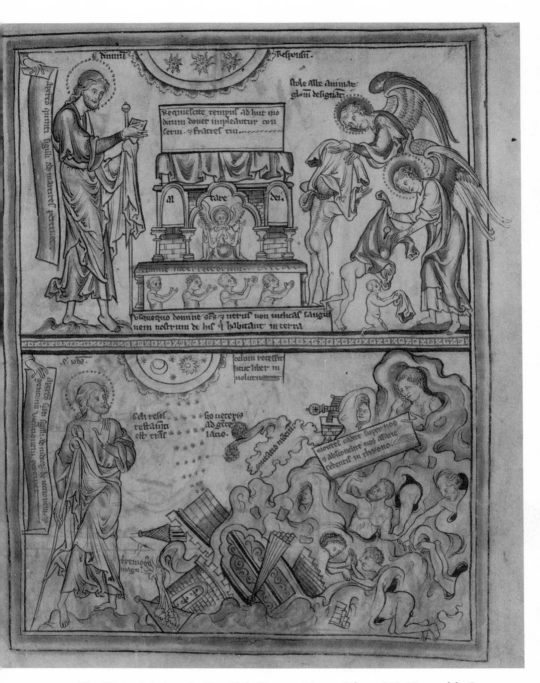

42. The fifth and sixth seals. New York, Pierpont Morgan Library MS. M. 524, fol. 3ʳ.
Photo: The Pierpont Morgan Library.

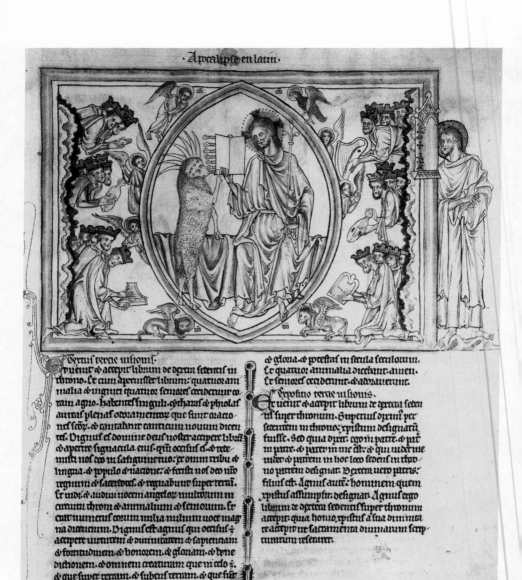

Tertius tercie visionis. [...] vruenit et accepit librum de dextra sedentis in throno. Et cum aperuisset librum: quatuor animalia et viginti quatuor seniores ceciderunt coram agno. habentes singuli cytharas et phiolas aureas plenas odoramentorum que sunt oraciones sanctorum. et cantabant canticum nouum dicentes. Dignus es domine deus noster accipere librum et aperire signacula eius: quia occisus es et redemisti nos deo in sanguine tuo: ex omni tribu et lingua et populo et naciones: et fecisti nos deo nostro regnum et sacerdotes. et regnabunt super terram. Et uidi: et audiui uocem angelorum multorum in circuitu throni et animalium et seniorum. Et erat numerus eorum milia milium uoce magna dicentium. Dignus est agnus qui occisus est accipere uirtutem et diuinitatem et sapienciam et fortitudinem et honorem. et gloriam et benedictionem. et omnem creaturam que in celo est. et que super terram. et subtus terram. et que sunt in mari. et que in ea sunt omnes audiui dicentes. sedenti in throno et agno. Benedictio et honor et gloria et potestas in secula seculorum. Et quatuor animalia dicebant. amen. Et seniores ceciderunt et adorauerunt.

Expositio tercie visionis. [...] Et uenit et accepit librum de dextra sedentis super thronum. Superius optinet per sedentem in throno: christum designatum fuisse. Sed quia dixit. ego in patre. et pater in me est: et qui uidet me uidet et patrem in hoc loco sedentem in throno patrem designat. Dextera uero patris: filius est. Agnus autem: hominem quem christus assumpsit: designat. Agnus ergo librum de dextera sedentis super thronum accepit quia homo christus a sua diuinitate accepit ut sacramenta diuinarum scripturarum reseraret.

43. Adoration of the Lamb. Metz, Bibliothèque municipale MS Salis 38, fol. 4ʳ. Photo: Service photographique de la Caisse nationale des Monuments historiques et des Sites.

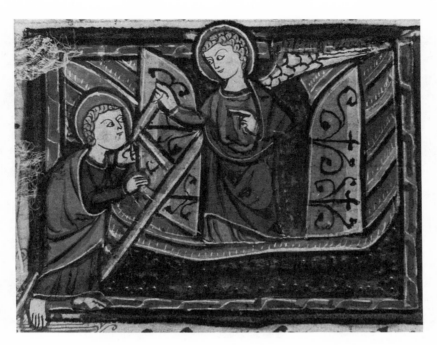

44. The open door. London, Lambeth Palace MS. 75, fol. 7ʳ. Photo: The Conway Library, Courtauld Institute of Art; by permission, Lambeth Palace Library.

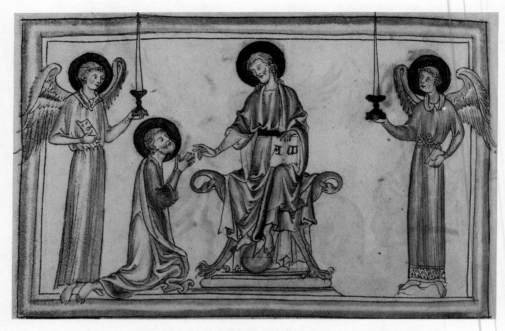

45. Saint John adores the Lord. London, British Library MS Add. 35166, fol. 30ᵛ.
Photo: By permission of the British Library.

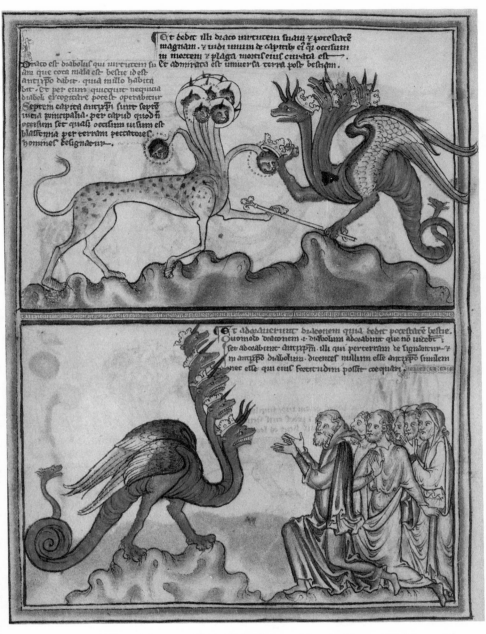

46. The Dragon and the Beast. New York, Pierpont Morgan Library MS. M.524, fol. 10ᵛ. Photo: The Pierpont Morgan Library.

47. Saint John on Patmos. London, Lambeth Palace MS. 75, fol. 3ʳ. Photo: The Conway Library, Courtauld Institute of Art; by permission, Lambeth Palace Library.

48. The angel casting the millstone. Paris, Bibliothèque nationale MS lat. 10474, fol. 38ᵛ. Photo: Bibliothèque nationale.

49. Saint John on Patmos. London, Lambeth Palace MS. 209, fol. 47ᵛ. Photo: The Conway Library, Courtauld Institute of Art; by permission, Lambeth Palace Library.

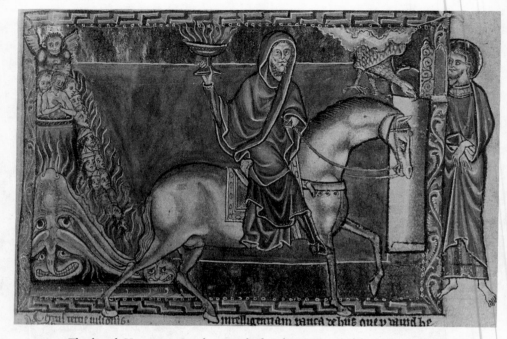

50. The fourth Horseman. London, Lambeth Palace MS. 209, fol. 6ʳ. Photo: The Conway Library, Courtauld Institute of Art; by permission, Lambeth Palace Library.

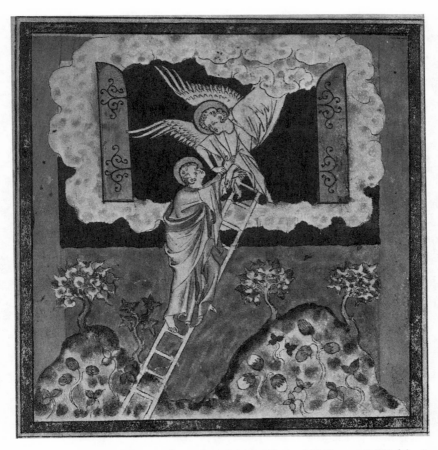

51. Saint John and the angel. London, British Library MS Roy. 19.B.XV, fol. 5ᵛ. Photo: By permission of the British Library.

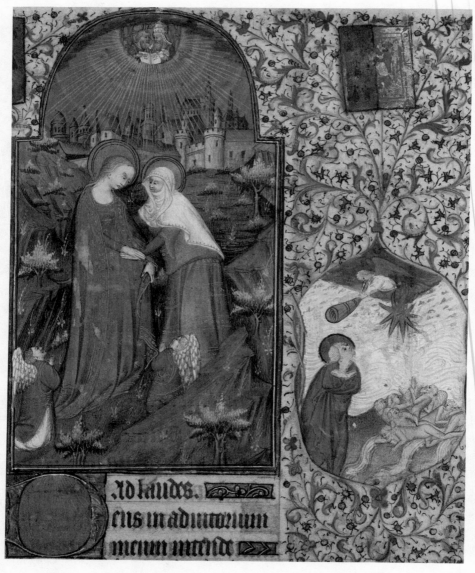

52. Opening of Lauds, with Apocalypse 7:10 in the right margin. Cambridge, Fitzwilliam Museum MS. 62, fol. 53ᵛ. Photo: By permission of the Syndics of the Fitzwilliam Museum.

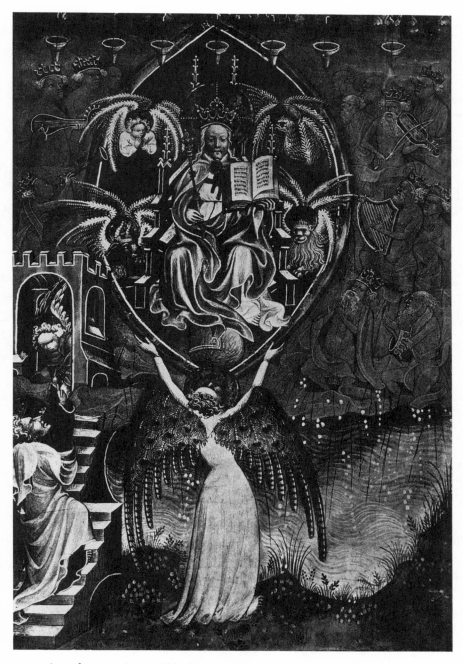

53. Apocalypse 4. Paris, Bibliothèque nationale MS néerl. 3, fol. 5ʳ. Photo: Bibliothèque nationale.

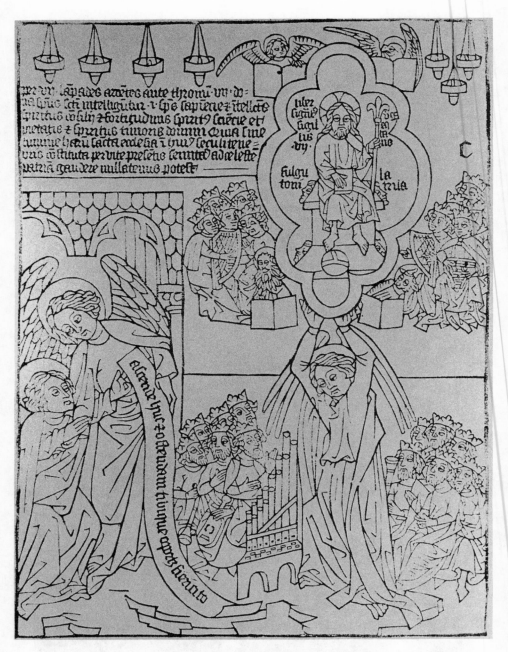

54. Apocalypse 4. First block-book Apocalypse, probably from the Haarlem shop of John or Lawrence Coster (ca. 1420). Photo: University of Chicago.

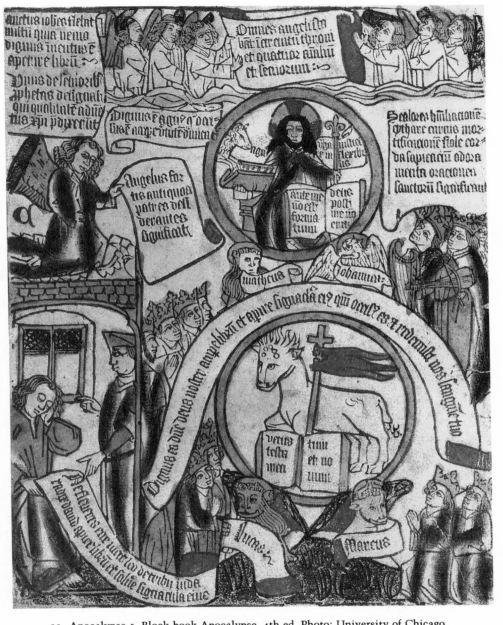

55. Apocalypse 5. Block-book Apocalypse, 4th ed. Photo: University of Chicago.

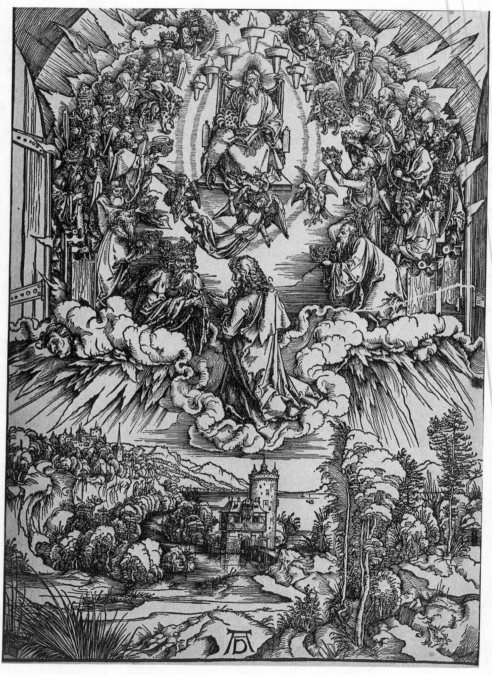

56. Apocalypse 4. Albrecht Dürer, *Apocalypsis cum figuris* (1498). Photo: University of Chicago.

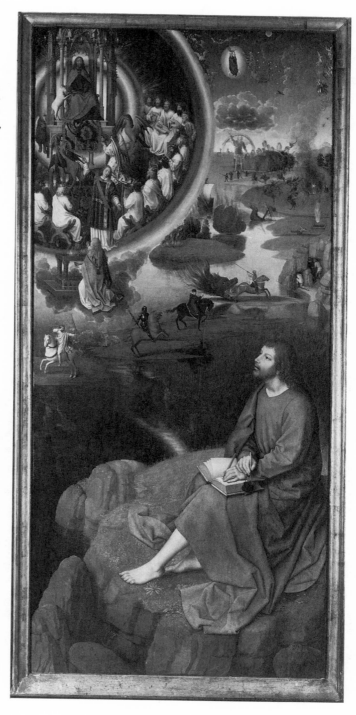

57. Vision of Saint John on Patmos. Bruges, Sint-Jans Hospital, Hans Memling's altarpiece, *The Mystic Marriage of Saint Catherine*, right panel. Photo: University of Chicago.

Introduction: The Apocalypse in Medieval Art

PETER K. KLEIN

THE APOCALYPSE IN EARLY CHRISTIAN MONUMENTAL ART

Apocalyptic motifs are rarely found in early Christian art from before Constantine, but in the fourth century they became prominent after the victory of Christianity and its establishment as state religion under Theodosius (391).[1] Significantly enough, select motifs depicting a theophany—images of God's triumph and the glories of heaven—merged with older Christian themes or resulted in entirely new types of imagery.[2]

This essay is the revised, enlarged, and annotated version of an article originally written for the *Enciclopedia dell'arte medievale* (Rome). I have chosen figures mostly of the less well known monuments and of those discussed in more detail. In the bibliographic references I try to give the most important and the most recent literature (since, at least for the manuscripts, I use the excellent "Census" by Richard K. Emmerson and Suzanne Lewis). I refer to F. van der Meer's Apocalypse coffee-table book, whose text is scientifically rather useless, because of its rich illustrations. I thank Florentine Mütherich, Gertrud Schiller, and Yolanta Zaluska for useful bibliographic references.

This paper was written in 1989; more recent literature is generally not included. However, I would like to call the reader's attention to Gertrud Schiller's recently published survey volumes of *Ikonographie der christlichen Kunst*, vol. V, 1 and 2: *Die Apokalypse des Johannes* (Gütersloh, 1990 and 1991).

This essay was translated from German by Roland Blaich and revised by the author.

[1] For the radical change of the early Christian political ideology in the fourth century, see François Paschoud, *Roma aeterna: Études sur le patriotisme romain dans l'Occident latin à l'époque des grandes invasions* (Rome, 1967), 169–322, and "La doctrine chrétienne et l'idéologie impériale romaine," in *L'Apocalypse de Jean: Traditions exégétiques et iconographiques*, ed. Yves Christe (Geneva, 1979), 31–72.

[2] Friedrich Gerke, "Das Verhältnis von Malerei und Plastik in der theodosianisch-honorianischen Zeit," *Rivista di Archeologia Cristiana* 12 (1935): 119–63 (cf. 135ff.); F. van der Meer, *Maiestas Domini: Théophanies de l'Apocalypse dans l'art chrétien* (Rome, 1938), 435–51; André Grabar, *Christian Iconography: A Study of Its Origins* (Princeton, 1968), 116.

The following may be cited as examples of this tendency: the Lamb on the mountain, the tree of life, and the Heavenly Jerusalem in depictions of the so-called *traditio legis*;[3] the scroll with the seven seals and the Lamb surrounded by the Four Living Creatures in images of the *hetoimasia*—the empty throne reserved for Christ and symbolizing his reign;[4] and the Lamb on the mountain, the Four Living Creatures, the Heavenly Jerusalem, and the Alpha and Omega in representations of Christ in the midst of the company of Apostles, as in the late fourth-century apse mosaic of S. Pudenziana in Rome (fig. 22).[5]

Somewhat later, in the fifth and sixth centuries, single Apocalypse motifs emerged in Rome. Most important of these is the worship of Christ or the Lamb by the twenty-four Elders (Apoc. 4–5) in the type of the *aurum coronarium* (ancient ceremonial homage to an emperor), which was rooted in the court ceremony of antiquity;[6] examples include the original fifth-

[3]See, e.g., *traditio legis* of the apse mosaics of old St. Peter's (reconstruction), the mosaics of S. Costanza, and a piece of gold glass in the Vatican, all from the fourth century. Cf. Tilmann Buddensieg, "Le coffret en ivoire de Pola, Saint-Pierre et le Latran," *Cahiers Archéologiques* 10 (1959): 157–95 (esp. fig. 13 [reconstruction of the apse mosaic of old St. Peter's]); Christa Ihm, *Die Programme der christlichen Apsismalerei vom vierten Jahrhundert bis zur Mitte des achten Jahrhunderts* (Wiesbaden, 1960), 127–29, pl. V.1 (S. Costanza); and Charles R. Morey, *The Gold-Glass Collection of the Vatican Library* (Vatican City, 1959), 19 no. 78 (gold glass in the Vatican). For the eschatological connotations of the early Christian *traditio legis*, see, among others, Walter Nikolaus Schumacher, "Dominus legem dat," *Römische Quartalschrift für Christliche Altertumskunde* 54 (1959): 1–39; Klaus Berger, "Der traditionsgeschichtliche Ursprung der 'Traditio legis,'" *Vigiliae Christianae* 27 (1973): 104–22; and Yves Christe, "Apocalypse et 'Traditio legis,'" *Römische Quartalschrift für Christliche Altertumskunde* 71 (1976): 42–55.

[4]See the inscriptions on the lost apse mosaic in Fundi, the mosaics of the chapel of S. Matrona in S. Prisco (near Capua Vetere) and of the triumphal arch of S. Maria Maggiore in Rome, and also the ivory chest from Pola (Venice, Museo archeologico): all from the fifth century. Cf. Carl-Otto Nordström, *Ravennastudien* (Uppsala, 1953), 46–54, pls. 11d, 12a–b (S. Maria Maggiore, Pola casket, S. Matrona); Buddensieg, "Coffret de Pola" (see n. 3), figs. 26, 48 (S. Maria Maggiore, Pola casket); Thomas von Bogyay, "Etimasie," in *Reallexikon zur Deutschen Kunstgeschichte*, vol. 6 (Stuttgart, 1969), 145–54 (bibliog.) and "Thron (Hetoimasia)," in *Lexikon der christlichen Ikonographie*, vol. 4 (Freiburg, 1972), 305–13; Violet Quarles van Ufford, "Bemerkungen über den eschatologischen Sinn der Hetoimasia in der frühchristlichen Kunst," *Bulletin Antieke Beschaving* 46 (1971): 193–207; and Josef Engemann, "Zu den Apsis-Tituli des Paulinus von Nola," *Jahrbuch für Antike und Christentum* 17 (1974): 21–46.

[5]See also the fresco in the catacombs of SS. Marcellino e Pietro, and the City Gate Sarcophagus in S. Ambrogio in Milan, both from the late fourth century. Cf. André Grabar, *Early Christian Art from the Rise of Christianity to the Death of Theodosius* (New York, 1968), figs. 234 (SS. Marcellino e Pietro), 290, 293 (City Gate sarcophagus in Milan); and Wolfgang Fritz Volbach, *Frühchristliche Kunst* (Munich, 1958), pl. 130 (S. Pudenziana, in color). See van der Meer, *Maiestas Domini* (see n. 2), 219ff.; Ihm, *Programme* (see n. 3), 12–15; Yves Christe, "Gegenwärtige und endzeitliche Eschatologie in der frühchristlichen Kunst: Die Apsis von Sancta Pudenziana in Rom," *Orbis Scientiarum* 2 (1972): 47–59; Ernst Dassmann, "Das Apsismosaik von S. Pudentiana in Rom," *Römische Quartalschrift für Christliche Altertumskunde* 65 (1970): 67–81; Josef Engemann, "Auf die Parusie hinweisende Darstellungen in der frühchristlichen Kunst," *Jahrbuch für Antike und Christentum* 19 (1976): 139–56, esp. 143–47.

[6]Cf. Theodor Klauser, "Aurum Coronarium," in *Reallexikon für Antike und Christentum*, vol. 1 (Stuttgart, 1950), 1010–20.

century mosaics on the facade of old St. Peter's (fig. 18), the triumphal arch
of S. Paolo fuori-le-mura in Rome (fig. 19), and the triumphal arch mosaic
of SS. Cosma e Damiano in Rome from 526 to 530 (fig. 1).[7] In this con-
text should also be mentioned the sixth-century mosaic on the triumphal
arch of S. Michele in Africisco in Ravenna, which depicts Christ en-
throned in the midst of the seven angels with trumpets (Apoc. 8:1–2).[8] Sig-
nificantly, the traditional imagery of the *hetoimasia* on the triumphal
arch of SS. Cosma e Damiano is so enriched with apocalyptic imagery (the
Lamb on the throne, the scroll with the seven seals, the seven candle-
sticks, the Four Living Creatures, the angels, the worship of the twenty-
four Elders) that it may be understood as an illustration of the Apocalypse
with elements of the *hetoimasia*. It is uncertain whether the poorly pre-
served representation of the seven candlesticks on the sixth-century fa-
cade of the basilica at Poreč (Parenzo)[9] was originally placed in a similar
context.

This "invasion" of early Christian art by apocalyptic motifs has usually
been understood, in eschatological terms, as representing a concern with
last-day events.[10] This view ignores, however, the primarily timeless and
triumphal character of these motifs, which, as Yves Christe has argued,
may be understood as renderings of the "present *parousia*."[11] The devel-
opment of these motifs significantly paralleled the allegorization and de-
historicization of the Apocalypse resulting from the exegesis of Tyconius

[7]Cf. van der Meer, *Maiestas Domini* (see n. 2), 89–96; Guglielmo Matthiae, *Mosaici
medioevali delle chiese di Roma* (Rome, 1967), 125–29, 203–13; Joseph Wilpert and
Walter N. Schumacher, *Die römische Mosaiken der kirchlichen Bauten vom IV.–XIII.
Jahrhundert* (Freiburg, 1976), 87–88, 328–30; and Yves Christe, "Apocalypse et inter-
prétation iconographique: Quelques remarques liminaires sur les images du règne de
Dieu et de l'église à l'époque paléochrétienne," *Byzantinische Zeitschrift* 67 (1974): 92–
100. See also the contribution of Dale Kinney in this volume.
[8]Cf. Yves Christe, "Nouvelle interprétation des mosaiques de Saint-Michel in Affri-
cisco à Ravenna," *Rivista di Archeologia Cristiana* 51 (1975): 107–24; and Arne Effen-
berger, "Bemerkungen zum antiarianischen Programm des Mosaiks von San Michele in
Affricisco," *Forschungen und Berichte: Staatliche Museen zu Berlin* 16 (1975): 245–54,
and *Das Mosaik aus der Kirche San Michele in Affricisco zu Ravenna* (Berlin, 1975), 41ff.
[9]Beat Brenk, *Spätantike und frühes Christentum* (Berlin, 1977), 306 and pl. 373 (with
bibliog.).
[10]See, e.g., Erich Dinkler, *Das Apsismosaik von S. Apollinare in Classe* (Cologne,
1964), 77–100; Beat Brenk, *Tradition und Neuerung in der christlichen Kunst des ersten
Jahrtausend: Studien zur Geschichte des Weltgerichtsbildes* (Vienna, 1966), 55–68;
Matthiae, *Mosaici medioevali* (see n. 7), 59–63; Dassmann, "Apsismosaik von S. Pu-
dentiana" (see n. 5); van Ufford, "Sinn der Hetoimasia" (see n. 4); Joachim Poeschke,
"Parusie," in *Lexikon der christlichen Ikonographie*, vol. 3 (Freiburg, 1971), 383–86;
P. Franke, "Marginalien zum Problem der Hetoimasia," *Byzantinische Zeitschrift* 65
(1972): 375–78; and Engemann, "Auf die Parusie hinweisende Darstellungen" (see n. 5).
[11]Cf. Yves Christe in "La colonne d'Arcadius, Sainte-Pudenzienne, l'arc d'Eginhard et
le portail de Ripoll," *Cahiers Archéologiques* 21 (1971): 31–42; "Gegenwärtige und
endzeitliche Eschatologie" (see n. 5); "Victoria-Imperium-Judicium: Un schème antique
du pouvoir dans l'art paléochrétien et médiéval," *Rivista di Archeologia Cristiana* 49
(1973): 87–109; "Apocalypse et interprétation iconographique" (see n. 7); "Saint-Michel
in Affricisco" (see n. 8); and finally, *La vision de Matthieu (Matth. XXIV–XXV): Ori-
gines et développement d'une image de la Seconde Parousie* (Paris, 1973).

and Augustine.[12] It also parallels the social and religious establishment of Christianity, a process that closely connected empire and Church, linked the concept of the divine right of kings with the belief that God has dominion over the whole world, and led to the conversion of classically educated elites.[13] As a result, God and especially Christ were no longer portrayed as the gentle Good Shepherd but rather, as the triumphant ruling emperor and *pantocrator.*

Single Representations of the Apocalypse

The monumental art of Rome and Latium from the ninth to the thirteenth centuries continued to use, almost unchanged, early Christian image types to portray the worship of the Lamb by the twenty-four Elders and the apocalyptic *traditio legis.* Examples in Rome include the Sala del Concilio in the Lateran, S. Prassede, S. Cecilia and S. Maria in Trastevere, S. Marco, S. Giovanni a Porta Latina, S. Sebastiano al Palatino, and S. Clemente;[14] and in Latium the apses and triumphal arches of the basilica at Sant'Elia near Nepi, S. Pietro in Tuscania, S. Silvestro in Tivoli, and SS. Abondio ed Abbondanzio in Rignano Flaminio.[15] The original Carolingian

[12]See Paula Fredriksen's essay in this volume. For the Apocalypse commentary of Tyconius (whose original text is lost) and its impact not only on Augustine but on all early medieval exegesis, see Traugott Hahn, *Tyconius-Studien: Ein Beitrag zur Kirchen- und Dogmengeschichte des 4. Jahrhunderts* (Dorpat, 1902); Wilhelm Kamlah, *Apokalypse und Geschichtstheologie: Die mittelalterliche Auslegung der Apokalypse vor Joachim von Fiore* (Berlin, 1935); Yves Christe, "Beatus et la tradition latine des commentaires sur l'Apocalypse," in *Actas del Simposio para el estudio de los códices del "Commentario al Apocalipsis" de Beato de Liébana* (hereafter *Actas del Simposio . . . Beato de Liébana*), vol. 1 (Madrid, 1978), 53–73; Sergio Alvarez Campos, "Fuentes literarias de Beato de Liébana," in ibid. 117–62; Georg Kretschmar, *Die Offenbarung des Johannes: Die Geschichte ihrer Auslegung im ersten Jahrtausend* (Stuttgart, 1985), 94–107; and Kenneth B. Steinhauser, *The Apocalypse Commentary of Tyconius: A History of Its Reception and Influence* (Frankfort on the Main, 1987).

[13]For the theological and ideological implications of this turning point of the early Christian Church, see Paschoud, *Roma aeterna* and "Doctrine chrétienne" (see n. 1); and Kurt Aland, "Das Verhältnis von Kirche und Staat in de Frühzeit," in *Aufstieg und Niedergang der römischen Welt* 2.23.1, ed. Wolfgang Haase (Berlin, 1979), 60–246 (cf. 106ff.).

[14]Edgar Waterman Anthony, *Romanesque Frescoes* (Princeton, 1951), 33, 41, 77, figs. 61, 83; Matthiae, *Mosaici medioevali* (see n. 7), 233–42, 279–314, pls. 144, 176, 177, 215, 228, 229, and *Pittura romana del medioevo,* vol. 2 (Rome, 1966), 94ff., 102ff., 131ff., 242ff., pls. 168, 170, 171; Hélène Toubert, "Le renouveau paléochrétien à Rome au début du XIIe siècle," *Cahiers Archéologiques* 20 (1970): 99–154; Yves Christe, "A propos du décor apsidial de Saint-Jean du Latran à Rome," ibid., 197–206; P. Jonas Nordhagen, "Un problema di carattere iconografico e tecnico a S. Prassede," in *Roma e l'età carolingia: Atti delle giornate di studio* (Rome, 1976), 159–66; Hans Belting, "I mosaici dell'aula leonina come testimonianza della prima 'renovatio' nell'arte medievale di Roma," in ibid., 167–82 (cf. esp. 172f. and fig. 182).

[15]Anthony, *Romanesque Frescoes* (see n. 14), 33, 69f., 71, 75, figs. 63, 65, 67, 68, 77, 78; Matthiae, *Pittura romana* (see n. 14), 30f., 36, 47, 97f., and figs. 16, 50, 51, 76, 77; Otto Demus, *Romanische Wandmalerei* (Munich, 1968), 118f., 122, 124f., and pls. (in two se-

mosaic of the adoration of the enthroned by the twenty-four Elders in the
cupola of the imperial chapel at Aachen (ca. 800)[16] was probably also pat-
terned after the Roman tradition of the *aurum coronarium* and the early
Christian triumphal arch mosaics. A reflection of this lost Aachen mosaic
may be found in the adoration of the Lamb of the late Carolingian Codex
Aureus of Saint Emmeram (ca. 870).[17] The early Christian and late antique
tradition is less evident in other single representations of apocalyptic
themes during the Carolingian period. Thus the illustration of Jerome's
Prologue *Plures fuisse* (fig. 4) in the Gospels of Saint Médard at Soissons
(Aachen, early 9th c.) combines a free variation of the early Christian–
Roman picture type of the adoration of the Lamb with a late antique
image of the sea (cf. the "sea of glass" in Apoc. 4:6) and also with illu-
sionistic architectural motifs (here symbolizing the Heavenly Jerusalem
of Apocalypse 21) drawn from the *scaenae frons*, the backdrop of the
ancient theater.[18]

It is more difficult to determine the origin of the medieval *majestas
domini* (i.e., the enthroned Christ in majesty), which was inspired
above all by the grand vision of God in Apocalypse 4–5, in contrast to the
Eastern type, which was inspired primarily by Ezekiel's vision.[19] The
Western "prototype"—only rudimentarily preserved in early medieval

quences, roman and arabic) XIII, XIX, 43, fig. 6; Peter Hoegger, *Die Fresken von S. Elia
bei Nepi* (Frauenfeld, 1975), 26–52, and figs. 1, 3, 9, 12.

[16]Hermann Schnitzler, "Das Kuppelmosaik der Aachener Pfalzkapelle," *Aachener
Kunstblätter* 29 (1964): 17–44; Hubert Schrade, "Zum Kuppelmosaik der Pfalzkapelle
und zum Theoderich-Denkmal in Aachen," ibid., 30 (1965): 25–37; F. van der Meer,
Apokalypse: Visionen des Johannes in de europäischen Kunst (Freiburg, 1978), figs.
33, 34.

[17]Munich, Bayerische Staatsbibliothek MS Clm 14000; see Otto Karl Werckmeister,
Der Deckel des Codex Aureus von St. Emmeram (Baden-Baden, 1963), 76–80; Joachim
E. Gaehde and Florentine Mütherich, *Karolingische Buchmalerei* (Munich, 1976), 16,
108, and pl. 38; van der Meer, *Apokalypse* (see n. 16), fig. 47; Wilhelm Koehler and Flo-
rentine Mütherich, *Die karolingischen Miniaturen*, vol. 5, *Die Hofschule Karls des
Kahlen* (Berlin, 1982), 175–77, 189f., and pl. 47; and Horst Fuhrmann and Florentine
Mütherich, *Das Evangeliar Heinrichs des Löwen und das mittelalterliche Herrscher-
bild* (exhibition catalog) (Munich, 1986), 37f. no. 2.

[18]Albert Boeckler, *Formengeschichtliche Studien zur Adagruppe* (Munich, 1956), 13–
16, pls. 6–9. See also Wilhelm Koehler, *Die karolingischen Miniaturen*, vol. 2, *Die Hof-
schule Karls des Grossen* (Berlin, 1958), 70ff.; Gaehde and Mütherich, *Karolingische
Buchmalerei* (see n. 17), 39f., pl. 4; and van der Meer, *Apokalypse* (see n. 16), fig. 45.

[19]For the history of the early *majestas domini*, see Walter W. S. Cook, "The Earliest
Painted Panels of Catalonia, II, 4: The Iconography of the Globe-Mandorla," *Art Bulletin*
6 (1923/24): 38–60; van der Meer, *Maiestas Domini* (see n. 2), passim; Ursula Nilgen,
"Der Codex Douce 292 der Bodleian Libraby zu Oxford" (Ph.D. diss., University Bonn.
1967), 51–60, 76–89, 105–15; M. Werner, "The Maiestas Domini and the Eastern Pen-
etration of Hiberno-Saxon Art," (Ph.D. diss., New York University, 1967); F. van der
Meer, "Maiestas Domini," in *Lexikon der christlichen Ikonographie*, vol. 3 (Freiburg,
1971), 136–42 (bibliog.); Gertrud Schiller, *Ikonographie der christlichen Kunst*, vol. 3,
Die Auferstehung und Erlösung Christi (Gütersloh, 1971), 233–45; and Herbert L.
Kessler, *The Illustrated Bibles from Tours* (Princeton, 1977), 36–42.

manuscripts—shows Christ with the book of seven seals seated on the globe or the throne, surrounded by the Four Living Creatures, who are depicted in their entirety and arranged in a centripetal square. Compare the *majestas* images in the Insular Codex Amiatinus (ca. 700) and in the early Carolingian Trier Apocalypse (early 9th c.), which are both based on Italian models of the sixth century.[20] This type was united with elements of the Eastern *majestas* type (mandorla, rainbow throne, arched stool, centrifugal orientation of the Four Living Creatures) at the Carolingian scriptorium of Tours in the second quarter of the ninth century, establishing the standard type for numerous renderings from the ninth to the thirteenth century in both the minor arts (book illumination, book covers, shrines, altar frontals, crosses, baptismal fonts, and so on)[21] and the monumental arts, especially apse paintings in Spain, France, and Germany.[22] In the eleventh century this type was enriched with the motif of the adoration of the twenty-four Elders who, in contrast to late antique tradition, are now enthroned, hold cups and musical instruments, and surround Christ in a half circle or a square. The earliest extant examples are a miniature in the Saint-Sever Beatus (mid-11th c.), a missal fragment in the treasury of Auxerre cathedral (late 11th c.), and the portal tympanum of Saint-Pierre, Moissac (fig. 23), from about 1120–30.[23] This type is repeated not only in numerous Romanesque portals but since the west portal of Chartres (1145–55), also in Gothic monumental art.[24]

Other individual apocalyptic themes that appear often in medieval art are the Last Judgment (Apoc. 20:11–15; Matt. 24–25) and the arch-

[20]Florence, Biblioteca Laurenziana, Cod. am. 1; Trier, Stadtbibliotek, Cod. 31. See Kurt Weitzmann, *Late Antique and Early Christian Book Illumination* (New York, 1977), 24 and fig. XVII; J. J. G. Alexander, *Insular Manuscripts sixth to ninth Century* (London, 1978), 32–35 no. 7 with (bibliog.) and pl. 26; James Snyder, "The Reconstruction of an Early Christian Cycle of Illustrations for the Book of Revelation: The Trier Apocalypse," *Vigiliae Christianae* 18 (1964): 146–62; *Trierer Apokalypse: Faksimileausgabe* (Graz, 1974), fols. 14v, 15v, 16v, etc.; and Peter K. Klein, "Der Kodex und sein Bildschmuck," in *Trierer Apokalypse: Kommentarband*, ed. R. Laufner and Peter K. Klein (Graz, 1975), 89–112.

[21]Cf. Cook, "Painted Panels" (see n. 19), 47ff.; Anton Baumstark, "Die karolingisch-romanische Majestas Domini und ihre orientalischen Parallelen," *Oriens Christianus*, ser. 3.1, 23 (1927): 242–60; and Kessler, *Bibles from Tours* (see n. 19), 38–42.

[22]See Yves Christe's essay in this volume. For the Romanesque type of the *Majestas domini*, see Robert Berger, *Die Darstellung des thronenden Christus in der romanischen Kunst* (Reutlingen, 1926); Hubert Schrade, *Die romanische Malerei: Ihre Majestas* (Cologne, 1963); and Franz Rademacher, *Der thronende Christus der Chorschranken aus Gusdorf: Eine ikonographische Untersuchung* (Cologne, 1964).

[23]Paris, Bibliothèque nationale MS. lat. 8878 (Saint-Sever Beatus). See Meyer Schapiro, "Two Romanesque Drawings in Auxerre and Some Iconographic Problems," in *Studies in Art and Literature for Belle Da Costa Greene*, ed. Dorothy Miner (Princeton, 1954), 331–49; Louis Grodecki, "Le problème des sources iconographiques du tympan de Moissac," in *Moissac et l'Occident au XIe siècle: Actes du Colloque International de Moissac* (Toulouse, 1964), 59–69; and Peter K. Klein, "Les sources non hispaniques et la genèse iconographique du Beatus de Saint-Sever," in *Saint-Sever; Millénaire de l'abbaye: Colloque International 1985* (Mont-de-Marsan, 1986), 317–33.

[24]Cf. Willibald Sauerländer, *Gotische Skulptur in Frankreich, 1140–1270* (Munich, 1970), 26 and pls. 1, 5, 16, 18, 24, 32, 37.

angel Michael fighting the Dragon (Apoc. 12:7–9). The Last Judgment has adorned the western walls and portals of churches since the ninth century,[25] the oldest extant example being the fresco of Saint Johann at Mustair (ca. 800).[26] In contrast to the Byzantine Last Judgment (for example the tenth-century ivory in the Victoria and Albert Museum and the eleventh-century Gospels at Paris, in the Bibliothèque nationale),[27] the Western Last Judgment is more closely tied to the Apocalypse, portraying, for example, the two angels with the books (Apoc. 20:12) situated on both sides of the Divine Judge. Saint Michael as dragon slayer is also frequently rendered throughout the Middle Ages in both minor and monumental art. Generally he stands triumphantly over the Dragon, whom he is about to kill with the lance.[28] Examples include the ivory from Charlemagne's palace school (ca. 810) which is now in Leipzig's Kunstgewerbemuseum[29] and the sculpture on the west facade of Saint-Gilles-du-Gard (2d quarter 12th c.).[30]

The Heavenly Jerusalem, the Bride of the Lamb, and the heavenly city of paradise (Apoc. 21–22) are also frequently depicted as a single motif, although these renderings may also include references not dependent on

[25]For the early medieval representations of the Last Judgment, see Brenk, *Tradition und Neuerung* (see n. 10), passim; Willibald Sauerländer, "Über die Komposition des Weltgerichtstympanons in Autun," *Zeitschrift für Kunstgeschichte* 29 (1966): 261–94; Beat Brenk, "Weltgericht," in *Lexikon der christlichen Ikonographie*, vol. 4. (Freiburg, 1972), 514–24 (cf. 516–20); and Peter K. Klein, "Zum Weltgerichtsbild der Reichenau," in *Studien zur mittelalterlichen Kunst, 800–1250: Festschrift für Florentine Mütherich*, ed. Katharina Bierbrauer, Peter K. Klein, and Willibald Sauerländer (Munich, 1985), 107–24.

[26]Linus Birchler, "Zur karolingischen Architektur und Malerei in Münster-Müstair," in *Frühmittelalterliche Kunst: Akten zum III. Internationalen Kongress für Frühmittelalterforschung* (Olten, 1954), 167–252; Brenk, *Tradition und Neuerung* (see n. 10), 107–18 and figs. 7–12, pls. 30–34.

[27]Paris, B. N., Ms. Gr. 74. For the history and standard type of the Byzantine Last Judgment, see Selma Jonsdottir, *An Eleventh Century Byzantine Last Judgment in Iceland* (Reykjavík, 1959), 15–26; Beat Brenk, "Die Anfänge der byzantinischen Weltgerichtsdarstellung," *Byzantinische Zeitschrift* 57 (1964): 106–26, and *Tradition und Neuerung* (see n. 10), 77–103; and Yves Christe, "Aux origines du Jugement dernier byzantin," in *Le Jugement, le ciel et l'enfer dans l'histoire du christianisme: Actes due XIIe rencontre d'Histoire religieuse tenue à Fontevraud*, ed. Société Française d'Histoire des Idées et d'Histoire Religieuse (Angers, 1989), 33–43.

[28]Cf. Max de Fraipont, "Les origines occidentales du type de Saint Michel debout sur le dragon," *Rèvue Belge d'Archéologie et d'Histoire de l'Art* 7 (1937): 289–301; Herbert Schade, *Dämonen und Monstren* (Regensburg, 1962), 29–32; François Avril, "Interprétations symboliques du combat de Saint Michel et du Dragon," in *Millénaire monastique du Mont Saint-Michel*, ed. Marcel Baudot, vol. 3 (Paris, 1971), 39–52; and Colette Lamy-Lasalle, "Les représentations du combat de l'archange en France au début du Moyen Age," in ibid., 53–64.

[29]Adolph Goldschmidt, *Die Elfenbeinskulpturen aus der Zeit der karolingischen und sächsischen Kaiser*, vol. 1 (Berlin, 1914), 12 no. 11, pl. 6; *Karl der Grosse: Werk und Wirkung* (exhibition catalog) (Aachen, 1965), 336f. no. 520; Wolfgang Fritz Volbach, *Elfenbeinarbeiten der Spätantike und des frühen Mittelalters*, 3d ed. (Mainz, 1976), 132 no. 222, pl. 103; Danielle Gaborit-Chopin, *Ivoires du Moyen Age* (Fribourg, 1978), 186 no. 54, and fig. 54.

[30]See, e.g., Whitney S. Stoddard, *The Façade of Saint-Gilles-du-Garde* (Middletown, Conn. 1973), 69 and fig. 89; and Bernhard Rupprecht, *Romanische Skulptur in Frankreich*, 2d ed. (Munich, 1984), 62, 130, and pls. 236, 237.

the Apocalypse.[31] Thus the Heavenly Jerusalem may be joined with the choirs of saints in paradise, which, together with the hosts of angels, either surround Christ or are guided by Saint Peter and the angels to the gate of the heavenly city. An example is the triumphal arch of S. Prassede at Rome (817–24), where Peter, Paul, and two pairs of angels receive the redeemed at the gate of the Heavenly Jerusalem, while inside the walls Christ is surrounded by angels, apostles, prophets, Saint Mary, and possibly *mater ecclesia*.[32] Despite their variants in detail, the wall paintings of the abbey church of Saint-Chef (Chapelle conventuelle; 3d quarter 11th c.),[33] the church of St. John the Baptist at Clayton (2d quarter 12th c.),[34] the Romanesque capitals of the tower porch at Saint-Benoît-sur-Loire (2d third 11th c.),[35] and the cloister of Moissac (1100)[36] suggest a similar theme. The latter two, however, lack the motif whereby the redeemed are escorted to the heavenly gate. In the late Romanesque vault paintings at the crossing in Braunschweig cathedral (2d quarter 13th c.)[37] and the west-

[31]For the Heavenly Jerusalem, its conception, and its numerous representations, see Norbert Schneider, *Civitas: Studien zur Stadttopik und zu den Prinzipien der Architektur im frühen Mittelalter* (Münster, 1973), 35–67; Marie-Thérèse Gousset, "La représentation de la Jérusalem céleste à l'époque carolingienne," *Cahiers Archéologiques* 23 (1974): 47–60; Yves Christe, "Et super muros eius angelorum custodia," *Cahiers de Civilisation Médiévale* 24 (1981): 173–79; Agostino Colli, "L'affresco della Gerusalemme celeste di S. Pietro al Monte di Civate: Proposta di lettura iconografica," *Arte Lombarda* 58–59 (1981): 7–20, and "La Gerusalemme celeste nei cicli apocalittici altomedievali e l'affresco di san Pietro al monte di Civate," ibid., 60 (1982): 107–24; M. L. Gatti Perer, ed. *La Gerusaleme celeste: Catalogo della mostra* (Milan, 1983); and Yves Christe, "La cité de la Sagesse," *Cahiers de Civilisation Médiévale* 31 (1988): 29–35.

[32]Cf. Matthiae, *Mosaici medioevali* (see n. 7), 237–39 and figs. 185–87; Walter Oakeshott, *The Mosaics of Rome from the Third to the Fourteenth Centuries* (London, 1967), 206f. and fig. 121; Gousset, "Jérusalem céleste" (see n. 31), 47f. and fig. 19; Richard Krautheimer and Spencer Corbett, "S. Prassede," in *Corpus Basilicarum Christianarum Romae*, ed. Richard Krautheimer, Spencer Corbett, and Wolfgang Frankl, vol. 3 (Rome, 1971), 235–58 (for the church and its decoration); van der Meer, *Apokalypse*, 56f. and fig. 31; Gatti Perer, *Gerusalemme celeste* see (n. 31), 188–90 no. 77.

[33]André Grabar in André Grabar and Carl Nordenfalk, *La peinture romane* (Geneva, 1958), 110f.; Nurith Cahansky, *Die romanischen Wandmalereien der ehemaligen Abteikirche Saint-Chef (Dauphiné)* (Bern, 1966), 33–71 and figs. 11–16; Demus, *Romanische Wandmalerei* (see n. 15), 136 (bibliog.), and pls. XXXIX, 81–83; Gatti Perer, *Gerusalemme celeste* (see n. 31), 243f. no. 166.

[34]Ernst W. Tristram, *English Medieval Wall Paintings*, vol. 1, *The Twelfth Century* (Oxford, 1944), 28f., 113–15, and pls. 36–43 (cf. 114, pl. 17). See also Demus, *Romanische Wandmalerei* (see n. 15), 170f. and fig. 38; Gatti Perer, *Gerusalemme celeste* (see n. 31), 221 no. 132.

[35]Bertrand, *Saint-Benoît-sur-Loire: Les chapiteaux de la tour-porche* (Saint-Benoît-sur-Loire, 1980), 35 and 34 (fig.); Eliane Vergnolle, *Saint-Benoît-sur-Loire et la sculpture du XIe siècle* (Paris, 1985), 97 and fig. 88.

[36]Ernest Rupin, *L'abbaye et les cloîtres de Moissac* (Paris, 1897), 225f. no. 10, and 225 (fig.); Raymond Rey, *La sculpture romane languedocienne* (Toulouse, 1936), fig. 108, and *L'art des cloîtres romans* (Toulouse, 1955), fig. 36.

[37]Demus, *Romanische Wandmalerei* (see n. 15), 193–95 (bibliog.) and pl. 220; Johann-Christian Klamt, "Die mittelalterlichen Monumentalmalereien im Dom zu Braunschweig" (Ph.D. diss., Free University at Berlin, 1968), 128–31.

ern gallery of Gurk cathedral (ca. 1260–70),[38] the radial type of the New Jerusalem as portrayed in the *Liber floridus*[39] is connected with a christological cycle (Braunschweig) or with representations of prophets of the Old Testament (Gurk). Two other Romanesque vault paintings—in the porch of Saint-Savin-sur-Gartempe (ca. 1100)[40] and in the upper church of Schwarzrheindorf (3d quarter 12th c.)[41]—also feature the choirs of the redeemed, yet without the heavenly city, since the New Jerusalem seems to be represented as the Bride of Christ (in both cases with mariological or ecclesiological connotations). Yet another iconographic connection is exhibited by the host of the redeemed in the complex wall paintings of the Allerheiligenkapelle at the cloister of Regensburg cathedral (ca. 1165). Based on the All Saints liturgy and the commentaries of Honorius Augustodunensis and Rupert of Deutz, the scenes and motifs of Apocalypse 7 (the retaining of the four winds, the angel of the East, the sealing of the tribes of Israel, the host of the elect before the throne of God) are merged with the type of the *pantocrator* of the Byzantine vault mosaics (cf. the Palatine Chapel in Palermo) to form a unique iconographic program.[42]

[38]Schrade, *Romanische Malerei* (see n. 22), 196–99, and p. 275 figs. 2, 3; Demus, *Romanische Wandmalerei* (see n. 15), 212–14 (bibliog), pl. CI; Gatti Perer, *Gerusalemme celeste* (see n. 31), 221f. no. 133.

[39]Cf. Paris, Bibliothèque nationale MS lat. 8865. See Hanns Swarzenski, "Comments on the Figural Illustrations of the Liber floridus," in *Liber floridus Colloquium: Papers Read at the International Meeting Held at the University Library Ghent* (1957), ed. Albert Dérolez (Gent, 1973), 21–30 (cf. 28 and fig. 21); Klein, "Kodex" (see n. 20), 106 and fig 63, and "Les cycles de l'Apocalypse du haut Moyen Age, IXe–XIIIe s.," in *Apocalypse de Jean* (see n. 1), 135–86 (cf. 150 and fig. 31); Colli, "Gerusalemme celeste" (see n. 31), 110, 114, and fig. 8; and Perer, *Gerusalemme celeste nei cicli* (see n. 31), 159f. no. 20. For the Paris copy, see n. 113 below.

[40]Elisa Maillard, *L'église de Saint-Savin-sur-Gartempe* (Paris, 1926), 37–39 and fig. 4; Itsuji Yoshikawa, *L'Apocalypse de Saint-Savin* (Paris, 1939), 20–23 and pl. IV; Schrade, *Romanische Malerei* (see n. 22), 48f., 48 (unnumbered fig.); Demus, *Romanische Wandmalerei* (see n. 15), 143; Raymond Oursel, *La Bible de Saint-Savin* (La Pierre-Qui-Vire, 1971), pls. 6, 7. In contrast, Brigitte Kurmann-Schwartz, in "Les peintures du porche de l'église abbatiale de Saint-Savin: Etude iconographique," *Bulletin Monumental* 140 (1982): 273–304 (cf. 278ff.), wants to see here the Virgin, surrounded by the elect, an interpretation that has been rejected with good reasons by Yves Christe in "A propos des peintures murales du porche de Saint-Savin," *Cahiers de Saint-Michel de Cuxa* 16 (1985): 219–43 (cf. 225ff.).

[41]Albert Verbeek, *Schwarzrheindorf: Die Doppelkirche und ihre Wandgemälde* (Düsseldorf, 1953), lv-lvii and figs. 54, 55; Schrade, *Romanische Malerei* (see n. 22), 69f. and figs. pp. 69, 124; Demus, *Romanische Wandmalerei* (see n. 15), 182 and fig. 46.

[42]Cf. Josef Anton Endres, *Beiträge zur Kunst- und Kulturgeschichte des mittelalterlichen Regenburgs* (Regensburg, 1924), 80–86 ("Die Wandgemälde der Allerheiligenkapelle zu Regensburg," 1912); Otto Demus, "Regensburg, Sizilien und Venedig," *Jahrbuch der Österreichischen Byzantinischen Gesellschaft* 2 (1952): 95–104, and *Romanische Wandmalerei* (see n. 22), 94, 188f., and pl. 206, fig. 51; and Jörg Traeger, *Mittelalterliche Architekturfiktion: Die Allerheiligenkapelle am Regensburger Domkreuzgang* (Munich, 1980), 35ff. and pls. 34–77.

Influence of Exegesis

Other Romanesque wall paintings, evidently influenced by the exegetic tradition, combine individual scenes of the Apocalypse as well. Thus in a mid-twelfth-century painting in the crypt of Auxerre cathedral (fig. 5), the Christ-Horseman—the Rider "Faithful and True" on the white horse (Apoc. 19:11–16)—appears in the manner of an imperial *adventus* in front of a huge *crux gemmata*,[43] accompanied by the heavenly army of the angel-horsemen, significantly all portrayed on the barrel vault just above the later, high-medieval apse painting, showing Christ between two seven-armed candlesticks (Apoc. 1:12–13).[44] Furthermore, on the apse wall painting of the church of Saint-Pierre-les-Eglises (fig. 6), probably dating from the tenth century,[45] Michael's battle with the seven-headed Dragon (Apoc. 12:7–9) is placed next to the adoration of the Magi. The Dragon spews "water" with one mouth, aiming at the enthroned Mary in the adoration scene. Hence this painting reflects the medieval interpretation of Apocalypse 12 (as in, e.g., Ambrose Autpert, Haimo and Remigius of Auxerre, and Berengaudus) that identifies the Mother of God as the apocalyptic *mulier amicta sole* (Woman clothed with the sun) and Herod

[43]For the motif of the imperial *adventus* as prototype for the victorious coming of Christ, cf. André Grabar, *L'empereur dans l'art byzantin* (Paris, 1936), 234–36.

[44]For the Auxerre crypt frescoes, see Paul Deschamps and Marc Thibout, *La peinture murale en France: Le haut Moyen Age et l'époque romane* (Paris, 1951), 88f., pl. XXXIII; Schrade, *Romanische Malerei* (see n. 22), 54f. and p. 260, figs. 4–6; Demus, *Romanische Wandmalerei* (see n. 15), 145f. and pls. LV, 124, 125; and Don Denny, "A Romanesque Fresco in Auxerre Cathedral," *Gesta* 25 (1986): 197–202. The literature on these frescoes has, however, overlooked the fact that early Medieval exegesis interpreted the heavenly Rider of Apocalypse 19 as an image of the resurrected Christ (cf. the *crux gemmata* behind the Auxerre Rider), comparing the Rider "Faithful and True" to the Christ theophanies of Apoc. 1:12–20 (vision of the seven candlesticks) and Apoc. 4 (majesty of Christ) and also to the first Rider of Apoc. 6:2. See, e.g., The Apocalypse commentaries by Ambrose Autpert, ed. Robert Weber (*CCCM* 27: 719ff.) and by Rupert of Deutz (*PL* 169: 1163). Cf. Yves Christe, "Traditions littéraires et iconographiques dans l'interprétation des images apocalyptiques," in *Apocalypse de Jean* (see n. 1), 109–34 (esp. 111, 127); and Peter K. Klein, "Rupert de Deutz et son commentaire illustré de l'Apocalypse à Heiligenkreuz," *Journal des Savants* (1980): 119–40 (esp. 137). Denny correctly points out the iconographic connections of the Auxerre fresco with the Family I of the early Apocalypse cycles (cf., e.g., representation of the "armies in heaven" of Apoc. 19:14 as angels on horseback and not as saints). In a rather speculative way, however, he tries to relate the Auxerre fresco to the idea of the Crusades, not discussing at all the exegetic interpretation of the heavenly Christ-Rider of Apocalypse 19! Moreover, Denny completely overlooks the fact that in the Auxerre crypt there are still recognizable fragments of other contemporary Apocalypse frescoes, notably those of the Woman and the Dragon of Apocalypse 12 (see Yves Christe's essay in this volume).

[45]For the controversial date of the frescoes of Saint-Pierre-les Eglises, see the recent short discussions by Xavier Barral i Altet, "930–1030: L'aube des temps nouveaux? Histoire et archéologie monumentale" and "Le décor monumental," in *Le paysage monumental de la France autour de l'an mil*, ed. Xavier Barral i Altet (Paris, 1987), 9–47 (cf. 42) and 115–31 (cf. 127); Matthias Exner, *Die Fresken der Krypta von St. Maximin in Trier und ihre Stellung in der spätkarolingischen Wandmalerei* (Trier, 1989), 201–4.

as the seven-headed Dragon of Apocalypse 12.[46] The individual apocalyptic scenes on several Romanesque capitals must also be understood against an exegetic or, more precisely, eschatological background. On choir capitals of the church of Saint-Nectaire (mid 12th c.) and at Saint-Pierre in Chauvigny (2d half 12th c.), for example, the motif of the Last Judgment by the archangel Michael, who judges men's souls, is combined in every case with scenes from the Apocalypse. At Chauvigny it is with the Whore of Babylon and the deserted Babylon (Apoc. 18:2–7),[47] whereas at Saint-Nectaire (fig. 7) it is with the first Horseman (on a white horse, with bow and arrow; Apoc. 6:1–2), who also reflects elements of the "Faithful and True" Christ-Horseman (his blood-stained gown, Apoc. 19:13) and of his angel-horsemen (cf. the wings of the Saint-Nectaire Rider).[48]

Gothic stained glass depicting Apocalypse scenes also uses a synthetic rather than a narrative approach. The most frequent theme is John's vision of the seven candlesticks (Apoc. 1:12–20), which, as we shall see below, is also popular in manuscript illumination. Examples are found in the ambulatory of Bourges cathedral (1210–15) (fig. 8),[49] the apse window of Lyon cathedral (early 13th c.),[50] the south rose window of Chartres cathedral (mid 13th c.),[51] and the west rose window of Sainte-Chapelle in Paris (renovated in the late 15th c.).[52] The Gothic stained glass parallels some of the iconography of the Romanesque Apocalypse cycles, Family III (discussed below), as evident in the vision of the seven candlesticks in the windows of Bourges and Lyon (compare the frontal view of the Son of Man, with the two swords in his mouth, as well as the place of the candlesticks and of Saint John within the composition). Similar parallels are apparent in several scenes depicted in the Apocalypse window of the

[46]Cf. the Apocalypse commentaries by Ambrose Autpert (*CCCM* 27: 448f.), Haimo of Auxerre (*PL* 117:1085), and Berengaudus (*PL* 17: 876f.).

[47]Yvonne Labande Mailfert, in *Poitou roman* (La Pierre-Qui-Vire, 1957), 120 and pls. 33–35; Raymond Oursel, *Chauvigny et ses monuments* (Poitiers, 1959), 22ff., and *Haut-Poitou roman* (La Pierre-Qui-Vire, 1975), 209–11 and pls. 74–77.

[48]This has been overlooked by the previous literature; see Bernard Craplet, *Auvergne romane*, 2d ed. (La Pierre-Qui-Vire, 1958), 159; and Zygmunt Swiechowski, *Sculpture romane d'Auvergne* (Clermont-Ferrand, 1973), 105 and fig. 81.

[49]Emile Mâle, *L'art religieux du XIIIe siècle en France*, 2d ed. (Paris, 1902), 368f. and fig. 169; van der Meer, *Apokalypse* (see n. 16), 144–46 and figs. 91, 92; Catherine Brisac, "La verrière de l'Apocalypse à la cathédrale de Bourges, 1210–1215," in *Texte et image: Actes du Colloque International de Chantilly, 1982* (Paris, 1984), 109–15 and pls. XXIV–XXVI; Louis Grodecki and Catherine Brisac, *Le vitrail gothique au XIIIe siècle* (Paris, 1984), 78 and fig. 67.

[50]Mâle, *Art religieux du XIIIe siècle* (see n. 49), fig. 166; van der Meer, *Apokalypse* (see n. 16) 142, fig. 93.

[51]Yves Delaporte and Etienne Houvet, *Les vitraux de la cathédrale de Chartres*, vol. 3 (Chartres, 1926), pls. VIII (color), CIC; van der Meer, *Apokalypse* (see n. 16), 133, 146, and fig. 89; Grodecki and Brisac, *Vitrail gothique* (see n. 49), 22 and fig. 11.

[52]Marcel Aubert et al., *Les vitraux de Notre Dame et de la Sainte-Chapelle de Paris* (Paris, 1959), 315 and pl. 89; van der Meer, *Apokalypse* (see n. 16), fig. 101.

ambulatory of Auxerre cathedral (1222–35),[53] especially the representa-
tion of the *mulier amicta sole*, of the Son of Man with the sickle, and of
the seven angels with trumpets at either side of the Lord. The French
Apocalypse windows and their scenes from the legend of Saint John (e.g.,
at Chartres, Lyon, and Auxerre)[54] were probably modeled on similar Ro-
manesque cycles, as were the slightly younger illustrated Gothic Apoca-
lypse manuscripts in England.[55] On the contrary, the largest Apocalypse
stained-glass cycle extant—the eighty-one scenes of the late Gothic east
window of York cathedral (1405–6)—already follows very closely the tra-
dition of the Gothic English Apocalypse manuscripts.[56]

The typological-allegorical character of Gothic Apocalypse windows is
most apparent in the south ambulatory window of Bourges cathedral (fig.
8). There, three central epiphanies of Christ (the vision of the candlesticks,
the Enthroned among the Elders, and the Son of Man with the sickle upon
the cloud) are linked to Saint Peter baptizing neophytes, to the twelve
Apostles and twelve Old Testament prophets, and to the Bride of the vic-
torious Lamb, who, as *ecclesia lactans*, breastfeeds two representatives of
the Old and the New Covenant. Themes of Pentecost and Ascension may
be detected as well in the image of the enthroned Christ and the Son of
Man upon the cloud. The sources for the Bourges program have been
sought in the Apocalypse commentary of Anselm of Laon (d. 1117),[57] and
Bishop William of Bourges (1199–1209) has even been presumed to be its
creator.[58] The choir window of Auxerre cathedral (see above) also includes
typological pairs portraying the enthroned Woman clothed with the sun
above the enthroned Son of Man with the sickle, as well as Christ en-
throned on the Lamb with the sealed book above the first Horseman with
the bow. Its exegetic sources remain unclear, though.

Other media contain references to the Apocalypse as well. There is some
question whether or not certain types of churches, such as the early Chris-
tian basilica or the Gothic cathedral, or individual buildings (such as the
Roman core of Trier basilica, the Westwerk of Corvey, and the tower porch

[53]Virginia Chieffo Raquin, *Stained Glass in Thirteenth Century Burgundy* (Princeton,
1982), 105f., 134f., and figs. 67–71, 76–77, 82, 101, pl. II; Grodecki and Brisac, *Vitrail
gothique* (see n. 49), 242 no. 15 and fig. 110.

[54]Cf. Raguin, *Stained Glass* (see n. 53), 134f.

[55]Brisac, in "Verrière de l'Apocalypse" (see n. 49), 109 n. 3, compares the Auxerre
Apocalypse window with the English Gothic Apocalypse cycles. Both groups, however—
the French windows and the English illustrations—should derive from a similar proto-
type of the Romanesque Family III, since the archetype of the English cycles must have
been approximately contemporary to the Auxerre Apocalypse window. Thus an influ-
ence of one Gothic group on the other seems rather improbable.

[56]Montague Rhodes James, *The Apocalypse in Art* (London, 1931), 17 no. 77; Frederick
Harrison, *Painted Glass of York* (London, 1927), 125f.; David O'Connor and Jeremy Ha-
selock, "The Stained and Painted Glass," in *A History of York Minster*, ed. G. E. Aylmer
and Reginald Cant (Oxford, 1977), 313–93 (cf. 365–67, figs. 117, 118).

[57]Mâle, *Art religieux du XIIIe siècle* (see n. 49), 368f.

[58]Brisac, "Verrière de l'Apocalypse" (see n. 49), 114f.

of Saint-Benoît-sur-Loire) may be understood as architectural symbols of the Heavenly Jerusalem.[59] Yet this is certainly true of a series of Ottonian and Romanesque chandeliers and censers, like the Hezilo chandelier (ca. 1054–79) at Hildesheim and the Barbarossa chandelier (1165–70) at the Palatine Chapel of Aachen.[60] Their inscriptions and formal structure clearly relate them to the Heavenly Jerusalem of the Apocalypse. Motifs from the Apocalypse were used also in other arts and crafts. The embroidered Hungarian coronation mantle donated by Saint Stephan (Budapest, National Museum) features Apocalypse motifs, as does the mantle donated by Otto III to the Roman monastery of S. Alessio, which depicted the entire Apocalypse ("a mantle in which the whole Apocalypse was marked out in gold").[61]

THE APOCALYPSE IN BOOK ILLUMINATION

Single Apocalypse Scenes

As might be expected, most individual Apocalypse scenes are found in illuminated books (Bibles, New Testament and Apocalypse manuscripts, Apocalypse commentaries, and occasionally other texts). Early examples are the two Apocalypse initials in the Carolingian Juvenianus Codex (1st quarter 9th c.).[62] One depicts God's commission to Saint John (Apoc. 1:1); the other shows John's vision on Patmos (Apoc. 1:10): he is represented sleeping or lying on his bed while in the spirit and awakened by an

[59]For these interpretations, see, e.g., Lothar Kitschelt, *Die frühchristliche Basilika als Darstellung des himmlischen Jerusalem* (Munich, 1938), 69–88; Alfred Stange, *Basiliken, Kuppelkirchen, Kathedralen: Das himmlische Jerusalem in der Sicht der Jahrhunderte* (Regensburg, 1964); and Carol Heitz, "Retentissement de l'Apocalypse dans l'art de l'époque carolingienne," in *Apocalypse de Jean* (see n. 1), 217–43.

[60]Adelheid Kitt, "Der frühromanische Kronleuchter und seine Bedeutung" (Ph.D. diss., University of Vienna, 1944); Friedrich Kreusch, "Zur Planung des Aachener Barbarossa-Leuchters," *Aachener Kunstblätter* 22 (1961): 21–36; Willmuth Arenhövel, *Der Zezilo-Radleuchter im Dom zu Hildesheim* (Berlin, 1975), 94–96; Marie-Thérèse Gousset, "Un aspect du symbolisme des encensoirs romans: La Jérusalem céleste," *Cahiers archéologiques* 30 (1982): 81–106.

[61]*MGHSS* 4:620. For the imperial Ottonian mantles with Apocalypse scenes, see Robert Eisler, *Weltenmantel und Himmelszelt*, vol. 1 (Munich, 1910), 22–25; Percy Ernst Schramm, *Herrschaftszeichen und Staatssymbolik* (Stuttgart, 1955), 579; Eva Kovács, "Casula Sancti Stephani regis," *Acta Historiae Artium* 5 (1958): 181–213; Endre Tóth, "Zur Ikonographie des ungarischen Krönungsmantels," *Folia Archaeologica* 24 (1973): 219–40; Eva Kovács and Zsuzsa Lovag, *Die ungarischen Krönungsinsignien* (Budapest, 1980), 59–79; and Elizabeth O'Connor, "The Star Mantel of Henry II" (Ph.D. diss., Columbia University, 1984).

[62]Rome, Biblioteca Vallicelliana M5. B. 25.2; see Wilhelm Messerer, "Zum Juvenianus-Codex der Biblioteca Vallicelliana," in *Miscellania Bibliotecae Hertzianae* (Munich, 1961), 58–68 (cf. 62); and Florentine Mütherich, "Manoscritti romani e miniatura carolingia," in *Roma e l'età carolingia: Atti delle giornale di studio, 1976* (Rome, 1976), 79–86 (cf. 81f. and figs. 55, 56).

approaching angel (fig. 9). Although these two initials are without parallel in later book illumination, the vision scene has surprising and so far overlooked analogues in a Romanesque capital from 1100 at the cloister of Moissac (fig. 10).[63]

Usually single Apocalypse scenes are limited in manuscript illumination to the vision of the Son of Man amid the seven candlesticks (Apoc. 1:12–20), either as a framed image or as an illuminated initial, as in several late Romanesque Bibles.[64] Sometimes this scene is combined with elements of the *majestas domini*. Thus the Christ-like Son of Man is shown enthroned on a globe or rainbow, holding a book or framed by a mandorla, as, for example, in the Gospels of St. Maximin (Trier, 1st quarter 11th c.),[65] and in the Admont Bible from Salzburg (fig. 11).[66] The Romanesque Apocalypse cycles of Family III (e.g., fig. 12) influenced several of these single representations of the vision of the candlesticks, as is evident in the frontal view of the Son of Man—his arms spread wide, the two swords in his mouth— or the portrayal to his right of Saint John lying prostrate before him. Examples are found in the early Romanesque Apocalypse manuscript in Prague, in the Admont Bible (fig. 11), and in the Bavarian Gumbert Bible.[67] In several manuscripts, the vision of the candlesticks is also combined with other scenes, although no underlying theme requires it. Among these are the Prague Apocalypse manuscript, with its dedicatory illumination; the Admont Bible (fig. 11), with the slaying of the Two Witnesses (Apoc. 11:7); and the Gumbert Bible, with scenes from the life of Jesus.[68]

[63]Rupin, *Moissac* (see n. 36), 237f. no. 17 and fig. 76; Marguerite Vidal, "Moissac," in *Quercy roman*, 3d ed. (La Pierre-Qui-Vire, 1979), 130 and pl. 49; Meyer Schapiro, *The Sculpture of Moissac* (New York, 1985), 42f. and fig. 56.

[64]E.g., Oxford, Bodleian Library, MS Laud misc. 752; and Clermont-Ferrand, Bibliothèque publique MS. 1. Cf. C. M. Kauffmann, *Romanesque Manuscripts, 1066–1190* (London, 1975), 123–25 no. 103 (bibliog.); and van der Meer, *Apokalypse* (see n. 16), fig. 7.

[65]Berlin, Staatsbibliothek, MS. Theol. lat. fol. 283. See Victor H. Elbert, *Das erste Jahrtausend: Tafelband* (Düsseldorf, 1962), 71 no. 321 and pl. 321; and Tilo Brandis, ed., *Zimelien: Abendländische Handschriften aus den Sammlungen der Stiftung Preussischer Kulturbesitz Berlin* (Wiesbaden, 1975), 37 no. 28 (bibliog.).

[66]Vienna, Oesterreichische Nationalbibliothek, Cod. ser. nov. 2702. See Georg Swarzenski, *Die Salzburger Malerei von den ersten Anfängen bis zur Blütezeit des romanischen Stiles* (Leipzig, 1913; reprint, Stuttgart, 1969), 72–79, esp. 77 and pl. XXVIII, fig. 97; and Otto Mazal and Franz Unterkircher, *Katalog der abendländischen Handschriften der Österreichischen Nationalbibliothek*, n.s., vol. 2, no. 1 (Vienna, 1963), 359–68 (cf. 368).

[67]For the Prague Apocalypse, Prague, Kapitulni knihovna MS. A.60.3, see Jan Kvet, "Une Apocalypse du XIe siècle de la Bibliothèque Capitulaire Saint-Guy de Prague," in *Mèlanges offerts à René Crozet*, vol. 1 (Poitiers, 1966), 241–51, fig. 1; and Richard Kenneth Emmerson and Suzanne Lewis, "Census and Bibliography of Medieval Manuscripts Containing Apocalypse Illustrations, ca. 800–1500," pt. 2, *Traditio* 41 (1985): 370 no. 37. For the Gumbert Bible, Erlangen Universitätsbibliothek MS Perg. 1, see Swarzenski, *Salzburger Malerei* (see n. 66), 129–38 (esp. 136) and pl. XLVIII, fig. 149; Walter Cahn, *Romanesque Bible Illustration* (Ithaca, N.Y., 1982), 252 no. 3 (bibliog.). For the Admont Bible, see n. 66.

[68]See nn. 66, 67 above.

In contrast to these, the historiated initial of the Apocalypse in the Ro-
manesque Bible of Saint-Bénigne, dating from the first quarter of the
twelfth century (fig. 13),[69] combines elements of the vision of the candle-
sticks with motifs from the Old Testament to form a complex typological
image. On the one hand, Christ is depicted in three different forms: he is
shown first as the Son of Man of the vision of the candlesticks (Apoc.
1:12–20), portrayed with the seven candlesticks, the seven stars, and the
seven angels in the seven churches; second, as the Christ of the *parousia*,
appearing "in the clouds" and beheld by "every eye" (Apoc. 1:7), he is por-
trayed with a cloud, his arms spread wide, beheld by angels and two point-
ing prophets; third, Christ is shown as a cosmological "embracing figure,"
whose hands embrace in their grasp almost the entire breadth of the
initial,[70] thus symbolizing the infinity of God (Apoc. 1:8) which surrounds
the entire cosmos. On the other hand, the seven-shaped Church of Christ
(the seven angels in the seven churches) is associated with the Old Testa-
ment Temple. For example, the grand candlestick in the center and the six
smaller ones flanking it are reminiscent of the seven-branched candlestick
of the Old Testament Temple;[71] the gown of the upper arch, which is like
a curtain, suggests the curtain of the Tabernacle; the arcade may refer to
the forecourt of the Temple; the two angels above the candlesticks recall
the two cherubim above the Ark of the Covenant; and the table with
the loaves of bread resembles the table of showbread in the Temple.[72]

[69]Dijon, Bibliothèque municipale MS. 2, fol. 470. For the Bible, see Charles Oursel,
"Les manuscripts à miniatures de la Bibliothèque de Dijon," *Bulletin de la Société
française de reproductions de manuscrits à peintures* 7 (1923): 5–33 (cf. 23–27); Cahn,
Romanesque Bible (see n. 67), 20 n. 65 (bibliog.); and Yolanta Zaluska, *L'enluminure et
le scriptorium de Cîteaux au XIIe siècle* (Cîteaux, 1989), 144–47, 262–63 no. 88. For the
Apocalypse initial of this Bible, see François Garnier, *Le langage de l'image au Moyen
Age: Signification et symbolique,* 2d ed. (Paris, 1982), 202f. and pl. 42 (with erroneous,
rather speculative interpretation, without any concrete reference to the exegetical tra-
dition); Yolanda Zaluska, *Manuscrits enluminés de Dijon* (Paris, 1990), notice 104 and
pl. 141.
[70]For this iconographic type, see A. C. Esmeijer, "La macchina dell'universo," in *Al-
bum Discipulorum aangeboden,* ed. J. G. van Gelder (Utrecht, 1963), 5–15; and Otto-
Karl Werckmeister, *Irisch-northumbrische Buchmalerei des 8. Jahrhunderts und
monastische Spiritualität* (Berlin, 1967), 120–29.
[71]Such is also suggested by the exegesis of Bede's Apocalypse commentary and its il-
lustration in a manuscript from Ramsey Abbey, dating about 1160–70, now in Cam-
bridge (St. John's College MS.H.6). For the Ramsey Abbey Bede commentary and its
illustration, see Peter Bloch, "Siebenarmige Leuchter in christlichen Kirchen," *Wallraf-
Richartz-Jahrbuch* 23 (1961): 55–190 (cf. 128 and fig. 73); Kauffmann, *Romanesque
Manuscripts* (see n. 64), 112 no. 86 (bibliog.) and pls. 244–45; George Henderson, *Bede
and the Visual Arts* (Newcastle upon Tyne, 1980), 20; Hayward Gallery, *English Ro-
manesque Art, 1066–1200* (exhibition catalog) (London, 1984), 122 no. 66; and Emmer-
son and Lewis, "Census and Bibliography" (see n. 67), pt. 2, 41 (1985): 367f. no. 34.
[72]We find all these elements in numerous medieval representations of the Jerusalem
Temple, e.g., in the Codex Amiatinus (Florence, Biblioteca Laurenziana) from about 700
and in the *Hortus deliciarum* (formerly Strasbourg, Bibliothèque munincipale), and in a
South German manuscript at Vienna (Österreichische Nationalbibliothek, Cod. 10),
both from the twelfth century. See Peter Bloch, "Nachwirkungen des Alten Bundes in

Following the exegesis of Ambrose Autpert, the two prophets in the lower spandrel might well depict Moses and Aaron, to whom appears the "glory of God" in a cloud (Num. 16:43), not unlike the theophany of Apocalypse 1:7. Portrayed with an incense vessel, they seem to be in the act of atonement for the Jewish people, who have been visited by a mortal plague (Num. 16:46–48), to which the naked corpse at the bottom may allude.[73]

Similarly complex is the frontispiece of an English manuscript of Augustine's *City of God* at Oxford (fig. 14), dating about 1130–40.[74] Below the City of God with the enthroned Christ among the Apostles are two scenes from Apocalypse 12, which in this context are of a christological and ecclesiological meaning. On the left, the Christ-like Michael drives Satan and his host from the heavenly city (Apoc. 12:7–9), whereas on the right, *ecclesia*, symbolized by the apocalyptic Woman clothed with the sun, protects a newly baptized soul, just reborn from sin, against the attack of Satan, the Dragon of Apocalypse 12. The "old," dead body of the baptized soul (cf. Rom. 6:22ff.) lies on a bed below.[75]

der christlichen Kunst," in *Monumenta Judaica: 2000 Jahre Geschichte und Kultur der Juden am Rhein, Handbuch* (Cologne, 1963), 735–81 (cf. 755f., figs. 75–78); Carol Herselle Krinsky, "Representations of the Temple of Jerusalem before 1500," *Journal of the Warburg and Courtauld Institutes* 33 (1970): 1–19 (cf. 17–19 and pls. 6a–6c); and Gérard Cames, *Allégories et symboles dans l'Hortus deliciarum* (Leiden, 1971), 21–29 and figs. 10–11.

[73]See the commentary by Ambrose Autpert to Apoc. 1:7: "Cum vero singulari numero nubis nomen interseritur, aliquando mansuetudinem Domini in electos, simulque animadversionem ultionis ostendit in reprobos, sicut in Numerorum libro et historialiter factum, et mystice figuratum legimus, quia 'loquente Domino ad Moysen et Aaron, murmuravit omnis multitudo filiorum Israhel sequenti die contra Moysen et Aaron. . . . Cumque oriretur seditio, et tumultus incresceret, Moyses et Aaron fugerunt ad tabernaculum foederis. Quod postquam ingressi sunt, operuit eum nubes, et apparuit gloria Domini. Dixit que Dominus ad Moysen: Recedite de medio multitudinis, etiam nunc delebo eos' (Num. 16:40–45). . . . Ecce etenim Dominus fugientes Moysen et Aaron nube protegit, contra murmurantes vero ex nube incendii fulmen emittit. In quibus nimirum verbis et actis patenter innuitur, quia in eo quod fideles famulos, Moysen et scilicet Aaron, Dominus in tabernaculo nube protegit, mansuetudo eiusdem pii Creatoris atque protectio in electos, per eandem nubem figuratur" (*CCCM* 27:51). The last sentence could even explain the curious motif of the "Umfassunsfigur" of Christ in the Dijon Bible, since this medieval figure type was often used to represent God as the creator and ruler of the universe (see n. 70 above). Ambrose Autpert does not, however, quote the subsequent passage of Numbers 16:46–48, about Aaron putting fire in the censer to make expiation for the people of Israel.

[74]Oxford, Bodleian Library, MS Laud misc. 469, fol. 7v. See Hanns Swarzenski, *Monuments of Romanesque Art* (London, 1954), 61, fig. 291; Kauffmann, *Romanesque Manuscripts* (see n. 64), 87 no. 54 (bibliog.) and pl. 147.

[75]Hence this part of the picture, which has no parallels in the other medieval illustrations of Augustine's *City of God* (for these illustrations, see Alexandre de Laborde, *Les manuscrits à peintures de "la Cité de Dieu*," vol. 1 [Paris, 1909], 192–201; and Schneider, *Civitas* [see n. 31], 39–48), follows the ecclesiological interpretation of Apocalypse 12. For the medieval exegesis of Apoc. 12, see Pierre Prigent, *Apocalypse XII: Histoire de l'exégèse* (Tübingen, 1959), passim.

In contrast to the rich iconography of single representations of apocalyptic scenes in medieval Bibles, the comparable images in Apocalypse commentaries are noticeably simple. An Ottonian Bede commentary at Einsiedeln (10th c.)[76] and an English Berengaudus commentary at Longleat House (ca. 1100)[77] both feature, in the upper portion of their frontispiece, the enthroned Christ and, in the lower part, the commission to Saint John (Apoc. 1:1). John, who is seated and ready to write, is commanded by the angel sent by God to write down the divine "revelation." Whereas in the Einsiedeln Bede commentary the enthroned Lord is depicted as the Christ of the *parousia* along with two angels who acclaim him, in the Longleat House Berengaudus commentary he is shown in the trinitarian *majestas* type, with the Christ-Lamb and the dove of the Holy Spirit on his lap, framed by the mandorla and surrounded by the Four Living Creatures.

Cycles of Apocalypse Illustrations

By far the richest illustrations of the Apocalypse are found in the illuminated manuscript cycles, which also influenced wall and panel painting, stained glass, monumental sculpture, metalwork, and the graphic arts. Medieval cycles of the Apocalypse are distinguished not only by their numerous illustrations (most contain fifty to eighty scenes) but also by continuous, centuries-old traditions that assume different characteristics depending on the epoch and country. Accordingly, the cycles can be categorized into various families and groups, each of which had its greatest influence in a certain area or epoch. Among these cycles are the Spanish Beatus Apocalypses of the early and High Middle Ages, the Gothic Anglo-French Apocalypses of the thirteenth and fourteenth centuries, the Italian cycles of the trecento, and the late Gothic apocalypse illustrations in the fifteenth-century block-books and printed Bibles of the Low Countries and Germany.

Late Antique and Early Christian Traditions (Family I). Although no Apocalypse cycles dating from late antiquity and early Christian periods have been preserved, they must have existed since the fifth or sixth

[76]Einsiedeln, Stiftsbibliothek MS. 176. See Ernest De Wald, "The Art of the Scriptorium of Einsiedeln," *Art Bulletin* 7 (1924/25): 79–90 (cf. 85f. and fig. 35); Meyer Schapiro, "A Relief in Rodez and the Beginning of Romanesque Sculpture in Southern France" (1963), in *Romanesque Art: Selected Papers*, ed. Meyer Schapiro (New York, 1977) 285–305 (cf. 293, fig. 12); and Emmerson and Lewis, "Census and Bibliography" (see n. 67), pt. 1, 40 (1984): 343f. no. 3. Contrary to the opinion of some scholars (De Wald and Emmerson and Lewis), this codex was not done for Otto I and his wife Adelheid; see Percy Ernst Schramm, *Die deutschen Kaiser und Könige in Bildern ihrer Zeit 751–1190*, 2d rev. ed. (Munich, 1983), 191.
[77]Longleat House MS 2; recently published by Michael Michael in "An Illustrated 'Apocalypse' Manuscript at Longleat House," *Burlington Magazine* 126 (1984): 340–43 and figs. 25–26; cf. also Emmerson and Lewis, "Census and Bibliography" (see n. 67), pt. 2, 41 (1985): 368 no. 35a.

centuries.[78] It is possible to reconstruct two entirely separate traditions: an early Christian–Roman prototype, which influenced the central European Apocalypse cycles throughout their many changes until the close of the Middle Ages,[79] and an early Spanish or North African prototype of the fifth or sixth century, which is confined almost entirely to Spain and is reflected in the Beatus Apocalypse illustrations.[80] Although the early Christian prototype of the Beatus illuminations can be reconstructed only indirectly, the late antique Italian archetype of the central European tradition can be grasped more precisely. It has been preserved relatively faithfully in the early Carolingian Trier Apocalypse (France, early 9th c.; fig. 3), which, except for insignificant deviations, represents both iconographically and stylistically a fairly exact copy of an Italian model of the sixth century.[81] The late antique model is evident not only in the visions of heaven (cf. the vision of the Lamb [fig. 3] with the facade mosaic of old St. Peter's [fig. 18] but also in the depictions of catastrophes and the representations of evil, such as the Dragon in the shape of a winged snake and the Whore of Babylon on the Beast, who is not unlike ancient images of the goddess Isis upon the dog Sothis.[82] Judging from the Trier copy, the late antique–Roman Apocalypse archetype must have been a cycle of nearly a hundred narrative illustrations arranged in framed picture columns as in the *Vatican Vergil* (Rome, ca. 400).[83] In the Trier Apocalypse and its late Carolingian copy in Cambrai (northern France, 1st half 10th c.),[84] this large

[78]As already supposed by James, *Apocalypse in Art* (see n. 56), 37; and Wilhelm Neuss, *Die Apokalypse des hl. Johannes in der altspanischen und altchristlichen Bibel-Illustration*, 2 vols. (Münster, 1931), 1:265f.

[79]See Peter K. Klein, "Der Apokalypses-Zuklus der Roda-Bibel und seine Stellung in der ikonographischen Tradition," *Archivo Español de Arqueologia* 45–47 (see n. 39) 136ff.

[80]Cf. Neuss, *Apokalypse des hl. Johannes* (see n. 78), 1:239–41; and Peter K. Klein, "La tradición pictórica de los Beatos," in *Actas del Simposio . . . Beato de Liébana* (see n. 12) (1980), 2: 99–104.

[81]Trier, Stadtbibliothek, Cod. 31, fol. 18v. Compare the stylistic parallels with the sixth-century mosaics at Rome and Ravenna and with the equally sixth-century Italian *Gospels of St. Augustine* (Cambridge, Corpus Christi College MS. 286). Cf. Klein, "Kodex" (see n. 20), 101–3. For the Trier Apocalypse, see also Emmerson and Lewis, "Census and Bibliography" (see n. 67), pt. 1, 40 (1984): 345f. no. 6.

[82]Klein, "Kodex" (see n. 20) and 93–97 and figs. 31–40, and "Die frühen Apokalypse-Zyklen und verwandte Denkmäler: Von der Spätantike bis zum Anbruch der Gotik" thesis of Habilitation, University of Bamberg, 1980. Cf., on the contrary, Franz von Juraschek, "Sinndeutende Kompositionsweise der Illustrationen zur Apokalypse im Frühmittelalter," *Arte del primo millenio: Atti del IIo convegno per lo studio dell'arte dell'alto medio evo, Pavia, 1950*, ed. Edoardo Arslan (Turin, 1953), 187–93 (cf. 192); and *Die Apokalypse von Valenciennes* (Linz, 1954), 26–34; and Brenk, *Tradition und Neuerung* (see n. 10), 170f.

[83]Rome, Vat. lat. MS. 3225; see David H. Wright, *Vergilius Vaticanus: Faksimile-Ausgabe des Codex Vaticanus Latinus 3225 der Biblioteca Apostolica Vaticana* (Graz 1980–84). See also Snyder, "Trier Apocalypse" (see n. 20) 153; and Klein, "Kodex" (see n. 20), 103.

[84]Cambrai, Bibliothèque municipale MS. 386. See Klein, "Kodex" (see n. 20), 60–61, 84–89, figs. 5, 15–19, 22–27, 34, 48, 59, 79–82; also Henri Omont, "Manuscrits illus-

cycle is compressed into seventy-four full-page miniatures. Another, perhaps early medieval variation of this late antique cycle in part influenced an early twelfth-century Apocalypse from southwest Germany, which is bound with Haimo of Auxerre's Apocalypse commentary in Oxford.[85]

Early Medieval Cycles (Family II). In addition to this direct succession of the late antique–Italian cycle evident in the Trier, Cambrai, and Oxford Apocalypses (Family I), two other, significantly larger early medieval Apocalypse traditions (Families II and III) also derive from the Roman archetype. They were derived indirectly, however, through the intermediary of a late antique prototype, dating already from the second half of the sixth century, in which the illustrations were reduced and altered. This prototype, for example, omitted the *content* of the messages to the churches of Asia Minor (Apoc. 2–3) and rendered the vision of God in Apocalypse 5 by placing the Lamb *upon* the throne (fig. 2), a scene patterned after the apocalyptically determined *hetoimasia* image in the fashion of the sixth-century triumphal arch mosaic of SS. Cosma e Damiano in Rome (fig. 1).[86] By the seventh century, the archetype of the early medieval Family II, to which belong only the Carolingian, Ottonian, and early Romanesque cycles of the period between 700 and 1100,[87] became severed from the tradition that was later to become a prototype for the Family III cycles.

The Family II cycles include the two Carolingian sister manuscripts in Valenciennes (Liege? early 9th c.)[88] and in Paris (northeastern France, early

trés de l'Apocalypse aux IXe et Xe siècles," *Bulletin de la Société Française de Reproduction des Manuscrits à peintures* 6 (1922): 84–93, pls. XXIX-XXXI; and Emmerson and Lewis," Census and Bibliography" (see n. 67), pt. 1, 40 (1984): 342f. no. 2.

[85]Oxford, Bodleian Library, MS Bodl. 352. For the manuscript see Otto Pächt and J. J. G. Alexander, *Illuminated Manuscripts in the Bodleian Library, Oxford*, vol. 1 (Oxford, 1966), 5 no. 66; Teresa Mroczko, "Geneza ikonografii Apokalipsy Wroclawskiej," *Roznik Historii Sztuki* 7 (1969), 47–106 (cf. 69ff.); A. G. Hassall and W. O. Hassall, *Treasures from the Bodleian Library* (London, 1976), 57–60; and Emmerson and Lewis, "Census and Bibliography" (see n. 67), pt. 2, 41 (1985): 369 no. 36. For the influence of Family I in the Oxford Haimo Commentary, see Mroczko, "Geneza ikonografii Apokalypsy," 75, 102–4; Klein, "Roda-Bibel" (see n. 18), 293, 295f., "Kodex" (see n. 20), 97, 111, and "Cycles" (see n. 39), 137f.

[86]Klein, "Kodex" (see n. 20) 109–11, and "Cycles" (see n. 39), 154–58. In the respective image of the Bamberg Apocalypse (Klein, "Cycles," fig. 2), the "throne" is given as a kind of city wall, probably referring to the Heavenly Jerusalem, which appears at the end of the Bamberg Apocalypse in a similar form, the Lamb being placed once again in the center, standing again on the seven-sealed book (cf. Apoc. 5:7–8, 21:27). See Klein, "Cycles," 154f. figs. 30, 40.

[87]For the Family II, which partly coincides with Neuss's "italischer Gruppe," in his *Apokalypse des hl. Johannes* (see n. 78), 1:264–66), see Klein, "Roda-Bibel" (see n. 78), 292–96, "Kodex" (see n. 20) 104ff., and "Cycles" (see n. 39), 138–42.

[88]Valenciennes, Bibliothèque municipale MS. 99; for the date and scriptorium see Bernhard Bischoff, "Panorama der Handschriftenüberlieferung aus der Zeit Karls des Grossen," in *Das geistige Leben, Karl der Grosse: Lebenswerk und Nachleben*, ed. Bernard Bischoff, vol. 2 (Düsseldorf, 1965), 233–54 (cf. 235); rpt.—with changed

178 PETER K. KLEIN

10TH C.).[89] These are based on a Northumbrian model from about 700,[90] which was probably a copy of those "imagines visionum Apocalypsis" that Benedict Biscop brought to England in 676 from his fourth journey to Rome to use as a model for the paintings on the north wall of the abbey church of St. Peter in Wearmouth.[91] The best-known member of Family II is the famous Ottonian Bamberg Apocalypse (Reichenau, 1001–2; cf. fig. 2),[92] but the group also includes two fragments of Apocalypse cycles: the late Carolingian Apocalypse fragment in Munich, which originated during the early tenth century in southern Germany, possibly at Reichenau;[93] and the fragment of a picture Apocalypse in Basel (southwest Germany).[94] Finally we may count as belonging to this tradition the wall paintings in the baptistery at Novara near Milan (early 11th c.),[95] the frescoes in the

opinions!—in Berhard Bischoff, *Mittelalterliche Studien*, vol. 3 (Stuttgart, 1981), 5–38 (cf. 8); *Karl der Grosse* (see n. 29), 271 no. 444; and Klein, "Kodex" (see n. 20) 104 n. 325. For the manuscript, see Omont, "Manuscrits illustrés" (see n. 84), 73–83, pls. XIV–XXVIII, Juraschek, *Apokalypse von Valenciennes* (see n. 82); J. J. G. Alexander, *Insular Manuscripts, Sixth to Ninth Century* (London, 1978), 82f. no. 64, pls. 302–9; and Emmerson and Lewis, "Census and Bibliography" (see n. 67), pt. 1, 40 (1984): 346f. no. 7.

[89]Paris, Bibliothèque nationale, MS Nouv. acq. lat. 1132. Cf. Henri Omont, "Un nouveau manuscrit illustré de l'Apocalypse au IXe siècle," *Bibliothèque de l'Ecole des Chartes* 83 (1922): 273–96; Adolph Goldschmidt, *An Early Manuscript of the Aesop Fables of Avianus* (Princeton, 1947), 22–35; Klein, "Kodex" (see n. 20) 104, n. 326 (for the date and scriptorium); and Emmerson and Lewis, "Census and Bibliography" (see n. 67), pt. 1, 40 (1984): 344f. no. 5.

[90]Carl Nordenfalk in André Grabar and Carl Nordenfalk, *Le haut Moyen Age* (Geneva, 1957), 122, 140; Klein, "Kodex" (see n. 20), 111, and "Cycles" (see n. 39), 143f. n. 34, 159.

[91]Goldschmidt, *Manuscript of the Aesop Fables* (see n. 89), 33ff.; Carl Nordenfalk, "Ein unveröffentlichtes Apokalypsenfragment," *Pantheon* 36 (1978): 114–18 (cf. 116f.). For the character of Biscop's "imagines" of the Apocalypse, see also Ernst Kitzinger, "The Role of Miniature Painting in Mural Decoration," in *The Place of Book Illumination in Byzantine Art* (Princeton, 1975), 99–142 (cf. 118f.); and Paul Meyvaert, "Bede and the Church Paintings at Wearmouth-Jarrow," *Anglo-Saxon England* 8 (1979): 63–77.

[92]For the place of the Bamberg Apocalypse in the iconographic tradition, see Neuss, *Apokalypse des hl. Johannes* (see n. 78), 1:247–67 (esp. 264); and Klein, "Roda-Bibel" (see n. 78), 274ff.; and "Cycles" (see n. 39), 140–44. For the manuscript and its date, see Alois Fauser, *Die Bamberger Apokalypse* (Wiesbaden, 1958), 11–19; Emmerson and Lewis, "Census and Bibliography" (see n. 67), pt. 1, 40 (1984) : 340–42 no. 1; and Peter K. Klein, "Die Apokalypse Ottos III. und das Perikopenbuch Heinrichs II.," *Aachener Kunstblätter* 56/57 (1988/89): 5–52.

[93]Munich, Bayerische Staatsbibliotek MS Clm 29270.12 (once 29159); see Nordenfalk, "Apokalypsenfragment" (see n. 91); and Klein, "Cycles" (see n. 39), 141. Considering the paleographic characteristics of the Munich fragment, the mid-eleventh-century date proposed by Nordenfalk (115) seems to be too late (information kindly provided by Bernhard Bischoff, Johanne Autenrieth, and Hartmut Hoffmann).

[94]Basel, Bibliothek der Universität, MS. N.I.4 Blatt C; see Emmerson and Lewis, "Census and Bibliography" (see n. 67), pt. 2, 41 (1985): 367 no. 33; and Peter K. Klein, "Das Fragment einer spätottonischen Bilder-Apokalypse in Basel," in *"Nobile claret opus": Festgabe für Ellen J. Beer, Zeitschrift für Schweizerische Archäologie und Kunstgeschicte* 43 (1986): 27–36.

[95]Umberto Chierici, "Il maestro dell'Apocalisse di Novara," *Paragone*, n.s., 21 (1966), no. 201 (Arte): 13–41; Peter Hoegger, "Ottonische Apokalypsen," *Unsere Kunstdenk-*

porch of Saint-Savin-sur-Gartempe (Vienne, ca. 1100),[96] and the stylisti-
cally as well as iconographically closely related wall paintings in the choir
of Saint-Hilaire-le-Grand at Poitiers (end 11th c.; fig. 33), which were re-
cently discovered.[97] The Apocalypse cycles of Family II reduce the number
of illustrations to at most forty to fifty scenes and simplify their compo-
sitions in an emblematic way, which is particularly evident in the
"Northumbrian" version represented by the Valenciennes and Paris Apoc-
alypses. The frescoes in Novara, Poitiers, and Saint-Savin, which unfortu-
nately are extant only in fragments, represent a specific monumental
tradition within Family II.[98]

Romanesque Cycles (Family III). Even more numerous but less coher-
ent as a group are the Apocalypse cycles of Family III, which, although
dominant in the Romanesque period, through their precursors and deriv-
atives extend from the Carolingian period to the late Gothic, from the
ninth century to the fifteenth and sixteenth centuries.[99] It is difficult to
give a general definition for the cycles of Family III; for they vary greatly
in detail and size, the number of illustrations ranging between six and
sixty scenes. They include wall paintings and book illuminations as well
as works of monumental sculpture. There is some accord in the treatment
of several themes, however: for instance, of the vision of the candlesticks
(cf. fig. 12), the messages to the seven churches, the vision of the Lamb
with the book, the Four Horsemen, and the Heavenly Jerusalem.[100] Fur-
thermore, the cycles of Family III, like other Romanesque Apocalypse
cycles, for the first time reflect a stronger influence of exegesis, especially
of the Apocalypse commentaries by Ambrose Autpert and Haimo of
Auxerre.[101]

mäler 20 (1969): 100–112; Janine Wettstein, *La fresque romane: Italie-France-Espagne*
(Geneva, 1971), 3–11; Betty Al-Hamdani, "The Frescoes of Novara and the Bamberg
Apocalypse," in *Actes du XXIIe Congrès International d'Histoire de l'Art*, vol. 1 (Budap-
est, 1972), 427–48; Marchita B. Mauck, "The Apocalypse Frescoes of the Baptistery in
Novara, Italy" (Ph.D. diss., Tulane University, 1975); Klein, "Roda-Bibel" (see n. 78),
275ff., and "Cycles" (see n. 39), 141–43.
[96]Yoshikawa, *Apocalypse de Saint-Savin* (see n. 40); Demus, *Romanische Wandma-
lerei* (see n. 15), 68–70, 140–43; Kurmann-Schwartz, "Peintures du porche" (see n. 40);
Christe, "A propos des peintures murales" (see n. 40), 219–37.
[97]Marie-Thérèse Camus, "A propos de trois dècouvertes récentes: Images de l'Apoc-
alypse à Saint-Hilaire-le-Grand de Poitiers," *Cahiers de Civilisation Médiévale* 32
(1989): 125–34.
[98]Klein, "Cycles" (see n. 39), 143.
[99]For the Family III and its tradition, see Klein, "Roda-Bibel" (see n. 78), 275ff.,
"Kodex" (see n. 20), 104ff., and "Cycles" (see n. 39), 144ff. For its Gothic derivatives,
see Peter K. Klein, *Endzeiterwartung und Ritterideologie: Die englischen Bilderapoka-
lypsen der Frühgotik und MS Douce 180* (Graz, 1983), 167.
[100]See n. 99 and Klein, *Frühen Apokalypse-Zyklen* (see n. 82).
[101]Peter K. Klein, "Les Apocalypses romanes et la tradition exégétique," *Cahiers de
Saint-Michel de Cuxa* 12 (1981): 123–40.

The first precursors of Family III are the Apocalypse scenes in the fron-
tispieces of the Carolingian picture bibles: the Moutier-Grandval Bible
(Tours, ca. 840), the Vivian Bible (Tours, ca. 846), and the Bible of S. Paolo
fuori-le-mura in Rome (Reims ? ca. 870).[102] For the first time, these fron-
tispieces show the Lamb and Lion on either side of the throne of Apoca-
lypse 5 and the angels inside, or on top of, the churches in the
representation of the messages of Apocalypse 2 and 3. Both motifs reoccur
in the Romanesque cycles of Family III. Since the Carolingian book illu-
minators borrowed only certain elements of this tradition, the origin of
the latter must antedate the beginning of Touronian Bible illustrations in
the years around 835.

The Family III cycles were fully developed by the eleventh and twelfth
century, as is evident in the Catalan Bible from S. Pere de Roda (2d half 11th
c.),[103] and the Lombard Beatus Apocalypse in Berlin (12th c.), which does
not follow the usual pictorial tradition of the Beatus manuscripts.[104] Both
cycles were formerly considered to belong to Family II.[105] Family III also
includes the Italian Apocalypse cycles of Romanesque wall paintings in
the crypt of Anagni cathedral (ca. 1100),[106] in the transept of the basilica at

[102]London, British Library MS Add. 10546 (Moutier-Grandual Bible); Paris, Bib-
liothèque nationale, MS lat. 1 (Vivian Bible). From the abundant literature on these Car-
olingian Bibles and their Apocalypse frontispieces, see Yves Christe, "Trois images
carolingiennes en forme de commentaire sur l'Apocalypse," Cahiers Archéologiques 25
(1976): 77–92; Klein, "Kodex" (see n. 20), 105ff.; Kessler, Bibles from Tours (see n. 19),
69–83; and Cäcilia Davis-Weyer, " 'Aperit quod ipse signaverat testamentum': Lamm
und Löwe im Apokalypsebild der Grandval-Bibel," in Festschrift für Florentine Müth-
erich (see n. 25), 67–74.
[103]Paris, Bibliothèque nationale MS lat. 6; see Neuss, Apokalypse des hl. Johannes
(see n. 78), 1:247–67; Peter K. Klein, "Date et scriptorium de la Bible de Roda: Etat des
recherches," Cahiers de Saint-Michel de Cuxa 3 (1972): 91–102, and "Roda-Bibel" (see n.
78), passim; François Avril, ed., Manuscrits enluminés de la péninsule ibérique, Bib-
liothèque Nationale (Paris, 1982), 31–43 no. 36 (Yolanta Zaluska); Cahn, Romanesque
Bible (see n. 67), 70–80, 292 no. 148; and Emmerson and Lewis, "Census and Bibliog-
raphy" (see n. 67), pt. 3, 42 (1986): 453f. no. 140.
[104]Klein, "Roda-Bibel" (see n. 78), 275ff., esp. 292f., "Kodex" (see n. 20) 105–12, and
"Tradición pictórica (see n. 80), 106. For the manuscript, Berlin, Staatsbibliotek, Theol.
lat., fol. 562; see Neuss, Apokalypse des hl. Johannes (see n. 78) 1:45–47, 247–67; Bran-
dis, Zimelien (see n. 65), 70 no. 49; Hoegger, Fresken in S. Elia (see n. 15), 61–71; Em-
merson and Lewis, "Census and Bibliography" (see n. 67), pt. 1, 40 (1984): 347f. no. 8;
and Bibliotheek Albert I, Los Beatos: Europalia 85 España (exhibition catalog) (Madrid,
1985), 102 no. 2.
[105]See, e.g., Neuss, Apokalypse des hl. Johannes (see n. 78), 1:247, 264; and Hoegger,
Fresken von S. Elia (see n. 15), 61ff.
[106]Klein, "Roda-Bibel" (see n. 78), 276ff., "Kodex" (see n. 20), 105, and "Cycles" (see n.
39), 147; Yves Christe, "L'ange à l'encensoir devant l'autel des martyrs," Les Cahiers de
Saint-Michel de Cuxa 13 (1982): 187–200. The Anagni crypt frescoes have been tradi-
tionally assigned to the middle of the thirteenth century (see, below, Demus, Hoegger,
Matthiae, etc.), but recently these frescoes have been dated with good reasons in the
time around 1100 (cf. Miklòs Boskovits, "Gli affreschi del duomo di Anagni: Un capitolo
di pittura romana," Paragone 30, no. 357 Arte [1979]: 3–41; and Yves Christe, "Un
chapiteau de Mozac avec les anges des vents d'Ap 7:1," Arte Cristiana, n.s., 733 [1989],
297–302, cf. 302). For the Anagni frescoes, see also M. Q. Smith, "Anagni: An Example

Sant'Elia near Nepi (ca. 1120–30),[107] and in the nave of S. Severo in Bardolino at Lake Garda (1st half 12th c.),[108] as well as the Apocalypse illustrations in two Veronese New Testaments dating from the first quarter of the thirteenth century.[109]

The tradition of Family III was not limited to Italy, however. The German miniature cycles of the Oxford Haimo Apocalypse commentary — which, as we saw above, is based in part on a Family I cycle[110]—and a liturgical manuscript with masses for the feast of angels,[111] which is stylistically closely related, also follow this tradition. They both date from the first half of the twelfth century. Close iconographic parallels link the Oxford cycle and the Apocalypse illustrations in the Liber floridus, a pictorial encyclopedia written by Lambert of Saint-Omer around 1120.[112] Both cycles contain approximately sixty scenes and arrange in a similar manner the Lamb and Lion on either side of the Enthroned with the sealed book (Apoc. 5). In the autograph manuscript of the Liber floridus at Ghent, the Apocalypse cycle is missing, although it is preserved in later copies, such as the Wolfenbüttel codex (Flanders, 3d quarter 12th c.) and the manuscript from the Chartreuse (Carthusian monastery) of Montdieu near

of Medieval Typological Decoration," Papers of the British School at Rome 33 (1965): 1–47; Matthiae, Pittura romana (see n. 14), 2:131–45; Demus, Romanische Wandmalerei (see n. 15), 58, 125f.; and Hoegger, Fresken in S. Elia (see n. 15), 62ff.

[107]Klein, "Roda-Bibel" (see n. 78), 276ff., "Kodex" (see n. 20), 105, and "Cycles" (see n. 39), 145. For the S. Elia Apocalypse frescoes, see esp. Hoegger, Fresken in S. Elia (see n. 15), 53–100.

[108]Klein, "Kodex" (see n. 20) 105; and "Cycles" (see n. 39), 146–49. For the Bardolino frescoes, see also Edoardo Arslan, La pittura e la scultura veronese dal secolo VIII al secolo XIII (Milan, 1943), 59–62; Anna Caiani, Gli affreschi della chiesa di S. Severo a Bardolino (Verona, 1968); Hoegger, Fresken in S. Elia (see n. 15), 62ff.; and Yves Christe, "Le cycle inédit de l'invention de la croix à S. Severo de Bardolino," Académie des Inscriptions et Belles-Lettres: Comptes rendus (January–March 1978): 76–101.

[109]Klein, "Cycles" (see n. 39), 147ff., and Endzeiterwartung (see n. 99), 70, 76. For these two New Testament manuscripts, Rome, Cod. Vat. lat. 39; and Chigi Cod. A.IV. 74; see Luba Eleen, "Acts Illustration in Italy and Byzantium," Dumbarton Oaks Papers 31 (1977): 255–78; Giovanni Morello and Valentino Pace, Codice Vat. lat. 39 della Biblioteca Vaticana, facsimile ed. (Milan, 1984); and Emmerson and Lewis, "Census and Bibliography" (see n. 67), pt. 3, 42 (1986): 455 nos. 142, 143.

[110]See n. 85 above.

[111]Brussels, Bibliothèque Royale MS. 3089; for this manuscript and its relation to the Oxford Haimo codex, see Pächt and Alexander, Manuscripts in the Bodleian Library (see n. 85), 1:6 no. 66; Christe, "Et super muros" (see n. 31), 176, fig. 5; and Colli, "Gerusalemme celeste nei cicli" (see n. 31), 114, fig. 10. See also Camille Gaspar and Frédéric Lyna, Les principaux manuscrits à peintures de la Bibliothéque Royale de Belgique, vol. 1 (Paris, 1937), 91f. no. 30; and Emmerson and Lewis, "Census and Bibliography" (see n. 67), pt. 3, 42 (1986): 470 no. 171.

[112]Gent, Bibliotheek van de Rijksuniversiteit MS 92; for the Apocalypse cycle of the Liber floridus see Léopols Delisle, "Notice sur les manuscrits du 'Liber floridus' " Notices et Extraits des Manuscrits de la Bibliothèque Nationale 38 (1906): 577–791; Swarzenski, "Figural Illustrations" (see n. 39), 21–30; and Klein, "Roda-Bibel" (see n. 78), 275ff., "Kodex" (see n. 20) 105–12, and "Cycles" (see n. 39), 146, 149, 155f., 159f.

Reims (Champagne, ca. 1260).[113] Other late Gothic copies of the *Liber flo-ridus* dating from the fifteenth and early sixteenth centuries have been preserved in The Hague, Chantilly, and Genoa .[114]

The historiated initials of the Apocalypse in the Mosan Bible of Stavelot (fig. 12),[115] dating from 1097, also derive from the Family III tradition, as do a number of Romanesque wall paintings in France (Saint-Chef;[116] Méobecq, fig. 34[117]), Catalonia (Pedret,[118] Polinyà[119]), and England (Canterbury).[120] The close iconographic and occasional stylistic parallels between the Catalonian and the Italian Family III Apocalypse cycles are striking. For example, the unusual combination of the martyrs under the altar (Apoc. 6:9–11) and the angel with the golden censer (Apoc. 8:3–4) is found both in the frescoes of Pedret and in the paintings of Anagni (see Yves Christe's essay herein, pp. 241–42).[121] Similar analogies are evident in the Catalonian fresco from S. Salvador in Polinyà (now in Barcelona, in the Museo Diocesano) and the Lombard Beatus Apocalypse in Berlin,

[113]Wolfenbüttel, Herzog August Bibliothek, Cod. Guelf. 1 Gud. lat. 2.0; Paris, Bibliothèque nationale MS lat. 8865; for these two manuscripts, see Jean Porcher, *Les manuscrits à peintures en France du XIIIe au XVIe siècles* (Bibliothèque nationale exhibition catalog) (Paris, 1955), 10f. no. 7; Wolfgang Milde, *Mittelalterliche Handschriften der Herzog August Bibliothek, Wolfenbüttel*, vol. 1 (Frankfort on the Main, 1972), 92–104; Swarzenski, "Figural Illustrations" (see n. 39), 27–30; Schnütgen-Museum Köln, *Monumenta Annonis, Köln und Siegburg: Weltbild und Kunst im hohen Mittelalter* (exhibition catalog) (Cologne, 1975), 89–102 no. A38; and Emmerson and Lewis, "Census and Bibliography" (see n. 67), pt. 3, 42 (1986): 459f. nos. 151, 152.

[114]The Hague, Koninklijke Bibliotheek MSS. 72.A.23 and 128.C.4; Chantilly, Musée Condé MS. 724, Genoa, Durazzo Pallavacini MS. A. IX. 9. See Swarzenski, "Figural Illustrations" (see n. 39), 21f., 27–30; and Emmerson and Lewis, "Census and Bibliography" (see n. 67), pt. 3, 42 (1986): 457–49 nos. 146–50.

[115]Waynes Robert Dynes, *The Illustrations of the Stavelot Bible* (New York, 1978); Cahn, *Romanesque Bible* (see n. 67), 265 no. 47 (bibliog.).

[116]See no. 33 above.

[117]Méobecq (Indre), former abbey church of Saint-Pierre: apse fresco, mid-twelfth century. See Yves Christe, "Le cavalier de Méobecq," *Bulletin Archéologique*, n.s. 12–13 (1976/77): 7–17.

[118]Christe, "Ange à l'encensoir" (see n. 106), 187ff. For the frescoes from S. Quirce at Pedret (ca. 1100), now in the Museo Diocesano at Solsona, see also Demus, *Romanische Wandmalerei* (see n. 15), 120f.; Betty Al-Hamdani, "Los frescos del apside principal de San Quirce de Pedret," *Anuario de Estudios Medievales* 8 (1972/73): 405–61; Joaquin Yarza Luaces, *El Bergueda* (Barcelona, 1985), 218–34; and Núria de Dalmases and Antoni José i Pitarch, *Els inicis i l'art romànic (s. IX–XII)* (Barcelona, 1986), 176–79.

[119]For the late twelfth-century frescoes from Polinyà, now in the Museo Diocesano at Barcelona, see Josep Gudiol i Cunill, *Els primitius, Els pintors: La Pintura mural* (Barcelona, 1927), 459–61; Charles L. Kuhn, *Romanesque Mural Painting of Catalonia* (Cambridge, Mass., 1930), 51f.; Anthony, *Romanesque Frescoes* (see n. 14), 175; Walter W. S. Cook and José Gudiol Ricart, *Pintura e imaginería románicas*, 2d ed. (Madrid, 1980), 67; Joan Sureda, *La pintura románica en Cataluña* (Madrid, 1981), 312f.; and Dalmases and José i Pitarch, *Els inicis* (see n. 118), 285–87.

[120]Canterbury cathedral, St. Gabriel's Chapel; second quarter of the twelfth century. See Tristram, *Twelfth Century* (see n.34), 15–21, 102ff. (esp. 16, 102–4, and pls. 1–19); C. R. Dodwell, *The Canterbury School of Illumination* (Cambridge, 1954), 39; and Demus, *Romanische Wandmalerei* (see n. 15), 172f.

[121]Christe, "Ange à l'encensoir" (see n. 106).

which both represent the fourth Horseman (Apoc. 6:7–8) holding a long lance, which he uses to stab to death men and animals (contrary to the text of Apocalypse 6:8: "And there was given him [i.e., the Horseman] power . . . to kill with *sword,*...and *with* the beasts of the earth" [emphasis added]).[122] Also related to the Family III tradition are the Romanesque capitals in the tower porch of Saint-Benoît-sur-Loire (cf. the Four Riders)[123] and the portal tympanum at La Lande-de-Fronsac (Gironde, 12th c.; fig. 36),[124] although the latter also borrows several motifs from the Beatus cycles.[125]

Other Romanesque Cycles. Romanesque Apocalypse cycles survive that are not a part of any family tradition and must be seen as independent creations. Among these are the Apocalypse capitals of the cloister at Moissac (compl. 1100; fig. 10), which are almost all in the southern gallery near the entrance to the church.[126] With the exception of the reliefs, which contain occasional parallels with the Beatus cycles (e.g., the Christ-angel with the sickle and the anthropomorphic Four Living Creatures)[127] or with the Carolingian Juvenianus codex of the Biblioteca Vallicelliana (e.g., the commission to Saint John, described above), the Moissac capitals are unique creations. The capitals of the southern gallery are arranged rhythmically, alternating between Old Testament, ornamental, and New Testament reliefs. Within this sequence, the capital with the New Jerusalem (Apoc. 21) is antithetically opposed to the capital with the similarly structured city of Babylon (Apoc. 17), comparable to the placement of the capital depicting David with his musicians as an antithesis to the capital with the

[122]Neuss, *Apokalypse des hl. Johannes* (see n. 78), vol. 2, fig. 248 (Berlin Beatus); Cook and Gudiol Ricart, *Pintura e imaginería* (see n. 119), fig. 67 (Polinyà); Dalmases and José i Pitarch, *Els inicis* (see n. 118), 288 (fig.) (Polinyà, in color).

[123]Bertrand, *Chapiteaux de la tour-porche* (see n. 35), 28 (fig.), 30 (fig.); Vergnolle, *Saint-Benoît-sur-Loire* (see n. 35), fig. 87. As in other cycles of the Family III, the respective capital of the porch of Saint-Benoît-sur-Loire shows the first Rider holding the bent bow, and the fourth Rider is characterized as Death, being followed by the mask of *infernus* (cf. analogous Family III representations in the Roda Bible, in the Méobecq and Anagni frescoes, and in the Veronese New Testament [Vat. lat. 39]).

[124]The frontal view and the outstretched arms of Christ as well as the seven stars being framed by a disk of the vision of the seven candlesticks of the Fronsac tympanum find parallels in Family III representations of the same image, for instance, in the Stavelot Bible, the Oxford Haimo codex, and the Veronese New Testament. These parallels have been overlooked in the previous literature on the La Lande-de-Fronsac tympanum; see Mireille Mentré, "Les sept églises et le fils de l'homme au tympan du portail sud, au prieuré béndictin de la Lande-de-Fronsac," *Cahiers de Saint-Michel de Cuxa* 8 (1977): 89–103; and Rupprecht, *Romanische Skulptur* (see n. 30), 36, 88 no. 67.

[125]These parallels were already noticed by Emile Mâle, in *L'art religieux du XIIe siècle en France* (Paris, 1922), 14f.; he mistook, however, the tympanum of La Lande-de-Fronsac (previously La Lande-de-Cubzac) for a direct copy of a lost Beatus manuscript.

[126]Rupin, *Moissac* (see n. 36), 213ff.; Mireille Mentré, "L'Apocalypse dans les cloîtres romans du Midi," *Cahiers de Saint-Michel de Cuxa* 7 (1976): 103–21 (cf. 104–6).

[127]Klein, "Apocalypses romanes" (see n. 101), 134f. and figs. 11, 12.

humiliation of the Babylonian king Nebuchadnezzar.[128] The recently dis-
covered wall paintings of Saint-Polycarpe (Aude; 2d half 12th c.)[129] are
even more difficult to categorize than the Moissac cloister capitals. For ex-
ample, the frescoes representing the vision of the candlesticks and the
messages to the seven churches, which are located on the western nave
vault, are without parallel in other cycles. Only the concentric composi-
tion of the adoration of the Lamb by the angels and the twenty-four Elders
(Apoc. 5), located on the vault before the apse, is reminiscent of the anal-
ogous location of the same scene in the cupola fresco of St. Margareten at
Neunkirchen in the Rhineland (before 1150),[130] where the Lamb is like-
wise placed in the center of a circular composition, surrounded by radially
arranged Elders and angels.

Other apocalyptic cycles are unique in that their iconography has been
particularly influenced by certain exegetic commentaries. For example, the
historiated initials illustrating the Apocalypse commentary of Rupert of
Deutz in a manuscript of the Cistercian monastery of Heiligenkreuz near
Vienna (3d quarter 12th c.) always relate to Rupert's interpretations.[131]
Thus, in accordance with Rupert's exegesis, the initial of Apocalypse 4 re-
lates the ostium apertum to Christ; the initial of Apocalypse 18 portrays
the Whore of Babylon as ruler over the many nations; and the Christ–
Horseman "Faithful and True" of Apocalypse 19 is identified with the first
Horseman of Apocalypse 6:1–2 by being depicted with bow and arrow.
What is really significant and innovative in Rupert's Apocalypse com-
mentary, however—his historical theology—is illustrated in a matutinal
or matins book from the Bavarian monastery of Scheyern (ca. 1205–27).[132]
Here the story of the Woman and her Son persecuted by the Dragon (Apoc.
12) is rendered in three successive allegorical miniatures, which are re-
lated historically to the birth of Christ; his crucifixion; and the early
Christian antitrinitarian heresy of Arius, Sabellius, and Photinus. In con-
trast, the Hortus deliciarum of Herrad of Hohenburg (formerly Strasbourg;

[128]The sequence of the western half of the south gallery capitals is (1) martyrdom of
Saint John the Baptist (New Testament); (2) birds in trees (decorative); (3) city of Babylon
(New Testament); (4) birds (decorative); (5) Nebuchadnezzar (Old Testament); (6) mar-
tyrdom of Saint Stephen (New Testament); (7) foliage (decorative); (8) King David and his
musicians (Old Testament); (9) heavenly Jerusalem (New Testament); and (10) pier with
Foliage (decorative).

[129]Marcel Durliat, "Les peintures murales de Saint-Polycarpe," Monuments Histo-
riques de la France (1977, no. 2): 23–30.

[130]Ruth Ehmke, "Die romanischen Wandmalereien in der Pfarrkiche zu Neunkirchen/
Sieg," Jahrbuch der Rheinischen Denkmalpflege 24 (1962): 23–30 and figs. 19–26; De-
mus, Romanische Wandmalerei (see n. 15), 181 and fig. 45.

[131]Cf. Klein, "Rupert de Deutz" (see n. 44), 119–40. For the codex, Heiligenkreuz,
Stiftsbibliothek, Cod. 83; see also Emmerson and Lewis, "Census and Bibliography" (see
n. 67), pt. 2, 41 (1985): 368 no. 35.

[132]Munich, Bayerische Staatsbibliothek MS Clm 17401; see Renate Kroos, "Die
Miniaturen und Initialen," in Das Matutinalbuch aus Scheyern: Faksimile der Bild-
seiten aus dem Clm 17401 der Bayerischen Staatsbibliothek, ed. H. Hauke and R. Kroos
(Wiesbaden, 1980), 45–90 (cf. 46–55); and Klein, "Apocalypses romanes" (see n. 101),
136–40.

2d half 12th c.) interprets the Woman and her son as *ecclesia*, in accordance with the ecclesiological interpretation in the *Speculum ecclesiae* of Honorius Augustodunensis.[133] Most Apocalypse illustrations in the *Hortus deliciarum*—the killing of the Two Witnesses, the fall of the angels, the Whore on the Beast, the fall of Babylon, and the Last Judgment—are also primarily exegetic in nature.[134]

The Apocalypse motifs and scenes on Romanesque shrines are also mostly determined by exegetic interpretations. The shrines may be designed as copies of the Heavenly Jerusalem, with the twelve Apostles, who are often depicted on the long sides of the shrines, representing the foundations of both the heavenly city and the temporal church as well as the assessors at doomsday. A typical example is the Servatius Shrine at Maastricht (Sint-Servaas, Meuse region; ca. 1160–70). The twelve Apostles are depicted on the shrine's long side, whereas on the front, Christ appears enthroned between the trees and above the water of life (Apoc. 22). In the roof reliefs, doomsday scenes are portrayed: the angels with trumpets, the resurrection of the dead, the clothing of the redeemed and the undressing of the damned (cf. Apoc. 6:9–11), the weighing of souls, and the awarding of the crown of life (Apoc. 2:10).[135] Similar connections are evident in the famous Dreikönigenschrein in Cologne cathedral (Nicholas of Verdun and the school of Cologne, 1181–1230).[136] In its upper story, Christ appears as judge of the world, flanked by the twelve Apostles, who function as assessors at court. The upper reliefs of the roof, which are now lost, showed judgment scenes—the angels with trumpets, the resurrection of the dead, the weighing of souls, the angels with the bowls full of the wrath of God (Apoc. 16), and the fall of Babylon—which were associated with other Apocalypse and apocryphal motifs, such as the testimony and slaying of the Two Witnesses and the overthrow of Antichrist.[137]

[133]Herrad *Hortus deliciarum* (see n. 72); Honorius Augustodunensis *Speculum Ecclesiae* (PL 172:1009). See Cames, *Allégories et symboles* (see n. 72), 123, fig. 126; Rosalie Green, ed. *Herrad of Hohenburg: Hortus deliciarum* (London, 1979), 1:224 and 2:458–59 no. 891; and Klein, "Apocalypses romanes" (see n. 101), 137 and fig. 14.

[134]Cf. Cames, *Allégories et symboles* (see n. 72), 111–16, 121–24; and Green, *Hortus deliciarum* (see n. 133), 1:90, 211, 217, 221f. and 2: pls. 2, 134, 140, 144, 148.

[135]Cf. Renate Kroos, *Der Schrein des Heiligen Servatius in Maastricht* (Munich, 1985), 143–207.

[136]For the Cologne shrine of the Three Magi and its iconography, see Josef Braun, "Die Ikonographie des Dreikönigenschreins," *Kunstwissenschaftliches Jahrbuch der Görresgesellschaft* 1 (1928): 29–39; Paul Clemen, *Der Dom zu Köln*, sec. 1.3 (Düsseldorf, 1937), 330–45; Hermann Schnitzler and Peter Block, eds., *Der Meister des Dreikönigenschreins* (Diözesanmuseum Köln exhibition catalog) (Cologne, 1964), 7–18 (bibliog.); and Anton Legner, ed., *Ornamenta Ecclesiae*, Schnütgen-Museum, Cologne (exhibition catalog) vol. 2 (Cologne, 1985), 216–24 no. E18 (bibliog.).

[137]The lost Apocalypse reliefs of the Three Magi Shrine have scarcely been discussed in the previous literature; see Braun, "Ikonographie des Dreikönigenschreins" (see n. 136), 34; Clemen, *Dom zu Köln* (see n. 136), 340, 342, figs. 268, 270 (old views of the shrine from 1781); Hermann Schnitzler, *Rheinische Schatzkammer: Die Romanik* (Düsseldorf, 1959), 39; and Schnitzler and Bloch, *Meister des Dreikönigenschreins* (see n. 136), 16, fig. 4 (old view from 1781).

The Beatus Manuscripts and Related Cycles. A separate tradition of Apocalypse cycles was established by the illustrations of the Apocalypse commentary of the Spanish monk Beatus of Liébana, written 776–84 in Asturia and based on older patristic commentaries.[138] The copies of the Beatus commentary were almost exclusively limited to Spain; only two of the extant manuscripts and fragments originated outside that country.[139] Ten copies include only the text, but another twenty-four illustrate the text with a cycle based on a fifth- or sixth-century Spanish or North African model.[140] These illustrations, inserted between the Apocalypse text and commentary and probably already added during the lifetime of Beatus, were originally simple, schematic images summarizing the essential elements of the Apocalypse text. Probably intended as a visual aid to help memorize the text, they thus formed an integral part of monastic-spiritual practice, Cassiodorus's *lectio divina,* which consisted of reading and memorizing, meditation and contemplation.[141]

The original cycle of illustrations is contained in the Beatus manuscripts of the first and second text edition (fig. 28).[142] Reflecting the cultural rise and increased European contacts of the kingdom of Asturias-León, the original picture version during the second quarter of the tenth century underwent a noticeable transformation in both style and composition—receiving, for example, background stripes in several colors—and a significant expansion in its iconography. Double-page spreads of the evangelists and their symbols were added, as were genealogical tables of the ancestors of Christ and an illustrated Daniel commentary by Saint Jerome.[143]

[138]Henry A. Sanders, ed., *Beati in Apocalipsin libri duodecim* (Rome, 1930); Sergio Alvarez Campos, "Fuentes literarias de Beato de Liébana," in *Actas del Simposio... Beato de Liébana* (see n. 12) (1978), 1:117–62; Eugenio Romero Pose, ed., *Sancti Beati a Liébana Commentarius in Apocalypsin,* 2 vols. (Rome, 1985). See also John Williams's essay herein.

[139]Cf. Manuel Mundó and Manuel Sánchez Mariana, *El comentario de Beato al Apocalipsis: Catálogo* (Madrid, 1976); Emmerson and Lewis, "Census and Bibliography" (see n. 67), pt. 1, 40 (1984): 347–79 nos. 8–32; and Bibliotheek Albert I, *Beatos* (see n. 104), 99–126.

[140]See n. 80 above.

[141]See esp. Jacques Fontaine, "Fuentes y tradiciones paleocristianas en el método espiritual de Beato," in *Actas del Simposio... Beato de Liébana* (see n. 12) (1978) 1:75–101; and Otto Karl Werckmeister, "The First Romanesque Beatus Manuscripts and the Liturgy of Death," in ibid. (1980), 2:165–92 (cf. 168–71). See also Mireille Mentré, "Note sur les perspectives utilisées dans les miniatures mozarabes," *L'Information d'Histoire de l'Art* 14 (1969): 115–22 (cf. 116), and *La miniatura en León y Castilla en la Alta Edad Media* (León, 1976), 81ff.

[142]E.g., Madrid, Biblioteca Nacional MS Vitr. 14-1; Escorial, Cod. &. 11.5; Burgo de Osma Cathedral MS. 1; see Peter K. Klein, *Der ältere Beatus-Kodex Vitr. 14-1 der Biblioteca Nacional zu Madrid: Studien zur Beatus-Illustration und der spanischen Buchmalerei des 10. Jahrhunderts* (Hildesheim, 1976), 176–217, esp. 216, and "Tradición pictórica" (see n. 80), 91–98, esp. 95.

[143]See n. 142 above and esp. John Williams, "The Beatus Commentaries and Spanish Bible Illustration," in *Actas del Simposio... Beato de Liébana* (see n. 12) (1980), 1:201–19.

These expanded cycles are contained in the Beatus Apocalypses in New York (ca. 950–60; fig. 29), in Madrid (968–70), in Valladolid (970), and in Gerona (975).[144]

The Beatus Apocalypse cycles continued to be copied into the thirteenth century. Several eleventh-century codices reflect a pictorial and textual relation to the liturgy of the dead, including those of Saint-Sever (fig. 27), S. Domingo de Silos, and S. Isidoro in León.[145] In the twelfth and thirteenth centuries, the Beatus tradition experienced a final revival, probably because of the many newly founded monasteries. The Cistercians especially commissioned new and at times richly illustrated copies of this highly esteemed Iberian monastic text, including the manuscripts from the Cistercian monasteries of S. Andrés de Arroyo (early 13th c.) and Las Huelgas (1220).[146] The influence of non-Spanish Apocalypse traditions is evident only occasionally in late Beatus manuscripts, as in the Navarra Beatus and the Arroyo Beatus.[147] The reason for the continuing "popularity" of the Beatus Apocalypse in the twelfth and thirteenth centuries is found less in the text, which by that time was entirely outdated, than in the extraordinary wealth of its images. The conceptual schematism of the illustrations corresponded exactly to the abstract tendencies of Romanesque art, but it found no equivalent in the new, more "realistic" Gothic style. Therefore it is not surprising that the eventual dominance of the Gothic—along with the ascent of courtly-secular patronage—meant the death of the centuries-old Beatus tradition.[148]

The influence of the Beatus Apocalypse cycles on other monuments was less than is often assumed.[149] In Spain, influence was limited essentially

[144]New York, Pierpont Morgan Library MS. M. 644; Madrid, Archivo Histórico Nacional, Cod. 1097B; Valladolid, Biblioteca de la Universidad, Cod. 433; Gerona, Cathedral MS. 7; see Emmerson and Lewis, "Census and Bibliography" (see n. 67), pt. 1, 40 (1984): 352–55, no. 11, 360f. no. 17, 368–70 no. 24, 378f. no. 32; and Bibliotheek Albert I, Beatos (see n. 104), 106 no. 6, 111 no. 12, 118 no. 21, 125 no. 32.

[145]Paris, Bibliothèque nationale MS lat. 8878; London, British Library MS Add. 11695; Madrid, Biblioteca Nacional, MS Vitr. 14-2; see Otto Karl Werckmeister, "Pain and Death in the Beatus of Saint-Sever," Studi Medievali, ser. 3a, 14 (1973): 565–626 (cf. 617ff.), and "First Romanesque Beatus Manuscripts" (see n. 141), 171ff.

[146]Paris, Bibliothèque nationale MS Nouv. acq. lat. 2290; New York, Pierpont Morgan Library MS. 429. See Peter K. Klein, "La fonction et la 'popularité' des Beatus, ou Umberto Eco et les risques d'un dilettantisme historique," in Études roussillonnaises offertes à Pierre Ponsich (Perpignan, 1987), 313–25 (cf. 315f.).

[147]See, e.g., the illustration of the Son of Man appearing in the clouds (Apoc. 1:7–8) in the Navarra Beatus (Paris, Bibliothèque nationale, MS Nouv. acq. lat. 1366; late twelfth century). Cf. Peter K. Klein, " 'Et videbit eum omnis oculus et qui eum pupugerunt': Zur Deutung des Tympanons von Beaulieu," in Florilegium in honorem Carl Nordenfalk octogenarii contextum (Stockholm, 1987), 123–44, esp. 131. See also the mouth of hell and the damned bound together by a rope in the "Last Judgment" of the Arroyo Beatus; cf. Bibliotheek Albert I, Beatos (see n. 104), 91 (color pl.).

[148]Klein, "Fonction et 'popularité' des Beatus" (see n. 146), 321.

[149]For that influence, see Xavier Barral i Altet, "Repercusión de la ilustración de los 'Beatos' en la iconografía del arte monumental románico," in Actas del Simposio . . . Beato de Liébana (see n. 12) (1980), 2: 33–50; and Klein, "Tradición pictórica," ibid., 104–6; and "Fonction et 'popularité' des Beatus" (see n. 146), 316ff.

to the kingdom of Asturias-León, the provenance of most extant Beatus manuscripts. Influence is evident already in tenth-century manuscripts from the Castilian scriptoria of Valeránica and S. Millán de la Cogolla (e.g., the *Moralia* (945); and the Códice de Roda, (late 10th c.).[150] Later influence is evident in the vault paintings of the "Panteón de los Reyes" in S. Isidoro at León (early 12th c.),[151] a world map from the Castilian monastery at Oña (late 12th c.),[152] and a Bible from the monastery at Uclés, New Castile (922–25).[153] In Catalonia, the influence of the Beatus tradition was limited to the Leonese Gerona Apocalypse (Gerona Catedral), which was brought to Gerona during the eleventh century and which in the twelfth century served as a model for a Catalonian Beatus Apocalypse[154] and for a capital in the cloisters of Gerona cathedral.[155]

Outside Spain, the influence of the Beatus Apocalypse cycle was even more sporadic. Other than occasional influence on Romanesque monumental sculpture in France (as noted above, for example, in the cloister capitals at Moissac, fig. 10, and the portal of La Lande-de-Fronsac, fig. 36), clear evidence of non-Spanish borrowing from the Beatus tradition exists only in the Romanesque wall paintings of S. Pietro al Monte at Civate, near Como (ca. 1100, fig. 32)[156] and in a few miniatures of the early Gothic English Apocalypse at Trinity College in Cambridge (ca. 1250–60).[157] These borrowings were evidently guided by the didactic-exegetic intentions of those who commissioned the work and, in the case of the Trinity College Apocalypse, by artistic considerations of the miniaturist.

The Anglo-French Gothic Apocalypse Cycles. By the middle of the thirteenth century the last early medieval tradition was replaced by new high-Gothic traditions that would determine Apocalypse illustrations until the

[150]Madrid, Bilioteca Nacional MS. 80; Madrid, Real Academia de la Historia, Cod. 78; see John Williams, "The Moralia in Job of 945: Some Iconographic Sources," *Archivo Español de Arqueología* 45–47 (1972/74): 223–50; and Manuel Díaz y Díaz, "Tres ciudades en el Códice de Roda: Babilonia, Nínive y Toledo," ibid., 251–65.

[151]As has been demonstrated by John Williams in his unpublished lecture at the Colloque International sur les Beatus (Brussels, November 1985).

[152]Milan, Biblioteca Ambrosiana MS. F. 105 sup.; Luis Vázquez de Parga, "Un mapa desconocido de la serie de los Beatos," in *Actas del Simposio . . . Beato de Liébana* (see n. 12) (1978) 1:271–78.

[153]Madrid, Biblioteca Nacional, MS925; see Klein, "Tradición pictórica" (see n. 80), 105, figs. 33, 34.

[154]Turin, Biblioteca Nazionale MS. I.II.1; see Carlos Cid and Isabel Vigil, "El Beato de la Biblioteca Nacional de Turín," *Anales del Instituto de Estudios Gerundenses* 17 (1964/65): 163–329 (cf. 183ff.); and Klein, *Beatus-Kodex* (see n. 142), 165f. 213f.

[155]Jaime Marqués Casanovas in *Sancti Beati a Liebana in Apocalpsin, Codex Gerundensis*, facsimile ed., vol. 2 (Olten, 1962), 72f.; Barral i Altet, "Repercusión" (see n. 149), 47f. and fig. 24.

[156]Hoegger, *Fresken in S. Elia* (see n. 15), 96; Klein, "Cycles" (see n. 39), 151f.; Barral i Altet, "Repercusión" (see n. 149), 49; Klein, "Tradición pictórica" (see n. 80), 105f.

[157]Cambridge, Trinity College MS. Royal 16.2, see Robert Freyhan, "Joachism and the English Apocalypse," *Journal of the Warburg and Courtauld Institutes* 18 (1955): 211–44 (cf. 234); Peter H. Brieger, *The Trinity Apocalypse*, facsimile ed. (London, 1967), 9–11; and Klein, *Endzeiterwartung* (see n. 99), 136f., 157, 164.

end of the Middle Ages. First and foremost among these is the tradition of English Apocalypse cycles. Also called "Anglo-Norman" or "Anglo-French" Apocalypses, since their text is often written in Anglo-Norman or Old French, these Apocalypses were common above all in England and France in the thirteenth and fourteenth centuries.[158] Probably based on a Romanesque Family III model, this new tradition originated in England around 1240,[159] in the context of eschatological expectations and controversies perhaps awakened by Joachim of Fiore's historical-prophetic interpretation of the Apocalypse.[160] In keeping with the Joachite prophecies, many expected the coming of Antichrist and the beginning of a new age of the Holy Spirit around 1260.

The archetype of the English tradition, reflected in the "Morgan group" of manuscripts (figs. 42 and 46), was at first merely a pure picture cycle accompanied by short quotations from the Apocalypse and excerpts from the eleventh-century Berengaudus commentary.[161] Very early, however, the archetype picture cycle was joined with the full text of the Apocalypse and longer selections from the Berengaudus commentary, the half-page pictures now being placed above the text (a practice already evident in a Morgan group manuscript in Paris, dating from about 1245 to 1255).[162] The English cycle, which mostly consists of between eighty and one hundred illustrations, often includes pictures showing the deeds of Antichrist as well as scenes of the apocryphal life of John.[163] The latter are mostly placed before or after the actual Apocalypse cycle, which thereby appears as a biblical *vita* of the saint.[164] The English cycle spread to northern France and Flanders in the late thirteenth century and to other parts of Europe by

[158]Léopold Delisle and Paul Meyer, *L'Apocalypse en français au XIIIe siècle: Bibl. nat. Ms. fr. 403*, facsimile ed., 2 vols. (Paris, 1900–1901); James, *Apocalyspe in Art* (see n. 56), 44–66; Freyhan, "Joachism" (see n. 157), passim; Klein, *Endzeiterwartung* (see n. 99), 65–184; Emmerson and Lewis, "Census and Bibliography" (see n. 67), pt. 2, 41 (1985): 370–409 nos. 38–117; Lucy Freeman Sandler, *Gothic Manuscripts, 1285–1385*, 2 vols. (London, 1986); Nigel Morgan, *Early Gothic Manuscripts*, vol. 2, *1250–1285* (London, 1988). See also Suzanne Lewis's essay herein.

[159]Klein, *Endzeiterwartung* (see n. 99), 159f.

[160]Freyhan, "Joachism" (see n. 157), 219–34; Klein, *Endzeiterwartung* (see n. 99), 171–77; Morgan, *Early Gothic Manuscripts* (see n. 158), 16.

[161]New York, Pierpont Morgan Library MS. 524; Oxford, Bodleian Library MS Auct. D.4.17. See Freyhan, "Joachism" (see n. 157), 218, 235f.; and Klein, *Endzeiterwartung* (see n. 99), 159f.

[162]Paris, Bibliothèque nationale MS fr. 403. See Freyhan, "Joachism" (see n. 157), 223f. n. 4, 235f.; Klein, *Endzeiterwartung* (see n. 99), 159; and Morgan, *Early Gothic Manuscripts* (see n. 158), 18, 63f. no. 103.

[163]For the Antichrist scenes in the Anglo-French Apocalypses, see Jesse J. Poesch, "Antichrist Imagery in Anglo-French Apocalypse Manuscripts" (Ph.D. diss., University of Pennsylvania, 1966), and "Revelation 11:7 and Relevation 13:1–10: Interrelated Antichrist Imagery in Some English Apocalypse Manuscripts," in *Art the Ape of Nature: Studies in Honor of H. W. Janson*, ed. Moshe Barasch and Lucy Freeman Sandler (New York, 1981), 15–33; Richard Kenneth Emmerson, *Antichrist in the Middle Ages: A Study of Medieval Apocalypticism, Art, and Literature* (Seattle, 1981), 110ff.; and Gosbert Schüssler, *Studien zur Ikonographie des Antichrist* (Munich, 1983), 223–42.

[164]Freyhan, "Joachism" (see n. 157), 225f.

the fourteenth.[165] This tradition, which developed into numerous groups and subgroups, consists of nearly a hundred extant manuscripts dating from the thirteenth to the fifteenth century. In the beginning, the English cycles were primarily didactic and exegetic,[166] since they were commissioned primarily by church and monastic institutions.[167] Chivalric and courtly tendencies soon appeared, though; for these Apocalypses were increasingly commissioned by aristocratic and courtly circles to serve as luxury manuscripts for private devotion and cultivated entertainment.[168]

The most important groups of the English Apocalypse cycle are the "Metz group" (e.g., figs. 43, 49, and 50), which developed in the middle of the thirteenth century from the archetypal Morgan group,[169] and the courtly "Westminster group" (e.g., figs. 45, 48), which developed a little later from both the archetype and the Metz group.[170] Two later subgroups of the fourteenth century also derive from the Metz group, the Apocalypses originating in the East Anglia fenlands[171] and the subgroup connected with the Cloisters Apocalypse in New York, which originated in Normandy.[172] The Trinity College Apocalypse in Cambridge summarizes the early English Gothic cycles by merging models of the Metz and Westminster groups with borrowings from the Beatus illustrations to form a convincing synthesis.[173]

[165]For the most recent list of these manuscripts, see Emmerson and Lewis, "Census and Bibliography" (see n. 67), pt. 2, 41 (1985): nos. 38–117.

[166]Freyhan, "Joachism" (see n. 157), 223–25, 229–32.

[167]Klein, *Endzeiterwartung* (see n. 99), 177; Suzanne Lewis, "Giles de Bridport and the Abingdon Apocalypse," in *England in the Thirteenth Century*, ed. W. M. Ormrod (Harlaxton, 1985), 109–19.

[168]Freyhan, "Joachism" (see n. 157), 225f., 232–34; George Henderson, "Studies in English Manuscript Illumination, Part II: The English Apocalypse I," *Journal of the Warburg and Courtauld Institutes* 30 (1967): 104–37 (cf. 116f.); Barbara Nolan, *The Gothic Visionary Perspective* (Princeton, 1977), 68–82.

[169]E.g., Metz, Bibliotêque municipale MS Salis 38; and London, Lambeth Palace MS. 209. See Eric G. Millar, "Les principaux manuscrits à peintures du Lambeth Palace de Londres," *Bulletin de la Société Française pour la Reproduction de Manuscrits à Peintures* 8 (1924): 1–66 (cf. 40–43); Freyhan, "Joachism" (see n. 157), 218f., 231; Jessie Poesch, "Review of Peter Brieger, 'The Trinity Apocalypse,'" *Art Bulletin* 50 (1968): 199–203 (cf. 202); and Klein, *Endzeiterwartung* (see n. 99), 161f.

[170]E.g., Malibu, Getty Museum MS Ludwig III.; and Oxford, Bodleian Library MS Douce 180. See Klein, *Endzeiterwartung* (see n. 99), 164–66.

[171]E.g., Oxford, Bodleian Library, Canon. Bib. lat. 62. See Lucy Freeman Sandler, *The Peterborough Psalter in Brussels and Other Fenland Manuscripts* (London, 1974), 62–87, 100–107, and *Gothic Manuscripts, 1285–1385* (see n. 158), 2:100–102 nos. 92, 93; and Klein, *Endzeiterwartung* (see n. 99), 162.

[172]New York, Metropolitan Museum, the Cloisters. See Florens Deuchler, Jeffrey M. Hoffeld, and Helmut Nickel, eds., *The Cloisters Apocalypse: An Early Fourteenth-Century Manuscript in Facsimile* (New York, 1971); Grand Palais, *Les fastes gothiques: Le siècle de Charles V* (exhibition catalog) (Paris, 1981), 304f. no. 252 (François Avril); and Klein, *Endzeiterwartung* (see n. 99), 67, 162f.

[173]Cambridge, Trinity College Ms. Roy. 16.2. Cf. Freyhan, "Joachism" (see n. 157), 234; Klein, *Endzeiterwartung* (see n. 99), 163f.; and Morgan, *Early Gothic Manuscripts* (see n. 158), 18, 74 no. 110. For a different view of the position of the Trinity Apocalypse, which considers this manuscript as one of the archetypes of the Anglo-French Apoca-

This version was adopted in the late thirteenth century in the English Apocalypses of the "French prose version" in reduced and simplified form (e.g., figs. 41, 44, and 47).[174] In similar fashion around 1300 the Westminster group formed the foundation for the French verse version [175] and then in the late fourteenth century for the wall paintings in the chapter house of Westminster Abbey in London.[176] Toward the end of the thirteenth century, yet another English subgroup emerged from elements of the Metz tradition.[177] One manuscript of this later subgroup—unfortunately no longer extant—must have served as a model for the famous Angers Apocalypse tapestry in the Angers Musée des Tapisseries,[178] which was commissioned by Duke Louis I of Anjou and woven in 1377–79 in the Parisian workshops of Nicolas Bataille, based on the cartoons by the Flemish painter Jean Bondol (Hennequin of Bruges).[179] The model English cycle,

lypses, see Brieger, *Trinity Apocalypse* (see n. 157), 5, 14; and Henderson, "English Apocalypse I" (see n. 168), 131–35.

[174]E.g., London, Lambeth Palace MS. 75; and Paris, Bibliothèque nationale MS Fr. 9574. See Freyhan, "Joachism" (see n. 157), 219, 221, 228, 232f.; Poesch, "Antichrist Imagery" (see n. 163), 276–80; A. H. Laing, "The Queen Mary Apocalypse (London, British Museum, Royal 19.B.XV)," (Ph.D. diss., Johns Hopkins University, 1971), 22–33; and Morgan, *Early Gothic Manuscripts* (see n. 158), 175–77 nos. 173a, 173b.

[175]E.g., Oxford, Bodleian Library, MS. Ashmole 753. See Freyhan, "Joachism" (see n. 157), 219, 221; and Poesch, "Antichrist Imagery" (see n. 163), 269–74, and "Revelation 11:7" (see n. 163), 29–31.

[176]An intermediary role between the thirteenth-century Westminster Apocalypses and the late fourteenth-century Westminster chapter house frescoes may have been played by a contemporary late fourteenth-century Westminster Apocalypse in Cambridge, Trinity College MS.B.10.2 (cf. Sandler, *Gothic Manuscripts, 1285–1385* [see n. 158], 2:176 no. 153). For the Westminster Apocalypse frescoes and their manuscript model, see *Royal Commission on Historical Monuments: An Inventory of the Historical Monuments in London*, vol. 1 (London, 1924), 9, 79–81, pls. 13–15; J. G. Noppen, "The Westminster Apocalypse and Its Source," *Burlington Magazine* 61 (1932): 146–59; Christel Hansen, *Die Wandmalereien des Kapitelhauses der Westminsterabtei London* (Würzburg, 1939), 14–27; and David Park, "Wall Painting," in *Age of Chivalry: Art in Plantagenet England, 1200–1400*, ed. Jonathan Alexander and Paul Binski (London, 1987), 125–30 (cf. 130).

[177]E.g., formerly Basel, Burckhardt-Wildt Colletion; Florence, Biblioteca Laurenziana MS Ashburnham 415; and London, British Library MS Add. 22493. See *The Apocalypse: A Series of Seventy-Seven Miniatures from an English Apocalypse* (Sotheby's sale catalog (London, 1983), 1–44, lots 31–68; Peter de Winter, "Visions of the Apocalypse in Medieval England and France," *Cleveland Museum of Art Bulletin* 70 (1983): 396–417; Nigel Morgan, "The Burckhardt-Wildt Apocalypse," *Art at Auction: The Year at Sotheby's 1982–1983* (London, 1983), 162–69; and Emmerson and Lewis "Census and Bibliography" (see n. 67), pt. 2, 41 (1985): 370 no. 38.

[178]George Henderson, "The Manuscript Model of the Angers 'Apocalypse' Tapestries," *Burlington Magazine* 127 (1985): 209–18.

[179]Contrary to the older literature, Fabienne Joubert and others have shown that Nicolas Bataille was not the weaver of the Angers tapestries but only a merchant and banker who financed this large project. For the Angers tapestries, see René Planchenault, *L'Apocalypse d'Angers* (Paris, 1966); Fabienne Joubert, "L'Apocalypse d'Angers et les débuts de la tapisserie historiée," *Bulletin Monumental* 139 (1981): 125–40; and Pierre-Marie Auzas et al., *L'Apocalypse d'Angers: Chef-d'oeuvre de la tapisserie médiévale* (Paris, 1985).

which must have been rather dry and mediocre, was thus translated in grandiose fashion into the monumental medium of the wall tapestries and the playful-courtly style of Franco-Flemish art.

Gothic Cycles on the Continent. Independent of the English cycles, several Gothic Apocalypse cycles based on the Romanesque Family III were created on the Continent in the thirteenth century. The *Bible moralisée,* a voluminous illuminated Bible commissioned by the French royal family and created around 1220 or 1230 in Paris, may serve as an example. The manuscripts of the *Bible moralisée* contain parallel Bible and commentary illustrations in the shape of small medallions placed side-by-side (e.g., fig. 30); approximately 150 scenes depicting the Apocalypse are matched by an equal number of moralizing commentary illustrations.[180] Yet another French cycle—the sculptures of the southern west portal of Reims cathedral, which include more than a hundred scenes depicting the Apocalypse and the life of Saint John—was created in the 1260s,[181] patterned to a large extent on a model based on the Romanesque Family III. The model may have been the somewhat earlier Gothic copy of the *Liber floridus* from the Chartreuse of Montdieu near Reims.[182]

The German Gothic Apocalypse cycles are also largely based on older models, especially those of the Romanesque Family III. The cycle illustrating Alexander Minorita's Apocalypse commentary (ca. 1242) contains eighty-five miniatures that represent the first attempt to offer a continuous historical-prophetic interpretation of the Apocalypse.[183] A literal ren-

[180]E.g., Vienna, Österreichische Nationalbibliothek, Cod. 1178; Toledo, Cathedral treasury MS vol. III; and London, British Library MS Harley 1527. See Alexandre de Laborde, *La Bible moralisée illustrée* (Paris, 1911–28), vols. 1–4 (plates), vol. 5 (text); Reiner Haussherr, "Sensus literalis und sensus spiritualis in der Bible moralisée," *Frühmittelalterliche Studien* 6 (1972): 356–80, and *Bible moralisée: Codex Vindobonensis 2554,* facsimile ed. (Graz, 1973); Robert Branner, *Manuscript Painting in Paris during the Reign of Saint-Louis: A Study of Styles* (Berkeley, 1977), 32–57; and Emmerson and Lewis, "Census and Bibliography" (see n. 67), pt. 3, 42 (1986): 460–64 nos. 153–58.

[181]Peter Kurmann, "Le portail apocalyptique de la cathédrale de Reims," in *L'Apocalypse de Jean* (see n. 1), 245–317, and *La façade de la cathédrale de Reims: Architecture et sculpture des portails* (Lausanne, 1987), 200–204, 231–239.

[182]Paris, Bibliothèque nationale ms. lat. 8865, cited at n. 113 above. See Kurmann, "Portail apocalytique" (see n. 181), 254–57,268f.; Klein, *Endzeiterwartung* (see n. 99), 77–79.

[183]E.g., Prague, Kapitulni knihovna MS Cim. 5; Dresden, Staatsbibliothek MS. A.117; Wroclaw, Biblioteka Uniwersytecka Ms. I. Q.19; and Cambridge, University Library MS. Mm.V.31. For the text of the Alexander commentary, see Alois Wachtel, "Die weltgeschichtliche Apokalypse-Auslegung des Minoriten Alexander von Bremen," *Franziskanische Studien* 24 (1937): 201–59, 305–63, and idem, ed., *Alexander Minorita: Expositio in Apocalypsin* (MGHQ1). For the illustrations and their iconographic sources, see Max Huggler, "Der Bilderkreis in den Handschriften der Alexander-Apokalypse," *Antonianum* 9 (1934): 85–150, 269–308; Teresa Mroczko, "Ze Studiów nad Apokalipsa Wroclawska," *Sredniowiecze: Studia o Kulturze* (Warsaw, 1961), 92–170; eadem, "Ilustracje apokalipsy we wroclawskim komentarzu Aleksandra O.F.M.," *Rocznik Historii Sztuki*

dering of the historical and allegorical interpretation of the commentary text is matched with a set of historical figures who appear as equivalents, by the addition of a second head with the appropriate symbolic attributes. Thus, in the scene depicting the restraining of the four winds (fig. 15), behind the head of the angel clothed with the sun appears the head of the Christian emperor Constantine, while the second heads of the four angels restraining the winds are designated by the inscriptions as the pagan emperors Maximus, Maxentius, Licinus, and Severus.[184] Although the Alexander Minorita commentary is preserved in only a few copies, it nevertheless influenced later cycles, such as the forty-five Apocalypse panels of a large-scale altarpiece painted around 1400 in the Hamburg workshop of Master Bertram.[185] The Apocalypse cycle of the Velislav Bible in Prague, which contains thirty-four miniatures (mid 14th c.), may also have been inspired by the Alexander cycle of a similar type.[186] The Apocalypse frescoes of the St. Mary Chapel at Karlstein Castle near Prague (ca. 1357–61) derive, however, from other, probably Italian, sources and must be understood in the context of the soteriologically oriented imperial iconography of Charles IV which determines the mural decoration of the castle.[187]

The iconography of some later German Apocalypse cycles occasionally also reflects specific political and spiritual ideologies. The illustrations of the Teutonic Knights Apocalypse by Heinrich von Hesler, which is a German verse paraphrase of the Apocalypse dating from 1310, occupy a special place, although the author was probably familiar with the Alexander

6(1966): 7–45; eadem, "Geneza ikonografii Apokalipsy Wroclawskiej," ibid., 7(1969): 47–106; and Emmerson and Lewis, "Census and Bibliography" (see n. 67), pt. 3, 42 (1986), 443–46nos. 118–22. See also David Burr's essay herein, pp. 99–100.

[184]Cf. Huggler, "Bilderkreis" (see n. 183), 127f. and fig. 5; C. M. Kauffmann, *An Altar-Piece of the Apocalypse from Master Bertram's Workshop in Hamburg* (London, 1968) fig. 16; and Thomas Raff, "Die Ikonographie der mittelalterlichen Windpersonifikationen," *Aachener Kunstblätter* 48 (1978/79): 71–218 (cf. 136f. and figs. 97, 98).

[185]Kauffmann, *Altar-Piece* (see no. 184), 14–26. For the scene of the restraining of the four winds on this altarpiece, see also Raff, "Windpersonifikationen" (see n. 184), 138 and fig. 99.

[186]Prague, Universitná knihovna MS. XXIII.C.124; see A. Matejcek, *Velislalova Bible a její místo ve vivoji knizni ilustrace gotické* (Prague, 1926); Gerhard Schmidt, "Malerei bis 1450," in *Gotik in Böhmen*, ed. Karl M. Swoboda (Munich, 1969), 167–321 (cf. 170); Karel Stejskal, *Velislai Biblia Picta*, facsimile ed., 2 vols. (Prague, 1970); Joachim M. Plotzek, "Bilder zur Apokalypse," in Anton Legner, ed., (exhibition catalog) *Die Parler und der Schöne Stil, 1350–1400*, vol. 3. (Cologne, 1978), 195–210 (cf. 196f.); Emmerson, *Antichrist* (see n. 163), 124ff.; and Emmerson and Lewis, "Census and Bibliography" (see n. 67), pt. 3, 42 (1986): 454f. no. 141.

[187]For the Apocalypse frescoes at Karlstein, see Antonín Friedl, *Mistr karlstejnské Apokalypsy* (Prague, 1950); Vlasta Dvoráková et al., *Gothic Mural Painting in Bohemia and Moravia, 1300–1378* (London, 1964), 92ff.; Vlasta Dvoráková and Dobroslava Menclová, *Karlstejn* (Prague, 1965), 141ff.; Schmidt, "Malerei bis 1450" (see n. 186), 201–4; and Plotzek, "Bilder zur Apokalypse" (see n. 186), 197–99.

commentary.[188] The pictures reflect at times the specific ideology of the Order of the Teutonic Knights. A crusading knight with the cross on his white robe is portrayed in the illustration depicting the struggle against Gog and Magog, for example, and the following picture shows the baptism of pagans and Jews by Teutonic Knights in the newly conquered Eastern territories.[189]

The Trecento Cycles in Italy. A specifically Italian tradition of the trecento, independent of the English and German cycles, is represented by the fourteenth-century Apocalypse cycles of Naples (cf. fig. 16), which were perhaps influenced by the frescoes of Cimabue and Giotto.[190] The monumental Apocalypse frescoes in the south transept of the upper church of S. Francesco in Assisi, executed by Cimabue and his work-shop between 1277 and 1280, are limited to a few scenes, all of which depict angels: the adoration of the Lamb by the Elders and angels, the four angels retaining the winds and the angel clothed with the sun, the seven angels with trumpets and the angel with the censer, the angel an-nouncing the fall of Babylon, and the angels fighting the Dragon.[191] Since the altar in the south transept was dedicated to the archangel Michael, these angels evidently relate to the liturgy of the angels and the relevant exegesis (for example, by Bonaventure).[192] They are certainly not in-tended as radical Franciscan and antipapal propaganda, as has occasionally been suggested.[193]

The Apocalypse frescoes in S. Chiara, which King Robert of Anjou com-missioned Giotto to paint during his stay in Naples (1328–32), are no

[188]Konigsberg, Staatsbibliothek MSS. 891 and 891b, both destroyed; Stuttgart, Würt-tembergische Landesbibliothek MS Hb. XIII.11 poetae germ.; see Karl Helm, ed, *Die Apokalypse Heinrichs von Hesler aus der Danziger Handschrift* (Berlin, 1907); Toni Hermann, *Der Bildschmuck der Deutsch-Ordensapokalypse Heinrichs von Hesler* (Königsberg, 1934); Schüssler, *Ikonographie des Antichrist* (see n. 163), 309–24; Raff, "Windpersonifikationen" (see n. 184), 138; and Emmerson and Lewis, "Census and Bib-liography" (see n. 67), pt. 3, 42 (1986): 447f. nos. 124, 125, 449f. no. 131.

[189]Hermann, *Bildschmuck* (see n. 188), 55, 68, 82; Schüssler, *Ikonographie des Anti-christ* (see n. 163), 322. A similar scene recurs in the Antichrist sequence of the Hesler Apocalypses (see Hermann, *Bildschmuck*, 32, 74; and Schüssler, *Ikonographie des An-tichrist*, 315ff.).

[190]A. zu Erbach-Fürstenau, "Die Apokalypse von Santa Chiara," *Jahrbuch der Preus-sischen Kunstsammlungen* 58 (1937): 81–106; Annegrit Schmitt, "Die Apokalypse des Robert von Anjou," *Pantheon* 28 (1970): 475–503.

[191]Cf. Augusta Monferini, "L'Apocalisse di Cimabue," *Commentari,* n.s., 17 (1966): 25–55; Hans Belting, *Die Oberkirche von San Francesco in Assisi* (Berlin, 1977), 61–67, 131–34; Yves Christe, "L'Apocalypse de Cimabue à Assise," *Cahiers Archéologiques* 29 (1980/81): 157–74; and Irene Hueck, "Cimabue und das Bildprogramm der Oberkirche von San Francesco in Assisi," *Mitteilungen des Kunsthistorischen Instituts in Florenz* 25 (1984): 280–324.

[192]Belting, *Oberkirche* (see n. 191), 66f.; Hueck, "Bildprogramm der Oberkirche" (see n. 191), 281ff.

[193]By Monferini, for instance in "Apocalisse di Cimabue" (see n. 191). See, on the con-trary, Belting, *Oberkirche* (see n. 191), 38–45, 65–68.

longer extant.[194] Giotto's Apocalypse fresco in the Peruzzi Chapel of S. Croce in Florence (ca. 1335?),[195] as well as the Apocalypse wall paintings in S. Maria Donna Regina at Naples,[196] which were made after 1317 by unknown Roman artists, exhibit striking parallels to the later Neapolitan cycles, such as the islandlike arrangement of the scenes and Saint John's squatting position on Patmos. It is reasonable to assume that Giotto's lost frescoes in S. Chiara were part of the same tradition. The main works of this tradition are two small Neapolitan panel paintings in the Stuttgart Staatsgalerie (ca. 1330–40), which portray forty-four Apocalypse scenes in light colors and are arranged, islandlike, in four registers against a dark-blue background.[197] The iconography of these altar panels reappears during the middle and late fourteenth century in Neapolitan manuscripts (e.g., the Hamilton Bible of ca. 1350; cf. fig. 16)[198] and in north Italian wall paintings and panel paintings such as Giusto de' Menabuoi's Padua baptistery frescoes (1378)[199] and Jacobello Alberegno's Torcello polyptych in the Venice Gallerie dell'Accademia.[200] This specifically Italian tradition, moreover, influenced cycles outside Italy as well. In addition to the Bohemian frescoes at Karlstein Castle already mentioned, the tradition influenced the second part of the Escorial Apocalypse, painted for the House of Savoy by Jean Colombe after 1482;[201] the same applies to the right wing of Hans Memling's Saint Catherine altarpiece in the Sint-Jans Hospital at

[194]Giorgio Vasari, *Le vite de' più eccellenti pittori, scultori e architettori* (1558), ed. G. Milanesi, vol. 1 (Florence, 1878), 390; Erbach-Fürstenau, "Apokalypse von Santa Chiara" (see n. 190), 81–83, 100.

[195]Leonetto Tintori and Eve Borsook, *Giotto: The Peruzzi Chapel* (New York, 1965), 25–28, 64f., and figs. 68–76.

[196]Ferdinando Bologna, *I pittori alla corte angioina di Napoli, 1266–1414* (Rome, 1969), 138; Schmitt, "Apokalypse des Robert von Anjou" (see n. 190), 482–84, 494, and figs. 1–2, 11, 34–35; Bernhard Degenhart and Annegrit Schmitt, "Marino Sanudo und Paolino: Zwei Literaten des 14. Jahrhunderts in ihrer Wirkung auf Buchillustrierung und Kartographie in Venedig, Avignon und Neapel," *Römisches Jahrbuch für Kunstgeschichte* 14 (1973): 1–137 (cf. 98f., 111, and fig. 83); E. Carelli and S. Casiello, *Santa Maria di Donnaregina* (Naples, 1975); R. Mormone, *La chiesa trecentesca di Donnaregina* (Naples, 1978), 21–26.

[197]Erbach-Fürstenau, "Apokalypse von Santa Chiara" (see n. 190); and Schmitt, "Apokalypse des Robert von Anjou" (see n. 190).

[198]Cf. Schmitt (see n. 190), 48off. and figs. 5, 7, 9, 10, 12, 13, 15, 19–23; Degenhart and Schmitt, "Marino Sanudo und Paolino" (see n. 196), 108–13 and figs. 130, 131; and Christe, "Apocalypse de Cimabue" (see n. 191), 163f. For the Hamilton Bible, see also Brandis, *Zimelien* (see n. 65), 68f. no. 48; and Emmerson and Lewis "Census and Bibliography" (see n. 67), pt. 3, 42 (1986): 452f. no. 138.

[199]Sergio Bettini, *Giusto de' Menabuoi e l'arte del Trecento* (Padua, 1944), 77–85 and figs. 110–21, and *Le pitture di Giusto de' Menabuoi nel battistero del duomo di Padova* (Venice, 1960), 64–67, and fig. 3, pls. 41, 42; van der Meer, *Apokalypse* (see n. 16), 194 and fig. 127.

[200]Cf., Kunsthistorisches Museum Wien, *Europäische Kunst um 1400* (exhibition catalog) (Vienna, 1962), 79f. nos. 1, 2 (bibliog.); and van der Meer, *Apokalypse* (see n. 16), 194f. and figs. 128, 129.

[201]Escorial, Biblioteca del Monasterio MS. Vitr. 5; see C. Gardet, *L'Apocalypse figurée des ducs de Savoie*, facsimile ed. (Annecy, 1969); *Apocalipsis figurado de los duques de*

Bruges (1475–79; fig. 57);[202] and even to the Russian icon by the master
Dionisii in the Kremlin's Uspensky Sobor Cathedral, from about 1500.[203]

Late Gothic Block-books and Printed Bibles. The oldest printed illus-
trated Apocalypses are the ones printed by handpress from wooden
blocks.[204] These block-book Apocalypses probably originated in the Neth-
erlands (Haarlem?; cf. fig. 54) in the second quarter of the fifteenth
century,[205] influenced by an illuminated Flemish Apocalypse manuscript

Saboya, facsimile ed., 2 vols. (Madrid, 1981); and Emmerson and Lewis, "Census and Bib-
liography" (see n. 67), pt. 2, 41 (1985): 380 no. 57.
 [202]Cf. Max Friedländer, *Hans Memling and Gérard David*, vol. 4, pt. 1, of *Early Neth-
erlandisch Painting* (Leyden, 1971), 77 no. 11, fig. 43; van der Meer, *Apokalypse* (see n.
16) 259–71 and figs. 168–75; and C. van Hooreweder, *Hans Memling in Sint-Jans Spital
in Brügge* (Bruges, 1984).
 [203]Michail V. Alpatov, *Il maestro del Cremlino* (Milan, 1963); Yves Christe,
"Quelques remarques sur l'icône de l'Apocalypse du maître du Kremlin à Moscou," *Zog-
raphe* 6 (1975): 59–67; and Carolyn W. Anderson, "Image and Text in the Apocalypse
Icon of the Dormition Cathedral of the Moscow Kremlin" (Ph.D. diss., University of
Pittsburgh, 1977).
 [204]For reproductions of the block-book Apocalypses, which were classified by Wilhelm
Schreiber into six recensions (*Manuel de l'amateur de la gravure sur bois et sur métal au
XVe siècle*, vol. 4 [Leipzig, 1902; reprint, Stuttgart, 1969], 160–216), see Paul Kristeller,
Die Apokalypse: Die älteste Blockbuchausgabe (Berlin, 1916), which reproduces the
Munich, Bayerische Staatsbibliothek MS Xyl. 4 (Schreiber II); Heinrich Theodore Mus-
per, *Die Urausgabe der holländischen Apokalypse und Biblia Pauperum*, 3 vols. (Mu-
nich, 1961), facsimile ed., of the London, British Museum MS (Schreiber III); and Sergio
Samek Ludovici and Cesare Angelini, eds., *Apocalisse xilografica estense* (Parma, 1969),
facsimile ed. of the Modena, Biblioteca Estense MS. AD.5.22 (Schreiber IV).
 [205]The archetype of the block-book Apocalypses, its date, and place of origin are rather
controversial issues among specialists. Generally scholars agree that the versions
Schreiber I and II are the oldest; only Musper, in "Die Urausgabe der Apokalypse," *Die
Graphischen Künste*, n.s., 2 (1937), 128–36, considers the version Schreiber III the ar-
chetype. Whereas Schreiber, in *Manuel de l'amateur* (see n. 204), 160ff., supposed that
the block-book Apocalypses originated about 1465 in the region between Liège and Co-
logne, Kristeller, in *Älteste Blockbuchausgabe* (see n. 204), 20, 24, and Musper, in *Uraus-
gabe der holländischen Apokalypse* (see n. 204), 16–22, dated the archetype as early as
1420–30; Joseph Schretlen, in *Dutch and Flemish Woodcuts of the Fifteenth Century*
(London, 1925), 11, and Musper assumed that it originated in the Netherlands, probably
in Haarlem. More recent scholarship mostly dates the earliest block-book Apocalypses
in the early 1450s, especially because of the watermarks of their paper (cf. Lamberto
Donati, "Osservazioni sperimentali sull'Apocalissi xilografica (I-II-III)," *Bibliofilia* 58
[1956]: 85–124, and "Dal libro xilografico al manoscritto: L'Apocalissi," in *Studi offerti
a Roberto Ridolfi* [Florence, 1973], 249–84; and Leonie von Wilckens, "Hinweise zu
einigen frühen Einblattholzschnitten und zur Blockbuchapokalypse," *Anzeiger des Ger-
manischen Nationalmuseums* 1978:7–23). This method of dating is not, however, with-
out problems; see Christian von Heusinger, "Review of W. L. Schreiber, Handbuch der
Holz- u. Metallschnitte des XV. Jahrhunderts (Stuttgart, 1976)," *Zeitschrift für Kunst-
geschichte* 42 (1979): 233–39, cf. 237f. Recent scholarship seems especially to overlook
the fact that the oldest *extant* block-book Apocalypses must not have been the earliest
ones produced! Thus, the second quarter of the fifteenth century seems to me the most
reasonable date for the archetype.

in the tradition of the oldest English Gothic cycle (the Morgan group).[206] A modified and more recent version of this Apocalypse from the fifteenth century is mirrored also in several contemporary Flemish and German Apocalypses.[207] The block-book Apocalypses feature more than ninety scenes of the Apocalypse and the life of Saint John, portrayed in a simplified linear-expressive style and arranged usually on forty-eight to fifty blocks, which are divided horizontally. Explanatory quotations from the Bible and commentaries are in Latin and inscribed within the pictures (cf. figs. 54 and 55). Over sixty copies have been preserved, which shows that the block-book Apocalypses were widely distributed in the Netherlands and Germany, especially among the lower clergy and educated laymen in the cities,[208] many of whom could read Latin. Perhaps their popularity is related to the activities of popular reform movements, such as the Brethren of the Common Life.[209]

More important for the later innovative development of late Gothic graphic prints are those Flemish Apocalypse manuscripts that condense the usual eighty to hundred illustrations of the English cycles to only a few compositions. Among these are the twenty-three whole-page miniatures contained in a Flemish Apocalypse manuscript in Paris (ca. 1400; fig. 53).[210] This tendency toward simplification and condensation of the traditional Gothic cycles is repeated yet more strongly toward the last quarter of the fifteenth century in the woodcut series of the German printed Bibles,[211] such as those in the Cologne Bible, printed by Heinrich Quentell

[206]For the manuscript models of the block-book Apocalypses, see esp. Gertrud Bing, "The Apocalypse Block-Books and Their Manuscript Models," *Journal of the Warburg and Courtauld Institutes* 5 (1942): 143–58; and von Wilckens, "Hinweise" (see n. 205), 13–20.

[207]E.g., New York, Pierpont Morgan Library MS. M.133; Chantilly, Musée Condé MS. 28; London, British Library MSS Add. 38121, 19896; and Wellcome Library MS. 49; and New York, Public Library MS De Ricci 15. To this group also belongs an older Flemish Apocalypse from about 1360–70, in Manchester, John Rylands Library, MS lat. 19. See n. 206 and Fritz Saxl, "A Spiritual Encyclopedia of the Later Middle Ages," *Journal of the Warburg and Courtauld Institutes* 5 (1942): 82–142; Kathryn Henkel, *The Apocalypse* (University of Maryland Art Gallery exhibition catalog) (College Park, 1973), 31–35; and Emmerson and Lewis "Census and Bibliography" (see n. 67), pt. 2, 41 (1985): 377f. no. 52, 386 no. 69, 395f. no. 88, and pt. 3, 42 (1986): 448f. nos. 127–29.

[208]Kristeller, *Älteste Blockbuchausgabe* (see n. 204), 8–9.

[209]Henkel, *Apocalypse* (see n. 207), 38–41.

[210]Paris, Bibliothèque nationale MS Néerl. 3; see Mariette Hontoy, "Les miniatures de l'Apocalypse flamande de Paris (Bibl. nat. Fonds Néerl. No. 3)," *Scriptorium* 1 (1946): 289–309; van der Meer, *Apokalypse* (see n. 16), 202–35 and pls. 137–59; and Emmerson and Lewis, "Census and Bibliography" (see n. 67), pt. 3, 42 (1986) : 452 no. 136.

[211]Kenneth Albert Strand, *German Bibles before Luther* (Grand Rapids, Mich., 1966); Horst Kunze, *Geschichte der Buchillustration in Deutschland: Das 15. Jahrhundert* (Leipzig, 1975); Walter Eichenberger and Henning Wendland, *Deutsche Bibeln vor Luther: Die Buchkunst der achtzehn deutschen Bibeln zwischen 1466 und 1522* (Hamburg, 1977).

in 1478–79,[212] which compress the entire substance of the Apocalypse into only nine pictures. Thus the Four Horsemen, which were formerly distributed into four separate scenes, are now brought together in one picture to form a single cavalcade (fig. 17). The blocks used in the Cologne Bible were used again in the Nürnberg Bible of Anton Koberger from 1483 (fig. 17) and were reverse copied in the woodcuts for the Strasbourg Grüninger Bible of 1485.[213]

These woodcut prints of the Koberger and Grüninger Bibles and perhaps also the block-book Apocalypses provided the raw material for Albrecht Dürer's famous sequence of fifteen Apocalypse woodcuts (fig. 56). They appeared in 1498, in simultaneous German and Latin editions, from Dürer's own publishing house, and in 1511 a new printing of the Latin edition was provided with a modified title page.[214] Dürer adopted significant compositional ideas and principles characteristic of the older printed Bibles and block-book Apocalypses. In addition to single motifs he adopted, above all, the principle of conflating several scenes into one unified, comprehensive composition, such as in the Four Horsemen or the seventh seal. He also endowed them, however, with a visionary power and immediacy through his creative synthesis of late Gothic dynamic linearism, Renaissance realism, and the humanist world view. Dürer set a standard that, though it was immediately emulated by other artists (for example, the woodcut series by Cranach the Elder, Holbein the Younger, Schäufelein, Altdorfer, and Burgkmair),[215] was never again achieved. Dominating Western Apocalypse

[212]R. Kautsch et al., eds. Die Kölner Bibel, 1478–1479, facsimile ed. with commentary (Amsterdam, 1979). See also Rudolph Kautzsch, Die Holzschnitte der Kölner Bibel von 1479 (Strasbourg, 1896); Wilhelm Worringer, Die Kölner Bibel (Munich, 1923); Severin Corsten, "Die Kölner Bilderbibel von 1479," Gutenberg Jahrbuch (1957): 72–93; Hildegard Reitz, Die Illustrationen der "Kölner Bibel," (Düsseldorf, 1959); Kenneth Albert Strand, Early Low-German Bibles (Grand Rapids, Mich., 1967); and Eichenberger and Wendland, Deutsche Bibeln (see n. 211), 65–86.

[213]For the Koberger and Grüninger Bibles, see Paul Ahune, La Bible de Jean Gruninger 1485 (Strasbourg, 1952); Erwin Panofsky, The Life and Art of Albrecht Dürer, 4th ed. (Princeton, 1955), 53–56; Philipp Schmidt, Die Illustration der Lutherbibel (Basel, 1962), 66–87; and Eichenberger and Wendland, Deutsche Bibeln (see n. 211), 91–109.

[214]For Dürer's woodcut Apocalypse and its iconographic sources, see Wilhelm Neuss, "Die ikonographischen Wurzeln von Dürers Apokalypse," in Volkstum und Kulturpolitik: Festschrift für Georg Schreiber (Cologne, 1932), 185–97; Hans Friedrich Schmidt, "Dürers Apokalypse und die Strassburger Bibel von 1485," Zeitschrift des Deutschen Vereins für Kunstwissenschaft 6 (1939): 261–66; Panofsky, Dürer (see n. 213), 51–59; Franz Juraschek, Das Rätsel von Dürers Gottesschau: Die Holzschnittapokalypse und Nikolaus von Cues (Salzburg, 1955); Karl Arndt, "Dürers Apokalypse: Versuche zur Interpretation" (Ph.D. diss., Universität Göttingen, 1956); Rudolph Chadraba, Dürers Apokalypse: Eine ikonologische Deutung (Prague, 1964); Karel Stejskal, "Novy vyklad Dürerovy Apokalypsy," Umeni 1 (1966): 1–64 (60–64: German summary); and Alexander Perrig, Albrecht Dürer oder Die Heimlichkeit der deutschen Ketzerei: Die "Apokalypse" Dürers und andere Werke von 1495 bis 1513 (Weinheim, 1987).

[215]See, e.g., Schmidt, Lutherbibel (see n. 213), 93ff.; Cäcilia G. Nesselstrauss, "Die Holzschnitte von Lucas Cranach zur ersten Ausgabe des Neuen Testaments von Luther und die Tradition der deutschen Wiegendrucke," in Lucas Cranach: Künstler und Ge-

imagery into the nineteenth century,[216] Dürer's woodcut Apocalypse represents the exact borderline between medieval and modern illustration of the Apocalypse.

sellschaft, ed. Peter Feist et al. (Wittenberg, 1973), 98–101; Germanishes National-museum (Nürnberg), Vorbild Dürer: Kupferstiche und Holzschnitte Albrecht Dürers im Spiegel der europäischen Druckgraphik des 16. Jahrhunderts (exhibition catalog) (Munich, 1978), 70–77 nos. 58–68; Peter Martin, Martin Luther und die Bilder zur Apokalypse (Hamburg, 1983); and Richard W. Gassen, " 'Komm lieber jüngster Tag'; Die Apokalypse in der Reformation," in Wilhelm-Hack-Museum (Ludwigshafen on the Rhine,) Apokalypse: Ein Prinzip Hoffnung? (exhibition catalog) (Heidelberg, 1985), 75–90.

[216]See, e.g., the Flemish Apocalypse tapestries from about 1540–53 (Valle de los Caidos and Madrid, Palacio Real), the French stained glass windows at Saint-Florentin (Yonne) from around 1529, at Chavanges (Aube) from 1550, at the Sainte-Chapelle in Vincennes from 1560–80, and at Saint-Nicolas in La-Ferté Milon (Aisne) from ca. 1598; furthermore the Bible illustrations by Mattäus Merian (Icones biblicae, 1625-27), Christoffel van Sicken (Bibels Tresoor, 1646), and Johann Ulrich Krauss (Historische Bilderbibel, 1705); finally, the Apocalypse cartoons (for the planned Camposanto of the Hohenzollern dynasty) from 1843–47 by Peter Cornelius (formerly Berlin, Nationalgalerie), and Eckard von Steinle's painting "Die Apokalyptischen Reiter" from 1838 (Mannheim, Kunsthalle). Cf. Louis Réau, "L'influence d'Albert Dürer sur l'art français," Bulletin de la Société des Antiquaires de France, 1924: 219–22, and Iconographie de l'art chrétien 2 no. 2 (Paris, 1957): 677–83; van der Meer, Apokalypse, (see n. 16) 46–49, 315–30, figs. 17, 18, 203–20; Wilhelm-Hack-Museum, Apocalypse: Ein Prinzip Hoffnung? (see n. 215), 121 nos. 52–56, 138 no. 60.

8

The Apocalypse
in Early Christian
Monumental Decoration

DALE KINNEY

To write a history of Apocalypse imagery in early Christian frescoes and mosaics is impossible; too many significant monuments are lost, and what survives is neither necessarily typical nor demonstrably unique. A responsible account can only describe and categorize what remains, pointing to similarities and differences without assuming that they constitute direct relationships, and bearing in mind what has disappeared without attempting to recover it by speculation. Despite these limitations, some generalizations seem unobjectionable. The Apocalypse is hardly known in early Christian mural art before about 350, but it makes a sudden and profuse appearance—an "invasion" according to Frederik van der Meer—in the latter part of the fourth century.[1] When it does appear, it is not as comprehensive or narrative imagery—no early Christian apse or wall painting represents the Apocalypse per se—but as a cadre of motifs. Often enough the motifs seem to be employed with straightforward reference to themes or episodes of the book, but sometimes, especially in apsidal imagery, they are combined with images and symbols from different iconographic traditions (for example, Christian funerary art or imperial propaganda) to create synthetic compositions that cannot be said to be textually based. Attempts to specify the meaning of these compositions have engendered an inconclusive but invigorating scholarly debate over the past twenty years.[2]

The motifs and compositions surveyed here are not peculiar to monumental painting; on the contrary, the same imagery occurs in nearly all

[1] Frederik van der Meer, *Maiestas Domini: Théophanies de l'Apocalypse dans l'art chrétien* (Vatican City, 1938), 445, 450.
[2] See, e.g., the discussion of the apse of S. Pudenziana summarized at the end of this chapter.

Christian visual media at around the same time.[3] Sculpture (namely, fig-
ured sarcophagi), commemorative objects (for example, pieces of gold
glass), luxury arts (ivory carving), and monumental painting were icono-
graphically interdependent; murals and mosaics are distinguished less by
their visual vocabulary than by what we can assume about their common
purpose and the conditions of their reception. The decoration of a basilica
was physically part of the sacred space and presumably in a mutually en-
hancing relationship with the rituals enacted in that space. It seems likely
that the imagery was selected with reference to the ritual, and the ritual
certainly provided a context for the viewer's reception of the imagery.

A survey of the use of Apocalypse motifs should begin by defining what
they are. This must be an arbitrary determination, partly because the
boundaries between the Apocalypse and other apocalyptic descriptions are
so permeable (for example, the verbal imagery of Apocalypse 4 overlaps
Isaiah 6 and Ezekiel 1), partly because the artistic visualization of the
Apocalypse was devised from a preexisting repertoire of conventional im-
ages, such as lambs and thrones, whose specific meaning is conditioned by
context. The list appended to this essay, containing all of the monuments
on which it is based, is conservative, that is, limited to images either
unique to the Apocalypse (such as the twenty-four Elders and the book
with seven Seals) or especially characteristic of it (like the Lamb). Crowns
and the cross (identified as the tree of life in Apocalypse 2:7, 22:2, 14) are
excluded as too commonplace, and thrones are counted only when accom-
panied by another image that is indisputably Apocalyptic (that is, depen-
dent on John's Apocalypse), like the book with seven seals.

Motifs selected by these criteria tend to cluster in Books 4 and 5. The
exceptions are also unusual in other respects: trumpeting angels (Apoc.
8:2) and heavenly Jerusalem (Apoc. 21:2, 10–27) because they appear so
rarely (respectively, once, App. no. 29; and thrice, App. nos. 1, 4, 21), and
the AΩ (Apoc. 1:8, 21:6, 22:13) for the opposite reason, because it was
ubiquitous. Disposed on either side of the Christian monogram, or chris-
mon, the Alpha and Omega appeared on all manner of objects made, seen,
used, and worn by Christians, including bricks, jars, rings, medallions,
coins, and slave collars. Though the motif occurs on a few inscriptions
datable before the time of Constantine, it was more frequently found af-
terward, especially from about the middle of the fourth through the early

[3]This generalization probably does not include manuscript illumination. No Apoca-
lypse manuscript of this period is known, but many scholars have argued the existence,
and even the iconography, of such manuscripts from Carolingian miniatures believed to
have been copied from them. Some of these arguments are detailed and persuasive, e.g.,
Cäcilia Davis-Weyer, " 'Aperit quod ipse signaverat testamentum': Lamm und Löwe im
Apokalypsebild der Grandval-Bible," in *Studien zur mittelalterlichen Kunst, 800–1250:
Festschrift für Florentine Mütherich*, ed. Katherina Bierbrauer et al. (Munich, 1985), 67–
74. If there were such illustrated manuscripts, it seems likely that they were iconograph-
ically distinctive: figuratively as well as physically closer to the text.

fifth centuries.[4] Except for the Lamb, AΩ is the only Apocalypse motif found in Roman catacomb painting, where it normally was combined, as in inscriptions, with the chrismon.[5] Some hold that it was an anti-Arian symbol, and this seems a possible explanation for those instances of monumental painting in which AΩ appears with the portrait, rather than the monogram or symbol, of Christ (App. nos. 2, 3, 18, 20). A vault painting in the Roman catacomb of SS. Marcellino e Pietro (App. no. 3), for example, shows the figure of Christ enthroned and, axially below him, the Lamb on Mount Sion. AΩ is painted beside Christ's nimbus and also inside the Lamb's, making a clear equation of the (human) victim and the resurrected divinity.

Anti-Arian or not, the AΩ symbol was not an automatic sign of the Apocalypse. Like some of the metaphors of Saint Paul, "Alpha and Omega" was a felicitous phrase that could be applied out of context to many situations. Generally it signified Christ's priority to the created world.[6] In monumental imagery, it seems to have acquired a specific Apocalyptic reference only in the fifth century, in programs that brought the AΩ/chrismon or AΩ/cross together with the Four Living Creatures.

After the AΩ, the Lamb (Apoc. 5:6–14, 6:1, 7:9–17, 14:1) is the first Apocalyptic motif encountered in monumental art. Friedrich Gerke traced its emergence on sarcophagi in the second half of the fourth century, and it appeared in painting about the same time.[7] It seems to have been a particular instance of the *agnus dei*, which occurs in fourth-century painting and sculpture in both narrative and nonnarrative compositions.[8] The Lamb is designated as the Lamb of the Apocalypse by attributes like the mound with rivers symbolizing Mount Sion, the throne, and a scroll with seven seals.[9] The animal itself is always a generic lamb, not the creature with seven horns and seven eyes described in Apocalypse 5:6, and thus it resembles the sheep that abound in earlier catacomb and sarcophagus imagery, for example, in representations of the Good Shepherd. Ambitious iconographers could play on these multiple biblical and visual associations. The best-known (though not necessarily typical) example is Saint Paulinus of Nola, whose explanatory inscriptions for two apse mosaics (App. nos. 13, 14) are preserved in a letter to Sulpicius Severus dated 403. Both apses apparently contained images of the Lamb on Mount Sion

[4]Fernand Cabrol and Henri Leclercq, *Dictionnaire d'archéologie chrétienne et de liturgie*, vol. 1 (Paris, 1924), 2–23.

[5]Examples are listed by Aldo Nestori, in *Repertorio topografico delle pitture delle catacombe romane* (Vatican City, 1975), 192, 204. The chrismon is the monogram of Christ, made with chi and rho, chi and iota, or a cross and rho (as in fig. 21 herein).

[6]Prudentius *Liber cathemerinon* 9.10–12 (ed. Maurice P. Cunningham, *CC* 126:47).

[7]Friedrich Gerke, "Der Ursprung der Lämmerallegorien in der altchristlichen Plastik," *Zeitschrift für die neutestamentliche Wissenschaft* 33 (1934): 164–65.

[8]Ibid., 160–96; Antonio Ferrua, S.J., "Scoperta di una nuova regione della Catacomba di Commodilla," *Rivista di Archeologia Cristiana* 35 (1958): 35–37, figs. 28, 30.

[9]Cf. van der Meer, *Maiestas Domini*, 29–30, 38–39.

(Apoc. 14:1). In one, according to the verse, the Lamb represented Christ as a member of the Trinity, as sacrificial victim, and as foundation of the Church. In the second apse, the Lamb was victorious victim and judge. Neither interpretation refers specifically to the Apocalypse, though the second seems inclined in that direction.[10]

In the painting in the catacomb of SS. Marcellino e Pietro mentioned earlier, the Lamb on the mount is shown between two pairs of male saints, while Christ above is enthroned between Saint Paul and Saint Peter (App. no. 3). The composition has the typical vertical structure of late antique acclamation scenes, in which the lesser (lower) figures raise their hands in praise of the honored central figure at the top (compare the column of Arcadius, fig. 20).[11] Although, as in this case, the Lamb is not always the object of the acclamation, it is consistently depicted in scenes of this general tenor, that is, in images of praise or glorification.[12] The acclamatory context has textual justification in Apocalypse 5:8, the Lamb at the throne, glorified by the Four Living Creatures and the twenty-four Elders, and in Apocalypse 14:1, the Lamb on Mount Sion, acclaimed by the Creatures, the Elders, and the 144,000. It is interesting that, except for the 144,000, these are the most common Apocalypse motifs in fifth- and sixth-century monumental imagery: the Elders, the Creatures, and the throne. Initially, they do not normally occur all together. The Lamb can be acclaimed by other lambs as on sarcophagi, by saints, or, in Saint Paulinus's apses, by the voice (probably symbolized by the hand) of God. The Creatures are often seen praising Christ or his symbols, and the Elders likewise were represented on the triumphal arch of S. Paolo fuori-le-mura (fig. 19) adoring the bust of Christ.

Two cases that seem atypical in this regard may not actually have been so. A verse by the poet Prudentius from around 400—the last stanza of forty-eight that seem to have been meant, like those of Saint Paulinus, to accompany pictures—described an adoration of the Lamb that seems unusually close to Apocalypse 5:6–12: "Four and twenty elders seated and resplendent with vessels and harps and each with his crown of honor are praising the Lamb that is blood-stained from the slaughter, and that alone

[10]Saint Paulinus of Nola *Epistula* 32.10, 17 (ed. Guilelmus de Hartel, *CSEL* 29:286, 292). For translations of the inscriptions, see Cäcilia Davis-Weyer, *Early Medieval Art, 300–1150* (reprint, Toronto, 1986), 20, 23. On the interpretation, see Josef Engemann, "Zu den Apsis-Tituli des Paulinus von Nola," *Jahrbuch für Antike und Christentum* 17 (1974): 21–34.

[11]Johannes Georg Deckers, Hans Reinhard Seeliger, and Gabriele Mietke, *Die Katakombe 'Santi Marcellino e Pietro,'* Repertorium der Malereien (Vatican City, 1987), 199–201 no. 3; Johannes Georg Deckers, "Constantin und Christus: Das Bildprogramm in Kaiserkulträumen und Kirchen," *Spätantike und frühes Christentum: Ausstellung im Liebieghaus Museum alter Plastik Frankfurt am Main,* ed. Dagmar Stutzinger (Frankfort on the Main, 1983), 274; Josef Engemann, "Akklamationsrichtung, Sieger- und Besiegtenrichtung auf dem Galeriusbogen in Saloniki," *Jahrbuch für Antike und Christentum* 22 (1979): 152–55.

[12]Gerke, "Ursprung der Lämmerallegorien," 170–74.

has been able to unroll the book and undo the seven seals."[13] The tex-
tual parallels are obvious, but it is not known how closely the verses
matched the pictures, nor indeed if the pictures were ever made.[14] An
adoration of the Lamb is also recorded as having been on the facade of
S. Pietro in Rome (App. no. 8), which was decorated by the consul Marin-
ianus and his wife Anastasia in the pontificate of Leo I (440–61). Their
mosaic is known from a drawing in an eleventh-century manuscript
now in Eton College (fig. 18), which shows the Elders in striding poses,
wearing crowns and holding up bowls toward the Lamb represented in the
gable. The winged Creatures hover below the Lamb, carrying books.[15]
Because a seventh-century note refers to the mosaic as "four animals
around Christ," scholars since the nineteenth century have conjectured
that the facade originally displayed a bust of Christ and that the Lamb was
a replacement made by Pope Sergius I (687–701), who is known to have
repaired the mosaic.[16] The fifth-century facade, according to this hypoth-
esis, would have had the same iconography as the contemporary arch
of S. Paolo.[17]

The visualization of the twenty-four Elders is consistent in the known
representations, which are all in Rome: S. Pietro (fig. 18), S. Paolo (fig. 19),
SS. Cosma e Damiano (fig. 1), and several later decorations for which these
served as models.[18] These images correspond only loosely to the written
account. The Elders do wear white, and at S. Pietro they apparently had
crowns on their heads (Apoc. 4:4). But (excepting always Prudentius) they
are not shown with harps or vials (Apoc. 5:8); they neither sit (4:4) nor fall
down before the Lamb (4:10, 5:8); they do not throw down their crowns
(4:10). In the Roman images, the Elders move upright and hold their of-

[13]Davis-Weyer, Early Medieval Art, 33.
[14]Cf. Cäcilia Davis-Weyer, "Komposition und Szenenwahl im Dittochaeum des Pru-
dentius," in Studien zur spätantiken und byzantinischen Kunst Friedrich Wilhelm De-
ichmann gewidmet, vol. 3, ed. Otto Feld and Urs Peschlow (Bonn, 1986), 19–20.
[15]Eton College, MS. 124, fol. 122; first published by Hartman Grisar, S.J., in "Die alte
Peterskirche zu Rom und ihre frühesten Ansichten," Römische Quartalschrift für
Christliche Altertumskunde 9 (1895): 240–48, 259–66. The manuscript contains a life
of Pope Gregory I, and the scene below the roof line (see fig. 18 herein) is the pope's
burial in the porch of S. Pietro.
[16]Louis Duchesne, ed. and trans., Le Liber pontificalis, vol. 1 (reprint, Paris, 1981), 375,
379 n. 34; Grisar, "Alte Peterskirche," 261, 264–66; van der Meer, Maiestas Domini, 93.
One of the strongest reasons for attributing the Lamb to Pope Sergius I is its prominence
in the dispute between Rome and Constantinople after the Quinisext Council in 692;
see Duchesne, Liber pontificalis 1:376, 381 n. 42, and Thomas F. X. Noble, The Republic
of St. Peter: The Birth of the Papal State, 680–825 (Philadelphia, 1984), 17.
[17]Scholars who reject this speculation include Stephan Waetzoldt; see Die Kopien des
17. Jahrhunderts nach Mosaiken und Wandmalereien in Rom (Vienna, 1964), 67.
[18]The triumphal arch of S. Paolo fuori-le-mura was decorated between 442 and 450;
see Stephan Waetzoldt, "Zur Ikonographie des Triumphbogenmosaiks von St. Paul in
Rom," in Miscellanea Bibliothecae Hertzianae (Munich, 1961), 20. The mosaic was
remade after the fire of 1823, which is why we rely on the reproduction by Giovanni
Ciampini (fig. 19). On SS. Cosma e Damiano, see no. 34 below.

ferings (crowns, or bowls at S. Pietro) out and upward.[19] Theodor Klauser recognized that this representation is related to the imperial ceremony called *aurum coronarium*, in which gifts conventionally called *coronae* (though they might be other precious objects or even money) were presented to the emperor by subject states or peoples. A domestic version of this ritual was the *aurum oblaticium*, a presentation to the emperor by a representative of the senate.[20] A depiction of the *aurum oblaticium* was identified in a sixteenth-century drawing of the base of a commemorative column erected in Constantinople by the emperor Arcadius (395–408; fig. 20).[21] The togate senators in the second register from the bottom (half destroyed) were represented by two leaders who held out bowls or crowns as presents to the Augusti, shown with arms upraised in the register above. The symmetrical arrays of standing Elders seem to belong to this realm of ceremonial representation. Their bent, obeisant posture (seen especially at S. Paolo, fig. 19) does not appear on the column base but is typical of images of the *aurum coronarium*.[22]

The mosaics of S. Pietro and S. Paolo, made just before the middle of the fifth century, are the earliest known images of the twenty-four Elders. The Four Living Creatures (Apoc. 4:6–9, 5:8–14, 7:11–12, 14:3, 19:4) were represented before then, in the apse of S. Pudenziana in Rome (fig. 22), made before 417, and possibly earlier in S. Giovanni in Fonte, the baptistery of the cathedral of Naples (fig. 21).[23] Unlike the Lamb and the Elders, the Creatures are not an obvious appropriation of a preexisting, nonapocalyptic convention or symbol, but like the other images, they were created in the Greco-Roman tradition of naturalism rather than as visualizations of the ecstatic text. The Eagle is a conventional eagle, and the others are a man and two animals with wings attached. They are not shown covered with eyes (Apoc. 4:6), and they more frequently have two rather than

[19]The Elders described by seventeenth-century writers in the old cathedral of Naples (App. no. 19) were kneeling; for this and other reasons, Yves Christe proposed that the mosaics must have been later than the early Christian period ("A propos du décor de l'arc absidal de Santa Restituta à Naples," in *Studien zur spätantiken und byzantinischen Kunst* 2:157–58.

[20]Theodor Klauser, "Aurum coronarium," *Mitteilungen des Deutschen Archäologischen Instituts: Römische Abteilung* 59 (1944): 129–53.

[21]Klauser, "Aurum coronarium," 145. The column base survives, but its reliefs do not; see Wolfgang Müller-Wiener, *Bildlexikon zur Topographie Istanbuls* (Tübingen, 1977), 252 fig. 285. The drawing was first published by E. H. Freshfield, in "Notes on a Vellum Album Containing Some Original Sketches of Public Buildings and Monuments, Drawn by a German Artist Who Visited Constantinople in 1574," *Archaeologia* 72 (1921/22): pl. XXIII.

[22]Klauser, "Aurum coronarium," 146–47.

[23]The apse mosaic of S. Pudenziana is dated to the pontificate of Innocent I (401–17) by an inscription recorded by Onofrio Panvinio in the sixteenth century; see Guglielmo Matthiae, "Restauri: Il mosaico romano di Santa Pudenziana," *Bollettino d'Arte* 31 (1937/38): 422–23. The Neapolitan mosaics are dated by style to the bishopric of Severus (400–408) by Jean-Louis Maier; see *Le Baptistère de Naples et ses mosaïques* (Fribourg, 1964), 69–76.

six wings (4:8). In the earliest examples, the Creatures are presented as busts, but it soon became more common to depict them at half-length, with limbs to hold wreaths (as at S. Maria Maggiore, App. no. 6) or books.[24]

In the Apocalypse, the Creatures sing the praises of the *sedens*, the indescribable one on the throne (4:6–9, 19:4), of the Lamb (5:8–14), or both (7:11). Monumental imagery corresponds to these passages, but again without being strictly illustrative. In seven monuments, the Creatures occur with emblems of Christ (the cross or chrismon) or with emblems or symbols upon a throne.[25] In two cases, they appear with the Lamb, and in three with busts of Christ.[26] Finally, in apse mosaics in Rome (App. no. 4), Salonika (App. no. 33), and possibly Ravenna (no. 26), the Creatures accompany a full-length figure of Christ enthroned.[27] A peculiarly Egyptian variant of this last type, very popular in the painted monastic chapels of Bawit (fig. 26; App. nos. 35, 36), includes the Old Testament detail of wheels under the throne (Ezek. 1:15–21); sometimes elements of the Ascension are present as well.[28] In these images the Creatures are disposed radially around the *sedens*, who is enclosed in an aureole or mandorla, as in the so-called *majestas domini* so common in later medieval art. In early Christian imagery it is a much rarer composition, appearing on extant monuments only in Salonika and Egypt (App. nos. 33, 35, 36).[29]

In Italy, the distribution of the Four Living Creatures with respect to the object of their adoration varies with the architectural context, and it can be two- or three-dimensional. In basilicas they commonly appear on vertical surfaces—usually triumphal or apsidal arches—arrayed horizontally in pairs, two on each side of the symbol or throne (figs. 1, 19).[30] An excep-

[24]Examples are listed by Marjorie de Grooth and Paul van Moorsel in "The Lion, the Calf, the Man and the Eagle in Early Christian and Coptic Art," *BABesch (Bulletin Antieke Beschaving)* 52–53 (1977/78): 238–39; the wreaths at S. Maria Maggiore are overlooked.

[25]With cross: App. nos. 4, 27; with chrismon: nos. 12, 28; with throne: nos. 6, 11, 18 (in no. 11 the Lamb is among the symbols on the throne).

[26]With Lamb: App. nos. 8, 10; with bust of Christ: nos. 7, 16, 31.

[27]The mosaic in S. Croce, Ravenna, was destroyed in the seventeenth century and is known only from its descriptive inscription, which names "Christ, Word of the Father," and "the winged witnesses" who "surround [Christ] saying a triple *sanctus* and amen." Though some have reconstructed it as an apsidal composition, Friedrich Wilhelm Deichmann argues (*Ravenna: Hauptstadt des spätantiken Abendlandes: Kommentar,* vol. 1 [Wiesbaden, 1974], 57) that the mosaic was on the inner wall of the facade; see App. no. 26, and n. 29 below.

[28]Christa Ihm, *Die Programme der christlichen Apsismalerei vom vierten Jahrhundert bis zur Mitte des achten Jahrhunderts* (Wiesbaden, 1960), 95–100, 201.

[29]If Friedrich Gerke's reconstruction of the lost mosaic in S. Croce in Ravenna is correct, that composition would have been similar, though embellished with the motif of the defeated lion or viper and basilisk from Psalm 90(91): 13; see "La composizione musiva dell'oratorio di S. Lorenzo Formoso e della basilica palatina di S. Croce a Ravenna," *Corsi di cultura sull'arte ravennate e bizantina* 13 (1966): 157. The objections to such a reconstruction were foreseen by Ihm, *Programme,* 171–72.

[30]Examples: App. nos. 5–8, 11, 31.

tional case is S. Pudenziana, where this arrangement is employed in an apse (fig. 22). More interesting are the vaulted chapels—baptisteries, oratories, and mausoleums—in which the Creatures could be placed in the four squinches that make the transition from walls to vault (fig. 21).[31] The object of their worship is shown above them, in the apex of the vault; this creates a theatrical spatialization of the two-dimensional convention mentioned earlier, according to which praise flows upward, from lesser to greater.[32] Simply by looking upward to see the images, the observer becomes a participant in this ritual of ascending acclamation.

The remaining motifs listed in the appendix are mostly accessories to the throne: the candelabra (not lamps; Apoc. 1:12–13, 20, 2:1, 4:5), the sea of glass (Apoc. 4:6), and the scroll (not a book) with seven seals (Apoc. 5:1).[33] The apsidal arch of SS. Cosma e Damiano in Rome, of the sixth or seventh century (fig. 1), is the first extant monument in which all of these attributes appear together.[34] The Lamb is included as well, reposing confidently on the seat of the throne, making this also the first preserved monumental image that combines the Lamb and the scroll with seven seals.[35] Despite this pregnant juxtaposition and the relative abundance of detail, the mosaic makes no move in the direction of dramatic narration; on the contrary, it is an additive, emblematic expansion of the hieratic composition of S. Paolo, with the same sense of infinite deferral.

In sixth-century Ravenna, by contrast, Apocalypse motifs are dispersed rather than concentrated, and they appear in unparalleled combinations. In the apse of S. Vitale (546–48), for example, the scroll with seven seals appears in the hand of Christ himself, who is seated on a symbolic globe (fig. 24). The Lamb is represented in the vault of the preceding chancel bay (fig. 25), in a scheme adapted from smaller groin-vaulted buildings of the

[31]Examples: App. nos. 10, 12, 22, 23, 27. In the chapel of S. Matrona (no. 18) and the Archbishop's Chapel in Ravenna (no. 28), which are groin vaulted and consequently have no squinches, the animals are respectively dropped to the wall surfaces or raised to the compartments of the vault.

[32]Engemann, "Akklamationsrichtung" (see n. 11 above).

[33]Candelabra: App. nos. 11, 19, 25; sea of glass: nos. 11, 29; scroll with seven seals: nos. 6, 11, 18, 30. In nos. 19 and 25, the candelabra may have accompanied images of Christ. Margherita M. Cecchelli argued that the sea in nos. 11 and 29 is the *mare vitreum mistum igne* of Apoc. 15:2; see "Osservazioni circa il mosaico di S. Michele in Africisco," *Felix Ravenna*, ser. 3, 31 (1960): 128–29.

[34]SS. Cosma e Damiano was a Roman government building consecrated as a church by Pope Felix IV (526–30) (Duchesne, *Liber pontificalis* 1:279). Guglielmo Matthiae has argued that the arch mosaics are of a later date, in the pontificate of Sergius I; see *Mosaici medioevali delle chiese di Roma*, vol. 1 (Rome, 1967), 209–11. Two Living Creatures on the arch and most of the twenty-four Elders were obscured in the seventeenth century, when the clear width of the nave was reduced.

[35]The combination of Lamb and throne is known in the early fifth century, on an ivory casket from Pola and, presumably, the apse of the basilica at Fundi; cf. Ihm, *Programme*, 138; also Gertrud Schiller, *Die Auferstehung und Erlösung Christi*, vol. 3 of *Ikonographie der christlichen Kunst* (Gütersloh, 1971), 196–200. The fact that there are no preserved fifth-century examples of the Lamb with the scroll does not, of course, mean that such images were not made then.

fifth century (cf. App. nos. 9, 10).[36] In S. Michele in Africisco, we find the only known example in early Christian art of the trumpeting angels (Apoc. 8:2), on an apsidal arch flanking two archangels and Christ enthroned.[37]

It is time to ask what this imagery means. Answers can be sought by investigating the literary and visual origins of each of the separate motifs. Thus, to take the throne as an example, one learns that the throne was an Old Testament image; a staple of imperial iconography; and a symbolic surrogate used in pagan, secular, and ecclesiastical ceremonial. In the Psalms, the throne is an attribute of the Lord's eternal dominion, and in Psalm 9, of his future judgment. The throne of a hellenistic ruler was an object of official adoration; and from the first century onward, thrones appear on the coins of Roman emperors, combined like the Apocalypse thrones with other emblems. At church councils, a throne bearing the codex of the Gospels embodied the presence of Christ.[38] Similarly, investigating the Four Living Creatures, one finds an Old Testament background and also a tradition of Christian exegesis. Commentators since the second century read the Creatures as symbols of the four evangelists, and the equation was a commonplace by the time they appeared in art. Its familiarity to iconographers is indicated by the fact that so often the Creatures carry books.[39]

The shortcomings of this essentially lexical approach, when applied to the interpretation of any given mosaic, are precisely those encountered in verbal decipherment from dictionaries: there is no a priori basis for selecting among multiple possible meanings (as in the case of the throne) and no means of recognizing extra- or counterlexical usage (as when the Creatures do not symbolize the evangelists).[40] The traditional appeal to context depends on the assumption that the context itself has a lexically specifiable meaning, but this is not demonstrably true of visual imagery. The apse of S. Pudenziana provides an exemplary instance of this and other interpretative problems.

[36]For a view of the ensemble, see Ernst Kitzinger, *Byzantine Art in the Making* (Cambridge, Mass., 1977), fig. 153. The date given here is that established by Deichmann, in *Ravenna: Kommentar*, vol. 2 (Wiesbaden, 1976), 188–89.

[37]The church of S. Michele was founded in 545 and dedicated in 547; the mosaics were made in that period. The apse and arch mosaics were removed from the church in 1843 or 1844 and are now on display in the Staatliche Museen in Berlin. Stylistically they cannot be considered original works of early Christian art, but the iconography is generally considered authentic (Deichmann, *Ravenna: Kommentar* 2:35, 38–39).

[38]Schiller, *Ikonographie* 3:193–94; Andreas Alföldi, "Insignien und Tracht der römischen Kaiser," *Mitteilungen des Deutschen Archäologischen Instituts: Römische Abteilung* 50 (1935): 134–39.

[39]Schiller, *Ikonographie* 3:184–87.

[40]These difficulties are addressed, in different terms, by Beat Brenk, *Tradition und Neuerung in der christlichen Kunst des ersten Jahrtausends: Studien zur Geschichte des Weltgerichtsbildes* (Vienna, 1966), 71–73; Engemann, "Apsis-Tituli," 42–46; and de Grooth and van Moorsel, "Lion, the Calf," 233–41.

The mosaic (fig. 22) portrays Christ on a gem-studded throne, surrounded by twelve Apostles.[41] He makes a gesture of speech with his right hand and holds open a book with his left, displaying the motto DOMINVS CONSERVATOR ECCLESIAE PVDENTIANAE (The Lord, Preserver of the Church of Pudentiana). Two women hold wreaths over the heads of Saint Paul and Saint Peter. Behind the figures is a portico with gilded roof tiles, an architectural skyline, and a mound supporting a tall gold and bejeweled cross. The Four Living Creatures float in a medium of wispy, variegated clouds, some of which are red. Sixteenth-century drawings record a dove and the Lamb, which seem to have been represented on an axis below Christ and the cross.[42]

Analyzed archaeologically, the image reveals several strata.[43] The basic composition of Christ seated among the twelve appears earlier in catacomb painting and is itself an adaptation of a pagan convention, the colloquium of philosophers. Overlaid on this scene of "Christ teaching" is a stratum of imperial paraphernalia: the throne, the halo, the *aurum coronarium*, the title *conservator*, and the emblematic cross, the potent sign that guaranteed imperial victory (cf. fig. 20).[44] Mixed with this layer is a third one composed of apocalyptic motifs: the Creatures, the heavenly city, the Lamb, the multivalent throne, and the cross, now understood as the sign of the Son of Man, "coming upon the clouds of heaven with great power and majesty" (Matt. 24:30).

A basic question is whether all or some of these strata constitute the meaning of the image, or whether one supersedes or subordinates the others. Johannes Kollwitz, for example, considered the imperial stratum predominant and described the subject as "the heavenly king, who comes to make an address to his community," the latter comprising the Apostles and also the real-life congregation.[45] Ernst Dassmann favored the apocalyptic layer, arguing that the composition shows Christ as final judge, though not in the act of judgment.[46] Yves Christe maintained that the subject is eschatological but without any reference to future events. "[It is] the manifestation of an already realized cosmic kingdom. . . . One must speak of present or realized, not of future or end-of-time

[41]The outermost Apostles were eliminated in 1588.

[42]Cf. Ihm, *Programme*, 130–32, pl. III. 2.

[43]Most clearly explicated by Ernst Dassmann, "Das Apsismosaik von S. Pudentiana in Rom," *Römische Quartalschrift für Christliche Altertumskunde* 65 (1970): 70–74.

[44]*Conservator* was also an epithet of Jupiter (Johannes Kollwitz, "Das Bild von Christus dem König in Kunst und Liturgie der christlichen Frühzeit," *Theologie und Glaube* 37-38 [1947/48]: 101 n. 37). On the cross, see André Grabar, *L'empereur dans l'art byzantin* (reprint, London, 1971), 32–34.

[45]Kollwitz, "Bild," 102.

[46]Dassmann, "Apsismosaik," 81. Before Dassmann, Erich Dinkler identified the subject as the moment of judgment at the Second Coming (*Das Apsismosaik von S. Apollinare in Classe* [Cologne, 1964], 54–55).

eschatology."[47] Josef Engemann objected that Christe's reading is too restrictive, that early Christian images typically encode a plurality of meanings, one of which, in S. Pudenziana, is Christ's second coming and the attendant judgment.[48] Geir Hellemo contends that the ambiguities in the imagery are purposefully unresolvable; the simultaneous utilization of biblical and imperial motifs creates "an open and ambiguous framework which balances on the border between the earthly and the heavenly, of the present and of the future."[49] The meaning of this and of all church apses, according to this author, is neither imperial nor eschatological but liturgical: "Apsidal imagery unifies and summarizes the central content of the eucharistic prayer."[50]

Refocusing on Apocalypse imagery in the light of this debate, it is useful first to review the data. Two gross patterns appear among the monuments in the Appendix: the predominance of motifs in Books 4 and 5 already mentioned, and a clear break just after 400. The motifs in use before then—AΩ and the Lamb—were freighted with christological significance and not specifically indexed to the Apocalypse; this is borne out by Saint Paulinus's inscriptions.[51] In the fifth century, by contrast, we find many combinations of Elders and Living Creatures with the symbol or image of Christ, which seem to function as visual précis of Apocalypse 4–5. As these books are themselves liturgical, a liturgical content for the images seems inescapable.[52] Conversely, it was probably the liturgical character of the text that recommended these motifs to iconographers. By "liturgical," we should understand not the theology and symbolism of the eucharistic sacrament but the more general practice of ritualized public worship. The imperial cult had already produced a liturgical iconographic vocabulary (fig. 20), which does much to explain the marriage of Christian and imperial imagery in our monuments. The celebratory character of the imagery is both part of its content and intrinsic to its nature as art. Public art in the late Roman Empire was panegyrical, and Christian public art unquestioningly took up the same role.

Why the break around 400? The matter deserves investigation. Diverse factors could be pertinent, including the significance of the perceived fall

[47]Yves Christe, "Gegenwärtige und endzeitliche Eschatologie in der frühchristlichen Kunst: Die Apsis von Sancta Pudenziana in Rom," Orbis Scientiarum 2 (1972): 52; see also, by the same author, La vision de Matthieu (Matth. XXIV–XXV): Origines et développement d'une image de la Seconde Parousie (Paris, 1973), 12–13, 26–27, 31–36, 75–78.

[48]Josef Engemann, "Images parousiaques dans l'art paléochrétien," in L'Apocalypse de Jean: Traditions exégétiques et iconographiques, ed. Yves Christe (Geneva, 1979), esp. 79–84.

[49]Geir Hellemo, Adventus Domini: Eschatological Thought in Fourth-Century Apses and Catecheses (Leiden, 1989), 63.

[50]Ibid., 281.

[51]See also the essay by E. Ann Matter in this volume.

[52]Cf. Leonard Thompson, "Cult and Eschatology in the Apocalypse of John," Journal of Religion 49 (1969): 330–50.

of Rome in 410 and the subsequent patronage of the Empress Galla Placidia, whose personal devotion to the author of the Apocalypse was probably a cause of some innovative imagery in Ravenna (App. nos. 25, 26) and who sponsored the triumphal arch mosaic of S. Paolo fuori-le-mura in Rome (no. 7).

APPENDIX

Apocalypse Motifs in Monumental Art, A.D. 350–565

AΩ	Alpha and Omega (Apoc. 1:8, 21:6, 22:13)
HJ	Heavenly Jerusalem (21:2, 21:10–27)
L	Lamb (5:6–14, 6:1, 7:9–17, 14:1)
SG	Sea of glass (4:6)
T	Throne (4:1–11, 5:1–14, 7:9, 7:15–17, 19:5, 20:4, 22:1)
Tr	Trumpeting angels (8:2)
4LC	Living Creatures (4:6–9, 5:8–14, 7:11–12, 14:3, 19:4)
4LCe	Living Creatures as evangelist symbols (post scriptural authorities: Irenaeus, Hippolytus, Victorinus, Jerome, and so on)
7C	Candelabra (1:12–13, 1:20, 2:1, 4:5)
7S	Seven seals (5:1)
24E	Elders (4:4, 4:10–11, 5:8–14, 7:11–12, 11:16, 14:3, 19:4)
()	Indicate "destroyed"

ITALY

Rome
1. S. Costanza, tower
 • ca. 350?
 • destroyed ca. 1620; recorded 1608.
 • (mosaic: L, HJ).
 • Adele Anna Amadio, *I mosaici di S. Costanza* (Rome, 1986), 40–41 no. 14, 52–53 no. 25.
2. Catacomb of Commodilla, cubiculum of Leo *officialis annonae*, end wall and vault
 • 375–80?
 • painting: AΩ/bust of Christ, AΩ/standing Christ, AΩ/chrismon.
 • Ferrua (as in n. 8), figs. 14, 22, 26.
3. Catacomb of SS. Marcellino e Pietro, crypt of the saints, vault
 • last quarter 4th c.?
 • painting: AΩ/enthroned Christ, AΩ/L.
 • Deckers, Seeliger, and Mietke (as in n. 11), 'Tafelband,' colorplates 2, 3a; cf. pl. 1.

4. S. Pudenziana, apse
 - 401–17.
 - partly destroyed 1588 and 1711; recorded 1595.
 - mosaic: HJ, T, 4LC, (L).
 - fig. 22; color photo: Wolfgang Fritz Volbach, *Early Christian Art* (New York, 1962), pl. 130; cf. Ihm (as in n. 28), pl. III.2.

5. S. Sabina, entrance wall
 - 422–32.
 - destroyed; recorded 1690.
 - (mosaic: 4LC).
 - Waetzoldt (as in n. 18), 21 fig. 10.

6. S. Maria Maggiore, triumphal (originally apsidal) arch
 - 432–40.
 - mosaic: T, 7S, 4LC.
 - Josef Wilpert and Walter N. Schumacher, *Die römischen Mosaiken der kirchlichen Bauten vom IV.–XIII. Jahrhundert* (Freiburg-im-Breisgau, 1976), pls. 68–70.

7. S. Paolo fuori-le-mura, triumphal arch
 - 422–50.
 - reworked 13th c.?; damaged 1823; remade; recorded 17th c.
 - (mosaic: 4LC, 24E).
 - fig. 19; also Wilpert and Schumacher (see no. 6 above), 87 fig. 58.

8. S. Pietro in Vaticano, facade
 - 440–61.
 - altered 692–701?; remade 1227–41; destroyed 1608–18; recorded 687–701 and 11th c.
 - (mosaic: L?, 4LCe, 24E).
 - fig. 18.

9. S. Giovanni in Laterano, baptistery, chapel of St. John the Evangelist, vault
 - 461–68.
 - remade.
 - mosaic: L.
 - Wilpert and Schumacher (see no. 6 above), pls. 80, 81.

10. S. Giovanni in Laterano, baptistery, chapel of St. John the Baptist, vault
 - 461–68.
 - destroyed; recorded 17th c.
 - (mosaic: L, 4LCe).
 - Wilpert and Schumacher (see no. 6 above), 92 fig. 62.

11. SS. Cosma e Damiano, apsidal arch
 - 526–30 or later.
 - partly destroyed 1626–32.
 - mosaic: L, T, 7S, SG?, 4LCe, 7C, 24E.
 - fig. 1.

Campania
12. Naples, S. Giovanni in Fonte, cupola and squinches
 • 4th–5th c.
 • mosaic: AΩ/chrismon, 4LC.
 • fig. 21; color photos, in Wilpert and Schumacher (see no. 6 above), pls. 8, 15, 18a–b.
13. Nola, Basilica Apostolorum, apse
 • ca. 400.
 • destroyed; recorded 403.
 • (mosaic: L).
 • Engemann (as in n. 10), figs. 1, 2.
14. Fundi, Basilica of Paulinus, apse
 • ca. 403.
 • destroyed; recorded 403.
 • (mosaic?: L, T?).
 • Engemann (as in n. 10), figs. 4, 5.
15. Naples, Catacomb of S. Gennaro, crypt of Cominia and Nicatiola, arcosolium
 • 5th c.?
 • painting: AΩ/St. Januarius standing.
 • Raffaele Garrucci, *Storia della arte cristiana*, vol. 2 (Prato, 1873), pl. 102.
16. Naples, Catacomb of S. Gaudioso, cubiculum vault
 • 5th c.?
 • painting: 4LCe.
 • Garrucci (see no. 15 above), pl. 105.
17. Naples, Catacomb of S. Gennaro, crypt of the bishops, arcosolium
 • mid-5th c.
 • partly destroyed.
 • mosaic: AΩ/cross, 4LCe.
 • Beat Brenk, *Spätantike und frühes Christentum* (Frankfort on the Main, 1977), pl. 25.
18. Santa Maria Capua Vetere (near), S. Prisco, chapel of S. Matrona, lunettes on three walls
 • 5th c.
 • partly destroyed.
 • mosaic: AΩ/bust of Christ, (L?), T, 4LC, 7S.
 • Wilpert and Schumacher (see no. 6 above), pls. 83–85; Brenk (see no. 17 above), pl. 23.
19. Naples, S. Restituta, apsidal arch
 • 5th or 6th c.?
 • destroyed after 1643; recorded 1623, 1643.
 • (mosaic: 7C, 24E).
 • Ihm (as in n. 28), 176–77 no. 33.

North Italy

20. Milan, S. Lorenzo Maggiore, chapel of S. Aquilino, southwest niche
 • 4th c.?
 • mosaic: AΩ/Christ seated.
 • *La Basilica di San Lorenzo in Milano*, ed. G. A. Dell'Acqua (Milan, 1985), figs. 159, 160; Wilpert and Schumacher (see no. 6 above), pl. 6.
21. Milan, S. Lorenzo Maggiore, chapel of S. Aquilino, vestibule
 • 4th c.?
 • partly destroyed.
 • mosaic: HJ?
 • *Basilica di San Lorenzo* (see no. 20 above), figs. 169–177.
22. Milan, S. Ambrogio, chapel of S. Vittore in Ciel d'Oro, squinches
 • 5th c.
 • remade 19th c.
 • (mosaic: 4LC).
 • Brenk (see no. 17 above), pl. 27; Giuseppe Bovini, "I mosaici di S. Vittore 'in ciel d'oro' di Milano," *Corso di cultura sull'arte ravennate . . .* 16 (1969): 73 fig. 1.
23. Vicenza, SS. Felice e Fortunato, chapel of S. Maria Mater Domini, squinches
 • 5th c.
 • mosaic: 4LC.
 • Brenk (see no. 17 above), pl. 21.
24. Albenga, Baptistery, niche vault
 • late 5th c.
 • mosaic: AΩ/chrismon.
 • Wilpert and Schumacher (see no. 6 above), pl. 86; Brenk (see no. 17 above), pl. 20.

Ravenna and Istria

25. Ravenna, S. Giovanni Evangelista, apse wall and apsidal arch
 • ca. 430
 • destroyed 1568; recorded 556–70, before 1589, and 1589.
 • (mosaic: 4LC, 7C?).
 • reconstructions: Deichmann (as in n. 27), figs. 67, 68.
26. Ravenna, S. Croce, entrance wall?
 • before 450.
 • destroyed 1602; recorded 556–70.
 • (mosaic: 4LC).
 • description: Deichmann (as in n. 27), 57; cf. n. 29 herein.
27. Ravenna, "Mausoleum" of Galla Placidia, barrel vaults and cupola
 • before 450.
 • mosaic: AΩ/chrismon, 4LC.
 • Friedrich Wilhelm Deichmann, *Frühchristliche Bauten und Mosaiken von Ravenna* (Baden-Baden, 1958), pls. 16–18, 22–25; color detail: Giuseppe Bovini, *Ravenna Mosaics* (Oxford, 1978), pl. 5.

28. Ravenna, Archbishop's Chapel, vault
 - 6th c.
 - mosaic: AΩ/chrismon, L, 4LCe.
 - Wilpert and Schumacher (see no. 6 above), pls. 93b, 94.
29. Ravenna, S. Michele in Africisco, apsidal arch
 - 545–47.
 - dismantled 1843; remade; damaged 1945; recorded 17th c.
 - (mosaic: L, Tr, SG?).
 - Ihm (as in n. 28), pl. VIII.2.
30. Ravenna, S. Vitale, apse and chancel walls and vault
 - 546–48.
 - mosaic: L, 7S, 4LCe.
 - figs. 24, 25; also Kitzinger (as in n. 36), fig. 153; color photos: Volbach (see no. 4 above), pls. 158, 161.
31. Ravenna (near), S. Apollinare in Classe, apse and apsidal arch
 - 547–49 and 7th c.
 - mosaic: AΩ/cross (6th c.), 4LCe (7th c.).
 - Volbach (see no. 4 above), pl. 173; Deichmann (see no. 27 above), pl. XIV.
32. Poreč (Parenzo), Basilica of Bishop Euphrasius, apse
 - 543–53.
 - mosaic: L.
 - Brenk (see no. 17 above), pl. 375.

GREECE

Salonika
33. H. David, apse
 - 5th–6th c.
 - mosaic: 4LCe.
 - Volbach (see no. 4 above), pl. 134.

EGYPT

Mt. Sinai
34. Monastery of St. Catherine, Church of the Virgin Mary, apsidal arch
 - 565–66.
 - mosaic: L.
 - George H. Forsyth and Kurt Weitzmann, *The Monastery of St. Catherine at Mount Sinai: The Church and Fortress of Justinian* (Ann Arbor, Mich., 1973), pls. CIII, CXXII.A.

Bawit
35. Chapels VI (now Cairo, Coptic Museum, Inv. no. 1220), XVII, XX (Coptic Museum no. 1120), XXVI (partly destroyed), XLII (partly destroyed),

XLV (partly destroyed), XLVI (partly destroyed), LI (partly destroyed);
apsidal niches
- 6th–7th c.
- painting: 4LC.
- fig. 26; Ihm (as in n. 28), pls. XIII.2; XIV.1; XXIV.1, 2, XXV.1, 2.

Saqqara
36. Monastery of Jeremiah, Chapels B (now Cairo, Coptic Museum; partly de-
 stroyed), D (partly destroyed), F; Cell 709 (partly destroyed), Cell 1733 (de-
 stroyed); apsidal niches
- 6th–7th c.
- painting: 4LC.
- Ihm (as in n. 28), 208 no. LIII.1.

BULGARIA

Sofia
37. Necropolis, Tomb 4, east wall
- 4th c.
- painting: AΩ/chrismon.
- Brenk (see no. 17 above), pl. 396b.

Purpose and Imagery
in the Apocalypse Commentary
of Beatus of Liébana

JOHN WILLIAMS

We are poorly informed about the life of Beatus, and the deductions made possible by his literary legacy are a better guide than the *vita* concocted by Juan Tamayo de Salazar (d. ca. 1662) for his *Martyrologium Hispanum*.[1] Beatus was probably born around the middle of the eighth century and lived at least beyond the *vita's* date of death, 19 February 798, in the monastery of S. Martín de Turieno (today Sto. Toribio) in the Asturian valley of Liébana.[2] That he was a member of the clergy is confirmed by a letter written by Paulus Alvarus of Córdoba,[3] and in his *Adversus Felicem*, Alcuin termed Beatus an abbot.[4] He was known to his contemporaries chiefly as the champion of orthodoxy against the Adoptionist teachings of Bishop Elipandus of Toledo. In opposition of Elipandus, Beatus composed the *Adversus Elipandum*,[5] a tract that earned him a letter of praise from Alcuin, who led the Carolingian campaign against Adoptionism. For the modern world, however, Beatus's fame is tied to an earlier work, the *Commentarius in Apocalypsin*. More precisely, it is the densely illustrated copies of this work which have made Beatus a familiar name in the history of medieval culture.

No copy of the commentary from Beatus's own era survives. The closest in time is an illustrated fragment now in Silos, from the latter part of the ninth century. We know the commentary from thirty-two medieval manuscripts, including fragments, dating from the ninth century to the

[1]*PL* 96:890–94.
[2]Luis Vázquez de Parga, "Beato de Liébana y los Beatos," in Bibliotheek Albert I. *Los Beatos: Europalia 85 España* (exhibition catalog) (Madrid, 1985), 3–7.
[3]Juan Gil, ed., *Corpus Scriptorum Muzarabicum*, vol. 1 (Madrid, 1973), 179.
[4]*PL* 101:133.
[5]*PL* 96: 893–1030; *Beati Liebanensis et Eterii Oxomensis adversus Elipandum, libri duo* (*CCCM* 59).

thirteenth.[6] After a brief preface and a longer *Summa dicendorum*, Beatus divided the entire Apocalypse into sixty-eight sections, or *storiae*, consisting of from a few verses of text to as many as eighteen. Each of these sections was followed by the *explanatio*, a more or less lengthy chain of exegetic passages provided by the writings of Jerome, Augustine, Gregory the Great, Ambrose, Fulgentius, Irenaeus, Tyconius, Apringius, Isidore of Seville, Gregory of Elvira, Baquiarius, and others.[7] Of these writers, the most important by far was the North African Tyconius (d. ca. 390), whose commentary on the Apocalypse supplied Beatus with much of the exegetic text.[8]

Beatus composed a preface for his commentary which is a model for the difficulties of establishing the motivation lying behind his extraordinary labors:

> At various times events of the Old Testament have been seen as prophecies of the nativity of our Lord and Savior, or of his incarnation, passion, and death, as well as his resurrection, reign, and judgment, by learned men in numerous books, and the most renowned of the holy fathers with proverbial brevity have shown that by the authority of the prophets the grace of faith is affirmed and the infidel's ignorance is proven. Although those who know the scriptures well will not be puzzled, it aids the memory to read them in brief discourses.
>
> *These things exposed in this book are not by me, but by the holy fathers, to be found in books signed by Jerome, Augustine, Ambrose, Fulgentius, Gregory, Tyconius, Irenaeus, Apringius, and Isidore. What is not understood when read in other books, will be in this, for it is written in common language, and although on some points it may go astray, it is written with absolute faith and devotion.*
>
> *Of all books, you may believe this one is the key, and if I offend the reader in something, may he be indulgent out of charity, which overcomes all* [italics mine].

[6]See Anscari Mundó and Manuel Sánchez Mariana, "Catalogación," in Bibliotheek Albert I, *Beatos*, 99–150; and Richard Kenneth Emmerson and Suzanne Lewis, "Census and Bibliography of Medieval Manuscripts Containing Apocalypse Illustrations, ca. 800–1500," pt. 1, *Traditio* 40 (1984): 347–79.

[7]The sources are collated with the text of Beatus in Sergio Alvarez Campos, "Fuentes literarias de Beato de Liébana," in *Actas del simposio para el estudio de los códices del "Comentario al Apocalipsis" de Beato de Liébana* (hereafter *Actas del Simposio*), vol. 1 (Madrid, 1978), 1–3, and in the recent edition of the text, ed. Eugenio Romero Pose, ed., *Sancti Beati a Liébana Commentarius in Apocalypsin*, 2 vols. (Rome, 1985). For a discussion of the sources, see idem, "La importancia de los 'Comentarios de Beato' en la historia de la literatura cristiana," *Compostellanum* 33 (1988): 53–91, esp. 62ff. See also the essay by E. Ann Matter earlier in this volume.

[8]For the Tyconian commentary and the Beatus text, see Kenneth B. Steinhauser, *The Apocalypse Commentary of Tyconius: A History of Its Reception and Influence* (Frankfort on the Main, 1987), 141–96. Although Steinhauser discounts the purity of Beatus's reflection of Tyconius's text, the fact remains that the single most important source for the Beatus commentary is Tyconian.

These are small things gathered from among many doctrines we have from good men. Of these, the discourses known to us have been interpolated so that they may support our discussion.

This then, holy father Etherius, I dedicate to you for the edification of the brothers' study, that as my colleague in religion you may enjoy it and be co-heir of my labors.[9]

With this introduction, Beatus put into the reader's hands a discourse on the Apocalypse running to some one thousand pages in its recent edition. Any expectation that this preface might confirm the specific motivation behind the considerable effort the commentary represents beyond the reference to edification, and an identification of the colleague to whom it is dedicated—is frustrated, not only because that question is not addressed but, even more so, because the very language of the introduction, with the exception of the paragraphs here italicized, is appropriated verbatim from the prefaces to the *Contra Iudaeos, De ortu et obitu patrum,* and *De officiis* of Isidore of Seville.[10] Even the final sentence, with its offer at least of a general goal in the words *ob aedificationem studii fratrum,* is taken, with the exception of the word *fratrum* and the substitution of the name Etherius, from the final sentence of Isidore's presentation of the *Contra Iudaeos* to his sister, Florentina.

Any attempt to uncover the motivation behind the compilation will have to begin with an acknowledgment that Beatus was a cut-and-paste editor and that any passage we select will give us the words and expression of an author long dead when Beatus composed his commentary. In his procedure, Beatus was following established exegetic traditions, and his sources were openly acknowledged, as we saw, in his preface. Eventually, in the final elaboration of Branch II of the manuscript tradition in the tenth century, the authors to whom he was indebted would receive the dignity of a collective portrait, as may be seen in the eleventh-century copy made in the Gascon abbey of Saint-Sever (fig. 27).[11] At the same time, we must grant his considerable efforts the dignity of being purposeful and recognize that in his capacity as editor he determined which sources were appropriate and how they should be marshaled. In this sense, the commentary was authored by Beatus. A more formidable obstacle to determining the targets of the commentary is the fact that, like Biblical exegesis in general, the interpretations harvested by Beatus remained on an atopical level. Any attempt to recognize a specific motive for the original commentary and its

[9]Henry A. Sanders, ed., *Beati in Apocalipsin libri duodecim* (Rome, 1930), 1–2; Romero Pose, *Sancti Beati* 1:3–5.

[10]The sources of the preface were first identified by H. L. Ramsay in "Le commentaire de l'Apocalypse par Beatus de Liébana," *Revue d'Histoire et de Littérature Réligieuse* 7 (1902): 419–47, esp. 424–25.

[11]Paris, Bibliothèque nationale MS lat. 8878, fol. 13v; Emmerson and Lewis, *Census and Bibliography,* no. 25.

illustrations and for the meaning, or function, of the copies subsequently made, will have to depend as much or more on historical reconstruction as on the commentary text itself.[12]

As I have noted, Beatus's name was chiefly associated with his championing of the cause of orthodoxy against the Adoptionist interpretation of Christology defended by Elipandus of Toledo. His commentary on the Apocalypse has often been identified as an anti-Adoptionist undertaking.[13] As the last book of the Bible, the Apocalypse proclaims both the end of history and the beginning of the eternal Kingdom of God. It describes the conditions of that end as a horrendous struggle against assorted evils, invoking in various guises false prophets, Antichrist, and other agents of Satan. The commentary of Tyconius, the source for much of the exegetic text, was written in the turmoil of sectarian war within the African church and persecution by the orthodox party of the Donatist faction that claimed the allegiance of Tyconius. It was an exegetic text that stressed the presence within the Church of good and bad members.[14] Thus the Apocalypse, by its nature—and the predominantly Tyconian commentary, by the historical circumstances that had produced it—were eminently suitable for reappropriation in the context of heresy and persecution.

Those proposing such a role for the Beatus commentary have never treated the question of the date of this composition with the seriousness it has to receive. Although he did not argue that it was composed in response to Adoptionist issues, Wilhelm Neuss did propose a single archetype composed about 785—that is, at the moment Adoptionism emerged.[15] In ar-

[12]The Beatus bibliography has relatively few items that address the general issue of function. See, however, Jacques Fontaine, "Fuentes y tradiciones paleocristianas en el método espiritual de Beato," in *Actas del Simposio* 1:77–101, 103–05; Karl Werckmeister, "The First Romanesque Beatus Manuscripts and the Liturgy of Death," in ibid., vol. 2 (1980, 165–92; Nourredine Mezoughi, "Beatus et 'les Beatus," in *El 'Beato' de Saint-Sever*, vol. 2 (Madrid, 1984), 21–31, esp. 28–30; and Peter K. Klein, "La fonction et la 'popularité' des Beatus, ou Umberto Eco et les risques d'un dilettantisme historique," in *Etudes roussillonnaises offertes à Pierre Ponsich* (Perpignan, 1987), 313–25. See also C. R. Dodwell, *Painting in Europe, 800–1200* (Baltimore, 1971), 98–99.

[13]Mateo del Alamo proposed that Elipandus was a direct target of the commentary; see his "Los comentarios de Beato al Apocalipsis y Elipando," in *Miscellanea Giovanni Mercati*, vol. 2 (Vatican City, 1946), 16–33, esp. 30–33. See also Betty Al-Hamdani, "Beatus of Liébana versus Elipandus of Toledo and Beatus' Illuminated Commentary on the Apocalypse," in *Actas del I Congreso de Andalucía*, vol. 1 (Córdoba, 1978), 153–63; and Klein, "Fonction," 315. The most determined argument that Adoptionism, and Elipandus in particular, were targets of the commentary is found in Steinhauser, *Apocalypse Commentary of Tyconius*, 141–96. Steinhauser is interested in diluting the Tyconius purity of the commentary and stresses its Beatine, Asturian character. He does not discuss the issue of the date of the commentary.

[14]See W. H. C. Frend, *The Donatist Church: A Movement of Protest in Roman North Africa* (Oxford, 1952), esp. 201ff.

[15]Wilhelm Neuss, in his original study, *Die Apokalypse des hl. Johannes in der altspanischen und altchristlichen Bibel-Illustration*, vol. 1 (Münster, 1931), 5, assigned the commentary, without argument, to the last third of the eighth century. He later pro-

guing for a single archetype and date, Neuss rejected Leopold Delisle's and Henry Sanders's belief in successive editions composed with Beatus's intervention. The first of these would have appeared in A.D. 776, a date appearing in a computation of world chronology in the two manuscripts employing the original recension of the text. Peter Klein has since evaluated the arguments for various editions with a rigorous attention to the evidence of the illustrations and concluded that the date of 776 is probably valid.[16] Thus the commentary seems to have been composed almost a decade before the Adoptionist controversy surfaced, and five or six years before Elipandus's elevation to the *cathedra* of Toledo.[17] Moreover, a text so ecclesiologically oriented would have been a most oblique response to Elipandus's teachings that the incarnate Christ in his human guise was a merely nominal, as opposed to the true, Son of God. Beatus *did* compose an anti-Adoptionist tract: the *Ad Elipandum*, which attacked Elipandus and his theology directly and explicitly. Adoptionism was not the only threat to orthodoxy in the peninsula in the second half of the eighth century.[18] Although it was to loom largest, controversies involving Easter, Christian observance of Jewish law, and various doctrinal matters would be associated with an Asturian bishop, Ascaricus, who, with Elipandus, would eventually be accused by Pope Adrian I (772–95) of holding Adoptionist views. Adrian's concern with Iberian orthodoxy antedated that controversy. He had written to the bishops of Spain exhorting them to shun heresy, and he had concurred in the sending of Bishop Egila to Spain to preach the orthodox faith. Of particular concern were the teachings of Migetius, a former papal missionary who fashioned bizarre doctrines after his arrival. It was in this context, and with a presumption that the Asturian church might be identified as the champion of orthodoxy, that Beatus would have composed his commentary. Although it is possible that the commentary on the Apocalypse came to be read through an

posed a date of ca. 785, in his "Probleme der christlichen Kunst in maurischen Spanien des 10. Jahrhunderts," in *Neue Beiträge zur Kunstgeschichte des 1. Jahrtausends: Frühmittelalterliche Kunst,* vol. 1, 2d ed., ed A. Alföldi (Baden-Baden, 1954), 249–84, esp. 254.

[16]Peter K. Klein, *Der ältere Beatus-Kodex Vitr. 14-1 der Biblioteca Nacional zu Madrid: Studien zur Beatus-Illustration und der spanischen Buchmalerei des 10. Jahrhunderts* (Hildesheim, 1976), 170ff. From conversations with Manuel Díaz y Díaz and Eugenio Romero Pose, I know that the idea of datable editions is still met with skepticism, although this skepticism in no sense favors 785 over 776. The computation of world chronology is discussed later in the essay.

[17]Wilhelm Heil, "Der Adoptionismus, Alkuin und Spanien," in *Das Geistige Leben,* ed. Bernhard Bischoff, vol. 2 of *Karl der Grosse,* ed. Wolfgang Braunfels (Dusseldorf, 1965), 95–155, esp. 100–101.

[18]See Zacarias García Villada, *Historia eclesiástica de España,* vol. 3 (Madrid, 1936), 56–58; and Edward Colbert, *The Martyrs of Córdoba, 850–859* (Washington, D.C., 1962), 51ff.

anti-Adoptionist lens, there is no evidence to make its conception a part of that polemic. Indeed, its composition would have preceded that battle.[19]

The most explicit declaration of purpose left by someone responsible for the copying and illumination of the commentary occurs in a copy made almost two hundred years after the original. It was provided by Maius in the colophon of the commentary written for the monastery of S. Miguel de Escalada and now in the Pierpont Morgan Library.[20] It states that the book was undertaken "so that those who know may fear the coming of the future judgment of the world's end" (293r). We have no evidence of apocalyptic preoccupations in Spain in the tenth century, so it is risky to assume that Maius's reference to the world's end arises from such a perspective—expecting the imminent return of Christ and the Last Judgment.[21] Beatus and his contemporaries may have had a different attitude toward the eschatological aspects of the Apocalypse. The traditional calculation of world chronology gave the earth an age of more than five thousand years. This understanding of history, combined with the millennial week, wherein the six ages of history would be followed by the eternal kingdom, or Sabbath, gave the year 800 its significance as the expected end of history.[22] The peninsula's heretical movements and the pagan domination of most of the peninsula may have been taken as the apocalyptic turmoil that would precede the triumph of the Church under Christ. Some writers have, indeed, concluded that his commentary reveals an expectation of the end of earthly time.[23] Beatus's text both supports and denies the proposition.

Arguments for an apocalyptic attitude on Beatus's part never fail to mention a derisive anecdote recounted by Beatus's antagonist, Elipandus, in a letter written to the bishops of Gaul in 793. Elipandus coupled Beatus with the heresiarch Migetius in a tale involving an unfulfilled prophecy of the end of the world to a certain Ordoño: "Now as Migetius predicted his resurrection on the third day after his death, Beatus prophesied to Ordoño of Liébana, in the presence of the people, the end of the world. In terror the

[19]For denials of the connection between the commentary and Adoptionism, see Heil, "Adoptionismus," 101; and Knut Schäferdiek, "Der adoptianische Streit in Rahmen der spanischen Kirchengeschichte I," Zeitschrift für Kirchengeschichte 80 (1969): 291–312, esp. 301.

[20]New York, Morgan Library, Ms. M.644; Neuss, des hl. Johannes Apokalypse 1:9–16.

[21]Umberto Eco did assume as much, citing Henri Focillon's L'an mil (Paris, 1952); see Umberto Eco, "Beato de Liébana, el Apocalipsis y el milenio," Cuadernos del Norte 3, no. 14 (1982): 2–20, and "Waiting for the Millennium," FMR 1, no. 2 (1984): 63–92; and Umberto Eco and Luis Vázquez de Parga, Beato di Liébana: Miniature del Beato di Fernando I y Sancha (Códice B.N. Madrid Vit. 14-2) (Parma, 1973). These are essentially the same texts.

[22]Richard Landes, "Lest the Millennium Be Fulfilled: Apocalyptic Expectations and the Pattern of Western Chronology, 100–800," in The Use and Abuse of Eschatology in the Middle Ages, ed. Werner Verbeke, Daniel Verhelst, and Andries Welkenhuysen (Leuven, 1988), 137–211.

[23]For arguments that he did, see Juan Gil, "Los terrores del año 800," in Actas del Simposio 1:217–47, esp. 222f.; and Landes, "Lest the Millennium Be Fulfilled," 192–94.

people fasted all that night and until the ninth hour on Sunday, when Ordoño, feeling hungry, declared 'Let us eat and drink, for if we are to die, let us be gratified.' The same [Beatus], pretending to be ill, arose on the third day, his body alive, but his soul dead."[24]

If this anecdote seems to vouch for the possibility that an eschatological purpose moved Beatus to compile his commentary, it is worth noting that it was related nearly twenty years after the commentary was composed and by someone who never missed an opportunity to heap scorn on Beatus. Elipandus's extravagance may be measured by the final sentence just quoted. It is one with his assertion in the same letter that Migetius had told a woman, "Amen, amen, I say to you, you shall be with me this day in paradise" (cf. Luke 23:43) and that Migetius had ordained a certain Rufinus as abbot of animals, repeating Christ's words, "Feed my sheep" (John 21:17). Moreover, if true, our story would mean that Beatus had publicly elected some moment before 793 for the final end, while his commentary ostensibly proclaimed, with all the weight of tradition, that the end of the sixth—penultimate—age would come in the year 800. The story offers questionable support for an apocalyptic interpretation of the commentary.

In so far as this expectation involved a spiritual interpretation of the thousand-year earthly reign of Apocalypse 20:1–6, Beatus depended on Tyconius. As Paula Fredriksen explains in her essay in this volume, Tyconius's spiritual, nonmaterialistic notion of the thousand-year reign of Christ had been instrumental in finally defeating the millennialist perspective of the early Church.[25] Indeed, Beatus omitted both from the *storia* and the *explanatio* (undoubtedly because the passage was taken over from Tyconius) verse 5 of Apocalypse 20 ("The rest of the dead did not come to life till the thousand years were finished. This is the first resurrection"), one of the prime textual bases of millennialist, materialistic eschatology. In the *explanatio*, the first resurrection is not physical but said to be conferred by baptism; and the number one thousand is not tied to a specific computation of ages but is interpreted as a symbolic reference to "this world, not to a perpetual time in which they will reign with Christ without end" (11.5.18–19).[26] It is also the time of the Church's reign through all time.[27]

The eschatological potential of Beatus's commentary had come to the fore earlier in the commentary, in Book 4 in the exegesis of the sealing of the 144,000 in Apocalypse 7. Here Beatus inserted a computation of chronology in which the sixth age of the world, the age that precedes the establishment of the kingdom, would end in the Spanish era 838 (A.D. 800),

[24]Gil, *Corpus Scriptorum Muzarabicum* 1:92, see also Colbert, *Martyrs of Córdoba,* 76–77.

[25]See also Wilhelm Kamlah, *Apokalypse und Geschichtstheologie: Die mittelalterliche Auslegung der Apokalypse vor Joachim von Fiore* (Berlin, 1935), 11–12; and Paula Fredriksen [Landes], "Tyconius and the End of the World," *Revue des Etudes Augustiniennes* 18 (1982): 59–75.

[26]Sanders, *Beati in Apocalypsin,* 605; Romero Pose, *Sancti Beati* 2:354.

[27]Ibid.

thus potentially within Beatus's own lifetime: "All the time from Adam to
Christ comes to 5227, and from the coming of our Lord Jesus Christ to the
present, era 814, is 776 years. Count, then, from the first man, Adam, to
the present era of 814 and you will have 5976 years. Therefore twenty-five
years remain in the sixth millennium. The sixth age will end in the era
838" (A.D. 800).[28] Beatus immediately followed this calculation with Isi-
dore of Seville's observation that "the time remaining for the world is not
subject to human discovery,"[29] and he structured succeeding paragraphs
around biblical passages traditionally interpreted as warnings against date
setting, such as Matthew 24:36, Mark 13:32, and Isaiah 63:4. The *storia*
closes (4.5.25) with a resounding negative: "For many put the day [of res-
urrection of the dead by the Lord] on Sunday, but who knows when, in
what year, at what hour, on what day, or in what era the day will come."[30]
The discussion of the sixth age begins with the declaration that "in truth
the world will end in the sixth millenium" (4.5.18: in veritate sexto
millesimo anno finiendus erit mundus . . .), but it is immediately con-
verted into a long christologically oriented discussion of time itself, days,
nights, and creation. Then, however, another warning is entered: "Now
the sixth age passes, the time from the coming of the Lord to the time
when the world ends and is judged" (4.5.68: Iam sextum saeculum fit,
quae nunc ab adventu Domini agitur, usque quo mundus finiatur, et veniat
ad iudicium). We do not know the source of the exegetic text that includes
the calculation of the ages. It is a typical kind of computation, but it is
highly unlikely that his source ended with the declaration that "twenty-
five years remain in the sixth millennium."[31] The passage of time had es-
tablished a new, post-Tyconian context that Beatus seems to have found
inescapable, and so he seems to swing back and forth between, on the one
hand, acceptance of the inevitable consequences of the structure of time
and, on the other, a traditional reluctance, reinforced by biblical injunc-
tions, to rely on human calculation. Even so, it probably was Tyconius

[28]Sanders, *Beati in Apocalypsin*, 367–68; Romero Pose, *Sancti Beati* 2:608–9. The
numerals are the ones appearing in the first edition texts of A.D. 776. Subsequent edi-
tions might change one or several of them, but not consistently. The cipher 5976 is
not the actual sum of the preceding numbers, but the final year of A.D. 800, expressed
only as the Spanish era 838, is the operative one. If the year of composition is included,
there were twenty-five years between A.D. 776 and A.D. 800. Later editions shortened
this time.
[29]Isidore of Seville, *Chronicon* (PL 83:1056); Sanders, *Beati in Apocalipsin*, 368;
Romero Pose, *Sancti Beati* 2:609.
[30]Sanders, *Beati in Apocalipsin*, 370; Romero Pose, *Sancti Beati* 2:611–12.
[31]The computation of ages appears in the *Chronicon Albeldensis*; see Juan Gil
[Fernández], José Moralejo, and Juan Ruíz de la Peña, eds., *Crónicas asturianas* (Oviedo,
1985), 155–56. In the seventh century, Julian of Toledo composed a handbook on the
events of the end of time, the *Prognosticum*; in it he definitively denied the ability to
predict the moment of the End (3.1). See J. N. Hillgarth, ed., *Sancti Iuliani Toletanae
sedis episcopi opera*, vol. 1 (Turnholt, 1976), 82. Beatus did not borrow from any of
Julian's influential writings.

who supplied the words that seem best to sum up the chief motive behind Beatus's labors: "thus, for all that has been said above, every catholic ought to ponder, wait and fear, and to consider these twenty-five years [that remain before the End] as if they were no more than an hour, and should weep day and night in sackcloth and ashes for their destruction and the world's, but not strive to calculate time."[32] The commentary was very probably composed as a handbook to help prepare the Christian community for the anticipated end of the world.[33]

Since all the surviving thirty-two copies were produced long after the supposed date for the beginning of the *eschaton*, the vitality of the commentary obviously did not depend on an apocalyptic context. The dedication cited above, with its reference to the brothers, and the history of the commentary, which is conventual except for the copy made for Fernando I in 1047, marks the commentary as a monastic artifact. Personal reading for spiritual enrichment would also be an exercise especially suitable, indeed traditional, for the contemplative life. The extensive glosses and correlations that mark such commentaries as the Vitrina 14-1, the Morgan 644, and the Gerona Beatus testify to readership and to the seriousness accorded the texts. Erasures that mark the face of Satan in such commentaries as Tábara (125r) and Lisbon (e.g., 186v, 201r) speak eloquently of individual contact with, and reaction to, the Beatus commentary.[34]

Such defacement testifies also to the communicative power of the illustrations.[35] A significant majority of the surviving manuscripts are illustrated with pictures based essentially on the narratives of the *storiae*. These are uniformly inserted between each *storia* and its *explanatio*. Because of the iconographic uniformity and the integral manner in which they are joined to the text, it has never been doubted that the first commentary, or one of the earliest copies made in Beatus's circle, was illustrated

[32]"Ita, ut supra dictum est, intelligere debet et expectare et timere omnis catholicus et hos XXV annos tamquam unam horam putare et die noctuque in cinere et cilicio tam se quam mundi ruinam plangere et de supputatione annorum supra non quaerere" (4.5.31; Sanders, *Beati in Apocalypsin,* 371; Romero Pose, *Sancti Beati* 2:614).

[33]The conclusion of Fontaine, "Fuentes y tradiciones," 78 n. 2.

[34]For *lectio divina,* see Jean Leclercq, *The Love of Learning and the Desire for God* (New York, 1961), 23ff., 77ff., and Willibrod Witters, "Travail et lectio divina dans le monachisme de St. Benoit," in *Atti del 7 Congresso Internazionale di Studi sull'Alto Medioevo,* vol. 2 (Spoleto, 1982), 551–61. For *lectio divina* as a function of the commentary, see Jacques Fontaine, *L'art préroman,* vol. 2 (Zodiaque, 1973), 357ff., and "Fuentes y tradiciones"; and Werckmeister, "First Romanesque Beatus Manuscripts," 167f.

[35]For discussions of the relationship of text and picture in the commentaries, see Mireille Mentré, *La miniatura en León y Castilla la Alta Edad Media* (Léon, 1976), 80f. Werckmeister proposed, in "First Romanesque Beatus Manuscripts," 169–70, that the illustrations had a role in "interiorizing" the content of the commentary and provided a "mnemotechnical" aid in the memorization of the text, according to ancient study practice; see also Fontaine, "Fuentes y tradiciones," 103. On the internalization of Christian imagery, see William Loerke, " 'Real Presence' in Early Christian Art," in *Monasticism and the Arts,* ed. T. G. Verdon (Syracuse, 1984), 29–51.

and served as the prototype for all Hispanic copies that followed.[36] This cycle of Apocalypse illustrations is independent of any other tradition. It seems an almost inescapable conclusion that the Tyconian model that provided the text was the source for the illustrations as well. Although it is true the Beatus illustrations are not informed by Tyconian exegesis, each one is a more or less literal pictorial version of the *storia* it follows, and the *storiae* are a version of the Vetus Latina associated with North Africa, undoubtedly the text employed in Tyconius's commentary. The retention of this text by Beatus as late as the eighth century is striking testimony to his dependence on his African model.[37]

In the final stage of its evolution, Beatus's commentary on the Apocalypse was illustrated by as many as one hundred and eight canonical images. Sixty-eight of these were inspired by and immediately followed the *storiae* into which the Apocalypse text had been divided. Seven were based on the text of the commentary: the map of the world, the Apostles, the Four Beasts and the Statue, the Woman on the Beast, the Ark of Noah, the palm, and the fox and the cock. To these were added the eight prefatory miniatures of the evangelists and their Gospels, fourteen pages presenting the genealogy of Christ, and the eleven illustrations that accompany Jerome's commentary to Daniel. This total could then be augmented in the most luxurious copies by the labyrinth of an ex-libris, the authors (see fig. 27), the cross, the Alpha and Omega, and the allegorical combat of bird and serpent. Biblical codices in the early medieval period might have a greater density of illustration, but Beatus's commentary was unrivaled for the wealth of its imagery. The visual opulence was considerably augmented in the tenth century, when the miniatures received frames. Banded, particolored backgrounds were also introduced, and the space devoted to the illustrations increased.[38]

The purpose served by the original set of illustrations is an issue on which it is difficult to move beyond speculation; for the function of the pictures that accompany a text is rarely explicit outside of scientific illustration and the obvious ends of embellishment. The only words we have on the issue of the function of the illustrations from an illustrator of a commentary were left us by Maius in the colophon of Morgan 644: "I have painted a series of pictures for the wonderful words of the stories [from the Apocalypse] so that those who know may fear the coming of the future judgment of the world's end" (293r). In other words, the verbal accounts of

[36]Neuss, *Apokalypse des hl. Johannes* 1:5, 186f., 237. Because he perceived the influence of the iconography of Sanders's second-edition manuscripts on Vitr. 14-1 and Saint-Sever, Klein in *Beatus-Kodex*, 210, introduced the possibility that the second edition was the first one illustrated.

[37]This conclusion about the source of the cycle will be argued in my forthcoming monograph, *The Illustrated Beatus: A Corpus of the Illustrations of the Commentary on the Apocalypse;* vol. 1 (London, in press).

[38]John Williams, "Las pinturas del comentario," Bibliotheek Albert I, in *Beatos* 19–20.

the *storiae* were made more immediate by the pictorial descriptions. That the commentary's long history is essentially one of illustrated copies is proof of the centrality of the miniatures in this particular tradition. In their literalness, the Apocalypse and Daniel illustrations are pictorial recapitulations of the biblical texts, with the advantages and limitations inherent in their own medium. They might serve as an efficient guide to a particular *storia*, if not its interpretation, even, we may imagine, to the point of substituting for the passage itself for an indoctrinated viewer. The illustrations could command separate attention and, in their concreteness, mediate between the text and the reader's imagination. Moreover, the constant and loquacious role played by the inscriptions, which accompany almost all miniatures in most copies, meant that the illustrations could function, in some sense, as a surrogate for the Apocalyptic text. Their partnership with that text, much stricter than with the lengthy pages of *explanatio* that followed, would have facilitated an independent perusal of the Apocalypse in textual and pictorial form.

A preoccupation with neither Adoptionism nor apocalypticism is detectable in the imagery attached to the Beatus commentary.[39] Aspects of the imagery have been traced, however, to an upheaval of another sort, the occupation of the peninsula by a "pagan race." Ostensibly the text seems untouched by the event. Not long before Beatus composed his commentary, John of Damascus (d. ca. 749), in a Christian territory occupied by Muslims at the other end of the Mediterranean, included Islam in his catalog of Christian heresies.[40] In contrast, the *De heresibus Christianorum* of the prologue to Book 2 in Beatus's commentary makes no mention of the followers of Muhammad.[41] Islam, poorly known as it was, would have been seen in the peninsula in Beatus's era as a heresy, not an antagonistic religion,[42] but it could have appeared as such in the commentary only if Beatus had abandoned his policy of letting his sources stand as received; for this section of the text is based on a pre-Islamic source, Isidore's *Etymologiae*. Since all of Beatus's sources predated the rise of Islam, there is nowhere in the commentary an explicit reference to Muhammad or his followers. Ishmael kept his original exegetic identity as a son of the unredeemed synagogue even though he had long been identified as the father of

[39]Dodwell in *Painting in Europe*, 98–99, perceived in text and picture an emphasis on the Incarnation, which he took to be anti-Adoptionist. It is not likely, however, that the pictures he cited—the Evangelists—were in the commentary in Beatus's lifetime.

[40]D. J. Sahas, *John of Damascus on Islam: The 'Heresy of the Ishmaelites'* (Leiden, 1972); Jean Meyendorff, "Byzantine Views of Islam," *Dumbarton Oaks Papers* 18 (1964): 115–32.

[41]Sanders, *Beati in Apocalypsin*, 129–30; Romero Pose, *Sancti Beati* 1:210–12.

[42]Kenneth Wolf, "The Earliest Spanish Christian Views of Islam," *Church History* 55 (1986): 281–93, esp. 289–90. This would be true even in the tenth century, according to F. R. Franke, "Die freiwilligen Märtyrer von Cordova und das Verhältnis der Mozaraber zum Islam," *Spanische Forschungen des Göresgesellschaft* 13 (1953): 50: "That Islam was a Christian heresy was for Eulogius and Alvarus an undoubted fact."

the Arabs by Jerome, Isidore, and others.[43] Antichrist, potentially Muham-
mad, remained tied to the age-old definitions.[44] The absence in the com-
mentary of explicit references to Islam and Muhammad certainly does not
preclude the identification of apocalyptic enemies with the Muslim usurp-
ers, but if readers were meant to see the false prophets and agents of Anti-
christ that thickly populate the Apocalypse as the adherents of Islam, this
expectation relied on the readers' conditioning and not on explicit signals
in the text. In being suprahistorical, biblical texts and liturgical prayers re-
mained efficacious for all situations, and this would be true for the com-
mentary as well. A decision about the presence or absence of an anti-
Islamic message in the commentary will depend on our reconstruction of
the Christian-Muslim confrontation, a task made difficult by the scarcity
of evidence. The commentary was composed and redacted during a period
when political and military conflict with the Muslims was minimal.[45]
More significantly, anti-Islamic sentiments would find explicit literary ex-
pression, but only (insofar as surviving examples are concerned) after the
passage of almost a century. The absence of contemporaneous anti-Islamic
rhetoric fits a pattern of slow articulation. It is imaginable, then, that Bea-
tus's generation had no consistent perception of the Muslims as the
"enemy."[46] Ironically, it is a treatise by Elipandus's ally in the Adoptionist
affair which allows us to imagine Islam as a specific clerical target during

[43]Sanders, *Beati in Apocalypsin*, 112; Romero Pose, *Sancti Beati* 1:184. See my "Gen-
erations Abrahae," *Gesta* 16, no. 1 (1977): 3–14. In such later commentaries as the Saint-
Sever (Paris, Bibliothèque nationale MS lat. 8878, fol. 51r) and Las Huelgas (New York,
Pierpont Morgan Library MS 429, fol. 35v), however, the lion is identified with the Ish-
maelites in addition to the kingdom of Babylon. For the commentary and Islam, see Me-
zoughi, "Beatus et 'les Beatus.' "

[44]Wolf, "Earliest Spanish Christian Views," n. 16: "It is interesting, too, that the fa-
mous commentary on the Apocalypse composed by Beatus of Liébana in the 770s should
be equally devoid of information about Islam. Although, as we shall see, the identifica-
tion of Muhammad and the forces of the Antichrist became a theme of anti-Muslim po-
lemic in the next century, Beatus was content to interpret Revelation as if the political
climate in the Mediterranean had not changed significantly since imperial times."

[45]L. G. Valdeavellano, *El feudalismo hispánico* (Barcelona, 1981), 163–96. The *Albel-
dense* attributed the peace that marked the reign of Silo (754–83) to his having a Muslim
mother (Gil [Fernández], Moralejo, and Ruíz de la Peña, *Crónicas asturianas*, 174).

[46]This is the conclusion of Ron Barkai, in *Cristianos y Musulmanes en la España me-
dieval* (Madrid, 1984), 19–30: "El cronista mozárabe ignora por completo el significado
religioso del conflicto cristiano-musulmán en España, aunque percibe que la conquista
de España es parte de la expansión del Islam por el mundo entero. . . . El elemento reli-
gioso solo existe—en la concepción de la conquista musulmana de España—como un
castigo divino (*iudicum Dei*) conforme al modelo bíblico de castigo al publo de Israel. . . .
En el análisis de la imagen del enemigo musulmán y de la autoimagen hispano-
cristiana, conjuntamente sorprende que en estas dos primeras crónicas [*Continuatio
Byzantina Arabica* (A.D. 741) and *Continuatio Hispana* (A.D. 754)] escritas después de la
conquista, los musulmanes no sean definidos como enemigo, nombre tan normal
cuando se trata de una confrontación de grupos anagonísticos. . . . En ninguna de las dos
crónicas se expresa la idea de reconquista, ni como un deseo inmediato" (29–30). On
Christian attitudes toward Islam, but chiefly ninth century, see Kenneth Wolf, *Christian
Martyrs in Muslim Spain*, (Cambridge, 1988), 86ff.

Beatus's era. In a letter to Alcuin, Charlemagne asked for a *Disputatio cum Sarraceno* by Felix of Urgel.[47] Perhaps it was a condition of Felix's return to good standing after the scandal of Adoptionism. Since it is lost, we cannot determine that, or the kinds of issues it dealt with. It would, at any rate, represent a counterpart to the *Ad Elipandum* in being target specific. If the commentary on the Apocalypse served the same anti-Islamic cause, it did so in an implicit, panacean mode not subject to our verification.

What was probably the commentary's chief contribution to the structure of Spanish resistance to the Muslim occupation could not have been anticipated by Beatus. In Book 2.3.17 (prologue), Beatus stated that the Apostle James evangelized Spain, and the map accompanying this passage included a portrait of the Apostle in the peninsula.[48] In the early ninth century, the "tomb of Saint James" would be discovered in Galicia, and eventually, in the twelfth century, the figure of Saint James the Moorslayer would evolve. In its first, Asturian stages, however, it is unlikely that the Apostle had an anti-Islamic significance in either the religious or military sense.[49]

A very different Muslim-Christian context was produced in the ninth and tenth centuries, beginning with the voluntary martyrs movement of 850 in Córdoba, a catalyst for emigration north and for the anti-Muslim spirit of the chronicles of the time of Alfonso III.[50] By this time, a brief, scurrilous life of Muhammad circulated in the peninsula, giving as the year of Muhammad's death era 666, the number of the Beast in Apocalypse 13:18.[51] In Andalusia, references to the "pagan" religion and its prophet became open and explicit. In 854, Paulus Alvarus dedicated the second part of his *Indiculus luminosus* to an exposure of Muhammad as a type of Antichrist and the beast of the prophecy of Daniel.[52] This was, for Spain, the first explicit literary association of biblical prophecy with the race that

[47]*MGHEp.* 4:284–85. Benjamin Kedar, in *Crusade and Mission: European Approaches toward the Muslims* (Princeton, 1984), 25, assigned the letter to 799, as did James Waltz, in "The Significance of the Voluntary Martyrs of Ninth-Century Córdoba," *Muslim World* 60 (1970): 143–159, esp. 148; he saw it as a response to Carolingian pressure on Felix to produce a proof of orthodoxy. Heil, however, dated it to before 788 ("Adoptionismus," 102–3).

[48]Sanders, *Beati in Apocalypsin*, 116; Romero Pose, *Sancti Beati* 1:192. For Beatus and the cult of Saint James, see Justo Pérez de Urbel, "Orígines del culto de Santiago en España," *Hispania Sacra* 5 (1952): 1–31; and Robert Plötz, "Der Apostel Jacobus in Spanien bis zum 9. Jahrhundert," in *Gesammelte Aufsätze zur Kulturgeschichte Spaniens* 20 (1982): 19–145, esp. 89–94.

[49]Odilo Engels, "Die Anfänge des spanischen Jakobusgrabes in kirchenpolitischer Sicht," *Römishce Quartalschrift für christliche Altertumskunde und Kirchengeschichte* 75 (1980): 146–70, esp. 157ff.

[50]Barkai, *Cristianos y Musulmanes*, 52–53.

[51]*PL* 115: 159–60. Eulogius of Córdoba encountered the text in the monastery of Leyre during a visit there in 848. See Colbert, *Martyrs of Córdoba*, 334–38; and Manual Díaz y Díaz, "Los textos antimohametanos mas antiguos en códices españoles," *Archives d'Histoire Doctrinale et Littéraire du Moyen Age* 37 (1970): 149–64.

[52]Colbert, *Martyrs of Córdoba* 269f.; R. W. Southern, *Western Views of Islam in the Middle Ages* (Cambridge, Mass., 1962), 22–23; Wolf, *Christian Martyrs*, 91ff.

had usurped most of the Spanish Christian kingdom. Beatus's commentary seems to have been known to Paulus Alvarus and must have contributed to the formation of an antiheretical literature that had Muhammad and Islam as its target.[53] Unlike Beatus, Paulus was writing within the crucible of Islamic-Christian religious confrontation. Under Alfonso III, Muslims would be recognized as an alien people in Asturian literature as well. In A.D. 883, an Oviedan cleric edited the so-called *Crónica profética*. Here the Muslim dynasties, beginning with that established by Abraham and Ishmael, were placed in the context of biblical prophecy in a freewheeling interpretation of Ezekiel 38–39. The biblical Gog would represent the Visigothic state, which would revenge itself on the Ishmaelites after 170 years—that is, in the coming year, 884—since the invasion was assigned, erroneously, to 11 November 714:

> Gog refers to the people of the Goths, from whom they descended and from whom they took their name. And when the prophet says to Ishmael, "You will easily enter the land of Gog and subdue Gog with your sword, and you will plant your foot on the back of the neck and will make them servants," this we understand has been accomplished, for Gog is Spain under the rule of the Goths, which, because of the sins of the Gothic people, was taken by the Ishmaelites, who subdued them with the sword and made them tributaries, as we see at the present time. The Saracens themselves, through wonders and signs in the stars, prophesy that their downfall is near and predict that the kingdom of the Goths will be restored by our prince. Also by revelations and signs many Christians foresee that our prince, the glorious Alfonso, will soon reign in all Spain.[54]

It is both this perception of Islam's place in the scheme of Spanish history and the settlement in León by immigrant Mozarabes with a fresh knowledge of Muslim intolerance that distinguish the tenth-century situation from that of Beatus's era. They also provide the actual historical background for the spectacular revival and reformation of the commen-

[53]The commentary's presence in Andalusia is reflected in the *De adventu Enoch* (Gil, *Corpus Scriptorum Muzarabicum* 1:126–33). Dominique Millet-Gérard, in *Chrétiens mozarabes et culture islamique dans l'Espagne des VIIIe–IXe siècles* (Paris, 1984), 199, detected reflections of the Beatus commentary in Alvarus's writings.

[54]Translated from the text found in Manuel Gómez Moreno, "Las primeras crónicas del la Reconquista: El ciclo de Alfonso III," *Boletín de la Real Academia de la Historia* 100 (1932), esp. 622–23; see also Gil [Fernández], Moralejo, and Ruíz de la Peña, *Cronicas asturianas*, 186–87, 261–62. Southern, in *Western Views of Islam*, 22, and Allan Cutler, in "The Ninth-Century Spanish Martyrs Movement and the Origin of Western Christian Missions to the Muslims," *Muslim World* 55 (1965): 321–39, esp. 329–30, both attributed an apocalyptic view to Eulogius of Córdoba and Paulus Alvarus; but see the convincing counter view of Wolf, *Christian Martyrs*, 93ff. The *Chronicon Albeldensis*, which included the *Crónica profética*, followed its enumeration of the six ages with a note disclaiming any ability on man's part to predict when the present—sixth—age might end (Gil [Fernández], Moralejo, and Ruíz de la Peña, *Cronicas asturianas*, 156–57).

tary in Leonese territory in the tenth century, when it took on the visual character most typically identified with the tradition today. Did this background in some sense inspire the artistic reform, which took place, after all, in frontier monasteries?

The answer is not subject to a simple yes or no. The addition of an illustrated Daniel commentary, which seems to have occurred at this moment, may well reflect an ideological turn; for the Book of Daniel, as we have seen, has been a key source for Paulus Alvarus in composing his condemnation of Muhammad. The conservative character of sacred texts and their exegesis meant Beatus's text would remain free of ideological editorializing. Gog and Magog would retain the metaphorical meaning Apringius had given them. Even though, as I have noted, a life of Muhammad circulating in the peninsula gave, as the year of Muhammad's death, Spanish era 666, the number of Beast in Apocalypse 13:18, the Beatus commentary tables with the names of Antichrist adding up to 666 were not expanded to include the name of Muhammad.

Since pictorial content was not subject to the same degree of conservative constraint as textual matter, the illustrations offered greater opportunity for reaction to an increasingly hostile Muslin posture.[55] There are, in fact, changes that seem clearly to target the culture of Andalusia. In the Branch I version of the manuscript tradition, the Whore of Babylon of Apocalypse 17:1–3, representing the primitive iconographic tradition, was depicted as a woman in traditional garb seated on a throne above diverging streams, a scene straightforwardly based on the text. This phase is represented well by the Madrid Biblioteca Nacional manuscript Vitrina 14-1 (fig. 28).[56] As may be seen in the New York Pierpont Morgan Library manuscript Morgan 644,[57] however, the Branch II version of this subject, representing a tenth-century Leonese revision of the primitive tradition, ignored the waters and seated her on a divan of stacked cushions (fig. 29). A richly ornamented crown completed the picture of Oriental majesty.

Since there is no Daniel commentary in the manuscripts that reflect the state of the tradition before the tenth century, iconographic change cannot

[55]Although Gonzalo Menéndez Pidal, in "Mozárabes y asturianos en la cultura de la alta edad media," *Boletín de la Real Academia de la Historia* 136 (1954): 137–291, esp. 151–52, originally proposed for the imagery of the tenth-century commentaries a reconquest role in identifying the enemy with Antichrist and prophesying their defeat, it was Karl Werckmeister in three articles written in the 1960s who provided the basic discussion of the reflection of Christian-Muslim confrontation in Spanish manuscripts. See his "Islamischen Formen in spanischen Miniaturen des 10. Jahrhunderts und das Problem der mozarabischen Buchmalerei," in *L'Occidente e l'Islam nell'alto Medioevo* (Spoleto, 1965), 933–47, "Die Bilder der drei Propheten in der *Biblia Hispalense*," in *Mitteilungen des Deutsches Archäologisches Institut* 4 (1963): 141–88, and "Das Bild zur Liste der Bistümer Spaniens im *Codex Aemilianensis*," ibid. 9 (1968): 399–423. See also Werckmeister's review of Jacques Fontaine's *L'art pre-roman hispanique* in *Speculum* 57 (1982): 604–7.

[56]Fol. 134v; Emmerson and Lewis, "Census and Bibliography," no. 18.

[57]Fol. 194v; Emmerson and Lewis, "Census and Bibliography," no. 24.

be pointed to; but the Feast of Belshazzar in the Daniel commentary took
place beneath a conspicuous horseshoe arch of alternating red and white
archivolts.[58] It is difficult to imagine the illuminator was not thinking of
the interior of the mosque of Córdoba and meaning the reader to associate
the profanity of Belshazzar with that pagan ruler's Islamic counterpart.[59]
Although the first part of this proposition may be acceptable without ar-
gument, the arrival at an anti-Islamic motive is not. Architectural ele-
ments imitating prototypes on the mosque of Córdoba had been taken over
by Christian builders a generation before the Daniel commentary had
been illustrated. Thus the church of Escalada, founded in 912, displayed
horseshoe arches of Islamic proportion and roll corbels, and even earlier
the church of Valdedíos, founded by Alfonso III, featured stepped crenela-
tions. In the depiction of even the Heavenly Jerusalem, for example, in the
Morgan Beatus (222v), stepped crenelations and horseshoe arches are
clearly visible.[60] More to the point for our Feast of Belshazzar, the conven-
tion of alternating red and white archivolts in a horseshoe arch was used
for the monastic doorway on the north side of the Mozarabic church of San
Cebrián de Mazote, a frontier settlement of 915–16.[61] If at least some Is-
lamic elements ceased being culturally specific in Islamic-Christian
terms, it is difficult to discriminate between the antagonistic quotation
and the neutral one. Nowhere is the paradox of the appropriation of the
"enemy's" insignia more evident than in the Rider in the Gerona Beatus
(134v), who participates in a venerable Christian iconography of victory
while accoutered like an Oriental warrior.[62]

The proposition of an anti-Islamic, ideological use of imagery is even
more seriously undermined by Christian culture's sharing of iconographic
traditions associated with the Muslim world. For example, the depiction
of the adoration of the Lamb, when it was modified in the tenth-century
copies, gained a complement of musicians based on those peopling the
ivory boxes of Córdoba.[63] Only in the twelfth century, it would seem, was
Islam unambiguously targeted in Christian imagery. Then a proper recon-
quest iconography would inform the tympanum of the palatine church in
the capital of León.[64] In Toledo in the middle of the twelfth century, at the
moment when this Mozarabic city would begin its history as a center for
the transmission not only of Arabic texts to Western Europe but of anti-

[58]John Williams, *Early Spanish Manuscript Illumination* (New York, 1977), pl. 19b.
[59]Gonzalo Menéndez Pidal, *Sobre miniatura española en la alta edad media: Corri-
entes culturales que revela* (Madrid, 1958), 30.
[60]Williams, *Early Spanish Manuscript Illumination*, pl. 20.
[61]I am grateful to Sabine Noack Haley for pointing this out to me in a photo of the
original campaign of restoration and for the knowledge that the pattern has come to
light again in the recent campaign.
[62]Williams, *Early Spanish Manuscript Illumination*, pl. 30.
[63]Ibid., pl. 17. See Klein, *Beatus-Kodex*, 216 n. 689.
[64]John Williams, "Generationes Abrahae: A Reconquest Iconography in León," *Gesta*
16, no. 2 (1977): 3–14.

Islamic literature as well, Muhammad himself would become the target in a derisive caricature invented for the *De generatione Mahumet*. It was a hybrid creature, man-horse-fish, described by Horace (*Ars poetica* 1.1–4) and used by Peter the Venerable as an analogue for the hybrid nature of Muhammad's doctrine.[65]

The last illustrated Beatus commentary was produced long before the peninsula was finally recovered. The meaning of the commentary as a response to the conditions of Muslim occupation may never have been entirely lost. Even so, it is probable that, even centuries earlier, the illustrated commentary had come to function as a self-sustaining tradition whose vitality was essentially independent of external stimulus.

[65]See Marie-Thérèse d'Alverny, "Deux traductions du Coran au moyen age," *Archives d'Histoire Doctrinale et Littéraire du Moyen Age* 16 (1948): 69–131, esp. 125–27, 82 (fig.).

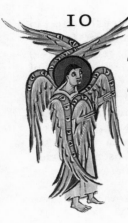

The Apocalypse in The Monumental Art of the Eleventh through Thirteenth Centuries

YVES CHRISTE

It used to be said that the Apocalypse, after playing a preponderant role in the monumental iconography of the fifth through the twelfth centuries, disappeared from Gothic art. This is only partially true. Even though around 1170 the *majestas domini* (with or without the twenty-four Elders of Apocalypse 4:4) was replaced by the coronation of the Virgin or the Last Judgment on the tympana of portals in early French Gothic architecture, it was maintained during the last quarter of the twelfth century and throughout the thirteenth century in other regions.[1] It also continued to occupy an important position in late Romanesque sculpture, appearing between 1150 and 1250, for example, on the portals of Saint-Trophime in Arles, S. Miguel d'Estella, and Santiago de Compostela;[2] on the pulpit of the baptistery in Pisa; and on the apsidal archs of S. Giovanni a Porta Latina in Rome, and S. Silvestro in Tivoli.[3] Even in the French royal domain, where the vision of Patmos generally appeared only in marginal details, as on the portals of the Last Judgment in Notre-Dame at Paris and Amiens, several exceptional compositions are

To shorten this essay, I have cited in the notes a very limited number of recent studies that provide lengthier and more detailed bibliographies. See in addition the bibliography at the end of the essay. The essay was translated from French by Tania B. Chomiak.

[1] The *majestas domini* (see the last section of this essay) appeared on the south portal of Burgos (ca. 1240) and on the portals of Saint-Pierre in Nevers and in Corbie (ca. 1200), where the Four Living Creatures (Apoc. 4:6) appear in the coronation of the Virgin. In stained glass it appears in the south transept rose window of Chartres and the axial window of Gargilesse (Indre). On Gargilesse, see M.-G. Schumacher, "L'église abbatiale de Gargilesse," *Congrès Archéologiques de France* (Bas-Berry) 142 (1987): 117–28.

[2] Arthur Kingsley Porter, *Romanesque Sculpture of the Pilgrimage Roads*, 2d ed. (New York, 1969), figs. 1372, 777, 822–23.

[3] Guglielmo Matthiae, *Pittura romana del Medioevo* (Rome, 1987), 2: on Tivoli, fig. 84; on S. Giovanni, figs. 92, 97.

worth noting. These include the portal of the collegiate church in Mantes (ca. 1180; fig. 31), the Apocalypse windows in the ambulatory of Saint-Etienne, the cathedral of Bourges (ca. 1220; fig. 8); the largely destroyed window in Saint-Etienne, the cathedral of Auxerre; the south side portal of Notre-Dame, Reims (ca. 1260); and the Apocalypse window in Sainte-Chapelle in Paris, a fifteenth-century reproduction of a thirteenth-century window.[4] Finally, after the thirteenth century, the Apocalypse regained its importance in Italy, as is evident in the Neapolitan "Hamilton Bible" (fig. 16).[5]

The apparent loss of interest in the Apocalypse in monumental Gothic sculpture, dating from the 1170s, does pose a problem, though, because it took place at the same time that the interpretation of the Apocalypse was undergoing a vast program of revision in Paris undertaken by exegetes working on the latter stages of the *Glossa ordinaria*.[6] As the essays in this volume by Randolph Daniel and David Burr note, during the late twelfth and thirteenth centuries, new interpretations of the Apocalypse set forth by Joachim of Fiore and various Franciscan commentators elicited a sharp opposition in the mid-thirteenth century with the condemnation of Gerard of Borgo San Donnino.[7] Furthermore, during the first half of the thirteenth century, the Apocalypse was the focus of attention for wealthy patrons—lay and clerical—notably in aristocratic circles in France and especially England. This interest is evident in the importance given the Apocalypse cycle in the *Bibles moralisées*[8] produced in Paris during the reigns of Philip Augustus, Louis VIII, and Louis IX on the one hand and, on the other hand, in the number, variety, and quality of the English illuminated Apocalypses which Suzanne Lewis discusses in the next essay. Just as the English cycles underwent rapid and substantial revisions, the Apocalypse cycle in the *Bibles moralisées* was also revised. The latter changed from the version recorded in the Vienna Österreichische Nationalbibliothek Codex 1179 (fig. 30) to that which is preserved in Toledo cathedral

[4] For the Bourges windows, see Catherine Brisac, "La verrière de l'Apocalypse à la cathédrale de Bourges," in *Texte et image: Actes du Colloque internationale de Chantilly* (Paris, 1984), 109–15, figs. 24–26. For the Auxerre Apocalypse fragments, see Virginia Chieffo Raguin, *Stained Glass in Thirteenth-Century Burgundy* (Princeton, 1982), figs. 67–71, 76–77, 82, 101, pl. II. For the Reims portal, see Peter Kurmann, "Le portail apocalyptique de la cathèdrale de Reims," in Yves Christe, ed., *L'Apocalypse de Jean; Traditions exégétiques et iconographiques* (Geneva, 1979), 245–317.

[5] On the Italian cycles, see Peter Klein's essay herein.

[6] Guy Lobrichon, *L'Apocalypse des théologiens au XIIe siècle* (Paris, 1979).

[7] On this difficult and complicated question, see also the contributions of Robert E. Lerner, Georges Marcel, and Annie Cazenave, in *The Use and Abuse of Eschatology, in the Middle Ages,* ed. Werner Verbeke, Daniel Verhelst, and Andries Welkenhuysen (Leuven, 1988), 359–403.

[8] See esp. Peter K. Klein, *Endzeiterwartung und Ritterideologie: Die englischen Bilderapokalypsen der Frühgotik und MS Douce 180* (Graz, 1983); and on the Apocalypse in the *Bibles moralisées*, Reiner Haussherr, "Über die Auswahl des Bibeltextes in der Bible moralisée," *Zeitschrift für Kunstgeschichte* 51 (1988): 126–46, esp. 129–33.

and the Pierpont Morgan Library.[9] Also around 1260, the south portal of the west facade of Reims cathedral was inspired by another illustrated Apocalypse cycle, that in Lambert of Saint-Omer's *Liber floridus*, especially the lavish Gothic copy now in Paris.[10]

All of this indicates much interest in the Apocalypse at the very moment it seemed to be disappearing from the repertoire of monumental art. The explanation for this curious phenomenon is unclear, although it is certain that the very illustrations of the Apocalypse that were disappearing from the "public domain" remained important in more restricted aristocratic circles. The situation would be the same in the fourteenth century at the court of the kings of Naples, where Charles of Anjou commissioned a new illustrated Apocalypse.[11] It is also worth remembering that the Bamberg Apocalypse (fig. 2) was commissioned by Otto III, whose coronation robe was embroidered with scenes of the Apocalypse.[12] Earlier royal interest in the Apocalypse is further evident in Charlemagne's Palatine Chapel in Aachen, which was modeled on the description of the New Jerusalem (Apoc. 21). Its cupola was decorated with the adoration of the Elders, and in the twelfth century, Frederick Barbarossa donated a light crown resembling the New Jerusalem.[13] Thus, from the ninth century to the fourteenth, the manner of illustrating the Apocalypse often developed in relation to courtly art and the symbolism of power.

APOCALYPSE MOTIFS: ESCHATOLOGICALLY OR ECCLESIOLOGICALLY SIGNIFICANT?

We know little about the overall meaning of the Apocalypse motifs still represented in Gothic portals and stained glass. It is worth noting, however, that in the art of the first part of the twelfth century (at Saint-Lazare in Autun, Saint-Pierre in Angoulême, Saint-Denis, Saint-Vincent in Mâcon, and so forth) the Four Living Creatures and the Elders are regularly associated with a triumphal theophany removed to the end of time and thereby connected with the Last Judgment. Similarly, in the arches of the main portal of Amiens cathedral (ca. 1230), twenty Elders accompany the return of Christ as described in Matthew, and in the south portal of Burgos cathedral, the Four Living Creatures and the Elders surround Christ the

[9]On these manuscripts, see Richard Kenneth Emmerson and Suzanne Lewis, "Census and Bibliography of Medieval Manuscripts Containing Apocalypse Illustrations, ca. 800–1500," pt. 3, *Traditio* 42 (1986): 462–64 nos. 155, 157, 158.

[10]Paris, Bibliothèque nationale lat. 8865; see ibid., 459 no. 151.

[11]The late medieval Apocalypse of the dukes of Savoy, now at the Escorial, combined an English and a Neapolitan cycle; see Emmerson and Lewis, "Census and Bibliography," pt. 2, *Traditio* 41 (1985): 380 no. 57.

[12]For the Bamberg Apocalypse, see ibid., pt. 1, *Traditio* 40 (1984): 340–42 no. 1.

[13]Carol Heitz, "Retentissement de l'Apocalypse dans l'art carolingien," in *Apocalypse de Jean*, ed. Christe, 231–32.

judge. At Amiens, John's vision of Christ standing in the midst of the can-
delabra (Apoc. 1:13) is portrayed at the apex of the exterior arch, while the
third and fourth Horsemen (Apoc. 6:5–8), as in Notre-Dame at Paris, at the
bottom of the arches on the right, complete the depiction of the suffering
damned. At the cathedral of Thérouanne in the diocese of Reims (now in
the Museum of Saint Omer), Christ the judge sits over a fortified city
where some buildings have crumbled, a clear allusion to the destruction of
Babylon (Apoc. 18:10.)[14]

Fortunately, the four folios (fols. 226–28) devoted to the vision of the
throne of God and the book with seven seals in the Latin *Bible moralisée*
of the Vienna Codex 1179 (fig. 30) reveal how Apocalypse 4–5, the two
most frequently illustrated chapters of John's vision, were represented at
the beginning of the thirteenth century during the reign of Louis VIII. Be-
low the medallions that illustrate more or less "literally" the biblical text
and which include, for the most part, the iconographic schemata of mon-
umental art, are accompanying medallions that explain the biblical text.
About two of every three of these medallions reflect an understanding of
the vision in terms of Christ's second coming or the Last Judgment. They
usually portray Christ displaying his palms, accompanied by the elect and
the damned, and presiding over the separation of the good from the evil. In
fact, these medallions interpret over half of the pericopes of Apocalypse
4–5 as images of the Second Coming, of Christ's appearance "secundum
carnem" at the end of time. Thus, if one could retrospectively understand
the evolution of theophanic iconography during the period between 1130
and 1240 in terms of this Parisian manuscript from about 1220, where the
literal illustration of the Apocalypse is systematically juxtaposed with its
symbolic interpretation, one would see that the image of Christ displaying
his palms while accompanied by the instruments of the Passion is the
most common arrangement and the most adequate allegorical treatment
of the celestial visions of Apocalypse 4–5. One could then better under-
stand why, on the one hand, Matthew's version of the Second Coming and
the Last Judgment is often accompanied by references to the Apocalypse,
while, on the other hand, the *majestas domini* and the adoration of the
Elders merge naturally into the Last Judgment (fig. 30).[15]

What would thus seem to be a rule of medieval iconography is, however,
challenged by the fact that in the exegetic tradition from the end of antiq-
uity until at least the twelfth century, the Apocalypse is only rarely un-
derstood in eschatological terms as a revelation about the end of time.
Instead, it is interpreted in ecclesiastical terms, as a record of the history
of the Church, of the Augustinian "millennium," of the time between the

[14]See Willibald Sauerländer, *La sculpture gothique en France*, 2d ed. (Paris, 1972): on
Amiens, pl. 165; on Paris, pls. 40, 41, 150; on Thérouanne, pl. 176.

[15]Such is already clear in Carolingian interpretations; see Rabanus Maurus *De fide
catholica rythmus*. Cf. Julius von Schlosser, *Schriftquellen zur Geschichte der Karol-
ingischen Kunst* (Vienna, 1896), 333–35 no. 933.

first and second Advents of Christ. In this broad allegorical tradition, Apocalypse 4–5 is, first and foremost, a vision of the glory of God already realized, a present eschatological reality. The visions of Christ in the midst of the candelabra and of the adoration of the Lamb (Apoc. 7:9–17), to cite only those sections of the Apocalypse that are most often represented in monumental art, are similarly understood. Finally, the vision of the New Jerusalem (Apoc. 21–22), rather than being only a revelation of the future destruction of the world, represents both present and future realities—it is an image of both what is and what is to come.[16]

Although this traditional ecclesiological conception of the Apocalypse is rarely developed in Gothic monumental art, it is evident particularly at Bourges cathedral, where the characteristic features of the Apocalypse window (fig. 8) are clearly ecclesiological rather than eschatological. The same is true for the left portal of the collegiate church in Mantes (fig. 31). Two angels flank the enthroned Christ, who in his right hand holds the book with the seven seals and in his left, a blank disk and a cross with a long staff decorated with a crown of thorns. From the tympanum he looks down upon the lintel, on which is sculpted the visit of the women to the tomb and the Resurrection with an empty tomb. Christ does not show his palms, and his feet are in the crystal sea, probably an allusion to the sea and the earth of Apocalypse 10:2. Following the interpretation of the vision of the Lamb that appeared to be slain (Apoc. 5:6), Christ is a glorified sovereign, the conqueror of death enthroned in heaven on the day of his resurrection. Contrary to what one would expect, then, this unusual composition does not allude to the Second Coming or the Last Judgment.

Also reflecting this ecclesiological understanding at the beginning of the fourteenth century is the Apocalypse of the "sails" at the crossing of the transept in the lower church of Assisi. Portraying a complex representation of angelic choirs, it was not meant to be a narrative cycle, strictly speaking, but a sort of summary of the vision of Patmos reduced to an abstract and synthetic restatement of its principle recapitulative motifs. The Christ of the vision between the candelabra, with the sealed book in his right hand, the sword across his mouth, and a key in his left hand, is portrayed on the medallion covering the keystone. He is accompanied by the Lamb, the Living Creatures, the seven candelabra, the seven lamps burning before the throne (Apoc. 4:5), the Four Horsemen, the twenty-four Elders, the Ark in the heavenly temple (Apoc. 11:19), and the angel with the sickle (Apoc. 14:14–15). At the base of the four ribs on which are painted the medallions and diamond-shaped lozenges that form the Apocalypse cycle, the four angels holding back the winds (Apoc. 7:1) are further depicted and, between these and the symbolic vision of the center, angels holding either trumpets (Apoc. 8:2ff) or vials (Apoc. 15). The angels that

[16]Yves Christe, "La cité de la Sagesse," *Cahiers de Civilisation Médiévale* 31 (1988): 29–35.

introduce the major recapitulative sections that gave rise to the traditional Tyconian interpretation—the angels of Apocalypse 7:1, 10:1, 14:6, and 20:1—are also present.[17] The angel ascending from the rising sun having the seal of the living God (Apoc. 7:2) has stigmata marked on his hands, which depiction is no doubt related to the traditional christological interpretation of this angelic figure.[18]

This brief survey of the principle monuments portraying the Apocalypse in Gothic art makes it easier to understand the evolution of these themes during the eleventh and twelfth centuries in Romanesque monumental art, where the absence of precise iconographic notations sometimes makes it difficult to determine the exact meaning of the references to the Apocalypse.

THE APOCALYPSE IN ROMANESQUE MONUMENTAL CYCLES

In studying Romanesque monumental narrative cycles, it is important to keep in mind that they have often been subordinated by synthetic images that affect the acceptance and rejection of certain motifs. In manuscripts, many complete cycles were preserved from the ninth century onward, whereas in monumental sculpture, Apocalypse cycles do not appear until just before the middle of the thirteenth century. The few rare exceptions are the lost paintings of Fleury-sur-Loire and the column capitals in Moissac (fig. 10). In the eleventh and twelfth centuries, the monumental cycles almost always broke off at the depiction of Apocalypse 12, at the vision of the Woman giving birth, her flight into the desert, or the angelic battle against the Dragon.[19] Among the mural paintings that conclude at Apocalypse 12 are the cycles of the baptistery in Novara (ca. 1000), S. Pietro al Monte in Civate (ca. 1080), Saint-Savin-sur-Gartempe (ca. 1080), Saint-Hilaire-le-Grand in Poitiers (ca. 1080), and S. Severo in Bardolino on Lake Garda (ca. 1150). In the cathedral of Anagni (ca. 1100) as well as in S. Quirce in Pedret (Catalonia, ca. 1080), the cycles include only

[17]On Tyconius, see my bibliography and Paula Fredriksen's essay in this volume.

[18]According to the most common interpretation, the angel probably represents Christ rather than Saint Francis, whom Bonaventure identifies with the angel of the sixth seal in his *Legenda major.* For these very learned scenes, see the precise schema proposed by Joachim Poeschke, *Die Kirche San Francesco in Assisi und ihre Wandmalereien* (Munich, 1985), 109 fig. 8. The angel with pierced hands is pointed to by another angel placed underneath, who also displays wounds on his hands. Is the latter perhaps a figure of Saint Francis?

[19]The Apocalypse cycles belong to different traditions arranged in groups. The monumental murals in Families II and III do not represent images from Apocalypse 15–20. On these groupings, see Peter K. Klein, "Die frühen Apokalypse-Zyklen und verwandte Denkmäler: Von der Spätantike bis zum Anbruch der Gotik" (Inaugural diss., University of Bamberg, 1980), and his essay in this volume. An incomplete cycle at Castel Sant'Elia is an exception. After portraying the flight of the Woman into the desert, it leaves enough room for some images based on later chapters.

the septenaries of the churches of Asia, the seals, and the trumpets. This
seems to have been the case also in Saint-Polycarpe in the Aude, in S. Mar-
gareten at Neunkirchen, and in the Allerheiligenkapelle in the cloisters of
Regensburg cathedral, where the decor is centered on Apocalypse 7.[20] Im-
ages from Apocalypse 13–19 are usually ignored or presented alone. The
Great Whore (Apoc. 17:3–6) and the deserted Babylon (Apoc. 18) on the
column capitals of Saint-Pierre in Chauvigny, or the Christ on horseback
(Apoc. 19:11–16) in the crypt of Auxerre cathedral, for example, are not in
a narrative sequence. The series of column capitals at Moissac also seem
to lack a logical order.[21]

This emphasis on the first part of the Apocalypse, which seems to be a
rule in monumental art, may have been purposeful from the start. In fact,
in exegesis, the summary visions of Apocalypse 1:12–14:20—that is, the
septenaries of the churches (1:12–3:28), the seals (4:1–8:1), and the trum-
pets (8:2–11:18), as well as the visions of the Woman and the Dragon and
of the adoration of the Lamb (11:19–14:20)—depict either the present or
the past rather than prophesy about the end of time. These visions con-
centrate on the history of the Church, on the vicissitudes of the Church in
its pilgrimage "from the first coming to the end of the world." Later, in the
visions of Apocalypse 15:1–20:15, the eschatological tone is more pro-
nounced, and the succession of images is more a revelation about the end
of time: "They linger over the last times."[22] It would therefore be the less
eschatological sections, those that focus more on the history of the
Church and, as Richard of Saint Victor would say, on the present—"they
pertain mostly to the course of present time"—that figure in monumental
art.[23] The heavenly Jerusalem is still portrayed, but it can be interpreted as
a revelation concerning the present Church just as easily as it could be
considered a prophecy of the End: "Many things found in the description
of the holy city relate more to the present merits of the saints than to fu-
ture rewards."[24]

The Civate cycle, of which a part of the explicative inscriptions has
been preserved, illustrates this point of view. The seven angels holding
trumpets represent the trials of the Church during the millennium, "Lo,
the Spirit with sevenfold voice loudly trumpets the different conflicts and

[20]See Peter Klein's comments above, p. 167.

[21]At Auxerre, the Christ on a horse that decorates the arch is accompanied on the
south wall by an image of the Woman harassed by the Dragon, now almost illegible. See
Otto Demus, Romanesque Mural Painting, trans. Mary Whittall (New York, 1970), pls.
123–24, LV.

[22]Glossa ordinaria (PL 114:735D): "ab adventu primo usque ad finem saeculi"; "circa
ultima tempora immorantur." The text is not by Walafrid Strabo; nor by Anselm of Laon,
but from his school.

[23]Richard of Saint Victor In Apocalypsin Joannis (PL 196:839): "maxime pertinent ad
cursum praesentis temporis."

[24]Peter Cantor In Apocalypsin, Munich, Bayerische Staatsbibliothek MS Clm 7937,
fol. 245v: "Multa quae in descriptione sanctae civitatis ponuntur, magis ad sanctorum
praesentia merita, quam ad futura premia spectare probantur"; cited by Lobrichon, in
Apocalypse des théologiens.

labors of the Church," while a grouping of Old and New Testament figures is interpreted allegorically based on the Woman with two eagle's wings (a symbol of *ecclesia*) who flees to the desert (during the millennium), "to be nourished [when] she is joined to the wings of the twofold law." The vision of the New Jerusalem, which is painted on the vestibule ceiling (fig. 32), is anchored on the cardinal virtues and includes Christ-Wisdom in its center holding the golden reed (Apoc. 21:15).[25] It also alludes to the millennium "as far as the course of present time," that is, to the era of the Church over which the river of life, as it spreads over the walls of the celestial city, flows. It branches into four streams and irrigates the entire universe: "From his feet is born a single fount of life / Divided into four, it flows through the whole world." The two verses would make no sense if the celestial Jerusalem, whence the virtues spring, were restricted to the future, that is, were only established in the new heaven after the destruction of the world.[26]

The choice of an introductory image for the monumental cycles is somewhat dependent on regional considerations. At Anagni cathedral, the introductory image is an adoration of the Lamb by the twenty-four Elders painted on the left side of the crypt's central apse.[27] The Elders, holding chalices, are standing below the Four Living Creatures, who surround the Lamb. This image is based on a Roman schema, which is also repeated on the apsidal arch in Castel Sant'Elia.[28] At Pedret, in contrast, the introductory image is an "empty" throne with the seven-sealed scroll placed on the seat. Adored by the Elders, the throne is associated with the *majestas domini* on the sanctuary vault. As in the apse of the crypt of Agnani cathedral, the Elders at Pedret have crowns above their heads,[29] and on the upper chevet wall several half-erased figures resemble the vision between the candelabra that introduces the adoration of the Elders on the vault of the bay that precedes the apse at Anagni.[30] At Saint-Savin, the inaugural image, which is painted on the interior tympanum of the portico, is a vision of Christ among the angels and Apostles, one of whom holds a triumphal cross at his side. Christ is not holding his palms out; he is in a round mandorla stamped with the Alpha and Omega, and he extends his arms.[31]

[25] See Demus, *Romanesque Mural Painting*, pl. 13.

[26] See my "Traditions littéraires et iconographiques dans l'élaboration du programme de Civate," in *Texte et image*, 117–34, and "Cité de la Sagesse."

[27] Demus, *Romanesque Mural Painting*, pl. 68.

[28] Ibid., pl. 44.

[29] Ibid., pl. 194.

[30] On the relation between Anagni (c. 1100 rather than c. 1250) and Pedret, see my "Le Christ à l'encensoir debout devant l'autel des martyrs," *Cahiers de Saint-Michel de Cuxa* 13 (1982): 187–200.

[31] See my "A propos des peintures murales du porche de Saint-Savin," *Cahiers de Saint-Michel de Cuxa* 16 (1985): 219–37. For a different approach, see Brigitte Kurmann-Schwartz, "Les peintures du porche de l'église abbatiale de Saint-Savin: Etude iconographique," *Bulletin Monumental* 140 (1982): 273–304, in which she understands this scene as a grand Last Judgment.

The apsidal decor at Saint-Hilaire in Poitiers is lost, unfortunately, but one can assume that it was a *majestas domini,* as at Méobecq, where the Apocalypse cycle was probably inspired by Poitiers.[32] The placement is the same—at the base of the apsidal niche—and, as in Saint-Hilaire, a depiction of an angel addressing John introduces the vision of the first Horseman (figs. 33, 34). At Méobecq, as on the choir of Saint-Hilaire, the Apocalypse cycle includes a series of historical portraits representing an idealized genealogy for the Berry abbey: on the right, Peter, his "disciple" Martial, and a figure that has faded; on the left, Saint Benedict, the founder of the order, and Cyran and Loyau, the founders of the abbey. If, then, the Apocalypse is a symbolic representation of the development of the Church in the "millennium," the portrait gallery in the apse at Méobecq is an illustration of Church history particularly appropriate for the abbey. I interpret the series of portraits of the bishops of Poitiers in the transept and the choir of Saint-Hilaire in the same way. In this church, though, it is important to note that the Altar of the Martyrs (Apoc. 6:9) is placed in line with the apse, over the matutinal altar, between the Horsemen and the scenes from Apocalypse 12: the Woman giving birth, Saint Michael's battle with the Dragon, and the Woman with the eagle's wings fleeing to the desert. The angel doling out robes to the martyrs (Apoc. 6:11) is on the left, opposite another angel, perhaps the angel with the golden censer (Apoc. 8:3). As in Pedret and Anagni, the angel with the censer at Saint-Hilaire is associated with the opening of the fifth seal.

The heavenly vision painted in the cupola of Novara baptistery has been completely destroyed. All that remains of its eight compartments are outlines of wings covered with eyes (Apoc. 4:8) and, in the central medallion, a gemmed bandeau that may have been a part of a ceremonial throne or of a triumphal cross. The same is true of the apsidal image and the scene on the back of the facade of S. Severo in Bardolino. One should note that in this church the Apocalypse cycle on the south wall of the nave is introduced by Nativity scenes and that opposite to it, on the north wall, is a bilevel scene of the discovery of the cross. At Novara, as in S. Maria Gualtieri at Pavia (ca. 1100) the image that introduces the tympanum scene is the angel with the censer,[33] which is placed opposite the entrance, in the axial position between the panel depicting the sounding of the first trumpet and the one depicting the vision of the Woman. This particular placement indicates that the destroyed image in the cupola was related to Apocalypse 8:2–5, which introduces the recapitulation of the septenary of trumpets. In the later cycles created around 1330 in Naples, the adoration

[32]Marie-Thérèse Camus, "A propos de trois découvertes récentes: Images de l'Apocalypse à Saint-Hilaire-le-Grand de Poitiers," *Cahiers de Civilisation Médiévale* 32 (1989): 125–34. On Méobecq, see my "Le cavalier de Méobecq," *Bulletin Archéologique,* n.s. 12–13 (1976–77): 7–17; and Eliane Vergnolle, "L'église Notre-Dame de Méobecq," *Congrès Archéologiques de France (Bas-Berry)* 142 (1987): 172–91.

[33]See Demus, *Romanesque Mural Painting,* pl. 2, upper.

of the Living Creatures and the Elders usually includes the seven angels with trumpets.[34] The same is true for Hans Memling's triptych of John the Baptist and John the Visionary (fig. 57). On the triptych's right panel, the angel with the censer appears directly below the heavenly vision of Apocalypse 4–5.

In Civate, the immense composition in the lunette of the east wall of the nave has been preserved in its entirety with all of its inscriptions.[35] The semicircle, which is divided into two registers, is dominated by the enthroned Christ—an image of the Father with unmoved visage—in a mandorla flanked by the angelic hosts battling the Dragon. On the left, an angel presents the Woman's child to Christ, while the Woman lies on a sort of sofa that straddles the two registers. The Dragon, opposite her and below the feet of Christ, threatens to devour her son. Two hexameters inscribed in a band on each side of Christ's head affirm that the scene is understood in present terms: "Snatched up to the Lord, he already is found on the Father's throne"; "He reigns on high. . . . " In the fresco, the Woman's son is assimilated with the figure of the Risen Christ on the Father's throne. He does not take part in the battle that Michael and his angels wage against Satan. This heavenly struggle unfolded during Christ's first coming and will continue to be played out on earth during the age of the Church, until the Dragon—"mortis amator"—is thrown into the sea of flames. As Peter Klein noted, on the one hand, the image of the Woman could suggest the Virgin at the Nativity,[36] but the inscription ("She grieves as she about to give birth but rejoices in the gift of the one she bears") confirms the ecclesiological symbolism of this figure and dispels this possibility. On the other hand, without reference to the two verses cited above, it would be difficult to see, in the small naked child that the angel presents to God, an image of Christ enthroned.

[34]See Annegrit Schmitt, "Die Apokalypse des Robert d'Anjou," *Pantheon* 28 (1970): 475–503.

[35]See Demus, *Romanesque Mural Painting*, pl. 17.

[36]See Peter K. Klein, "Les apocalypses romanes et la tradition exégétique," *Cahiers de Saint-Michel de Cuxa* 12 (1981): 128–30, on Apoc. 12. The mural paintings in the apse of Saint-Pierre-les-Eglises, near Chauvigny, also seem to suggest a Marian interpretation of the Woman of Apocalypse 12. The voyage and the adoration of the Magi on the left of the axial window are actually opposite an image of the combat of Saint Michael on the right, below a Nativity (fig. 6). The seven-headed Dragon, struck by the archangel's spear, vomits a torrent of water toward the Woman and Child in the adoration of the Magi. These paintings are badly damaged, but restoration is planned. Three panels, dominated by the adoration of the Magi, are illegible and unidentifiable. Like Carol Heitz, who undertook the dating proposed by Deschamps, I am inclined to date them from between the end of the tenth century to after the early years of the following century, because they were partially covered by two columns that were attached to the interior wall of the apse during a Romanesque restoration. To push execution of the images to the second half of the twelfth century, as proposed by Otto Demus, hardly seems plausible; see his *Romanesque Mural Painting*, pls. 114–15, and—for an extension of former studies—Yves-Jean Riou, *Chauvigny: Saint-Pierre-les-Eglises* (Chauvigny, 1989), with a complete bibliography.

At Civate, the illustration of the text of the Apocalypse is primarily literal, the allegorical elements added discreetly. For example, in the New Jerusalem scene (fig. 32), the golden reed is given to Christ rather than to the angel (Apoc. 21:15), and the cardinal virtues are depicted on the corners of the city—"The eternal vision of peace in fourfold virtue." The inscriptions fortunately inform us of the ideas behind this concept and correct a possible *ad litteram* reading. The smaller details of this well-ordered iconographic program enable the text and its visual interpretation to be understood as representing a precise symbolic reality carefully conveyed beneath the literal cover. Just as one is not surprised to see the quite rare image of Christ-Wisdom painted in the center of the New Jerusalem in the narthex, it seems natural that Christ in majesty should be central to the nave illustration of the Woman and the Dragon. It is apparent from the history of the visual tradition of Apocalypse 12, however, that this conception is unique to Civate.[37]

The positioning of the angelic hosts at Civate, in a semicircle around the enthroned Christ above the Dragon, who stretches horizontally along the entire length of the lower register, predates by a quarter century the principles of composition of the great Romanesque portals. In these, the stationary Christ with the angels piercing Satan are portrayed on the tympanum, whereas the seven-headed Dragon and the Woman giving birth are placed on the elongated rectangle of the lintel.

VARYING TREATMENTS OF THE APOCALYPSE IN ROMANESQUE PAINTING AND SCULPTURE

While the Apocalypse cycles play an important role in mural painting, they figure only rarely in monumental sculpture, in particular on column capitals, where one would expect them to develop. The early example of the tower of Saint-Benoît-sur-Loire (ca. 1030–40) was not followed except in the cloisters of Moissac (ca. 1100, fig. 10), where it appears to be disordered. Elsewhere—in the ambulatories of Saint-Nectaire (Puy-de-Dôme) and Saint-Pierre in Chauvigny and at Saint-Pierre in Mozac, where a capital decorated with an image of the four angels restraining the winds was found (fig. 35)—references to the Apocalypse are few, discreet, and scattered. The one exception worth noting is the capitals on the transept crossing of Gargilesse in Berry, which are decorated with images of the twenty-four Elders.[38]

[37]See Klein, *Der ältere Beatus-Kodex Vitr. 14–1 der Biblioteca Nacional zu Madrid* (Hildesheim, 1976). Civate can be compared only to Branches IIa and IIb of the Beatus manuscripts, where the enthroned Christ appears above the Dragon threatening the Woman.

[38]On Gargilesse, see n. 1 above. On Mozac—or Mozat—see my "Un chapiteau de Mozac avec les anges des vents d'Ap 7:1," *Arte Cristiana*, n.s., 733 (1989): 297–302.

Narrative images are still rarer near a triumphal image on a portal or facade. The Two Witnesses of Apocalypse 11, usually interpreted as Enoch and Elias, portrayed on the right upper register of the tympanum at Autun are sometimes cited as examples, as are the seated Apostles on the lintel of the royal portal at Chartres; but the interpretation of these images is not certain. Similarly, the scene on the right capital of the portal of Saint-Pierre-et-Saint-Paul at Montceaux-l'Etoile cannot be identified as John swallowing the little book (Apoc. 10:8–10).[39] The personage kneeling before the angel who is showing him the image on the nearby tympanum is actually wearing a chlamys; he is more like a soldier and therefore cannot be John. As Peter Klein proposes, the seven figures wearing horn-shaped and Phrygian caps who are portrayed on the portal at Beaulieu as being confounded by the Second Coming of Christ in the clouds, "Behold, he comes with the clouds," may refer to Apocalypse 1:7.[40] Generally, though, grand Romanesque sculpture concentrates on only one Apocalypse theme, the *majestas domini*. It develops as an adoration of Christ or of the Lamb by the Four Living Creatures and the Elders. The vision of Christ between the candelabra—for example, on the south portal of the small church of La Lande-de-Fronsac (Gironde; see fig. 36)—[41] is ignored, as is the New Jerusalem. In Romanesque sculpture, I know of no other image of the angels with chalices or trumpets, of the Woman giving birth, or of the war in heaven except in the abridged form of Saint Michael crushing the Dragon.[42]

In comparison with the monumental tradition of the fifth and sixth centuries, therefore, the eleventh and twelfth centuries saw an impoverishment in the apocalyptic expression of the heavenly vision in monumental sculpture. The representations of the earlier centuries include as many references to Apocalypse 1:12–20 and 10:1 (for example, on the exterior facade of Poreč on the Adriatic and in the apse of SS. Cosma e Damiano, fig. 1) and to Apoc. 8:2–5 (in the apse of S. Michele in Affricisco at Ravenna) as to Apocalypse 4–5 (in the apse of S. Pudenziana, fig. 22, and the arches in S. Paolo fuori-le-mura, fig. 19; and SS. Cosma e Damiano, fig. 1). From this perspective, the gradual disappearance of Apocalypse references in Gothic sculpture can be understood as continuing the evolution of Romanesque monumental iconography. By 1170, this evolution was overshadowed by the omnipresence of the *majestas domini* or the *majestas agni*, often accompanied by the Elders. There were, then, no more frequent

[39]Emile Mâle, *Religious Art in France—the Twelfth Century: A Study of the Origins of Medieval Iconography*, trans. Marthiel Mathes (Princeton, 1978), fig. 84.

[40]Peter K. Klein, "Et videbit eum omnis oculus et qui eum pupugerunt': Zur Deutung des Tympanons von Beaulieu," *Florilegium in Honorem Carl Nordenfalk Octogenarii Contextum* (Stockholm, 1987), 123–44.

[41]Mâle, *Religious Art in France*, fig. 7.

[42]Among the numerous images that reflect this stereotypical formula, see, for example, the porch of Saint-Benoît-sur-Loire, where Michael felling the Dragon is associated, somewhat in the manner of Saint-Pierre-les-Eglises (fig. 6), with a flight to Egypt.

allusions to the Apocalypse in Romanesque sculpture (for example, none in the capitals at Autun and Vezelay) than in Gothic sculpture.

But as we have seen, monumental painting included many important Apocalypse cycles, and with the development and improvement of restoration techniques in the past few years, several new cycles have been discovered.[43] Since with few exceptions these cycles concentrate on Apocalypse 1–12 and 21–22, it is clear that the tradition of Romanesque painting attenuated by an eschatological perspective was continued in the High Middle Ages in the lost cycles at St. Peter in Wearmouth, at Saint Pierre de Fleury, and on the portico of Reims cathedral and that this pictorial tradition is distinctly different from the sculptural tradition. Beginning in the twelfth century, after the attempts to develop a sculptural cycle in the tower of Saint-Benoît and in the cloisters of Moissac (fig. 10), references to the Apocalypse in monumental sculpture were eliminated or simply reduced to marginal details. The importance of the Apocalypse cycles in Romanesque monumental painting is thus quite exceptional. Aside from Apocalypse commentaries—which multiplied toward the end of the eleventh century—the Apocalypse is rarely cited in patristic and exegetic literature in the early Middle Ages, for example. A quick survey of the indexes of the critical editions of Latin patrology from the fifth to the twelfth centuries confirms this phenomenon.

If one observes a fundamental difference between the ways in which monumental sculpture and monumental painting represent narrative Apocalypse cycles, there is no such difference in their treatment of synthetic Apocalypse images. With only a few variations, they are the same whether portrayed on an apse or portal, a Gospel frontispiece or book cover, a reliquary or tomb. In this particular sphere, Romanesque art in all its forms followed a common iconographic tradition that can be traced to the Carolingian era and that made uniform the principal motifs of the great theophanic visions of Romanesque and even Gothic art. This Carolingian heritage, for example, is evident in variations of the *majestas domini* in which the enthroned Christ within a mandorla is framed by the Four Living Creatures (figs. 37–39).It also influenced the usual treatment of the Second Coming according to Matthew, in which Christ, removed from the cross, presides over the separation of the good and the evil, the classic arrangement in Romanesque and Gothic sculpture.

The Twenty-Four Elders in Monumental Sculpture and Painting

In Romanesque representations of the *majestas domini*, the "twenty-four" Elders, contrary to paleochristian and Carolingian representations,

[43]For example, Novara, Méobecq (which had not been identified as such), Saint-Lizier, Saint-Polycarpe, Saint-Hilaire, and, in part, Saint-Sernin in Toulouse. Most recently: S. Maria Gualtieri at Pavia and Seppanibale near Fasano (Brindisi).

became more autonomous. They were no longer automatically associated with the presence of the Four Living Creatures or even with Christ or the Lamb, and they vary in number, even though the significance of their changing numbers is unknown.[44] In Autun they are sculpted in the first archivolt of a Last Judgment tympanum dominated by a Christ in a mandorla carried by four angels. In the west portal of the priory at Anzy-le-Duc, they are similarly sculpted in the archivolt, but this time they accompany an Ascension dominated by Christ in a mandorla carried by two angels.[45] At Notre-Dame in Etampes, where the tympanum similarly depicts the Ascension, thirty-six seated figures fill the three archivolts. The twenty-two figures in the two interior archivolts hold long-necked flasks and stringed instruments, and the rest show phylacteries. At least some of these figures are the Elders of the Apocalypse or allegorical representations of apostles, patriarchs, and prophets. Because there are no inscriptions or distinct identifying attributes, the logic of this arrangement is unclear.[46]

During the twelfth century and the first half of the thirteenth, the Elders were usually portrayed in the archivolts of the portals. In this respect, Gothic sculpture simply continued a tradition established in the early twelfth century. It is an exception for the Elders to appear on the tympanum, as in the portico of Saint-Pierre, Moissac (fig. 23). They are instead usually seated, wearing crowns and holding stringed instruments and various receptacles such as goblets, chalices, and vials of perfume—the "harps, and golden bowls full of incense" of Apocalypse 5:8. They would retain, then, the seated position and the crowns from Apocalypse 4:4 and the bowls and harps from Apocalypse 5:8. In Italy, where the early Christian tradition had been imposed on the treatment of the Elders (standing, moving forward in ceremonial lines with slow steps), these now hold chalices and no longer the crowns of the *aurum oblaticium* from the senatorial protocol. They are now usually crowned. Beyond the Alps, in Romanesque and Gothic sculpture, they no longer necessarily accompany the heavenly vision of the Apocalypse. At Oléron-Sainte-Marie they are shown above a descent from the cross, and they most often complete a depiction of the Second Coming according to Matthew 24 or Acts 1:9–11.

A typology of the images of the Elders in the art of the eleventh through thirteenth centuries remains to be established; conclusions cannot yet be drawn, for new evidence could be surprising.[47] It seems that the Elders

[44]There are only two on the portal in Charlieu, eight around the Lamb on the portal of Saint-Michel d'Aiguilhe in Puye, ten in Bourges, and twenty in Amiens, but there are thirty-one in Aulnay and fifty-four in Saintes.

[45]Mâle, *Religious Art in France*, fig. 83.

[46]Sauerländer, *Sculpture gothique*, pl. 31.

[47]Whereas the Elders are regularly associated with a judiciary theophany—with Matthew's description of doomsday as at Saint-Denis and Amiens, Christ carried by angels as at Autun, Mâcon, or Saint-Paul de Varax (Ain)—the *majestas domini* rarely, if ever, introduces a Second Coming and, even less, a Last Judgment. The Living Creatures appear around Christ at Saint-Trophime in Arles, in Santiago de Compostella, and on the

moved into a secondary, even peripheral, role during this period after hav-
ing played a preponderant role in earlier iconography.[48] They lost their im-
portance once they were pushed into the portal archivolts in the company
of angels, the vices and virtues, the zodiac, and the labors of the months.
In the sculpture of ancient Aquitaine, in fact, they were reduced to simple
fill-in figures. In contrast, in southwestern France, the theme of the
twenty-four Elders seems to have been used quite casually. In Aulnay, in
the south of Poitou, thirty-one seated Elders, wearing crowns and holding
hurdy-gurdies and bowls, are pictured on the third archivolt of the south
transept portal. They are arranged in a half-circle, under a group of fan-
tastic beings and animals and above a group of twenty-four standing, ha-
loed figures holding books or containers, speaking to each other.[49] In the
exterior archivolt at Saint-Marie-des-Dames in Saintes, fifty-four crowned
Elders stand holding goblets and viols. They dominate a repetitive depic-
tion of the massacre of the innocents on the third archivolt, a Lamb in a
circle surrounded by the Living Creatures on the second, and a hand of
God on a circle carried by two angels on the first.[50] At Saint-Croix in Bor-
deaux, the crowned Elders are depicted in the prothesis on either side of a
seated figure at the apex of the exterior archivolt.[51] Finally, at Oléron-
Sainte-Marie, the twenty-four Elders, sitting and holding bowls and long-
necked vases, are arranged in two groups on either side of a Lamb in a
phylactery with the inscription "In the cross is salvation—in the cross is
life." They dominate several genre scenes: the making of a barrel, the prep-
aration of cans of salmon, a pork salting, and so forth. The tympanum, as
noted earlier, depicts a descent from the cross above a Christogram with
the Alpha and Omega.[52]

In early Gothic sculpture, the Elders are regularly present and seem to
have grown in importance. They are often on the archivolts of the portals
and accompany a *majestas domini*. The exceptions are Etampes, which
depicts an Ascension, and Saint-Denis, which portrays a Last Judgment.
At Saint-Denis (ca. 1130–40), the twenty-four Elders are seated, grouped in
threes, fours, or fives in the three exterior archivolts of the main portal, in
direct relation to the separation of the good from the evil on the first archi-

facade of Angoulême cathedral, where several rare judiciary details complete a trium-
phal Ascension. They are missing from Münster, S. Angelo in Formis, Oleggio near No-
vara, Negrentino in Tessin, Burgfelden, and S. George in Reichenau. They are also absent
from Conques, Autun, Beaulieu, Saint-Denis, Saint-Jouin-de-Marnes in Poitou, and
probably also Mâcon. There is no rule, therefore, but one can claim that, before 1150, the
majestas domini was used reluctantly as an introductory image for the Last Judgment.
 [48]The exceptions include the tympanum at Moissac (fig. 23) and the paintings at
Saint-Quirze de Pedret, Saint-Martin de Fénouillar, and Saint-Martin de Thévet.
 [49]Bernhard Rupprecht, *Romanische Skulptur in Frankreich*, 2d ed. (Munich, 1984),
pls. 78–79.
 [50]Ibid., pls. 84–85.
 [51]Ibid., pl. 110.
 [52]Ibid., pl. 212.

volt, and the Second Coming according to Matthew on the tympanum.[53] In as much as is still evident after the massive restoration of 1839–40, the figures were bearded and held musical instruments (lyres and viols) and long-necked receptacles. It appears that they did not wear crowns. Their hats vary from one figure to another. If it is necessary to trust Dobret's restoration, it is also necessary to point out that Abbot Suger saw their venerable ensemble as the choir of prophets and patriarchs from the Old Testament. In the exterior archivolt, the ten Elders framing the dove of the Holy Spirit are in a foliage reminiscent perhaps of a rod of Jesse.[54] One also finds in the exterior archivolt of the Sainte-Anne portal at Notre-Dame, Paris, standing figures whose headdresses echo those that are in Saint-Denis today. They are not holding goblets, but musical instruments, and are terraced, along with other figures holding phylacteries, below a bust of Christ with a sword held in both hands across his mouth.[55] These may have been Elders originally intended to accompany an image of Christ in majesty and later combined with other elements, but I think the portal was conceived as a whole representing the Virgin, the Elders, and the vision of Christ (Apoc. 1:12–20).

It is not a Christ in judgment and on his cross, as at Saint-Denis, but a classical *majestas domini* surrounded by the twenty-four Elders that is on the main portal of the west facade of Notre-Dame, Chartres.[56] Arranged in each of the two exterior archivolts in four groups of six, the Elders, bearded and crowned, hold bowls, lyres, and viols. Twenty of them are seated, while the remaining four, depicted in the extension of the lintel below the archivolts, stand in front of their chairs, as in the cupola at Aachen or in the Codex Aureus in Regensburg.[57] They frame the twelve angels sculpted on the first archivolt and the twelve Apostles sitting in groups of three on the lintel. The two unidentified figures sculpted on the lintel on either side of the twelve Apostles may be, as at Autun, the Two Witnesses of Apocalypse 11:3–4, Enoch and Elias. It should be kept in mind, however, that their participation in the heavenly vision and the presence of the Elders around the *majestas domini* does not mean that the portal is to be understood as a representation of Christ's second coming.[58]

[53]Mâle, *Religious Art in France*, fig. 152.

[54]For a detailed description, see Summer McKnight Crosby and Pamela Z. Blum, "Le portail central de la façade occidentale de Saint-Denis," *Bulletin Monumental* 131 (1973): 209–66.

[55]Sauerländer, *Sculpture gothique*, figs. 40–41.

[56]Mâle, *Religious Art in France*, fig. 267.

[57]On the Codex aureus of Regensburg, see Edouard Jeauneau and Paul Edward Dutton, "The Verses of the 'Codex aureus,'" *Etudes érigéniennes* (Paris, 1987), 75–120. On Aachen, see the little-known but essential study by Janina Kalinowska, "Akwizgran: Przyczynek do poznania pierwotnego programu ikonograficznego dekoracji mozaikowej Kaplicy palacowej karola wielkiego," *Folia Historiae Artium* 18 (1982): 5–23 (with a French summary). More accessible is Heitz's article in Christe, *Apocalypse de Jean*.

[58]I identify both the central portal of the west facade of Chartres and the main portal of Moissac as images of Christ's present glory.

As at Chartres, the twenty-four Elders in Angers cathedral are depicted with the *majestas domini*. They are in the two outside archivolts and frame the angels placed in the two inside archivolts. They are seated and crowned and are holding bowls and stringed instruments. The same is true in Bourges, on the south portal of the cathedral. Only ten Elders in the second archivolt frame a choir of fourteen angels. This portal, made in 1160 but not put in place until only around 1225, was planned for a different location.[59]

In Romanesque as well as in early Gothic sculpture, then, the use of the group of Elders increased, although in an unorganized manner. When they are depicted along with twelve Apostles, as at Autun, Chartres, and Amiens, or above Old Testament figures in the splays of the portal, there are, in a sense, too many of them. Exegetic tradition considers this group an idealistic image of the Old and New Testaments, the Apostles, and the representatives of the Old Law who together constitute the complete Church government. They are even depicted together with the Virgin, as in S. Cecilia in Trastevere, Rome (9th c.), in the choir of Saint-Martin in Fénouillar, on the tomb of Saint-Junien near Limoges, and in the eastern rose window of Laon cathedral.[60] Furthermore, they resemble vassals around a master—or a mistress—whom they honor with their presence in a feudal manner that is as unassuming as it is omnipresent.

As strange as this may seem, the Elders, who are disseminated throughout monumental sculpture, are rarely represented in monumental painting, particularly in the apsidal areas where the usual presence of the *majestas domini* would have normally evoked them. It is here, on the apsidal arch, but also in the apse itself, as in Anagni, that they are usually depicted from the fifth century to the thirteenth in Italy. It is astonishing to note that Romanesque painting, which has assigned so much importance to illustrations of the Apocalypse, neglected it at this point, all the more so because an image of the Elders associated with a heavenly vision was common in contemporary miniatures. There are some exceptions, including paintings at S. Margareten at Neunkirchen on the Sieg (Lower Rhine, ca. 1140), Saint-Polycarpe in the Aude,[61] Saint-Quirze in Pedret (ca. 1080), and Saint-Martin in Fénouillar. The most significant assembly of the Elders in Romanesque painting is in the church of Saint-Martin, Thévet (Berry).[62] Arranged on two registers at the base of the vault and on the upper parts of the west, south, and north partitions of the choir, the Elders are here related to the Apostles. These paintings have unfortunately deteriorated badly, but one fragment of a resurrection of the dead has been pre-

[59]Sauerländer, *Sculpture gothique*, pl. 37.
[60]Yves Christe, "Quelques exemples d'influences italiennes sur l'art roman catalan," *Etudes roussillonnaises offertes à Pierre Ponsich* (Perpignan, 1987), 267–71.
[61]Demus, *Romanesque Mural Painting*, 175 fig. 45; see also Peter Klein on Saint-Polycarpe, in his essay herein.
[62]Demus, *Romanesque Mural Painting*, pl. 158.

served and suggests an approximate idea of the whole composition: the Elders, bearded, crowned, holding hurdy-gurdies and long-necked vases full of perfume, preside over a Last Judgment with the Apostles. Christ the judge had been depicted in the apse painting, which is now gone. On the west wall, above and on either side of the apsidal arch, nine figures have been partially preserved: eight Elders and the Apostle Thomas. On the south and north walls, only the lower halves of twelve enthroned figures are distinguishable, as are traces on the base of the vault of another alignment of similar figures.[63]

Autonomous images of the twenty-four Elders are quite rare in monumental painting, whose iconography seems to be distinct from the iconography of monumental sculpture. I can see no explanation for this odd phenomenon. It is possible, however, to draw two conclusions at this point, before examining in more detail the standard treatment of the *majestas domini*. First, Romanesque and Gothic sculpture include only a few narrative scenes based on the Apocalypse, whereas illustrated cycles inspired by this text play a primary role in the monumental painting of the eleventh through thirteenth centuries. Second, although the Elders are present throughout monumental sculpture of the period, they are only sporadically represented in monumental painting. Other points worth noting include the fact that although most narrative cycles in Romanesque monumental painting end at Apocalypse 12, many illustrated manuscripts cover the entire text from beginning to end. Finally, several Romanesque and pre-Romanesque buildings—the tower portico at Saint-Benoît-sur-Loire; the portico of Saint-Pierre in Moissac; the portico, which no longer stands, of Saint-Martial in Limoges; and the portico of Lesterps in Limousin—were modeled on the New Jerusalem, "in quadro posita" (foursquare), pierced by three arcades on each side. In this respect, Romanesque architecture continues the tradition of the antenave begun during the Carolingian era in Corvey and probably also in Saint-Riquier.[64]

THE MAJESTAS DOMINI

The predominant Apocalypse theme in the demicupola of the apse, on the choir vault, on the portal, and on the facade of large and small churches of the eleventh and twelfth centuries is the *majestas domini*: an image of Christ, either standing or seated, usually portrayed in a mandorla framed by the Four Living Creatures. This stereotypical formula unflaggingly

[63]Depending on whether one or two are restored above the side choir windows, there are fourteen or sixteen, for a total of thirty-five or thirty-seven figures. On this misunderstood grouping, see Dominique Poulain, "L'ancienne église de Thévet-Saint-Martin," *Congrès Archéologiques de France (Bas-Berry)* 142 (1987): 322–36.

[64]Yves Christe, "Et super muros eius angelorum custodia," *Cahiers de Civilisation Médiévale* 24 (1981): 173–79.

repeated in Romanesque painting and sculpture underwent only minor variations, even though the iconographic context in which it appeared varied greatly from one monument to the next. In its extreme fixity, the *majestas domini* quickly became something like a seal, expressing, in abstract terms outside space and time, the manifestation of the glory of God.

The form of the *majestas domini* during the eleventh and twelfth centuries—the Four Living Creatures arranged on the diagonals, portrayed full-length in a centrifugal position moving away from the mandorla but with their heads and necks turned toward their backs to look at Christ—is a creation of Carolingian art (figs. 37–40). It slowly became incorporated into ninth-century currents modeled on Eastern celestial visions, using an amalgam of disparate elements, and it finally adopted several stable motifs that were no longer modified. In the West, its arrangement in the manner of Saint Andrew's cross occurred regularly in paleochristian art from at least the middle of the fifth century.[65] In most early examples, the Creatures, portrayed either in half or full length, are in a centripetal position moving toward the mandorla, as in the Amiatinus codex of Florence, which is an eighth-century Northumbrian manuscript modeled on an earlier Cassiodorus codex.[66] Note, too, that the diagonal arrangement of the Creatures, seen in many variations in manuscripts and furnishings (especially the Apocalypses of Trier, Cambrai, Valenciennes, and Paris[67]), rarely occurs in earlier monumental art, where an aligned arrangement prevails, either in the apse, as at S. Pudenziana (fig. 22), or on the upper register of the apsidal arch, as at S. Paolo fuori-le-mura (fig. 19), SS. Cosma e Damiano (fig. 1), and S. Prassede.

Western medieval art retained the centrifugal positioning and the order of the Four Living Creatures from the pattern of the apses in Bawit (Nile Valley; fig. 26) and in Hs. David in Salonica, of the Pantocrator Grotto in Latmos, and of the "archaic" chapels in Cappadocia. The Man is portrayed on the upper left and is a counterpart to the Eagle on the right, whereas the Lion on the lower left is opposite the Ox on the right. This formula may be based on Ezekiel 1:10; for the order in Apocalypse 4:7 is somewhat different: "And the first living creature is like a lion: and the second like a calf and the third has the face, as it were, of a man, and the fourth is like an eagle flying." The depiction of the Creatures with half their bodies hidden by a mandorla, medallion, or the luminous cloud surrounding Christ, however, would not be retained by Western iconographic tradition, which preferred the full-length representation of the animals.

[65]See, for example, the Creatures around Christ on the doors of S. Sabina, Rome, and around a cross on the codex held by an African prelate in a funerary mosaic on the Crypt of the Bishops in the Naples catacombs. On the Naples mosaics, see Martin Werner, "The Durrow Four Evangelist Symbols Page Once Again," *Gesta* 20 (1981): 23–33, fig. 2.

[66]Florence, Biblioteca Laurenziana MS Amiatinus 1, fol. 796v, in J. J. G. Alexander, *Insular Manuscripts from the Sixth to Ninth Centuries* (London, 1978), no. 7, pl. 26.

[67]For these manuscripts, see Emmerson and Lewis, "Census and Bibliography," pt. 1, 342–47 nos. 2, 5, 6, 7.

We can follow the development of the Western tradition in several manuscripts from Tours: from the Weingarten Gospels (ca. 830), in which the upper halves of the animals are depicted in the centripetal position; to the Lothair Gospels (ca. 849–51; fig. 37), which portray only the upper halves of the Creatures, turned away from the mandorla in the centrifugal position; to the Mans Gospels (ca. 855; fig. 39), one of the last Tours manuscripts.[68] Here the Creatures are portrayed full length in the centrifugal position with heads turned toward Christ; they are placed in the diagonal corners of the page, which are defined by the almost pure geometric line of the mandorla. The depiction of the Creatures in a centrifugal position with their heads turned over their backs toward the center of the composition, for example in the Moutier-Grandval Bible (ca. 835–40),[69] thus developed in the ninth century and became the typical representation in Romanesque iconography. As in the Metz Coronation Sacramentary (fol. 5r), where the Creatures seem to emanate from the glory of God; in the Bamberg Apocalypse (early 11th c., fig. 2); and in another Reichenau manuscript preserved in Hildesheim (Dombibliothek MS. 688, fol. 84r),[70] this representation gave the Creatures a kind of dramatic tension that is still evident in the monumental sculpture of Saint-Pierre at Moissac (fig. 23) and Saint-Fortunat at Charlieu (Fig. 40) and in the mural decorating the east apsidal dome of Saint-Gilles at Montoire.[71]

After the middle of the ninth century, the space in which the various figures comprising the *majestas domini* were placed tended to become compartmentalized. Until then, Christ and the Creatures, when they were not simply enclosed in a disk or a medallion, seemed to float in an undefined space. From the 850s, the mandorla was depicted as a geometric figure superimposed on a rectagular form to delineate regular diagonal corners in which to place the Creatures. The Creatures slowly became more abstract, and the depiction of the Adoration tended increasingly to be dictated by ornamental lines, the compartmentalization of space leading to more linear and abstract images. Most important, an illusion of movement recoiling and converging toward the central figure of God—frontal, immobile, and isolated in the mandorla—was created; it would be

[68]For the Weingarten Gospels, see Stuttgart, Württembergische Landesbibliothek MS. H.B.II.40, fol. 1v; for the Lothair Gospels, see Paris, Bibliothèque nationale MS lat. 266, fol. 2v; for the Mans Gospels, see Paris, ibid., 261, fol. 185r.

[69]London, British Library MS Add. 10546, fol. 499r.

[70]The Metz Coronation Sacramentary is Paris, Bibliothèque nationale, MS lat. 1141; see Robert G. Calkins, *Illuminated Books of the Middle Ages* (Ithaca, N.Y., 1983), pl. 97. For the Bamberg Apocalypse, see n. 12. For an excellent collection of *majestas domini* images and a tentative historical typology, see Ursula Nilgen, *Der Codex Douce 292 der Bodleian Library zu Oxford* (Bonn, 1967); see also Franz Rademacher, *Der Thronende Christus der Chorschranken aus Gusdorf: Eine ikonographische Untersuchung* (Graz, 1964).

[71]For Charlieu, see Mâle, *Religious Art in France*, fig. 32; for Montoire, see Demus, *Romanesque Mural Painting*, pl. 165 and detail on 55.

developed some two and a half centuries later in Romanesque painting and sculpture.

In the south portal tympanum at Moissac (fig. 23), for example, the entire composition of the *majestas domini* is ordered around the immobile center, with everything converging toward Christ, giving the scene's various witnesses an air of ecstasy about his sudden appearance. This *reversio* movement originates at Christ's feet, where his robe is lifted slightly to his right. This movement is appropriated and amplified by the Four Living Creatures, whose decorative metamorphosis and tightening of muscles reveal the fear and attraction caused by the divine vision. The iconographic schema is, nonetheless, a simple *majestas domini* in which some elements are modified for greater expressiveness. The mandorla has practically disappeared, blending in with the back of the throne, but its presence is confirmed by the agitated attitude of the Creatures and the calming visages of the seraphim. As in Charlieu on the north facade of the narthex, the christocentric movement of the animals, first centrifugal and then centripetal, is greatly exaggerated. With the zodiac depicted in its entirety, the master of Moissac, just like the master of Charlieu, reproduced the extreme tension evident in the Metz Coronation Sacramentary miniature. At Moissac, two seraphim or two six-winged cherubim are placed between Christ and the Elders. The one on Christ's right seems to be approaching while holding a closed scroll, whereas the angel on Christ's left seems to draw away, while holding an open scroll. This same detail appears on the lintel of the Ascension tympanum sculpted on the south portal of Saint-Sernin in Toulouse.[72] I agree with Nourredine Mezoughi's very thorough iconographic study of the portal in Moissac, which explains this unusual detail by citing Isidore of Seville (who was followed by Rabanus Maurus and Ambrose Autpert) in interpreting the wings of the seraphim symbolically: "The Lord is partly hidden and partly revealed in the seraphim. They cover his face and feet because the things before the world and those to come after it we cannot know."[73] It is possible to understand the seraphim carrying the closed scroll as holding the mysteries of God, whereas the other seraphim holds that which is accessible to us: "Each has six wings, because in the present age we only have knowledge of what was done in the six days in relation to the world's construction."[74]

In this sense, the Moissac portal is an image of the glory of God in the present, "in praesenti saeculo," more than of the Second Coming. It is a revelation of the triumph of God in a celestial Jerusalem—the portico of the abbey church—already established on earth. The parable of Lazarus

[72]Mâle, *Religious Art in France*, fig. 42.

[73]Rabanus Maurus *De universo* 1.5 (*PL* 111:30). See Nourredine Mezoughi, "Le tympam de Moissac: Etudes d'iconographie," *Cahiers de Saint-Michel de Cuxa* 9 (1978): 171–200.

[74]Rabanus Maurus *De universo* 1.5 (*PL* 111:30). The text parallels Isidore of Seville *Etymologiae* 7.7 (*PL* 82:274).

and the evil wealthy man sculpted on the west base of the arch is a way of portraying the future of the just and the reprobates without delving into the inaccessible *post mundum* secrets of God. At Moissac, as much as at Charlieu (fig. 40) and on the main portal of the west facade of Chartres, I understand the *majestas domini* to be an image of a present and actualized Christ in all his divinity, not an image of the Second Coming.

Conclusion

My argument stressing the present ecclesiological, rather than the future eschatological, significance of the *majestas domini* in Romanesque monumental sculpture and murals is based on the generally accepted exegetic interpretation of the vision of heaven and the Lamb in Apocalypse 4–5.[75] This opening image, which introduces the septenary of the seals (Apoc. 4:1–8:1), is repeated in an abridged form in Apocalypse 11:16–18 and 19:1–10, which conclude the septenaries of trumpets (Apoc. 8:2–11:18) and bowls (Apoc. 15:1–19:10). These two latter visions, which conclude the two repetitive periods covering the whole of Church history, "from the first coming to the end of the world," obviously are concerned with Christ's second coming. In Apocalypse 11:16–18, the adoration of the Elders is introduced by the sounding of the seventh trumpet, which is a prelude to the end of time. Contrary to what happened in Apocalypse 4:8— where the creatures who proclaim the triple "sanctus" call to the "Lord God Almighty, who was, and who is, and who is coming" ("qui venturus est")—the Elders, who fall face down now omit in their acclamation the "qui venturus est" because it no longer has an object: the Lord they await in Apocalypse 4–5 has come.[76] Although these three images of adoration are apparently synonymous, the obvious implications of *parousia* and judgment in the last two are only discreetly evoked in the first.

It is regrettable that in many art historical discussions of Apocalypse imagery, the vision of John on Patmos has been considered, without any justification, as simply the revelation of doomsday and that such discussion have been based on a division of the text that dates back only to the thirteenth century. As a result, the opening of the seventh seal, which concludes the septenary of the seals, is reported at the beginning of Apocalypse 8, as a prelude to the septenary of the trumpets. Similarly confusing, the image of the Ark in the Temple (Apoc. 11:19), which introduces the image of the Woman and the Dragon in Chapter 12, is detached from it to serve as a conclusion to Chapter 11. Similar divisions of the text also explain other errors and misunderstandings, especially in interpreting the

[75]Yves Christe, "Les représentations médiévales d'Ap IV(–V) en visions de Secondes Parousies: Origines, textes et contexte," *Cahiers Archéologiques* 23 (1974): 61–72.

[76]See, for example, Ambrose Autpert *Expositio in Apocalypsin* (ed. Robert Weber, CCCM 27:437).

angel emerging from the rising sun (Apoc. 7:2), the powerful angel clothed by the clouds (Apoc. 10:1), and the Horseman Faithful and True (Apoc. 19:11). All of these figures are placed at the beginning of recapitulative sections, "from the beginning, from the Incarnation, from the Passion, from the Resurrection,"[77] and should have therefore been considered as allegorical images of Christ in his first coming. From Victorinus of Pettau (4th c.) to the end of the twelfth century at least, the powerful angel of Apocalypse 10:1, for example, was usually identified as a figure synonymous with that of Christ in the midst of the candelabra (Apoc. 1:12–20), which introduces the seven churches of Asia (Apoc. 1:12–3:22). According to medieval exegesis, furthermore, the image of Christ among the clouds (Apoc. 1:7), which refers to his second coming, should be distinguished from the latter triumphal image of the triumphant Christ (Apoc. 1:12–20). The portal tympanum of La-Lande-de-Fronsac, which portrays Christ with the candelabra, the seven stars, and the seven arcades that symbolize the seven churches of Asia, should, therefore, be understood as an image of the divine present, not of the Second Coming.[78] It is also interesting to note that the vision among the clouds from Apocalypse 1:7 appears only rarely in illustrated cycles.[79] In monumental painting and sculpture, to my knowledge, it received no attention, except perhaps on the south portal tympanum of Saint-Pierre at Beaulieu, if indeed we are to understand the seven small figures in Oriental dress as those who behold Christ in the clouds (Apoc. 1:7).[80] In Beaulieu, they participate in the Second Coming according to Matthew, in the victory of the triumphant crucified Christ. Their marginal presence in this type of image seems logical, but the Beaulieu example is an isolated case.[81]

[77]See, for example, ibid., xx: "In praefatione huius operis promisse me recolo, huius libri narrationis ordinem singulis locis aperire. Unde nunc breviter notandum video hoc genus locutionis. Auctor etenim huius Revelationis, a primo usque ad sextum narrando perveniens sigillum, ordinem narrationis custodisse videtur. Sed praetermisso interim septimo, ad initium incarnationis Christi redit, et ea quae executus ferat, mutatis enigmatum figuris, breviter recapitulat, atque easdem duas narrationes septimo sigillo concludit. Quae vidilicet recapitulatio non semper isto modo, sed diversis fit modis, sicut per singula monstrare curabimus. Aliquando enim ab origine dispensationis Christi, aliquando a passione eius, aliquando a medio tempore, aliquando de sola ipsa persecutione, aut non multo ante dicturus recapitulat. Nunc autem, ut praemisimus, descripto sexto sigillo, ad originem redit, eadem breviter aliter dicturus." All this by way of an introduction to the internal recapitulation of Apocalypse 7:1.

[78]Mâle, Religious Art in France, fig. 7.

[79]It is absent from Families II and III; it appears only in an abridged form in Family I and is only depicted in detail in the illustrations of the Beatus commentary.

[80]Mâle, Religious Art in France, fig. 153.

[81]See Klein, "Zur Deutung des Tympanons von Beaulieu." To this rare example of the integration of an Apocalypse motif into a Last Judgment in Romanesque art, I add another from the portal of Saint-Vincent at Mâcon. On the lower register, to the left, Christ welcomes the elect by holding out to them a star and a crown, just as in the crypt at Anagni. Apparently the welcome of the elect into the city of paradise is, at

We saw earlier that the *majestas domini*, both an excellent and appropriate image for depicting the glory of God, rarely introduced the Last Judgment. Along the same lines, in the judiciary repertoire of monumental art during the eleventh through the thirteenth centuries the references to the Apocalypse are almost nonexistent. In the margin of a Last Judgment, they appear only after the beginning of the thirteenth century, with the Horsemen in Paris and in Amiens; the Christ holding a sword across his mouth, also in Paris and Amiens; and the besieged Babylon in Thérouanne. Keeping a mind that the ensemble on the south portal of the west facade of Notre-Dame in Reims is an exception, one must admit that, before the middle of the thirteenth century, the Apocalypse was not associated, as has been thought, with the end of time. Essentially, the iconography of the Last Judgment developed independently of the Apocalypse, which contributed, as a regular motif, only the assembly of the twenty-four Elders.

BIBLIOGRAPHY

General studies include Otto Demus, *Romanesque Mural Painting,* trans. Mary Whittall (New York, 1970); Bernhard Rupprecht, *Romanische Skulptur in Frankreich,* 2d ed. (Munich, 1984); Willibald Sauerländer, *La sculpture gothique en France,* 2d ed. (Paris, 1972); and Arthur Kinglsey Porter, *Romanesque Sculpture of the Pilgrimage Roads,* 2d ed. (New York, 1969). On narrative and synthetic Apocalypse cycles, see Frederick van der Meer, *Majestas Domini* (Rome, 1938); Peter K. Klein, "Die frühen Apokalypse-Zyklen und verwandte Denkmäler" (Inaugural diss., University of Bamberg, 1980), on cycles of Families I, II, and III; and Peter K. Klein, *Der ältere Beatus-Kodex Vitr. 14–1 der Biblioteca Nacional zu Madrid* (Hildesheim, 1976), on the Beatus manuscripts (Family IV). For the iconography of Apocalypse imagery, see Yves Christe, ed., *L'Apocalypse de Jean* (Geneva, 1979), and "Le 'Visiones' dell'Apocalisse dall'undicesimo al tredicesimo secolo," forthcoming; and Peter K. Klein, "Programmes eschatologiques et fonctions historiques des portails du XIIe siècle," *Cahiers de Civilisation Médiévale* 33 (1990): 317–49.

For the tradition of medieval Apocalypse exegesis, see Wilhelm Kamlah, *Apokalypse und Geschichtstheologie* (Berlin, 1935); Guy Lobrichon, *L'Apocalypse des théologiens au XIIe siècle* (Paris, 1979); Georg Kretschmar, *Die Offenbarung des Johannes* (Stuttgart, 1985); Kenneth B. Steinhauser, *The Apocalypse Commentary of Tyconius* (Frankfort on the Main, 1987); and

Mâcon, an eschatological transposition of the episode preceding the opening of the sixth seal. For an illustration, see Willibald Sauerländer, "Über die Komposition des Weltgerichts-Tympanon in Autun," *Zeitschrift für Kunstgeschichte* 29 (1966): fig. 13 and n. 56.

Martine Dulaey, "La sixième règle de Tyconius et son rèsumé dans le *De doc-trina christiana,*" *Revue des Etudes Augustiniennes* 35 (1989): 83–103, which mistakenly includes Primasius among the sources for Beatus.

My own work tends to priviledge a noneschatological interpretation. For other approaches, including studies of images not included in my analyses, see Josef Engemann, "Auf die Parusie hinweisende Darstellungen in der frühchri-stlichen Kunst," *Jahrbuch für Antike und Christentum* 19 (1976): 139–56, trans. Yves Christe and Elisabeth Gattlen in my *L'Apocalypse de Jean,* 73–107; Bernard McGinn, *Visions of the End* (New York, 1979); Richard Kenneth Em-merson, *Antichrist in the Middle Ages* (Seattle, 1981); and Werner Verbeke, Daniel Verhelst, and Andries Welkenhuysen, eds., *The Use and Abuse of Es-chatology in the Middle Ages* (Leuven, 1988).

I I

Exegesis and Illustration in Thirteenth-Century English Apocalypses

SUZANNE LEWIS

Since the ground-breaking studies of Léopold Delisle and Paul Meyer appeared in 1901,[1] textual scholars and art historians have been investigating illuminated Apocalypses of the Gothic period in various ways. Thus far, however, the impact of the accompanying commentaries on the formation of new iconographic traditions has not played a significant role in the philological equation. Two distinctive cycles of Apocalypse illustrations were created in England in the mid-thirteenth century. One was designed for a text accompanied by excerpts compiled from the Latin commentary of Berengaudus; the other, the so-called Corpus-Lambeth stem,[2] was made for an anonymous French prose gloss. The seventy-nine illustrated manuscripts that constitute the Anglo-French tradition of illustrated Apocalypses[3] all descend from these two seminal configurations of image, text, and exegesis.

More than a dozen illustrated Apocalypses with Berengaudus commentaries (listed in my Appendix) survive from the thirteenth century. For the most part, the glosses consist of contemporary compilations of Latin excerpts; the only vernacular translation is represented by the Trinity Apocalypse. Although the French prose gloss became dominant among the illustrated Apocalypses produced in the next two centuries, only three extant manuscripts (see the Appendix) date from the thirteenth century. The preponderance of commentaries suggests that the initial idea of the

[1]Léopold Delisle and Paul Meyer, *L'Apocalypse en français au XIIIe siècle: Bibl. nat. Ms, fr. 403,* 2 vols. (Paris, 1900–1901).

[2]The core of six thirteenth- and fourteenth-century English manuscripts was first recognized by Aileen Laing; see her "The Corpus-Lambeth Stem: A Study of French Prose Apocalypse Manuscripts," *Manuscripta* 21 (1977): 18.

[3]See Richard Kenneth Emmerson and Suzanne Lewis, "Census and Bibliography of Manuscripts Containing Apocalypse Illustrations, ca. 800–1500," pt. 2 *Traditio* 41 (1985): 370–409 nos. 38–117.

illustrated Apocalypse called for a glossed text. The exegetic apparatus was dropped only occasionally, in one case to be replaced by a vernacular verse translation appearing beneath the Latin text in the French metrical version.[4] Indeed it can be shown that all Anglo-French Apocalypses, whether furnished with commentaries or not, descend from one of the distinctive cycles of illustration created for the Berengaudus and French prose glosses.[5]

Textus glossatus: THE COMMENTARIES

In the English Apocalypses, short segments of text comprising only a few verses are headed by an illustration and followed by a brief commentary. Although the half-page format of large, tinted drawings above the glossed text in the Berengaudus manuscripts (figs. 42, 43, 45, 46, 48, 50) differs radically from the irregular dispersion of small but heavily painted miniatures in books equipped with the French prose gloss (figs. 41, 44, 47), both cycles disrupt the integrity and flow of the text. Larger dramatic and narrative structures tend to become lost as each moment is isolated, causing the reader to linger over each picture, text, and gloss. The reader's perspective shifts from one of expectancy geared to what happens next in a normal narrative mode to one of leisurely contemplation. Differing from twelfth-and thirteenth-century Bibles in which a continuous text is enveloped by marginal or interlinear glosses, the Gothic illuminated Apocalypse offers a structure that effectively moves the reader's experience from a temporal, sequential context to a timeless framework conducive to a different mode of understanding the text.

Laid out in double columns on the page, the commentary is sometimes differentiated from the text only by differently colored or flourished versals, as in Trinity R.16.2 and Lambeth 75, or by the rubrics "Textus" and "Expositio," as in Metz and Lambeth. In Paris lat. 10474 and Douce, however, the layout takes on the appearance of a more traditionally glossed text where the commentary is written in a script only half the size of that for the Apocalypse. In Getty and Add. 35166, the disjunctive effect becomes even more pronounced in the strong contrast between the scriptural text and the glosses accentuated in rubric. The most pronounced disruption occurs in the Gulbenkian and Abingdon Apocalypses, which contain fully illustrated commentaries on separate pages alternating with the illustrated Apocalypse text.[6]

[4]See Paul Meyer, "Version anglo-normande en vers de l'Apocalypse," Romania 25 (1896), 174–257. Three fourteenth-century manuscripts known as the gamma group, however, also contain the French prose gloss.

[5]A detailed analysis will be given in my forthcoming study, Picturing Visions: The Gothic Illustrated Apocalypse and Its Thirteenth-Century English Archetypes.

[6]See Nigel Morgan, Early Gothic Manuscripts, vol. 2, 1250–1285 (London, 1988), 106–112 nos. 127, 128.

Of the twenty-two manuscripts dating from the second half of the thirteenth century, all but seven contain Berengaudus commentaries, suggesting that the exegetic text served as an essential component in the initial conception of the English illustrated Apocalypse.[7] At least six different compilations of excerpts from the Berengaudus commentary appear in the extant manuscripts. Although selections often overlap, no two redactions are exactly alike. Compilations of glossing texts in turn coincide with groups of manuscripts recognizably related by the number, sequence, and iconography of their illustrations, such as those headed by Metz or Getty (see Appendix), confirming a critical link between the commentary and the formation of the pictorial cycles.

Since the earliest extant manuscript copies of the Berengaudus text date from the twelfth century[8] and the line of interpretation closely resembles that taken by Rupert of Deutz,[9] the commentary can be regarded as a twelfth-century work. The exegesis is close to the kind of scholastic expansion of glosses represented by Richard of Saint Victor (d. 1173), which interprets the Apocalypse as a recapitulation of superimposed epochs "from the birth of the Church until the end of the world." Berengaudus offers a conservative allegorical reading of the Apocalypse. Faithful to the principle of *recapitulatio* inaugurated by Tyconius in the fourth century, the struggles and triumphs of the Church are seen in a timeless framework extending from the Incarnation to the Second Coming. Although, as Yves Christe points out, the articulative and recapitulative system of successive visions may vary from one twelfth-century commentator to the next,[10] Berengaudus typically perceives the Apocalypse as a vision of the celestial Church and of the present and future struggle of the terrestrial Church for its eschatological realization.

Because a canonical interpretation of the Apocalypse already existed at the beginning of the thirteenth century, in the last version of the *Glossa ordinaria*,[11] the Gothic compilers' selection of a marginal and out-of-date commentary such as that of Berengaudus engenders speculation about the genesis of the English illustrated Apocalypse. Judging from the number of extant medieval copies, the Berengaudus commentary appears to have enjoyed widespread popularity among monastic readers in England in the twelfth century. A dozen surviving manuscripts

[7]The entire text of Berengaudus *Expositio super septem visiones* is printed in *PL* 17:843–1058.

[8]See Friedrich Stegmüller, *Repertorium Biblicum Medii Aevi*, vol. 2 (Madrid, 1960), 196–97 no. 1711.

[9]See Guy Lobrichon, "Une nouveauté: Les gloses de la Bible," in *Le Moyen Age et la Bible*, ed. Pierre Riché and Guy Lobrichon (Paris, 1984), 109; he regards Berengaudus as a contemporary of Anselm of Laon. But cf. Peter Klein's essay herein, p. 189.

[10]Yves Christe, "Ap. IV–VIII,1 de Bède à Bruno de Segni," *Etudes de la civilisation médiévale: Mélanges offerts à Edmond-René Labande* (Poitiers, 1975), 146.

[11]See Yves Christe, "Apocalypses anglaises du XIIIe siècle," *Journal des Savants* II (1984): 84–86.

are recorded as having belonged to English monastic libraries.[12] It would indeed appear likely that the first illustrated versions were designed and produced for clerical readers.[13] The exegetic text addresses itself to matters of doctrine; the authority of the Church, its priesthood, sacraments, and preachers; and the conversion of heretics and Jews. Within an antiworldly ecclesiastical framework, the faithful are consistently perceived as the corporate body of the Church universal and are never appealed to as individual believers. Although the Berengaudus commentary had its origins in the Benedictine world of the twelfth century, its reformist message appears to have been recognized as an opportune legacy by the thirteenth-century compilers of illuminated Apocalypses. Its adaptation to the needs of the secular bishops who assumed jurisdiction over the monastic houses within their dioceses is particularly evident in the illustrations provided for the glosses in the Gulbenkian and Abingdon Apocalypses.[14] The Berengaudus commentary represents an older, more conservative Benedictine view that was first popular in unabridged, unillustrated copies in English monastic houses in the twelfth century.[15] Although its Latin text remained largely inaccessible to lay readers when it was recast in its abridged thirteenth-century illustrated form, the Berengaudus commentary became a book whose pictures, like those in contemporary psalters, rendered it useful for private devotion among lay men and women, as attested by the Lambeth and Douce Apocalypses.

In contrast, the French prose gloss accompanies an Anglo-Norman translation, constituting a wholly vernacular access to the Apocalypse

[12]Cambridge: Corpus Christi MS. 134 (Peterborough or Pentney), Gonville and Caius MS. 301 (Canterbury), Pembroke MS. 85 (Bury St. Edmunds), and Trinity B.1.16 (Canterbury); Durham: Cathedral MS. A.I.10; London: Lambeth MSS. 358 (Canterbury); Berlin: Staatsbibliothek MS. lat. 350 (Rochester cathedral priory); Oxford: Bodleian Library MS Douce 330 (Lessness) and Auct. D.4.15 (Kyme), St. John's MS. 73 (Reading), Trinity MS. 34 (Kingswood); and Longleat House MS. 2 (St. Benet Holme). See also N. R. Ker, *Medieval Libraries of Great Britain*, 2d ed. (London, 1964), 12, 58, 59, 64, 90. According to the *Indiculus* of Walter the Chanter, St. Albans owned a copy of the Berengaudus commentary in the twelfth century; see R. W. Hunt, "The Library of the Abbey of St. Albans," in *Medieval Scribes, Manuscripts and Libraries: Essays Presented to N. R. Ker*, ed. M. B. Parkes and Andrew Watson (London, 1978), 270.

[13]See Peter K. Klein, *Endzeiterwartung und Ritterideologie: Die englischen Bilderapokalypsen der Frühgotik und MS Douce 180* (Graz, 1983), 177.

[14]On the commentary illustrations, see my "Giles de Bridport and the Abingdon Apocalypse," in *England in the Thirteenth Century: Proceedings of the 1984 Harlaxton Symposium* (Nottingham, 1985), 107–19, and "*Tractatus adversus Judaeos* in the Gulbenkian Apocalypse," *Art Bulletin* 68 (1986): 543–66.

[15]There is no evidence to suggest that the Berengaudus commentary was already, in the twelfth century, illustrated by a Romanesque cycle that in turn could have inspired the mid-thirteenth-century archetype. The only extant illustrated twelfth-century copy contains a single frontispiece with two scenes in double registers; see Michael A. Michael, "An Illustrated Apocalypse Manuscript at Longleat House," *Burlington Magazine* 126 (1984): 340–43.

text.[16] While the compilations of extracts from the Berengaudus text represent adaptations of an older, longer tract to conform to the requirements of Gothic pictorial manuscripts, the French prose gloss is a new work reproduced in its entirety. Like the Berengaudus compilations, however, the French prose gloss is based on a Latin model. The Anglo-Norman text represents a translated redaction of the same Latin gloss that provided the more abbreviated text for the *Bible moralisée* (fig. 30) and thus constitutes a variant of the *Glossa ordinaria.*[17]

In contrast to the allegorical and spiritual thrust of the Berengaudus commentary, the French prose gloss most frequently draws admonitory moral lessons from the text by defining dogma and addressing itself to strengthening Church discipline. For example, where Berengaudus uniquely interprets the vision of Apocalypse 4 as a divine manifestation of the Church to the faithful, the French prose gloss gives a christological and moral reading, introduced by equating the door opened in heaven with good priests listening to holy Scripture.[18] The French prose gloss takes on the character of a sermon in which John's visions are transformed into moral lessons. Directed at the clergy, the *moralités* deal with abuses within the Church, "good and bad preachers," simony, heresy ("false priests" and "false clerics"), and the corruption of ecclesiastical power. Eschewing the historical and prophetic structure of the six ages in traditional apocalyptic exegesis, the French prose gloss treats the struggles of the Church and its clergy against the forces of corruption and heresy as an ongoing process rooted in the present. John thus represents the ideal of the good priest, and in explanation of Apocalypse 4:2 ("I was in the spirit"), the reader is told that "thanks to God's grace, he cast aside vain cares for temporal things."

When compared with the complexity and subtlety of Berengaudus's theological exegesis, the didactic explanations of the text in the French prose gloss can be characterized as simple and prosaic. Whereas the older commentary invites contemplative spiritual meditation, the French prose

[16]A redaction of the French prose gloss based on Fr. 403 is printed in Delisle and Meyer, *Apocalypse,* 1:1–131. Contrary to frequent assertions that thirteenth-century canon law had strictly forbidden lay persons to read the Bible in the vernacular, see Leonard E. Boyle, "Innocent III and Vernacular Versions of Scripture," *Studies in Church History* (Oxford, 1985), 97–107, which demonstrates that the three letters of Innocent III to the bishop of Metz usually cited as evidence for the papal proscription cannot be reasonably interpreted as a condemnation of translations and that "no universal or absolute prohibition of the translation of Scripture into the vernacular nor the use of such translations by the clergy or laity was ever issued by any council of the Church or any pope."

[17]Argued from a close comparison between the Apocalypse commentary in Vienna, Österreichische Nationalbibliothek, Cod. 1179, which probably represents the earliest extant version of the *Bible moralisée,* and the French commentary in Fr. 403, Gunther Breder, in *Die lateinische Vorlage des altfranzösischen Apokalypse-Kommentars des 13. Jahrhunderts* (Münster, 1960), 55–82, demonstrates their dependence on a common prototype.

[18]Delisle and Meyer, *Apocalypse,* 1:17.

gloss rallies the reader to deal with its moral imperatives as a series of practical remedies to contemporary problems. Departing from the earlier Benedictine outlook expressed in the Berengaudus text, the French prose gloss represents the views of a generation of moral theologians active in the schools at the end of the twelfth century and in the early decades of the thirteenth,[19] not only in its moralizing, reformist interpretation but also in its practical, activist focus on preaching, preachers, penitence, and confession as well as worldly temptation, the corruption of power, heresy, the Jews, and the coming of Antichrist. Like the Berengaudus-glossed manuscripts, the illustrated French prose glossed version was perhaps initially designed for clerical readers. Its outlook is no longer monastic, however, but profoundly influenced by the increasingly more powerful mendicant orders.

Glossa depictus: THE INTERPRETIVE ROLE OF THE ILLUSTRATIONS

Although precedents exist in the Apocalypse illustrations created for the glossed text compiled by the Spanish monk Beatus of Liébana (figs. 28, 29) and the commentary of Rupert of Deutz,[20] full cycles of Apocalypse illustrations uniquely designed to interpret an accompanying gloss first appear in the early thirteenth-century miniatures of the *Bible moralisée* (fig. 30).[21] Unlike the *Bible moralisée* and the later Gulbenkian and Abingdon Apocalypses, which contain illustrations for their commentaries as well as the text, the new English cycles are comprised of miniatures that pictorialize the text and gloss in the same image. The Berengaudus and French prose commentaries constitute essential components of the thirteenth-century English illustrated Apocalypses; they provide the critical textual framework and impetus for the creation of two distinctive new cycles of Apocalypse illustration.

Each commentary exerted a profound, distinctive, and direct impact on the choice, conception, and design of the illustrations in the two cycles. This influence can be seen, for example, in their respective representations of the sixth seal. In response to its French prose gloss, the Corpus-Lambeth cycle (fig. 41) pictures "all the kings of the earth, and the princes, and the tribunes, and the rich, and the strong, and everyone, bond and free,

[19]Cf. ibid., 1:ccxiv–ccxxii; Delisle and Meyer regarded the work as expressing later mendicant views.

[20]The standard work on the Beatus manuscripts is still Wilhelm Neuss, *Die Apokalypse des hl. Johannes in der altspanischen und altchristlichen Bibel-Illustration,* 2 vols. (Münster, 1931). On the series of early twelfth-century historiated initials reflecting the commentary of Rupert of Deutz, see Peter K. Klein, "Rupert de Deutz et son commentaire illustré de l'Apocalypse à Heiligenkreuz," *Journal des Savants* 11 (1980): 119–40.

[21]See Breder, *Vorlage,* 12–14, 81–82.

[hiding] themselves in the caves and in the rocks of the mountains" (Apoc. 6:15), as safely isolated groups within protective cocoons at the base of the composition to represent the saints who are severed from the rest of a society that has been corrupted by Antichrist; a darkened disk and crescent appear at each end of a wide series of striated bands across the top of the picture to represent "the sun . . . black as sackcloth" and the "moon . . . as blood," cursorily evoking the pervasive evil power of the antimessiah.[22] In contrast, Berengaudus interprets this passage as a reference to the rejection of the Jews and the calling of the pagans, marked by the earthquake that signifies the destruction of Jerusalem by the Romans.[23] Hence the earthquake of Apocalypse 6:12–17 provides the impetus for the pictorial rendering of fallen walls, gates, towers, and people fleeing from the destroyed city to hide in caves (fig. 42). At the left, John limps away as a wounded casualty, leaning on his staff as if it were a makeshift crutch padded with wads of drapery tucked under his arm. In the Corpus-Lambeth version, the more comforting image is left unmediated by his presence.

In the Berengaudus cycles, illustration and exegesis work together to promote a theological comprehension of the text, as the reader is invited to "see" John's visions on several allegorical levels. In contrast, the Corpus-Lambeth cycle created for the French prose gloss transforms John's experiences into a series of moral lessons in pictorial *exempla* that take on the character of sermons. Despite their disparity in character and tone, however, the two thirteenth-century English cycles of illustration use similar pictorial strategies to impress upon their readers the doctrinal and moral imperatives of their respective commentaries. Both introduce graphic representations of elements from the glosses not given or even implied in the Apocalypse text. For example, in the Berengaudus illustration for Apocalypse 5:7–14 represented by the Metz Apocalypse (fig. 43), the book is displayed in an open position with its loosened seals prominently visible to signal the gloss in which the exegete asks, "How can the book be opened before the seals are broken?" to which he then responds that it is to be understood spiritually, just as the prophecies of Christ are given in the Old Testament.[24] Corresponding to the French prose gloss, which interprets John's ascent to the door opened in heaven (4:1) as the good priest listening to holy Scripture in his battle against the vices, the Corpus-Lambeth manuscripts (see fig. 44) represent the seer, like Jacob, climbing a ladder in heaven to create a metaphorical image of the struggle toward moral perfection.[25] In Add. 35166 (fig. 45) two angels appear with lighted tapers

[22]Delisle and Meyer, *Apocalypse*, 1:32.
[23]*PL* 17:923–24.
[24]*PL* 17:890–91.
[25]Delisle and Meyer, *Apocalypse*, 1:17. The metaphor goes back to the writings of the sixth-century Byzantine ascetic John Climacus; see John Martin, *The Illustrations of the Heavenly Ladder of John Climacus* (Princeton, 1954). In the West, the image's currency is attested by the *Scala coeli minor* of Honorius Augustodunensis

in the last illustration, referring to the commentary on Apocalypse 22:16, in which Berengaudus calls Christ the bearer of light (*lucifer*).[26]

Both cycles break with long-standing traditions of Apocalypse illustration to introduce new pictures, frequently making eccentric ruptures in the text to accommodate them. In Metz and Getty, the text begins in the middle of Apocalypse 13:2 "Et dedit illi draco" (And the Dragon gave him), for the insertion of a new representation of the Dragon transferring his power, symbolized in the form of a royal sceptre, to the Beast from the sea, thus drawing attention to the Berengaudus gloss on this passage as Antichrist's corruption of power, while Morgan 524 (fig. 46) adds a mock-ritual gesture of coronation to stress the exegetic point.[27] Lambeth 75 similarly adds a new picture of the angel holding a cross-staff to denote that its French prose gloss interprets the "seal of the living God" (7:2) as the "sign of the cross."[28] Traditional Apocalypse iconography is frequently modified to dramatize an interpretive aspect of the commentary as, for example, in Lambeth 75, where John is revived by Christ instead of the angel (fig. 47) to reflect the gloss on 1:17–20.[29] For the illustration of the angel casting the millstone into the sea (18:21–24), where Berengaudus characterizes the angel as Christ "whose strength is beyond human comprehension" and the millstone as the weight of "all the great multitude of sins," the designer of Paris lat. 10474 (fig. 48) expands the action into a cyclic sequence in which the Herculean figure first hoists the enormous stone disc onto his shoulder before hurling it into the sea.

Berengaudus picture cycles survive in forty-eight manuscripts. Their wide currency and influence can in part be attributed to their conception as a continuous series of half-page pictures in which the relationship between image and text is both spacious and flexible. Unlike Corpus-Lambeth, which rigidly structures the Apocalypse into a fixed sequence of short glossed segments, the Berengaudus cycles can be expanded and compressed at will, because the glossing texts extracted from the longer commentary can be arbitrarily selected, just as the sequencing of scriptural verses can be manipulated to form shorter or longer glossed segments beneath the half-page illustrations. The illustrated Berengaudus commentary appears to have been conceived primarily as a cycle of pictures to which the texts were attached. While the Corpus-Lambeth Apocalypse was designed as an illustrated vernacular text, the pictorial cycles in the Berengaudus Apocalypses tended to gain ascendancy over their glossed

(PL 172:1239–43), as well as the diagrammatic representations in the *Speculum Virginum* and the *Hortus deliciarum*. On the ladder of virtues, see Adolf Katzenellenbogen, *Allegories of the Virtues and Vices in Medieval Art* (New York, 1964), 22–26.

[26] PL 17:1055.

[27] PL 17:967.

[28] Delisle and Meyer, *Apocalypse*, 1:34.

[29] Ibid., 1:4; see also 1:14.

texts and perhaps even supplant them where their aristocratic lay and even clerical owners were not fully literate in Latin.

Among the thirteenth-century Berengaudus manuscripts, more than half include an illustrated life of Saint John comprising from eight to twenty-four scenes as a graphic response to the commentary. In his explanation of Apocalypse 1:2, the exegete argues that the writer of the Apocalypse must be none other than John the Apostle and Evangelist: "This book was written not by another John but by the one who wrote the Gospel, he who at the marriage feast [at Cana] reclined on the breast of the Lord in which all treasures of wisdom and knowledge are concealed. . . . Therefore he guaranteed the testimony of the word of God when he said, 'In the beginning was the Word, and the Word was God.' "[30] In a full-page picture appended to Lambeth 209 (fig. 49), John is seated on the island of Patmos, commanded to write his Apocalypse (1:11) in an open codex before him, while a long scroll is unfurled from his lectern bearing the incipit of his Gospel "In principio erat verbum" (In the beginning was the Word) to establish his identity as John the Evangelist. In the Berengaudus cycles, the author-seer is represented not only when the narrative requires his presence as a protagonist in the drama but also as a preceptor whose visible reactions directly affect the reader's perception and understanding of the illustrated vision. Aside from the few passages where the text explicitly requires a representation of John writing, however, he is not characterized as *auctor*. His role transcends reportage to serve a more direct authenticating function for the reader; his graphic presences validate the experience of his visions in the written record by reenacting his seeing and hearing of each event.[31] John frequently witnesses them as a spectator physically isolated from the vision as he stands outside the frame (see figs. 43, 50), suggesting that he shares a place in the corporeal world of the reader, apart from the spiritual, timeless realm depicted within the frame. By demonstrating his extraordinary ability to move from one realm to the other by shifting his position back and forth, within and outside the frame, John becomes a powerful intermediary through whom the reader can "see" and experience his visions "in the spirit."

[30]*PL* 17:844. When Berengaudus begins with his declaration that Saint John the Apostle and Evangelist was the author, noting that "there exist others that were composed not by him but by another," he is observing a convention in academic prologues which calls for the discussion of authenticity, for which a short *vita auctoris* was sometimes provided; see A. J. Minnis, *Medieval Theory of Authorship: Scholastic Literary Attitudes in the Later Middle Ages* (London, 1984), 20. On the reference to the wedding banquet at Cana, see Eleanor S. Greenhill, "The Group of Christ and St. John as Author Portrait: Literary Sources, Pictorial Parallels," in *Festschrift Bernhard Bischoff zu seinem 65. Geburtstag,* ed. Johanne Autenrieth and Franz Brunhölzl (Stuttgart, 1971), 406–16.

[31]For a discussion of the pervasive mistrust of texts over the testimony of witnesses in the twelfth and thirteenth centuries, see M. T. Clanchy, *From Memory to Written Record* (London, 1979), 203–8; and Michael Camille, "Seeing and Reading: Some Visual Implications of Medieval Literacy and Illiteracy," *Art History* 8 (1985): 26–49.

The Berengaudus picture cycle begins with a representation of John sleeping on the island of Patmos which serves as both the concluding illustration for the life of John leading up to his exile and the initial illustration of the Apocalypse text. In its emphatic ecclesiological reading of the text as an allegory of the Church as a corporate entity, the second miniature represents the seven churches of Asia in a composite illustration for Apocalypse 1:4–12. Following the early thirteenth-century innovations made in the *Bible moralisée*, a number of new illustrations expand the traditional medieval repertory of Apocalypse illustrations to respond to the commentary. Thus, for example, a representation of the Woman in Apocalypse 12 being given wings draws the reader's attention to the explication of the event as the Church receiving the two Testaments,[32] while the marriage of the Lamb responds to the gloss's interpretation of the Bride as *ecclesia*.[33]

The broadly spaced monumental figures of the half-page illustrations in the Berengaudus cycles (see figs. 42, 43, 45, 46, 48, 50) develop the narrative at a leisurely pace, inviting the reader to linger and enter their world to experience the text on another plane. The curiously static, frozen quality of suspended animation that characterizes many of the miniatures engenders contemplation and reflective "reading." For example, in the illustration of the fourth Horseman in Lambeth 209 (fig. 50), the Rider turns to gaze directly at the reader, demanding to be perceived and understood on a symbolic or allegorical level.[34] The events of the long narrative are connected only as the facets of a cut diamond relate to the whole gem, to be turned and shifted in the light as each brilliant new shape comes into view and reflects what has been lost in shadow. Designed as facing pairs of illustrations interrelated both in a compositional and a narrative sense, the graphic interpretations of the text achieve an extraordinary breadth of meaning. Indeed, to avoid the appearance of two almost identical compositions on facing pages, the designers of the Metz-Lambeth and Getty recensions reversed the sequence of the adoration by the twenty-four Elders (Apoc. 4:9–11) and John being consoled by the Elder (5:2–5), with resultant shifts in the reader's understanding of the two events. In the Berengaudus cycle, the text is frequently broken in the middle of a verse to accommodate a new graphic focus on glossed elements of the text. The text has been structurally particularized into isolated, quasi-independent moments that can stand alone, to be comprehended on the three different levels of illustration, text, and commentary, with the pictorial image holding a dominant place in the reader's perception at the head of a hierarchically ordered vertical sequence. The Berengaudus cycle ends uniquely, with a representation of John kneeling before the Lord (fig. 45). By ignoring

[32]*PL* 17:964.
[33]*PL* 17:1010.
[34]See Meyer Schapiro, *Words and Pictures: On the Literal and Symbolic in the Illustration of a Text* (The Hague, 1973), 29–30, 34–49.

the admonitory epilogue and focusing on John's final vision of the Lord, the entire focus of the pictorial narrative shifts to the ultimate spiritual experience of John's visual contemplation of the face of God. What he could glimpse only imperfectly in the preceding visions is now fully revealed before him.

The distinctive cycle of illustrations created for the French prose gloss occurs in twenty-five manuscripts. Heading the core group, Fr. 9574 and Lambeth 75 are fully painted, with patterned grounds of heavy, flat color or burnished gold (see figs. 41, 44, 47).[35] Executed in an elegant French-influenced style, the thirteenth-century manuscripts are full quarto size, of roughly the same dimensions as the Berengaudus Apocalypses. Fr. 9574 and Lambeth 75 are laid out in two columns of large script, with most miniatures spanning the width of the page, while the others are aligned within a single column. For the most part, the relationship between text and illustration, albeit close, gives the impression of an ill-fitting picture cycle awkwardly adapted from another format. In comparison with the spacious half-page format in the Berengaudus manuscripts, the earliest Corpus-Lambeth cycles seem oppressively dense as they crowd text and illustration into every available space on the page. Figures constantly overlap and break out of the frame, and an irregular " bite" is frequently taken from the upper right corner of the illustration to make room for the completion of the text. In other instances, the picture is expanded into an irregular stepped format to accommodate the figures within the frame.

As in the Berengaudus cycles, Corpus-Lambeth's text is divided into short glossed segments, each comprising a few verses, but the text divisions differ, and only sixty-nine of the eighty-nine articles are illustrated. The text divisions are very probably based on the lemmas in the Latin commentary on which the French gloss was based and, in some cases, reflect irregular breaks observed in older commentaries, as, for example, between the first two verses in Apocalypse 8, between 14:12 and 14:13, and between 12:8 and 12:9, as well as the merging of 11:19 and 12:1–2. As in the Morgan and Metz recensions in the Berengaudus group, Apocalypse 10:11 is given at the beginning of Apocalypse 11, probably reflecting lemmas in the commentary. The Apocalypse text itself is fairly complete, with only a few omissions at 7:5–8, 9:21, and 10:7. The Anglo-Norman translation is not, however, always literal but composed of an intelligent paraphrase in which passages are sometimes interpreted, perhaps with the aid of another commentary.

Unlike the Berengaudus cycles, Corpus-Lambeth is never accompanied by an illustrated life of John but is prefaced by an early thirteenth-century prologue that begins "Seint Pol li apostle" (Saint Paul the Apostle), with a

[35] Fr. 9574 stands closest to the archetype. Lambeth 75 is flawed by a mistake on fol. 16, where the picture above the text for the first trumpet has been omitted, thus displacing the remaining illustrations of the trumpets; but the other core manuscripts are correct and resemble Fr. 9574.

historiated initial usually containing the figure of Paul holding a sword.[36]
Diverging from the Berengaudus cycles, which begin with the first verse
of the Apocalypse and a representation of John on Patmos, Corpus-
Lambeth begins its text with Apocalypse 1:9–11, the first eight verses
having been summarized in the prologue. The initial miniature then
represents John preaching, so as to reflect the gloss in which John is said
to signify the good priests of holy Church.[37] A representation resembling
that of John on Patmos in the Berengaudus cycle appears as the third il-
lustration in Corpus-Lambeth (fig. 47) in conjunction with the text for
1:17–20, but the shift in context causes the angel to be supplanted by
Christ who, instead of bringing a message on a scroll, tries to wake the
sleeping seer to express the commentary's allusion to John as "almost
dead" to the glories of the world (p. 4). The seven churches of Asia are
not illustrated either collectively for 1:11 or separately for Apocalypse 2–
3; instead, a small illustration heads the text of 2:1–7, in which John is
seated at his desk, instructed to write by the angel, to signal the meaning
of the gloss that interprets the angelic command as the Lord entrusting
the care of souls to his priests through their labor, patience, and good ex-
ample (p. 6).

Unlike the Berengaudus cycles, Corpus-Lambeth introduces an illus-
tration of the door opened in heaven (fig. 44) to stress the gloss in-
terpreting John in Apocalypse 4:1 as the good priest listening to holy
Scripture to battle against the vices (p. 17). Corpus-Lambeth also adds
an illustration for 5:11–14, in which the multitude of angels and twenty-
four Elders worship the Lamb to reflect the "saints in Holy Church"
from the gloss (p. 26). Each of the Four Horsemen in Apocalypse 6 wears
a gold crown to signal his identification with Christ. The text for 7:1
is isolated, and 7:2–4 is given an additional illustration to represent "an-
other angel ascending from the rising of the sun, having the seal of the
living God" as a cross to respond to the gloss's interpretation of this pas-
sage as the Son of God descending from heaven to defeat Satan (p. 34). An-
other illustration unique to Corpus-Lambeth has been added for 7:13–17,
in which the Elder speaks to John, an episode interpreted in the gloss as
the teaching, of holy Scripture, that the Lord will suffer tribulation in this
life to lift the hearts and souls of humankind through his passion (p. 36).

Unlike most Berengaudus cycles, Corpus-Lambeth includes an illustra-
tion for Apocalypse 12:1–2 which harks back to the old Carolingian tra-
dition of showing the Woman in the sun standing on the crescent moon in
a frontal orant pose, with the sun superimposed on her abdomen, to reflect
the French prose gloss in which the Woman becomes a personification of
holy Church, while Christ, who is the true sun, illuminates her by his

[36]C. 1220 a new prologue, until recently misattributed to Gilbert of Poitiers, was in-
troduced at the head of the Parisian glossed Apocalypse; see Lobrichon, "Nouveauté,"
113.
[37]Delisle and Meyer, *Apocalypse*, 1:2. Pages given in the text are to this edition.

grace (p. 58). The next illustration in Corpus-Lambeth further differs from
the Berengaudus sequence by referring directly to the Nativity of Christ in
the reclining Woman nursing the child, as she is threatened by the Dragon,
for 12:3–6, to illuminate the gloss's assertion that "the male child signi-
fies Jesus Christ who is born of Holy Church" (p. 59). For 12:7–12, Corpus-
Lambeth offers a small illustration depicting the fall of Satan's angels,
drawing the reader's attention to the gloss's interpretation of the devils de-
feated by holy men in the Church (pp. 60–61) but omits two illustrations
normally given in the Berengaudus cycles—the Woman given wings and
the war against the Woman's seed—to correspond with its text, which, un-
like those in the Berengaudus manuscripts, does not divide 12:13–18 into
three glossed segments.

Also reflecting the text in the Corpus-Lambeth version, the Harlot of
Babylon is represented only once in Apocalypse 17:1–5, in contrast with
the Berengaudus cycles, which divide the text of the first six verses into
two illustrated segments. Corpus-Lambeth, however, adds an illustration
of the angel prophesying the destruction of the Beast to isolate and dra-
matize the text for 17:7–18, which is omitted in many Berengaudus manu-
scripts and which the long French gloss interprets as Christ coming to
battle against Antichrist. The last two illustrations form a radical depar-
ture from the Berengaudus cycles by omitting the images of John adoring
first the angel and then the Lord, for 22:8–9 and 22:10–15. Instead, a min-
iature representing Christ and the angel appears at the head of 22:16–17 to
mark the French glossed text that reads "Christ sent his angel to attest to
these things, mean[ing] that the Lord sent Holy Scripture as testimony of
his secrets to his people" (p. 129). The last miniature shows Christ preach-
ing, presumably exhorting his audience with the admonitions from
22:18–21, glossed as "Here are the wicked Jews and heretics who negate
the true interpretation of Holy Scripture . . . and the false preachers who
preach for glory and earthly riches. . . . Those who say, 'Come, Lord Jesus'
signify the great desire of the holy Church to be glorified by the coming of
Christ to judgement" (pp. 130–31).

Whereas the Berengaudus cycles begin with John dreaming on Patmos,
Corpus-Lambeth is launched by an image of John preaching; instead of
culminating in John's vision of Christ, in the latter we see Christ him-
self preaching, in an unmistakable reflection of the preoccupation of
the French commentary with preachers and preaching. John plays a far
less important role, however, in the Corpus-Lambeth Apocalypse cycle,
where he appears only when required by the text, in scenes involving
instructions or commands from an angel.[38] In contrast with his role in
the Berengaudus cycles, John functions not as a mediator between the

[38]In only one isolated instance does John stand outside the frame as a spectator; in the
illustration of the first vision, John does not kneel, or fall prostrate before the Lord, but
stands outside, turning away from the vision.

reader and his visions but as an integral part of the narrative, in which he
serves as the embodiment of the ideal priest or preacher in accordance
with the gloss.

The Corpus-Lambeth cycle further reflects its commentary in tend-
ing to ignore the recapitulation of the seven churches, seals, trumpets,
and vials; for the seven churches are omitted altogether, and four of the
seven vials have been omitted from the cycle of illustrations. In com-
parison with the Berengaudus cycles, the illustrations are simpler, more
heavily compartmentalized, and emblematic. Although the deep, reso-
nant colors and burnished gold in the thirteenth-century manuscripts
provide striking optical markers throughout the text, the miniatures
are pictorially and dramatically reduced to their bare essentials. Rarely
more complex than the historiated initials in psalters, Corpus-Lambeth's
illustrations serve a similar function in momentarily riveting the read-
er's eye on a brilliant configuration of painted figures to introduce the
text. The images function to initiate reading, just as the text inspires ac-
tion, in marked contrast to the Berengaudus cycles, where the images
dominate the page and inspire the reader to pause in a more leisurely
contemplation.

Both English cycles reveal sensitive and complex responses to the com-
mentaries which would suggest that a large measure of responsibility for
the overall layout, selection of subjects, and their interpretive relationship
to the glossed text in the English Apocalypse cycles should be ascribed to
someone more appropriately characterized as the "designer of the book,"
who was most likely a theologically trained cleric rather than a draughts-
man, painter, or scribe.[39] The kind of literate, educated person who de-
signed the model layout (ordinatio) or textual pictorial programs at the
level of complexity and intellectual sophistication observed in the
thirteenth-century English Apocalypse cycles could most plausibly be
identified with the compiler of the gloss. This is most evident in the Be-
rengaudus cycles, where the various compilations of extracts have the
same pictorial programs as, for example, in the Metz group, the Paris lat.
10474–Douce pair, or Getty and Add. 35166.

The most compelling evidence that the Berengaudus cycles were created
by compilers working with a complete text is offered by the graphic por-
trayal of interpretive elements from the commentary which are not in-
cluded in the abbreviated redactions given in the various illustrated
manuscripts. This practice would tend to preclude the intervention of art-
ists and scribes in the selection of texts and iconography for the minia-

[39]As Sandra Hindman points out in "The Roles of Author and Artist in the Procedure
of Illustrating Late Medieval Texts," Text and Image, Acta 10 (1983): 34–38, by the time
an illuminator began work on a manuscript, the layout of the page; the ruling, writing,
and rubricating of the text; and the selection as well as placement, size, and format of
the miniature had already been determined.

tures. A striking case in point occurs in the illustration of the fourth Horseman. In the Metz and Morgan 524 manuscripts (see fig. 50) as well as in the Getty and Add. 35166, the Rider carries a flaming cup in an unmistakable pictorial reference to the commentary on Apocalypse 6:8, which explains that this Rider is called Death because the people of Israel fell into mortal sin, quoting from Deuteronomy 32:22: "A fire is kindled in my wrath, and shall burn even to the lowest hell."[40] None of the extant thirteenth-century English Apocalypses includes this part of the commentary in its gloss, however. Indeed, the designer of the Trinity Apocalypse attempted to adjust the pictorial model to a text that omitted the explanatory reference by representing the Horseman with an empty bowl. The only extant allusion to the exegesis appears in Morgan 524, but the inscription does not quote the commentary verbatim. Instead, the paraphrase is apparently intended to explicate the illustration rather than the text; for it refers to the "fire which the rider carries in his hand" (Per ignem quem sessor manum gestat), strongly suggesting that the reference to the Berengaudus commentary was copied from a set of written instructions compiled by the designer of the pictorial cycle, based on his familiarity with the full text.

In the thirteenth century, the art of compilation achieved an elevated status in purported value as well as in the thought and energy invested in the process.[41] With the rediscovery of Aristotelian logic came a desire to make texts available in a rearranged, condensed form, newly divided into lemmas, marked paragraphs, headings, rubrics, and in some cases, pictures. Compiling became an important industry that derived its usefulness from the layout and organization of the text and its exegetic apparatus.[42] In the case of the thirteenth-century English illustrated Apocalypse, *ordinatio* and *compilatio* were apparently merged into a single creative undertaking.

The evolution of the Corpus-Lambeth and Berengaudus cycles over more than two centuries, first in England and then in France, offers a complex history of generations of book designers meeting the changing needs of owners and readers. Although the two cycles developed from unique archetypes created in response to their distinctive glosses, variations in format and iconography can be recognized in groups of related manuscripts modeled after different prototypes descending from each archetype. The progressive selection, rejection, and modification of models not only provide paths leading back to the origins of the English

[40]*PL* 17:920. See my "*Tractatus adversus Judaeos*," 560.
[41]For a detailed discussion, see M. B. Parkes, "The Influence of the Concepts of *Ordinatio* and *Compilatio* on the Development of the Book," in *Medieval Learning and Literature: Essays Presented to Richard William Hunt*, ed. J. J. G. Alexander and M. T. Gibson (Oxford, 1976), 115–41.
[42]Ibid., 127–28.

illustrated Apocalypses, enabling us to reconstruct their archetypes, but also reveal how the book was perceived and read over three centuries.[43]

APPENDIX

Thirteenth-Century Apocalypses and Their Texts

LATIN TEXT WITH BERENGAUDUS COMMENTARY

Metz, Bibliothèque municipale MS Salis 38 (Metz)
Cambrai, Bibliothèque municipale MS.B.422
London, Lambeth Palace Library MS. 209 (Lambeth)
Oxford, Bodleian Library MS Tanner 184

Lisbon, Calouste Gulbenkian Museum MS. L.A. 139 (Gulbenkian)
London, British Library MS Add. 42555 (Abingdon)

Formerly Basel, Burckhardt-Wildt Collection
London, British Library MS Add. 22493 (fragment)

New York, Pierpont Morgan Library MS. M.524 (Morgan 524)
Oxford, Bodleian Library MS Auct. D.4.17

Malibu, J. Paul Getty Museum MS Ludwig III.1 (Getty)
London, British Library MS Add. 35166 (Add. 35166)

Paris, Bibliothèque nationale MS lat. 10474 (Paris lat. 10474)
Oxford, Bodleian Library MS Douce 180 (Douce)

FRENCH TEXT WITH BERENGAUDUS COMMENTARY

Cambridge, Trinity College MS. R.16.2 (Trinity R.16.2)

FRENCH PROSE GLOSSED TEXT

Paris, Bibliothèque nationale MS fr. 9574 (Fr. 9574)
London, Lambeth Palace Library MS. 75 (Lambeth 75)

Paris, Bibliothèque nationale MS fr. 403 (Fr. 403)

[43]For further discussions of the production and reception of illuminated Gothic Apocalypses, see my "English Gothic Illuminated Apocalypse, Lectio divina, and the Art of Memory," Word and Image 7 (1991): 1–32; "The Apocalypse of Isabella of France: Paris, B.N. MS fr. 13096," Art Bulletin 72 (1990): 224–260, and "The Enigma of Fr. 403 and the Compilation of a Thirteenth-Century English Illustrated Apocalypse," Gesta 29 (1990): 31–42.

LATIN TEXT WITHOUT COMMENTARY

Cambridge, Trinity College MS. B.10.6

FRENCH TEXT WITHOUT COMMENTARY

Windsor, Eton College MS. 177
London, Lambeth Palace Library MS. 434

LATIN TEXT WITH FRENCH METRICAL TRANSLATION

Cambridge, Fitzwilliam Museum MS McClean 123

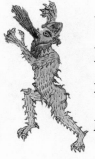

Visionary Perception and Images of the Apocalypse in the Later Middle Ages

Michael Camille

Wharfore þis book among þise oþere bokes of þe newe lawȝe is cleped prophesie for þat seint Iohan seiȝ it in gostlich siȝttes for oo. siȝth is bodilich whan he sent it. þat oþere is gostlich als it were a semblaunce whan we seen it in sleep oiþer makyng semblaunt of any þing at oþere þinges ben bitokned by. As pharao seiȝ in Egipte in slepe as it telleþ in Genesis. And Moyses seiȝ wakande a grene bussh brennande. & ne brent nouȝth as it is writen in Exodi. Þe þrid manere of siȝth is cleped intellectuel. Þat is whan þe gost aliȝtteþ þe understondyng of þe soules. & dooþ hem seen on niȝttes þe spirites & þe priuetes of god als mychel as his wille is to shewen hem. As seint poule was rauisht in to þe þrid heuene & seiþ e priuetes of god þat it falleþ noman to seien And seint Iohan seiȝ in þis manere nouȝth onlich þe figures ac he understood what it was to menen, & wroot it in an yle of þe Cee þat is cleped Pathmos.[1]

As this prologue to the fourteenth-century Middle English prose Apocalypse makes clear, John's vision must be distinguished as a third and higher mode of seeing, different both from bodily perception and from dream, or "gostliche," sight. It is a mode in which the truth of hidden things is not only witnessed but intellectually understood by the percipient. The text is based on Gilbert of Poitiers' standard biblical preface, but the status of John's vision had previously been discussed by Richard of Saint Victor in the twelfth century and by Saint Augustine.[2] It was during

[1] E. Fridner, *An English Fourteenth-Century Apocalypse Version with a Prose Commentary* (Lund, 1961), 3–4.

[2] Samuel Berger, *Les prefaces jointes aux livres de la Bible dans les manuscrits de la Vulgate* (Paris, 1902), 28. The prologue simplifies the Victorine and Augustinian scheme of fourfold ascent, in which John's visions are not of the highest intellectual, but the penultimate spiritual, type (see Augustine *De genesi ad litteram* 12.26, 53–54). For the history of the three kinds of vision debate, see J. K. P. Torell, *Théorie de la prophétie et*

the later Middle Ages, which saw the rising eschatological expectations of radical religious groups such as Lollards and Hussites but also a new, subjective emphasis on private devotion, that this visionary aspect of the Apocalypse became important for scholarly exegetes and lay readers alike as they sought to understand the nature of Saint John's experience in terms of their own spiritual lives. It is this space between apocalyptic image and audience that concerns me in this essay.

Of all the biblical books, the Apocalypse is the one predicated on the sense of sight, highest of the senses according to the new Aristotelian learning: "And I, John, am he who heard and saw these things" (Apoc. 22:8). In the fourteenth and fifteenth centuries, the ways in which people saw and heard were multiplying, in both scale and medium. In addition to illustrated manuscripts in Latin and in prose and verse vernaculars, tapestries, sculptural programs, individual statues, and later, printed books all served to convey the phantasmagoric forms of Dragons, locusts, the Woman clothed with the sun, and extraterrestrial battles to an audience whose expectations, approaching the years 1400 or 1500, were of witnessing these things for themselves. Late medieval representations of the Apocalypse either transform earlier models or evolve novel means of representing revelation in this climate of heightened popular enthusiasm. Yet studies of this material tend to discount much of it as a degeneration of iconography from the great thirteenth-century Anglo-French tradition, either into mediocre manuscript repetitions or into "popular" block-books, and only finally to be redeemed by the new beginning of Dürer's 1498 woodcut series.[3] This modernist genealogical approach has failed to understand not only how transformations of technology, such as printing, affected the reception of the Apocalypse but also how the new demands and expectations of late medieval audiences were met by the artists and illuminators who continued to illustrate it. Three aspects of the late medieval Apocalypse imagery strike me as particularly responsive to the audience's changing cultural context and interpretative framework: (1) the changing relationship of images to the text, (2) the impact of more "naturalistic" modes of representation in the fourteenth and fifteenth centuries, and (3) the pictorial focus of John as "subject" of the visionary narrative.

The three-levels-of-vision prologue with which I began appears also in the glossed French prose version. In a manuscript illustrated by the London artist of the Queen Mary Psalter, John's vision in Apocalypse 4:1 is

philosophie de la connaissance aux environs de 1230 (Louvain, 1970), and for their impact on art, Madeline Caviness, "Images of Divine Order and the Third Mode of Seeing," *Gesta* 22 (1982):99–120.

[3]General studies of Apocalypse illustration that include a discussion of later medieval works are M. R. James, *The Apocalypse in Art* (London, 1931); Don Denny and J. D. Farquhar, *The Apocalypse* (University of Maryland Department of Art exhibition catalog) (Washington, D.C., 1973); and Frederick van der Meer, *Apocalypse: Visions from the Book of Revelation in Western Art* (New York, 1978).

depicted not by having him look through a small door as into a framed pic-
ture that represents his vision (as he does in several thirteenth-century
examples) but by having him physically clamber up a ladder to the "doors
of heaven" (fig. 51).[4] This image (on fol. 5v) follows the framing scenes of
John dreaming on Patmos (fol. 2v) and then writing to the churches (3r)
and serves to represent his ascension into the state of "espirite," as the
text translates "in the spirit" (Apoc. 4:2). The text below begins "Apres
cest vist seint Johan" (after this Saint John saw), an often-repeated phrase
that suggests the priority of image over text—a feature of most manu-
scripts of the glossed French prose as well as the metrical versions. They
recall examples of the so-called first family of English thirteenth-century
Apocalypses, which were essentially picture books with captions.[5] With
their illustrations of knightly battles and conquests over the fantastic
beasts, the vernacular translations of the text have been seen as appealing
to the tastes of the "courtly" audience of romance, but it cannot always be
assumed that vernacular illustrated manuscripts were produced only for
nonclerical audiences. The few manuscripts containing evidence of own-
ership suggest a varied audience that also includes minor clergy and mo-
nastic groups, especially those of women.[6]

For this diverse group of readers, the fourteenth-century Apocalypse was
more than a "romancelike" picture book. It was still laden with allegorical
significance. The exegetic framework was still paramount in these manu-
scripts, which explains why the illustrations continue the schematic rep-
resentations of the numbers, symbols, and objects of each stage of John's
vision (the sevens, the fours, and so forth) in a format that ultimately

[4]London, British Library MS Royal 19.B.XV; see Richard Kenneth Emmerson and
Suzanne Lewis, "Census and Bibliography of Medieval Manuscripts Containing Apoca-
lypse Illustrations 800–1500," pt. 2, *Traditio* 41 (1985): 389 no. 75. The ladder in this
miniature would seem to be a particularly English touch; see R. Crabtree, "Ladders and
Lines of Connection in Anglo-Saxon Religious Art and Literature," in *Medieval Art and
Antiquities: Studies in Honour of Basil Cotte*, ed. Myra Stokes and T. L. Burton (Cam-
bridge, 1987), 43–53. See also Suzanne Lewis's essay herein, p. 265.

[5] New York, Pierpont Morgan Library MS. M.524; and Oxford, Bodleian Library MS
Auct. D.4.17; see Emmerson and Lewis, "Census and Bibliography," pt. 2, 397 no. 90,
399 no. 95; and Nigel Morgan, *Early Gothic Manuscripts*, vol. 2, *1250–1285* (London,
1988), nos. 122, 131.

[6]Cambridge, Corpus Christi College MS. 20 (Emmerson and Lewis, "Census and Bib-
liography," pt. 2, 372 no. 42), an abridged Latin Apocalypse with metrical version and
prose commentary and 106 illustrations, bears the arms (fol. 1) of Baron Cobham of Kent
(1260–1339); see Lucy Freeman Sandler, *Gothic Manuscripts, 1285–1385*, vol. 1 (Lon-
don, 1986), no. 103 ills. 262, 263. The glossed French prose Apocalypse, Oxford, New
College MS. 65 (Sandler, *Gothic Manuscripts*, no. 7; Emmerson and Lewis, "Census and
Bibliography," pt. 2, 403 no. 102) was made for Lady Johanna de Bohun (d. 1283). Cam-
bridge, Fitzwilliam Museum MS Mclean 123, containing an abridged Latin and French
metrical version and an unfinished picture cycle, was made for Nuneaton Nunnery in
Warwickshire (Emmerson and Lewis, "Census and Bibliography," pt. 2, 373 no. 45), and
London, British Library MS Royal 15.D.II (Sandler, *Gothic Manuscripts*, no. 34) may
have been made for an abbey of Cistercian nuns. Some of the most important thirteenth-
century illustrated Apocalypses were made for prominent laywomen.

depends on twelfth-century diagrammatic schemata. But whereas the Berengaudus gloss, popular in England during the previous century, had interpreted the events of the Apocalypse in terms of history—the Church's eventual triumph over Antichrist—the possibly Franciscan commentary in the French prose version has a different emphasis. It is concerned to admonish the clergy and revise the rules for individual morality, so the Apocalypse monsters represent hypocrites and *faus clers*. Saint Johan signifies *"le bon prelat,"* and his being "in the spirit" in the scene of his entry into the doors of heaven (fig. 51) is interpreted as his transcendence of "worldly things" (*temporeus choses*) and his victory over *"les vices."*[7] Copies of the prose and metrical versions are often bound with compilations of vernacular moralizing texts on the virtues and vices, which is not suprising considering how much the Franciscan gloss similarly emphasizes penance and preparation: the ascending scale of Christian life, the "trois degrez en sein Glise"—signified by the grass, plants, and trees of Apocalypse 9:4.

This more didactic and intimate exegetic tradition, focusing on the life of the individual Christian, has its impact on manuscript layout. Instead of a clear separation of image, text, and gloss, as in most thirteenth-century illustrated versions, the French prose text mingles the biblical account and its interpretation. This suggests that readers were using these manuscripts in a different way; no longer carefully referring from text, to image, to gloss, as was the case with the Trinity College Apocalypse, with its Berengaudus gloss, but using the pictures primarily as cues to moralistic interpretation, almost bypassing the text in the process. In both verse and prose Apocalypses, the traditional format of one half-page picture per page is retained, but these pictures are often very large, and the text performs a subsidiary, captionlike role beneath (fig. 51). In manuscripts of the French metrical version, the text is often abbreviated, garbled, and of far less import than the lavishly painted illustrations above it.[8] Moreover, those parts of the text that are *visually* repetitive, such as John's letters to the seven churches, are often truncated, so as to leave more room for the dynamic movement of the Four Horsemen and the six trumpets, the priority being given to the unfolding, almost cinematic images. Although the picture cycles in these manuscripts are all based on thirteenth-century prototypes, several that have as yet been little studied make unique additions or portray unusual aspects of the gloss, suggesting a thoughtful transformation rather than static copying.[9] Another fruitful area of

[7]Fridner, *English Fourteenth Century Apocalypse*, 29–30.
[8]This aspect is discussed by Brent A. Pitts in "Versions of the Apocalypse in Medieval French Verse," *Speculum* 58 (1983): 31–58.
[9]See U. C. Fox, "An Anglo-Norman Apocalypse from Shaftesbury Abbey," *Modern Language Review* 8 (1913): 36–42, for virtues and vices associated with the Apocalypse. Peter of Peckham's *Lumiere as lais* is another illustrated text paired with the glossed French prose version.

investigation would be the combination of vernacular texts and glosses on the Apocalypse with the Latin Berengaudus gloss which makes many of these manuscripts multipurpose forms of communication, offering within the same book different texts to different audience groups, from the semi-illiterate novice or lay sister (who can "read" the pictures) to the serious monastic exegete.[10]

It is, however, a measure of the success of the ninety or so scenes of the standard thirteenth-century Anglo-French Apocalypse cycle (if one can use the term *standard* before the advent of printing) that it was copied for two centuries without significant alterations, providing the models for the Angers Tapestries as late as 1373.[11] In the "translation" from book to tapestry, the images become completely autonomous from any text or commentary. What other biblical book would have been well enough known to be legible without any accompanying inscriptions? Another remarkable work that indicates that the scenes of the Apocalypse were so familiar that they could be recognized and interpreted independently is a Book of Hours dating to around 1420 in the Fitzwilliam Museum, Cambridge, from the workshop of the famous Rohan Master (fig. 52).[12] In this unique instance, 139 marginal illustrations, based on the archetypal Anglo-French series, are reduced in size so as to fit into the outer margins from folios 29v to 98v. Redeployed so as to become a pictorial "gloss" on the Hours of the Virgin, they provide evidence of the ways in which artists redefined the traditional cycle for new settings. Their placement is significant considering that the Woman of Apocalypse 12 was interpreted by Berengaudus as "the blessed Virgin Mary because she is the mother of Holy Church."[13] The theme of the *virgo in sole* had by this date been carved in wood or stone as

[10]For example, the unusual chivalric emphasis in Oxford, Lincoln College MS lat. 16 (Sandler, *Gothic Manuscripts*, no. 72; Emmerson and Lewis, "Census and Bibliography," pt. 2, 402 no. 101). Manuscripts produced in fourteenth-century France have received little attention thus far; see Patrick de Winter, "Visions of the Apocalypse in Medieval England and France," *Bulletin of the Cleveland Museum of Art* (December 1983): 396–417; and Florens Deuchler, Jeffrey M. Hoffeld, and Helmut Nickel, *The Cloisters Apocalypse* (New York, 1971).

[11]George Henderson, "The Manuscript Model of the Angers 'Apocalypse' Tapestries," *Burlington Magazine* 127 (1985): 209–18.

[12]Emmerson and Lewis, "Census and Bibliography," pt. 3, *Traditio* 42 (1986): 468 no. 168; see John Harthan, *The Book of Hours* (London, 1977), 116–7. The Apocalypse subjects and the other marginal sequences taken from Guillaume de Deguileville's *Pelerinages* are listed in M. R. James, *A Descriptive Catalogue of the Manuscripts in the Fitzwilliam Museum, Cambridge* (Cambridge, 1895), 156–74. For the relationship between marginal subjects and the Book of Hours format, see my "Illustrated Manuscripts of Guillaume de Deguileville's 'Trois Pelerinages' 1330–1420" (Ph.D. diss., University of Cambridge, 1985).

[13]See L. J. Bergamini, "From Narrative to Icon: The Virgin Mary and the Woman of the Apocalypse in Thirteenth Century Art and Literature" (Ph.D. diss., University of Connecticut, 1985); and for the late medieval autonomous images of the Woman of Apocalypse 12:1–2 in prints and statues, as well as her subsequent association with the Immaculate Conception, see Denny and Farquhar, *Apocalypse*, 16–19.

an autonomous devotional image allying Marian imagery closely with apocalyptic exegesis.

One instance of how the designer of the Cambridge Hours played on the relation between *horae* text, its standard illustration, and the marginal Apocalypse sequence occurs in the opening page of lauds (fig. 52). Adjacent to the conventional subject of the Visitation, the marginal roundel depicts heaps of naked, dying figures, victims of the third trumpet of Apocalypse 8:10. The first reader of this book, Yolande of Aragon, mother of René of Anjòu, could recall the text behind this meeting of the two women, the Magnificat's "He hath scattered the proud" (Luke 1:51), or look to the text of lauds on the next page, "the workers of iniquity shall be scattered" from Psalm 91:10 (Vulgate). Throughout the Hours of the Virgin, similar associations are made, redefining the Apocalypse narrative within the devotional structure of the *horae* experience. The Cambridge manuscript's marginal Apocalypse, like the lavish eighty-four scenes painted on bright red backgrounds for the duc de Berry in 1415, shows the continuing influence of the Berengaudus commentary in the later Middle Ages.[14] Commentaries, as much as the texts themselves, were of course capable of being read anew, and as Barbara Nolan points out, the Berengaudus gloss, in addition to its historical-prophetic function, "systematized even as it intensified the reading of Revelation as a linear narrative pertinent to the temporal lives of contemporary Christians."[15]

The increasing autonomy of the picture cycle is a parallel development to what I have termed elsewhere the "image explosion" of the later Middle Ages and what Johann Huizinga characterized so well in his overview of a society saturated with images.[16] But this notion of the superfluity and decadence of late medieval religious imagery needs questioning. Emphasis should instead be placed on the constant effort by artists to rethink and clarify earlier medieval models in the light of new spiritual trends. A product of this effort often seen as a precursor to Dürer's Apocalypse is a Flemish manuscript dating from around 1400 that devotes one full-page miniature to each of the twenty-two chapters of the Apocalypse (fig. 53). The volume is very large (19 by 25.8 cm), and on the verso opposite each picture is a compressed version of the the text in West Flemish as well as the Berengaudus gloss. Each opening forms a complete text-image unit, so there is little need for inscriptions for words to interrupt the scintillating vistas and atmospheric spaces of John's vision. It has been noted that the sequence conflates the ninety or more images of the traditional cycle, but

[14]For the illustrations in New York, Pierpont Morgan Library MS M.133 (Emmerson and Lewis, "Census and Bibliography," pt. 3, 395 no. 88), see Millard Meiss, *French Painting of the Time of Jean de Berry,* vol. 3, *The Limbourgs and Their Contemporaries* (London, 1974), 252–56 figs. 787–92.

[15]Barbara Nolan, *The Gothic Visionary Perspective* (Princeton, 1977), 9–12, 68–83.

[16]Michael Camille, *The Gothic Idol: Ideology and Image-Making in Medieval Art* (Cambridge, 1989), 197–241; Johann Huizinga, *The Waning of the Middle Ages* (London, 1924).

it is more significant that this compression of narrative into more complex single images means that events run into one another and are thus less diagrammatically depicted than had previously been the case.[17] These illustrations can function as meditative structures on their own, the reader following the narrative within each frame.

Looking once again at Apocalypse 4, where John sees the door open in heaven (fig. 53), the use of space to evoke visionary movement is in marked contrast to earlier Gothic versions of the scene (fig. 51). Also, if we compare this sequence in the Flemish manuscript with the first block-book Apocalypse, produced in Haarlem in the shop of John or Lawrence Coster only twenty years later, we see how a very similar compositional model has been used to strikingly different effect (fig. 54). It is not just that the medium of the block-book enforces radical linear simplicity upon the image, but also that this creates a much more viable field in which pieces of the text can function once again. Those who bought the block-book Apocalypse did not require a copy of the full text, only cues to trigger their memory. The stark directness of black on white, the lack of any hatching to create light and shade effects, and the fragments of text on scrolls and labels give a monumental simplicity to the vision that perhaps functioned as a neutral space for further meditation and projection.

The Haarlem Apocalypse ranks as the very first printed book that suggests the power of the Apocalypse text in the history of the technology of reproduction. Just as cultural historians could argue that evolution of a new medium like cinema is in some measure a response to the needs and expectations of an audience consuming the seamless naturalism of late nineteenth-century capitalist fictions, the earliest block-book Apocalypse answers an increased demand by people to own their own eschatological exegetic images (in opposition to the cathedral Last Judgments) modeled on the products of manuscript culture but reproducible in larger quantities. Subsequent editions filled in every available space with captions including parts of the Berengaudus gloss, even to the extent of labeling the obvious Evangelist symbols of Apocalypse 5:6 (fig. 55). The six fifteenth-century editions are often described as "popularizations" of the earlier visual tradition. Yet the very same iconography occurs in contemporary manuscript spiritual encyclopedias aimed at Latin literates, a fact that should make us question the all-too-easy association of the printed with the popular.[18] The Apocalypse block-books produced in the Netherlands

[17]Paris, Bibliothèque nationale MS Neerl. 3. The miniatures are fully described by Mariette Hontoy in "Les miniatures de l'Apocalypse flamande à Paris," *Scriptorium* 1 (1946–47), and are beautifully reproduced in their entirety in van der Meer, *Apocalypse*, 202–35.

[18]The relationships between the block-books and fifteenth-century manuscripts in the Wellcome Library, London, and the Pierpont Morgan Library, New York, are discussed by Gertrud Bing in "The Apocalypse Block-Books and Their Manuscript Models," *Journal of the Warburg and Courtauld Institutes* 5 (1954): 143–58.

and Germany in the 1470s have also been linked to the educational aims of groups like the the the Brethren of the Common Life, whose interests included wider lay literacy and teaching.[19] Their clearly labeled objects indeed make perfect teaching tools for the basics of Latin numeracy and vocabulary.

The predominance of image over text almost breaks down in the block-book Apocalypses as they are crammed with labels and Latin texts in a diagrammatic way, didactic intentions overruling any aesthetic requirements (fig. 55). Although similar in format to the earliest Anglo-French picture-book Apocalypses in combining words and pictures within the frame, the block-books address very different concerns. One important difference was a result of the xylographic printing process itself. Because the surface had to be damp to receive the ink, the blocks could only be printed on one side of the paper, making the block-books even more like autonomous single prints, not part of a continuous process of reading. Also, the number of scenes is reduced to forty-eight (nearly half the length of the Anglo-French cycle), partly because of the expense of producing each block. Theologically cruder and less attractive than their manuscript ancestors, these images nevertheless resonate with the political and spiritual movements of the late fifteenth century. Their dynamic representations of Antichrist and his hordes could, because of the possibility of multiple copies and editions, spread much further and be used to stimulate the imagination of orthodox believer and radical reformer alike.

Dürer's 1498 woodcut series is innovative in the very means of its production. Never before had a book and its illustrations been designed and published by the artist himself. It is this stamp of authorial presence that made these prints valuable and sought after by collectors not long after their publication but also today cut out from their context.[20] Dürer rejected the careful alignment of text and pictures basic to both the Anglo-French tradition and its offshoots like the Flemish full-page version (fig. 53). Instead, he prints the entire Apocalypse text, continuously on the versos of the woodcuts, so that the back of the final scene is blank. As Erwin Panofsky noted, this means he must *not* have wanted the reader to compare specific scenes in the woodcuts with passages in the text, as did most earlier Apocalypse cycles, but "to absorb the whole text and the whole sequence of pictures as two self-contained and continuous

[19]Denny and Farquahar suggested this in *Apocalypse,* 39–40. There is no evidence for the printers of block-books, but for a chronology, see Theodor Musper, "Die Datierung und Lokalisierung der ältesten gedruckten Bücher und Laurens Janzoon Coster," *Die graphische Kunste* 3 (1938): 51; and Arthur M. Hind, *An Introduction to a History of Woodcut,* vol. 1 (New York, 1963), 218–23.
[20]Peter W. Parshall's "The Print Collection of Ferdinand Archduke of Tyrol," *Jahrbuch der Kunsthistorischen Sammlungen in Wien* 42 (1982): 139–84, traces the beginnings of the idea of collecting an artist's oeuvre rather than prints classified according to subject matter.

versions of the same narrative."[21] The vast size of the each page in folio (30 by 32.8 cm) adds to the striking effect of a set of spectacular but discrete visual experiences.

Panofsky also demonstrated the ways in which Dürer omitted certain repetitions and inconsistencies in the narrative, an instance of artistic license taking perogative over the flow of events which is unthinkable in the earlier tradition. Moreover, he noted that Dürer's pictorial language, with its muscular naturalism and richness, totally transformed his earlier models so that "every increase in verisimilitude and animation strengthens rather than weakens the visionary effect."[22]

This observation brings us to the issue of naturalism in the late medieval representation of John's vision, how it is the construction of the fictional space, not the format, which controls the viewer's reception of the narrative. There are few manuscript cycles of the fourteenth century that depart in any major way from the traditions established in the previous century, until the fourteen full-page images of the Flemish manuscript (fig. 53). Here, the diagrammatic and numerical conformity, which had been both successful for and a hindrance to the Anglo-French cycle, is done away with and the pictorial possibilities of space and light are called into play. Another important device makes this an altogether different visual experience from the half-page format of the Anglo-French Apocalypses, where the figures are kept at the same size and height, their feet firmly planted on a groundline. This device is the taller rectangular space in which figures vary in scale and viewpoint with each scene, responding to the temporal trajectory of the narrative, slowing down and then gaining in intensity. For example, after the ninth illustration with its many tiny figures representing the crammed events of Apocalypse 9 (the fifth and sixth trumpets, the locusts, and the fire-breathing leopard-horses), in the tenth scene, depicting the angel with the face like the sun giving the book to John, the artist "zooms in" on the two figures, making them more

[21]Erwin Panofsky, *The Life and Art of Albrecht Dürer* (Princeton, 1945), 52. Dürer published the fifteen large cuts of the Apocalypse including a prefatory scene of the martyrdom of Saint John simultaneously in both Latin and German editions in Nürnberg in 1498, using Koberger's two-column type. The title, *Die heimlich offenbarug iohanis*, and *Apocalypsis cum figuris* appear on a separate sixteenth block together with a cut of Saint John and the Virgin and Child in the second Latin edition of 1511. It is almost impossible to get a sense of the way the text interacted with the pictures because of the way the woodcuts have been separated off as "art" today. Kenneth A. Strand, *Dürer's Apocalypse: The 1498 German and 1511 Latin Texts in Facsimile* (Ann Arbor, 1969) does not reproduce the pictures in relation to the text, but for some idea of this, see Alexander Perrig, *Albrecht Dürer oder Die Heimlichkeit der deutschen Ketzerei* (Weinheim, 1987), fig. 2.

[22]Ibid., 55–60. For more discussion of the way woodcuts recast medieval narrative modes, see Michael Camille, "Reading the Printed Image: Illuminations and Woodcuts of the *Pelerinage de la vie humaine* in the Fifteenth Century," in *Printing the Written Word: The Social History of Books circa 1450–1520*, ed. Sandra Hindman (Ithaca, N.Y., 1991).

than half the size of the frame.[23] The same change in viewpoint and scale occurs in the last scene of the river of life and John rebuked by the angel (Apoc. 22:9), where the events once again are calmed. The second picture compresses all the events of Chapter 4 again into a larger-scale affair with John being taken up "in the spirit" on the lower left. Because the text describes how "the throne was set in heaven," it is literally put in place by a great angel. The twenty-four Elders around the throne are subtly painted in white highlights, and apart from their shimmering gold crowns, they merge with the blue background like figures painted on cloth. The whole manuscript is full of such illusionistic effects. The artist was still responsive to the hierarchy of vision, however, and thus Christ appears in a mandorla, as he does in the compartmentalized Anglo-French manuscripts of a hundered years earlier.

Dürer was thus not the first artist to use lighting effects to convey the thunders and lightnings and other apocalyptic conflagrations; for this series has some of the most atmospheric renderings of the rain of fire and hailstones of Apocalypse 8. This interest in climatic effects and landscape recalls the ways in which some exegetes, especially those influenced by Aristotelian natural science, were trying to explain the tumultuous events of the Apocalypse in terms of nature. It is as if Dürer is able to combine the new pictorial idiom of naturalism, seen clearly in the tranquil landscape below, with the theological nominalism of experiential observation that was current in the late fifteenth century. The thunders breaking under the throne and spreading over the trees and hills are the natural phenomena whereby Dürer domesticates the Apocalypse.

Wall paintings and altarpieces tend to retain the compartmentalized and abstract forms of the thirteenth century because they have to carry the pictorial message to viewers a long distance away. It is in manuscripts and later printed books, objects to be perused at close quarters and lovingly pored over by flickering candles, that we see the most spectacular pictorial experiments with the space of the apocalyptic vision.[24] The block-book version would seem to many to be the "crudest" in terms of style, but in fact its presentation of visionary spaces is highly sophisticated, using angles and edges, blocks of form, and outlines to suggest different realms of reality. The "Come up hither" scene of the Haarlem block-book page (fig. 54), unlike the Flemish manuscript (fig. 53), contains no shading and therefore cannot indicate the steps up to the vision or the

[23]Paris, Bibliothèque nationale MS Neerl. 3, fol. 11, reproduced in van der Meer, *Apocalypse*, 218.
[24]Monumental examples, much less studied than their manuscript counterparts and not always directly dependent on them, include a Neapolitan panel in Stuttgart, dating from ca. 1330 and discussed in van der Meer, *Apocalypse*, 194–97; a German Apocalypse altarpiece in the Victoria and Albert Museum based on the Alexander Minorita commentary, for which see C. M. Kauffmann, *An Altarpiece of the Apocalypse from Master Bertram's Workshop in Hamburg* (London, 1968); and the almost totally unpublished fifteenth-century wall paintings in the chapter house at Westminster Abbey.

Elders swirling around the throne. Instead, each pictorial component has its separate compartment divided by a thin line. Likewise the seven lamps do not hang in front of the space illusionistically but have to be separated, four on one side and three on the other, in order to lay everything relevant out within the picture-field. The fact that the angel turns outward to face the viewer—whereas in the Flemish painting he turns inward, inviting us to look there too—is a measure of the difference between the intimate interiority of the manuscript and the didactic clarity of the block-book versions. The lamps in Dürer's version of this scene (fig. 56) are subtly situated so as to curve, the outermost, central one projecting into our space. The angel does not physically present the vision but gestures to it as to a dramatic spectacle taking place behind a proscenium arch. Indeed, the whole upper part of the print is arranged as a dynamic moment of a continuous action, the heavy wooden doors having been thrust open on their hinges. Such minute attention to mechanical and functional detail, such as the hinged, reversible backs of the Elders' seats, serves to implicate the viewer in the image.

It is not that Dürer's naturalistic, Italian-influenced style produces *better* images of the Apocalypse. Indeed, one could argue that the rise of perspective and other naturalistic tricks in the fifteenth century actually created problems in religious imagery by submitting Christ to the sublunary situation of being protrayed foreshortened or with his back turned. In the earlier cycles, right up through the woodcuts in the Quentell-Koberger Bible (fig. 17) published in Cologne in 1478–79 and then in Nürnberg in 1483 (which had some influence on Dürer's series), the figure of God upon the throne is the biggest in the composition,[25] reflecting a thousand years of hieratic ordering of the divine in the pictorial space. In Dürer's print, in contrast, God is far back on his throne and it is John, at the very center of the image, who is the most imposing and important figure.

Each of the apocalyptic visions has a viewpoint, observing the conflagrations in heaven as though recording meteorological data in a treatise on natural science. In this respect, it is significant that Dürer himself experienced visionary dreams of apocalyptic tumults and storms, which he recorded on paper in 1528.[26] Although one senses the importance of direct observation in these woodcuts, it is significant that the visionary observer is not always present. In discussing the figure of John in Dürer's work, Panofsky suggested that what he defined as his new naturalistic style also allowed the artist to dispense with the traditional repetition of the figure in each scene. This was because medieval images in "their non-

[25] For the Quentell-Koberger Bible's influence on Dürer, see Panofsky, *Life and Art of Albrecht Dürer*, 53 and fig. 74.

[26] For the drawing, now in the Kunsthistorisches Museum, Vienna, see Fedja Anzelewsky, *Dürer: His Art and Life* (Fribourg, 1980), fig. 239; and for celestial phenomena like comets recorded in paint as portents by the young Dürer, see J. M. Massing, "Dürer's Dreams," *Journal of the Warburg and Courtauld Institutes* 49 (1986): 237–44.

naturalistic style, not even admitting of a clear distinction between a miracle and a natural event, could hardly distinguish a vision from a miracle, without including the visionary."[27] It is misleading to suggest in this way that medieval illustrators of the Apocalypse were unable to distinguish natural events from visionary ones. Indeed it was absolutely crucial that this distinction be made, as is especially clear in thirteenth-century Anglo-French illustrations, where artists often used the figure of John at the left of each scene, peering into, looking through a hole at, or otherwise catching glimpses of his *visio*. This form was chosen not because these illustrators were unable to suggest the status of the vision without including its percipient but because visionary perception, by its very definition, issued from the intellect of a visionary. The same is true of the fourteenth-century prose and verse illustrations (fig. 51), where ingenious means of incorporating the seer into the scene are devised, all in order to make it clear that the pictures represent John's "spiritual" observations. John is present as the percipient—as witness, not author, of these events. His authority is vested not so much in his having written down what he saw as in his having seen it. The image must ratify this ocular and oral witness from the very beginning of the history of Apocalypse illustration.

In the later Middle Ages, the figure of the percipient is just as important in pictorial cycles, in contexts such as the Angers Tapestries, the Cambridge Hours (fig. 52), and even the radical rethinking of the Flemish Apocalypse in Paris (fig. 53), where John is always present. The increasing importance of the authorial voice in later medieval writing, especially as framed in prologues and Scholastic methods of division, has been studied by Alistair Minnis in relation to literary production. Looking at the development of the commentaries suggests a similar pattern. In the Berengaudus gloss, as Nolan says, "John is a minor figure in the narrative, the transparent instrument through whom the vision is presented."[28] In the commentary of the French prose version, John's role as the focus of visionary consciousness is more crucial to the unfolding moralizations. The block-books continue to stress the figure of John at the left of each scene, sometimes showing him in the pose of the "dreamer," which was such an important paradigm for poetic dream visions in this period (fig. 55). At a time when exactly what constituted a vision of the divine was being debated in Scholastic circles, ratified by papal decrees, and encountered by mystics like John Ruusbroec, John's ascent into the spirit became an aspiration for many. The ideal of ascending beyond the visual, itself a rare idea in the mystical tradition, was practically impossible for most people

[27]Panofsky, *Life and Art of Albrecht Dürer*, 58.

[28]Nolan, *Gothic Visionary Perspective*, 12; and for the general interest in authorship in this period, see Alistair J. Minnis, *Medieval Theory of Authorship: Scholastic and Literary Attitudes in the Later Middle Ages* (London, 1984).

whose devotional frameworks were constructed through images.[29] In this respect, the Apocalypse provided a model for seeing and interpreting vision which was to have a profound impact on a whole range of devotional images, altarpieces, statues, and narratives.

A good example of Saint John as percipient of the apocalyptic vision is the right wing of Hans Memling's large altarpiece of the mystic marriage of Saint Catherine painted in 1479 and now in Bruges (fig. 57). John's vision is directly associated with the mystical union portrayed in the center of the altarpiece. The large size of the saint, shown seated on Patmos and gazing off into space beyond, rather than at the subjects from the Apocalypse depicted in minute detail above, makes him the devotional focus of viewing. The nonfocused gaze of the saint and the empty pages of the book before him suggest that the visionary experience is in midflow. Memling attempts to suggest movement too in the Horsemen, the Woman with the Dragon, and the great angel, all depicted in the distance. The pictorial language of the Flemish *ars nova*, in its crystalline luminosity and infinitesimal depth, focuses not so much on the Apocalypse as a series of events but on John as their witness. The problem with this image is its effacement of the sequential and temporal nature of the Apocalypse, which is difficult to convey in one field without recourse to miniaturization. It is a difficulty Dürer did not face when, not long afterward, he started work on his series of woodcuts dramatizing the same subject.

Although in some scenes Dürer does omit the percipient from the picture, in the first two Apocalypse scenes Saint John *is* present. In the first, he kneels prominently in the foreground facing the Son of Man and the vision of the candlesticks. In the next, he is further away, as if moving closer to divinity, and "in the spirit" witnesses the doors open in heaven, his back-turned figure looking not across at but into the space of vision (fig. 56). Dürer follows the text, so only where John is actually mentioned as a respondent or actor in the narrative does Dürer include his figure. For medieval visualizers, the Apocalypse had been not so much a text but a series of experiences, all of which were witnessed, felt, and understood by the saint, and all of which thus include his perception of them. Most significant is that fact, that for Dürer and his audience, the biblical text and its visualization was enough, and no exegetic framework interrupts the tenacity of the "felt" experience. This textual veracity alone with the denial of the interpretative framework that had been fundamental to all previous independent Apocalypse cycles presages the Reformation's focus on scriptural veracity rather than interpretative strategies.[30] In Dürer's time, es-

[29]For the problem of "imageless devotion," see the discussion by Jeffrey Hamburger in "The Visual and the Visionary: The Image in Late Medieval Monastic Devotions," *Viator* 20 (1989): 161–82.

[30]For Luther's less-than-enthusiastic reception of the Apocalypse, see Jaroslav Pelikan, "Some Uses of the Apocalypse in the Magisterial Reformers," in *The Apocalypse in English Renaissance Thought and Literature*, ed. C. A. Patrides and Joseph Wittreich (Manchester, 1984), 75.

pecially nearing the year 1500, the Apocalypse had to be seen as prophetic. With no gloss or commentary to come between its visionary events and the reader, its images were open to wider interpretation than ever before.

The "new" vision of Dürer's *Apocalypsis cum figuris* is his omission of John from many of the woodcuts. In the famous third scene of the Four Riders, the artist elides our vision—that is, the subjective viewers' vision—with John's, so that *we* become the percipients of the visionary experience, unframed, unmediated by an internal spectator. Medieval artists, always aware of the secondary nature of a picture as a simulacrum—a representation of some other thing—did not seek to suggest that the visions they painted be identical to ours. That would be to make them corporeal fictions, fleeting or "gostliche" dreams, to use Gilbert of Poitiers' definition. Dürer, fashioning himself in the new role of artist "genius" could, for the first time in the history of art, pick up on the ambiguities of John's visions. By excluding their authoritative witness, Dürer typically locates *himself*, or rather his representations, at the site of revelation. Notice that the only words in the image are the letters of the monogram spelling out his name, the identity and authorship of the work. Dürer the visionary looks forward to a time when the artist rather than the mystic would be the mediator of a "higher" form of perception.

PART THREE

The Apocalypse in
Medieval Culture

13

Introduction:
The Apocalypse in
Medieval Culture

RICHARD K. EMMERSON

In the preface to his remarkable book *A Rebirth of Images*, Austin Farrer reflects on his "wrestling with the Apocalypse" and suggests why this enigmatic final book of the Scripture so captured the imagination of the Middle Ages: "It is the one great poem which the first Christian age produced, it is a single and living unity from end to end, and it contains a whole world of spiritual imagery to be entered into and possessed."[1] The Apocalypse, "The Revelation of Jesus Christ" (Apoc. 1:1), was considered by some exegetes to be the only biblical book authored by Christ, although one Scholastic commentator identified God as "the principal and primary efficient cause; Christ, the secondary; the angel, the mediate; and John, the immediate."[2] Its "immediate" human author, John, was accorded the highest status in medieval thought; for he was "our Lord's most intimate associate."[3] The imaginative power of its visual imagery, the poetic beauty of its heavenly liturgy, and its memorable symbolic representation of the cosmic battle between good and evil not only fascinated medieval artists, as we have seen in Part II of this volume, but also a wide range of poets, historians, homilists, and theologians. In fact, as the culmination of the Christian canon, the Apocalypse was considered the "flower of theology."[4]

[1] Austin Farrer, *A Rebirth of Images: The Making of St. John's Apocalypse* (1949; reprint, Albany, N.Y., 1986), 6.

[2] John Russel *Commentary of the Apocalypse*, Oxford, Merton College MS. 172, fol. 52ʳ; in Alastair J. Minnis, *Medieval Theory of Authorship: Scholastic Literary Attitudes in the Later Middle Ages*, 2d ed. (Philadelphia, 1988), 81. See also Anthony Luttrell, "Federigo da Venezia's Commentary on the Apocalypse, 1393/94," *Journal of the Walters Art Gallery* 27–28 (1964–65): 58.

[3] Gregory of Tours *Historia francorum* 10.13, trans. Lewis Thorpe, *The History of the Franks* (New York, 1974), 562.

[4] See Eustache Deschamps, Balade 186, line 28, in *Ouvres complètes de Eustache Deschamps*, ed. Le Marquis de Queux de Saint-Hilaire, vol. 2 (Paris, 1880), 3. See also

Scholarship has not fully appreciated the full extent of the influence of the Apocalypse on medieval culture, perhaps because to a large extent this influence is so pervasive that it has been easier for scholars to narrow their focus to examine more striking apocalyptic mentalities and Joachist expectations. Not only has the literary history of the Apocalypse in the English Middle Ages not been written, as Penn Szittya notes in his essay, but the history of its influence on other medieval literatures is only now being investigated. Even more surprising, given the essentially liturgical nature of the Apocalypse, its complex place in Christian worship is little studied. Largely because modern historians have dismissed apocalyptic structures as antihistorical, scholarship has even avoided examining in depth allusions to the Apocalypse in medieval historiography. The essays in Part III therefore differ from those in the first two parts, which study specific expositions and illustrations of the Apocalypse in areas that *have* been explored by scholars for some time and which follow the well charted approaches of historical exegesis and iconography. Beginning to trace the influence of the Apocalypse in a wide range of medieval didactic, liturgical, historical, and literary works, the Part III essays are more suggestive and evocative than definitive.

To a certain extent, grouping these essays together is dictated more by organizational than methodological considerations. The umbrella term "medieval culture" is intended not to invoke *Geistesgeschichte* or some other reductionist approach but instead to serve as a handy rubric that is deliberately open-ended. It allows for a wide-ranging analysis restricted neither by disciplinary categories nor by such artificial distinctions as religious/secular or elite/popular. What ties these essays together is a recognition that the Apocalypse is ubiquitous, all pervasive like the innumerable eyes on Chaucer's cosmic goddess Fame:

> And therto eke, as to my wit,
> I saugh a gretter wonder yit,
> Upon her eyen to beholde;
> But certeyn y hem never tolde,
> For as feele eyen hadde she
> As fetheres upon foules be,
> Or weren on the bestes foure
> That Goddis trone gunne honoure,
> As John writ in th'Apocalips.[5]

Ælfric's discussion of the Apocalypse in *The Old English Version of the Heptateuch: Ælfric's Treatise on the Old and New Testament and His Preface to Genesis* (ed. S. J. Crawford, EETS 160:61).

[5]Chaucer *The House of Fame* 1372–85, in *The Riverside Chaucer*, ed. Larry D. Benson, 3d ed. (Boston, 1987). All citations of Chaucer are to this edition. See also Robert Boenig, "Chaucer's *House of Fame*, the Apocalypse, and Bede," *American Benedictine Review* 36 (1985): 263–77.

And, as is evident in the above allusion to the Four Living Creatures (Apoc. 4:6), Apocalypse imagery is limited neither to religious texts nor even to Christian settings. It resonates throughout a surprising number of "secular" texts, even ones like the *House of Fame*, which invokes "the god of slep" (69) when recounting its visionary experience.

When these echoes are investigated, they often suggest an underlying pattern, so that although Chaucer explicitly cites Morpheus to ensure that he accurately relates his vision, he implicitly recalls a higher divinity and thus perhaps another visionary mode: "he that mover ys of al, / That is and was and ever shal" (81–82). When we realize that these are the very words of praise with which the Four Living Creatures laud the Lord God Almighty (Apoc. 4:8), that this dream vision describes a heavenly temple, and that Chaucer's inspired guide is an Eagle, the traditional symbol of John, then the poem's apocalyptic resonances take on fuller significance. The essays that follow begin to investigate such significance in a variety of medieval texts and contexts. Their authors recognize that neither the Apocalypse nor any other element of medieval culture "can be understood in isolation," to borrow E. H. Gombrich's words, and instead they attempt to "transcend the particular, suggesting to other students of culture fresh ideas about the innumerable ways various aspects of a civilization can interact."[6]

APOCALYPSE AS LITERARY GENRE

One reason why the immense influence of the Apocalypse on medieval culture has not been fully appreciated is that modern scholarship has primarily sought to discover an "apocalypse" genre or form in medieval literature.[7] It is true that many visionary works based on early Christian

[6]E. H. Gombrich, *In Search of Cultural History* (Oxford, 1969), 41, 44. For a recent study tracing apocalyptic resonances in a variety of medieval texts, from Joachim of Fiore to Chaucer, see Richard K. Emmerson and Ronald B. Herzman, *The Apocalyptic Imagination in Medieval Literature* (Philadelphia, 1992).

[7]The best-known of such attempts is Morton Bloomfield's *Piers Plowman as a Fourteenth-Century Apocalypse* (New Brunswick, N.J., 1962), 9–10, which, although recognizing that "it is doubtful whether such a literary form existed," termed *Piers Plowman*, "in a basic sense," an apocalypse. A more recent, although no more successful, attempt to distinguish a medieval apocalypse genre is Kathryn Kerby-Fulton's *Reformist Apocalypticism and Piers Plowman* (Cambridge, 1990), which defines apocalypse "as *the* mode of fully developed visionary narrative within the religious tradition" (96) but which cites no examples beyond the early Christian *Shepherd of Hermas*, a work whose form is the subject of much scholarly dispute. For other discussions of apocalypse as a genre or a mode, see Valerie M. Lagorio, "The Apocalyptic Mode in the Vulgate Cycle of Arthurian Romances,"*Philological Quarterly* 57 (1978): 1–22, which stretches apocalypse categories to identify Mordred as Antichrist and argue that "the Arthurian Millennium coincides with the appearance and final disappearance of the Holy Grail, a messianic interregnum lasting 400 years and ending with the deaths of Galahad and Arthur" (14, 8); Y. Le Hir, "L'element biblique dans *La quête del Saint Graal*," in *Lumiere du Graal*, ed. Rene Nelli (Paris, 1951), 108; and Eithne M. O'Sharkey, "The

models, such as the *Visio Pauli*, were well known and popular in the Middle Ages. This highly imaginative work, which purports to elaborate on that which Paul stated "man may not repeat" (2 Cor. 12:4), includes cosmic dialogue, otherwordly journeys, and descriptions of hell and heaven. As Theodore Silverstein has noted, it is "a complete Baedecker of the other world."[8] Although the *Visio Pauli* does borrow from the Apocalypse, it represents only isolated features of the generic elements that scholars associate with formal apocalypses. It and other medieval works involving supernatural tours, such as the *Navagatio Brendani*, *Visio Tnugdali*, and *Visio Thurkilli*, the visions recorded in Gregory's *Dialogues* and Bede's *Ecclesiastical History*, various accounts of visits to Saint Patrick's purgatory, and several Old French visionary narratives, are better understood as comprising a distinctly medieval literary type, the otherwordly journey.[9] Interestingly, as a group they draw little from the Apocalypse of John and are remarkably nonapocalyptic in that, as Aron Gurevich notes, they seem unconcerned with the movement of history or the future advent of Christ in judgment: "Visionaries wander through the Other World while remaining in earthly time, in the current moment. Retribution awaits a man not sometime in the future, but right now."[10]

More obviously dependent on John's vision and sometimes cited as evidence that an apocalypse genre was known in the Middle Ages is the so-called *Apocalypsis Goliae*.[11] A twelfth-century Latin poem formerly at-

Influence of the Teachings of Joachim of Fiore on Some Thirteenth Century French Grail Romances," *Trivium* 2 (1967): 54–55. Even less successful is Michael D. Cherniss's attempt to delineate a medieval apocalypse genre based on Boethius's *Consolation of Philosophy* in such works as John Gower's *Confessio amantis* and Chaucer's *Book of the Duchess*; see Cherniss, *Boethian Apocalypse: Studies in Middle English Vision Poetry* (Norman, Okla., 1987); and for a critique, my review in *Studies in the Age of Chaucer* 10 (1988): 134–37.

[8]Theodore Silverstein, *Visio Sancti Pauli: The History of the Apocalypse in Latin together with Nine Texts* (London, 1935), 5. For the early Christian Apocalypse of Paul, see Edgar Hennecke, *New Testament Apocrypha*, ed. Wilhelm Schneemelcher and trans. R. McL. Wilson, vol. 2 (1965; reprint, Philadelphia, 1976), 755–98.

[9]See D. D. R. Owen, *The Vision of Hell: Infernal Journeys in Medieval French Literature* (Edinburgh, 1970); Peter Dinzelbacher, *Vision und Visionsliteratur im Mittelalter* (Stuttgart, 1981); Martha Himmelfarb, *Tours of Hell: An Apocalyptic Form in Jewish and Christian Literature* (Philadelphia, 1983); and Henricus Fros, "Visionum Medii Aevi Latini Repertorium," in *The Use and Abuse of Eschatology in the Middle Ages*, ed. Werner Verbeke, Daniel Verhelst, and Andries Welkenhuysen (Leuven, 1988), 481–98. For more popular studies, see Carolly Erickson, *The Medieval Vision: Essays in History and Perception* (New York, 1976); and Carol Zaleski, *Otherworld Journeys: Accounts of Near-Death Experience in Medieval and Modern Times* (Oxford, 1987). For translations, see Eileen Gardiner, ed., *Visions of Heaven and Hell before Dante* (New York, 1989).

[10]Aron Gurevich, *Medieval Popular Culture: Problems of Belief and Perception*, trans. Janos M. Bak and Paul A. Hollingsworth (Cambridge, 1988), 136. See Gurevich's rich chapter, "The *Divine Comedy* before Dante," 104–52.

[11]Karl Strecker, ed., *Die Apokalypse des Golias* (Rome, 1928); trans. F. X. Newman, *The Literature of Medieval England*, ed. D. W. Robertson, Jr. (New York, 1970), 253–61. See also F. X. Newman, "The Structure of Vision in 'Apocalypsis Goliae,'" *Mediaeval Studies* 29 (1967): 113–23.

tributed to Walter Map, it grimly satirizes a host of ecclesiastical abuses under the guise of witnessing "que Johannes viderat" (what John saw). Thus, after an angel commands Golias to look up (lines 55–56), at once he is "in spiritu" (58; cf. Apoc. 1:10) and sees flashes of lightning resembling those witnessed by John in his vision of heaven (Apoc. 4:5). He also sees a man holding seven candlesticks and seven stars (73–75; cf. Apoc. 1:13, 16) and a book with seven seals (81–84; Apoc. 5:1). The breaking of the first seal reveals the Four Living Creatures of Apocalypse 4:6—the Lion, Ox, Eagle, and Winged Man—who are identified not as the four evangelists but as members of the Church hierarchy: pope, bishop, archdeacon, and dean (89–144). As the visionary watches, another five seals are broken to reveal the corruption of these and other ecclesiastics (149–332). The opening of the seventh seal, introduced by a spectacular shout that shakes the heavens (337; cf. Apoc. 8:5), introduces the savage condemnation of an abbot and fellow depraved monastics (341–408), the culmination of the poet's anticlericalism in which his "bitterness exceeds all bounds."[12] It was for this satire on the monastics and their "magister stomachus" (master stomach, 384) that the poem was known in the later Middle Ages. In the famous banquet scene of *Piers Plowman*, for example, Patience comments that the gluttonous Master of Divinity, "now he hath dronken so depe he wole devyne soone / And preven it by hir Pocalips. . . ."[13] The reference is probably to *Golias*, which would serve as a "gula regula" (gluttony rule; *Golias*, 392) for the obese, hypocritical friar.

Does this reference to a "Pocalips" suggest a literary type, though? The issue is complicated, for although *Golias* does not claim to be an apocalypse, some late medieval manuscripts refer to it as *apocalipsis*.[14] Such a title may recognize it simply as a parody of the canonical Apocalypse, and, of course, a parody of a literary work does not constitute its form. *Golias* is essentially a satire that inverts many of the images and events recorded by John to suggest how the "septem ecclesiis, que sunt in Anglia" (the seven churches in England) (68) differ radically from the seven churches in Asia (Apoc. 2–3). Its framework, moreover, is classical rather than biblical. At the beginning, the visionary reclines under Jove's tree and at first sees Pythagoras, "God knows, not I, whether in the body" (8; cf. 2 Cor. 12:2), and his vision ends as he falls from heaven like Cato (433). *Golias* includes elaborate descriptions of the seven liberal arts (13–20) and a catalog of classical authorities (37–52), with a language that draws on the discourse of academic wit rather than of visionary judgment. Rather than castigating specific contemporaries, comparing them with the hellish images of

[12] F. J. E. Raby, *A History of Secular Latin Poetry*, 2d ed., vol. 2 (Oxford, 1957), 218.

[13] William Langland, *The Vision of Piers Plowman: A Complete Edition of the B-Text*, 13.89–90, ed. A. V. C. Schmidt (London, 1978). All references to *Piers Plowman* are to this edition and are cited by passus and line number. On the reference to the "Pocalips," see my " 'Coveitise to Konne,' ' Goddes Privetee,' and Will's Ambiguous Visionary Experience in *Piers Plowman*," in *Suche Werkis to Werche: Essays on Piers Plowman in Honor of David C. Fowler*, ed. Míčeál F. Vaughan (East Lansing, Mich., 1992).

[14] Strecker, *Golias*, 7.

the Apocalypse, and threatening damnation at doomsday, *Golias* concentrates on timeless ecclesiastical satiric types and uses etymological explanations (265–68) and repeated word play to unmask their true nature: "Quisque de monacho fit demoniacus" (Any monk whatsoever can become demonic) (381). Finally, its self-deprecatory tone—the visionary is distracted from his revelation by a stomach pang—differs diametrically from the life-and-death seriousness that characterizes apocalypses. *Golias* alludes to the Apocalypse, but it is not an apocalypse in form.

Closer in spirit to an apocalypse is Hildegard of Bingen's *Scivias* (1141–58), one of the most extraordinary works of medieval literature. Its highly esoteric and composite images, although stimulated by the symbolism of the Apocalypse and other biblical and religious works, are remarkably original. Hildegard's portrayal of Antichrist arising from within the Church, rather than from the margins of medieval society (typically from the Jews or Babylon), reflects her visionary originality.[15] The state of *ecclesia* is vividly symbolized through a radical conflation of the heavenly Woman of Apocalypse 12 and the Whore of Apocalypse 17. Thus the virtuous Woman so strikingly featured in Hildegard's previous visions now appears as a grotesque: "The image of the woman before the altar in front of the eyes of God that I saw earlier was now also shown to me again so that I could also see her from the navel down. From the navel to the groin she had various scaly spots. In her vagina there appeared a monstrous and totally black head with fiery eyes, ears like the ears of a donkey, nostrils and mouth like those of a lion, gnashing with vast open mouth and sharpening its horrible iron teeth in a horrid manner."[16] Usually, though, Hildegard's visions distinguish symbols of good from evil, the dualistic imagery being resistant to conflation, denying the possibility of middle ground, and repeatedly condemning moral lukewarmness, which causes Christians to forget about heaven (2.7.5).

Hildegard is a particularly important visionary because she claims, without hesitation, to be a prophet illumined directly by God. In the "Protestificatio" to the *Scivias*, she relates how in her forty-third year she saw "a very great brightness from which a voice from Heaven spoke" (cf. Apoc. 1:10–11), commanding her to speak and write what she sees and hears. This burning light, which inflamed her heart, immediately enabled Hilde-

[15]The image is illustrated in Wiesbaden, Hessische Landesbibliothek MS Hs. 1, and reproduced in *Hildegardis Scivias* (ed. Adelgundis Führkötter and Angela Carlevaris, CCCM 43, 43A: 576f). All section references are to this edition. For Hildegard's understanding of Antichrist, see Horst Dieter Rauh, *Das Bild des Antichrist im Mittelalter: Von Tyconius zum deutschen Symbolismus*, 2d ed. (Münster, 1979), 497–527. For the traditional understanding of Antichrist, see my *Antichrist in the Middle Ages: A Study of Medieval Apocalypticism, Art, and Literature* (Seattle, 1981), 74–107.

[16]Hildegard *Scivias* 3.11, trans. Bernard McGinn, *Visions of the End: Apocalyptic Traditions in the Middle Ages* (New York, 1979), 101. The full text of *Scivias* has recently been translated by Mother Columba Hart and Jane Bishop (New York, 1990).

gard to understand the Psalter, the Gospels, and the books of the Old and New Testament, although she wrote Guibert of Gembloux (1175) minimizing her own education and her ability to understand anything other than what she received in vision.[17] Emphasizing the pure, unmediated nature of her revelation, Hildegard's prophetic calling is continually reaffirmed by her heavenly voice, and like John, who invokes those who have ears to hear his prophecy (cf. Apoc. 13:9), she often concludes her visionary accounts with the formula "But whoever with vigilant eyes sees and with attentive ears hears, he may offer an embracing kiss for these mystic words which from me, living, emanate" (2.1.17). There is no question, then, that Hildegard understood herself to be a prophet and was so accepted by eminent churchmen such as John of Salisbury. Her prophecies, along with those of "Methodius" and Joachim, are cited with approbation by Vincent of Beauvais in his *Speculum historiale* and are best known in the *Pentachronon* (c. 1220), an anthology compiled by the Cistercian Gebeno of Eberbach.[18] Hildegard's fame rests on her role as prophet, but there is no evidence that the *Scivias* or any other medieval work was understood as an apocalypse in a formal sense.

The search for a medieval apocalypse genre is complicated by the scholarly difficulties of categorizing even the Apocalypse of John. While debating the distinguishing features of the genre in biblical and early Christian literatures, scholars have questioned whether the Apocalypse can be termed an "apocalypse." Austin Farrer is certainly right that "the apocalyptic tradition contains nothing like the form of the Christian Apocalypse. It supplies plenty of material, but it does not supply the form."[19] Medieval readers, furthermore, took John at his word when he referred to his Revelation as a "prophecy" (Apoc. 1:3). Even the academic prologues to the Apocalypse by the Scholastic commentators, which are very concerned with *distinctiones* and reflect a subtle sense of the various *modi agendi* of the scriptural books, repeatedly classify the Apocalypse as a *modus prophetialis* or *modus revelativus*, linking it not only with Daniel, the Old Testament work usually designated an "apocalypse" by modern

[17]Peter Dronke, ed. and trans., *Women Writers of the Middle Ages: A Critical Study of Texts from Perpetua (+203) to Marguerite Porete (+1310)* (Cambridge, 1984), 168, 252. On the life of Hildegard, see Sabina Flanagan, *Hildegard of Bingen 1098–1179: A Visionary Life* (New York, 1989).

[18]Vincent of Beauvais *Speculum historiale* 32.107, in vol. 4 (Strassburg, 1473); Barbara Newman, *Sister of Wisdom: St. Hildegard's Theology of the Feminine* (Berkeley and Los Angeles, 1987), 22. The prophecies of Hildegard included in fourteenth- and fifteenth-century "prophetic anthologies" are usually from the *Pentachronon*. See Marjorie Reeves, *The Influence of Prophecy in the Later Middle Ages: A Study in Joachimism* (Oxford, 1969), 536–40; and Kerby-Fulton, *Reformist Apocalypticism*, 28–31.

[19]Farrer, *Rebirth of Images*, 305. See James Kallas, "The Apocalypse—An Apocalyptic Book?" *Journal of Biblical Literature* 86 (1967): 69–80; and John J. Collins, "Pseudonymity, Historical Reviews and the Genre of the Revelation of John," *Catholic Biblical Quarterly* 39 (1977): 329–43.

scholarship, but also with Isaiah and the other prophets and occasionally even with Psalms.[20]

This last association, along with the tendency in medieval exegesis to couple the Apocalypse with the Song of Songs, deserves careful investigation, for it may help explain why the Apocalypse influenced medieval literature not through its generic form but through its imagery. E. Ann Matter suggests in her essay that the tendency of early medieval exegesis to associate the Song of Songs and the Apocalypse is due to their appropriation in ecclesiological and christological interpretations. It would appear that such interpretations, even with the increasing interest after the twelfth century in the "historical" patterns of the Apocalypse, continued to inform later medieval exegesis. Certainly these books resemble each other in important ways, including their central marriage imagery and use of poetic language. It is interesting, furthermore, that although they contributed richly to allegorical and visual iconography, they rarely served as sources for the elaborate typological systems evident in medieval art and didactic works such as the *Biblia pauperum* and *Speculum humanae salvationis*.[21] In the Later Middle Ages, when historical correspondences were emphasized and when the *littera* of the biblical text became increasingly the focus of exegesis, their *litterae*—in contrast to those of the Old Testament historical books, the Gospels, Acts, and the Epistles—had to be approached as *fabulae*, their *materia* requiring spiritual interpretation. The Apocalypse thus provided a hermeneutic challenge for the exegete and visionary, as well as a complex of liturgical songs, poetic images, romance motifs, and dramatic figures for the imaginative author.

A GRAMMAR OF APOCALYPSE IMAGERY

Many medieval poems, songs, sermons, and mystical and historical writings include brief allusions to the Apocalypse. It would scarcely be possible to construct a full typology or even to establish a checklist of Apocalypse images like that developed for early Christian art by Dale Kinney, although such a project alone would reveal the tremendous influence of this fascinating and highly visual and poetic biblical book on more than a thousand years of medieval literary culture. Here it is only possible to sketch an outline for a grammar of Apocalypse imagery, which would be comprised of three interrelated yet distinct stages: first, a catalog of im-

[20]See Minnis, *Medieval Theory of Authorship*, esp. 124–26, 132–38.

[21]See my "*Figura* and the Medieval Typological Imagination," in *Typology and English Medieval Literature*, ed. Hugh Keenan (New York, 1992), 7–42, and my "Introduction," *The Biblia Pauperum Codex Palatinus Latinus 871 in the Vatican Library* (Yorktown Heights, N.Y., 1989). For an example of allegorical and visual iconography using apocalyptic symbolism, see Rosemond Tuve, *Allegorical Imagery: Some Mediaeval Books and Their Posterity* (Princeton, N.J., 1966), 102–6.

ages and motifs, ordinary objects and simple actions given significance by
repetition; second, an investigation of their associations and settings
within the visionary landscape of the Apocalypse; and third, an analysis
of the apocalyptic agents that manipulate these objects, motivate these
motifs, and move within this landscape. Most of this essay focuses on
how these three stages would be developed by discussing a limited but
representative number of Apocalypse images, settings, and figures and cit-
ing a few examples to illustrate their pervasiveness in a variety of medi-
eval works.

The Images and Motifs

The first stage in establishing a grammar of Apocalypse imagery would
concentrate on individual objects reiterated throughout the Apocalypse
(for example, the book, in Apoc. 1:11, 3:5, 5:1, 6:14, 10:2, 10:8–10, 13:8,
17:8, 20:12, 20:15, 21:27, 22:9–10, and 22:18–19), isolating their particu-
larizing attributes (such as the book of prophecy, the book sealed with
seven seals, and the little book), and noting consistent contextual fea-
tures (as in the way the book of life is repeatedly associated with the
Last Judgment and, in medieval interpretation, specifically with God's
foreknowledge).[22] As part of this cataloging stage, instructions and actions
involving these particularized objects also need to be examined. Often
these actions seem ritualized, creating the many stunning motifs that
make the Apocalypse memorable and influential in later literature. For ex-
ample, John's eating of the little book (Apoc. 10:10; cf. Ezek. 3:1) is cited
oftentimes in a nonapocalyptic context that nevertheless makes evident
its source in the Apocalypse. Saint Jerome cites the motif to suggest the
certainty of those to be saved in contrast to his own uncertain spiritual
condition. In describing his recently baptized foster-brother, Bonosus, who
has withdrawn to a small island near Aquileia, Jerome laments that Bono-
sus "sits in the safe retreat of his island, the bosom of the Church, and
perhaps, like John, he is even now eating God's book; I lie in the tomb of
my sins, bound in the chains in iniquity, and wait for the Lord's gospel cry:

[22]See Otto of Freising Chronica 8.16, trans. Charles Christopher Mierow, The Two
Cities: A Chronicle of Universal History to the Year 1146 A.D., ed. Austin P. Evans and
Charles Knapp (New York, 1928), 475; Ælfric's "Sermo ad Populum in Octavis Pente-
costen Dicendus" 465–72, in Homiles of Ælfric: A Supplementary Collection, vol. 1 (ed.
John C. Pope, EETS 259:441); and the famous "Dies Irae" 13–15, in Hymns of the Roman
Liturgy, ed. Joseph Connelly (London, 1957), 254. Although commonplace in medieval
doomsday literature, the book's range of meanings is much wider. In "Altus prosator," a
sixth-century hymn ascribed to Colum Cille, the sealed book represents a kind of secret
knowledge available only to Christians; see J. H. Bernard and R. Atkinson, eds., The
Irish Liber Hymnorum, vol. 1 (London, 1892), 77. In the Lollard "Sermon of Dead Men,"
it is identified with the Bible; see Lollard Sermons (ed. Gloria Cigman, EETS 294:240).
Gertrude of Helfta imagines John as "a kind of court recorder," writing in the book the
good and bad deeds of her convent; see Caroline Walker Bynum, Jesus as Mother: Studies
in the Spirituality of the High Middle Ages (Berkeley and Los Angeles, 1982), 188.

'Jerome, come forth.' "[23] The allusion to the book is explicit, but it should not overshadow the harmony of other resonances: Bonosus, like John, is on an island (Apoc. 1:9); Jerome, like the devil, is in "chains" (Apoc. 20:1–2); and the awaited gospel cry recalls the trumpetlike voice commanding John to "come up hither" (Apoc. 4:1), the voice from heaven at the resurrection of the Two Witnesses (Apoc. 11:12), the invitation to the marriage supper of the Lamb (Apoc. 19:9), and the vision's concluding summons (Apoc. 22:17).

Jerome's comment suggests that if we are to recognize the imaginative and wide-ranging use of Apocalypse images and motifs in later literature, we must keep two considerations in mind. First, a brief allusion may bear meaning beyond its apparent initial significance; and second, apocalyptic imagery may often be wrenched out of context to be used for purposes that seem quite foreign to those of the original scriptural setting. Thus, to condemn the papacy, John Gower in his Vox clamantis alludes to the striking image of John bowing to the angel (Apoc. 22:8). Unlike the angel, the pope states:

"Quem tamen in terris celestis ciuis honorem
Respuit, hunc repetit curia nostra sibi;
Flectitur inde genu, que pedes post oscula nostros
Mulcent, vt Cristi pes foret alter ibi."[24]

This vivid contrast and subsequent condemnation develop the poet's understanding of society and religion as reflecting a world turned upside down, in which he, John, the modern-day prophet crying in the wilderness, must "honor" a dishonorable institution. Along with many other Apocalypse allusions in this bitter poem (for example, the association of Wat Tyler's followers with the armies of Gog and Magog [Apoc. 20:7]), this motif provides a partial explanation for Gower's despairing picture of "these times."[25]

Because images and motifs are often taken out of their original contexts, in tracing influence one must take care to determine that a literary example is based on the Apocalypse rather than another biblical source. Sometimes the literary text will cite the Apocalypse, as is often the case with sermons, but generally one must look for other clues. For example, one notable motif used in a variety of ways in late medieval literature is

[23]Jerome Epistola 7.3, trans. and ed. F. A. Wright, Select Letters of St. Jerome (1933; reprint, Cambridge, Mass., 1980), 23. Cf. John 11:43.

[24]John Gower Vox clamantis 3.11.961–64, in The Complete Works of John Gower, vol. 4, The Latin Works, ed. G. C. Macaulay (Oxford, 1902), 132–33; trans. Eric W. Stockton, The Major Latin Works of John Gower (Seattle, 1982), 138: "Even though this celestial being refused such an honor while on earth, our court insists upon it for itself. Hence the knee is bent to us and kisses soothe our foot as if the foot of a second Christ were there."

[25]Gower Vox Clamantis 1.9.680, p. 41; cf. Apoc. 20:7; see also 1.10.749, p. 43. For Gog and Magog, see 1.10.765–68, p. 43.

Christ's knocking at the door (Apoc. 3:20), which one Lollard sermon interprets as signifying the third "advent" of Christ, which "is goostli and is doun eueri day. . . . Pat is: 'I stonde at þe dore' (þat is, of mannes soule) 'and knocke.' "[26] But this motif should not be confused with Christ's promise in the Sermon on the Mount: "Knock, and it shall be opened to you" (Matt. 7:7; Luke 11:9). The Apocalypse motif differs from the gospel promise in that, first, it is Christ who knocks and, second, responding to the knock leads to a "supper." Thus, although the sermon delivered by Chaucer's Parson to the Canterbury pilgrims does not cite the Apocalypse, his allegorization is close enough to the biblical text to make his source explicit: " 'I was atte dore of thyn herte,' seith Jhesus, 'and cleped for to entre. He that openneth to me shal have foryifnesse of synne. I wol entre into hym by my grace and soupe with hym,' by the goode werkes that he shal doon, whiche werkes been the foode of God; 'and he shal soupe with me' by the grete joye that I shal yeven hym."[27]

Once a motif is identified as a commonplace in medieval sermons and other didactic works, the well-known "popular literature" of the late Middle Ages, then it is possible to detect its echoes in unexpected circumstances. The "Wakefield Master," for example, may be recalling and inverting the motif of Christ's knocking at the door when in the Towneley *Second Shepherds' Play* he portrays Mak knocking at his cottage door, a scene that recalls other Apocalypse images as well. As Kenneth E. Johnson has recently argued, Mak as parodic Christ (or perhaps as comic Antichrist) demands entrance to "sup" *on* the stolen lamb with his wife, who welcomes him in a "mock-apocalyptic style" alluding to Apocalypse 1:7: "Lo, he commys with a lote / As he were holden in the throte."[28] Although Mak's knocking on his cottage door to enlist Gill into his conspiracy seems far removed from the image of Christ's knocking, the Apocalypse motif should not be ignored in the play's daring parody of Christ's first coming.

A few other examples of representative images and motifs that would need to be cataloged in the first stage of a grammar will suggest the variety of ways in which the treasure of the Apocalypse was mined by medieval authors. Although literary treatments of doomsday, like artistic ones, are more dependent on Christ's words in Matthew 24–25 than on the Apocalypse, certain common judicial features, such as the book of life, are

[26]"First Sunday in Advent," in *Lollard Sermons* (EETS 294:2); see also Hildegard *Scivias* 1.2.25.

[27]Chaucer, *Parson's Tale* X.287–89. Students of Chaucer need to test carefully the "allusions" listed in Lawrence Besserman's *Chaucer and the Bible: A Critical Review of Research, Indexes, and Bibliography* (New York, 1988), 384–87.

[28]"Behold, he comes with a noise / As if he were held by the throat." *The Second Shepherds' Pageant* 409–10, in *Medieval Drama*, ed. David Bevington (Boston, 1975), 397. See Kenneth E. Johnson, "The Rhetoric of Apocalypse in Van Eyck's 'Last Judgment' and the Wakefield *Secunda Pastorum*," in *Legacy of Thespis: Drama Past and Present*, ed. Karelisa V. Hartigan (Lanham, Md., 1984), 38–39.

based on the Apocalypse, as is the Judge's title, the "Alpha and Omega," the first and the last:

> Ego sum alpha et omega, primus et novissimus.
> I God, greatest of degree,
> in whom begyning non may bee,
> that I am pearles of postee,
> nowe appertly that shalbe preeved.[29]

These divine words, traditionally introducing dramatizations of dooms-day, are apt, for they serve as both an inaugural and a concluding signature (Apoc. 1:8; 22:13) for the Apocalypse and symbolize God's role throughout salvation history. The God of the Chester Whitsun Cycle thus cites the title not only at the beginning of the *Last Judgment* but also at the beginning of the *Fall of Lucifer*, in the first words of the entire cycle:

> Ego sum alpha et oo,
> primus et novissimus.
> It is my will it shoulde be soe;
> hit is, yt was, it shalbe thus. (1:1–4)

Literary descriptions of events leading to doomsday also draw on Apocalypse motifs, such as the blowing of trumpets and the horrendous dissolution of nature, and these were such commonplace expectations that their cosmic symbolism could be transferred to moments of national catastrophe and personal crisis. For example, although the epic setting of the *Song of Roland* is not explicitly apocalyptic, Stephen Nichols has argued that Roland's blowing of the olifant draws on a "tightly knit connotation system of horn imagery" that includes not only the trumpet of doomsday, but also the trumpetlike voice of Apocalypse 1:10.[30] On a more personal level, the Old English poet Cynewulf (9th c.) interweaves his runic signature into vivid descriptions of the heavenly King's final judgment; for "it is against that Day he begs for the help of prayers."[31] Such interest is not

[29]*The Chester Mystery Cycle*, no. 24: *Last Judgment*, lines 1–4 (ed. R. M. Lumiansky and David Mills, EETS SS 3). All quotations cite this edition by play and line numbers. Last Judgment plays stage Christ introducing doomsday by establishing his eternal and omnipotent nature; see, e.g. the *Jour du Jugement* 1692–97, in Emile Roy, ed., *Le Jour du Jugement: Mystère français sur le Grand Schisme* (Paris, 1902), 243.

[30]Stephen G. Nichols, Jr., *Romanesque Signs: Early Medieval Narrative and Iconography* (New Haven, Conn., 1983), 180–91. For the iconography of judgment in *Roland*, see also William R. Cook and Ronald B. Herzman, "Roland and Romanesque: Biblical Iconography in *The Song of Roland*," *Bucknell Review* 49 (1984): 21–48, esp. 26–27.

[31]Kenneth Sisam, *Studies in the History of Old English Literature* (Oxford, 1953), 23. See also Roberta Bux Bosse and Norman D. Hinton, "Cynewulf and the Apocalyptic Vision," *Neophilologus* 74 (1990): 279–93. For Cynewulf's treatment of doomsday, see *Elene* 1236–1321, in *The Vercelli Book*, ed. George Philip Krapp (New York, 1932); and *Christ II* 797–814 and *Juliana* 695–716, both in *The Exeter Book*, ed. George Philip Krapp and Elliott Van Kirk Dobbie (New York, 1936).

unusual in Anglo-Saxon poetry, which is fascinated with doomsday. *Christ III*, for example, alludes to the Lord's coming "like a wily thief . . . in the black night" (cf. Apoc. 3:3, 16:15), the gathering of the faithful on Mount Sion (Apoc. 14:1), the blowing of the trumpets, earthquakes, astronomical signs, and most insistently, fire:

> Þonne bið untweo þaet þaer Adames
> cyn, cearena full, cwiþeð gesargad,
> nales for lytlum, leode geomre,
> ac fore þam maestan maegenearfeþum,
> ðonne eall þreo on efen nimeð
> won fyres waelm wide tosomne,
> se swearta lig, saes mid hyra fiscum,
> eorþan mid hire beorgum, ond upheofon
> torhtne mid his tunglum. Teonleg somod
> þryþum baerneð þreo eal on an
> grimme togaedre. Grornað gesargad
> eal middangeard on þa maeran tid.[32]

The tripartite conflagration of all creation may allude to the fires that accompany the first three trumpets, which burn up "the third part" of the earth and sea and which include a burning mountain and star (Apoc. 8:7–10). A similar emphasis on the fiery destruction of the world is evident in the enigmatic Old High German poem *Muspilli* (9th c.), which describes the burning of mountains, the drying up of rivers, and the smouldering of the heavens.[33]

Other motifs drawn from the Apocalypse also indicate the terrors of the last days, when sinners will hide themselves from the face of the Lord, saying "to the mountains and the rocks, Fall upon us, and hide us from the

[32]*Christ III* 960–71, in *Exeter Book*, ed. Krapp and Dobbie; trans. Charles W. Kennedy, *Early English Christian Poetry* (New York, 1963), 270:

> Then shall be clear how the kin of Adam
> Full of sorrow weep in distress,
> Nor for little cause, those hapless legions,
> But for the greatest of all griefs
> When the dark surge of fire, the dusky flame,
> Seizes all three: the seas with their fish,
> The earth with her hills, and the high heavens
> Bright with stars. The destroying fire
> In fiercest fury shall burn all three
> Grimly together. And the earth
> Shall moan in misery in that awful hour.

See also *Judgment Day II*, in *The Anglo-Saxon Minor Poems*, ed. Elliott Van Kirk Dobbie (New York, 1942), 58; trans. R. K. Gordon, *Anglo-Saxon Poetry* (New York, 1954), 284–88. For these poems, see L. Whitbread, "The Doomsday Theme in Old English Poetry," *Beiträge zur Geschichte der deutschen Sprache und Literatur* (Halle) 89 (1967):452–81.

[33]*Muspilli* 2, in *An Old High German Reader*, ed. Charles C. Barber (Oxford, 1964), 79–82; see also Herbert W. Sommer, "The *Muspilli*-Apocalypse," *Germanic Review* 35 (1960): 157–63.

face of him that sits upon the throne, and from the wrath of the Lamb" (Apoc. 6:16).[34] The contrast between the startling extremes of dooms-day and the middling coziness of contemporary moral laxitude is effec-tively emphasized in Anselm of Canterbury's "Meditation to Stir Up Fear": "O bitter voice of the day of the Lord, O man, luke-warm and worthy to be spewed out, why are you sleeping? He who does not rouse himself and tremble before such thunder, is not asleep but dead."[35] In addition to recalling the "bitter voice" and "thunder," which are often compared with the trumpets of doomsday, Anselm refers to a grotesque image with which John condemns the morally contemptible: "because thou art lukewarm, and neither cold, nor hot, I am about to vomit thee out of my mouth" (Apoc. 3:16). The destructiveness of such hypoc-risy is personified in Jacopone da Todi's Laud 53, where *Ecclesia* weeps because "I am slain by the lukewarm," whereas the *Visio Pauli* notes that for those who "are neither hot nor cold" a special place in the river of fire awaits.[36]

Similarly used in medieval literature to condemn the lukewarmness, moral laxity, and religious hypocrisy of the last days is the image of the fourth Horseman, which appears at the opening of the fourth seal: "And behold a pale horse, and he who was sitting on it, his name is Death, and hell was following him" (Apoc. 6:8). During the twelfth century, exegetes and historians interpreted the Four Horsemen as symbolizing various se-quential stages in Church history, and the pale and deathlike fourth Horseman was associated with the present hypocrisy of the Church. In his continuation of the *Roman de la rose*, Jean de Meun develops this notion, comparing the hypocritical Astenance Contrainte to the pale horse of the Fourth Seal:

> le cheval de l'Apochalipse
> qui senefie la gent male,
> d'ypocrisie tainte et pale;
> car cil chevaus seur soi ne porte
> nule coleur, fors pale et morte.[37]

[34]See, e.g., Lactantius *Divine Institutes* 7.26, trans. Bernard McGinn, *Apocalyptic Spirituality* (New York, 1979), 77; Jacopone da Todi *Lauds* 15, trans. Serge Hughes and Elizabeth Hughes (New York, 1982), 96; the Lollard "Sermon of Dead Men," 225; and the Perugia Last Judgment play, discussed by Kathleen C. Falvey in "The Two Judgment Scenes in the 'Great' St. Andrew Advent Play," in *Italian Culture*, vol. 2, ed. Douglas Radcliff-Umstead (Binghamton, N.Y., 1982), 24.

[35]*The Prayers and Meditations of St. Anselm*, trans. Benedicta Ward, S.L.G. (New York, 1973), 222.

[36]See Jacopone *Lauds* 53, p. 171; and *Visio Pauli*, trans. Gardiner, *Visions of Heaven and Hell* (see n. 9 above), 36.

[37]Guillaume de Lorris and Jean de Meun *Roman de la rose* 12038–42, ed. Felix Lecoy, vol. 2 (Paris, 1966); trans. Charles Dahlberg, *The Romance of the Rose* (1971; reprint, Hanover, N.H., 1983), 210: "the horse in the Apocalypse that signified the wicked peo-ple, pale and stained with hypocrisy; for that horse bore no color upon himself except a

Jean uses such imagery to reveal the true nature not only of the false Beguine but also of her treacherous companion, the hypocritical Jacobin Faus Semblant, and to condemn other religious charlatans.

Although in cataloging apocalyptic motifs it may seem that they are generally employed negatively, to condemn rather than to praise, certain virtues stressed in the Apocalypse, such as patience (Apoc. 1:9, 2:2, 2:3, 2:19; 3:10, 13:9), are developed in medieval literature. The banquet during which Patience instructs Will (*Piers Plowman* 13) may thus allude to this apocalyptic virtue, which is to be rewarded by the marriage banquet of the Lamb (Apoc. 19:9). The poem's praise of "Patient Poverty" may also be based on "the patience and the faith of the saints" (Apoc. 13:10), which Langland, like John, associates with charity and contrasts with the wealth of the reprobate. Patience is also central to the retelling of the story of Jonah by the *Pearl*-Poet, who often draws on apocalyptic imagery. In *Patience*, Jonah, who is emphatically not patient, criticizes God's long-suffering mercy: "Py longe abydyng wyth lur, Py late vengaunce."[38] This passage echoes the cry of the souls calling out from under the altar: "How long, O Lord (holy and true) does thou refrain from judging and from avenging our blood on those who dwell on the earth?" (Apoc. 6:10). Counseled to be patient "for a little while," the souls are rewarded with white robes, which the Apocalypse repeatedly associates with the redeemed, especially with martyrs (cf. Apoc. 7:13–14).[39]

The first stage of a grammar of Apocalypse imagery would help highlight the most important Apocalypse motifs developed in medieval literature. Perhaps the most significant motif is the chaining of the Dragon: "And I saw an angel coming down from heaven, having the key of the abyss, and a great chain in his hand. And he laid hold on the dragon, the ancient serpent, who is the devil and Satan, and bound him for a thousand years" (Apoc. 20:1–2). Its significance may be due to its juxtaposing of the two major traditions of Apocalypse exegesis: the ecclesiological, which approaches Apocalypse imagery as allegorically portraying the Church's

pale, dead one." See also Richard Kenneth Emmerson and Ronald B. Herzman, "The Apocalyptic Age of Hypocrisy: Faus Semblant and Amant in the *Roman de la rose*," *Speculum* 62 (1987): 612–34.

[38]"Thy long enduring of injury, Thy late vengeance" (*Patience* 419, in *The Poems of the Pearl Manuscript*, ed. Malcolm Andrew and Ronald Waldron [Berkeley and Los Angeles, 1979], 202); Andrew and Waldron note that "Jonah here criticizes God for possessing the very qualities to which he directed his prayer from the belly of the whale" (202). All references are to this edition. Sandra Pierson Prior, who considers this passage to be an allusion to 2 Pet. 3:7–13, notes other Apocalypse allusions in "*Patience*—Beyond Apocalypse," *Modern Philology* 83 (1986): 337–48.

[39]Hildegard explains to Guibert of Gembloux that the original clothing of paradise was a radiant-white robe; see Dronke, *Women Writers*, 169, 253. In his *Compendium of Revelations*, Savonarola describes the saints he sees in heaven as those who " 'have washed their garments in the blood of the Lamb' " (Apoc. 7:14); trans. McGinn, *Apocalyptic Spirituality*, 252.

continuing battle against evil, and the eschatological, which understands much of the same imagery as symbolically prophesying last-day events. The motif celebrates the mitigating of Satan's power during the age of the Church and promises its ultimate defeat at the end of the world. In early Church and later orthodox exegesis, as Robert E. Lerner explains in his essay, the binding of the Dragon and the subsequent millennium represent the restriction of Satan's power during the period of the Church, until his release shortly before the end of the world. Thus Jacopone da Todi concludes that contemporary evils must indicate that "the ancient serpent has broken out of captivity."[40] The binding of the Dragon is not limited to the ecclesiological and eschatological understandings, however. It could be construed in personal terms, as we perceived above in Jerome's comment on Bonosus, for example, and in moral terms as in the climax of Hildegard's *Ordo virtutem*. There, Humility urges Victory and her companion virtues to bind the devil and then proclaims: "Gaudete, o socii, quia antiquus serpens ligatus est!"[41]

The binding, as the Easter hymn of Fulbert of Chartres (ca. 970–1028) emphasizes, was accomplished by Christ at his crucifixion and resurrection:

> Quo Christus, invictus leo,
> dracone surgens obruto,
> dum voce viva personat,
> a morte functos excitat.[42]

It became a common motif in artistic and literary treatments of the Harrowing of Hell. In the Towneley *Harrowing of Hell*, for example, Jesus at first threatens to bind Satan to a stake and then, after much demonic ranting, fulfills the threat in a scene with great comic as well as dramatic power:

> Jhesus: Nay, feynde, thou shal be feste,
> That thou shall flit no far.

[40]Jacopone *Lauds* 50, p. 166.

[41]"Rejoice, o companions, for the ancient serpent is bound!" (Hildegard of Bingen *Ordo virtutem* 227, in *Poetic Individuality in the Middle Ages: New Departures in Poetry, 1000–1150*, ed. Peter Dronke [Oxford, 1970], 190). See also Hildegard's vision of the "worm" chained in *Scivias* 2.7., p. 161.

[42]Fulbert of Chartres "Chorus novae Ierusalem" 5–8, in *The Oxford Book of Medieval Latin Verse*, ed. F. J. E. Raby (Oxford, 1959), 179 no. 128; trans. Bernard McGinn, "Symbols of the Apocalypse in Medieval Culture," *Michigan Quarterly Review* 22 (1983): 277:

> On this day Christ, the unconquered lion,
> Rises and overthrows the Dragon
> While he cries out with a loud voice
> And raises the dead from death.

See also the sermon for "Second Sunday in Lent," in Cigman, *Lollard Sermons*, 150.

Sathan: Feste? Fi[e], that were a wikyd treson!
 Bel ami, thou sal be smitt.
Jhesus: Devill, I commaunde the[e] to go downe
 Into thy sete where thou shall sit!
 [*Satan is cast down into hell pit.*]
Sathan: Alas, for doyll and care!
 I sink into hell pit![43]

Similarly, after the long disquisition by the four daughters of God and in
the midst of Satan's legalistic claims on the souls of the dead, Jesus in
Piers Plowman settles all arguments with one simple act:

"Thus by lawe," quod Oure Lord, "lede I wole fro hennes
Tho [leodes] that I lov[e] and leved in my comynge.
And for thi lesynge, Lucifer, that thow leighe til Eve,
Thow shalt abyen it bittre!"—and bond hym with cheynes. (18.402–4)[44]

The chaining of the Dragon, instead of following the deadly plagues
and the fall of Babylon, now takes place during Christ's first rather than
second advent. Its historical context has been shifted, but its hellish set-
ting remains.

The Visionary Landscape

The second stage in developing a grammar of Apocalypse imagery, then,
is to examine the settings for these apocalyptic images and motifs. The
book with seven seals, for example, is opened in the midst of a brilliant
heavenly court that includes the twenty-four Elders and the Four Living
Creatures worshiping the Lamb, one of the most powerful images in Apoc-
alypse iconography (see fig. 23), as Yves Christe notes in his essay in his
discussion of the grand Romanesque portals. This court, which continu-
ally praises the Lamb and Son of Man, is the source of many literary de-
scriptions of heaven:

 Heofonas sindon
 faegre gefylled, Faeder aelmihtig,

[43]Towneley *Harrowing of Hell* 353–60, in Bevington, *Medieval Drama*, 605–6. The
binding of Satan during the Harrowing of Hell is a feature of the *Descensus Christi ad
inferos* that was attached to the *Acts of Pilate*; see Hennecke, *New Testament Apocry-
pha* 1:474.
[44]For other apocalyptic features in *Piers Plowman*, see my "The Prophetic, the Apoc-
alyptic, and the Study of Medieval Literature," in *Poetic Prophecy in Western Literature*,
ed. Jan Wojcik and Raymond-Jean Frontain (Rutherford, N.J., 1984), 49–54; and Robert
Adams, "Some Versions of Apocalypse: Learned and Popular Eschatology in *Piers Plow-
man*," in *The Popular Literature of Medieval England*, ed. Thomas J. Heffernan (Knox-
ville, Tenn., 1985), 194–236.

ealra þrymma þrym, þines wuldres
uppe mid englum ond on eorðan somod.[45]

Similarly, the Pearl-Maiden describes to the confused visionary of *Pearl* the "note ful nwe" sung during the adoration of the Lamb (Apoc. 5:8–9):

"As harporez harpen in her harpe,
Þat nwe songe þay songen ful cler,
In sounande notez a gentyl carpe;
Ful fayre þe modez pay fonge in fere.
Ryȝt byfore Godez chayere
And þe fowre bestez þat Hym obes
And þe aldermen so sadde of chere,
Her songe þay songen, neuer þe les."[46]

But the Apocalypse stresses that the power and glory of the Lamb is not limited to heaven but that the Lamb is worshiped by "every creature that is in heaven, and on the earth, and under the earth" (Apoc. 5:13). Thus, in *Piers Plowman*, Jesus claims dominion not only over heaven but also over hell: " 'Ac my rightwisnesse and right shal rulen al helle, / And mercy al mankynde bifore me in hevene' " (18.397–98). John's cosmic visionary landscape encompasses not only the mundane geography of Asia Minor but also the extremes revealed when a door was opened in heaven (Apoc. 4:1) and when the bottomless pit was unlocked (Apoc. 9:2). In portrayals of doomsday, the dualism of this cosmic landscape is particularly evident, the Apocalypse providing many details for descriptions of the pains of hell and the joys of heaven. The *Visio Thurkilli*, for example, draws on the

[45]*Phoenix* 626–29, ed. N. F. Blake (Manchester, 1964); trans. Kennedy, *Early English Christian Poetry*, 247:

The heavens are filled
With Thy wondrous glory, Almighty God,
Splendour of splendours, with angels above
And on earth below.

[46]*Pearl* 881–88, in Andrew and Waldron, *Poems of the Pearl Manuscript*; trans. Sara de Ford et al., *The Pearl* (Arlington Heights, Ill., 1967):

"As harpers harp upon the harp,
The new-found song they sang out clear.
In resounding notes, in gentle carp,
The fair modes that they found cohere.
And right before God's throne, and near
The four beasts who His power confess,
The elders all with sober cheer
Sang their song, nevertheless."

Subsequent translations are also from this edition. For analysis of *Pearl* in apocalyptic terms, see Barbara Nolan, *The Gothic Visionary Perspective* (Princeton, 1977), 156–204. J. Stephen Russell argues, in *The English Dream Vision: Anatomy of a Form* (Columbus, Ohio, 1988), that *Pearl* is "a deconstruction of the discourse of eschatology" (160).

Apocalypse to describe both the "aqua sulphurea bullienti" (boiling sul-
phurous water) and the "templum aureum" (golden temple).[47]

In the late Middle Ages the Scholastic penchant for structure reached
even into hell. As in Dante's *Inferno,* the geography of hell was mapped
and the specific functions of each region detailed. The catalogs of pains
drew on the vivid imagery of the Apocalypse, particularly the "fire and
brimstone" of Apocalypse 21:8. The thirteenth-century lyric "The Late-
mest Day," for example, describes a "bitter bath . . . of brimstone and of
boiling pitch" in which Satan tears souls with a rake, and the Lollard "Ser-
mon of Dead Men" explains that the sixth pain of hell includes "þe fire þat
shal brenne hem þere, of brymston and of piche, as Jon seiþe in þe
Apocalipse."[48] More vividly, Chaucer's Parson embellishes this image in
his condemnation of adultery: "Seint John seith that avowtiers shullen
been in helle, in a stank brennynge of fyr and of brymston—in fyr for hire
lecherye, in brymston for the stynk of hire ordure" (X.840). Given the ten-
dency in apocalyptic literature to portray evil as an inversion of good, it is
not surprising that some punishments in hell suggest parodic counter-
parts of heaven. For example, at the conclusion of the Old English *Christ
and Satan,* which versifies the temptation in the desert, the victorious
Christ sentences Satan to measure hell with his own hands, a fitting pun-
ishment that recalls the angel's measurement of the New Jerusalem with
a golden reed (Apoc. 21:15).[49]

A similar inversion is at work in the *Visio Pauli,* which describes the pit
of hell as a well sealed with seven seals. There are clear parallels with
John's heavenly vision of the book with seven seals. Both Paul and John,
for example, at first weep at what they see and are comforted by an angel.
Unlike the book that the Lamb opens, however, the sealed well is to re-
main forever closed, so that it becomes an image of exclusion and sor-
row rather than inclusion and joy. As the angel explains to Paul, " 'If any
are thrown into the well of the abyss, and it is sealed over them, there
will never be any recollection made of them in the presence of the Fa-
ther and the Son and the Holy Ghost or of the holy angels.' "[50] A little
later, Paul sees the throne of God worshiped by the twenty-four Elders and
the Four Living Creatures, thus underscoring the contrasts between the
seven-sealed well of hell and the seven-sealed heavenly book. Thus, al-
though Gurevich rightly contrasts the "cosmic proportions and colourful

[47]Ralph of Coggeshall *Visio Thvrkilli,* ed. Paul Gerhard Schmidt (Leipzig, 1978), 28,
36; trans. Gardiner, *Visions of Heaven and Hell,* 232, 235.
[48]"The Latemest Day" 73–75, in *English Lyrics of the Thirteenth Century,* ed. Carle-
ton Brown (Oxford, 1932), 48; "Sermon of Dead Men," 232. See also Lactantius *Divine
Institutes* 7.26, trans. McGinn, *Apocalyptic Spirituality,* p. 77.
[49]*Christ and Satan* 695–722, in *The Junius Manuscript,* ed. George Philip Krapp (New
York, *1931*). See Thomas D. Hill, "The Measure of Hell: *Christ and Satan* 695–722,"
Philological Quarterly 60 (1981):410.
[50]*Visio Pauli,* trans. Gardiner, *Visions of Heaven and Hell,* 43; for the throne of God,
see 45.

grandeur" of the Apocalypse with the "torture-chambers" of the *Visio*, and although the latter does heap "tortures upon tortures," its visionary landscape occasionally mirrors the heavenly features of the Apocalypse. To cite another instance, the fact that in hell there are 144,000 tortures (an archetypal apocalyptic number with its root in the twelves so prevalent in the Apocalypse) implies that the tortures are prepared as hellish versions of the rewards promised the 144,000 elect of Apocalypse 7:4.[51]

According to the Apocalypse, the 144,000 are signed by the angels to designate them as God's servants and to protect them from the calamities of the last days. They are invited to the marriage supper of the Lamb to become the citizens of heaven. The Middle English *Pearl* capitalizes on this image to portray heaven and the Pearl-Maiden as bride of Christ. In her explanation of her singular status, the visionary maiden, who is among the 144,000, explicitly cites John's account of his vision:

> " 'I seghe,' says John, 'þe Loumbe Hym stande
> On þe mount of Syon ful þryuen and þro,
> And wyth Hym maydennez an hundreþe þowsande,
> And fowre and forty þowsande mo.' " (867–70)[52]

Indeed *Pearl* provides one of the most elaborate and detailed poetic descriptions of heaven based on the Apocalypse found in medieval literature. Thus the Dreamer compares his radiant vision with John's, the poetry underscoring their similar experience by stressing forms of "sight":

> As John þe apostel hit sy3 with sy3t,
> I sy3e þat cyty of gret renoun,
> Jerusalem so nwe and ryally dy3t,
> As hit watz ly3t fro þe heuen adoun.
> Þe bor3 watz al of brende golde bry3t,
> As glemande glas burnist broun,
> With gentyl gemmez anvnder py3t,
> With bantelez twelue on basyng boun,
> Þe foundementez twelue of riche tenoun;
> Vch tabelment watz a serlypez ston,
> As derely deuysez þis ilk toun
> In Apocalyppez þe apostel John. (985–96)[53]

[51] See Gurevich, *Medieval Popular Culture*, 129.

[52] " 'The Lamb,' says John, 'I could perceive
 Stand brave on Zion's mount, and near
 Him one hundred thousand maidens cleave.
 Fourty-four thousand more appear.

[53] Like John the Apostle, with vision's sight,
 I saw that city much renowned:
 Jerusalem new and royally dight,
 As from the heavens descended. Round

This stanza introduces more than a hundred lines describing the New Jerusalem, its precise measurements, dazzling precious stones and gold streets, and the "perfect pearl inviolate" (1038) adorning its portals.[54] This "parfyt perle" recalls "þat pryvy perle" (12) with which the poem begins, suggesting that, just as the Bride of the Lamb is conflated with the holy city (Apoc. 21:9–10), the Pearl-Maiden is fused into her own heavenly landscape.

The site of John's visionary landscape that most influenced medieval religious literature is the New Jerusalem. Bonaventure argues that the three theological virtues perfect the "image of our soul," making it "like the heavenly Jerusalem," and that once the inner senses are reformed through affective experience, "our spirit is made hierarchical in order to mount upward, according to its conformity to the heavenly Jerusalem which no man enters unless it first descend into his heart through grace, as John saw in the Apocalypse."[55] It is thus not surprising that many mystical visionaries, such as Hadewijch of Brabant, who "was taken up in the spirit on the feast of Saint John the Evangelist," are granted visions of the New Jerusalem.[56] The city is also an emblem of a future reality—of life after death, the City of God in which Christians seek to become eternal citizens and even building blocks. Thus, in her sequence for Disibod, a seventh-century Irish bishop who had been exiled from his see, Hildegard praises the saint as the "prelate of the true city," associating him with the cornerstone of the temple.[57] In his account of the death of Francis, Bonaventure notes that after receiving the stigmata the saint suffered greatly, so that "he was squared like a stone to be fitted into the construction of the Heavenly Jerusalem."[58]

> The city burnished gold was bright
> As crystal coruscating. Found
> Beneath were precious gems; upright
> Were pillars twelve on bases bound.
> The twelve foundations were richly crowned
> And every tier was a separate stone,
> As deftly describes this holy ground,
> In the Apocalypse, the Apostle John.

[54]Critics have noted that these elaborate descriptions resemble portrayals of the New Jerusalem in the Anglo-French illuminated Apocalypses; see Nolan, *Gothic Visionary Perspective*, 199–200; Muriel A. Whitaker, " 'Pearl' and Some Illustrated Apocalypse Manuscripts," *Viator* 12 (1981): 183–96; and Sarah Stanbury, "Visions of Space: Acts of Perception in *Pearl* and in Some Late Medieval Illustrated Apocalypses," *Mediaevalia* 10 (1988): 133–58.

[55]Bonaventure *Itinerarium* 4.3–4, trans. Ewart Cousins, *Bonaventure* (New York, 1978), 89, 90. Bonaventure (4.3, p. 89; 7.4, p. 113) also cites Apocalypse 2:17 to suggest the mystery and uniqueness of mystical wisdom.

[56]See Hadewijch, Vision 10, trans. Mother Columba Hart, *Hadewijch: The Complete Works* (New York, 1980), 287.

[57]Hildegard *Symphonia armonie celestium revelationum*, trans. and ed. Barbara Newman, *Symphonia* (Ithaca, N.Y., 1988), 186–89.

[58]Bonaventure *Legenda major* 14.3, trans. Cousins, *Bonaventure*, 317.

The New Jerusalem, as Chaucer's Parson teaches when the pilgrims approach Canterbury, should also be the goal of Christians on the pilgrimage of life:

> "And Jhesu, for his grace, it me sende
> To shewe yow the wey, in this viage,
> Of thilke parfit glorious pilgrymage
> That highte Jerusalem celestial." (X.48–51)

Awareness of this ultimate goal of pilgrimage enunciated by the final speaker in the polyglot *Canterbury Tales* provides a crucial eschatological dimension to Chaucer's great human comedy.[59] The image of the New Jerusalem may also be a model for prominent cities in other quests, so that in Huon de Méry's *Li tornoiemenz Antecrit*, the city of Esperance, which is called the "Montjoie de paradis," is associated with the heavenly city, and in the *Queste del Saint Graal*, the city of Sarras is "an image of the Heavenly Jerusalem."[60] In Edmund Spenser's *Faerie Queene*, Contemplation leads the Red Cross Knight to see "The New Jerusalem, that God has built / For those to dwell in that are chosen his."[61]

The symbolism of the New Jerusalem is rich, varied, and dynamic. It may symbolize *ecclesia*, whether localized as in the "Urbs beata Jerusalem," a hymn for the dedication of a church, or universalized as in Joachim of Fiore's equation of the New Jerusalem with Holy Mother Church.[62] Nor is it limited to eschatological and ecclesiastical interpretations; for it has tropological implications relating directly to the moral state of the individual Christian. Thus, toward the conclusion of his *Psychomachia*, Prudentius describes the victory of the virtues over the vices as resulting in the building of a temple in the soul of the Christian that is suitable for the Son of Man to inhabit.[63] Faith measures the temple's foundations with a

[59]See Richard Kenneth Emmerson and Ronald B. Herzman, "*The Canterbury Tales* in Eschatological Perspective," in *Use and Abuse of Eschatology*, ed. Verbeke, Verhelst, and Welkenhuysen, 404–24.

[60]O'Sharkey, "Teachings of Joachim of Fiore," 55. See Huon de Méry *Li tornoiemenz Antecrit* 1234–54, in *Ausgaben und Abhandlungen aus dem Gebiete der romanischen Philologie*, ed. Georg Wimmer, vol. 76 (Marburg, 1888). For the *Queste del Saint Graal*, see *The Quest of the Holy Grail*, trans. P. M. Matarasso (Baltimore, 1969).

[61]Edmund Spenser *The Faerie Queene* 1.10.52.2–3, 57.2–3, ed. Robert Kellogg and Oliver Steele (Indianapolis, 1965), 201–2. Quotations, all from this edition, are cited by book, canto, stanza, and line numbers.

[62]Joachim of Fiore *Liber de concordia Noui ac Veteris Testamenti* 4.1.45, ed. E. Randolph Daniel (Philadelphia, 1983): "ascendit quasi nouus dux de Babilone, uniuersalis scilicet pontifex noue Ierusalem, hoc est sancte matris ecclesie" (402). For "Urbs beata Jerusalem," see Frederick Brittain, ed., *The Penguin Book of Latin Verse* (Baltimore, 1962), 127–28. Writing to Charles IV, Cola di Rienzo equates the New Jerusalem with the empire; see McGinn, *Visions of the End*, 240–41.

[63]Prudentius *Psychomachia* 816–19, in *Prudentius*, ed. H. J. Thomson (Cambridge, Mass., 1961). All citations in the text are to this edition. See also McGinn, "Symbols of the Apocalypse," 276.

golden reed to determine that all four sides are square (826–29; cf. Apoc. 21:15–16); and doors opening to the east, south, west, and north are inscribed with the names of the twelve Apostles (830–39; cf. Apoc. 21:13–14). The description of the rich gems brightly shining from its walls is particularly elaborate (Apoc. 21:18–20):

> ingens chrysolitus, nativo interlitus auro,
> hinc sibi sapphirum sociaverat, inde beryllum,
> distantesque nitor medius variabat honores.
> hic chalcedon hebes perfunditur ex hyacinthi
> lumine vicino; nam forte cyanea propter
> stagna lapis cohibens ostro fulgebat aquoso.
> sardonicem pingunt amethystina, pingit iaspis
> sardium iuxta adpositum pulcherque topazon.
> has inter species smaragdina gramine verno
> prata virent volvitque vagos lux herbida fluctus.
> te quoque conspicuum structura interserit, ardens
> chrysoprase, et sidus saxis stellantibus addit. (854–65)[64]

Within the temple, a hall is built for Wisdom to dwell and to govern. By basing his soul-temple of Wisdom on John's description of the heavenly city, Prudentius not only identified the future salvation of the Christian with the immediate victory of the virtues over the vices, but as Macklin Smith states, he "turned narrative into mystical vision, transformed the moral soul-struggle in time into eternal aesthetic perfection."[65]

The splendid imagery of the heavenly city caught the imagination of medieval writers. For example, the Lollard "Sermon of Dead Men" exults in the prospect that the New Jerusalem will shine brightly, not from the sun "but almyȝty God shal liȝten it, and his launterne is þe lombe."[66] In his famous De contemptu mundi, Bernard of Cluny praises the city as a

[64]
> A chrysolite ingrained with gold is set
> Between a sapphire and a beryl green,
> And their joint glow gives rise to varied charms.
> Here a chalcedony is steeped with light
> From neighboring hyacinth; for that dark stone
> Shone nearby with its limpid purple depths.
> The amethyst imbues the sardony,
> The jasper and topaz, the sardius.
> Among these, emeralds shine like meadows green,
> and verdant light flows forth in billowing waves.
> Thou too, bright chrysoprase, dost gild this shrine,
> And thy star joins the other glittering stones.

Trans. M. Clement Eagan, The Poems of Prudentius, vol. 2 (Washington, D.C., 1965), 108.

[65]Macklin Smith, Prudentius' Psychomachia: A Reexamination (Princeton, 1976), 204. See also Hildegard Scivias 3.10.31, p. 341.

[66]"Sermon of Dead Men," 236.

place of rest and peace in contrast to the struggles and miseries of the world, exclaiming that beauty and joy is beyond comprehension: "Nescio, nescio quae jubilatio, lux tibi qualis, / Quam socialia gaudia, gloria quam specialis."[67] Poets not only emphasize the beauty of the New Jerusalem but also cite its features as the hallmark of cherished values. The pilgrim in Guillaume de Deguileville's *Pelerinage de la vie humaine* sets out for the New Jerusalem, which he sees in an inward glass as excelling "off bewte / Al other in comparyson"; and in his "Love Rune" (ca. 1270) Thomas of Hales compares maidenhood with New Jerusalem's precious stones.[68] The details of the city are appropriated in descriptions of lavish wealth, so that Fulcher of Chartres describes how the Christians, after winning a minor skirmish near Ascalon, discover in the Saracen tents a "vast princely wealth," including the twelve kinds of precious stones exactly as enumerated in Apocalypse 21:19–20.[69]

In medieval literature Jerusalem is a real, historical, earthly city as well, the city of Old Testament prophets and kings and the site of Christ's salvific death. In her long disquisition to the obtuse dreamer, the Pearl-Maiden distinguishes between the "olde" city in "Judy londe" and the "nwe" city of the "Apocallypce." In both, Christ plays a key role:

> "Þe olde Jerusalem to vnderstonde,
> For þere þe olde gulte watz don to slake.
> Bot þe nwe, þat ly3t of Godez sonde,
> Þe apostel in Apocalyppce in theme con take.
> Þe Lompe þer withouten spottez blake
> Hatz feryed þyder Hys fayre flote." (941–46)[70]

But even as an earthly city, Jerusalem seems to resemble John's heavenly one. In the Old English *Christ I*, for example, which in formulaic verse describes Christ's advent as a babe, the city becomes eternal, pure, and heavenly:

[67]Bernard of Cluny *De contemptu mundi: A Bitter Satirical Poem of 3000 Lines upon the Morals of the XIIth Century by Bernard of Morval, Monk of Cluny*, ed. H. C. Hoskier (London, 1929), lines 271–72: "I know not, I know not what jubilation, what kind of light is yours, / How social your joys, how individual your glory."

[68]See John Lydgate, trans., *The Pilgrimage of the Life of Man* 323–31 (ed. F. J. Furnivall, EETS 77:9); and Thomas of Hales "Love Ron" 169–84, in Brown, *English Lyrics of the Thirteenth Century*, 73.

[69]Fulcher of Chartres *Historia Hierosolymitana* 1.31.10, trans. Frances Rita Ryan, *A History of the Expedition to Jerusalem, 1095–1127*, ed. Harold S. Fink (1969; reprint, New York, 1973), 127.

[70] "In the old Jerusalem, understand,
 The ancient sin He could forsake.
 But the New ordained through God's command
 The Apostle in Apocalypse could take
 As theme. There the spotless Lamb could make
 Thither His way with His lovely lot."

Eala sibbe gesihð, sancta Hierusalem,
cynestola cyst, Cristes burglond,
engla eþelstol, ond þa ane in þe
saule soðfaestra simle gerestað,
wuldrum hremge. Naefre wommes tacn
in þam eardgearde eawed weorþeð.[71]

Just as medieval authors knew Jerusalem as a real place, so they knew Babylon as a contemporary city. Fulcher of Chartres refers to Babylon the Great in Syria, Babylonia (Egypt), and the king of Babylon. *Le saint voyage de Jherusalem*, Ogier d'Anglure's account of a pilgrimage to the Holy Land in 1395–96, describes in some detail Babylon on the Nile, which boasts "a church where the blessed Virgin Mary and her dear child Our Lord Jesus Christ stayed for seven years."[72] Babylon's symbolism, though, remained compelling, so that Joachim of Fiore scoffs at a literal identification: "Which Babylon? Could it be the metropolis of the Chaldeans? Of course not, but the one which it signifies."[73] Occasionally the city could be cited neutrally, as when Joachim of Fiore, who often identified Babylon with the empire, states as a commonplace that "not only may a person be a type of another person, but also a multitude of a multitude, as Jerusalem of the Roman church, Samaria of Constantinople, Babylon of Rome, Egypt of the Byzantine Empire, et cetera."[74]

Nevertheless, Babylon's emblematic significance is usually as powerfully negative as Jerusalem's is positive. Babylon often represents the ultimate defeat of the city of man on earth, the destruction of "the great city" that has "become the habitation of demons" (Apoc. 18:2), which John's vision describes with great relish. Demonic symbolism is evident in expectations that Antichrist will be born in Babylon, a heritage made commonplace by the standard *vita* of Antichrist, Adso of Montier-en-Der's

[71]*Christ I* 50–55, in Krapp and Dobbie, *Exeter Book;* trans. Kennedy, *Early English Christian Poetry,* 86:

O holy Jerusalem, Vision of peace,
Fairest of royal seats, City of Christ,
Homeland of angels, in thee for ever
Rest the souls of the righteous alone
In glory exulting. No sign of sin
In that city-dwelling shall ever be seen.

[72]Ogier d'Anglure *Le saint voyage de Jherusalem* 244; trans. Roland A. Browne, *The Holy Jerusalem Voyage of Ogier VIII, Seigneur d'Anglure* (Gainesville, 1975), 57. See also Fulcher of Chartres *Historia Hierosolymitana* 1.34.5, 3.12.2, 1.31.1, pp. 134, 237, 125.
[73]Joachim of Fiore "Commentary on an Unknown Prophecy," trans. McGinn, *Visions of the End,* 133. Cf. also Isaiah 13:19–22.
[74]Joachim of Fiore, *Liber de concordia* 2.1.2, p. 64; trans. Daniel, *Apocalyptic Spirituality,* ed. McGinn, 122. See also the captions on Joachim's *figura* of the seven-headed Dragon, 136.

tenth-century *Libellus de Antichristo.*[75] In the *Ludus de Antichristo* (ca. 1160), which stages the kings of Jerusalem and Babylonia playing crucial roles in the career of the Last World Emperor, Jerusalem quickly accepts the spiritual rule of the German emperor, whereas Babylonia, which is associated with *gentilitas* (paganism), must be defeated.[76]

Such a contrast between Jerusalem and Babylon is common; in fact, the thought of one almost always immediately leads to the other. Symbolically they suggest the contrast between the soul's exile and its true home. In "Sabbato ad Vesperas," Abelard expresses his desire to return "ad Jerusalem / a Babylonia," which reminds us that the Jerusalem-Babylon dichotomy is drawn not only from the Apocalypse but from Psalms, Daniel, and other prophets.[77] But an Old Testament setting does not necessarily depreciate Babylon's apocalyptic associations. After the introductory processional in the twelfth-century *Danielis ludus* from Beauvais, for example, the satraps praise Baltassar by juxtaposing the two cities and their present conditions: "Ridens plaudit Babylon; Jherusalem plorat."[78] But as the play progresses, the action increasingly stresses Jerusalem's power over Babylon, culminating in a scene that recalls Last Judgment iconography: Daniel is removed from the lion's den as the satraps are cast in. This prefiguration is underscored by Daniel's concluding prophecy and the angel's immediate proclamation of the birth of Christ. Just as the apocalyptic Babylon must be destroyed before Christ's second coming, the play shows Babylon's destruction before his first coming.

The Jerusalem-Babylon contrast is appropriated to attack the corruption of the Church, particularly to distinguish between *ecclesia* and *synagoga,* the "synagogue of Satan" (Apoc. 2:9, 3:9). In his *Inquisitor's Manual* (ca. 1324), Bernard Gui reports that the Beguins taught that at the end of the sixth period of Church history, "the carnal Church, Babylon, the great har-

[75]*Adso Dervensis: De ortu et tempore Antichristi* (ed. Daniel Verhelst, *CCCM* 45); trans. McGinn, *Apocalyptic Spirituality,* 81–96, esp. 91. For Adso's significance, see my "Antichrist as Anti-Saint: The Significance of Abbot Adso's *Libellus de Antichristo,*" *American Benedictine Review* 30 (1979): 175–90. For Antichrist's birth, see my *Antichrist in the Middle Ages,* 79–83.

[76]*Ludus de Antichristo,* in *Der Antichrist: Der staufische Ludus de Antichristo* ed. Gerhard Gunther (Hamburg, 1970); trans. John Wright, *The Play of Antichrist* (Toronto, 1967). See Rauh, *Bild des Antichrist im Mittelalter,* 365–415; and my *Antichrist in the Middle Ages,* 166–72. In the *Prophecies de Merlin* (ca. 1275), Babylon at first joins forces with the Last World Emperor; see Lucy Allen Paton, *Les prophecies de Merlin* 175, vol. 1 (London, 1926), 221; trans. Peter Dembowski, *Visions of the End,* ed. McGinn, 185.

[77]Abelard "Sabbato ad Vesperas" 29–30, in *Mediaeval Latin Lyrics,* ed. Helen Waddell, 4th ed. (1933; reprint, Baltimore, 1952), 176. See also Honorius Augustodunensis *Speculum Ecclesiae,* (*PL* 172:1093); Bernard of Clairvaux *Parabola* 2 (*PL* 183:761); and Giacomino da Verona, "De Jerusalem celesti" and "De Babilonia civitate infernali," ed. Esther Isopel May (Florence, 1930).

[78]"Babylon applauds laughing; Jerusalem weeps." *Play of Daniel* 56, trans. and ed. Bevington, *Medieval Drama,* 140.

lot, shall be rejected by Christ, just as the synagogue of the Jews was rejected for crucifying Christ."[79] Associating Babylon with the institutional church, furthermore, was not limited to heretics. Earlier, Philip, the Chancellor of the University of Paris (1218–36), condemned the extravagant wealth of the Church by comparing it to Babylon's invasion of Solomon's temple: "quod in templum Salemonis / venit rex Babylonis."[80] As Petrarch explains in a letter to Francesco Nelli, some things must be learned through their contraries: "Do you wish to know the beauty of God, see how obscene his enemies are. You do not have to search far; they dwell in Babylon."[81] By Babylon, of course, Petrarch means Avignon, the site of the fourteenth-century "Babylonian captivity" of the papacy and the subject of his virulent poetic condemnations:

> De l'empia Babilonia ond' e fuggita
> ogni vergogna, ond' ogni bene e fori,
> albergo di dolor, madre d' errori,
> son fuggito io per allungar la vita.[82]

Clearly Petrarch takes seriously the voice from heaven that urges all to flee Babylon: "Go out from her, my people, that you do not share in her sins, and that you may not receive of her plagues" (Apoc. 18:4). In a letter written some thousand years earlier (ca. 382), Jerome urged Marcella also to flee Babylon, which, with its seven hills (Apoc. 17:9), he identified with Rome.[83] More typically, fleeing Babylon is understood allegorically, accomplished through repentance and penitence. Joachim of Fiore, for example, urges Christians to "do penance for having rejected God's word and abandoned the bosom of the Chaste Mother who is now lowly and despised and preferred the Whore who rules over the kings of the earth" and insists, "depart from her through confession and penance."[84]

[79]Bernard Gui, *Inquisitor's Manual* 4, trans. W. L. Wakefield and A. P. Evans, *Heresies of the High Middle Ages* (New York, 1969), 424.

[80]"Because the king of Babylon comes into Solomon's Temple." See "Dic, Christi veritas," discussed by Peter Dronke in *The Medieval Lyric* (New York, 1969), 56.

[81]Trans. Robert Coogan, *Babylon on the Rhone: A Translation of Letters by Dante, Petrarch, and Catherine of Siena on the Avignon Papacy* (Madrid, 1983), 91.

[82]Petrarch, Rime 114, in *Rime, trionfi, e poesie latine*, ed. Ferdinando Neri (Milan, 1951), 156; trans. Joseph Auslander, *The Sonnets of Petrarch* (London, 1931), 91:

> From impious Babylon, where all shame is dead,
> All goodness banished to extremest bounds,
> Nurse of black errors, lair of brutish hounds,
> I, too, in hope of longer life have fled.

[83]Jerome *Epistolae* 46.11 (*PL* 22:490). On Rome-Babylon, see also Commodian's *Instructiones* 1.41 (ed. Joseph Martin, *CC* 128:33–34).

[84]Joachim of Fiore "Letter to All the Faithful," trans. McGinn, *Apocalyptic Spirituality*, 115, 117.

Apocalyptic Agents

Joachim's reference to the Whore reminds us that "the great harlot, who sits upon many waters, with whom the kings of the earth have committed fornication" (Apoc. 17:1–2) is the most memorable "citizen" of Babylon. The third stage in a grammar of Apocalypse imagery focuses on the Whore and the many other agents that populate John's visionary landscape. These agents include heavenly animals, such as the Four Living Creatures and the Lamb (Apoc. 4–6), as well as the numerous beastial incarnations of evil in Apocalypse 9 and 11–13. They include countless angels, such as the "angel ascending from the rising of the sun, having the seal of the living god" (Apoc. 7:2), whom Bonaventure identified with Saint Francis in his *Legenda maior.*[85] Immense groups, such as the multitude "of all nations, and tribes, and peoples" (Apoc. 7:9) and the hordes of Gog and Magog (Apoc. 20:7), play important roles as well.[86] The "humanlike" agents range from the surrealistic and divine Horsemen (Apoc. 6:2–9; 19:11–13) to martyrs, prophets, and John, who is no passive spectator in the apocalyptic drama. A thorough consideration of the Apocalypse in medieval literary culture must therefore include these numerous figures who motivate the action of the apocalyptic vision.

These agents are often paired, so that the representatives of good and evil confront each other directly. Thus the Two Witnesses, generally identified with the Old Testament Enoch and Elias, oppose "the beast that comes up out of the abyss" (Apoc. 11:3–7), whom medieval exegetes almost unanimously understood to symbolize Antichrist. These opponents appear throughout didactic, visionary, historical, and polemical literature, from the *Divine Institutes* of Lactantius, the homilies of Ælfric and Wulfstan, and Hildegard's *Scivias* to Otto of Freising's *Chronica*, Berengier's *De l'avenement Antecrist*, the Middle High German *Entecrist*, the Middle English *Cursor mundi* and *Pricke of Conscience*, and John Wycliff's insistent attacks on the minions of Antichrist. Furthermore, they are principal characters in numerous lyric poems, dream visions, and elaborate plays, which constitute an extensive subgroup of medieval apocalyptic literature.[87] Several major works such as the *Ludus de Antichristo*; Huon de Méry's visionary romance, *Li tornoiemenz Anticrit*; Langland's

[85]Bonaventure *Legenda major* prol.1, trans. Cousins, *Bonaventure*, 181.

[86]On interpretations of Gog and Magog, who appear in literary treatments of the Alexander romances, see Andrew Runni Anderson, *Alexander's Gate, Gog and Magog, and the Inclosed Nations* (Cambridge, Mass., 1932); and my *Antichrist in the Middle Ages*, 83–89.

[87]See my *Antichrist in the Middle Ages*, 34–73 on exegetic interpretations, 146–203 on literature. See also Wilhelm Bousset, *The Antichrist Legend: A Chapter in Christian and Jewish Folklore*, trans. A. H. Keane (1896; reprint, New York, 1985); and Klaus Aichele, *Das Antichristdrama des Mittelalters, der Reformation und Gegenreformation* (The Hague, 1974).

Piers Plowman; and the Chester cycle *The Coming of Antichrist* develop this tradition at great length.

The Whore of Babylon and the virtuous cosmic Woman of Apocalypse 12 comprise one of the most potent pairs of apocalyptic agents. Conflating the Old Testament equation of apostasy and fornication with memories of paganism and the Babylonian captivity, the Whore came to symbolize a rampant and apparently officially endorsed moral corruption. Whether or not Langland equates Lady Meed with the Whore of Babylon, as a courtesan dressed in scarlet who is "pryvee" (*Piers Plowman* 2.15, 23) in the papal palace at Avignon, she certainly takes on that role in the topsy-turvy moral landscape of the Visio, especially in contrast to Lady Holy Church (*Piers Plowman* 1).[88] In Italy, the Whore's association with corrupt ecclesiastics was repeatedly emphasized. Jacopone da Todi has *Ecclesia* lament that "the scandalous lives" of her "bastard sons" are the reason why "infidels call me 'the whore,' " and Dante condemns the simoniac popes in *Inferno* 19 by linking them with the woman that sits on the waters "puttaneggiar coi regi."[89] In his letter to Nelli, Petrarch similarly draws on this imagery to condemn the Avignon papacy: "The worst of all things are there in Babylon situated on the banks of the fierce Rhone, the famous, rather, the infamous prostitute who fornicates with the kings of the earth! You are indeed the very one that the Evangelist saw in spirit."[90]

This association of the Whore of Babylon and the false church culminates in the Protestant polemic of *The Faerie Queene,* where Spenser portrays Duessa, wearing a triple crown and a purple robe, riding on a seven-headed Beast that combines features of the demonic agents of Apocalypse 12 and 13:

> His tail was stretched out in wondrous length,
> That to the house of heavenly gods it raught;
> And with extorted power and borrowed strength,
> The ever-burning lamps from thence it brought
> And proudly threw to ground, as things of nought.
> And underneath his filthy feet did tread
> The sacred things and holy hests foretaught.
> Upon this dreadful beast with sevenfold head
> He set the false Duessa, for more awe and dread. (1.7.18)

[88]See D. W. Robertson, Jr., and Bernard F. Huppé, *Piers Plowman and Scriptural Tradition* (Princeton, 1951), 35–53.

[89]See Jacopone *Lauds* 54, p. 171; and Dante *Inferno* 19.106–8, in *The Divine Comedy,* ed. Charles S. Singleton (Princeton, 1970), 1.1:198–99: "committing fornication with the kings." In a contemporary but much more revolutionary treatment of this imagery, Fra Dolcino identifies the Whore of Babylon with the entire institutional church; see Bernard McGinn, "Apocalyptic Traditions and Spiritual Identity in Thirteenth-Century Religious Life," in *The Roots of the Modern Christian Tradition,* ed. E. Rozanne Elder (Kalamazoo, Mich., 1984), 29–31.

[90]In Coogan, *Babylon on the Rhone,* 91–92.

The contrast between "the face of falsehood" and Una, the true church, is particularly emphasized when the Red Cross Knight strips the "foul Duessa," who is revealed to be "a loathly, wrinkled hag" (1.8.46.8).

Probably because of John's memorable portrait of the Whore of Babylon, that city's association with fornication is taken for granted in much medieval literature. Thus the *Jour du Jugement* stages Antichrist's conception in a Babylonian brothel by a Jewish whore and a devil, Angingnars, who seduces her with the romance language of "courtoisie."[91] Less dramatic but more daring is the sequence by Hermann of Reichenau (1013–54) on the conversion of Mary Magdalene. Although not exactly the Whore of Babylon, Mary is portrayed as a foul whore *from* Babylon, whose perverse pleasures are cataloged in some detail. Mary is released from the demonic "bestiis de Babylonicis" when she washes Christ's feet. Her citizenship is then also transferred from Babylon to the New Jerusalem, which is the city where celestial maidens and angels dance and glorify God. As Peter Dronke comments, "The concluding vision, in effect, is one of earthly and heavenly beings alike dancing in the divine garland: Babylon is transmuted into Jerusalem in this dance, as it had been transmuted within, in the heart of the Magdalen."[92]

Whereas Babylon is identified with the Whore, the New Jerusalem is linked with a virtuous cosmic Woman who is described as "clothed with the sun, and the moon was under her feet, and upon her head a crown of twelve stars" (Apoc. 12:1). One of the most popular of the many apocalyptic agents, the *mulier amicta sole* is a dominant image not only in medieval art but also throughout medieval literature. Although at first primarily identified with *ecclesia*, the Woman could be associated with both the Church and the Virgin Mary by the early Middle Ages.[93] In his *Dialogue on Miracles*, Caesarius of Heisterbach (ca. 1180–1240) allegorizes Apocalypse 12 to equate Virgin and Woman:

> This woman is the Virgin Mary, brighter than the sun in the splendour of charity; the moon, that is the world, is beneath her feet to show her contempt for earthly glory; she is crowned with all the virtues as with a diadem gemmed with stars; and, a higher dignity than all these, she is pregnant with the Divine offspring.[94]

[91]*Jour du Jugement* 193–341, in Roy, *Mystère français*, 218–20.

[92]Dronke, *Medieval Lyric*, 47. For an edition, see Clemens Blume, *Liturgische Prosen des Mittelalters* (Leipzig, 1904), 204–6.

[93]Carol Falvo Heffernan argues in *The Phoenix at the Fountain: Images of Woman and Eternity in Lactantius's Carmen de Ave Phoenice and the Old English Phoenix* (Newark, Dela. 1988), 117–24, that the Old English *Phoenix* draws on the imagery of Apocalypse 12 to associate the Phoenix with both *ecclesia* and Mary. For interpretations of Apocalypse 12, see Ewald Vetter, "*Mulier amicta sole* und Mater Salvatoris," *Münchner Jahrbuch der bildenden Kunst* 9–10 (1958–59): 32–71.

[94]Caesarius of Heisterbach *The Dialogue on Miracles* 7.1, trans. H. von E. Scott and C. C. Swinton Bland (London, 1929), 1:453–54. See also "Miracle de la Nativite Nostre Seigneur Jhesu Crist," in *Miracles de Nostre Dame*, ed. Gaston Paris and Ulysse Robert, (Paris, 1876), 247.

This equation, which Bernard of Clairvaux developed in his sermon on the Assumption of the Virgin, is commonplace in the numerous lyrics praising Mary.[95] Hildegard extends the image of the pregnant *mulier amicta sole*, moreover, to mediate between Eve and Mary. In "O virga ac diadema," a sequence for the Virgin, she praises Mary for "the new sun" from her womb that cleanses "omina crimina Eve," while in *De operatione Dei*, she interprets the Dragon's rage against the Woman and her child (Apoc. 12:4) as representing Satan's envy and fear that Eve would be "the root of the whole human race." The Dragon thus "said to himself that he would never cease to pursue her until he had drowned her in the sea, as it were; for in the beginning he had deceived her."[96]

The portrayal of the Woman harassed by the Dragon is particularly popular in the Anglo-French illustrations of Apocalypse 12, where she resembles a romance heroine, a damsel in distress. Romance connections are similarly evident in *Li tornoiemenz Antecrit*, which among its cast of heroines includes the Virgin Mary, who is explicitly compared to the Woman described "en l'apocalipse."[97] In her conflict with the Dragon, the apocalyptic Woman is aided by the archangel Michael, who is the most important of the many angels that guide John, announce stages in his vision, and otherwise intervene in the cosmic action. William Caxton's translation of the *Golden Legend* exemplifies the high status accorded Michael in the late Middle Ages. It celebrates his great victories, past, present, and future, how "the archangel which bare the banner of the celestial host, came and chased Lucifer out of heaven," how he and the other angels continue to oppose devils in the present, to "fight for us against them, and deliver us from their temptations," and finally, how Michael will in the last days finally destroy Antichrist.[98] Michael's role as destroyer of Antichrist is the logical result of the identification of the Dragon's tail with Antichrist in much medieval exegesis and didactic literature.[99] Thus Michael the Dragon-slayer plays a crucial role not only at the beginning but also at the conclusion of history, in the Chester *Coming of Antichrist*, killing the pseudo-Christ in a scene that anticipates the cycle's concluding *Last*

[95]See, for example, the lyric sometimes ascribed to William of Shoreham, "Marye, mayde mylde and fre," in *Religious Lyrics of the Fourteenth Century*, ed. Carleton Brown, 2d ed., rev. G. V. Smithers (Oxford, 1952), 49 no. 32, lines 67–72. For Bernard, see "Dominica infra octavam Assumptionis B. V. Mariae Sermo" (*PL* 183:429–38).

[96]*De operatione Dei* 2.5.16 (*PL* 197:915); trans. Barbara Newman, *Sister of Wisdom*, 113. For "O virga ac diadema," see Barbara Newman, *Symphonia*, 128–31.

[97]Huon de Méry *Tornoiemenz Antecrit* 1405–87, pp. 64–65. Florence Sandler, in "The Faerie Queene: An Elizabethan Apocalypse," in *The Apocalypse in English Renaissance Thought and Literature*, ed. C. A. Patrides and Joseph Wittreich (Ithaca, N.Y., 1984), 156, discusses the ways in which Spenser's romance conflates Queen Elizabeth and Una with the Woman of Apocalypse 12.

[98]*William Caxton's The Golden Legend*, ed. F. S. Ellis (London, 1900), 188–90. On Michael's role in the death of Antichrist, see my *Antichrist in the Middle Ages*, 101–3.

[99]"Þe dragon es understanden þe fende / And his taille anticrist þat folowed at þe ende" (*Pricke of Conscience* 4425–26, ed. Richard Morris [London, 1865]).

Judgment play.[100] This scene also reminds us that Michael is commonly portrayed as the angel of judgment and that in the *Visio Pauli* he plays a crucial role as the "angel of the covenant" who leads the righteous souls into paradise.[101]

One of the most beautiful literary celebrations of this great apocalyptic hero is Alcuin's sequence composed for Charlemagne. The poet praises the archangel as "Prince of the citizens of heaven" and as the chief protector of Christians against Satan. In one rich stanza he alludes not only to the great heavenly battle between Michael and the Dragon (Apoc. 12:7–10) but also to the silence in heaven (Apoc. 8:1) that precedes the trumpets of doomsday and to the praise of the remnant (Apoc. 15:3–4):

> Tu crudelem cum draconem forti manu straveras,
> faucibus illius animas eruisti plurimas.
> hinc maximum agebatur in caelo silentium,
> millia millium et dicunt "salus regi domino."[102]

It is as Dragon-slayer, then, that Michael is most praised, and just as the Woman and the Whore play roles in medieval romance, so does Michael. For example, as one of the leaders of the forces of Esperance in the *Tornoiemenz Antecrit*, Michael captures Antichrist.[103] And although dragons threatening women who are rescued by dragon-slaying heroes are commonplace in medieval romances and should be associated with Michael and the Dragon only with caution, some, such as the seven-headed dragon and Red Cross Knight in *The Faerie Queene* are clearly dependent on the Apocalypse.

Even when the association is not explicit, medieval readers may have understood such dragons as modeled on the seven-headed Dragon. Sometimes the dragon/serpent may be identified by a distinguishing characteristic. The "twisted venomed snake" of the lyrical exorcism in the famous *Carmina Burana* manuscript, for example, has a sweeping tail (Apoc. 12:4) that "drew in his proud wake / One third part of heaven's stars":

[100]In *Chester Mystery Cycle* no. 23, lines 625–28. See my " 'Nowe ys common this daye': Enoch and Elias, Antichrist, and the Structure of the Chester Cycle," in *"Homo, Memento Finis": The Iconography of Just Judgment in Medieval Art and Drama*, ed. David Bevington et al. (Kalamazoo, Mich., 1985), 89–120.

[101]*Visio Pauli*, trans. Gardiner, *Visions of Heaven and Hell*, p. 21.

[102]Alcuin "Sequentia de Sancto Michaele" 21–24, ed. Waddell, *Mediaeval Latin Lyrics*, 100–101:

> Thou with strong hand didst smite the cruel dragon,
> And many souls didst rescue from his jaws.
> Then was there a great silence in heaven,
> and a thousand thousand saying "Glory to the Lord King."

[103]Huon de Méry *Tornoiemenz Antecrit* 1362–71, p. 63.

Omnis creatura phantasmatum
que corroboratis principatum
serpentis tortuosi,
venenosi,
qui traxit per superbiam
stellarum partem tertiam.[104]

Earlier, Notker Balbulus interpreted the "draco" in his sequence for the "Festival of Holy Women" by identifying it with the "serpens" that once deceived a woman.[105] As Michael Camille notes in his essay, the Anglo-French illuminated Apocalypses increasingly took on romance elements appealing particularly to female patrons. But just as the romances influenced Apocalypse illustrations, so Apocalypse imagery influenced romances. It is not surprising, for example, that in the *Queste del Saint Graal*, Bors, Galahad, and Perceval receive an apocalyptic vision of the winged Man, Eagle, Lion, and Ox—accompanied by a heavenly voice and a thunderclap—as evidence that they will succeed in their quest; nor is it surprising that at a time when French illuminated Apocalypses and *Bibles moralisées* were filled with seven-headed Dragons, the marvelous beast of the *Perlesvaus* became in the later grail romances of the mid-thirteenth century a dragonlike creature that, in one manuscript, is portrayed as a seven-headed dragon.[106]

The certainty of ultimate victory is one of the most common themes of the Apocalypse, which frequently follows the devastation of demonic agents with representations of their subjugation by divine agents, of the Dragon by Michael, of the seven-headed Beast by the Lamb, of Babylon by the New Jerusalem. As one critic has recently written, "The basic theme of Revelation was that of celestial order and stability versus terrestrial disorder and mutability. The vision of John was one of a progressively disintegrating world upon which the Salvation symbol of the Lamb, finally surrounded by the eternally stable New Jerusalem, had been imposed."[107] Thus, although it sometimes seems that the agents of evil crowd out those of good, the Apocalypse depicts several figures representing Christ not

[104]"Omne genus demoniorum" 5–10, trans. and ed. Waddell, *Mediaeval Latin Lyrics*, 210–11: "Every phantom creature, ye / Who hold the principality / Of that twisted venomed snake / Who drew with him in his proud wake / One third part of heaven's stars." See also Thibaut of Champagne's allusion to the strife between Gregory IX and Frederick II in his Chanson 56.31–40, ed. A. Wallenskold, *Les chansons de Thibaut de Champagne, roi de Navarre* (Paris, 1925), 196. In *Les faictz et dictz de Jean Molinet*, the "tres furieux dragon" is equated with "le Turc infidelle" (ed. Noel Dupue [Paris, 1936], 17).

[105]Notker Balbulus "In natale sanctarum feminarum," trans. and ed. in *Poetry of the Carolingian Renaissance*, ed. Peter Godman (Norman, Okla., 1985), 318–21.

[106]See *Queste of the Holy Grail*, trans. Matarasso, 243–45. For the romance dragon, see Bibliothèque nationale MS fr. 755, fol. 4ᵛ; discussed in Edina Bozoky, "La 'Bete Glatissant' et le Graal: Les transformations d'un thème allegorique dans quelques romans arthuriens," *Revue de l'Historie des Religions* 186 (1974): 141.

[107]Nichols, *Romanesque Signs*, 31.

only as the suffering savior but also as the victorious judge. The Lamb is particularly prominent in early Christian art (see Dale Kinney's essay), reverberating as well throughout the liturgy and medieval literature. It often represents the profound paradox of the weak and powerless in combat against the arrogant and mighty:

> Comment convenoit il que l'aignel tant benigne
> Fust mis a tel meschief et a mort tant indigne,
> Bien croy que tout fust fait pour vaincre le maligne,
> Et pour nous demonstre d'amour un certain signe.[108]

In medieval literature, the Lamb is associated with martyrs and virgins, particularly with dead children, probably because Apocalypse 14 is read at the Feast of Holy Innocents. Thus not only the Pearl-Maiden but also the young schoolboy who is killed by the "cursed folk of Herodes al newe" in Chaucer's *Prioress's Tale* (VII.574) are compared to the followers of the Lamb (Apoc. 14:4):

> O martir, sowded to virginitee,
> Now maystow syngen, folwynge evere in oon
> The white Lamb celestial—quod she—
> Of which the grete evaungelist, Seint John,
> In Pathmos wroot, which seith that they that goon
> Biforn this Lamb and synge a song al newe,
> That nevere, flesshly, wommen they ne knewe. (VII.579–85)

The marriage imagery associated with the Lamb could be appropriated as well by the mystic visionary, who thus becomes identified with the Bride of the Lamb. Thomas de Cantimpré's life of Lutgard of Aywieres, for example, relates how, during the service, the visionary perceived "that Christ, with the outward appearance of a lamb, was positioning Himself on her breast. . . . He would place His mouth on her mouth and by thus sucking would draw out from her breast a melody of wondrous mellowness."[109] In less personal terms, the apostles, martyrs, and the entire company of the elect who imitate the Lamb are identified as the Bride of the Lamb in Hildegard of Bingen's *Symphonia*. The Lamb is omnipres-

[108]"Rossignol" 201–204, the French version of John Pecham's *Philomena praevia*; see J. L. Baird and John R. Kane, *Rossignol: An Edition and Translation* (Kent, Ohio, 1978), 78–79:

> How could it be that such a gentle lamb
> Should be subjected to such a misfortune and such an unworthy death?
> All this was done, I know, in order to conquer the Evil One,
> And to give us a clear token of his great love.

[109]Margot King, ed. and trans., *The Life of Lutgard of Aywieres by Thomas de Cantimpré*, (Saskatoon, 1987); cited by Jeffrey Hamburger, "The Visual and the Visionary: The Image in Late Medieval Monastic Devotions," *Viator* 20 (1989): 168.

ent in the *Symphonia*, where, as in Hildegard's sequence for Saint Ur-
sula, the Lamb is an emblem not simply of passive suffering but also of
joyous victory:

> Hoc audiant omnes celi
> et in summa symphonia
> laudent Agnum Dei,
> quia guttur serpentis antiqui
> in istis margaritis
> materie Verbi Dei
> suffocatum est.[110]

In one of the most forceful poetic treatments conflating many victorious
images, Prudentius in his "A Hymn before Sleep" describes how the Lamb
of God wields a "flaming two-edged saber" (Apoc. 19:15) which is "death,
the first and second" (Apoc. 20:6). The Lamb is the avenger, the apocalyp-
tic judge:

> hic praepotens cruenti
> extinctor Antichristi,
> qui de furente monstro
> pulchrum refert tropaeum.[111]

But the poet seems less interested in the specific actions of the Lamb
than in John's vision, and his description emphasizes the visionary
power of John, who is unique among the disciples of Christ. Noting
that whereas the impious suffer terrifying dreams, the virtuous receive
visions revealing celestial secrets, Prudentius praises this supernatural
power:

> evangelista summi
> fidissimus Magistri

[110]In Barbara Newman, ed., *Symphonia*, 242–43:

> Let all the heavens hear it
> and praise God's Lamb in great harmony—
> for the neck of the ancient serpent
> is choked in these pearls
> strung on the Word of God.

See also "Responsory for the Apostles," 164–65; and "Antiphon for Martyrs," 170–71.
[111]Prudentius "A Hymn before Sleep" 101–4, in *Liber cathemerinon*, ed. Thomson,
Prudentius; trans. Eagan, *Poems of Prudentius*, vol. 1 (Washington, D.C., 1962), 43:

> With Antichrist He battles
> In conflict fierce and bloody.
> and from the raging Monster
> Brings back a splendid trophy.

signata quae latebant
nebulis videt remotis.[112]

Unlike other Christians, who, encumbered by the mundane, expect no
prophetic revelation but hope only for peaceful sleep, John's slumber is so
tranquil "that his mind with gift prophetic / Through all of Heaven wan-
dered" (115–16).

John as Visionary Model

Once a grammar of Apocalypse imagery, motifs, settings, and agents is
established, it is necessary to turn from the features of John's vision to the
role of John himself. He is, as I have noted, an actor within his vision, fall-
ing as if dead (Apoc. 1:17), weeping (Apoc. 5:4), eating the little book
(Apoc. 10:10), and adoring the angel (Apoc. 22:8). At first taken up "in
spirit" from his exile on Patmos (Apoc. 1:10), he is further taken "in
spirit" when already in vision (Apoc. 4:1–2; 17:3), a phenomenon that may
have influenced the dream-within-a-dream formula of Piers Plowman (11
and 16). The contemporary Anglo-French illuminated Apocalypses seem
particularly fascinated with John's role, portraying him not only as vision-
ary agent but also as a very active observer peering through clouds, win-
dows, and portals, responding to each new event with emotion and even,
in the Trinity College Apocalypse, aging during the action of his vision.[113]
In both literature and art, John occasionally seems to receive greater at-
tention than many features of his vision, being most prominently por-
trayed, for example, in the right panel of Hans Memling's Mystic Marriage
of Saint Catherine triptych (fig. 57).[114]
 Although Eusebius of Caesarea and some other early Christians ques-
tioned both the canonical status of the Apocalypse and John the Evange-
list's authorship, in the early Middle Ages such questions were swept away
and John was given a legendary life that emphasized his status as visionary
and contributed to his extraordinary prominence. According to Gregory of
Tours, after Domitian's death, John returned from exile not to die but to

[112]Lines 77–80, trans. Eagan, ibid., 42:

> That faithful friend of the Master,
> Evangelist of the Highest,
> Saw through the clouds receding
> Things sealed from mortal vision.

[113]Cambridge, Trinity College MS.R.16.2; no. 50 in Richard Kenneth Emmerson and
Suzanne Lewis, "Census and Bibliography of Medieval Manuscripts Containing Apoca-
lypse Illustrations, ca. 800–1500," pt. 2, Traditio 41 (1985): 376–77. For a facsimile, see
Peter Brieger, The Trinity College Apocalypse (London, 1967).
[114]See Frederick van der Meer, Apocalypse: Visions from the Book of Revelation in
Western Art (New York, 1978), 258–71.

climb "into the tomb while still alive. It is said that John will not expe-
rience death until our Lord shall come again at the Judgement Day, for he
himself said in his Gospel: 'I will that he tarry till I come.' "[115] This leg-
endary detail is the kind of experience usually reserved for the great apoc-
alyptic players, rather than for the visionary himself—for Enoch and Elias
who await Antichrist in the earthly paradise, or for the seven-headed Beast
whose death wound is healed (Apoc. 13:3). John's special relationship with
Jesus is also stressed and directly related to his ability to clarify the mys-
teries of heaven:

> Seynt Iohn, that was a martyr fre,
> on Crystis lappe a-slepe lay he,
> of hevyn he saw þe preuete,
> aduocatur conviuio.[116]

As Aldhelm emphasizes, John was "The outstanding disciple of Christ
the King, coming before all the others, beloved with great affection."[117]
As his namesake John the Baptist explains to a nun in a vision recorded
by Caesarius of Heisterbach, John was blessed with the power to reveal in
the Apocalypse "the very deepest things in heavenly pictures."[118] John's
roles as beloved evangelist and as privileged revelator are thus almost al-
ways linked, perhaps suggesting to later visionaries that faithful devotion
to the Lamb and attention to the Apocalypse will be rewarded with vision-
ary gifts.

John's Apocalypse, in fact, becomes the book that holds the future. His
visions, as Aldhelm notes, "are now written on parchment and read
throughout the world."[119] As the most important visionary book in the
Middle Ages, it was associated with the book with seven seals which it so
vividly describes, the book that, as Prudentius states in the *Liber cathe-
merinon*, reveals the future:

> ipsum Tonantis agnum
> de caede purpurantem,

[115]Gregory of Tours *Historia francorum* 1.26, p. 85. On canonicity and authorship, see
Robert M. Grant, *Eusebius as Church Historian* (Oxford, 1980), 126–27; and Minnis,
Medieval Theory of Authorship, 132–33.

[116]"Saint John, who was a noble martyr, / on Christ's lap asleep lay he, / he saw the
privacy of heaven; / he is called to the banquet." "A Song for the Epiphany" 9–12, in
Religious Lyrics of the Fifteenth Century, ed. Carleton Brown (Oxford, 1939), 122. See
also Hildegard "O dulcis electe," ed. Barbara Newman, *Symphonia*, 169; and the Chester
Prophets of Antichrist 22:173–80 (see n. 29 above).

[117]Aldhelm "On the Altars of the Twelve Apostles" 5.10, in *Carmina ecclesiastica*,
trans. Michael Lapidge and James L. Rosier, *Aldhelm: The Poetic Works* (Cambridge,
1985), 53.

[118]Caesarius of Heisterbach *Dialogue on Miracles* 8.51, 2:51.

[119]Aldhelm "On the Altars" 5.16, p. 53.

 qui conscium futuri
 librum resignat unus.[120]

Except that the book is no longer sealed. John has made it his own, and the
angel commands: "Do not seal up the words of the prophecy of this book:
for the time is at hand" (Apoc. 22:10). Thus open and ready to be inter-
preted, the book became the touchstone for later "prophets." Joachim of
Fiore's sudden understanding of "the fullness of this book" is well known,
and its meaning obsessed many others, such as the enigmatic John of
Rupescissa, who, according to Jean Froissart, "claimed to prove his utter-
ances by the Apocalypse."[121] Later, on the eve of the Reformation, Roger
Dods, who according to the register of Bishop Longland was aware of "a
certain story of a woman in the Apocalypse, riding upon a red beast," testi-
fied that a vicar taught him to read so that " 'he should have understand-
ing in the Apocalypse, wherein he said, that he should perceive all the false-
hood of the world, and all the truth.' "[122] Less radical if equally eccentric
visionaries, such as Hildegard of Bingen and Hadewijch of Brabant, also
understand John's experience as a model for their own, describing how they
are "taken up in the spirit" and hear voices "like thunder" (Apoc. 6:1).[123]
 It is more difficult to ascertain the extent to which John as visionary in-
fluenced the conception and portrayal of the first-person narrators that
characterize the many spiritual quests and dream visions of the later Mid-
dle Ages. In his essay below, Ronald Herzman suggests that the Apoca-
lypse may be understood as a model for Dante's *Commedia*, and Peter
Hawkins has recently compared Dante at the end of *Purgatorio* to John:
"For just as John *in spiritu* discerned in the midst of seven golden lamp-
stands one like the Son of Man, who commands him to write down what
he will be shown of 'what is and what is to be hereafter' (Rev. 1:19), so the
pilgrim is soon to be called by Beatrice, first to behold an apocalyptic vi-
sion and then to write about it: 'ritornato di la,' she says, 'fa che tu scrive'
(*Purg.* 32.105)."[124] Certainly, the repeated commands to write which John

[120]Lines 81–84, trans. Eagan, *Poems of Prudentius* 1:42:

 The Lamb of God empurpled
 With blood of cruel slaying,
 Him who alone can open
 The book that holds the future.

[121]Joachim of Fiore *Expositio in Apocalypsim* (1527; reprint, Frankfort on Main, 1964),
fol. 39ᵛ; trans. McGinn, *Visions of the End*, 130. Jean Froissart *Chronicles*, trans. Geof-
frey Brereton (New York, 1969), 165–66.
[122]See John Foxe *Acts and Monuments*, ed. George Townsend, vol. 4 (reprint, New
York, 1965), 237; and Sharon L. Jansen, *Political Protest and Prophecy under Henry VIII*
(Woodbridge, Suffolk, 1991).
[123]Hadewijch, Vision 11, in Hart, *Hadewijch*, 289.
[124]Peter S. Hawkins, "Scripts for the Pageant: Dante and the Bible," *Stanford Litera-
ture Review* 5 (1988): 85. John Freccero has drawn an analogy between the concluding
roles of the Apocalypse in Scripture and *Paradiso* in the *Divine Comedy*; see his "An
Introduction to the *Paradiso*," in *Dante: The Poetics of Conversion*, ed. Rachel Jacoff
(Cambridge, Mass., 1986), 216.

received from the angel guides (Apoc. 1:19, 2:1, 2:8, 2:18, 3:1, 3:14, 14:13, 19:9, 21:5) may have served as injunctions for later visionaries, who, like Will in *Piers Plowman*, seem compelled to write what they see: "Thus I awaked and wroot what I hadde ydremed" (19.1). Moreover, although Barbara Nolan is right that, strictly speaking, the obtuse narrator in *Pearl* is "no St. John in his visionary journey," he is clearly modeled on John, who right to the end of his vision continues to ask questions and even blunder in attempting to worship the angel.[125] John's ghost haunts this most moving and resplendent apocalyptic poem, especially in its description of the New Jerusalem, where "John" is the concatenating word that links stanzas 82–87 and where the narrator repeatedly compares his experience to the Revelator's. Another explicit equation of John and visionary poet is drawn by John Gower, who concludes the Prologue to the first book of his "prophetic" *Vox clamantis* with the following request: "Insula quem Pathmos suscepit in Apocalipsi, / Cuius ego nomen gesto, gubernet opus."[126] The poet clearly identifies with John, not only by name but also by vocation.

Finally, the Apocalypse may have influenced the medieval conception of "the book" as a symbol of political, religious, and natural totality and unity. Like William the Conqueror's "Domesday Boke," as Penn Szittya shows in his essay below, its symbolic value takes on mythical proportions. The book provides principles of order, becoming the basis for both judgment of the past and prophecy of the future. It is particularly influential in visionary works. In his life of Saint Nicetius, for example, Gregory of Tours relates how in a vision the saint witnessed an angel holding a massive book that enumerated all the Frankish kings.[127] Similarly, the "Dies Irae" refers to the Book of Apocalypse 20:12 as that in which "the total is contained," suggesting that all salvation history is providentially set forth in the book of life.[128] Because the blessed are not only those who are inscribed within the book of life but also those who keep "the words of the prophecy of this book" (Apoc. 22:7), that is, of the Apocalypse, the two books serve analogous purposes. Of course the Apocalypse is also the "Revelation of Jesus Christ," so that both the book of John's prophecy and the book of life can be associated with Christ. Thus, in one poetic line, Jacopone da Todi has Christ identify himself with two prominent apocalyptic books—"I am the book of life, sealed with the seven

[125]Barbara Nolan, *Gothic Visionary Perspective*, 196. For possible influence on the spiritual quests, see 139–40; and Forrest S. Smith, *Secular and Sacred Visionaries in the Late Middle Ages* (New York, 1986), 11–12.

[126]Gower *Vox clamantis* 1.prol.57–58; trans. in Stockton, *Major Latin Works of John Gower*, 50: "May the one whom the Isle of Patmos received in the Apocalypse / And whose name I bear, guide this work." For a comparison of Gower's prologue with Gilbert of Poitiers's Apocalypse prologue, see Minnis, *Medieval Theory of Authorship*, 168–77.

[127]See Gregory of Tours *Life of the Fathers*, trans. Edward James (Liverpool, 1985), 119. Gurevich argues, in *Medieval Popular Culture*, that "the 'book of life' mentioned here is an obvious borrowing from Revelation" (115).

[128]"Dies Irae" 15; trans. Connelly, *Hymns of the Roman Liturgy*, p. 254.

seals"—suggesting that he is a universalizing book, one "that all men may read, / And all will profit from its reading."[129] These books and the Word are all embracing, unified by their totality and sufficiency, so that the Apocalypse is also "The Revelation [in] Jesus Christ."

The fierce curse that concludes the Apocalypse, warning future genera-
tions not to change the prophecy (Apoc. 22:18–19), also implies that this book is understood to be a perfect unity and totality, a divine prophecy not to be changed by human agency. At the conclusion of his *Historia franco-
rum*, Gregory of Tours echoes this curse, but it is most closely appropri-
ated by Hildegard: "Therefore, if anyone of his own accord perversely add anything to these writings that goes beyond their clear intent, he deserves to be exposed to the punishments here described; or if anyone perversely remove any passage from them, he deserves to be banned from the joys that are here shown."[130] The deadly seriousness of this warning suggests that even for a visionary such as Hildegard, who emphasized the aural and visual elements of her prophecies, the totality and unity of the written "book" is inviolate. In a more positive allusion to Apocalypse 22:12, the pilgrim poet, having reached the Empyrean in the concluding canto of *Paradiso*, witnesses in the "Eternal Light" the "universe" of all creation "legato con amore in un volume."[131] This universalizing book serves as a fitting emblem not only for Dante's great visionary poem of God's justice and love but also for the Apocalypse and its multiform influence on the book of medieval culture.

[129]Jacopone *Lauds* 40, p. 141.
[130]Hildegard *Liber vitae meritorum*, trans. Dronke, *Women Writers*, 160. For Gregory of Tours, see *Historia francorum* 10.31, trans. Thorpe, *History of the Franks*, 603. Richard Landes suggests in "Lest the Millennium be Fulfilled: Apocalyptic Expecta-
tions and the Pattern of Western Chronography, 100–800 CE," in *Use and Abuse of Eschatology*, ed. Verbeke, Verhelst, and Welkenhuysen, 167, that Gregory's insistence that his *Historia* not be changed is related to its potentially being misused in support of millenarianism.
[131]Dante *Paradiso* 33.86, ed. and trans. Singleton, *Divine Comedy* 3.1:376–77: "bound by love in one single volume." See Jesse M. Gellrich, *The Idea of the Book in the Middle Ages: Language Theory, Mythology, and Fiction* (Ithaca, N.Y., 1985), 157–66.

The Apocalypse and
the Medieval Liturgy

C. CLIFFORD FLANIGAN

This essay takes its point of departure from what, at least on first consideration, seems an extraordinary paradox. As the other essays in this book demonstrate, the biblical Apocalypse had an enormous influence on many areas of medieval culture. Yet, at least on first consideration, its impact on the medieval liturgy seems minimal. This claim needs immediate qualification, however. Liturgy is not only what is written in the pages of a liturgical book. It includes the visual elements of a ritual space, what the faithful see as they perform the rites or as they enter a church to do so. It also includes often unwritten elements, such as customary (and therefore unwritten) actions and texts, which frequently are to be found only in separate books or which simply had memory as their source. Certainly scenes from the Apocalypse adorned church walls and altarpieces, and quotations from it and verbal echoes of its texts are to be found in many hymns from throughout the Middle Ages. Yet if we turn to the texts regularly used in liturgical celebration, we discover that aside from monastic *lectio continua*, in which the entire Scripture was read more or less sequentially in the course of a year, the Apocalypse was seldom used for the lessons in the eucharistic celebration or in the Divine Office.

There are, of course, notable exceptions to this claim. In the ordinary (that portion of the liturgical texts which remains substantially the same throughout the year), echoes of the book can be found in the Sanctus. Within the proper (those parts of the text of the rite which are used only on a specific occasion), the biblical book left its mark in a major way only on a few days. It was frequently evoked in the rites for the dedication of new churches, where accounts of the heavenly architecture as described by John were recited in order to sacralize the new space for worship. Here, for example, is a responsory from the matins office for this occasion and for

the annual commemoration of the dedication of a church: "I saw the holy city, the new Jerusalem, descending from heaven, prepared by God.* And I heard a voice from the throne saying, 'Behold the tabernacle of God with men, and it will dwell with them.' "[1]

To this piece, various versicles were added in different medieval liturgical manuscripts. The performance of a responsory involved intertwining of the main respond text (as given above) with repeated chantings of its final section (indicated here by an asterisk), the versicle attached to it, and the first half of the Gloria Patri. Here are the most frequent versicles joined with this quotation from the Apocalypse to form a complete responsory:

> And he who was sitting on the throne said "Behold I make all things new." And I heard. . . .
>
> I saw the new heaven and the new earth, and the holy city Jerusalem descending from the heavens. And I heard. . . .
>
> I saw the city of Jerusalem descending from heaven, adorned as a bride for her groom. And I heard. . . . [2]

The Apocalypse had an even more pervasive influence on the liturgy for All Saints Day, a festival that celebrated the whole body of the saints, those whose names were widely known and those known only to God. As a feast instituted relatively late in the history of the liturgy, its texts are primarily taken from the texts of already established feasts of individual saints and categories of saints, especially for virgins and for martyrs. Yet some new texts were provided for this occasion, and these were mostly adapted from the Apocalypse. The usual epistle reading at the eucharistic liturgy, for example, was Apocalypse 7:2–12. In the shorter day hours of the office, the brief "chapter" selections are taken over directly from John's book, and the majority of the antiphons that frame the psalms recited at lauds and vespers are either strightforward quotations or reworkings of pieces from the Apocalypse. But again it is in the matins responsories that the Apocalypse is most fully exploited to provide a kind of sung ritual commentary on the celebration. Not surprisingly, many of these texts, coming as they do from a monastic milieu, emphasize the role

[1] "Vidi civitatem sanctam Jerusalem novam descendentem de caelo a Deo paratam, et audivi vocem de throno dicentem, Ecce tabernaculum Dei cum hominibus, et habitabit cum eis" (Rene-Jean Hesbert, *Corpus antiphonalium officii* [Rome, 1963–79], 4:459).

[2] V: Et ait qui sedebat in throno: Ecce nova faceo omnio. Et audivi. . . .

V: Vidi caelum novum et terram novam, et civitatem sanctam Jerusalem descendentem de caelis. Et audivi. . . .

V: Vidi civitatem Jerusalem descendentem de caelo, ornatam tanquam sponsam viro suo. Et audivi . . . (ibid.).

of virginity in the making of a saint. Here is a typical example, again with possible alternative versicles used in different geographic locations:

> One hundred and forty-four thousand were taken from the earth. These are those who have not defiled themselves with women. They remained virgins. Therefore they are reigning with God, and the Lamb of God is with them.
>
> V: These are they who have come from the great tribulation and have washed their robes in the blood of the Lamb. Therefore they were taken. They remained virgins. . . .
>
> V: And no falsehood was found in their mouths. They are without stain before the throne of God. Therefore they are reigning. . . .
>
> V: I saw the Lamb standing on Mount Zion, and with him a hundred and forty-four thousand. These are those who have not defiled themselves. . . . [3]

Perhaps the most interesting, as well as the most complex, use of the Apocalypse in the medieval liturgy occurs in the Feast of the Holy Innocents on 28 December. This holy day commemorates the slaying of the children of Bethlehem by order of Herod the Great in his vain attempt to kill the baby Jesus (Matt. 2:16–18). The "historical" basis of the Holy Innocents Day (most contemporary exegetes read Matthew's story as a symbolic or theological account rather than as a report of actual events) is patently grim, but since the feast occurs within the Christmas cycle, there was an inevitable tendency to give it a joyful coloration. Thus there is a certain ambiguity about this holy day, an ambiguity seen in the later medieval practice of celebrating it in one of two ways, depending on when in the week it fell. If, in a given year, it occurred on a Sunday, it was celebrated as a triumph of martyrs, with red vestments and the singing of the Gloria in excelsis Deo, the Alleluia before the gospel, and the *Ite missa est* in the Mass. But the feast was kept as a penitential rite, with purple vestments and without the joyful solemn chants, if it fell on a weekday. Yet neither aspect of the feast was ever completely expunged from its medieval celebration, and the means by which the tragic temporal and the

[3] Centum quadraginta quatuor milia qui empti sunt de terra hi sunt cum mulieribus non sunt coiniquinati, virgines enim permanuerunt, ideo regnant cum Deo, et Agnus Dei cum illis.

V: Isti sunt qui venerunt ex magna tribulatione, et laverunt stolas suas in sanguine Agni. Ideo empti. Virgines enim permanuerant. . . .

V: Et in ore ipsorum non est inventum mendacium; sine macula sunt ante thronum Dei. Ideo . . .

V: Vidi supra montem Sion Agnum stantem, et cum eo quadraginta quatuor milia. Hi sunt . . . (ibid., 70).

joyful eschatological themes were fused was the incorporation of the account of John's apocalyptic vision of the martyrs at the heavenly liturgy into Matthew's narrative. This fusion can be seen already in Prudentius's (348–ca. 410) mannered yet lovely *Cathemerinon* 12, in which the image of the innocents as *"flores martyrum"* (martyr-flowers) whom the persecutor of Christ destroyed "lucis ipso in limine . . . ceu turbo nascentes rosas" (on the very threshold of life . . . as the stormy wind kills roses at their birth) is combined with an image in which it is said to these children that "aram ante ipsam simplices / palma et coronis luditis" (you now play with palms and crowns before the altar in innocence), apparently in a kind of eternal childhood in the heavens.[4] Prudentius's text passed into the medieval liturgy when, in revised form, it became an office hymn for the Christmas cycle.

The epistle reading for the medieval Holy Innocents eucharistic rites, Apocalypse 14 beginning at verse 1, describes the virgin martyrs who follow the Lamb. In this way, the gospel reading, Matthew's account, was given an eschatological perspective. The antiphon and psalm verse of the introit for the day is taken from Psalm 8, where it is said, "Out of the mouth of babes, O God, and of sucklings, You have perfected praise because of your enemy." Thus the very beginning of the Mass marks the triumph of these first Christian martyrs. There is, of course, no specific reference to John's Apocalypse in these words, but the sequential experience of the liturgical texts by worshipers would likely lead to the melding of John's eschatological perspective with that of the epistle reading so that the psalm verses of the introit could be understood as the song the innocents sing as they follow the Lamb in the performance of the heavenly liturgy. The use of the Apocalypse in the office liturgy is more explicit, especially in the psalm antiphons of lauds and vespers. In one of these, for example, the innocents are described as those "nursing children who were murdered by the wicked king for the sake of Christ, and who follow the Lamb who is Himself without spot; they constantly sing 'Glory to You, O Lord.' "[5] Another psalm is framed with this antiphon: "They will walk with me in white robes, because they are worthy, and I will not erase their names from the book of life."[6] Yet another reports that "under the throne of God all the saints cry out 'Avenge our blood, O our God.' "[7] These antiphons provide excellent examples of how the medieval liturgy appropriated biblical materials to create an environment that then served in turn to interpret the verses themselves. These antiphons do not consist of di-

[4]*Prudentius*, vol. 2, ed. and trans. H. J. Thompson (Cambridge, Mass., 1949), 110f.

[5]"Innocentes pro Christo infantes occisi sunt, ab iniquo rege lactantes sunt, ipsum sequuntur Agnum sine macula, et dicunt semper, Gloria, tibi, Dominus" (Hesbert, *Corpus antiphonalium officii*, 3:286).

[6]"Ambulabunt mecum in albis, quoniam digni sunt, et non delebo nomina eorum de libro vitae" (ibid., 44).

[7]"Sub throno Dei omnes sancti clamant: Vindica sanguinem nostrum, Deus noster" (ibid., 493).

rect quotations from the Apocalypse; yet they are filled with echoes and references to that text. And though in some cases they make no explicit reference to the innocents, the liturgical context makes it inevitable that they be understood as descriptions of them. Perhaps the culmination of this kind of interpretative interplay between the story of the innocents, the text of the Apocalypse, and the ever-shifting perspectives of the Christmas liturgy is to be found in the moving twelfth-century *Ordo Rachalis*, a so-called "liturgical drama" about the innocents preserved in the *Fleury Playbook*.[8]

Striking as these examples are, they are minority voices. If we look at the totality of texts of the medieval liturgy, it is clear that the impact of the Apocalypse is decidedly limited; statistically speaking, references to it are relatively rare. This weak influence is especially surprising if we look at the biblical book through the prism of medieval liturgiology. It is customary to speak of three different kinds of medieval liturgical books: texts of the liturgy, such as sacramentaries, antiphonaries, and lectionaries; texts that describe the actions that must be performed in liturgical celebration, such as directories, agendas, customaries, and calendars; and finally, interpretations of the liturgy, books that explain why a certain text appears in the cursus or why the rubrics demand a particular gesture. There are bits and pieces of such explanations from Christian antiquity, but this latter genre first became popular in the ninth and tenth centuries. Its most famous and influential example is the *Liber officialis* of Amalarius of Metz, in which allegory is used to produce elaborate explanations of liturgical words and actions.

These types of texts certainly postdate the biblical Apocalypse. Our earliest texts for liturgical celebration stem from the second century, and fullfledged books describing ritual actions or systematic interpretations of rites do not appear until the early Middle Ages. Yet it is possible to find predecessors of all three types in the Apocalypse itself. The liturgical character of John's book is universally acknowledged; indeed a generation ago Massey Shepherd argued that it had its source in a primitive paschal celebration.[9] John's Apocalypse contains many pieces with a clear doxological character which have seemed to most modern interpreters to be based on a primitive Christian liturgy. Examples of such pieces include the acclamation near the beginning of the book, "To him who has loved us and washed us from our sins in his own blood, and made us to be a kingdom, and priests to God his Father—to him belong glory and dominion for

[8]Karl Young, *The Drama of the Medieval Church*, vol. 2 (Oxford, 1933), 110–13. For studies that seek to situate this text in its complex relationship to medieval biblical interpretation and the liturgy, see Robert Guiette, "Reflexions sur le drama liturgique," in *Mélanges offerts à Rene Crozet*, vol. 1, ed. Rene Gallais and Yves-Jean Fous (Poitiers, 1966), 197–202; and my "Rachel and Her Children: From Biblical Text to Medieval Music Drama," in *Metamorphosis and the Arts*, ed. Breon Mitchell (Bloomington, Ind., 1979), 31–42.

[9]Massey Shepherd, *The Paschal Liturgy and the Apocalypse* (Richmond, Va., 1960).

ever and ever. Amen" (Apoc. 1:5–6), and the liturgical song of the Four Living Creatures, "Holy, holy, Holy, the Lord God almighty, who was and who is and who is coming" (4:8), as well as the song of the Elders, spoken from their thrones surrounding the heavenly altar, "Worthy art thou, O Lord our God, to receive glory and honor and power, for thou hast created all things, and because of thy will they existed and were created" (Apoc. 4:11).

Such liturgical pieces are frequently accompanied by descriptions of ritual actions. According to John, the chief heavenly throne is surrounded by twenty-four thrones. The Elders who occupy these thrones wear white vestments and golden crowns. At appropriate moments in the heavenly liturgy, different participants move in various directions, bow, rise, prostrate themselves, and assume other typical ritual postures. Incense is often burned and censors are swung. Indeed, one of the chief concerns of the book seems to be to describe the ritual actions of the heavenly liturgy. In addition to such descriptions of liturgical actions, there are brief explanations and interpretations of the heavenly ritual which in many ways anticipate the kinds of explanations we find in medieval liturgical commentaries. For example, an Elder explains the identity of the people in white vestments who suddenly break into the ritual: "These are they who have come out of the great tribulation, and have washed their robes and made them white in blood of the Lamb" (Apoc. 7:14). And even closer to the moralizing spirit of medieval liturgical commentators are those interpretations in which, for example, we are told that the Bride is clothed with linen, "for fine linen is the just deeds of the saints" (19:8), or that the Lamb has seven horns and seven eyes, "which are seven spirits of God sent forth into all the earth" (5:6), or that the golden bowls of incense held by the Elders "are the prayers of the saints" (5:8). The presence of such elements in the biblical book, elements seldom found elsewhere in the New Testament and never in such profusion, make more urgent the question of why the Apocalypse should have made so little impact on what we might call both the theory and the practice of the liturgy in the Middle Ages.

In seeking an answer to this question, it is perhaps useful to turn briefly to some paradigmatic notions about religion and ritual which prevail in recent cultural theory. Religion, Clifford Geertz has said, is "a system of symbols which acts to establish powerful, pervasive, and long-lasting moods and motivations in men by formulating conceptions of a general order of existence and clothing these conceptions with such an aura of factuality that the moods and motivations seem uniquely realistic."[10] Rituals are among the chief practices by which a religion accomplishes this purpose. Practitioners of a ritual usually think of their religion "as encap-

[10]Clifford Geertz, *The Interpretation of Cultures: Selected Essays*. (New York, 1973), 90.

sulated in these discrete performances which they exhibit to visitors and to themselves." Rituals, then, are models of a society's structure and system of values. As such, they have the utilitarian purpose of conveying a characteristic way of understanding the world which enables its practitioners to be sustained in their beliefs. Liturgies are thus by no means devices separated from the rest of life. For this reason, the proper object of liturgiological scholarship must be the way in which specific rituals support and communicate a world understanding. To quote Geertz once again, "The tracing of the social and psychological role of religion is thus not so much a matter of finding correlations between specific ritual acts and specific secular social ties. . . . More, it is a matter of understanding how it is that men's notions, however implicit, of the 'really real' and the dispositions these notions induce in them, color their sense of the reasonable, the practical, the humane, and the moral."[11]

This orientation suggests that the task before us is to explore some of the ways in which the ritual experience encoded in the Apocalypse served the purpose of world construction for Christians of the first century and then to speculate on why it did so only partially for Christians in the Middle Ages. We begin with the obvious observation that John's book is an apocalypse and that it manifests most of the markers of that genre so popular with Jewish and Christian audiences in the centuries preceding the beginning of the Common Era (see Bernard McGinn's introductory essay). But unlike other apocalypses, John's presents its message in a liturgical setting. Although such a setting has literary precedents (cf. Isaiah 6), ritual plays a uniquely pervasive role in John's texts, where the vision of what is to come is identical to what is happening at the present moment in the heavenly liturgy. For example, one of the devices used in the Apocalypse to reveal the future is the opening of a number of seals on a book held by the Lamb, and this device is wholly inserted in a ritual context: the Lamb appears before the main throne and the Elders. He takes the scroll from the One sitting on the throne, and this ceremonial action causes the Four Creatures and the twenty-four Elders, with harps in one hand and censors in the other, to prostrate themselves before the Lamb and sing the great acclamation "Worthy art thou to take the scroll and to open its seals; for thou wast slain, and hast redeemed us for God with thy blood, out of every tribe and tongue and people and nation, and hast made them for our God a king and priests, and they shall reign over the earth" (Apoc. 5:9–10). Then another group, the thousands of thousands, sing another doxology, and this in turn is followed by a hymn and its liturgical culmination in the Elders' "Amen." Only then are the seals broken, and several pageantlike scenes follow. But even in these scenes, the liturgical setting is not forgotten. In the vision associated with the fifth seal, the "souls of those who had been slain for the word of God" appear under the altar, and they are

[11]Ibid.

given ceremonially appropriate white vestments (6:9f). Similarly, when the sixth seal is opened, the ensuing destruction makes everyone beg to be hidden "from the face of him who sits upon the throne" (6:16). In the final third of the book, where phantasmagoric image is piled upon phantasmagoric image, the liturgical setting might seem lost; but after the great scene of the fall of Babylon, the narrative reminds us that these visions are granted as part of a ritual setting. The multitude sings yet another hymn ("Alleluia! salvation and glory and power belong to our God. For true and just are his judgments"), and this hymn is followed by a number of responses and doxologies (19:1ff). Even in its final vision of a new heaven and a new earth, with its abolition of the Temple and the usual forms of ritual celebration, the apocalyptic vision of the book is grounded in the liturgical; for in the new creation, there remains "the throne of God and of the Lamb" (22:3); thus the heavenly liturgy is continued, albeit in a new key.

It is customary to think of the biblical Apocalypse as oriented toward the future, and at one level this is obviously so; but to over emphasize the book's distinction between the horrendous present and hopeful future is to minimize unduly its liturgical setting. Once the letters to the seven churches have been completed, the vision of "what must take place after this" is given only when the seer accepts the invitation to "come up hither" and so finds himself "in the spirit" and present before the throne at which the heavenly liturgy is celebrated. The architectural arrangement of this heavenly church has striking similarities with what we know about Christian assemblies in the century after John wrote, where the eucharist was celebrated presided over by a bishop from his throne, surrounded by his elders. Rather than speak of a dichotomy between past and future in the Apocalypse, it would perhaps be more adequate to speak of a liturgical sense of time in which past and present seem inextricably mixed, so that what is expected in the future is experienced in the present celebration of the cult. For example, the close connection between the visions and the ritual celebration is emphasized by the seer's report that his apocalyptic experiences occurred when he was "in the spirit" on "the Lord's Day," Sunday, when both heaven and earth celebrated the Resurrection of Christ as inaugurating a new era. In the Hebrew prophetic literature, the term *the Lord's Day* designates the moment of divine intervention in human history (cf. Amos 5:18–20, Isa. 2:12, and Zeph 1:7). John himself suggests such eschatological connotations in Apocalypse 16:14, where he describes the great destruction that is to befall the earth as "the great day of the Almighty God." The Pauline corpus also repeatedly designates the *parousia* of Christ as "the day of the Lord" (1 Thess. 5:2; 2 Thess. 2:2; 1 Cor. 5:5; 2 Cor. 1:14). This falling together of the senses of the term *day of the Lord* suggests that to celebrate the Resurrection of Jesus on the Lord's Day is to experience already the day of the Lord which marks the eschatological turning of the ages. Here, ritual celebration is not only oriented toward the

future (as medieval ritual celebration generally was not), but it is the actual experience of that future.

The conjunction of present and future is not unique to John, since his words are to be read to the churches of Asia Minor, presumably when the congregation assembled on the Lord's Day. The conclusion of the book seems also to anticipate a liturgical consumption of this text, and what we know of the early reception of the book certainly confirms this impression. And as Jean Daniélou showed in his still-definitive study of the notion of the eighth day in early Christian communities, Sunday was marked as a time for eschatological thought and for the realization of the future *eschaton* in the worship of the community. The celebration of the Resurrection provided a foretaste of the anticipated resurrection of all humans and the entire cosmos.[12] Later eras considered the biblical Apocalypse a very peculiar book indeed, one that required special techniques of interpretation. But the Church of the first two centuries, whatever other difficulties it had with the book, understood how it ties together the liturgical and the eschatological. This eschatological sense of liturgy in the early Church has been strikingly described by Alexander Schmemen:

> The messianic Kingdom or life in the new aeon is "actualized"—becomes real—in the assembly of the Church, in the *ecclesia*, when believers come together to have communion in the Lord's body. The Eucharist is therefore the manifestation of the Church as the new aeon. It is participation in the Kingdom as the *parousia*, as the presence of the Resurrected and Resurrecting Lord. It is not the "repetition" of His advent or coming into the world, but the lifting up of the Church into his *parousia*, the Church's participation in His heavenly glory.[13]

From this perspective we can reconstruct something of that world of meaning which participation in the liturgy offered the early Christians. Here there is no absolute division between past, present, and future; for what has happened in the past becomes the basis for the present experience of the future. Time is not something wholly corrupt, but the arena in which a cosmic salvation is being worked out. Salvation is not an escape from time but an experience of the saving future in the present moment of worship. The world certainly stands under judgment; the times are evil; but these beliefs are held only in connection with a radical belief in the redemption of the world and John's new heaven and new earth. Salvation is not so much a matter for the individual "soul" as for great collectives playing out their roles in a larger scheme of things. Ritual in the Apocalypse mediates an understanding of things which is strongly subversive of established political and cultural institutions; indeed to participate in the

[12]Jean Daniélou, *The Bible and the Liturgy* (Notre Dame, Ind., 1956).
[13]Alexander Schmemen, *Introduction to Liturgical Theology* (New York, 1966), 57.

liturgy is to experience in advance the overthrow of those institutions in favor of a wholly different scheme of things, one that is believed to be divinely ordained.

What the seer of the Apocalypse anticipated did not, of course, come to pass. The Church's developing self-understanding was reflected in its changing forms of worship and was communicated through these changed forms. Skipping more than a half-millennium between the time of the writing of John's book to a period that saw the development of the medieval liturgy, we see a very changed situation. The "secular" authority, rather than being the oppressor of the Church, as is the case in the Apocalypse, is now deeply involved in its life. The future seems stretched out to a distant conclusion, and eternity is something to be reached by individual "souls" at different moments. Rather than actualizing the future coming of Christ in the present communal celebration, Christian ritual is thought to teach "truths" about the three comings of Christ, past, present, and future. Indeed, the medieval liturgy seems preoccupied with commemorating past events, especially the life of Jesus, on which the major feasts of its annual cursus are based.

Such changes are only to be expected, though they have not always been given their due in professional liturgiology. What is needed is a heuristic device that will enable us to understand how the early medieval liturgy, and the view of life it mediated and created, is different from its ancient counterpart. But in helping us make this distinction, our model needs also to be sensitive to continuities, to the things John's liturgy and the medieval liturgy have in common. Since rituals are practices in which a society's prevailing dominant discourses are shaped and given their most forceful symbolic expressions, they are also unavoidably the place of intersection and even of conflict between competing ways of interpreting things. This situation makes their interpretation difficult. Furthermore, since rituals are among the most permanent institutions in a society's history, they often continue in use long after the dominant discourses to which they were originally tied have lost their hegemonic powers. Thus rituals abide, but their interpretations are subject to constant change. The history of the medieval liturgy must therefore be a history of incessant alteration in which diverse practices, tied to various dominant or subordinate discursive formations, appear and disappear and perhaps reappear. Inherited forms are filled with ever-new content by systems of interpretation which are themselves enmeshed in various ideological practices. Yet these forms, to a certain degree, at least, have a life and a history of their own. In addition, the history of medieval liturgy is one in which linguistic slippage is always taking place.

Seen from this perspective, the multiplicity of receptions of the biblical Apocalypse in the Middle Ages falls into place. This once highly ritualistic discourse lost some of its power and even became suspect when the discourses about time and eschatology to which it was tied in ritual celebra-

tion were reinterpreted in the third and fourth centuries. As several of the early essays in this volume show, the book as a whole and individual elements from within it were appropriated by new discourses that emerged within the Christian community. The makers of the medieval liturgy were very much like the *bricoleurs* who play an important role in Claude Lévi-Strauss's notion about myth;[14] they drew on many of the discourses circulating in various places in their cultures to create a ritual that was always traditional yet always new. Yet somehow the text of the biblical Apocalypse played only a minor role in this process.

We can only speculate about the reasons for this turn of events. Perhaps it is the mere fact that a discourse so strongly oriented toward past events in salvation history as the Western medieval liturgy is, could do little with the future-oriented emphasis of the Apocalypse. In any case, where fragments of the Apocalypse do appear in ritual books, they do so as representatives of a minority voice in the service of the discursive practices of the prevailing ideology. The later medieval rites for burial provide a good example of this process; for here a few quotations from the biblical book appear in a context that emphasizes the fate of the individual Christian soul about to appear before the awful Divine Judge. John's book, of course, depicts incredible horrors and punishments, but they are reserved for the opponents of God, not the Christians for whom he intends his eschatological message as a word of comfort in the midst of tribulation.

It is tempting to end this essay on this note, stressing the discontinuities between the Apocalyspe of the first century and the liturgy of the High Middle Ages. Though hegemonic discursive practices seek for totality, they are seldom completely successful, and that is certainly true for our subject; an orientation toward a future breaking into the present by virtue of cultic acts remained a possibility, albeit a minor one, throughout the Middle Ages. Liturgical history, like history in general, has all too often neglected minority voices, thus unintentionally placing itself at the service of the very hegemonic discourses it seeks to describe. We may be able to avoid that error here by considering a single place (there are certainly others) in the Western rite where the eschatological orientation of the Apocalypse remained as possibility, always capable of being actualized.

Perhaps the moment in the eucharistic liturgy when this eschatological orientation (or at least an orientation to the present heavenly liturgy portrayed in the Apocalypse) could most strikingly make its appearance is in the intoning of the Sanctus. Aside from the eucharistic prayer in the *Apostolic Tradition* of Hippolytus (which witnesses to liturgical practices in Rome at the beginning of the third century), the Sanctus seems to be a part of every eucharistic liturgy. It is always tied to a preface that precedes it, in which the great saving acts of the divine economy are enumerated and

[14]Claude Lévi-Strauss, "The Structural Study of Myth," in *Myth: A Symposium*, ed. Thomas A. Sebeak (Bloomington, Ind., 1958), 81–106.

celebrated. Though the text of this preface varies from liturgy to liturgy, and by details even within different texts of the same liturgical family, for the purposes of this essay, we can consider the form that appeared in mass books of the Roman rite from the late Middle Ages, citing here the so-called Common Preface and the Sanctus that followed:

It is truly meet and just, right and beneficial to our salvation, that we should at all times and in all places give thanks to You, O holy Lord, Father almighty and everlasting God, through Christ our Lord. Through whom the angels praise Your majesty, the dominions worship it, the powers stand in awe, the heavens and the heavenly hosts and the blessed seraphim join together in celebrating their joy. With whom we, your supplicants, pray You to join our voices also praising You and saying:

Holy, holy, holy Lord God of Hosts. Heaven and earth are full of Your glory. Hosanna in the highest.

Blessed is He that comes in the name of the Lord. Hosanna in the highest.[15]

The subject of this preface is unmistakably the heavenly liturgy described in John's Apocalypse; the angels here offer perpetual praise to the Father through the Son. But the text does not present this heavenly celebration merely as an objective description. It implores that "we," that is, the contemporary celebrants of the rite, might be admitted into this company, so that by saying what is said "there" in heaven, "we" can, in our place in time, be already transported "there" and share in the heavenly activities. Thus the Sanctus holds out the possibility that each worshipper can become like John and "come up" into the heavens and participate in the heavenly ritual. And this is so although this text is not directly taken from the Apocalypse. Many scholars believe that the Sanctus is derived from the triple "holy" exclamations of synagogue worship. Be that as it may, the immediate biblical source for this Christian liturgical piece is Isaiah 6, where the prophet sees and hears the seraphim singing the threefold "holy" before the throne of Yahweh. Yet the liturgical text alters its

[15] Vere dignum et justum est, aequum et salutare, nos tibi semper, et ubique gratias agere: Domine sancte, Pater omnipotens, aeterne Deus: per Christum Dominum nostrum. Per quem majestatem tuam laudant Angeli, adorant Dominationes, tremunt Potestates, Caeli, caelorumque Virtutes ac beati Seraphim, socia exsultatione concelebrant. Cum quibus et nostras voces, ut admitti jubeas deprecamur, supplici confessione dicentes:

Sanctus, Sanctus, Sanctus, Dominus Deus Sabaoth. Pleni sunt caeli et terra gloria tua. Hosanna in excelsis.

Beatus qui venit in nomine Domini. Hosanna in excelsis. (*Missale Romanum, Mediolani, 1474*, vol. 1, Robert Lippe [London, 1899], 206).

biblical source in several ways, most significantly by adding "et caeli" (and heaven) to the Isaianic "Plena est *omnis terra* gloria eius (The whole earth is full of His glory)." This alteration has no doubt taken place under the influence of Apocalypse 4:8, where the threefold "holy" is recited in heaven by the Four Creatures. Thus the liturgical alteration of the biblical *Vorlage* stresses the joining of heaven and earth in ritual action: the Roman preface explictly requests that "we" be admitted into the event. Many of the earlier Eastern rites emphasize this understanding. In the liturgy of Saint Mark, for example, a rite that reflects ancient Coptic ritual, a curtain was drawn aside at the beginning of the Sanctus to reveal a depiction of choirs of thousands of angels standing in the divine presence and calling out to each other.[16]

There can be little doubt that the Sanctus entered the liturgy at a time when the eschatology of the Apocalypse remained in some way a component in the discourses through which Christians made sense of their experiences. But did it continue to be understood that way in the West in the Middle Ages? For the most part, the answer to that queston would seem to be negative. In what is perhaps the most influential commentary on the liturgy in the Middle Ages, Amalarius of Metz's *Liber officialis*, written in the first half of the ninth century, the Sanctus is treated with surprising brevity in comparison with most of the other parts of the eucharistic ritual.[17] For Amalarius, the liturgy exists to teach theological, historical, and even scientific lessons that can be extracted from it by allegorical techniques. One of the ways Amalarius understood the Mass is as an imitation of the life of Jesus. Employing a phrase frequently found in his writings, he explains that the preface "reminds us" (*reducat ad memoriam*) of Jesus' retiring with his disciples for the praying of the high priestly prayer, an act recounted in John 13. Amalarius notes that the preface is said at the altar and claims that this "visible altar" should cause us to remember both the "altar on high" and the altar of our hearts, which we offer to God. Of the Sanctus itself, Amalarius has little more to say other than to report its supposed institution in the Roman rite by Pope Sixtus and to list the names of the nine orders of angels. Thus it would seem that Amalarius knows little of the eschatological sense of liturgical celebration testified to in the Apocalypse. For him, liturgy is a didactic exercise in which clerics instruct laity. Yet the older notion of liturgical celebration has left its traces, even in this pedantic commentator; for after glossing the orders of angels, he unexpectedly adds: "To these nine orders is added another, a tenth, that of the human condition. It is from the voice of this order that the priest says 'We beseech you to command that our voices may be joined

[16]F. E. Brightman, *Liturgies Eastern and Western,* vol. 1 (Oxford, 1896), 131.
[17]Jean-Michel Hanssens, ed., *Amalarius episcopi opera liturgica omnia* vol. 2 (Vatican City, 1948), 324ff.

with theirs [those of the angels].' "[18] For Amalarius, this claim is probably intended more as a statement of metaphysical fact than as a description of ritual experience. Still, this trace of an earlier liturgical model points to the way that one discourse about ritual cannot fully efface another and so leaves open the possibility for an understanding of the Common Preface and Sanctus—which is to say, an understanding of self and the world— that considerably differs from that offered in most Carolingian talk about the liturgy. The newer mode of discourse dominates but is unable to extinguish the older, and so the Apocalypse and the discursive practices encoded in it could continue to make their influence felt.

Amalarius's liturgical commentaries are intellectual reflections on the liturgy; they are products of the study rather than the chancel. But in the century after the appearance of his work, the practice of liturgical troping flourished; and thus there emerged explanations and glosses on the liturgy intended for use during cultic celebration. Tropes are musical and textual embellishments and expansions of preexisting liturgical texts. Though their purpose seems to have been largely doxological, they frequently reveal how the worshipping community in which they were employed understood the texts of its rite. Almost any liturgical text was open to troping, and the Sanctus was no exception. The famous *Winchester Troper*, for example, contains at least eight tropes for this part of the liturgy. These tropes, as well as those in repertories related to them, contain brief acclamations referring to one of the persons of the Trinity following each appearance of the word "Sanctus" (Holy). Here for example, is a typical Sanctus trope from the Winchester repertory:

Holy	God the Father Almighty
Holy	The Only Begotten Son of God
Holy God	The Spirit, the Paraclete, the will of Both; Glory be to the One God.
Hosanna	Let us all sing to God on high.[19]

This text was given an elaborate and jubilant musical setting and in performance it no doubt had an effect far different from that of reading Amalarius's explanation of the Sanctus. But read as verbal text without musical notation, it has much in common with Amalarius's understanding of the rite. The expansion of the Sanctus is purely theological and didactic; the singers direct their "Hosanna" to God "in altissimis," but there

[18]Ibid., 327: "His novem ordinibus praelibatus ordo decimus conditionis humanae adnexus est, ex cuius voce dicit sacerdos: 'Cum quibus et nostras voces ut admitti iubeas deprecamur.' "

[19]Walter Howard Frere, ed., *The Winchester Troper* (London, 1894), 65f.:

Santus	Deus omnipotens pater:
Sanctus	Dei filius atque unigenitus:
Sanctus Deus	Spiritus paraclytus, voluntas amborum, uni deo gloria:
Osanna	In altissimis deo omnes dicamus.

is little indication that this is anything but a locative expression that des-
ignates where the deity is thought to be and, by implication, where the
earthly worshipers are not. Though the text being glossed is intimately re-
lated to the Apocalypse, there is nothing of the spirit of that biblical text
here. Indeed for all of the musical jubilation, there is little reference to any
kind of ritual experience. The God encountered in cultic celebration,
even at this especially heightened moment, is identified as the one who
is defined in theological terms controlled by clergy. Ritual celebration is
the place one conforms to these definitions and reinforces them by repe-
tition. The doxological passes into the theological, so that the two are vir-
tually equated. This trope, then, and others like it, are products and
perpetuators of the same early medieval discourse about the liturgy that
we see in Amalarius's writings. If we were to judge only by this trope, it
would be safe to assume that the early liturgical discourse in evidence in
the Apocalypse, with its severing of the customary boundaries between
present and future, time and eternity, had disappeared from the West by
the tenth century.

But such an assumption would be premature and hasty. Appearing on
the same page as this piece in Walter Frere's edition of *The Winchester
Troper* is the following trope, also for use with the Sanctus:

Holy	God, the unbegotten Father,
Holy	His only begotten Son,
Holy Lord	The Holy Spirit, the Paraclete, proceeding from both,
God of Sabbaoth	Glory, victory, and eternal exaltation be to our God on high.
Blessed is He	All whom You have redeemed by Your grace from
. . .[*Hosanna*]	eternal death
in the highest	Sing Hosanna.
	By your death, treading down the law of death,
	Restoring us to life,
	Giving your flesh to God the Father
	As a ransom and as a living sacrifice for our sake,
	We, rising with You,
	We, now sitting with you in Heaven as a sharer of the riches of the Kingdom,
	We, therefore, ask that when You come as judge to determine the merits of everyone,
	That you join us with the saints and angels,
	With whom we may sing to You.[20]

[20]*Sanctus* Deus pater ingenitus
Sanctus Filius eius unigenitus
Sanctus dominus Spiritus sanctus paraclitus ab utroque procedens
Deus sabbaoth Gloria victoria et salus aeterna sit deo nostro in
 excelsis.

In some ways this trope is markedly similar to the first one considered. It too seems concerned with theological precision; indeed, its opening lines literally repeat and paraphrase the opening lines of the first trope. The term *in excelsis* seems to function locatively here, and in other details as well, the initial lines could be understood in a way consistent with the dominant early medieval ritual discourse. But as it begins to expand the Benedictus, the text takes a different turn. The address to "our God" in the previous line, which seems to refer to the God of those in the present liturgical assembly, now expands so that those who sing the Benedictus are designated as "All whom You have redeemed by Your grace from eternal death." The antecedent of this pronoun "our" must obviously extend both temporally and geographically beyond the locally defined group of singers. The last lines indicate the specifically eucharistic setting of the trope and the liturgical text it expands, so that the sacrifice of the mass is tied to the sacrifice of Christ, which is its ritual archetype. Thus the text depicts the "all" as incorporated into Christ, as "rising with You" (Christ). Striking in this regard is the use in the Latin text of present instead of perfect participles, suggesting again a sense of time that is not strictly chronological or historical. Finally, the "all" are envisioned—again in the present tense—as seated with Christ in heaven. Here the model of liturgical action encoded in the Apocalypse breaks forth, and it is from this perspective ("therefore") that we can understand the last lines. Eternity is already present in the rite, and at the same time it has not yet fully arrived; the liturgy is only a foretaste of that which is to come. And so the piece concludes with a prayer that at the future day of Judgment "we" might be admitted into the company of the angels and of the saints. One could hardly find a more direct statement of the eschatologically oriented ritual discourse of the Apocalypse in the whole of the Western liturgy. Yet it stands in a collection of liturgical pieces that seem on the whole to mediate a quite different view of ritual experience. That view was, by all indications, coming to dominate liturgical production and reception. But as this trope indicates, discursive practices associated with the older understanding of liturgy were still available, though that availability was lim-

Benedictus . . . in excelsis Osanna omnes tua gratia
Quos a morte redemisti perpetua:
Morte tua ius mortis cum principe procalcans
 vite nos reparans:
Deo patri dans carnem te pro nobis pretium et
 vivam hostiam:
Tecum nos resuscitans:
Tecum in celis collocans et regni largiris
 consortium.
Te ergo deposcimus, ut cum iudex adveneris
 cunctorum discernere merita nos cum angelis
 et sanctis socies,
Cum quibus tibi canamus.

ited by the established practices for liturgical interpretation that were rapidly becoming the norm.

We have thus far considered the texts of the early medieval liturgy and the interpretation laid on those texts. But we can reach a similar conclusion if we consider the ritual actions associated with the cult. According to most anthropological theory, ritual acts are believed to possess their effective power by virtue of the mimetic gestures they require. To do what was once done—or what is now done in that other world, or what will be done in the future—is to be somehow incorporated into those past, present, or future actions and thereby to become beneficiaries of their power. Thus if the Sanctus is to transport the faithful into the heavens, it must be sung by all of the faithful, who by this corporate action imitate heavenly actions. Such a practice is certainly envisioned by the text in the Roman rite, and such indeed was the case in the early and patristic churches. In the West by the early Middle Ages, however, the laity was increasingly becoming a spectator to the liturgy rather than a participant in it. The *Admonitio generalis* of 789, in which the Carolingian court attempted to regulate, among other things, liturgical practice in the empire, insists that the celebrant of a mass should sing the Sanctus with the people before beginning the canon proper.[21] Here we have evidence that in the early Middle Ages the faithful were still singing the Sanctus; perhaps the very fact that the language in which they sang this chant was by this time not their everyday language but a special "church" language heightened their sense of singing a heavenly song.

But if the *Admonitio* points to the possibility of a continuing cultic participation by the people in the language of the Apocalypse, it also simultaneously points in an opposite direction. Charlemagne's text speaks to a discursive practice in which the Mass was becoming a priestly cult, one in which the divine presence was connected with the words and actions of the hierarchy rather than with those of the worshipping community. The *Admonitio* seeks to correct a practice in which the celebrant's actions could be carried out independently of the words and deeds of the congregation. This new model for understanding liturgical actions envisioned an almost magical reactualization of the past brought about solely by those possessing the powers of priesthood, rather than by a cultic participation of the congregation in the present and the future. Such a ritual understanding came to dominate Europe in the medieval period and inevitably mediated an understanding of self and world far different from that encoded in the Apocalypse. Of such changes, liturgical history is made. But what is important for the present argument is that the reference in the *Admonitio generalis* to the singing of the Sanctus points to the possibility of two opposing discourses about ritual existing side by side in the empire's cultic practices. Historically, one pointed to the past practices, the other to those

[21]*MGHLL* 2.1:59.

of the future; but both seem possibilities in the Carolingian moment. Eventually, like most of the liturgy, the Sanctus was assigned to a choir or was spoken by the celebrant, and lay participation was thus precluded. But even this exclusionary practice cannot be said to have resulted in complete control of all liturgical practice and its interpretation. Though it is clear that the singing or recitation of the Sanctus was generally a clerical function by the tenth century, there is also evidence that the chant sometimes continued to be assigned to the entire congregation. Honorius Augustodunensis describes it this way in his twelfth-century *Gemma animae*, for example.[22] Whenever the Sanctus was performed in this manner, the possibility existed for an eschatological understanding of it and of the liturgy as a whole.

Traces of such an understanding can be found as a kind of minority discourse even in the liturgical commentators of the High Middle Ages. An eschatological understanding would, of course, be in sharp contrast to the prevailing discourses about ritual in the High Middle Ages, according to which the liturgy is performed *in* time, by clergy, in order to teach doctrinal truths about eternity and to bring about a favorable condition for those already out of time or those who would at some future time—but not at the present moment—be in eternity. We should not imagine, however, that some worshipers held to the first view, while others embraced the second, nor that these two views provide the only interpretive models for understanding and using the liturgy. The point is, rather, that multiple discourses and discursive practices about ritual existed side by side, one of them dominant, the other subordinant, but neither sufficiently powerful utterly to reduce this ideological heteroglossia to an ideological monologue.

Let me cite only one more of many possible details concerning the history of the Sanctus which points to the simultaneous continuity and discontinuity of the ritual discourses linked to the Apocalypse in the High Middle Ages. In the thirteenth century it became customary to ring bells during the singing of the Sanctus. This practice is almost invariably explained as a warning to the congregation, now often separated from the liturgical action by a rood screen, that the elevation of the consecrated species, the most sacred moment in the high medieval Mass, was approaching. From this perspective the ringing of the bell testifies to an understanding of the eucharistic celebration which is strikingly different from the one in John's Apocalypse. But in one of those incredibly rich footnotes frequently found in his magisterial *The Mass of the Roman Rite*, Joseph Jungmann suggests that there are other ways of understanding this high medieval practice.[23] He points to the customary bell ringing at the

[22]*PL* 172:556.
[23]Joseph Jungmann, *The Mass of the Roman Rite: Its Origins and Development (Missarum Sollemnia)*, trans. Francis A. Brunner, vol. 2 (New York, 1955), 131 n. 22.

solemn intonation of the Te Deum (a chant that, though Jungmann does not note it, seems tied to the understanding of ritual found in the Apocalypse), where the ringing suggests the joyful worship of God by all things heavenly and earthly. Jungmann also alludes to the practice of accompanying the singing of the Gloria in excelsis with every available musical instrument on Holy Saturday, when this text returns to the liturgy for the first time since the beginning of Lent. Here again is a ritual text that refers to joint worship of heaven and earth and in which musical instruments are used to sign this fact. Because several medieval liturgical documents report that, during the singing of the Sanctus, large tower bells, rather than handbells, were used, Jungmann suggests that the ringing bells at the Sanctus may have originally had the purpose of pointing to the celebration of the heavenly liturgy rather than to the approach of the awesome consecration and elevation. Such a claim is a striking one; for most liturgical historians would agree that nothing could be more indicative of the understanding and use of the eucharistic liturgy in the High Middle Ages than the focus on the priestly consecration which the Sanctus bell signals. Yet, if Jungmann's claims are valid—as indeed seems likely—that same device could, even in a time utterly dominated by the hierarchical paradigm of ritual, be interpreted in terms of another understanding of the liturgy, one similar to that found in the ancient Apocalypse.

These examples by no means exhaust the ways in which the eschatological understanding of ritual found in the biblical Apocalypse left its trace on words and actions connected with the Sanctus. Nor is the Sanctus the only place in which that trace is to be found; an examination of the texts, practices, and interpretations connected with the Te Deum, for example, would likely yield similar results. No doubt a consideration of hymns, not merely as texts but as practices, would shed new and perhaps complicating light on the tentative and preliminary view offered here. But for now it is time to move toward a conclusion: As an essay on the place of the Apocalypse in the Middle Ages, this discourse suggests that the study of such a subject must move beyond the citing of texts and statistics to take into account the cultural function of a traditional text within an ever-changing historical process. More broadly, I hope it also highlights the role liturgical studies can and should play in the broader arena of medieval studies. One of the great challenges that confronts us now that the study of the Middle Ages has become popular is to find a way to enable liturgical studies, at present a marginal and all too ecclesiastical subject, to move to a position more befitting its hermeneutic potential in the human sciences.

15

The Exercise of
Thoughtful Minds:
The Apocalypse in
Some German Historical
Writings

KARL F. MORRISON

The very hiding of truth in figures is useful for the exercise of
thoughtful minds and as a defence against the ridicule of
unbelievers, according to the words, "Do not give to dogs what is
holy" (Matt. 7:6).
—Thomas Aquinas *Summa theologiae* Ia, q. 1, a. 9, *ad* 2

Silences can be telling. This interpretive commonplace,
so regularly proven in daily life, is a key to a strange fact about historical
writing in Germany during the twelfth century. Although apocalyptic
speculation was rife in that place and time, and although the Apocalypse
inspired great works of art in different media, direct citation of the text of
the Apocalypse itself was generally neglected in the very writings for
which it might have served as a common focus: namely, in historical
writings, compositions in which authors brought imagination and lan-
guage to bear on the specific task of locating themselves in the broad
course of human experience as it moved toward its appointed end. A
tendency "equating history and Scripture" gathered momentum among
writers of the eleventh and early twelfth centuries.[1] Yet, at the center of

[1] Stephen G. Nichols, Jr., *Romanesque Signs: Early Medieval Narrative and Iconogra-
phy* (New Haven, Conn., 1983), 64. On the correspondence that Rupert of Deutz drew
between his own prophetic interpretation of history and the Apocalypse as prophecy,
see Maria Lodovica Arduini, *Rupert von Deutz (1076–1129) und der "Status Christiani-
tatis" seiner Zeit: Symbolisch–prophetische Deutung der Geschichte* (Cologne,
1987), 392–424, esp. 402–3. In general, see Richard Kenneth Emmerson, *Antichrist
in the Middle Ages: A Study of Medieval Apocalypticism, Art, and Literature* (Seattle,
1981).

their speculations, the Apocalypse appears to have said cryptically little to them.[2]

In previous studies, I have explored some chambers of meaning created by other silences in these texts.[3] It was perplexing to find that historical writings appeared to be fragmentary, inconsistent, and self-contradictory and that this was true even of works actually prepared and offered as masterpieces or state papers. Exploring silences between the apparent fragments produces the impression that they express a common esthetic judgment, an expectation of how the audience was expected to read. Authors presupposed that, with habits formed in scriptural exegesis, their readers would seek unity of meaning, not only in the words of the text but between and across the lines, that they would practice the method Rupert of Deutz described as understanding (or hearing) beneath the sounds of words.[4] Reading was an exercise in cryptography, and it anticipated not unitary meaning (as in the case of literal interpretation) but multiple (as in that of figurative).[5]

Authors of the cult objects known as histories presupposed that their readers would play a kind of game, that their minds would delve between the lines, break the textual code, and establish unspoken associations, perhaps even associations unexpected by the author, filling the obscurities in the words and the spaces between the lines. The play demanded an exercise of visual as well as verbal imagination. History was spectacle; the

[2] See R. W. Southern, "Aspects of the European Tradition of Historical Writing, 4: The Sense of the Past," *Transactions of the Royal Historical Society,* 5th ser., 23 (1973): 256: The "only contribution [of 'early twelfth-century English monastic writers'] to universal history was to fit these microscopically small events into the system of earlier scholars. They took no account of the end of the world."

[3] See my "Interpreting the Fragment," in *Hermeneutics and Medieval Culture,* ed. Patrick Gallacher and Helen Damico (Albany, N.Y., 1989), 27–37, "Otto of Freising's Quest for the Hermeneutic Circle," *Speculum* 55 (1980): 207–36, "Anselm of Havelberg: Play and the Dilemma of Historical Progress," in *Religion, Culture and Society in the Early Middle Ages: Studies in Honor of Richard E. Sullivan,* ed. John J. Contreni and Thomas F. X. Noble (Kalamazoo, Mich., 1987), 219–56, and "The Church as Play: Gerhoch of Reichersberg's Call for Reform," in *Popes, Teachers, and Canon Law in the Middle Ages: Festschrift for Brian Tierney,* ed. Stanley Chodorow and James Ross Sweeney (Ithaca, N.Y., 1989), 114–44. The following articles are in the same vein: "Peter Damian on King and Pope: An Exercise in Association by Contrast," *ACTA* 11 (1984): 89–112, and "Hermeneutics and Enigma: Bernard of Clairvaux's *De Consideratione,*" *Viator* 19 (1988): 129–51. The critical ideas guiding these studies are set forth in my book *"I Am You": The Hermeneutics of Empathy in Western Literature, Theology, and Art* (Princeton, 1988), esp. pt. 3 ("Understanding Understanding: The Silence of Words") and pt. 4 ("Understanding Understanding: The Invisibility of Art"); chap. 7 (191–237) is devoted to Gerhoch of Reichersberg.

[4] "Subintellegere" or "subaudire" (Rupert of Deutz *Commentum in Apocalypsim* 1.1, 5.9, 6.10 [*PL* 169:851, 1004, 1011]).

[5] Ibid., 1.1 (*PL* 169:830): "Hoc autem cum dicit, non ad multitudinem codicum, sed ad magnitudinem spectat sensuum, quos etiam nunc, cum pauci sint libri, universos capere non possunt, qui in mundo sunt. . . . "

text, a script with inexplicit stage directions; the reading, a performance before the mind's eye, but between and across the lines.[6]

Thus far, in examinations of individual authors, I have not investigated the limits of the cryptological game: in other words, of what Paul Veyne has called the "constitutive imagination."[7] The particular subjects and themes in individual works are so diverse as to make it very difficult to establish points of correspondence. Moreover, the reasons for some omissions are past finding out. Yet, throughout all their writings, Otto of Freising, Rupert of Deutz, and their contemporaries wove a thread common in all Christian literature: the problem of evil, with its corresponding call for theodicy. Few scriptural texts brought the question of God's responsibility, not only for afflictions but also for moral evil, to the fore as sharply as the Apocalypse. In this essay I examine how historical writers fit the Apocalypse into their interpretive strategies and thereby identify some outer limits of the hermeneutic game in which they expected their readers to follow them.

A SURVEY OF THE FIELD AFTER THE GAME

As we consider artifacts of the twelfth century, we are in the position of spectators who arrive at a field after the game is over. The subject of the place given to the Apocalypse in historical writings of the twelfth century magnifies the silences on the abandoned playing field. Quotations of the Apocalypse are so rare that the subject almost appears nonexistent.

We have learned, however, not to ignore the silences in texts, especially when elements are conspicuously present by their absence. If words are positive values in the text, then the silences in the words, the spaces where what is unsaid in the said flash back and forth, are negative values that cannot be left aside. For writers of the twelfth century—certainly ecclesiastical ones—the chiaroscuro of revelation that concealed was, if not the name of the game, at least the prevalent strategy of play. And this is particularly true of authors professed to lives in which silence was part of the discipline of prayer and worship as well as of renunciation, writers whose works were intended to stir readers to inward meditation. Consequently, coming to the palaestra after the game is over, we shall have to gauge, as nearly as we can, what kind of silence marked their access to the revelations of John.[8]

[6] See also, in addition to the articles cited in n. 3 above, my study, *History as a Visual Art in the Twelfth-Century Renaissance* (Princeton, 1990).

[7] Paul Veyne, *Did the Greeks Believe in Their Myths? An Essay on the Constitutive Imagination*, trans. Paula Wissing (Chicago, 1988).

[8] Cf. Otto of Freising *Chronicon* 8.3 (*MGHSSrrG* 396): "At non est mirum, si Dominus ecclesiam suam de nichilo suscitatam et ad summum in terra fastigium, ut supra diximus, exaltatem ante ultimae tribulationis bravium, ne longo dissoluta otio in amore sui creatoris torpeat, excitatam gravissima prius exerceat palestra."

What traces of the play can we recover? There are elements of violence and beauty. Certainly, violence was at the heart of the play; for violence is woven into the substance of the message of salvation, and thus into the course of sacred history. "Violence," in René Girard's words, "is the heart and secret soul of the sacred."[9] Writers of history were by no means pacifists. Their concern was with making the distinction between evil violence and good, and with the eventual triumph of the good. The sharp point at which their thought focused was the violence of sacrifice, with its moral horror.[10]

The authors turned again and again to beauty as a principle of understanding. Beauty was cognate with violence. This was, in part, because of ancient aesthetic connection between wholeness and beauty. Before turning to the theme of violence, then, we need to trace some contours of beauty. Twelfth-century writers found the wholeness to which the Apocalypse witnessed somewhere other than in the text itself. In Rupert's mind, the perception of wholeness did not lie in the words, accessible to all, including doubters and heretics. "What sequence (*series*) of holy Scripture," he wrote, "is either more beautiful on the surface than the Apocalypse, or more abundant in meaning?"[11] The "beauty of the surface" was, in part, a matter of rhetorical finesse; for John, the "great *orator,*" skilfully deployed the rhetorician's tricks.[12] Yet it is also clear from what has already been said that the beauties of the surface, no less than the opulence of meaning that they concealed, could be apprehended only by those who were able to detect "the great and delightful beauty of mystery."[13] The search for occult sympathies, inherited from Neoplatonic hermeticism, remained essential to the beauty of spiritual intelligence.

The obscure beauty of the Apocalypse was inaccessible to many, including heretics and those who applied the literalist "Jewish understanding" to its text. Decorum required interpreters to leave some things unsaid, lest ease of access cheapen the treasures of Scripture; and interpreters were under no obligation to exhibit the beauties that they detected to their enemies and rivals.[14] Indeed, the very bases of the exegete's perceptions of beauty were inaccessible. For, given the fact that authentic interpreters required inspiration by the same Spirit who inspired the writers of Scripture,

[9] René Girard, *Violence and the Sacred,* trans. Patrick Gregory (Baltimore, 1977), 31; cf. 19.

[10] Ibid., chaps. 1 ("Sacrifice"), 2 ("The Sacrificial Crisis").

[11] Rupert of Deutz *Commentum in Apocalypsim, Epistola ad Fridericum Coloniensem (PL* 169:826).

[12] Ibid., 1.1, 8.13 (beauty through aptness of antiphrasis), 9.15 ("beautiful digression"), 9.16 (trope), 10.17–18 (irony), 11.19 (metaphor) (*PL* 169:847, 863–64, 1065, 1111, 1119, 1133, 1152, 1172).

[13] Ibid., 1.1 (*PL* 169:846–47).

[14] Otto of Freising *Chronicon* 8.35 (*MGHSSrrG* 457); Gerhoch of Reichersberg *Tractatus in Psalmum 64* prol. B.16, 49, 51, 146, 154 (*MGHLdl* 3:441, 447, 459, 460, 482, 486–87). Rupert of Deutz commented that the deliberate obscurity of Scripture kept its content from being cheapened, because difficulties repelled the irreverent (*Commentum in Apocalypsim* 6.10, 12.12 [*PL* 169:1011, 1208]).

that perception sprang from the secret place of contemplation. The exegete's moments of spiritual enlightenment, Gerhoch of Reichersberg wrote, were fountainheads from which he drew streams of waters for others but which must be kept hidden.[15]

Thus, along with belief that Scripture contained multiple, hidden meanings, doctrines concerning the charismatic gifts of the exegete enlarged the possibilities for varied aesthetic judgments. The analogy between divine inspiration and charismatic intoxication underscored the freedom of those judgments from routine, or stereotyped, human conventions.[16]

It is notable that, despite the affinity that they sensed between history and theater, very few writers cast the interplay of beauty and violence according to the dramatic scenario of apocalypticism. Moreover, those few—notably Anselm of Havelberg, Gerhoch of Reichersberg, and Otto of Freising—employed only scattered elements from the Apocalypse.[17] They never considered it as a whole. Instead, they contented themselves with brief, scattered citations, which they wove into fabrics of strands drawn from other sources and arranged into patterns of their own invention, rather than into the context given by the author of the Apocalypse.[18] Following Bede, even Rupert of Deutz, who composed a word-by-word commentary on the book, gave no attention to the principles of coherence underlying its organization.

Eclecticism further diminished the place of the Apocalypse in historical writing. For the historical writers in question departed not only from the Apocalypse but also occasionally from apocalypticism as an organizing principle of human experience. Anselm of Havelberg was able to explain changing stages in Christian history as symbolized by the seven seals on

[15] Gerhoch of Reichersberg De investigatione Antichristi 2.75, in Gerhohi Reichersbergensis Praepositi Opera Hactenus Inedita, ed. Friedrich Scheibelberger, vol. 1 (Linz, 1875), 333–36. On secret visions that Rupert of Deutz was compelled to reveal, see John H. Van Engen, Rupert of Deutz (Berkeley and Los Angeles, 1983), 346, 349–51. Cf. Otto of Freising Chronicon 1.prol., 8.7 (MGHSSrrG 10, 401).

[16] On Gerhoch of Reichersberg, see my "I Am You", 207 (and n. 79), 231, and "Church as Play," 120–21. Cf. Otto of Freising on the intoxication of the saved with a torrent of divine pleasure (in paradise) (Chronicon 8.29 [MGHSSrrG 440]). On the inebriation of the saved, see Rupert of Deutz Commentum in Apocalypsim 11.21, 12.22 (PL 169:1194, 1203 [in paradise]).

[17] By my count, Anselm of Havelberg, in the Dialogues, quoted fourteen (or fifteen) verses from five chapters of the Apocalypse; Otto of Freising, in the Chronicle, twenty-one verses from seven chapters; Gerhoch of Reichersberg, in the De investigatione Antichristi, twenty-two verses from ten chapters and, in the Liber de novitatibus huius temporis, eight verses from eight chapters and, in the Tractatus in Psalmum 64, eighteen (or nineteen) verses from nine chapters. See below, at n. 73. Quite naturally, authors occasionally ornamented their texts with illustrative quotations from the Apocalypse, generally without any implicit or explicit reference to the actual content of the book.

[18] Outside the rarefied air of historical speculation, this characteristic conflation of texts occurred when Premonstratensian brethren attempted to blend verses abstracted from Daniel and the Apocalypse into an explosive rule of life (Vita Norberti Archiepiscopi Magdeburgensis 13 (MGHSS 12:685–86).

the Lamb's book (Apoc. 6, 8:1); but the consistency of petty minds did not keep him from setting forth, in the same work, two other periodizations of all sacred history, the one threefold, the other, sixfold.[19] Otto of Freising also employed a variety of periodizations, some inspired by the various septenaries of the Apocalypse and the ten horns of the Beast, others by Daniel's vision of four world empires. But he also invoked other explanations of change that undercut the entire apocalyptic theology, including naturalism (the tendency of all human things to change, grow old, and decay), aimless mutability, and the crazy spin of Fortune's wheel.[20] Indeed, he wrote at one point, worldly strivings had no more meaning than reptiles' churnings in the depths of the sea, while Christ's bark rode serenely on the waves.[21]

The effect of eclecticism, therefore, was to ignore the "total structure" of the Apocalypse and to dismember whatever coherence its author had given it "from one end to the other," replacing that intended coherence with a kaleidoscope that moved continually with the reader's glance.[22] Some, Rupert commented, held that it was wrong to add to what the Fathers had written. They had, indeed, opened one or two wells from which to draw the living waters, as Abraham had done. But, Rupert continued, no one could object if exegetic sons of the Fathers opened new wells, as did Isaac when the Philistines stopped his father's wells, to dig out living waters by their own ingenuity (even as they confided in God alone) from the promised land of Scripture.[23] It was the artful ingenuity (*artificiosum ingenium*) of the artist in the work that people loved, Gerhoch wrote, rather than the work itself, even as they loved God, the divine artist, in his creatures, rather than the things made by him.[24]

Exegetes contended, however, that far from violating the integrity of the Apocalypse, they were apprehending its inner unity. Indeed, authentic interpreters were parts of the mysterious beauties that they perceived, architectural elements in an eternal structure. Theirs was not the illusory beauty of the prostitute. They were not beautiful in the eyes of men, when they were struck and beaten, but in the eyes of God they were beautiful, and, by blows of tribulation, they were polished to become yet more

[19] Anselm of Havelberg *Antikeimenon* 1.5–13 (*PL* 188:1147–60); see n. 37 below.

[20] Otto of Freising *Chronicon* 1.prol., 2.12–13, 3.45, 6.prol., 9, 17 (*MGHSSrrG* 6–8, 80–82, 179, 261–62, 271, 277–78).

[21] Ibid., 6.prol. (*MGHSSrrG* 261–62).

[22] Jacques Elull, *Apocalypse: The Book of Revelation*, trans. George W. Schreiner (New York, 1977), 50, 52, 65, 205. See Wilhelm Kamlah, *Apokalypse und Geschichtstheologie: Die mittelalterliche Auslegung der Apokalypse vor Joachim von Fiore* (Berlin, 1935), 116. On Gerhoch of Reichersberg's artistic liberties with the text, see Horst Dieter Rauh, *Das Bild des Antichrist im Mittelalter: Von Tyconius zum deutschen Symbolismus* (Munich, 1973), 449.

[23] Rupert of Deutz *Commentum in Apocalypsim, Epistola ad Fridericum* (*PL* 169:826–28); cf. Gen. 27:15–25.

[24] Gerhoch of Reichersberg *Tractatus in Psalmum 27* 2 (*PL* 193:1224); *Tractatus in Psalmum 144* 4 (*PL* 194:964).

beautiful, precious living stones in the foundation of the heavenly Jerusa-
lem, all gleaming, but with diverse shades of beauty, none being entirely
like any other. Yet, since all participated in the same glory imparted by the
Holy Spirit, their likeness was dissimilar and their unlikeness, similar. No
two had the same bent (*habitudo*) of mind—that is, of the inner man,
where they were confirmed in one and the same Christ.[25] They were built
as living stones into the heavenly Temple as though they were dots in a
circle, each equidistant from the center.[26] The books of Scripture ex-
pressed the common participation of their authors in the same beauty, un-
der the tautological rule of dissimilar likeness and similar unlikeness.
Rupert himself gave many indications of his own freedom to expand the
text according to this esthetic.[27]

Techniques of expanding the text, supposedly under inspiration, rested
on the proposition that all Scripture witnessed to the christological "mys-
teries," which Rupert identified as "Incarnation, Passion, Resurrection,
Ascension, the gift of the Holy Spirit (the Paraclete), the calling of the
Gentiles, and Christ's Second Coming for judgment."[28] Of course, this
proposition established a general symbolic concordance among all scrip-
tural texts; but it also ratified particular affinities between the Apocalypse
and other books. It seemed evident that there must be literal affinities be-
tween the Apocalypse and other writings assumed to have been composed
by John, the beloved Apostle (including the Gospel and the catholic Epis-
tles of John).[29] The recurrence of four apocalyptic Beasts in the books of
Daniel, Ezekiel, and the Apocalypse enabled exegetes to think that the
Apocalypse elucidated the earlier prophecies and, consequently, that the

[25] Rupert of Deutz *Commentum in Apocalypsim* 10.17, 12.21 (*PL* 169:1137, 1201–2);
see also 10.18 (*PL* 169:1155). Cf. Rupert's term with Aristotle's definition of metaphor as
"an intuitive perception of the similarity in dissimilars" (*Poetics* 1459a).

[26] Cf. Gerhoch of Reichersberg *Tractatus in Psalmum 18* 11 (*PL* 193:930). Idem, *Trac-
tatus in Psalmum 45* 6 (*PL* 193:1575–76), and *De aedificio Dei* 3 (*PL* 194:1203).

[27] E.g., Rupert of Deutz *Commentum in Apocalypsim* 4.5 (*PL* 169:924–25). Another,
more common expansion of the text was the association of the first (white) Horseman of
Apocalypse (6:2) with Christ (Apoc. 19:11). For this expansion in the hands of Rupert
and Gerhoch, see nn. 39, 44 below. It also interestingly appears in Hermann-Judah *Opus-
culum de Conversione Sua* 21, with another cross-reference to Apocalypse 3:20 (*MGHQ*
4:123, 125). Anselm also interpreted the white horse as the period when Christ was
physically present in the Church, but not as the Incarnation itself (*Antikeimenon* 1.7 [*PL*
188:1149]).

[28] Rupert of Deutz *Commentum in Apocalypsim* 4.5 (*PL* 169:925), and see n. 44 be-
low. Rauh, *Bild des Antichrist*, 198, 208. Kamlah, *Apokalypse und Geschichtstheologie*,
103: "Die Schriftmeditation hat die Aufgabe, die veritates des Glaubens zu betrachten."
Rupert employed a four-part distinction in addition to the seven-part one just cited. The
four Beasts of the Apocalypse, he wrote, represented *Christi sacramenta: incarnatio,
passio, resurrectio*, and *ascensio*. Anselm of Havelberg set forth a five-part division in
his *Antikeimenon* 1.4 (*PL* 188:1146): "ut per singulos articulos fidei omnia sacramenta
Christi et ecclesiae ad plenum cognoscerent, et mysterium incarnationis, nativitatis,
passionis, resurrectionis, ascensionis revelata facie viderent."

[29] For the common authorship of the Apocalypse and the catholic Epistles of John, see
Rupert of Deutz *Commentum in Apocalypsim* 4.5 (*PL* 169:927).

books could be read as mutually illuminating. The burden of these charismatic assumptions, of course, was profoundly ahistorical, perhaps even antihistorical.

Plainly, the authors with whom we are concerned used the Apocalypse as a source of raw materials. The compositional demands of their individual works determined whether, and how, it should be quarried. Three examples suffice to illustrate the artistic freedom with which they used the Apocalypse to sustain predetermined expositions on the theme of violence. (I am not concerned here with the considerable degree to which genre shaped content.)

Anselm of Havelberg's *Dialogues* consists of three books, the first, a response to those who mistrusted change in the Church, and the last two, the reconstruction of a debate between Anselm and Bishop Nicetas of Nicomedia, held in Constantinople (1136). References to the Apocalypse occur exclusively in the last seven chapters (7–13) of Book 1, where Anselm developed his doctrine that the seven seals on the Lamb's book allegorically represented seven states (*status*) of the Church. He made no effort to weave this doctrine, or other elements drawn from the Apocalypse, into the first part of Book 1 or Books 2 and 3.

Texts by Gerhoch of Reichersberg and Otto of Freising likewise illustrate compartmentalization of elements from the Apocalypse dictated by compositional structure. Gerhoch's *Tractatus in Psalmum 64* can represent other works by him. This *tractate*, which Gerhoch considered an *oratio*, was composed in six parts, according to ancient rhetorical conventions. Although scattered citations of the Apocalypse occur elsewhere,[30] by far the greatest concentration occurs in the fifth section, the *confutatio* (chaps. 123–69). An ardent defender of what he understood to be the authentic rule of Saint Augustine for communal life, Gerhoch undertook in the *confutatio* a vehement denunciation of the rival Aachen rule. He portrayed the Aachen rule as a supreme example of ecclesiastical abuse in his day, one that the elect must endure, as wheat among tares, until the apocalyptic harvest.

Finally, Otto of Freising confined his direct citations of the Apocalypse entirely to the last book of the *Chronicle*. To be sure, there are references to the two cities in prefatory and concluding sections of other books, but these lack direct quotations, and, having no development in the main narrative of individual books, they suggest an appliqué work of revision, rather than consistent organizing principles. (Otto inclined to rest such apocalypticism as occurs in his first seven books on texts in Daniel seconded by citations from Isaiah and Ezekiel.) The subject of Book 8, Otto wrote, was the states into which the city of Christ and the evil city would enter after this life, although, in fact, he devoted considerable attention to

[30] E.g., in the *exordium* (chaps. 1–13), chap. 2; in the *partitio* (chaps. 15–74), chaps. 18, 60, 71; and in the *conclusio* (chaps. 170/1–76), chap. 170.

the exaltation of the evil city by Antichrist. There, his reading of the Apoc-
alypse gave him occasion to delight in higher speculative reaches, with the
Apostle Paul and, especially, with Dionysius the Areopagite, "the divine
philosopher."[31] Thus, in subject and in method of discourse, Otto recog-
nized that Book 8 differed from all the previous sections.[32]

Patterns of citation emphasize both the different structures of the three
works and the specific functions for which the authors employed the
Apocalypse: Anselm, to dramatize unity of faith amidst manifold changes
in its earthly conditions (status); Gerhoch, to excoriate a way of life espe-
cially hatefully to himself; and Otto, to speculate on the posthistory of the
two cities.

At another level of structure, the ways in which authors glossed partic-
ular texts from the Apocalypse also illustrate the dominance of authorial
intent. Citations of the Apocalypse are rare, especially ones with accom-
panying glosses, and citations of the same verses by different authors are
even rarer. As indicated, Anselm of Havelberg provides only one gloss on
a passage from the Apocalypse, his allegoresis on the seven seals. Though
not in his apocalyptic treatises, Gerhoch of Reichersberg did, in his
Tractatus in Psalmum 19, advert to a segment, at least, of that passage
(Apoc. 6:1–6, the first four seals only). Since Otto of Freising left no
meditation on the seven seals, I refer instead to Rupert of Deutz's com-
mentary on the Apocalypse in order to provide a third point of reference.
It is tempting to suppose, from the outset, a difference in perspective be-
tween the two Augustinians (Anselm and Gerhoch) and the Benedictine
(Rupert).

One is immediately struck by several structural aspects of Anselm's
treatment. His discourse runs continuously from the sixth seal (Apoc.
6:12–17) to the seventh (8:1), ignoring the intervening chapter (Apoc. 7).
Furthermore, his expositions of the allegorical sense of individual seals (or
status of the church) vary markedly. By far the longest discourse is that on
the fourth opening (the pallid horse). Like the confutatio of Gerhoch's
tractate on Psalm 64, Anselm's elaboration of the fourth opening owed its
particular richness to a zeal to portray the revival of the Augustinian rule
by Norbert of Xanten as a note of righteousness in the eschatological
drama. Anselm's shortest discourse is that on the fifth opening (the saints
calling for vengeance from beneath the altar).[33]

The relative lengths of the sections reflect Anselm's argument concern-
ing violence in Church history. For even though he asserted that the seven
status "succeeded one another from the advent of Christ until, at the last,

[31] Otto of Freising Chronicon 8.30 (MGHSSrrG 442).

[32] Ibid., 8.prol. (MGHSSrrG 391).

[33] The measurements in the Migne text are: first seal, 3 ½ inches; second seal, 8 ½
inches; third seal, 14 ½ inches; fourth seal, 45 inches, including 6 inches devoted to an
invectio against hypocrites; fifth seal, 3 inches; sixth seal, 8 ½ inches; seventh seal, 11
¼ inches.

all things will be consummated,"[34] the sequence did not proceed by tidy chronological steps like the six "ages" of the Church,[35] or like the three periods of divine manifestation: the Old Testament, when God the Father was preached manifestly and the Son, obscurely; the New Testament, when God the Son was manifested, but the deity of the Holy Spirit was cryptically revealed; and the apostolic era, when the Holy Spirit openly disclosed its Godhood.[36] Indeed, the first three *status* of the Church do follow a chronological sequence: the advent of Christ, the ministry of the Apostles under persecution, and the heresies of the patristic age. With the fourth seal (deception and hypocrisy), however, sequence becomes simultaneity.

In Anselm's portrayal, the dangers of subversion from within by false brethren persisted from Christ's day until his own. To be sure, a sequence of sorts ran from persecution (which brought patience), to the subtle deception of heretics (which brought wisdom), and to the illusions of false brethren and hypocrites (which brought endurance). But the chronological "now" of the fifth *status*, when the souls of the saints cried out for the Lord to avenge their blood, encompassed all periods. The sixth and seventh *status* recapitulated the earlier stages, but in a higher power that also comprehended the future. The sixth, the times of Antichrist, brought a combination of bloody persecution and subversion of faith.[37] The seventh was the beatific silence of contemplation in which, for the saints, the truth of all figures and sacraments from the beginning of the world would be revealed, and all things consummated through and with God. Thus, Anselm was able to conclude that, while knowledge of truth had grown from age to age, truth itself, and the virtues of faith, hope, and charity, had changed no more than God, who draws all things to himself.

Anselm read the account of the seven seals as an allegory of spiritual unity latent in historical mutability. Gerhoch of Reichersberg truncated the account, adverting only to the first four openings (the Horsemen) as part of an elaborate exposition on the dangers of false brethren and how they and their deceptions were to be dealt with.[38]

[34] Anselm of Havelberg *Antikeimenon* 1.7 (*PL* 188:1149).

[35] Ibid., 1.3–4 (*PL* 188:1144–47).

[36] Ibid., 1.6 (*PL* 188:1147–48). Cf. the periods before the Law, under the Law, and under grace (ibid., 1.13 [*PL* 188:1160]); also the three "transpositions," first, when the people of God forsook idols and submitted to the Law; next, when they passed from Law to Gospel; and finally, in the future, when they will pass from this transitory world to things that can not be moved (ibid., 1.5 [*PL* 188:1147]).

[37] The chronological flexibility of Anselm's thinking is indicated by his reference to Julian the Apostate as Antichrist (*De ordine canonicorum Regularium* 7 [*PL* 188:1096]).

[38] Elsewhere, Gerhoch did employ one of the Apocalypse septenaries to distinguish epochs in Church history: that is, the seven trumpets, which he identified with gifts of the Holy Spirit in *De ordine donorum Spiritus Sancti.* Both Anselm and Gerhoch borrowed from Rupert of Deutz in their periodizations. See Peter Classen, *Gerhoch von Reichersberg: Eine Biographie* (Wiesbaden, 1960), 108–14, esp. 111–12; and Rauh, *Bild des Antichrist,* 437.

The structure of this segment of Gerhoch's tractate on Psalm 19, like that of Anselm's exegesis, reveals where his emphasis on the theme of violence fell. His interpretation of the pallid horse (the fourth opening, representing hypocrisy and heresy) is the longest.[39] To accentuate his argument, however, he began his exegesis with the second opening (red horse, persecution by the sword) and transposed the first opening (white horse, Christ) so that it immediately followed his discussion of the pallid horse. In this way, he set up a direct contrast between Christ-as-truth and covert deceivers, represented by Judas. He also prepared for an extended portrayal of the conflict between authentic and false believers.

Throughout his writings, Gerhoch, as a moralist, censured what he considered abuses of his day. Occasionally, he referred to particular usages or general circumstances (such as the practice of the Aachen rule, the papacy's resort to armed warfare, and episcopal corruption) as signs that the last day was present. He rarely identified specific events or persons with the apocalyptic scenario; even this tentative, and very occasional, identification set him apart from many other writers.[40] This vagueness characterizes the tractate on Psalm 19. Although Gerhoch established identifying points in the past—for example, the red horse of persecution by the sword is represented by the persecutions under Nero and Diocletian—the dangers represented by the red, black, and pallid horses were continually present in the Church, and indeed in the monastic life, where, to nullify the manly rule of justice, the devil still used weapons entrusted to the rider of the pallid horse.[41] Edom had persecuted Christ in Jacob, Christ's persona; and the saints crying from beneath the altar are Rachel's slaughtered children, who are no more but hereafter will truly be.[42]

With unusual irony, Gerhoch enlivened his contrast between Christ and the false brethren by portraying Christ as a deceiver, a role that like those of Jacob and Rachel was not chronologically limited. Christ, the white horse, triumphed over the red horse when he deceived Herod, by escape and flight, and Pontius Pilate, by resurrection. In his own person, he also vanquished the black horse, deceiving the adversaries of truth by his most careful and wise responses. In his members, he had eluded the red horse and its Rider through the martyrs and taken away the power of the black horse and its Rider through the confessors. His dealing with the pallid horse, represented by Judas, also involved a masquerade. For, while Christ washed Judas's feet along with those of the other Apostles, and in charity kept him at the banquet of his table, he excluded Judas from the

[39] The interpretation of the pallid horse occupies 30 ½ inches of type in the Migne edition. The others are first seal (white horse, representing Christ), 7 ¼ inches; second seal (red horse, representing persecution by the sword), 2 inches; third seal (black horse, representing heresy), 13 inches.

[40] Rauh, *Bild des Antichrist*, 425–26, 430, 437–40, 456, 467–74.

[41] PL 193:949, 952.

[42] PL 193:950–51.

sacrament of his body and blood. Christ's betrayer lacked constancy of faith in the doctrine of Christ, which he heard, and constancy of patience in the Passion of Christ, which he saw. Even now, Gerhoch added, Christ continues to exclude those like Judas who, although they actually receive the sacramental elements, remain unfed by the mystical delight of that life-giving bread.[43]

We now turn from the Augustinians to the Benedictine. As part of a verse-by-verse commentary on the Apocalypse, Rupert's exegesis of the seven seals lacked the omissions and transpositions noticed in the discourses by Anselm and Gerhoch. In his account, the openings of the sixth and seventh seals are divided, as in the scriptural text, by Chapter 7. Rupert's interpretation has in common with the others, however, the use of the Apocalypse to illuminate the author's preestablished contentions, a template in his mind, rather than the original content of the Apocalypse. Rupert's pattern, unlike Anselm's, had nothing to do with historical periodization, and, unlike Gerhoch's, it had nothing to do with Church discipline. Rupert employed the account of the seven seals as a test case demonstrating his argument that all Scripture pertained to the seven mysteries of Christ. His address was christological.[44]

As in the other two cases, structure locates the author's emphasis on the theme of violence in Church history. In Rupert's *Commentary*, the subject comes to center stage with the openings of the fifth and sixth seals. The Lamb broke the fifth seal when Christ, having ascended into heaven, sent the Holy Spirit upon the Apostles, to lead them into all truth.[45] Without

[43] *PL* 193:952–53; cf. Otto of Freising *Chronicon* 8.prol. (*MGHSSrrG* 390): Otto declined to imitate the subtlety of those who debate whether the wicked in the Church actually enter into sacramental communion when they receive the consecrated elements.

[44] See n. 27 above; Rupert of Deutz *Commentum in Apocalypsim* 4.5, 6 (*PL* 169:925, 940). Rupert's template appears in the ways in which he identified the seven seals: first seal (white horse, the Incarnation of Christ), the good Samaritan rescues the beaten Jew; second seal (red horse, the Passion), persecution of Christ and the saints, with special reference to the punishment visited on the Jews by the destruction of Jerusalem under Vespasian and Titus and the Diaspora; third seal (black horse, Resurrection), false brethren, represented by the Jews who offered bribes to conceal the Resurrection and by Judas the deceiver; fourth seal (pallid horse, Ascension), expressed by Christ enthroned in his humanity and divinity on the right hand of majesty, provoking the envious denials of heretics, Jews, and Gentiles; fifth seal (saints crying out from beneath the altar, outpouring of the Holy Spirit), exemplified by the vengeance inflicted on the Jews for killing Christ and the triumph of the saints, their robes washed in the blood of the Lamb; sixth seal (natural portents, vocation of the Gentiles), represented by the destruction visited on the Jews, through which the word of God was spread from Judaea into all the world; seventh seal (silence in heaven, the Last Judgment and consummation of the age), to be accomplished by final vengeance on the killers of the saints, who are to be slain so that they may slay no more.

[45] The lengths of the sections are: first seal (white horse), 15 ¼ inches; second seal (red horse), 11 ¼ inches; third seal (black horse), 17 inches; fourth seal (pallid horse), 22 ¼ inches; fifth seal (saints beneath the altar), 52 ¼ inches; sixth seal (natural portents), 42 ¼ inches; seventh seal (silence in heaven), 7 ¼ inches.

minimizing the perils of deception through heretics and false brethren (the fourth seal), which preoccupied Anselm and Gerhoch, Rupert gave his fullest consideration to the theme of vengeance. The opening of the fifth seal, to which Anselm devoted his most cursory remarks, presented Rupert the occasion for a most elaborate discourse on the triumph that the saints would enjoy over their persecutors when their robes were washed white in the blood of the Lamb. To Rupert's eyes, the opening of the sixth seal provided a historical illustration of the vengeance that God had in store for his people's enemies. For the Lamb broke the sixth seal, Rupert wrote, when, after the Jews had despised God's will and slain Christ, the Romans destroyed Jerusalem, massacred its inhabitants, and sent the remnant, captive, into all the world. Thenceforth, God left Judaea desolate and called the Gentiles.

Despite their variations in length, the seven discourses on the openings of the seven seals were carefully written to form a series of parallels. Unlike Anselm and Gerhoch, Rupert composed each of the first six discourses according to the same six-part order. Isolated by Chapter 7 from the first six openings, the discourse on the seventh opening departs from the standard organization, although it does preserve some structural elements of the others.[46] In effect, Rupert composed a series of rhetorical tableaux intended, by their corresponding lines and disposition of masses, to emphasize the unity of his christological program. Finally, Rupert's focus on Christ entailed a historical content quite different from what their focus on the Church had produced for the two Augustinians. His attention to events in the life and mission of Christ inevitably required him to employ the conflict between Christ and the Jews, and thus it engaged his sense that the Jews, like the Romans, were members of the devil's body.[47]

Rupert stated his polemical theme softly at the outset, in his discourse on the first seal. The white horse represented Christ's incarnation, he wrote, and this beast was an analogue of that other on which the good Samaritan laid the wounded Jew and carried him to safety. The Samaritan, Rupert concluded, represented God; the beast, Christ's pure humanity.[48] When he turned to the opening of the second seal (the red horse, Christ's passion), Rupert discarded this gentle tone. By their role in Christ's agony

[46] Like Gerhoch in his tractate on Psalm 64, Rupert employed (with variations) the conventional six-part division of the *oratio: exordium,* quotation of the text from the Apocalypse that introduced the symbol of a given seal; *narratio,* texts adduced from scriptural books other than the Apocalypse in order to associate the particular seal with one of the seven christological mysteries; *partitio,* addition of other scriptural verses to indicate the range of prophecy and fulfillment to be followed in this discourse; *confirmatio,* exegesis on the seal itself, identification of the attributes of the figure, and relation of them to the christological event represented by it; *confutatio,* adversion to enemies or deniers of the christological event represented by this figure; and *conclusio,* a brief moral, or summary.

[47] Rauh, *Bild des Antichrist,* 226–30.

[48] PL 169:941.

and death, the Jews had brought upon themselves a heavy retribution that again disrupted the peace: namely, the terrible destruction of Jerusalem and the dispersal by Vespasian and Titus. Seal by seal, Rupert returned to the Jews as personifying the malignity of Christ's enemies. (At the fourth seal—the pallid horse representing the ascension into heaven of Christ as God and man—the enviousness of the Jews was subordinated to that of Arius, whose literalism, however, was regarded as a tool for "Judaizing" the Church.)[49] The climax of his theme came in the discourses on the fifth and sixth seals, which he crowned with a striking contrast between God's vocation of the Gentiles, the children of promise, and his rejection of the Jews, the children of flesh. With precision, he drew out the asymmetry between the heavenly Jerusalem and its earthly namesake, the synagogue of Satan, exalted with intolerable pride and crushed by siege, warfare, hunger, and fear.

Although Rupert identified the opening of the sixth seal with the vocation of the Gentiles, his extensive remarks concerned almost entirely the reverse side of that coin: the Roman conquest of Judaea following upon the reprobation of the Jews. In the discourse on the seventh seal, representing the Last Judgment and the consummation of all things, there is no reference to the Jews, although, given what Rupert had written earlier, it is not possible to ignore his statement that, at the end, final vengeance—the "wrath of the Lamb"[50]—would be visited on the killers of the saints, that they would be exterminated so that they could kill no more.

Such were some of the beauties that Rupert found in the text of the Apocalypse. They were not far different from the beauty that Otto of Freising found in the fact that, knee-deep in the blood of the vanquished, the Crusaders rode into Jerusalem on the eighth day of the siege (1099). For, Otto wrote, Christ's Resurrection occurred after the Sabbath, on the eighth day, to demonstrate that the Jewish Law had been abolished.[51]

There was a timelessness in Rupert's exegesis similar to that expressed by Anselm and Gerhoch. The spiritual world might be inhabited by many persons, but Rupert reduced them to a few types. All persecutors, regardless of chronology, were reduced to one body and were called one Beast, just as all who used words to deceive were reduced to one body called "the pseudoprophet." Thus Rupert was able to think that, although Antichrist had not yet come, Nero had come in his spirit, and heresiarchs of the early

[49] On Jewish literalism, see Rupert of Deutz *Commentum in Apocalypsim* 1.1, 2.2, 4.5 (*PL* 169:848, 852, 854, 875, 936); see also Otto of Freising *Chronicon* 8.26 (*MGHSS-rrG* 431). On Arian literalism as a tool for "Judaizing" the Church and rendering it a synagogue of Satan, see Rupert of Deutz *Commentum in Apocalypsim* 7.12 (*PL* 169:1059–60); Gerhoch of Reichersberg *Tractatus in Psalmum 64.* 119–20 (*PL* 194:79).

[50] Rupert of Deutz *Commentum in Apocalypsim* 4.6 (*PL* 169:958).

[51] Otto of Freising *Chronicon* 7.4 (*MGHSSrrG:* 314); cf. 3.prol. (*MGHSSrrG* 134): "Pulchre igitur eadem urbs caput antea fuit mundi, quae postmodum futura fuit caput ecclesiae."

Church had been "antichrists."[52] Likewise, the Apocalypse represented all writers or interpreters of Scripture, whom the Church received, as having one faith and speaking by one and the same Spirit, as seven angels having seven phials.[53] Above all, Christ was always present, and at his crucifixion, he washed from their sins all believers who had been and who were yet to be; for in the Church they were all members of his body, "concorporal" with his flesh.[54]

The cast of characters was reduced to types, but the key to the timeless beauties of their actions was violence, and not only retributive vengeance on the enemies and deniers of Christ—for, as Rupert taught, if the Lamb had not been slain, he could not have unsealed the book.[55] Fittingly, therefore, the exegeses with which we have been concerned were also determined, in form and content, by the polemical objectives of the authors: Anselm's rejection of the rejectors of novelty; Gerhoch's invective against presumed corrupters of the Church, including the majority of prelates and, especially, practitioners of the Aachen rule; and finally, Rupert's sustained polemic against the Jews.

What has thus far emerged? A pattern of self-concealment. Twelfth-century writers quoted, and in these cases applied, the aphorism that the task of art was to conceal itself. Their individualism allowed them to assert that readers loved not the written texts but the author (or at least his "artful ingenuity") in the work. Their ardent polemics arose from, and addressed, contemporary circumstances. And yet, both the author and the circumstances disappear into an atmosphere of timelessness and placelessness. They are invisibly at the center of the composition, like the blank on which a mandala focuses. At the very center are the charismatic gifts vouchsafed to authentic interpreters; and these too were concealed in the secrecy that hedged about with awe the holiness of private revelation. Thus we have found, and been able to explain very partially, the black hole around which texts formed. Did the Apocalypse disappear into the same creative hole as the author, his circumstances, and his charismata?

TOWARD THE LIMITS OF THE GAME

Certain aspects of the game are now clear. What I have said underscores artistic freedom to control the materials, which is also to say the subject

[52] Rupert of Deutz *Commentum in Apocalypsim* 1.1, 2.2, 6.10, 11, 11.19 (*PL* 169:846, 853, 865, 867, 1006, 1016, 1029, 1174).

[53] Ibid., 10.17 (*PL* 169:1129–30).

[54] Ibid., 1.1 (*PL* 169:840–42, 847). For Gerhoch of Reichersberg's reference to Jacob as a persona of Christ, see n. 42 above.

[55] Ibid., 4.5 (*PL* 169:932); see also 8.13 (*PL* 169:1083): Christ pours out his own blood; Antichrist, the blood of others. Otto of Freising evaded answering the question of whether God could have saved anyone without shedding his own blood (*Chronicon* 4.18 [*MGHSSrrG* 206]).

of violence. My comments on the ahistorical, and possibly antihistorical, use of materials from the Apocalypse also suggest the perspective of time-lessness and placenessness from which the authors wrote. That perspec-tive was by no means a fixed point, nor was the object in view a motionless figure. The reduction of historical figures to types produced se-quences and repetitions that were ahistorical because they rendered all ages in some sense both sequential and simultaneous. Gerhoch of Reich-ersberg captured that simultaneity when he portrayed the saved as living stones built into a circular Temple, each equidistant from their common center, Christ. But his figure was static. Those writers came closer to cap-turing the dynamic who assimilated it to Ezekiel's concentric wheels, turning, ever imparting immutable truths to believers, yet never retracing their tracks as they moved toward the end of the world.[56] The exegete, in-cluding the historical exegete, wrote from a perspective on the rim of the turning wheel of prophecy, a wheel whose circularity was plain from the fact that it combined all times, past, present, and future.[57]

The problem of evil as raised by the Apocalypse menacingly endangered this esthetic and authorial perspective, for reasons present in comments we have already encountered in the reprobation of the Jews and, quite dif-ferently, in those concerning the inspiration of the interpreter. Partial and eclectic as it was, recourse to the Apocalypse cast into high relief a major flaw at the very heart of the interpretive enterprise: the responsibility of God for erroneous belief and, consequently, for moral evil. Texts, both from the Old and the New Testament, affirmed that Satan, and Antichrist, could work only as, and as long as, God permitted. Indeed, they taught that God, who had sent an evil will into Saul, also sent the spirit of error upon the unrighteous "that they should believe a lie; that they all might be damned who believed not the truth, but had pleasure in unrighteous-ness."[58] Otto of Freising recalled that the prophet Jeremiah had portrayed Babylon as a golden cup in Jehovah's hand, a chalice from the wine of which the whole earth became drunken and mad (Jer. 51:7).[59] The Apoc-alypse reinforced the conviction that God permitted Antichrist to deceive both the wise and the foolish in order that prophecies, and the divine plan for the redemption of the world, might be fulfilled. Did not God inevitably create the shadows of evil and the light of good with the same gesture?[60]

[56] Rupert of Deutz *Annulus, sive dialogus inter Christianum et Judaeum* (PL 170:597). See also Joachim of Fiore, *Enchiridion super Apocalypsim*, ed. Edward K. Burger (Toronto, 1986), 10–12.

[57] Rupert of Deutz *Commentum in Apocalypsim* 1.1 (PL 169:831). On circular per-spective, see Rudolf Arnheim, *The Power of the Center: A Study of Composition in the Visual Arts* (Berkeley and Los Angeles, 1988), esp. chap. 3 ("The Viewer as Center"), 36–50.

[58] 1 Kings 18:10; 2 Thess. 2:10–11; cf. Rom. 1:28, as considered by Otto of Freising *Chronicon* 6.20 (MGHSSrrG 284).

[59] Otto of Freising *Chronicon* 8.20 (MGHSSrrG 420, 422–23).

[60] Ibid., 8.20 (MGHSSrrG 422).

The wretchedness of Job and the passions of Christ and his martyrs gave ample occasion to attempt to explain why God visited temptation, pain, and death upon those who were faithful to him. Was it not to test their faithfulness, to stimulate ardent love of God and banish spiritual sloth, to inculcate contempt for the world and yearning for the future life, to chasten and guide the beloved, purifying them in the furnace of tribulation?[61] Such were acts of "pedagogical and medicinal" correction; they enhanced the glory of faithful witness.[62]

But admitting the possibility that God could intrude mistaken identities into the minds of his own, or permit Antichrist to do so, carried violence to the heart of the hermeneutic enterprise itself and rendered even charismatic understanding indefinite and provisional.

The treatises by Anselm of Havelberg and Gerhoch of Reichersberg lack formal theodicies.[63] Anselm's entire argument that divine wisdom led its elect *gradatim* (by stages), *paulatim* (little by little), or *quasi furtim* (as though covertly) toward the perfection of the Gospel, and his contention that the Lord could make lambs out of wolves, or at least negate the danger of wolves to his lambs, did not provoke him to ask the reasons for the delay. He did not ask, as Otto of Freising did, why God so long postponed the coming of Christ and why the Lord allowed Antichrist so savagely to afflict his city.[64]

It was "most demented and impious," Rupert wrote, to suspect that God was the author of hatred or guile. If God hardened the heart of Pharaoh and enabled other proud and wicked rulers to achieve their desires, it was so that eventually their wrongdoing could produce happiness for others and so that the judgments God had foretold through his saints and prophets could be fulfilled. Even the triumph of Antichrist over all earthly kingdoms and the diabolic workings that it entailed had been predicted by the prophets and by Christ himself in the Gospels; for the kingdoms of this world could do nothing against God's purpose, nothing that God had not foreknown and predicted.[65]

[61] Cf. Ibid., 3.43 (*MGHSSrrG* 177). God wished martyrs to be put to flight before they were slain so that the treasures of their relics would be spread in divers places and provinces.

[62] Cf. Anselm of Havelberg, *Antikeimenon* 1.5, 6 (*PL* 188:1147, 1148).

[63] Gerhoch was content with the conviction that God permitted wheat and tares, good fish and bad, to mingle in his Church until the Last Judgment. He also recognized that, even while true prophets could be deceived by false prophets and be slain by an angry God for their disobedience, they might find mercy from God after he had been placated by their deaths (*Tractatus in Psalmum 64* 146, 159 [*PL* 194:98, 107]). Likewise, there is no formal theodicy in Anselm's extant writings, but cf. *Antikeimenon* 1.1, 10 (*PL* 188:1143, 1153); *Liber de ordine Canonicorum regularium* 1 (*PL* 188:1093); and *Antikeimenon* 1.3 (*PL* 188:1146).

[64] Anselm of Havelberg *Liber de ordine canonicorum regularium* 8 (*PL* 188:1101); *Antikeimenon* 1.5, 6 (*PL* 188:1147, 1149). Otto of Freising *Chronicon* 3.prol., 8.3 (*MGHSSrrG* 130–35, 396).

[65] On Rupert's conception of evil as a positive element in the divine economy, see Rauh, *Bild des Antichrist*, 198–200. See also, in general, Kamlah, *Apokalypse und Geschichtstheologie*, 59–60.

Otto of Freising's philosophical studies convinced him that only what is self-sufficient and most truly good can most truly be called good: namely, God. All other goods were called so by virtue of their degree of proximity to God, or by reference to their use or purpose ("good for something"). Thus the betrayal and crucifixion of Christ were not good for the Jews or for Judas, but they were good for "us" and for the whole world; and the appalling anguish of the Second Crusade was not good for the expansion of territories or physical ease, but it was good for the souls of many. For this reason, God permitted the Crusade to be proclaimed by Pope Eugenius III and preached by Saint Bernard of Clairvaux, perhaps withholding the spirit of prophecy from the latter.[66]

Otto was able to understand that God permitted his city to be afflicted by Antichrist so as to rouse it from torpor and exercise it in love of its creator in that most grievous gymnasium (palaestra).[67] He was able to understand why God wished Nero—whom some said had not died but would return as Antichrist—to rule the world, a most wicked enemy of the Church; for a divine asymmetry existed in the simultaneous rule of Nero over the world and of Saint Peter over the Church, both in the city of Rome, an asymmetry that expressed the "beauty" with which the victorious government of the Church was to supersede that of the Roman Empire.[68] But, just as he could not fathom why the spirit of prophecy had evidently left Saint Bernard when he preached the Second Crusade, Otto could not apprehend the hidden judgments by which God sent the spirit of error upon those whom he made to believe a lie, and caused the peoples to become drunken from the wine of Babylon's fornication—that is, from the false wisdom and sophistical reasonings that drove the simple to madness.[69]

Otto knew the example of the prophet Habakkuk, who protested to God because he permitted his people to be oppressed and their oppressors to prosper.[70] But frank remonstrance with the Almighty was not Otto's way. In other instances, when he confronted the secret counsels of God, he resorted to Christian agnosticism, arguing that we can not explain what we cannot understand.[71] Overarching all his explanations and evasions was the proposition of benign obscurity which Otto applied specifically to the doctrine that the Kingdom of God would come swiftly, as a thief in the night. Allowing no time for second thought, the Lord's voice would, with dreadful suddenness, sound the End. One had to believe that God had

[66] Otto of Freising *Gesta Friderici* 1.65 (*MGHSSrrG* 91–93).

[67] Otto of Freising *Chronicon* 8.3 (*MGHSSrrG* 396).

[68] See n. 51 above; ibid., 3.prol., 15, 16, 4.prol., 8.2 (*MGHSSrrG* 134, 153–54, 155, 181, 394). See also Otto's explanation of the reason for which God wished Tiberius to slaughter the Roman Senate: ibid., 3.11 (*MGHSSrrG* 147).

[69] Ibid., 8.3, 20 (*MGHSSrrG* 396–97, 422–23).

[70] Ibid., 2.12 (*MGHSSrrG* 81).

[71] On two occasions, he took recourse to Rom. 11:33 ("O altitudo"): ibid., 3.prol., 4.18 (*MGHSSrrG* 131, 206).

ordained this ever-impending doom, not in cruelty, but in wisdom, so that
the faithful would be always fearful of the Judge's coming, always ready to
give account.[72]

As they performed their tasks of symbolic cryptology on the issue of
God's responsibility for evil, the authors with whom we are concerned did
not resort to the Apocalypse. The "subintellection" by which they com-
posed their theodicies established connections among passages in other
books of Scripture, but not with John's visions of the last times.[73] Why,
then, did the authors with whom we are concerned, despite their joy in
occult sympathies, avoid the Apocalypse as a source of proof texts in their
discussions of evil and especially in their theodicies?

The absence of specific citations from the Apocalypse can surely not be
explained by doubts about that book's authenticity, or by disesteem for its
author, whom they thought to have been Christ's beloved disciple. Nor
was there a prevalent aversion to its narrative content. To be sure, political
theories emerging in a world of controversy may have helped delegate the
Apocalypse to the realm of the conspicuously absent. In its very concep-
tion, the Apocalypse was a text of political subversion, and experiments in
applied apocalypticism had made their disruptive effects evident in indi-
vidual monasteries.[74] Otto of Freising saw approaching storm clouds when
he observed that the prophecies applied by some to Nero, by others to An-
tichrist, and by himself to royal government had been applied by still oth-
ers to the priesthood and the Roman see.[75] Yet the authors under review
did not shrink from conflict. Indeed, the fact that some of them allowed
their treatises to be dominated by polemical objectives limited to their
own circumstances may have contributed to the rapidity with which the
works plunged into the oubliette of time.[76]

There was, however, a greater reason than discretion to consign the
Apocalypse to the unsaid in the said, to leave it present by its absence. For
its hidden meaning delivered to believers the dreadful quandary of explain-
ing God's responsibility for moral evil, through the deceptions of Anti-
christ, the pseudoprophet, and their ministers. It implicitly questioned the
charismatic understanding of the interpreter himself. Thus the puzzle of

[72] Ibid., 8.7 (*MGHSSrrG* 400).

[73] Rupert of Deutz's theodicy (*Commentum in Apocalypsim* 10.17 [*PL* 169:1145–46])
consists entirely of citations from the books in the Old Testament and a gloss by Au-
gustine. In the *Deeds of Frederick*, Otto of Freising was prompted to write a theodicy by
the catastrophe of the Second Crusade, citing the books of Genesis, Luke, and James
(*Gesta Friderici* 1.65 [*MGHSSrrG* 91–93]); see also the appended letter by Pope Eugenius
III (1.66 [*MGHSSrrG* 94–95]). His theodicean sections in the *Chronicle* likewise appeal
to scriptural authorities other than the Apocalypse (2.12, 47, 3.prol., 4.prol., 6.20, 7.7, 34,
8.3, 20 [*MGHSSrrG* 81, 124, 130–35, 181, 284, 317–18, 369, 396, 422]).

[74] E.g., *Vita Norberti Magdeburgensis* 13 (*MGHSS* 12:685–86).

[75] Otto of Freising *Chronicon* 8.2 (*MGHSSrrG* 395).

[76] On Rupert's brief *Nachleben*, see Kamlah, *Apokalypse und Geschichtstheologie*,
103–4. On the other historians in question, see my *History as a Visual Art*, 213–14.

art could become a trap, the reciprocating actions of Ezekiel's double wheels, a sacred doublecross.

The mimetic character of holiness, which is also to say of violence, also came into play. The violence of sacrifice, in which one "kill[s] a man to save a man,"[77] was the extreme expression of divine love, and it called for emulation. Far from the empire, and barred by her gender from the priesthood, Christina of Markyate grasped this in a vision of unspeakable joy. God asked her whether she was willing for the spiritual friend for whom she was pouring out ardent intersessions to undergo the pains of death for God's sake. In the wordlessness of immense feeling, she answered that, in love, she would gladly slay him with her own hands, as Abraham had been ready to kill his only son.[78] The typological analogy between Abraham's willingness to sacrifice Isaac and God the Father's willingness to sacrifice his only son cannot have been far from Christina's application of the tautological aesthetics of dissimilar likeness and unlike similarity to her own relationship with a man of flesh and blood. What infusion of sacramental ardor guided priests who did make and offer the body and blood of Christ and who were consecrated to offer themselves also as species of sacrifice to God?[79] Priests and prelates participated in judgments of capital punishment; they took up the sword of iron. They drenched even the papal Curia with human blood. When they carried the mimetic character of violence beyond the controls of ritual, did they emulate the Divine Avenger in their fulfillment of his prophecies, as they claimed, or pollute their hands and lips, imitating the four bloodthirsty Beasts envisioned by Daniel?[80]

Perhaps they and their critics were equally deluded in their elaborate hybrids of similarity and unlikeness. Perhaps what the exegetes took to be the performance of the prophet's wheels was actually the random spin of Fortune's. The doctrine of salvation which they shared comprised, with their metaphysics, one vast but fragile theodicy.[81] In addition to the evanescence of their polemical objectives, the tentativeness with which the authors posed this central issue of evil in a divinely ordered world, and the incompleteness with which they addressed it in silent reverence for their own charismata, may have contributed to the fact that their writings, singular as they were, had so ephemeral an appeal.

[77] Girard, *Violence and the Sacred*, 10.

[78] C. H. Talbot, ed. and trans., *The Life of Christina of Markyate, a Twelfth Century Recluse* (Oxford, 1959), 180.

[79] Gerhoch of Reichersberg *Tractatus in Psalmum 64* 62 (*MGHLdl* 3:465); Rupert of Deutz *Commentum in Apocalypsim* 1.1 (*PL* 169:841).

[80] Gerhoch of Reichersberg *Tractatus in Psalmum 64* pref. B.61–62 (*MGHLdl* 3:439–43, 464–65).

[81] Cf. Maurice de Wulf, in *Histoire de la philosophie médiévale*, 6th ed., vol. 1 (Paris, 1934), 166, on Anselm of Canterbury: "Le métaphysique d'Anselme se résume en une vast théodicée."

It was easier to understand that God built the redeemed into his Temple as living stones than to explain how, once in place, they could become diseased and how, once leprous, they could be removed, cast out, and burned into lime by the same Divine Architect who had chosen them. Rejected by the Divine Architect and cast into hell's furnace, the impious yet contributed to the beauty of his building and to the saints' eternal joy in God. For, from their destruction was made the bond of charity which held together the just, the mortar between those exquisitely squared and polished stones.[82] Neither loving submission nor the assumption of a divine order appears to have induced twelfth-century historians to be willing to entertain the prospect of being damned for the glory of God. God's responsibility for physical evils could be controlled by rationales of theology and by all the visual and performing arts of cult. But, before the full development of Scholasticism, God's responsibility for moral evil was beyond such controls. Its consequences put wholeness and beauty alike in jeopardy; for they reduced the barriers to explaining human experience as not merely as the sport of a deceitful God but even as the random play of Fortune or the mutual rivalry among reptiles of the sea. The world of cult, of which our histories are fragments, was made possible by the violence epitomized in the doctrine that the Lamb could not have opened the book without being slain. Only that control, and the postulates of charismatic love on which it depended, transformed a world of unsignifying violence into the beauty that the imaginative arts disclosed in their iridescent figures.[83] Even without resort to the idea of God as a trickster, it was evident, as Thomas Aquinas later wrote, that the presence of evil in the world posed a reason to deny the existence of God.[84]

Why, Rupert asked, did John weep, when no man in heaven or earth was able to open the Lamb's book, sealed with seven seals? The mighty cry of the angel—"Who is worthy to open the book and to break its seals?"—signified the great desire of the holy people of old, Rupert continued, but of itself it was too little to reduce John to tears. Yet to this voice was added

[82] See Honorius Augustodunensis *Elucidarium* 3.79–109, 114–21, as quoted by Herrad of Hohenburg in *Hortus deliciarum*, in *Herrad of Hohenbourg: Hortus Deliciarum*, ed. Rosalie Green et al., vol. 2 (London, 1979), 452. This text was one of many that Herrad included in a monumental program of words and pictures illustrating the Last Judgment. See also Bede, *Commentary on 1 Peter 2:5*, trans. David Hurst, *Bede the Venerable: Commentary on the Seven Catholic Epistles* (Kalamazoo, Mich., 1985), 82, omitting the reduction of the impious to lime. The premise that mortar was strengthened by the admixture of animal blood appears in William Fitzstephen's reference to the Tower of London as a Roman building "caemento cum sanguine animalium temperato" (*Vita Sancti Thomae Cantuariensis Archiepiscopi* pref. [*PL* 190:105]).

[83] See Rauh, *Bild des Antichrist*, 201: "Deutlich herrscht bei Rupert die Tendenz, die Profanhistorie als endlose Folge von Krieg und Blutvergiessen, von Entzweiung und Verrat abzuwerten."

[84] Thomas Aquinas *Summa Theologiae* Ia, q. 2, a. 3, *ad* 1.

the unction of which John spoke elsewhere—"you have an anointing from the Holy One and you know all things" (1 John 2:20)—such that, in his excess of soul, he wept because of the sweetness of the things that he saw, and in his weeping he experienced how truly the desire of those holy ones had called for tears.[85]

[85] Rupert of Deutz *Commentum in Apocalypsim* 4.5 (*PL* 169:927).

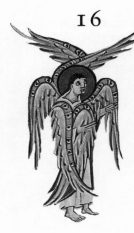

16

Domesday Bokes: The Apocalypse in Medieval English Literary Culture

PENN SZITTYA

In 1086, only a year before his death, William the Conqueror ordered the entire English nation surveyed and reduced to writing. His commissioners accomplished this monumental task, in the face of fear and resistance by the populace, in less than two years, and the results were distilled into a huge royal book in two volumes. By the middle of the next century, the book was widely known among the English as "Domesday," the *liber qui vocatur Domesday*, and was regarded with awe.[1] The name is puzzling; William's catalog of his conquered English domain is not much more than a series of lists of landowners, land values, manors, subtenants, boroughs, freemen, sokemen, unfree peasants, slaves, livestock, and geld assessments, and it could hardly be further removed from the apocalyptic cataclysms of Judgment Day. Only one medieval explanation for the name survives, and it is problematic. It occurs in the *Dialogus de Scaccario*, written around 1179 by Henry II's treasurer, Richard Fitz Nigel:

This book is metaphorically called by the native English, Domesday, i.e. the Day of Judgment. For as the sentence of that strict and terrible last account cannot be evaded by any skilful subterfuge, so when this book is appealed to on those matters which it contains, its sentence cannot be quashed or set aside with impunity. That is why we have called the book

I would like to thank my colleagues Jason Rosenblatt and Joseph Sitterson for their conversation and sage advice in the early stages of this project.

[1]Contemporary records consistently describe the fear generated by the survey and associate it with calamities and apocalyptic disasters; see Dorothy Whitelock et al., eds., *The Anglo-Saxon Chronicle: A Revised Translation* (London, 1961), 161–63; and C. Stevenson, "A Contemporary Description of the Domesday Survey," *English Historical Review* (1907): esp. 74, 77.

'the Book of Judgment' [*liber iudiciarius*], not because it contains deci-
sions [*sententia*] on various difficult points, but because its decisions, like
those of the Last Judgment, are unalterable.[2]

Fitz Nigel's explanation at first glance seems to suggest that the Domes-
day Book was used to make judgments, presumably in land disputes, as a
reference of last resort; hence its association with the Last Judgment.
M. T. Clanchy has pointed out, however, that there is little evidence of the
book—or written documents in general—being used in this way until the
thirteenth century.[3] In fact, Clanchy argues, the early evidence suggests
"its function was symbolic rather than practical."[4]

If Domesday was not used in making judgments, why then was it asso-
ciated with the Last Judgment? It has not been recognized that behind Fitz
Nigel's famous account lies an unspoken analogy between the Domesday
Book and the book of life described in Apocalypse 20:11–15, an analogy
that draws much of its point from current notions of the political theology
of kingship. The *liber vitae* of the day of doom is a fearfully exact register
of the inhabitants of the blessed kingdom: "if anyone was not found writ-
ten in the book of life, he was cast into the pool of fire." This authoritative
register is wielded by a royal figure who sits on a great white throne in the
kingdom of heaven (Apoc. 20:11). The analogy between the English royal
book and the book of life, tacitly posed by the name Domesday, thus also
connects two thrones, two kings, and two kingdoms whose citizens have
been inscribed into a book.

These latter analogies are familiar in eleventh- and twelfth-century po-
litical theology, especially in England and Normandy. What Ernst Kantor-
owicz calls Christ-centered kingship had as its most extreme exemplars
the Anglo-Saxon kings before the conquest, especially Edward the Con-
fessor, whose legitimate successor William claimed to be. Christian kings
in Anglo-Saxon culture had long been identified with Christ.[5] Similar
ideas came to be developed by Norman writers after 1066. Perhaps the
clearest statement of the christocentric theory in this period is that of an
anonymous Norman writing within a decade and a half of William the

[2]Richard Fitz Nigel *Dialogus de Scaccario,* trans. and ed. Charles Johnson (Oxford,
1983), 64.

[3]M. T. Clanchy, *From Memory to Written Record: England, 1066–1307* (Cambridge,
Mass., 1979), 19–20: "There are only ten references extant specifically to the use of in-
formation connected with the Domesday Book between the time it was made and the
death of Henry I in 1135. . . . After Henry I's reign, there is no further evidence of
Domesday Book being searched for specific information . . . until a plea roll of 1221."

[4]Ibid., 18.

[5]See Ernst H. Kantorowicz, *The King's Two Bodies: A Study in Mediaeval Political
Theory* (Princeton, 1957), chap. 3; David C. Douglas, *William the Conqueror: The
Norman Impact upon England* (Berkeley and Los Angeles, 1964), 253–54; Henry A.
Myers, *Medieval Kingship* (Chicago, 1982), 216–17; and William A. Chaney, *The Cult of
Kingship in Anglo-Saxon England* (Berkeley and Los Angeles, 1970), 195–96, 211, 246,
248, 251.

Conqueror's death. The Norman Anonymous speaks of the Christian king as "*christomimetes*—the 'actor' or 'impersonator' of Christ who on the terrestrial stage presented the living image of the two-natured God."[6]

That William the Conqueror was zealously cultivating the idea of a christocentric kingship is beyond dispute. His elaborate coronation ceremony emphasized the religious nature of his office as a priest-king, a *Christus domini*.[7] Thereafter, at every Easter, Pentecost, and Christmas, William marked his kingship with the ceremonial crown-wearings that became one of the signatures of his rule.[8] According to the *Carmen de Hastingae proelio* by William's contemporary, Bishop Guy of Amiens, the crown itself was adorned with twelve rare gems nearly identical to the twelve precious stones said to adorn the foundations of the twelve walls of the celestial city in Apocalypse 21:19–20. They are, in the order of the *Carmen*, ruby, jacinth, topaz, sapphire, sardonyx, chalcedony, jasper, sard, chrysolite, beryl, emerald, and chrysoprase.[9] Thus the Conqueror's crown alludes to the heavenly kingdom, of which the English kingdom is but a shadow; it is "nothing else but a representation of the heavenly Jerusalem."[10] The christological ostentation of both the crown and the crown-wearing ceremonies was not lost on the popular level. A biographer of Lanfranc reports that a clerk who saw William attired in glory on one of these occasions cried out, "Behold, I see God."[11]

The Domesday Book, like William's crown, became one of the privileged signs of a christocentric kingship. And it quickly attained a symbolic status comparable to other emblems of royal authority. Fitz Nigel reports that Domesday regularly traveled with the king in the royal treasury, where it was "the inseparable companion . . . of the royal seal."[12] But it was more: like the apocalyptic register of Apocalypse 20, the Domesday

[6]Kantorowicz, *King's Two Bodies*, 47. On the Norman Anonymous, see also Douglas, *William the Conqueror*, 257–58.

[7]See Douglas, *William the Conqueror*, 249–56.

[8]Ibid., 249.

[9]*The Carmen de Hastingae proelio of Guy, Bishop of Amiens*, ed. Catherine Morton and Hope Muntz (Oxford, 1972), 49, lines 755–82. The only difference between the jewels of the crown and those in the Apocalypse is the substitution of ruby for amethyst. But as Morton and Muntz point out (49 n. 3), Guy's word for ruby is "carbunculus," which may stand for any red gem, and amethyst (in medieval lore) is red. For disputes about the historical accuracy of the contents of Guy's poem, see Morton and Muntz, xv–lix; R. H. C. Davis, "The *Carmen de Hastingae proelio*," *English Historical Review* 367 (1978): 241–61; and Elisabeth M. C. van Houts, "Latin Poetry and the Anglo-Norman Court, 1066–1135: The *Carmen de Hastingae proelio*," *Journal of Medieval History* 15 (1989): 39–62. On William's crown, see Percy Ernst Schramm, *Herrschaftszeichen und Staatssymbolik*, vol. 2 (Stuttgart, 1955), 393 ff.

[10]Schramm, *Herrschaftszeichen und Staatssymbolik* 2:601.

[11]Douglas, *William the Conqueror*, 258; Milo Crispin *Vita Lanfranci* (PL 150:53); see also G. H. Williams, *The Norman Anonymous of 1100* (Cambridge, Mass., 1951), 161.

[12]Fitz Nigel *Dialogus* 62–63. Book and seal, both emblems of royal authority, are also intertwined in the Apocalypse, where Christ alone has the power to open the book "sealed with seven seals" (Apoc. 5:1).

Book was a microcosm of the kingdom it surveyed. It embodied the kingdom as a text.

Domesday's textuality was perceived as significant. Fitz Nigel, a century after the Conquest, associates the Conqueror's new royal power with writing. One of William's most important achievements, he claims, was the introduction of "the rule of written law," centrally and consistently administered throughout the nation. And the beginning of written law was, for Fitz Nigel, inextricably intertwined with the making of the Domesday Book, since there the nation and its property were for the first time reduced to writing.[13] If so, the royal book is significant not only as an embodiment of the nation but as an emblem of both the new power of writing and the beginning of the momentous change "from memory to written record."[14]

In other important ways, the Anglo-Norman hegemony brought into being by the conquest created a new kingdom. The English were suddenly, and more widely than ever in their history, a conquered people. A new social order emerged with the Norman takeover of land and property. The loose regional federations of the Anglo-Saxon era abruptly ended, and with the institution of a centralized monarchy and a centralized bureaucracy, England began to become what for the first time could be thought of as a single kingdom. Of all these changes, as a register and textual microcosm of the new kingdom, Domesday was a fitting record and memorial. The English might not have thought it a new heaven, but it was incontrovertibly a new earth.

The popular name of the Domesday Book thus epitomizes the centrality of the Apocalypse to English culture of the Middle Ages. Especially after the conquest, a sense of a special relationship of the Apocalypse to England arises, fostered by a sense of analogy between the *regnum Anglorum* and the *regnum angelorum*, between the island kingdom and the celestial kingdom envisioned by Saint John.[15] This sense of analogy culminates, to mention only the best-known example, in Book 1 of Edmund Spenser's *Faerie Queene*, where the Red Cross Knight is archetypal romance hero but also Saint George and, finally, the apocalyptic Christ, who saves a kingdom that is at once England and the celestial Jerusalem.[16] If Domes-

[13]Ibid., 63.

[14]Clanchy comments, "Although Domesday Book had not brought the people under the rule of written law in any specific sense, it had associated writing with royal power in a novel and unforgettable way" (*From Memory to Written Record*, 20).

[15]France and Germany—or more specifically, the French monarchy and the German Empire—also figured prominently in apocalyptic literature, but most characteristically in connection with the Last World Emperor myth, which never figures in English speculations; see Bernard McGinn, *Visions of the End: Apocalyptic Traditions in the Middle Ages* (New York, 1979), 117–18, 246–48, 270–72.

[16]See Florence Sandler, "*The Faerie Queene*: An Elizabethan Apocalypse," in *The Apocalypse in English Renaissance Thought and Literature*, ed. C. A. Patrides and Joseph Wittreich (Ithaca, N.Y., 1984), 148–74.

day is an earthly *liber vitae*, then the new England after the conquest is a terrestrial analogue of the "new heaven" of Apocalypse 21, ruled by a Christ-like king, metaphorically as well as literally a conqueror.

THREE MOMENTS IN THE HISTORY OF THE APOCALYPSE

Besides the Domesday Book, English contributions to the cultural history of the Apocalypse in the Middle Ages are substantial. They include, for example, the most influential Latin commentary on the Apocalypse between Saint Jerome and the twelfth century, the first cycle of Apocalypse pictures to appear in a church in Northern Europe, the first vernacular translation of Adso of Montier-en-Der's *Libellus de Antichristo*, the largest group of illuminated Apocalypse books ever to appear in the West, and a large and distinguished body of Middle English poetry and drama heavily infiltrated by the Apocalypse.[17] English contributions are in some respects distinct from those of the rest of Europe, except for Normandy. In England, there is very little chiliastic or millenarian thought in the Middle Ages, despite its florescence in the English Renaissance. In the thirteenth century and after, there are few references in England to Joachim of Fiore or to the Spiritual Franciscan writers who appropriated his ideas, little of the current historicizing of the Apocalypse occurring elsewhere, and a conspicuous preservation and popularization of the conservative Tyconian tradition of Apocalypse interpretation long beyond its waning in other parts of Europe. Conservativism is a hallmark of English readings of the apocalypse.

Because the subject is so vast and so many materials are still unpublished, the literary history of the Apocalypse in the English Middle Ages remains to be written.[18] By its nature, as the Domesday Book illustrates, any such study would have to be a cultural history. Practically all literary appropriations of the Apocalypse also impinge on other subjects: medieval

[17]The commentary is Bede's *Explanatio Apocalypsis* (*PL* 93:133–206), on which see Gerald Bonner, *Saint Bede in the Tradition of Western Apocalyptic Commentary* (Newcastle on Tyne, 1966); and Joseph F. Kelly, "Bede and the Irish Exegetical Tradition on the Apocalypse," *Revue Bénédictine* 92 (1982): 393–406. The picture cycle was painted around 674 in the Abbey church of St. Peter in Wearmouth, where Benedict Biscop had brought a series of "imagines" of the Apocalypse from southern Europe (see Bede in *PL* 94:718). For the translation of Adso, see Arthur Napier, *Wulfstan: Sammlung der ihm zugeschriebenem Homilien* (Berlin, 1883; reprint, Dublin, 1967), Homily XLII, pp. 191–205; and Richard Kenneth Emmerson, "From *Epistola* to *Sermo*: The Old English Version of Adso's *Libellus de Antichristo*," *Journal of English and Germanic Philology* 82 (1983): 1–10.

[18]The closest thing to such a history is Richard Kenneth Emmerson's important *Antichrist in the Middle Ages: A Study of Medieval Apocalypticism, Art, and Literature* (Seattle, 1981). This is the best study of the conservative, orthodox exegetic tradition concerning Antichrist and contains a great deal of material about England. It is not restricted, however, to England or to the Apocalypse and, given its subject, does not touch on major sections of the text of the Apocalypse.

art, ecclesiology, exegesis, heresy, social theory and social crisis, historiography and historical theory, kingship, political theology, religio-military theory, popular culture, to name only the most conspicuous. This essay therefore can hope to offer no more than a few strokes in an outline of such a history. Most important, it is possible to isolate, besides the conquest, three culturally significant "moments" in the English history of the Apocalypse. Each is marked by the emergence of a vernacular literary form (or forms) with some kind of close relationship to the biblical Apocalypse. Chronologically, two of these moments bracket the conquest, beginning roughly at the end of the tenth century and again in the mid-thirteenth. The third begins at the end of the fourteenth century. I outline synchronically (and briefly) the materials that constitute each of these moments before tracing diachronically, in several brief excursuses, a few clusters of ideas that a cultural history of the Apocalypse in England might profitably pursue.

The Anglo-Saxon Homilists. Around the end of the tenth century and the opening of the eleventh, England was swept by anxiety about the nearness of the End, perhaps because of the approach of the year 1000, or because of the revived maraudings of the Danish between 980 and 1014, or because of the corruption in English society that Wulfstan addresses in his famous *Sermo Lupi ad Anglos* (1014).[19] One result of the intense apocalyptic speculation of the period is a spate of vernacular homilies written by churchmen but intended for a wide public. They include the homilies and sermons of Wulfstan, bishop of London and archbishop of York and Worcester, between roughly 990 and 1014; the *Catholic Homilies* (ca. 990) of Ælfric, abbot of Eynsham; the anonymous Blickling homilies (before 971); and the Vercelli homilies (compiled around 1000).[20]

Apocalyptic fears of course occur elsewhere in the period, occasionally in unexpected places like saints' lives or Byrhtferth's *Manual* or the Latin

[19]For some skepticism about eschatological expectations concerning the year 1000 in England, see Dorothy Bethurum, ed., *The Homilies of Wulfstan* (Oxford, 1952), 278–79. For Wulfstan's *Sermo*, see Dorothy Whitelock, ed., *Sermo Lupi ad Anglos*, 3d ed. (London, 1963), and for the Danish raids, 14–15.

[20]For Wulfstan, see Bethurum, *Homilies*, esp. nos. I–V; and Napier, *Wulfstan*. For Ælfric, see the *Catholic Homilies*, in *The Homilies of the Anglo-Saxon Church*, ed. Benjamin Thorpe (London, 1844), esp. the preface to the first series (1.2–6) and Homily XXXV; and his "Sermo de die iudicii," in *Homilies of Ælfric: A Supplementary Collection*, vol. 2, EETS 260: 584–612). For the Blickling homilies, see *The Blickling Homilies of the Tenth Century* (ed. Richard Morris, EETS 58, 63, 73; reprint in 1 vol., London, 1967), esp. Homilies IV, VII, IX–XI. For the Vercelli homilies, see Max Förster, ed., *Die Vercelli-Homilien: I.–VIII. Homilie* (Hamburg, 1932); and Paul E. Szarmach, ed., *Vercelli Homilies IX–XXIII* (Toronto, 1981), esp. Homilies XI and XV. See also Milton McC. Gatch, "Eschatology in the Anonymous Old English Homilies," *Traditio* 21 (1965): 117–65, and *Preaching and Theology in Anglo-Saxon England: Ælfric and Wulfstan* (Toronto, 1977), c.III, pp. 60–116.

charters of Edgar's reign (959–75), which the scribes often open with a
formula announcing "terminus cosmi appropinquare," according to the
prophecy of Christ in Matthew 24:7, "For nation will rise against nation,
and kingdom against kingdom."[21] And it may well be true that the immi-
nence of judgment was a major fear throughout the Anglo-Saxon period, at
least from the time of Bede's influential commentary on the Apocalypse
in (roughly) 703.[22] Certainly Anglo-Saxon poetry has a reputation of being
infused with a dominant "apocalyptic mood."[23] Still, it is striking that al-
most all the apocalyptic Old English poetry, regardless of dates of compo-
sition, survives in just four manuscripts and that each of these four was
compiled by someone around the year 1000.[24] Even if the poems within
them are not of the century, these codices reflect the anxieties of tenth-
century culture and are not neutral repositories of unconnected, earlier
texts. The Vercelli codex as a whole, for one example, clearly shares the
dominant tenth-century interest in eschatology. It has recently been ar-
gued that its seemingly miscellaneous mix of prose and poetry, homiletic
and narrative, was designed as a coherent monastic *florilegium* in three
"booklets," each concluding with eschatological material. As in practi-
cally all the other major homiletic collections and much of the poetry of
this period, the eschatological focus complements an urgent call for repen-

[21] See the *Life of St. Neot*, ed. Richard Wuelcker, in "Ein angelsaechsisches Leben des
Neot," *Anglia* 3 (1880): 114; and *Ælfric's Lives of Saints* (ed. Walter W. Skeat, EETS 76:
304, 352); *Byrhtferth's Manual* (ed. Samuel Crawford, EETS 177:240); and Walter Birch,
Cartularium Saxonicum (London, 1885–93), nos. 1083 (for A.D. 962), 1099 (963), 1113
(963), 1115 (963), 1152 (964?), 1216 (968), all of which have an identical formula, and also
nos. 1158 (964?), 1295 (973).
[22] See n. 17 above for Bede's commentary. See also *De temporum ratione* (PL 90:520–
78); and the Latin poem "De Die Iudicii" (CC 122:439–44), which is the direct source of
the Anglo-Saxon poem "Judgement Day II." Bede quotes another alphabetic Latin poem
on the day of Judgment, beginning "Apparebit repentina dies magna," in *De arte met-
rica*, chap. 24 (MGH Poetae 4.2: 507–10).
[23] The phrase is Charles W. Kennedy's in *Early English Christian Poetry* (New York,
1963), 251. Three Anglo-Saxon poems directly concern Judgment Day: *Christ III*, in *The
Christ of Cynewulf*, ed. Albert S. Cook, 2d ed. (Boston, 1909); *Judgment Day I* and *Judg-
ment Day II*, both in *Anglo-Saxon Poetic Records*, ed. G. P. Krapp and E. V. K. Dobbie,
vol. 3 (New York, 1936) and vol. 6 (New York, 1942). For discussion, see Karma Lochrie,
"Judgment and Spiritual Apocalypse in Old English Eschatological Poetry," *Dissertation
Abstracts International* 42 (1982): 4008A; Graham D. Caie, *The Judgment Day Theme
in OE Poetry* (Copenhagen, 1976); Thomas D. Hill, "Vision and Judgement in the OE
Christ III," *Studies in Philology* 70 (1973): 233–42; and Leslie Whitbread, "The Dooms-
day Theme in Old English Poetry," *Beiträge zur Geschichte der deutschen Sprache und
Literatur* 89 (1967): 452–81. Three poems attributed to Cynewulf end with visionary
passages about doomsday, judgment, and the celestial city: *Elene* and *Juliana*, both in
Krapp and Dobbie, *Anglo-Saxon Poetic Records*, vol. 2 (New York, 1932); and *Christ II*,
in Cook, *Christ of Cynewulf*. On apocalypticism in *Beowulf*, see James Earl, "Apoca-
lyptism and Mourning in *Beowulf*," *Thought* 57 (1982): 362–70; and M. E. Goldsmith,
The Mode and Meaning of Beowulf (London, 1970).
[24] Stanley Greenfield, Daniel Calder, and Michael Lapidge, *A New Critical History of
Old English Literature* (New York, 1986), 130.

tance in the Vercelli compilation, penitence being a natural consequence of the proximity of the Last Judgment.[25]

The Ango-Norman Illuminated Apocalypse Books. After the Norman Conquest, another apocalyptically significant moment begins in the middle of the thirteenth century and extends into the fourteenth; this is the period of the invention and popularization of the English illuminated Apocalypse books, which have been called "without doubt the foremost graphic representation of the Apocalypse to appear in the West between the time of the Beatus and Carolingian series and . . . Dürer."[26]

In her essay in this book, Suzanne Lewis has treated the twenty-two thirteenth-century Apocalypses of English origin, and the reader is referred to this excellent account of their history. In addition to the manuscripts listed in her appendix, there are some twenty-eight illustrated Apocalypses of English origin from the fourteenth century.[27] With our focus on texts (as opposed to illuminations), it is also important to notice Lewis's demonstration that these Apocalypses almost always contain selections from one of two previously circulating commentary texts. One was a twelfth-century Latin gloss written by a Benedictine named Berengaudus in the twelfth century. The other was a vernacular (French) prose gloss composed in the thirteenth century, probably by Franciscans. Together, these two glosses, one Latin and one vernacular, along with the *ordinatio* of the books in which they appear—that is, the conjunction of biblical text, learned commentary, and picture cycle—exemplify a coalescence of the learned and the popular that characterizes the history of the Apocalypse in England.[28]

The Latin Berengaudus commentary dominated thirteenth-century Apocalypses; the French prose gloss, the fourteenth-century texts. Although these commentaries and the early illuminated Apocalypses in which they first appeared may have been designed for clerical readers, many of the later Apocalypses were owned by lay people, often aristocratic, often female, sometimes royal. In addition, the fourteenth century

[25]E. O. Carragáin, "How Did the Vercelli Collector Interpret *The Dream of the Rood,*" *Occasional Papers in Linguistics and Language Learning* 8 (1981): 63–104, esp. 66–67. For the complementarity of eschatology and repentance, see Gatch, "Anonymous Old English Homilies," 144, 159.

[26]Brent A. Pitts, "Versions of the Apocalypse in Medieval French Verse," *Speculum* 58 (1983): 32 n. 3.

[27]Catalogued by Suzanne Lewis in her collaborative project with Richard Kenneth Emmerson, "Census and Bibliography of Medieval Manuscripts Containing Apocalypse Illustrations, ca. 800–1500," pt. 2, *Traditio* 41 (1985): 370–409. The fourteenth-century English MSS are nos. 40, 42, 43, 46–48, 51, 53, 56, 65, 70, 73–76, 91–94, 96, 97, 99, 101–103, 105, 116, 117.

[28]On *ordinatio,* see M. B. Parkes, "The Influence of the Concepts of *Ordinatio* and *Compilatio* on the Development of the Book," in J. J. G. Alexander, ed., *Medieval Learning and Literature: Essays Presented to Richard William Hunt* (Oxford, 1976), 115–41.

contains clear evidence of the popularization of these Apocalypse com-
mentaries independent of the sumptuous illuminated manuscripts that
only the wealthy could afford. The French prose gloss was translated (at
least three times) into Middle English and joined with one of several Mid-
dle English translations of the Apocalypse text itself. These later, modest,
unillustrated Apocalypses with commentary circulated as independent
texts, unaccompanied by other biblical books. Seventeen such manu-
scripts survive from various periods of the fourteenth century, and their
relations are sufficiently complex to suggest the disappearance of a sub-
stantial number of others.[29]

In 1901, Léopold Delisle and Paul Meyer suggested that the French prose
gloss was clearly mendicant in origin.[30] That hypothesis, which has never
been investigated further, is particularly interesting in light of the number
of Apocalypse commentaries written by English members of the mendi-
cant orders in the fourteenth and late thirteenth centuries, nearly all of
them unpublished. Among the Franciscans, John Russel (d. 1305) and
Henry de Cossey (d. 1336) both lectured on the Apocalypse as masters of
theology at Cambridge; Thomas de Docking (d. after 1269) was regent
master at Oxford, where two treatises on the Apocalypse survive which
are (uncertainly) attributed to him; John Ridewall, regent at Oxford around
1330, wrote a *Lectura in Apocalypsim*, no longer extant, but known from
extracts quoted by other mendicant commentators; John Pecham, arch-
bishop of Canterbury (d. 1292), may have written a lost commentary on
the Apocalypse, apparently quoted by Russel; Hugh of Newcastle (d. 1322)
wrote a *Tractatus de victoria Christi contra Antichristum*, which in large
measure is concerned with the Apocalypse.[31] Robert Holcot (d. 1349), the

[29]On the Middle English Apocalypses with commentary, see Elis Fridner, *An English
Fourteenth Century Apocalypse Version with a Prose Commentary* (Lund, 1961). Frid-
ner prints the best MS of the earliest of two separate Middle English translations of the
French prose gloss; he also conveniently prints the French prose gloss, taken from the
edition of Léopold Delisle and Paul Meyer (see next note).

[30]Léopold Delisle and Paul Meyer, *L'Apocalypse en français au xiiie siècle: Bibl. nat.
ms fr. 403,* 2 vols. (Paris, 1900–1901), ccxvii–ccxix.

[31]Russel's Apocalypse commentary (Stegmüller No. 4920) survives only in Oxford,
Merton College MS. 172; see Beryl Smalley, "John Russel O.F.M.," *Recherches de Théo-
logie Ancienne et Médiévale*) 23 (1956): 277–320. On Henry Cossey's commentaries
(Stegmüller Nos. 3158–61)—which survive in Oxford, Bodleian Library MSS Laud misc.
85 and (perhaps) Rawlinson C. 16; London, Lambeth Palace MS. 127 (fragmentary); and
Washington, D.C., Holy Name College MS. 69—see M. R. James, *A Descriptive Cata-
logue of the Western Manuscripts in the Library of Christ's College, Cambridge* (Cam-
bridge, 1905), 29–30; and A. G. Little, *Franciscan Papers, Lists, and Documents*
(Manchester, 1943), 139–41. On Thomas Docking (Stegmüller Nos. 8111, 8111.1), to
whom an Apocalypse commentary is attributed in Oxford, Balliol College MS. 149, see
Little, *Franciscan Papers*, 98–121, esp. 102; and Jeremy Catto, "New Light on Thomas
Docking, O.F.M.," *Medieval and Renaissance Studies* 6 (1968): 136. On Ridewall, see
Smalley, "John Russel," 303, "Robert Holcot, O.P.," *Archivum Fratrum Praedictorum* 26
(1956): 54–56, and "John Ridewall's Commentary on *De Civitate Dei*," *Medium Ævum*
25 (1956): 140–53. On Pecham, see Smalley, "John Russel," 311–12. On Hugh of New-
castle, see C. V. Langlois, "Hugo de Novocastro or de Castronovo, Frater Minor," in

Oxford Dominican famous for his postils on the book of wisdom, also published a lengthy series of thirty-three lectures on the Apocalypse.[32] Such concerted interest among the mendicant schools at Oxford and Cambridge perhaps suggests that Delisle and Meyer's argument that the French prose gloss expresses a mendicant outlook might merit more substantial investigation.

Ricardian Poetry. A third culturally significant moment in the English appropriation of the Apocalypse occurs in the late fourteenth century, especially the Ricardian era, when England was shaken by a series of crises. The twenty years after 1369 constituted a continuing disaster for England in its long and expensive war with France: the once-vast English territories in France dwindled to Calais (precariously held) and the coastline between Bordeaux and Bayonne; the English navy lost control of the sea; the English coastal towns were attacked frequently and often torched; the English armies were plagued by desertion; the country staggered under the burden of taxation necessary to support the war effort. There were serious rebellions in Scotland and Wales. In 1376 the Black Prince died, followed a year later by his father, Edward III. The new king, Richard II, was ten years old. In 1378, the entire Western Church was rent by the Great Schism. In 1381, the Peasants' Revolt with its accompanying violence was precipitated by the burden of the new poll taxes, along with other social injustices. In May of 1382 there was an extraordinary earthquake in England, at exactly the moment when a council of ecclesiastics was meeting in the Blackfriars' Church in London to condemn the doctrines of John Wycliff. Not long thereafter, there was a fresh outbreak of the black plague that had been decimating England at intervals since 1348. In 1383 the English invaded Flanders in support of Urban VI. In 1384, John Wycliff died at Lutterworth, and the Lollard movement was beginning to spread. As if to give voice to the feeling among the English that this period of crisis foreshadowed the End, Thomas Wimbledon preached a famous sermon in the vernacular at Saint Paul's Cross, arguing that "þis day of wreche is nyӡe," and relaying (without enthusiasm) the report of one unnamed commentator that the End would occur in 1400.[33]

Essays in Medieval History Presented to Thomas Frederick Tout, ed. A. G. Little and F. M. Powicke (Manchester, 1927), 269–75; and esp. Emmerson, *Antichrist in the Middle Ages*, 77–96.

[32]On Holcot (Stegmüller Nos. 7426, 7427, surviving in Leipzig, University MS. 169; Prague, Kapitel MS. 221; Uppsala MS C 104; and Vatican MSS Vat. lat. 4234 and Chis. A IV 84), see Smalley, "Robert Holcot, O.P.," 5–97.

[33]Ione Kemp Knight, ed., *Wimbledon's Sermon: Redde rationem villicationis tue* (Pittsburgh, 1967), 112, 116. See also the discussion of this sermon in Richard Kenneth Emmerson and Ronald Herzman, "*The Canterbury Tales* in Eschatological Perspective," in *The Use and Abuse of Eschatology in the Middle Ages*, ed. Werner Verbeke, Daniel Verhelst, and Andries Welkenhuysen (Leuven, 1988), 406–9.

The turmoil and upheaval of the 1370s and 1380s produced some of the greatest poems of the English Middle Ages and certainly the most concentrated cluster of "apocalyptic" poetry in English literary history before the Renaissance. William Langland's *Piers Plowman*, in its B version, seems to have been completed between 1377 and 1379 or 1381; its C version, between 1379 or 1381 and 1385.[34] Late in the decade, Chaucer was beginning the *Canterbury Tales*, whose perspective, as has recently been argued, is fundamentally eschatological.[35] John Gower wrote *Mirour de l'omme* around 1378 and shortly before the Peasants' Revolt completed a first version of *Vox clamantis*, adding another book condemning the revolt after 1381.[36] The *Pearl*, though not datable with any exactitude, is generally agreed to be of the late fourteenth century, probably not later than 1390. Finally, the earliest recorded performance of an extant Corpus Christi cycle, with the attendant doomsday play and sometimes Antichrist plays, took place in 1378 at York.[37] It is thus with considerable justice that Charles Muscatine has labeled the poetry of this period the poetry of crisis.[38]

Throughout the history of the Apocalypse in England, as elsewhere in Europe, there is a constantly shifting dialectic between the popular and the learned, the vernacular and the Latin, the social and the ecclesiastical or institutional understanding of Saint John's vision. The three historical moments I have identified are all periods of coalescence, when the popular

[34]The exact dating is a matter of dispute. For a succinct summary of the issues, see George Kane, "The Text," in *A Companion to Piers Plowman*, ed. John A. Alford (Berkeley and Los Angeles, 1988), 184–86.

[35]For the dating of the text, see Larry Benson, ed., *The Riverside Chaucer*, 3d ed. (Boston, 1987), xxix. For its eschatology, see Emmerson and Herzman, "*Canterbury Tales* in Eschatological Perspective." For the Apocalypse elsewhere in Chaucer's work, see Robert Boenig, "Chaucer's *House of Fame*, the Apocalypse, and Bede," *American Benedictine Review* 36 (1985): 263–77. All of Chaucer's allusions to the Apocalypse are listed in Lawrence Besserman, *Chaucer and the Bible* (New York, 1988), 384–87.

[36]For dates of Gower's works, see John Fisher, *John Gower: Moral Philosopher and Friend of Chaucer* (New York, 1964), 94–95, 106ff.

[37]David Bevington, *Medieval Drama* (Boston, 1975), 235. For critical studies of some of these plays, see Richard Kenneth Emmerson, " 'Nowe Ys Common This Daye': Enoch and Elias, Antichrist, and the Structure of the Chester Cycle," and Pamela Sheingorn and David Bevington, " 'Alle This Was Token Domysday to Drede,' " both in *Homo, Memento Finis: The Iconography of Just Judgment in Medieval Art and Drama* ed. David Bevington (Kalamazoo, Mich., 1985), 89–120, 121–46; David J. Leigh, "The Doomsday Mystery Play: An Eschatological Morality," in *Medieval English Drama: Essays Critical and Contextual*, ed. Jerome Taylor and Alan Nelson (Chicago, 1972), 260–78; Linus Lucken, *Antichrist and the Prophets of Antichrist in the Chester Cycle* (Washington, D.C., 1940); Leslie Martin, "Comic Eschatology in the Chester *Coming of Antichrist*," *Comparative Drama* 5 (1971), 163–76; and Clifford Davidson, "The Lost Coventry Drapers' Play of Doomsday and Its Iconographic Context," *Leeds Studies in English* 17 (1986): 141–58.

[38]Charles Muscatine, *Poetry and Crisis in the Age of Chaucer* (Notre Dame, Ind., 1972). Robert Lerner has characterized this period as *The Age of Adversity* (Ithaca, N.Y., 1968).

and the learned appropriations of the Apocalypse came together in some (usually vernacular) literary form, though obviously in different ways and in often radically different forms. In all three moments and their characteristic literary forms, however, we can see cutting across normal generic and formal lines certain clusters of ideas that represent these coalescences. Such ideas can be best explored diachronically.

Apocalypse and Romance

Art historians have suggested a general connection between the later Anglo-Norman illuminated Apocalypses and Arthurian romance: "Artists and patrons alike recognized in the Apocalypse the one Biblical text which fell into line with the upper-class literary entertainment of the day. The Apocalypse, regarded superficially, dealt with the same subjects as, say, Chrétien de Troyes' romances, ladies in affliction, noble knights riding into battle, magic and mysteries and monstrous beasts."[39] More substantively comparable than Chrétien's twelfth-century works, however, are the romances of the thirteenth century, written after the Arthurian legend had taken a decisive turn toward the religious and allegorical. Many thirteenth-century romances, especially those concerned with the grail, reflect what Peter Klein has called the connection of *"Endzeiterwartung"* and *"Ritterideologie"*—the apocalyptic and religious conception of knighthood which arose around the time of the Crusades.[40] The association of romance and apocalypse, eschatology and knighthood, remains a prominent feature of the Arthurian tradition, both in literary works and in military orders like the Knights Templar, until its culmination in Spenser's *Faerie Queene*.[41]

The audiences and patrons for "upper-class literary entertainment" like romance were comprised in part of women, and it is striking how many of the surviving English illuminated Apocalypses were associated with aristocratic female owners and readers: Jeanne de Leybourne, Countess of Huntingdon (d. 1367); Blanche of France, daughter of King Philippe de Long (ca. 1320); Johanna Bishopstone (late 15th century); Queen Joan of Scotland (ca. 1360); Lady de Quincy (ca. 1260); Caecilia Welles, third daughter of Edward IV (d. 1507); Eleanor of Provence, wife of Henry III

[39]George Henderson, "Studies in English Manuscript Illumination. Part II: The English Apocalypse, I," *Journal of the Warburg and Courtauld Institute* 30 (1967): 116. See also R. Freyhan, "Joachism and the English Apocalypse," ibid. 18 (1955): 255.

[40]Peter Klein, *Endzeiterwartung und Ritterideologie: Die englischen Bilderapokalypsen der Frühgotik und MS Douce 180* (Graz, 1983). See also Erich Köhler, *L'aventure chevaleresque: Ideal et realité dans le roman courtois* (Paris, 1974); Eugene Anitchkoff, *Joachim de Flore et les milieux courtois* (Rome, 1931); and *Romania* 56 (1930): 526–57.

[41]See Sandler, *"Faerie Queene"* (see n 16).

(ca. 1250); Eleanor of Castile, wife of King Edward I (ca. 1270).[42] In addition, some of these Apocalypses were owned by or associated with nunneries, including Nuneaton in Warwickshire, Greenfield in Lincolnshire, Longchamp, and Shaftesbury nunneries.[43] The tradition of female interest in the Apocalypse can be traced back to earlier times: Adso, the abbot of Montier-en-Der, wrote his influential *Libellus de Antichristo* around 954, at the specific request of the queen of France, Gerberga, wife of Louis IV.[44]

Among apocalyptic romances, by far the most influential is the massive prose Vulgate cycle of Arthurian romances (ca. 1225).[45] This French cycle is the direct source of most of Sir Thomas Malory's *Morte D'Arthur* and therefore a major influence on English romance. It is a work, one scholar has said, of "apocalyptic historiography—an epitome of universal history from Eden to the mid-fifth century" and pervaded by an apocalyptic mode that manifests itself in such commonplaces of apocalyptic writing as pseudonymous revelations, esoteric prophecies and paraenesis, the division of history into world ages, the messianic Last World Emperor, the advent of Antichrist, and the last signs heralding the millennium.[46]

The genesis of the Vulgate cycle coincides chronologically with the genesis of the English Apocalypses, and in a milieu that was, likewise, probably monastic.[47] Like the illuminated Apocalypses, the Vulgate cycle is a glossed text. In the Apocalypses, the glosses are interwoven with the text (in various formats); in the romance cycle, the glosses are incorporated into the narrative, through the monks or hermits who appear at climactic

[42]All these manuscripts and most of their owners are described in Emmerson and Lewis, "Census and Bibliography," pt. 2," 370–409, specifically, nos. 42, 110, 402, 71, 78, 74, 50, 98. Lady de Quincy's ownership of Lambeth Palace MS. 209 is remarked in M. R. James, *The Apocalypse in Art* (London, 1931), 64, and in his catalog of MSS at Lambeth Palace (Cambridge, 1930–32). Eleanor of Provence's relationship to the Trinity College Apocalypse is suggested by Peter Brieger, in *The Trinity College Apocalypse: An Introduction and Description* (London, 1967), 14.

[43]See Lewis and Emmerson, "Census and Bibliography," nos. 45, 74, 110. For Greenfield, see James, *Apocalypse in Art*, 65; and Peter Brieger, *English Art, 1216–1307* (Oxford, 1968). For Shaftesbury, see the Giffard Apocalypse, written by the nunnery's chaplain around 1300, in *An Anglo-Norman Rhymed Apocalypse with Commentary*, ed. Olwen Rhys (Oxford, 1946). For the association of vernacular Bibles and Bible translation with nunneries, see Margaret Deansley, *The Lollard Bible* (Cambridge, 1920), 109–17, 336–42.

[44]Ed. Daniel Verhelst as *De Ortu et tempore Antichristi* (*CCCM* 45).

[45]The standard edition of the Vulgate cycle is H. O. Sommer, ed., *The Vulgate Version of the Arthurian Romances*, 8 vols. (Washington, D.C., 1908–16).

[46]Valerie M. Lagorio, "The Apocalyptic Mode in the Vulgate Cycle of Arthurian Romances," *Philological Quarterly* 57 (1978): 1–22. See also Barbara Nolan, *The Gothic Visionary Perspective* (Princeton, 1977), xiii; Charlotte Morse, *The Pattern of Judgment in the Queste and Cleanness* (Columbia, Mo., 1978); and P. M. Matarasso, *The Redemption of Chivalry* (Geneva, 1979).

[47]For the monastic origins of the Anglo-Norman Apocalypses, see Suzanne Lewis's chapter herein. For the monastic origins of the Vulgate cycle, see P. M. Matarasso, *The Quest of the Holy Grail* (Baltimore, 1969), 25–27; Etienne Gilson, "La mystique de la grâce dans *La queste del Saint Graal*," *Romania* 51 (1925): 321–47; and Matarasso, *Redemption*.

moments to explain to the bewildered characters the spiritual *senefiaunce* of the mysterious events that constitute the plot of Arthurian history. These embodied and speaking glosses in the Vulgate cycle are the product of the same historical sensibility that inscribed the subtext explicitly and prominently onto the page of the illuminated Apocalypse manuscripts.[48] Arthurian history *was* salvation history, whose meaning was often hidden. Therefore the quests that dominate the Vulgate cycle, like the quest of Saint John in the Apocalypse and of his readers, are ultimately quests for meaning, to be wrested from the mysterious pages of salvation history.

By the thirteenth century, then, as Arthurian romance became more apocalyptic, the Apocalypse in its turn came to be perceived as allied with romance—a major cultural shift from Anglo-Saxon times, where the primary narrative model was the epic. *Beowulf*, pervaded by an apocalyptic mood and by eschatological allusions, is a plot of triumph and disaster, not a plot of quest.[49] Conversely, homiletic texts from the period (as well as religious poetry) tend to borrow for the judgment scene or the cosmic battles of the Apocalypse the vocabulary of heroic poetry. The plot of the Apocalypse which in the thirteenth century comes to focus on Saint John and therefore on the quest for meaning, focuses in Anglo-Saxon heroic perspective on the action of the central figure in its plot, that is, Christ as royal, epic hero.[50]

The convergence of romance and apocalypse in the thirteenth century was not confined to the Arthurian stories, however. Richard Emmerson and Ronald Herzman have argued convincingly that the *Roman de la rose*, one of the canonical texts for English as well as French literary tradition, is written in an apocalyptic mode and set in an "apocalyptic age of hypocrisy," symbolized in the poem by "the horse in the Apocalypse that signifies the evil people, pale and tinged with hypocrisy," that is, the pale horse that appears in Apocalypse 6:8 at the opening of the fourth seal.[51]

There is another area in which the biblical Apocalypse and romances converge, and that is in the complex of values, ideology, and language that are generally labeled "courtly." Filtered through a romantic lens, the

[48]Eugene Vinaver links the emergence of the exegesis industry in the cathedral schools with the emphasis on hidden *sen* in the Arthurian romances; see his *The Rise of Romance* (New York, 1971), 18.

[49]Earl, "Apocalyptism and Mourning in *Beowulf*" (see n. 23). Likewise, the Old French epic has been seen as colored by the Apocalypse; see Stephen G. Nichols, Jr., *Romanesque Signs: Early Medieval Narrative and Iconography* (New Haven, Conn., 1983), chap. 5, esp. 18off.; and William R. Cook and Ronald B. Herzman, "Roland and Romanesque: Biblical Iconography in the *Song of Roland*," *Bucknell Review* 49 (1984): 21–48.

[50]See Gatch, *Preaching and Theology*, 62–63, 116, 126–27, and "Anonymous Old English Homilies," 161–65.

[51]Richard Kenneth Emmerson and Ronald B. Herzman, "The Apocalyptic Age of Hypocrisy: Faus Semblant and Amant in the *Roman de la rose*," *Speculum* 62 (1987): 612–34; Félix Lecoy, ed., *Le roman de la Rose* (Paris, 1965–70), lines 12038–40: "le cheval de l'Apochalipse qui senefie la gent male, d'ypocrisie tainte et pale."

Apocalypse *is* a romance plot, depicting the establishment of a court and kingdom, albeit through a long process of scourging and purgation during which the forces of darkness will be quelled. The court is the court of heaven, its throne surrounded by a rainbow, by twenty-four Elders with crowns of gold, by seven lamps burning, by Four Living Creatures with eyes before and behind (Apoc. 5). The defender of this kingdom, with eyes of flame, rides a white horse, is crowned with many diadems, is clothed in a garment sprinkled with blood, and bears a sharp sword that smites the nations (Apoc. 19). After the victory of his armies, a triumphal marriage takes place, accompanied by a bounteous wedding feast, and a new king-dom is established which will last forever (Apoc. 19, 21).

This religio-courtly plot is the one understood by the poet of the *Pearl*, the Middle English poem that owes the most extensive textual debt to the Apocalypse. Sections 14 through 19 (lines 781–1152), constituting roughly one-third of the poem, paraphrase or translate long sections of the biblical book, all conspicuously devoted to the court of heaven and its triumph: the Lamb sitting on the right hand of God, holding the book sealed with seven seals (Apoc. 5:1–14); the 144,000 virgins who constitute the king-dom of the blessed, sealed by Christ, with his name written on their fore-heads, and clothed in white robes (Apoc. 7:9–14, 14:1–5); the marriage of the Lamb to his spouse (Apoc. 19:7–8); new heaven and new earth, with a detailed description of the New Jerusalem, its walls, foundations, precious stones, and river of life (Apoc. 21:1–27, 22:1–5).[52]

These passages concerned with the court of heaven and the marriage of the Lamb are integrated into a poem that gives every appearance when it begins of being a traditional courtly poem. It opens in a garden, with a lov-er's lament for a lost "pearl" who is described in the most physical terms: "so smal, so smoþe her sydeȝ were" (6). In the garden, like the lovers of courtly dream visions (including the *Roman de la rose*), the poet falls asleep and has an instructive vision. But it gradually becomes evident that the poem is a palimpsest: underneath its apparently courtly plot and am-orous language ("fordolked of luf-daungere," 11) lies a spiritual plot and re-ligious language inscribed at the deepest level of the poem.

At the center of *Pearl*, both spatially and substantially, is a debate be-tween the dream maiden and the uncomprehending poet about the mean-ing of *cortaysye*, a debate that springs from the poet's inability to understand how the Pearl-Maiden, but two years old when she died, could be the Bride of Christ and the Queen of Heaven. He thought that title be-longed to the Virgin Mary, the "Quen of cortaysye," a phrase given major prominence as the concatenation phrase of Section 8. The maiden, how-ever, explains that "the court of þe kyndom of God alyue" (445) has a unique property not shared by earthly courts: *all* who come there are

[52]For a list of all the Apocalypse allusions in *Pearl*, see E. V. Gordon, *Pearl* (Oxford, 1953), 165–67.

queen or king, and yet none deprives others of royal rank or dignity. The irrational *cortaysye* of this court is replicated in the irrational economy of heavenly love: each sinless soul is the Bride of the Lamb, and yet none deprives the others of any portion of his love.[53] The maiden therefore takes issue when the dreamer, unthinkingly drawing on a courtly commonplace, calls her a "matchless maid and immaculate" (780). Unblemished she is, she replies, but not "matchless," certainly not in this court where all are brides:

> We are all brides of the Lamb so dear,
> One hundred and forty-four thousand strong,
> In Apocalypse the words appear. . . .
> Thousands on thousands . . .
> [John] saw on Mount Sion . . .
> Arrayed for the wedding . . .
> In the city called New Jerusalem. (14.785–92)[54]

Jerusalem is the final word (and hence the concatenation term) for all five stanzas of Section 14 and names their subject. It is the first occurrence of the word *Jerusalem* in the poem, and it precipitates the elaborate account of the heavenly city which occupies the next sections (14–19), nearly the rest of the poem, drawn in the main from the Apocalypse. The celestial city receives such extended attention precisely because it is the constitutive emblem of the court of the maiden/Queen, where love, marriage, and joy are corporate rather than private. By synecdoche, any Bride of Christ is one with the city, as the Apocalypse itself suggests by portraying the city as Bride: "I saw the holy city, New Jersualem . . . made ready as a bride adorned for her husband" (Apoc. 21:2).

The *Pearl*-Poet's portrayal of heaven as a court, and his emphasis on the romance plot of the Apocalypse (love, marriage, the establishment of a kingdom) are shared in varying degrees by the English illuminated Apocalypse manuscripts. One critic has suggested that numerous details in the poem are more likely to derive from the illuminations of the Anglo-Norman tradition than from the Vulgate text itself: the trees with metallic leaves and indigo trunks (75–80); the square book (836); the whiteness of the fleece of the Lamb and its resemblance to pearls (1112); the "rede golde cler" on his seven horns (1111); the angels with their censers (1121–22); but above all, the gaping wound in Christ's side (1135–38), of which there is no mention in the Apocalypse itself.[55] Whether the poet actually used an illuminated Apocalypse may never be known, but it is clear that his

[53]*Pearl* 15; cf. Dante's *Purgatorio* 15.67–75.
[54]The translation is Marie Boroff's, in her *Pearl* (New York, 1977).
[55]Muriel A. Whitaker, "*Pearl* and Some Illustrated Apocalypse Manuscripts," *Viator* 12 (1981): 183–96.

domestication, demystification, and selective emphasis on the courtly plot of the Apocalypse are all attributes that the Anglo-Norman Apocalypses share.

THE APOCALYPSE AND MEDIEVAL NARRATOLOGY

In *The Sense of an Ending*, Frank Kermode describes a complex and historically variable relationship of analogy between what he calls eschatological fictions or "fictions of the End" (exemplified above all by the Apocalypse) and literary fictions.[56] Kermode's interest is vested in modern fiction and the modern apocalypse, but his linkage of the history of eschatological thought to literary theory suggests an important project for literary historians and theorists of the Middle Ages: to investigate how the Book of the Apocalypse was read as a narrative of history and how it provided a model or analogue for many kinds of narratives, including texts not normally thought of as "literary."[57]

A few scholars have already begun to demonstrate the analogy between the narrative of the Apocalypse and medieval vernacular narratives. Barbara Nolan's *The Gothic Visionary Perspective* has called attention to the emergence of new narrative forms in response to new historical modes of understanding the Apocalypse, especially in the thirteenth century.[58] Stephen Nichols, in *Romanesque Signs*, has portrayed scriptural texts, especially the Gospels and the Apocalypse, as models of the new "biaxial narrative structure" that appears in Romanesque chronicles and in chansons de geste and the *Chanson de Roland*.[59] Talbot Donaldson has proposed that the breakdowns in narrative form at the end of *Piers Plowman*—violation of a rational time sense, mixing of past and future, confusion of literal and metaphorical, and so on—are modeled on those of the Book of the Apocalypse.[60]

Other aspects of apocalyptic narrative remain to be explored. For example, there is a close relationship between some of the peculiarities of medieval textuality and apocalyptic narrative form. Medieval texts are often

[56]Frank Kermode, *The Sense of an Ending: Studies in the Theory of Fiction* (London, 1966).

[57]Erich Auerbach, in *Literary Language and Its Public in Late Latin Antiquity and in the Middle Ages* (New York, 1965), esp. 45ff., 178ff., and 326ff., has discussed the role of the Bible as a model of literary style in the Middle Ages. E. R. Curtius, in *European Literature and the Latin Middle Ages* (New York, 1963), 46–47, describes the English theologians Aldhelm and Bede as the first to recommend the Bible as a stylistic model.

[58]Nolan, *Gothic Visionary Perspective*, xv–xvii. She emphasizes a new understanding of the biblical book as a linear narrative (6–8, 19, 21, 64–65, 68, 78) and of Saint John's role as visionary and narrator (5, 7–9, 12, 14–15, 18, 21–22, 55, 70, 63–64, 66–67, 77–79, 139–40).

[59]Nichols, *Romanesque Signs* (see n. 49).

[60]Talbot Donaldson, "Apocalyptic Style in *Piers Plowman* B XIX–XX," *Leeds Studies in English*, n.s., 14 (1983): 74–81.

not fixed but in flux; they undergo major revisions and reformulations over time; their authorship may be multiple; the idea of an authentic text is problematic; medieval scribes, compilers, and supervisors of manuscript production seem to feel an authority sometimes rivaling the author's in controlling the text. Most of the works prominently considered here demonstrate some features of this *mouvance,* as Paul Zumthor has called it, of medieval texts.[61]

The Apocalypse demonstrates a similar *mouvance,* not so much as a written text but as a prophecy of the text of history and its end. Like the Vulgate cycle, *Piers Plowman,* the *Canterbury Tales,* and the Corpus Christi cycles, the historical text the Apocalypse implies is an "unfinished" one, in need of continuing revision and reinterpretation as conditions and circumstances change. Its significance changes with the passage of time, its reader/interpreter always caught, as Kermode says, in the middle of the plot, in a moment of crisis. Like the evolution of the text of *Piers* or of the Vulgate cycle, the evolution of Apocalypse interpretation is a history of anxiety—in those cases, about the meaning of a text; in this case, about the meaning of history, which can only be made clear by a terminus that is uncertainly near.

Another prominent concept in the medieval understanding of the narrative of the Apocalypse was the principle of *recapitulatio.* This principle was clearly enunciated by the fourth-century North African theologian, Tyconius, whose seven rules for the interpretation of the obscurities of Scripture (with special reference to the Apocalypse) were given wide currency by Augustine in the *De doctrina Christiana* and later by Bede, who includes them in the prologue to his *Expositio Apocalypsis.*[62] All these rules are of interest for medieval narratology, but especially the sixth. Augustine describes Tyconius's account of biblical *recapitulatio* thus: "Some things [in Scripture] are described as though they follow each other in the order of time, or as if they narrate a continuous sequence of events, when the narrative covertly refers to previous events which had been omitted."[63] Narrative sequence in the Apocalypse, in other words, is

[61]For *mouvance,* see Paul Zumthor, "Anonymat et 'Mouvance,' " in *Essai de poétique médiévale* (Paris, 1972), 65–75, and "Tradition and 'Mouvance,' " in *Speaking of the Middle Ages,* trans. Sarah White (Lincoln, Neb., 1986), 59–62. Examples of *mouvance* in the textual histories of apocalyptic texts can be found in the Vulgate cycle through Malory (see E. Jane Burns, *Arthurian Fictions: Rereading the Vulgate Cycle* [Columbus, Ohio, 1985]); the *Roman de la rose; Piers Plowman* (see George Kane, "The Text," in Alford, *Companion to Piers Plowman,* 175–200); Gower's *Vox clamantis;* the English Corpus Christi cycles; and Chaucer's *Canterbury Tales* (see Donald Howard, *The Idea of the Canterbury Tales* [Berkeley and Los Angeles, 1976]).

[62]Tyconius's treatise, the *Liber regularum,* was edited by F. C. Burkitt as *The Book of Rules of Tyconius* (Cambridge, 1894). For Augustine's summary of the seven rules, see *De doctrina Christiana* 3.30.42–37.56, e.g., trans. D. W. Robertson, *On Christian Doctrine* (New York, 1958), 104–17. Bede's discussion, largely lifted from Augustine, occurs in the prologue (*PL* 93:131–34).

[63]Augustine *De doctrina Christiana* 3.36.52, trans. 113.

frequently a deceptive indication of the chronological order of events; for often the narrative returns to begin again at a point from which it had seemingly departed. This principle lies behind what one scholar has called "the Tyconian tradition of Apocalypse interpretation," which dominated all commentary on the book for eight hundred years.[64]

Tyconius's—and Augustine's and Bede's—accounts of the narrative movement of the Apocalypse describe a model of narrative sequence whose subject might easily be mistaken for apocalyptic secular narrative. Some analogue of narrative *recapitulatio* characterizes most of the medieval narratives thematically associated with the Apocalypse. The interlace structure of *Beowulf;* the *laisses similaires* of the *Chanson de Roland;* the *entrelacement* of the Vulgate cycle; the repeated movement from wandering to conversion to pilgrimage in *Piers Plowman;* the typological structure of the Corpus Christi cycles—all these constitute secular narrative techniques analogous to biblical *recapitulatio.* The Apocalypse cannot be alone responsible for this narrative mode, of course. The nonlinear, recapitulative mode in secular narrative is historically, culturally, and generically widespread, even in works that show no thematic relationship to the Apocalypse, and to some extent it derives from unrelated factors, like oral tradition. But Tyconius and Augustine meant *recapitulatio* to describe a feature of biblical style in general, and it seems reasonable to think that this mode of understanding the literary text of the Bible might have provided a tool that allowed the poets to conceptualize their own literary practices.

THE APOCALYPSE AS AN ECCLESIOLOGICAL TEXT

Early in his *Explanatio Apocalypsis,* Bede described the general subject of the Apocalypse as "the wars and intestine tumults of the Church," the revelation of which was needed "to strengthen the preachers of the faith against the opposition of the world." The revelation was "wrapped up . . . in mystical words, that it might not be manifested to all, and become lightly esteemed."[65] Three principles are enunciated here that dominate English (and Anglo-Norman) Apocalypse commentary down to the end of the fourteenth-century: the subject of the Apocalypse is ecclesiological; the primary audience for whom the Apocalypse was intended was churchmen, specifically preachers; and the Apocalypse is a privileged text, whose esoteric language is designed to restrict the understanding of its mysteries to an ecclesiastical elite. The dialectic of blindness and insight, thematized within the Apocalypse ("He who has an ear, let him hear"), is also

[64]Bonner, *Saint Bede,* 5. See Wilhelm Kamlah, *Apokalypse und Geschichtstheologie: Die mittelalterliche Auslegung der Apokalypse vor Joachim von Fiore* (Berlin, 1935), esp. chap. 2 ("Die Geschichtstheologie der Tychoniustradition").

[65]Trans. Edward Marshall, *The Explanation of the Apocalypse by the Venerable Beda* (Oxford, 1878), 1–3, 11 (*PL* 93:129, 133).

present outside it, in the commentaries' division of readers into the blind and the visionary.

These principles are evident across a wide range of Apocalypse commentaries composed or copied in England. They include both the Berengaudus commentary and the French prose commentary popular in the English or Anglo-Norman illuminated Apocalypses, the translated commentary joined with the Middle English Apocalypses, and the English mendicant commentaries of the thirteenth and fourteenth centuries.[66] They also include Apocalypse commentaries by the preeminent secular theologian of the fourteenth century, John Wycliff, and by England's foremost mystic and devotional poet, Richard Rolle of Hampole.[67] Less well known commentators are Robert of Bridlington (d. 1180), the prior of the Augustinian Canons at Bridlington in Yorkshire, who wrote *In septem visiones Apocalypseos*; John de Lanthony, another twelfth-century Augustinian Canon (and subprior of Lanthony), who compiled a collection of extracts from authorities like Victorinus of Pettau, Primasius, Bede, and Berengaudus, called *De expositoribus libri Apocalypsis*.[68] In addition, there is a sizable number of English manuscripts that contain as-yet-unidentified treatises on the Apocalypse, whose authorship and exact provenance remain unknown.[69]

[66]See, for example, the essays of David Burr and of Suzanne Lewis herein. Yves Christe traces "l'interprétation essentiellement ecclésiale" of the Apocalypse in his "Ap. IV-VII, 1 de Bède à Bruno de Segni," *Etudes de la civilisation médiévale, IXe-XIIe siècles: Mélanges offerts à Edmond-René Labande* (Poitiers, 1975), 145–53.

[67]Wycliff's unpublished *Postilla super Apocalipsim* survives in Oxford, Bodleian MS. 716, fols. 159v–71v, and Magdalene College MS. 55, fols. 239v–48v. For a summary of this tract and dating to 1371, see Gustav Adolf Benrath, *Wyclifs Bibelkommentar* (Berlin, 1966), 300–309. Richard Rolle's similarly conservative commentary is only a fragment, covering up to Apocalypse 6:2. It has been dated to 1331–39 and edited by Nicole Marzac, *Richard Rolle de Hampole, 1300–1349: Vie et oeuvres suivies du tractatus Super Apocalypsim* (Paris, 1968); trans. Robert Boenig, *Richard Rolle: Biblical Commentaries* (Salzburg, 1984). See also J. P. H. Clark, "Richard Rolle as Biblical Commentator," *Downside Review* 104 (1986): 165–213.

[68]On Robert of Bridlington, see Beryl Smalley, "Gilbertus Universalis Bishop of London, 1128–1134, and the Problem of the 'Glossa ordinaria,' " *Recherches de Théologie Ancienne et Médiévale* 7 (1935): 248–61, and 8 (1936): 32–34; and Smalley, "John Russel," 299. His Apocalypse commentary (Stegmüller No. 7383) survives in Oxford, Bodleian MS. 864, and Troyes, Bibliothèque publique MS. 563. The "Robertus Prior" frequently quoted in John of Lanthony's compilation on the Apocalypse (London, Lambeth Palace MS. 119; Stegmüller No. 4757) no doubt is John's fellow Augustinian and contemporary of Bridlington. In addition, Stephen Langton (d. 1228), English cardinal and archibishop of Canterbury, is credited (uncertainly) with a short treatise on the Apocalypse (Stegmüller Nos. 7935–36), on which see G. Lacombe, "Studies on the Commentaries of Cardinal Stephen Langton," pt. 1," *Archives d'Histoire Doctrinale et Littéraire du Moyen Age* 5 (1930): 148–50; and Robert Grosseteste appears to have left his own glosses on the Apocalypse to the Oxford Franciscans; see Smalley, "John Russel," 309–10.

[69]E.G., London, British Library Harleian MS. 3225, fols. 2–19 (Stegmüller No. 9631), and British Library Add. MS. 40165 B, fols. 35–69 (Stegmüller No. 9699); Cambridge, Pembroke College MS. 102 (Stegmüller No. 8962; once a Bury St. Edmund's MS), II, fols. 62–108, and Cambridge University MS. Dd X 16, fols. 58–104 (Stegmüller No. 8933); and two Durham Cathedral MSS.: A I 9, fols. 219–233 (Stegmüller No. 9076) and A IV 18, fols. 64–251, 252–95 (Stegmüller Nos. 9083, 9084).

Many of the English commentaries recorded above have never been pub-
lished, and some have not been studied in modern times. There are major
differences both in detail and in general approach among them. But even a
cursory examination reveals that most of them are conservative, ortho-
dox, and above all ecclesiological. Richard Rolle, who may serve as a typ-
ical example, asserts that "the matter in this book is a revelation made
about the Church . . . showing the condition of the Church according to
both the present state and the future."[70] As Guy Lobrichon has pointed
out, this sense of the fundamentally ecclesiological subject of the Apoca-
lypse goes back to Jerome and Augustine, who saw that the collapse of
the Roman Empire was of little consequence if the perfection of human
history, as revealed in the Apocalypse, was to be vested in the eternal
Church.[71]

If the general subject of the Apocalypse is the Church, the specific
meanings of its esoteric details are often ecclesiological as well, with an
emphasis on the symbolism of the Church and of preachers and their func-
tions. The Woman clothed with the sun (Apoc. 12:1) is the Church.[72] The
144,000 (Apoc. 7), each tribe representing an individual virtue, comprise
the totality of holy Church.[73] Saint John is the archetype of the preacher;
he is the chosen scribe of the vision because, as Apostle and evangelist,
his historical role elsewhere in the New Testament pertains to the
Church's role of preaching the Gospel.[74] The four Beasts before the throne
of heaven (Apoc. 4:6–9) are holy preachers; the circle of seats around the
throne (4:4) is the Church; the twelve pearls of which each gate is com-
posed signify the successors of the Apostles and the doctors of the Church;
among the gems that form the foundations of the city wall, emerald
signifies holy preachers.[75] The celestial city of Jerusalem itself represents
the Church, which will come down from heaven with the Lord of the
Judgment.[76]

Corresponding to the ecclesiological focus of most English (and no
doubt, non-English) commentaries on the Apocalypse is the relative ab-
sence of the Apocalypse from contemporary interpretations of secular or

[70]Boenig, Rolle, 143. See also Wycliff in Benrath, Bibelkommentar, 301 n. 826; Rhys,
Anglo-Norman Rhymed Apocalypse, 1–2; Fridner, English Fourteenth Century Apoca-
lypse Version, 4 (as well as the French prose gloss printed there); Berengaudus, PL
17:845; and Brieger, Trinity College Apocalypse, 18–19.
[71]Guy Lobrichon, "Conserver, réformer, transformer le monde: Les manipulations de
l'Apocalypse au Moyen Age Central," in The Role of the Book in Medieval Culture: Pro-
ceedings of the Oxford International Symposium 1982, ed. Peter Ganz, vol. 2 (Turnhout,
1986), 77.
[72]Brieger, Trinity College Apocalypse, 13.
[73]Lobrichon, "Conserver, réformer, transformer le monde," 80.
[74]Brieger, Trinity College Apocalypse, 18.
[75]Boenig, Rolle, 180, 182; Berengaudus, PL 17:1041–42, 1045; Brieger, Trinity College
Apocalypse, 50–51.
[76]Berengaudus, PL 17:1033; Brieger, Trinity College Apocalypse, 49; Wulfstan, in
Bethurum, Homilies, Ia, p. 113, line 21.

natural events that later ages would call "apocalyptic," like the Danish in-
vasions of the late tenth century, or in the late fourteenth century the
Peasants' Revolt, the black plague, or the disastrous French wars. When
these *are* interpreted in a biblical and eschatological frame of reference,
the interpretation is much more often formed from the synoptic apoca-
lypse, especially Matthew 24 and 25, than from the final book of the
Bible.[77]

The ecclesiological emphasis of Apocalypse exegesis is absorbed into
many popular literary works, for example, *Piers Plowman* and *Pearl*. Lang-
land's narrative of salvation ends with an allegorical history of the
Church, culminating in the appearance of Antichrist, whose followers
have as their chief goal, in the final passus of the poem, breaking down
Unity Holy Church. In *Pearl*, as the poem unfolds, the subject gradually
shifts from the Pearl-Maiden to the heavenly city in which she resides.
This city, as the commentaries say explicitly, is the celestial Church. But
the shift in subject is only apparent, because "the holy city . . . made ready
as a bride" (Apoc. 21:2) is, by the irrational trope of heavenly love, one
with each Bride of Christ who resides within it, who shares equally with
all other Brides all of Christ's love. By a theological synecdoche, the Pearl-
Maiden has an identity that is simultaneously singular and corporate, in-
dividual and ecclesiological.

The three clusters of ideas treated above barely begin to indicate the
Apocalypse's role in medieval English literary culture. For example, I have
said little about the connection between the Apocalypse and social crisis
that develops in the Richardian period. This connection is well known to
readers of the end of *Piers Plowman*, where the social, moral, and eccle-
siastical crises of Langland's era explode into a narrative of the coming
of Antichrist and the beginning of the End.[78] The documents of the
Peasants' Revolt show hints of an apocalyptic frame of mind among its

[77]Examples include Blickling Homily X, in Morris, *Blickling Homilies*; Wulfstan's es-
chatological homilies (see n. 20); the Antichrist and Judgment plays of the English Cor-
pus Christi cycles; and Wycliff's *De Antichristo* 2. 3–4 of the *Opus evangelicum*, ed.
Johann Loserth (London, 1896).

[78]See Morton Bloomfield, *Piers Plowman as a Fourteenth Century Apocalypse* (New
Brunswick, N.J., 1961); Robert Adams, "Some Versions of Apocalypse: Learned and Pop-
ular Eschatology in *Piers Plowman*," in Thomas J. Heffernan, ed., *The Popular Literature
of Medieval England* (Knoxville, Tenn., 1985), 194–236, and "The Nature of Need in
'Piers Plowman' XX," *Traditio* 34 (1978): 273–301; Douglas Bertz, "Prophecy and Apoc-
alypse in Langland's *Piers Plowman*, B-Text, Passus XVI to XIX," *Journal of English and
Germanic Philology* 84 (1985): 313–28; Richard Kenneth Emmerson, "The Prophetic,
the Apocalyptic, and the Study of Medieval Literature," in Jan Wocjcik, ed., *Poetic
Prophecy in Western Literature* (Rutherford, N.J., 1984), 40–54; B. S. Lee, "Antichrist
and Allegory in Langland's Last Passus," *University of Cape Town Studies in English* 2
(February 1971): 1–12; and Mary Carruthers, "Time, Apocalypse, and the Plot of *Piers
Plowman*," in *Acts of Interpretation*, ed. Mary Carruthers and Elizabeth D. Kirk (Nor-
man, Okla., 1982), 175–88.

leaders.[79] At least one poet hostile to their cause saw the revolt as the loos-
ing of Satan predicted in Apocalypse 20:7; John Gower, in fact, compares
England to Patmos, and himself to John the Apostle as a visionary of the
End.[80] Apocalypse 20 is also the subject of John Wycliff's late polemic *De
solutione Sathanae*, where he cautiously locates the beginning of the final
crisis of the Church in the period of Innocent III's papacy and in the found-
ing of the mendicant orders.[81] The Apocalypse was central to the concerns
of medieval England's only popular heretical movement, the Lollards, who
drew their inspiration from Wycliff. One anonymous Lollard wrote an im-
mense and violently topical Apocalypse commentary, the *Opus arduum*,
composed in Latin in prison in 1390.[82] But perhaps the most interesting
evidence of Lollard obsession with the Apocalypse comes from a popular
rather than a learned source: the depositons of Walter Brute, made to
Bishop Trefnant before his trial in 1392. Brute's comments take us back to
the special relationship between the Apocalypse and England which we
glimpsed earlier.

Antichrist, he says, has appeared in England, "And why this motion is
come to pass in this kingdom rather than in other kingdoms, methinks
there is good reson; because no nation of the Gentiles was so soon con-
verted unto Christ as were the Britons, the inhabitants of this kingdom."[83]
The rapidity of the English conversion (in the time of Lucius, king of the
Britons) was exceeded only by their steadfastness; for "after the receiving
of the faith, they never forsook it." And thus the British are, in a sense,
God's chosen people: "It seemeth to me the Britons, amongst other na-
tions, have been, as it were by the special election of God, called and con-
verted to the faith." One sign of God's election is that "of this kingdom did
St. John, in the Apocalypse, prophesy" (Apoc. 12). There, the Woman
clothed with the sun, who has just brought forth a male child, is attacked
and pursued by a great Dragon. She escapes into the wilderness, where she
is protected by God for 1,260 days. The Woman, says Brute, is the Church,

[79]See Rodney Hilton, *Bond Men Made Free: Medieval Peasant Movements and the En-
glish Rising of 1381* (London, 1973), 223–24; Norman Cohn, *The Pursuit of the Millen-
nium*, rev. ed. (New York, 1961), 201–3; and R. B. Dobson, ed., *The Peasants' Revolt of
1381*, 2d ed. (London, 1983), 379–80.

[80]For Apocalypse 20 and the Peasants' Revolt, see John Gower *Vox clamantis* 1.9.680,
729–40 and 1.10.749, 757–82, in *The Complete Works of John Gower*, vol. 4, (Oxford,
The Latin Works, ed. G. C. Macaulay, 1902); for the link of the revolt to Judgment Day,
see ibid., 1.8.665–68; for the analogy of the two Johns, see ibid., 1. prol. 57–58.

[81]Printed in *Polemical Works*, ed. Rudolf Buddensieg vol. 2 (London, 1883), 391–400.
See my *Antifraternal Tradition in Medieval Literature* (Princeton, 1986), 167–72.

[82]This unpublished work exists in thirteen MSS, mainly from areas of Hussite activity
on the continent. Anne Hudson has given the only extensive account of this work in "A
Neglected Wycliffite Text," *Journal of Ecclesiastical History* 29 (1978): 257–79.

[83]This deposition can be found in *Registrum Johannis Trefnant, ep. . . . Herefordensis,
1389–1404*, ed. W. W. Capes (London, 1916), 285–358; all the quotations below are taken
from 291–96. The translation is from John Foxe, *Acts and Monuments*, vol. 3 (1841; re-
print, New York, 1965), 142–43.

which "by faith did spiritually bring forth Christ into the world." The place to which she flees is England; for "it is well-known that this kingdom is a wilderness or desert place . . . because it is placed without the climates."[84] The period of protection was 1,260 years from the English conversion, because "for so many [years] . . . the Britons continued in the faith of Christ, which thing cannot be found so of any Christian kingdom but of this desert." Therefore, "considering that the Britons were converted to the faith of Christ . . . by an election and picking out amongst all the nations of the heathen, and that after they had received the faith, they did never start back from the faith for any manner of tribulation; it is not to be marvelled at if, in their place, the calling of the Gentiles be made manifest, to the profiting of the gospel of Jesus Christ, by the revealing of Antichrist." It is plain that, for Brute, England is a desert not because of its moral weakness but because of the strength of its faith. Here is where Antichrist will appear because here is where Antichrist will be defeated. For Walter Brute, as for English readers of the Apocalypse from William the Conqueror to Edmund Spenser, this English kingdom, chosen by God, adumbrates the celestial kingdom to come.

[84]England's marginality as a desert place is also highlighted, though with a different intention, by Gower, whose *Vox clamantis* cries out *in deserto*, that is, England. Brute's desert is a good one, Gower's a wasteland.

17

Dante and the Apocalypse

Ronald B. Herzman

To say that the Apocalypse has influenced Dante's *Commedia* must lie somewhere between a commonplace and an understatement. After all, no work of medieval literature draws so directly and comprehensively from the Book of the Apocalypse as do the last cantos of the *Purgatorio*, wherein the pageant of Church history presented there for the Pilgrim and the reader would be unintelligible without some knowledge of the Apocalypse. In this section, too, consistent references to Christ's second coming provide a framework for understanding the coming of Beatrice, Dante's guide for the *Paradiso*. Even apart from these concentrated references, the poem is studded with quotations from the Apocalypse. Canto 17 of the *Inferno*, for example, begins with a description of the beast Geryon, who brings Dante and Virgil down to the *bolgias* (pits) of the fraudulent. His human face and beast's tail surely derive from the description of the locust beast of Apocalypse 9:7–10:

> Ecco la fiera con la coda aguzza. . . .
> La faccia sua era faccia d'uom giusto. (*Inferno* 17.1, 10)
> (Behold the beast with the pointed tail. . . .
> His face was the face of a just man.)

As the Apocalypse has it, "Their faces were like the faces of men. . . . And they had tails like those of scorpions."[1] Or again, when Dante meets his great-great-grandfather Cacciaguida in the central cantos of *Paradiso*, his coming has been anticipated because Cacciaguida has read it in a book

[1] Quotations from the *Commedia* are from *The Divine Comedy*, trans. and ed. Charles S. Singleton (Princeton, 1970–75). For Geryon, see John Block Friedman, "Antichrist and the Iconography of Dante's Geryon," *Journal of the Warburg and Courtauld Institutes* 35 (1971): 113–21.

that has obvious references to the book of life of Apocalypse 3:5, 20:12–15, 21:27, and 22:19.

> E seguì: "Grati e lontano digiuno,
> tratto leggendo del magno volume
> du' non si muta mai bianco né bruno
> solvato hai, figlio . . ." (*Paradiso* 15.49–52)

(And he continued: "Happy and long felt hunger, derived from reading in the great volume where white or dark is never changed, you have relieved my son . . .")[2]

For a third example, the "wondrous river" of light of *Paradiso* 30.61–69 has as its most direct analogue the paradisal river of Apocalypse 22.[3] These references to beast, book, and river could be multiplied to the point that this entire essay would become little more than an annotated catalog of apocalyptic imagery in the *Commedia*.

Indeed, as is the case with so many broad topics connected with the poem, a book-length study of its apocalyptic elements would be necessary to cover the topic adequately. As it turns out, such a study has been written, though it is a study that goes in the opposite direction of our hypothetical list and conceives of apocalypticism so broadly that it is less an analysis of the relationship between the poem and the Apocalypse itself than a somewhat impressionistic description of apocalyptic and prophetic attitudes throughout Dante's work. It is a study more concerned with apocalypticism as a point of view in Dante than with an analysis of the *Commedia*.[4] The aim of my essay is both more modest and more focused: to show how an understanding of the references to the Apocalypse within the *Commedia* can help open out meaning in the poem.

At the heart of much of the analysis of the thematic relationship between the *Commedia* and the Apocalypse is an assumption that, for the most part, apocalyptic thought in the poem is connected to unveiling the future and doing so in rather specific terms. In particular, the Apocalypse is often invoked in an attempt to uncover or decipher what is taken to be Dante's cryptic predictions of a Last World Emperor, a monarch to

[2]See Jeffrey Schnapp, *The Transfiguration of History at the Center of Dante's Paradiso* (Princeton, 1986), 146 n. 90, for a discussion of the apocalyptic significance of Cacciaguida's "volume."

[3]Albert B. Rossi, "*Miro gurge* (*Par.* XXX, 68): Vergilian Language and Textual Pattern in the River of Light," *Dante Studies* 103 (1985): 95–96 n. 9.

[4]Nicolo Mineo, *Profetismo e Apocalittica in Dante: Strutture et temi profetico-apocalittici in Dante dalla Vita Nuova alla Divina Comedia* (Catania, 1968), 90–101 ("Il genere apocalittico e la *Divina Commedia*"). Much of the book consists of generic discussions and distinctions. See also Dennis Costa, *Irenic Apocalypse: Some Uses of Apocalyptic in Dante, Petrarch, and Rabelais* (Saratoga, Calif., 1981). Raoul Manselli's article "Apocalisse" in the *Enciclopedia Dantesca*, ed. Umberto Bosco (Rome, 1970–78), 1:315–17, is also useful for discussing the relationship of Dante to Joachist traditions of interpretation.

come who will, in Marjorie Reeves's phrase, do nothing less than "end
civil strife and set the world aright."[5] Such a prediction within the poem
would seem to link Dante's lifelong search for the most secure and har-
monious form of government both to a long-standing Western European
expectation of the coming of a great monarch and to a Joachist tradition
that infused this expectation with the spiritual energies of the so-called
third *status* of history.[6] Interesting as such speculation has been, it has two
major drawbacks that keep it from providing the unique or even the most
satisfactory key to interpretation of Dante's apocalyptic concerns in the
Commedia. First, the speculation itself has never reached consensus. If
Dante had a specific emperor in mind, the combined efforts of 650 years of
scholarship have been unable to name him conclusively. Second, and for
our purposes more significant, this scholarly speculation has tended to de-
flect interest in Dante's use of the Apocalypse from other areas in the
Commedia where it can be found and more profitably analysed. The ten-
dency to equate apocalypse with prediction has probably been unnecessar-
ily restricting in Dante scholarship.

Such emphasis on apocalypticism-as-prediction cannot be understood
apart from its implied sense of what the poem is about, which is, from our
perspective, also unnecessarily restricting. This restricting viewpoint
takes the *Commedia* to be essentially and primarily a poem of ideas, the
most important of which continue Dante's earlier political position, es-
pecially as it is systematically expounded in the *De monarchia*. According
to this viewpoint, the poem—though more sophisticated, systematic, and
energetic than his earlier work—expounds the same political position he
presented in the first book of the *Monarchia*. There, Dante argues that hu-
mans have two ends, an earthly and a divine. According to Kenelm Foster's
interpretation of this view as it is applied to the *Commedia*, the *Inferno*
and the *Purgatory* are those parts of the poem which deal with the earthly
end of man, while the *Paradiso* is the part that deals with the heavenly
end. But even when they do not become this specific in their interpreta-
tion, those who hold this position maintain the assumption that Dante
continues in the *Commedia* to give each of these ends its due; that is, he
continues to treat the human and the divine goals as essentially separate.[7]

[5]Marjorie Reeves, *Joachim of Fiore and the Prophetic Future* (New York, 1976), 64; see
also her *The Influence of Prophecy in the Later Middle Ages: A Study in Joachimism*
(Oxford, 1969).
[6]See Reeves, *Prophetic Future*, 60–66.
[7]Kenelm Foster expresses this position in *The Two Dantes and Other Studies* (Berke-
ley and Los Angeles, 1977). The very title of his work expresses his position: "However,
in this essay [the first of three in the collection and bearing the title "The Two Dantes"]
I am mainly concerned with a deep strain in Dante . . . which, as it seems to me, never
wholly conformed to the new pattern imposed by the shift towards other-worldliness
and the surrender of autonomy" (161). Patrick Boyde states that, in the *Commedia*, "his
return to Beatrice, and his acceptance of a more specifically Christian or other-worldly
point of view, seem to me less important than his return to poetry." My position is,

In its emphasis on man's earthly end, the first book of the *Monarchia* deals with the conditions necessary for peace and harmony: it argues that if humanity is ever to live in unity and peace and to fulfill the divine purpose for which humans were created, there will have to be a supreme ruler whose jurisdiction extends throughout the world.[8] To carry this perspective into the *Commedia*, where Dante is much more concerned with combining theory with contemporary practice (that is, combining theory with the realities of history as he has understood and experienced them) is to assume that the hunt must be on for the specific supreme ruler Dante believed would bring about the fulfillment of this possibility. Such a reading of the poem assumes that Dante continues to be concerned in the *Commedia* with the historical fulfillment of the imperial ideal.[9] Thus, in the most important of these references in the poem from an apocalyptic point of view, the "cinquecento diece e cinque" (five hundred, ten, and five or DXV) of *Purgatorio* 33:43 has been identified with a temporal monarch (most often with Henry VII of Luxembourg) by applying to the numbers in Dante's text a cryptographic interpretation that follows the pattern of interpretation of the numbers of Apocalypse 13:18. Just as, in the Apocalypse, the number of the Beast, "666," becomes the basis for an interpretation by giving to the numbers their letter equivalents, so also in Dante:

> ch'io veggio certamente, e però il narro,
> a darne tempo già stelle propinque,
> secure d'ogn' intoppo e d'ogne sbarro,
>
> nel quale un cinquceneto diece e cinque
> messo di Dio, anciderà la fuia
> con quel gigante che con lei delinque. (*Purgatorio* 33.40–45)

(for I see surely, and therefore I tell of it, stars already close at hand, secure from all check and hindrance, that shall bring us a time wherein a Five Hundred, Ten, and Five, sent by God, shall slay the thievish woman, with that giant who sins with her.)[10]

rather, that the Christian point of view and the return to poetry are inseparable aspects of the same reality. See Boyde, *Dante Philomethes and Philosopher: Man in the Cosmos* (Cambridge, 1981), 37.

[8]Dante *Monarchia* 1.4–10. See also Boyde, *Dante Philomethes and Philosopher*, 34 ff., for a summary and an attempt to situate the *Monarchia* in relation to the *Comedy*.

[9]Thus Reeves writes, in *Prophetic Future*, "The greatest exponent of an earthly beatitude under the rule of a single emperor was, of course, Dante. In his letter to the Prince and People of Italy in 1310 he hailed the coming of the Emperor Henry VII in almost messianic phrases and he saw the true freedom of Florence and the other cities of Italy in terms of their obedience to God's chosen vessel" (64). There is no suggestion in Reeves that Dante ever abandoned this point of view.

[10]The literature on DXV is, not surprisingly, enormous. See Singleton's notes and the bibliography contained therein (vol. 2, pt. 2, 813–15). As Singleton points out, Edward More made the assertion that this prophecy applies specifically to Henry VII (in *Studies*

In a similarly debated cryptic prediction at the beginning of the poem, the identity of the greyhound in *Inferno* 1 who will come "to save that fallen Italy for which the maid Camilla gave her life" (line 106) has provoked a good deal of scholarly speculation. So also have the references in the *Paradiso* which speak of an imminent judgment on the spiritual corruption of the day, for example the passage beginning at *Paradiso* 27.61.[11]

Since these cryptic references in the poem are tantalizingly apparent, there is something to be said for this search, but only so long as it does not claim to be the exclusive way to deal with apocalyptic resonances that are more widespread and fundamental. The *Commedia* is a philosophical poem, a poem of ideas, to be sure.[12] And among the most important of the issues and ideas the poem addresses profoundly is the question of how humans are to be governed. Moreover, Dante clearly was not satisfied with abstract and theoretical answers to this question; for he engaged it in the most specific terms. Throughout the *Commedia* he repeatedly refers to the politics of his day, and to be sufficient, his answers had to engage the turbulence of Florentine and Italian politics. As T. S. Eliot put it, "He is the least provincial [European poet]—and yet that statement must be immediately protected by saying that he did not become the 'least provincial' by ceasing to be local. No one is more local."[13] To speculate on Dante's answers to these cruxes in the poem is therefore to assume that Dante has a "local" answer for the universa¹ problems of government he raises in the poem.

But there is a danger in seeing the poem primarily from the perspective of its ideas—that of turning it into a kind of rhymed *Summa*, wherein the poetry exists for the sake of presenting ideas in a memorable form—for then one fails to take into account what is most distinctive about this poem as poem. One of the most fruitful ways of looking at the poetics of the *Commedia*, as much recent scholarship has shown, is to see how it focuses on the continuing conversion of Dante the pilgrim.[14] The fact that

in *Dante: Third Series, Miscellaneous Essays* [Oxford, 1903; reprint, 1968]). More comprehensive still is the *Enciclopedia Dantesca* article and bibliography (2:10–14) by Pietro Mazzamuto, who also accepts the identification of the DXV with Henry VII. Two other works contain seminal analyses and, through their notes, important bibliographic information: R. E. Kaske, "Dante's 'DXV' and 'Veltro,' " *Traditio* 17 (1961):185–252; and Albert L. Rossi, " 'A l'ultimo suo': *Paradiso* XXX and Its Vergilian Context," *Studies in Medieval and Renaissance History*, n.s., 4 (1981): 39–88.

[11]See Singleton, *Divine Comedy* 1. 2.17ff. and 3.2.433 for notes to these passages.

[12]Boyde, for example, begins his study of the poem with a comparison between Dante and Lucretius as a way of getting at the philosophical texture of the *Commedia* (*Dante Philomethes and Philosopher*, 1–40).

[13]T. S. Eliot, "A Talk on Dante," in *Dante in America: The First Two Centuries*, ed. A. Bartlett Giamatti (Binghamton, N.Y., 1983), 227. (First given at the Italian Institute in London and published in *The Adelphi* in 1951).

[14]The essays of John Freccero provide the most systematic of such treatments; they have been conveniently collected and published as *Dante: The Poetics of Conversion*, ed. Rachel Jacoff (Cambridge, Mass., 1986).

it is a poem of conversion, beginning with Dante the wayfarer in a dark wood of error and ending with his vision of God face to face, has implications that are now eliciting varied and impressive scholarship. The "ideas" in the poem, according to this approach, are no less important, but they must be understood as they are incorporated into the pilgrim's—and the reader's—continuing journey of discovery. Thus looking at the political matrix of the poem in this way minimizes the separation between earthly and heavenly ends, because in the process of conversion the two move closer together; and it also helps to account for those references to the Apocalypse which, while they are not connected to prediction of future imperial harmony, are yet systematic and consistent within the fabric of the poem. The question I want to address is What are the apocalyptic implications of taking the *Commedia* to be fundamentally a poem of conversion?

Like John, who begins the Apocalypse in exile on the island of Patmos and ends with a vision of the New Jerusalem, Dante the pilgrim begins in a dark wood of error and ends seeing God face to face. The poem's structure therefore implies a constant process of learning for the pilgrim. The most obvious consequence of this structure is that at any point along the way the pilgrim knows more than he did previously. One could emphasize, therefore, the way in which the pilgrim's knowledge and experience at any moment of the pilgrimage are built on what has come before, as grace builds on nature and Beatrice builds on Virgil. But from the point of view of the poetics of conversion, this is a less accurate and less satisfactory way to describe the pilgrim's progress than to say that at any point in the journey it continues to be necessary to reevaluate the past in the light of the present.[15] Throughout the *Commedia*, Dante as the paradigm Christian is called to a new way of life that requires nothing less than a transvaluation of his past life. This is what is meant by repentance, by conversion. As the pilgrim's responses in both hell and purgatory make clear, such reevaluation is clearly necessary to correct his moral deficiencies of both intellect and will. But even more important, it is necessary because, for the pilgrim, no present position can be adequate in the light of the infinite consummation toward which the poem is pointing. It is precisely because that consummation is infinite that no present position can be definitive.

Now since the poem frequently makes both direct and oblique reference to Dante's earlier works—to the *Vita nuova*, the lyrics, the *Convivio*, and the *Monarchia*—it is important to extend this approach to these works as

[15]Perhaps the most comprehensive of the recent studies that deal with Dante in these terms is Teodolinda Barolini's *Dante's Poets: Textuality and Truth in the Comedy* (Princeton, 1984). I have found the formulations of the contemporary theologian Stanley Hauerwas useful in describing this paradigm of the Christian life; see his essay "Character, Narrative, and Growth in the Christian Life," in *A Community of Character* (Notre Dame, Ind., 1981).

well, and to see these works too as, by definition, inadequate when understood in the light of conversion. To use the language of current criticism, the *Commedia* exists in a palinodic relationship with Dante's own earlier works. He refers to these works to show their inadequacy in the light of his movement toward God. It is not the case that he has come to see all of his previous positions as wrong, and it is surely not the case that he is no longer concerned with the issues they raise—the *Monarchia* still defines the matrix of political ideas of the *Commedia*, to take the example most relevant for our purposes. Rather, the good is superseded by the better, the better by the necessity to proceed continually toward the best.

According to the poetics of conversion, the sinners that Dante encounters in the *Inferno* must be viewed not simply as embodiments of a particular sin as classified and categorized by Cicero, Aristotle, and Thomas Aquinas. They are not simply sinners as such. Rather, their negative examples are alternative modes of behavior that speak directly to the pilgrim's life and that he must learn from and then apply that learning to the crucial decisions he must make as poet and statesman in his journey from exile to the heavenly Jerusalem. From Francesca da Rimini he must learn how not to read a book. From Farinata and Cavalcante, how not to engage in partisan politics. From Pier della Vigne, how not to respond to exile. Though sometimes less obvious, it is no less true that the souls he meets in *Paradiso* likewise present possible modes of behavior, this time positive models. In other words, when reading the *Paradiso*, readers must train themselves to see that the figures and their example are specifically directed to the pilgrim and what he has to learn, as well as being universal models of behavior, mirrors of cosmic order. One of the most vivid and significant examples of this typological connection occurs in the circle of the sun, in the life of Francis of Assisi that is retold by Thomas Aquinas in Canto 11. What is it that Dante the pilgrim should learn from Francis of Assisi?

The answer is in some ways as obvious as it is profound: "Francis can teach Dante that he must learn to do without." Not a bad lesson for the pilgrim to take with him into exile. In fact, the whole galaxy of Franciscan virtues has especial resonance for the pilgrim about-to-become-exile: from Francis, Dante has to learn analogous ways of becoming a mendicant, becoming a peacemaker, and becoming humble. Moreover, the stigmatized Francis, the saint who embodies a martyrdom without death, sets in motion a lesson that Dante learns more completely from his great-great-grandfather Cacciaguida in the next circle; the poetics of martyrdom, for Dante, begin with Francis. The quintessential Franciscan virtues, stressed over and over throughout an extensive narrative and pictorial tradition, are poverty and humility.[16] The linkage between these virtues and the

[16] For a convenient summary of the relevant literature, see John V. Fleming, *An Introduction to the Franciscan Literature of the Middle Ages* (Chicago, 1977).

needs of the pilgrim can be specified with perhaps even more precision. He must learn humility because by nature—by temperament and by personality—his besetting sin is pride. A proof text for this is to be found in *Purgatorio* 13, wherein Dante, having just emerged from the terrace of the proud to the terrace of the envious, says that when he returns he will not have to stay long here, but "far greater is the fear that holds my soul in suspense, of the torment below" (lines 136–37); but such a text merely confirms what a reading of the *Commedia* as a whole specifies. He must learn poverty because by circumstance he will become an exile and must deal with the powerlessness of exile. It is only through the virtue of poverty that, like John, he can learn how exile turns to vision.

The Francis who teaches these virtues to Dante is, of course, Bonaventure's Francis. In one of Dante's most brilliant and audacious displays of compression and synthesis, Bonaventure's *Legenda Major*—retold by Thomas Aquinas (who manages somehow both to be true to the letter and spirit of Bonaventure and to be true to himself, maintaining necessary distinctions while keeping Bonaventure's poetic energy)—becomes the channel through which pilgrim and reader learn about Francis.[17] It is important to point out that the story Bonaventure presents is not simply that of Francis, but of the apocalyptic Francis—Francis the forerunner of the last times, the figure of *renovatio* within the Church, the angel of the sixth seal. Quoting both Apocalypse 6:12 and 7:2, Bonaventure says:

> And so not without reason
> is he considered to be symbolized by the image of the Angel
> who ascends from the sunrise
> bearing the seal of the living God,
> in the true prophecy
> of that other Friend of the Bridegroom,
> John the Apostle and Evangelist.
> For "when the sixth seal was opened,"
> John says in the Apocalypse,
> "I saw another Angel
> ascending from the rising of the sun,
> having the seal of the living God."[18]

It is likewise important to point out that Dante the poet does a good deal to guarantee that this apocalyptic energy remains in *his* (that is to say Bonaventure's, that is to say Thomas's Bonaventure's) portrait of Francis.

[17]The complexity of the rhetorical strategies involving Dante, Thomas, and Bonaventure in the circle of the sun has been treated in an excellent study of these cantos by Teodolinda Barolini, "Dante's Heaven of the Sun as a Meditation on Narrative," *Lettere Italiane* 40 (1988): 3–36.

[18]*Bonaventure: The Soul's Journey into God, The Tree of Life, The Life of Francis,* trans. Ewert Cousins (New York, 1978), 181.

That energy is present, for example, in the solar imagery with which the life of Francis begins in *Paradiso* 11:42 and following. The image is taken from the apocalyptically charged prologue to the *Legenda Major*, which is in part a reference to Apocalypse 7:2. Thus Dante explicitly and emphatically calls attention to the apocalyptic dimensions of Francis's life. Apocalyptic energy is present as well in an iconographically precise connection between Beatrice's appearance in this canto (within the sun and surrounded by a crown of twelve stars, that is, the twelve luminaries of the heaven who form a circle of light above Dante and Beatrice) and the Woman clothed with the sun of Apocalypse 12: "And a great sign appeared in the heavens: a woman clothed with the sun, and the moon was under her feet, and upon her head a crown of twelve stars."[19] It is present most of all in the description of the stigmatization of Francis, which is, among other things, striking visual proof for both Bonaventure and Dante that Francis is indeed the angel of the sixth seal.

The stigmatization of Francis is the climax of Dante's description even as it is the climax of Francis's life:

> Nel crudo sasso entra Tevero e Arno
> da Cristo prese l'ultimo sigillo
> che le sue membra due anni portarno. (*Paradiso.* 11:106–8).

(Then on the harsh rock between Tiber and Arno he received the last seal which his limbs bore for two years.)

From the perspective provided by the Apocalypse, this is certainly an interesting way to describe the site of Francis's reception of the stigmata, La Verna, which is, after all, a mountain in Tuscany and not an island rock. But Dante's image suggests that Francis is, like John in exile on Patmos, on an island. The apocalyptic resonances of the passage go well beyond this, however. Defining the stigmata as the final seal explicitly refers the reader to the other seals that help define the meaning of Francis's life. The previous lines of this canto note how Francis receives the first seal along with permission from Pope Innocent III to found the order and receives the second seal with the approval of the rule of 1223 by Pope Honorius. In each case, a forceful metonymy defines the meaning. The document represents the historical fact, the seals from the popes authenticating the order's foundational documents. The visual daring of the third seal is thus heightened in a rich visual pun, the blood-red wounds of the stigmata being compared with the red wax seals of the documents. The force of the comparison is that the stigmata as seal authenticates Francis's likeness to Christ, just as the papal seal authenticates the rules for the order. Dante

[19]See Rebecca S. Beal, "Beatrice in the Sun: A Vision from Apocalypse," *Dante Studies* 103 (1985): 57–78, esp. 58.

compresses one of the central ideas of the *Legenda Major:* Francis has become a document to be read, a document written by God and authenticated by this seal, which is at the same time proof of his likeness to the crucified Christ.

Of equal importance is another juxtaposition Bonaventure forcefully articulates throughout the *Legenda.* He equates the sealing-through-the-stigmata with the angel of the sixth seal from Apocalypse 7, thus giving an apocalyptic meaning to Francis's life that is as unmistakably clear and forceful. Bonaventure identifies Francis as the angel of the sixth seal three times in the course of the *Legenda Major:* in the Prologue, where the sophisticated theology of the work is systematically laid out; in the fourth chapter, where the image of the stigmata is connected with the growth, development, and ultimate meaning of the order; and most important for our purposes, in the thirteenth chapter, which describes the reception of the stigmata at length.[20]

In this way of reading, Francis himself is a sealed document and thus can be understood as a more explicit and self-conscious embodiment of what Dante the poet would have us see in the *Commedia* as a whole: each character and event a document written by the hand of God, to be read at continually deepening levels. The typology of conversion, relating, as it does, Francis's life to Dante's, would affirm that the character about whom this is most emphatically and definitively true is Dante the pilgrim himself. To learn humility, poverty, and peacemaking from Francis is thus to learn how to turn himself into a book to be read by his readers. The Apocalypse itself provides a possible support for this way of reading, insofar as it is the revelation of Jesus Christ: both a document and a revelation— Christ reveals the vision to John, but the vision also reveals Christ, so that both the book and Christ are being read.

This connection between what Dante learns and the apocalyptic language that often accompanies his growth can also be seen by moving forward in the *Paradiso* from the circle of the sun to the circle of Mars. I have already alluded to a rich complementarity between Francis and Cacciaguida as figures from whom Dante must learn, figures whose lives and lessons he must bring into the present and carry with him into exile. In the case of Francis, Dante must "learn to do without." In the case of Cacciaguida, he must learn first, how to be a crusader, which becomes another way of learning how to turn his exile into a pilgrimage. He must learn to be a crusader with the pen rather than with the sword, of course, which is precisely the analogical link by which he can learn that his exile might become a crusade, and his crusade might become a pilgrimage, again by a

[20]A study of the apocalyptic energies of the *Legenda Major* has recently been completed by Richard Kenneth Emmerson and myself: *The Apocalyptic Imagination in Medieval Literature* (Philadelphia, 1992), chap. 2 ("The *Legenda Maior:* Bonaventure's Apocalyptic Francis"). See also my "Dante and Francis," *Franciscan Studies* 42 (1982): 96–114.

typological connection with Cacciaguida, whose crusade was also an exile from Florence and his pilgrimage both to the earthly and to the heavenly Jerusalem:

> "Poi seguitai lo 'mperador Currado;
> ed el mi cinse de la sua milizia
> tanto per bene ovrar li venni in grado,
> Dietro li andai incontro a la nequizia
> di quella legge il cui popolo usurpa,
> per colpa d'i pastor, vostra giustizia.
> Quivi fu'io da quella gente turpa
> disviluppato dal mondo fallace,
> lo cui amor molt'anime deturpa;
> e venni dal martiro a questa pace." (*Paradiso* 15:139–48)

("Afterward I followed the Emperor Conrad, who girt me with his knighthood, so much did I win favor by good work. I went, in his train, against the iniquity of that law whose people, through fault of the Pastors, usurp your right. There by that foul folk was I released from the deceitful world, the love of which debases many souls, and I came from martyrdom to this peace.")

The pilgrim must learn more fully from Cacciaguida how to be a martyr, even as he began to learn this lesson from Francis in the previous circle. (And once again, John provides a silent model, since he too is a martyr as well as an exile, a fact that is emphasized in those illuminated manuscripts that are framed by his *vita*.)[21] Cacciaguida suffered the literal martyrdom of the crusader, Francis the spiritual martyrdom of the stigmata. Dante will suffer the spiritual martyrdom of his exile, but in his exile he will also be a crusader. As the cross is sealed on Francis by the stigmata, which is at the same time the apocalyptic sign of the angel of the sixth seal in the circle of the sun, so is Dante similarly sealed by the cross that is the dominant image and apocalyptic sign of the circle of Mars.

When the pilgrim ascends to the circle of Mars, he sees rays of light "crossed in the holy sign / which quadrants make when joining in a circle" (*Paradiso* 14:101–2) and learns that the rays are themselves made of the souls of the martyrs who are the inhabitants of Mars. And as the tenor of the discussion thus far has strongly suggested, it is here that Dante learns that he must take up his own cross. But the cross that Dante first sees and then literally becomes part of is much more than a planetary memorial of the cross that was the actual instrument of Christ's martyrdom: the cross that is to imprint its seal on the pilgrim in this circle is the escha-

[21]For example, Chantilly, Musée Condé MS. 28; El Escorial, Biblioteca del Monasterio MS E. Vitr. V; Eton College Library MS. 177; London, British Library MS Add. 22493. For a listing of these manuscripts, see Richard Kenneth Emmerson and Suzanne Lewis, "Census and Bibliography of Medieval Manuscripts Containing Apocalypse Illustrations, ca. 800–1500," pt. 2, *Traditio* 41 (1985): 370–409.

tological sign of the Son of Man, the cross imprinted on the cosmos, the apocalyptic cross of Christ's final victory and Last Judgment. Though there is no need to rehearse in detail what Jeffrey Schnapp has done so splendidly in imprinting the eschatological cross so permanently onto our reading of these cantos, it is profitable and necessary to draw some conclusions from his work.[22]

First, the apocalyptic connections between the two circles, of the sun and Mars, are significant. What Francis embodies in the circle of the sun, the pilgrim learns that he too must attempt in the circle of Mars. Francis, as Bonaventure was able to definitively show, was not just a saint, but unique among the saints, a saint among saints; and it is totally appropriate that Dante learns how he too can be a document for others to read.[23] Just as Bonaventure was concerned with Francis's place in a comprehensive scheme of salvation history, so Dante the poet attempts to show that understanding Dante the pilgrim as a book to be read allows us to read him in tandem with the book of the universe, that the twin focuses of the poem, the personal and the cosmological, are parts of the same reality.

Second, these two interconnected examples extend and solidify my hypothesis on Dante's use of apocalyptic imagery throughout the *Commedia*. The *Commedia* viewed as a whole is about the growth of a pilgrim who starts in a dark wood of error and ends seeing God face to face. At certain places along the way, that growth is more explicit, more self-conscious; that is, there are moments throughout the poem where it is easier to see the growth of the pilgrim as the explicit rather than the implied subject of a given canto. It is in precisely those places that the apocalyptic imagery of the *Commedia* is most in evidence. I suggest that this it not fortuitous, that in fact this apocalyptic imagery is precisely intended to fix the pilgrim's personal growth within a cosmic scheme.

The example that most clearly indicates this intention in the *Inferno* is Canto 19, the canto of the simoniac popes, a canto studded from beginning to end with imagery taken directly from the Apocalypse. To take the most striking instance, though by no means the only one, the denunciation of the corruption and degeneracy of the papacy is informed by the language of Apocalypse 17:1–2: "Come, I will show thee the condemnation of the great harlot who sits upon many waters, with whom the kings of the earth have committed fornication." Dante's appropriation of this imagery is rather precise:

[22]Schnapp's discussion of the eschatological meaning of the cross also contains in passing valuable references to the way in which the language of the Apocalypse is present in the *Commedia* (*Transfiguration of History*, e.g., 109, 146).

[23]In "Dante and Francis," I suggest that "the pilgrim himself is indeed a work of art to be read, literally insofar as he is the subject of the *Commedia*, but also allegorically: he is a book to be read with full Franciscan implications. . . . We must learn to read Dante himself both as the work of art-in-progress whose model is the souls in *Purgatorio* X and XI, and the finished work of art whose model is the Francis of *Paradiso* XI" (113–14). See also Emmerson and Herzman, "Bonaventure's Apocalyptic Francis," chap. 2 in *Apocalyptic Imagination*.

Di voi pastor s'accorse il Vangelista,
 quando colei che siede sopra l'acque
 puttaneggiar coi regi a lui fu vista;
quella che con le sette teste nacque,
 e da le diece corna ebbe argomento,
 fin che virtute al suo marito piacque. (*Inferno* 19:106–11)

(It was shepherds such as you that the Evangelist had in mind when she
that sitteth upon the waters was seen by him committing fornication
with the kings: she that was born with the seven heads, and from the ten
horns had her strength, so long as virtue pleased her spouse.)

The obvious reason for this apocalyptic imagery is that the degeneration of
the papacy in the present, which is the subject of the canto, is meant to be
seen as a foreshadowing, an adumbration of the evils of the last days. Sim-
ilarly, the judgment that Dante places on these popes is meant to be seen
as an adumbration of the Last Judgment. In this canto the "clear echoes of
the Last Judgment give strength to Dante's present and 'local' denuncia-
tion of the perversion of the Spirit in his own time by giving it the defin-
itiveness and finality of the consummation of Christian history."[24]

Again, it is important not to see this as the only purpose of the canto's
apocalyptic imagery and thus to overlook the way in which this imagery
is also related to the pilgrim's growth, a growth that is conspicuously a
part of the canto's movement, so much so that more than any other canto
in the *Inferno*, this one is a microcosm of the poem as a whole: Dante
moves from ignorance to knowledge, from literal incomprehension to spir-
itual vision. The judgment that frames the canto is appropriate to this
growth: at the beginning, the poet announces the trumpet of judgment, a
judgment clearly related to the sounding of the seventh trumpet of Apoc-
alypse 11:15–18. At the end, there is a less obvious but equally important
allusion to judgment, an oblique but nonetheless unmistakable reference
to the separation of the sheep from the goats of Matthew 25:31–33, one of
the most important apocalyptic passages in Scripture not taken from the
Apocalypse:

Quivi soavemente spuose il carco,
 soave per lo scoglio sconcio ed erto
 che sarebbe a le capre duro varco. (*Inferno* 19:130–32)

(Here he gently set down his burden, gently because of the rugged and
steep crag, which would be a hard passage for goats; from there another
valley was disclosed to me.)

The goats are those who have been left behind, but Dante is a sheep who
continues on his journey. From the perspective of the present action of the

[24]Emmerson and Herzman, *Apocalyptic Imagination*, 410.

poem, the pilgrim in this canto comes to a greater awareness of sin, which allows him to distance himself for the first time from the sinners he encounters, literally and figuratively. At the same time, Dante's separation from the goats and his forward movement toward the bottom of the *Inferno* points to that moment when judgment becomes a more explicit theme for the pilgrim, the moment when his own judgment and the imagery of the Last Judgment are fused: the coming of Beatrice and the apocalyptic pageant at the end of the *Purgatorio*.

Perhaps the best way to discuss this most apocalyptically charged moment of the *Commedia* is by referring to a recent study of the final cantos of the *Purgatory* by Peter Dronke.[25] He would have us play down the allegorical reading called for by the pageants of Church history presented in these cantos (what R. E. Kaske has called " 'history' as it exists in the mind of God, and history as it is allowed to work itself out in a material universe")[26] precisely in order to concentrate on the personal aspect of the poem, neglected in his view by the emphasis on the allegorical. But to do this, however much it may serve to direct our attention to important neglected aspects of the poem, is to ignore a great deal. For one thing, it is to ignore the most consistently detailed appropriation of apocalyptic imagery in all of literature, let alone medieval literature. (These images include, for example, the twenty-four Elders, the four Beasts, and the seven lamps of Apocalypse 4. They include reference to the Whore of Apocalypse 17 and the Beast of Apocalypse 13. They include the the symbolic processions of seven at the heart of the structure of the Apocalypse.) But equally important, the cantos connected with the coming of Beatrice at the end are the poet's most sustained effort to fuse the personal and the cosmic; thus to concentrate on one at the expense of the other is precisely to miss what they are fundamentally about.

Presenting nothing less than a pageant of all Christian history, these cantos develop their imagery directly from the Book of Apocalypse. Readers of the *Commedia* must be grateful for Kaske's detailed analyses of the apocalyptic sources of these cantos, in two characteristically learned articles.[27] I am all the more easily able to present an overview of the apocalyptic meaning of these cantos because of his detailed researches. Canto 29 includes a series of symbolic scenes recapitulating the various *aetates* of salvation history that are drawn from interpretation of the Apocalypse. Canto 32 presents a seven-part history of the tribulations of the Church suffered during its various *tempora*, based on the exegesis of the opening of

[25]Peter Dronke, *Dante and Medieval Latin Traditions* (Cambridge, 1986).

[26]R. E. Kaske, "Dante's *Purgatorio* XXXII and XXXIII: A Survey of Christian History," *University of Toronto Quarterly* 43 (1974): 211.

[27]In addition to Kaske's article cited in the previous note, see his "The Seven *Status Ecclesiae* in *Purgatorio* XXXII and XXXIII," in *Dante, Petrarch, Boccaccio: Studies in Italian Trecento in Honor of Charles S. Singleton,* ed. Aldo S. Bernardo and Anthony L. Pellegrini (Binghamton, N.Y., 1983), 89–113.

the seven seals of Apocalypse 6–8. In Canto 33, this history shifts to a veiled prophecy of the Second Coming, once again using the language of the Apocalypse, including references to the Beast of Apocalypse 17:8–9 and to the rivers of paradise of Apocalypse 22. Indeed, the appearance of Beatrice herself, central to these cantos and the entire *Commedia*, is structured to be read as a second coming carefully fashioned by the poet to parallel the apocalyptic Second Coming of Christ in judgment, and the judgment she imposes on the pilgrim brings to a climax a process begun in *Inferno* 19.

And yet Dronke's impulse is certainly right; these cantos do contain what are among the most personal revelations of the *Commedia*, certainly the most personal up to this point and arguably of the entire poem. The recapitulation of Christian history is paralleled in that the explicit conversion of the pilgrim recapitulates a history that is uniquely Dante's, from his earliest life to the fictional present. Moreover, Beatrice is his personal judge and savior and, in at least one important way, is conspicuously unlike the universal symbols drawn from the Apocalypse. Both as character and as symbol, she is the construct of the poet, someone whose very existence for us depends on the fact that Dante has inscribed her into his poem and given her a place of honor within a universal drama.[28]

Which is the center, Dante's conversion or the eschatological pageant? Clearly both, in the sense that each needs the other for its fuller explication. Thus here too, as in the examples from the *Paradiso* and *Inferno*, the personal and the cosmic come together and offer an interpretive paradigm for the entire poem: the need to understand one as it is intensified by the other. The *Commedia* is an apocalyptic text not primarily because of its cryptic references to the future but because it places the present in a coherent scheme of history by exploring the relationship between the particular and the general, between Dante's personal drama and God's plan for the governance of the cosmos. Conversion involves the continual attempt to try to see things more and more from a God's-eye perspective and, therefore, a continual attempt to see how human and divine perspectives merge. Dante's apocalypticism is one of the ways in which this attempt can be made.

Returning to the vexing puzzle of the DXV in the light of this ongoing process of the pilgrim's conversion brings me to some tentative final comments. If Dante has a historically specific person in mind, he has certainly make it difficult, if not impossible, for centuries of readers to crack the code and make a positive identification. All those who have chosen Henry VII as the answer to this crux have to deal with the somewhat embarrassing fact that he died in 1313 and therefore left Dante's supposed hope for a universal ruler frustrated. In this regard, the fictional date of the poem,

[28] And one with apocalyptic significance, as I have already suggested. In addition to the Woman clothed with the sun, it might be possible to see Beatrice—like the maiden in *Pearl*—as an image of the Bride of the Lamb.

1300, is far less important than the date of composition, which must be after 1313. But suppose Dante himself has no answer. What might at first seem a kind of critical cop-out can be seen to have a real thematic and structural consistency. If Dante has provided for his readers puzzles to which he has no answer in this and in similar cruxes, it is a sign that it is not for him (or for us) to know, a sign to wait in joyful hope for the return of Christ in majesty (as Kaske would have it),[29] and maybe to wait as well for the coming of a ruler who will set things right. Once again, the Apocalypse provides a model for the pilgrim—this time, in the patience in the martyrs of Apocalypse 6:10: "And they cried with a loud voice, saying 'How long, O Lord, holy and true, dost thou refrain from judging and from avenging our blood on those who dwell on the earth?'" Dante is, in this reading, no less passionately concerned with questions of justice and of how humans are to be ruled, but his concern is that of someone bearing witness, someone who has given up his compulsion to manipulate history. He stands as someone who, through his poem, is still passionately concerned to do his part, even while recognizing that he can wait for God to work it out in his own good time.

I have suggested that John—whose own "pilgrimage" leads him to the New Jerusalem, who is both scribe and visionary as Dante is both poet and pilgrim, who is both exile and even a kind of martyr—should be seen as a model for Dante.[30] We can also recognize that the Apocalypse provides the model for Dante's open-ended patience and waiting. Do I finally want to suggest, then, that the Apocalypse was directly and consciously understood by Dante as a model for the *Commedia*? However speculative such an assertion must remain, what is not speculative is that Dante saw himself writing in imitation of the Bible. By reminding ourselves that the Apocalypse is not only a recapitulation of Church history but also a recapitulation of the Bible itself,[31] we allow ourselves to see the Apocalypse as a key text in our attempts to understand the *Commedia* on ever-deeper levels.

[29] In "Dante's 'DXV' and 'Veltro,' " Kaske argues, passim, for the sign as an adumbration of the Second Coming and against the identification with Henry VII. But see Rossi, "*Paradiso* XXX and Its Vergilian Context," for cautions about ignoring the political-imperial dimensions of the text.

[30] For John as scribe and visionary, see Barbara Nolan, *The Gothic Visionary Perspective* (Princeton, 1977), 66.

[31] So that, as Jesse Gellrich writes in *The Idea of the Book in the Middle Ages* (Ithaca, N.Y., 1985): "What Thomas of Celano said in the thirteenth century of the Book of Apocalypse was the implied understanding of the Bible from writings of the earliest fathers of the church. Apocalypse, said Thomas 'is the book in which the total is contained' ('Liber . . . in quo totum continetur')" (32).

Contributors

DAVID BURR is Professor of History at Virginia Polytechnic University. He has worked extensively in the history of Franciscan thought in the Middle Ages, with a special concentration on the figure of Peter Olivi. His most recent book is *Olivi and Franciscan Poverty: The Origins of the "Usus Pauper" Controversy* (Philadelphia, 1989).

MICHAEL CAMILLE is Associate Professor of Art History at the University of Chicago. His work, applying the "new art history" to medieval art, includes studies of medieval literacy, the relationship of text and image, and visual narratives in illuminated manuscripts. His first book is *The Gothic Idol: Ideology and Image-Making in Medieval Art* (Cambridge, 1989).

YVES CHRISTE is Professor of the History of Art at the University of Geneva. He specializes in the iconography of the divine theophanies, of the Last Judgment, Apocalypse, and more recently, of Genesis. He has published *Les grands portails Romans* (Geneva, 1969), *La vision de Mathieu* (Paris, 1973); and *La vision de saint Jean: Sens et développement des visions synthétique de l'Apocalypse* (Paris, 1993).

E. RANDOLPH DANIEL is Professor of Medieval History at the University of Kentucky, Lexington. He is well known for his studies of Joachim of Fiore and Franciscan apocalypticism and has published a critical edition of the first four books of Joachim's *Liber de Concordia* (Philadelphia, 1983).

RICHARD K. EMMERSON is Professor and Chair of English at Western Washington University. Interested in the intersection of medieval religion, art, and literature, he has published on drama, illuminated Apocalypse manuscripts, and visionary poetry. His books include *Antichrist in the Middle Ages* (Seattle, 1981) and *The Apocalyptic Imagination in Medieval Literature*, coauthored with Ronald Herzman (Philadelphia, 1992).

C. CLIFFORD FLANIGAN is on the Comparative Literature and Medieval Studies faculties at Indiana University. He has written widely on medieval

drama and liturgy and, together with Thomas Binkley, created historical reconstructions of a number of medieval Latin liturgies and music dramas.

PAULA FREDRIKSEN is the Aurelio Professor of Scripture in the Religion Department at Boston University. Working in ancient Mediterranean Christianity, she has published on Paul, Hellenistic Judaism, conversion, and Augustine. Her most recent book is *From Jesus to Christ: The Origins of the New Testament Images of Jesus* (New Haven, 1988).

RONALD B. HERZMAN is State University of New York Distinguished Teaching Professor at the College at Geneseo. His teaching and research interests focus on Dante, Chaucer, and Franciscan literature. His most recent book is *The Apocalyptic Imagination in Medieval Literature*, coauthored with Richard K. Emmerson (Philadelphia, 1992).

DALE KINNEY is Professor of History of Art at Bryn Mawr College. Her research specialties are late antiquity and medieval Italy, especially the art of medieval Rome. Her publications on early Christian art and architecture include contributions to *Age of Spirituality*, ed. K. Weitzmann (New York, 1979), *Byzantine Studies/Etudes byzantines* 9 (1982), and *Milano, una capitale da Ambrogio ai carolingi*, ed. C. Bertelli (Milan, 1987).

PETER K. KLEIN is Professor of Art History at the University of Marburg and at the University of California, Los Angeles. He has published widely on medieval Apocalypse manuscripts, including *Der ältere Beatus-kodex Vitr. 14-1 der Biblioteca Nacional zu Madrid* (Hildesheim, 1976) and facsimiles and studies of the Trier and Douce Apocalypses.

ROBERT E. LERNER is Professor of History at Northwestern University and a Fellow of the Medieval Academy of America. He has made important contributions to the history of late medieval heresy and mysticism and also to the study of medieval apocalypticism, as illustrated in his book *The Powers of Prophecy* (Berkeley and Los Angeles, 1983).

SUZANNE LEWIS is Professor of Art History at Stanford University. She has published studies on early Christian architecture, as well as Byzantine and early medieval art. Her present major interest centers on text-image configurations in illuminated manuscripts of the Gothic period. Her most recent book is *The Art of Matthew Paris in the Chronica Majora* (Berkeley and Los Angeles, 1987).

BERNARD MCGINN is Naomi Shenstone Donnelley Professor of Historical Theology and the History of Christianity at the Divinity School of the University of Chicago. His major interests include the development of apocalyptic thought and the history of mysticism. The first volume of his four-volume history of Western Christian mysticism, *The Foundations of Mysticism*, appeared in 1991 (New York).

E. ANN MATTER is Professor of Religious Studies at the University of Pennsylvania. She is especially concerned with the history of medieval exegesis, notably in the Carolingian period. Her most recent book is *The Voice of My Beloved: The Song of Songs in Western Medieval Christianity* (Philadelphia, 1990).

KARL F. MORRISON is Lessing Professor of History and Poetics at Rutgers University and is a Fellow of the Medieval Academy of America. His many contributions to the intellectual history of the Middle Ages and Western Europe in general are widely known. Among the most noted of these is *I Am You: The Hermeneutics of Empathy in Western Literature, Theology, and Art* (Princeton, 1988).

PENN SZITTYA is Professor of English and Director of Medieval Studies at Georgetown University. He studies medieval English literature and is presently completing the volume on the *Pardoner's Tale* for the Chaucer Variorum. His first book is *The Antifraternal Tradition in Medieval Literature* (Princeton, 1986).

JOHN WILLIAMS is Professor of Fine Arts at the University of Pittsburgh. He specializes in medieval Spanish illuminated manuscripts. His publications include *Early Spanish Manuscript Illumination* (New York, 1977) and, most recently, with Barbara Shailor, a facsimile edition, *A Spanish Apocalypse: The Morgan Beatus Manuscript* (New York, 1991).

Name Index

Index of Biblical Citations

Library of Congress Cataloging-in-Publication Data

The Apocalypse in the Middle Ages / edited by Richard K. Emmerson and
Bernard McGinn.
 p. cm.
 Includes bibliographical references and index.
 ISBN 0-8014-2282-5 (alk. paper). — ISBN 0-8014-9550-4 (pbk. :
alk. paper)
 1. Bible. N.T. Revelation—Criticism, interpretation, etc.—
History—Middle Ages, 600–1500. I. Emmerson, Richard Kenneth.
II. McGinn, Bernard, 1937– .
BS2825.2.A833 1992
228'.06'0902—dc20

 92-52750